UNDERSTANDING ART: A CONCISE HISTORY

Lois Fichner-Rathus

The College of New Jersey

Australia • Brazil • Canada • Mexico • Singapore • Spain United Kingdom • United States Understanding Art: A Concise History Lois Fichner-Rathus

THOMSON

WADSWORTH

Publisher: Clark Baxter Senior Development Editor: Sharon Adams Poore Assistant Editor: Erikka Adams Editorial Assistant: Nell Pepper Development Project Manager: Julie Yardley Executive Marketing Manager: Diane Wenckebach Marketing Assistant: Kathleen Tosiello Marketing Communications Manager: Brian Chaffee Senior Project Manager, Editorial Production: Kimberly Adams Creative Director: Rob Hugel Executive Art Director: Maria Epes

© 2008 Thomson Wadsworth, a part of The Thomson Corporation. Thomson, the Star logo, and Wadsworth are trademarks used herein under license.

ALL RIGHTS RESERVED. No part of this work covered by the copyright hereon may be reproduced or used in any form or by any means—graphic, electronic, or mechanical, including photocopying, recording, taping, Web distribution, information storage and retrieval systems, or in any other manner—without the written permission of the publisher.

Printed in the United States of America 1 2 3 4 5 6 7 11 10 09 08 07

Library of Congress Control Number: 2006940184 ISBN-13: 978-0-495-10168-0 ISBN-10: 0-495-10168-0 Print Buyer: Rebecca Cross Permissions Editor: Joohee Lee Production Service: Lachina Publishing Services Photo Researcher: Linda Sykes Cover Designer: Tani Hasegawa Cover Image: © 2006 Sherrie Levine/ Jablonka Galerie, courtesy Museum Morsbroich, Leverkusen, Germany. Photograph © Nic Tenwiggenhorn, © 2006 Artists Rights Society (ARS), New York. Cover Printer: Courier Corporation/Kendallville Compositor: Lachina Publishing Services Printer: Courier Corporation/Kendallville

Thomson Higher Education 10 Davis Drive Belmont, CA 94002-3098 USA

For more information about our products, contact us at: Thomson Learning Academic Resource Center 1-800-423-0563

For permission to use material from this text or product, submit a request online at http://www.thomsonrights.com.

Any additional questions about permissions can be submitted by e-mail to **thomsonrights@thomson.com**.

CONTENTS

Preface vi

1. Introduction 1

What Is Art History? 2 Art in Context 2

Style 2

COMPARE + CONTRAST David's The Oath of the Horatii with Kruger's Untitled (We Don't Need Another Hero) 8

Subject Matter, Form, Content, Iconography 10 Subject Matter 10 Form 10 Content 10 Iconography 10

The Vocabulary Of Art 12 Visual Elements 12 Principles of Design 14 Mediums 14

2. The Art of the Ancients 17

Prehistoric Art 18 MAP 2-1 Prehistoric Europe 18 Paleolithic Art 18 Mesolithic Art 20 Neolithic Art 21 Art of the Ancient Near East 22 Sumer 22 MAP 2-2 The Ancient Near East 22 Akkad 24 Babylonia 25 Assyria 26 Persia 26 Egyptian Art 27 Old Kingdom 27 Middle Kingdom 31 New Kingdom 31 The Amarna Revolution: The Reign of Akhenaton and Nefertiti 32

A CLOSER LOOK King Tut: The Face That Launched a Thousand High-Res Images 33
Aegean Art 36
MAP 2-3 Greece (Fifth Century BCE) 36 The Cyclades 36 Crete 37 Mycenae 39
ARTTOUR Jerusalem 42

3. Classical Art: Greece and Rome 45

Greece 46 Geometric Period 46 Archaic Period 47

A CLOSER LOOK The Women Weavers of Ancient Greece 48 Early Classical Art 54 Classical Art 54 Late Classical Art 58 Hellenistic Art 60 The Etruscans 61 Architecture 62 Sculpture 62

Rome 62 *The Republican Period 63* **MAP 3-1** The Roman Empire (2nd century CE) 63

The Early Empire 66

COMPARE + CONTRAST Stadium Designs: Thumbs-Up or Thumbs-Down 68 *The Late Empire* 72

ARTTOUR Rome 74

4. Christian Art: From Catacombs to Cathedrals 77

Early Christian Art 78 The Period of Persecution 78 The Period of Recognition 79 Byzantine Art 79 San Vitale, Ravenna 80 Hagia Sophia, Constantinople 81 Later Byzantine Art 82

Early Medieval Art 82 *Carolingian Art 84* MAP 4-1 Europe (c. 800 CE) 84

Manuscript Illumination 85 Ottonian Art 85

COMPARE + CONTRAST Savoldo's *St. Matthew* with Two Carolingian *St. Matthews* 86

Romanesque Art 88 Architecture 89 Sculpture 91 Manuscript Illumination 92 Tapestry 93

A CLOSER LOOK Hildegard of Bingen 94

Gothic Art 95 Architecture 95 Sculpture 98

5. The Renaissance 102

The Renaissance102Fifteenth-Century Northern Painting102Flemish Painting: From Page to Panel102MAP 5-1Renaissance Europe (c. 16th century)102

German Art 106 The Renaissance in Italy 107 The Early Renaissance 107 Cimabue and Giotto 107 The Renaissance Begins, and So Does the Competition 109 Renaissance Art at Midcentury and Beyond 113 The High Renaissance 115 High and Late Renaissance in Venice 121

COMPARE + CONTRAST The "Davids" of Donatello, Verrocchio, Michelangelo, and Bernini 122 High and Late Renaissance outside Italy 127 Mannerism 128 ARTTOUR Florence 130

6. The Age of Barogue 133

The Baroque Period in Italy 134
MAP 6-1 Europe (mid-18th century) 134
A CLOSER LOOK Art Meets History: The Funeral of a Pope 136
COMPARE + CONTRAST Susannah and the Elders by Tintoretto and Gentileschi 142
The Baroque Period Outside Italy 144
Spain 144
Flanders 146
Holland 147

France 150 England 152 The Rococo 153 Enlightenment, Revolution, the Scientific, and the Natural 154 ARTTOUR London 156

7. Art Beyond the West 159

MAP 7-1 Art beyond the Western Tradition 160 African Art 160 **COMPARE + CONTRAST** Picasso's Nude with Drapery with an Etoumba Mask 163 Oceanic Art 165 Polynesia 166 Melanesia 166 Native Art of the Americas 167 Native Arts of Mexico 167 A CLOSER LOOK Cambios: The Clash of Cultures and the Artistic Fallout 170 Native Arts of Peru 171 Native Arts of the United States and Canada 172 Islamic Art 173 Indian Art 174 Chinese Art 178

Japanese Art 180

8. Modern Art 185

Neoclassicism 186 Neoclassical Sculpture 188 Neoclassical Architecture 188

Romanticism 189

COMPARE + CONTRAST Ingres's Grande Odalisque, Delacroix's Odalisque, Cézanne's A Modern Olympia, and Sleigh's Philip Golub Reclining 192 The Academy 194

Realism 195

 COMPARE + CONTRAST Titian's Venus of Urbino, Manet's Olympia, Gauguin's Te Arii Vahine, Valadon's The Blue Room, and Eidos Interactive's Lara Croft 200
 Impressionism 202

Photography 206 Portraits 206

Photojournalism 207 Art Photography 207 Postimpressionism 208

A CLOSER LOOK Why Did van Gogh Cut Off His Ear? 212

Expressionism 214

American Expatriates 216

Americans in America 217

A CLOSER LOOK Weaving Together Biblical and

Personal Stories 219 The Birth of Modern Sculpture 220 Art Nouveau 220 Architecture 220 ARTTOUR Paris 224

9. The Twentieth Century: The Early Years 227

The Fauves 228 Expressionism 230 Die Brücke (The Bridge) 230 Der Blaue Reiter (The Blue Rider) 231 The New Objectivity (Neue Sachlichkeit) 232 Cubism 232 Analytic Cubism 234 Synthetic Cubism 236 Cubist Sculpture 236 Futurism 238 A CLOSER LOOK The Illusion of Motion: Explosions in the Shingle Factory 240 Early Twentieth-Century Abstraction in the United States 242 Early Twentieth-Century Abstraction in Europe 244 Constructivism 244 Fantasy and Dada 246 **COMPARE + CONTRAST** Leonardo's Mona Lisa, Duchamp's Mona Lisa (L.H.O.O.Q.), Odutokun's Dialogue with Mona Lisa, and Lee's Bona Lisa 248 Dada 250 Surrealism 251 Architecture 253 The Bauhaus 253 Frank Lloyd Wright 254 **ARTTOUR** Chicago 256

10. Contemporary Art 259

Contemporary Art 260 Painting 260 The New York School: The First Generation 260

Turning the Corner toward an Abstract Expressionism 260 Focus on Gesture 262 Focus on the Color Field 265 Combined Gesture and Color-Field Painting 266 The New York School: The Second Generation 268 Color-Field Painting 268 Figurative Painting 269 Pop Art 271 Hyperrealism 273 Op Art (Optical Painting) 275 New Image Painting 275 Pattern Painting 277 The Shaped Canvas 277 Neo-Expressionism 278 Sculpture 280 Sculpture at Mid-Twentieth Century 280 Contemporary Figurative Sculpture 281 Contemporary Abstract Sculpture 283 **COMPARE + CONTRAST** Delacroix's *Liberty Leading* the People, Kollwitz's Outbreak, Catlett's Harriet, and Goya's And They Are Like Wild Beasts 286 Feminist Art 288 Site-Specific Work 291 A CLOSER LOOK Guerrilla Girl Warfare 292 A CLOSER LOOK Christo and Jeanne-Claude: The Gates, Project for Central Park, New York, 1979-2005 294 Video Art 296 Digital Art 298 Architecture 300 Modern Architecture 301 Postmodern Architecture 304 Deconstructivist Architecture 304 A Portfolio of Art in the New Millennium 307 A CLOSER LOOK Jacques-Louis David on a Brooklyn Tennis Court 310 **ARTTOUR** New York 316

Glossary 318

Index 322

PREFACE UNDERSTANDING ART: A CONCISE HISTORY

The history of art can be taught with different emphases. An instructor may concentrate on the evolution of styles, on the chronology of monuments, on the historical context of a work of art, or some measure of each. Art history can feel like a whirl-wind tour, or the opposite: a painstakingly detailed analysis of the whos, whats, and wheres behind a work of art. I, for one, like to keep the history in the history of art, despite the fact that so many of my students initially balk at this approach. I can see their reasons for what they are—too much information, too many dates, men and their wars, irrelevant facts, boring characters. "But," I counter, "history is a story, and who doesn't like a story?"

It is particularly troublesome when a certain trepidation about studying history finds its way into my art history classes. Not only is this a great story, I think to myself, but it has lots of pictures. Sometimes, somewhere along the line, there is a disconnect between the teacher's enthusiasm for the subject and the contagiousness that ought to infect the student. My approach to teaching and writing about art and art history has always aimed to create or reinforce that connection. Art history is fascinating and it is fun. Who doesn't like a story stocked with intrigue, personalities, money, faith, and power? Sounds like a miniseries to me.

Understanding Art: A Concise History is a compendium, not an encyclopedia. It contains, in brief form, the essential information on the chronology and context of art—concise and comprehensive at the same time. It is intended as a flexible framework for professors who may have their own cache of favorite materials, primary sources, and visual images. My desire is to collaborate with them, to do, as it were, some team teaching. It is also my desire to reach students with a text that is accessible and interesting to read. Some may go on to become art historians, but all, I hope, will go on to become museumgoers with a life-long interest in understanding art.

Features

Understanding Art: A Concise History contains unique features that stimulate student interest, emphasize key points in art history, and reflect the ways in which professors teach. **Compare and Contrast**[™] These features show two or more works of art side by side and phrase questions that help students focus on stylistic and technical similarities and differences. They parallel the time-honored pedagogical technique of presenting slides in class for comparison and contrast. Consider the "Compare and Contrast *Susannah and the Elders* of Tintoretto with that of Gentileschi" (see Chapter 6). Tintoretto and Gentileschi tell more or less the same Biblical story about Susannah, but we see that in Tintoretto's version, Susannah could be viewed as something of a temptress, whereas Artemesia Gentileschi portrays Susannah as a victim of prying eyes and lies.

Exercises on *ArtExperience Online* are directly linked to the Compare and Contrast features.

A Closer Look These features offer insights into artists' personalities and delve into various topics in greater depth. Chapter 2's "King Tut: The Face That Launched a Thousand High-Res Images" describes how contemporary scanning techniques have helped us to form a picture of the face of a ruler who lived some 3,300 years ago. Chapter 8's "Why Did van Gogh Cut Off His Ear?" offers a number of explanations, including psychoanalytic hypotheses, for why the postimpressionist mutilated himself. Chapter 10's "Christo and Jeanne-Claude: *The Gates, Project for Central Park, New York, 1979–2005*" highlights a monumental installation that transformed the winter heart of the city of New York.

These features are expanded upon further through Web links and InfoTrac[®] College Edition resources in *Art-Experience Online*.

ArtTours[™] The text includes ArtTours on the cities of Jerusalem, Rome, Florence, London, Paris, Chicago, and New York. Each ArtTour is rich in photographs and works of art. The ArtTours are no mere lists of works and sites and museums in these cities. Instead, the tours literally walk students through the cities, providing them with routes they can take to benefit from the cultural riches that are available.

The companion *Art Experience Online* expands on the ArtTours with helpful "travel guide" information, such as additional photos, maps, restaurant guides, and links to useful Web pages. The tours are meant to encourage students

to travel as well as to guide them once they have reached their destinations.

Quotations Quotations at the top of pages by artists, critics, and others allow students to "get into the minds" of artists and others in the art world. For example, Chapter 10, "Contemporary Art," includes quotations by Joseph Kosuth, Adolph Gottlieb, Lee Krasner, Willem de Kooning, Agnes Martin, Henry Moore, Jean Tinguely, Daniel Libeskind, *http://www.designboom.com/portrait/beecroft.html* (on the performance art of Vanessa Beecroft), Ken Feingold, Sarah Lucas, William Pope.L, and Kara Walker.

Glossary Key terms are boldfaced in the text and defined in a glossary at the end of the textbook.

Ancillaries

ArtExperience Online Available with every new copy of the book, this online resource includes most of the images that are shown and discussed in the text. Resources include:

Flashcards containing almost every image from the text enable students to create study sets, hide or show the caption information for review purposes, and take notes that they can save on their computer hard drives.

Interactive Modules explore the foundations of art covering visual elements, principles of design, style, form, and content—illustrating the function or topic and then providing interactive exercises or questions.

In the Studio video segments give students a real-life look at studio art classes, including interviews with students and professors discussing the art-making process.

Compare & Contrast expands on the text feature with interactive exercises enabling students to check their knowledge and progress.

Art Tours expand on the text feature with "travel guide" information.

In addition, the Web site offers: brief "Field Trips," such as photos of Monet's garden at Giverny, the Piazza della Signoria in Florence, and Olmsted's Central Park in New York City, tutorial quizzing, museum links, InfoTrac College Edition exercises, Internet activities, artist flashcards with pronunciations, and more.

Student Resources

Study Guide by Ruth Pettigrew (Colorado State University) helps students to learn the terms, works of art, and concepts in each chapter. The assignments and projects foster an understanding of art in different media, time periods, and styles.

Thinking and Writing About Art, written by Lois Fichner-Rathus, enhances students' critical thinking and interpretive skills.

Instructor Resources

Multimedia Manager brings digital images into the classroom with this one-stop lecture and class presentation tool that makes it easy to assemble, edit, and present

customized lectures for your course using Microsoft Power-Point. The CD-ROM provides high-resolution images (maps, diagrams and many of the fine art images from the text) in PowerPoint presentation format, or in individual file formats compatible with other image-viewing software. The **zoom feature** allows you to magnify selected portions of an image for more detailed display in class. You can also easily customize your classroom presentation by adding your own images. The Multimedia Manager also includes the Resource Integration Guide, an electronic Instructor's Manual and a Test Bank with multiple-choice, matching, short-answer, and essay questions in ExamView computerized format. Also included are text-specific Microsoft PowerPoint slides created for use with JoinIn[™] on Turning Point[®] software for classroom personal response systems ("clickers").

Instructor's Manual and Test Bank by William Allen (Arkansas State University) includes summaries and methods for approaching the chapters, in addition to test questions.

ExamView[™] Computerized Testing helps create, deliver, and customize tests and study guides (both print and online) in minutes with this easy-to-use assessment and tutorial system. ExamView offers a Quick Test Wizard and an Online Test Wizard, step-by-step guides through the process of creating tests. The software's unique capability shows you the test onscreen exactly as it will print or display online.

Slide Set: A set of slides contains 150 images from the text. Webtutor Toolbox for Blackboard or Web CT: Preloaded with content and available via a free access code when packaged with this text, WebTutor ToolBox pairs all the content of this text's Book Companion Web site with sophisticated course management functionality. You can assign materials (including online quizzes) and have the results flow automatically to your grade book. WebTutor ToolBox is ready to use as soon as you log on—or you can customize its preloaded content by uploading images and other resources, adding Web links, or creating your own practice materials. Students only have access to student resources on the Web site. Instructors can enter an access code for passwordprotected Instructor Resources.

Acknowledgments

I am indebted to the support and expertise of a fine group of Thomson Higher Education/Wadsworth publishing professionals: Clark Baxter, Publisher; Sharon Adams Poore, Senior Development Editor; Erikka Adams, Assistant Editor; Nell Pepper, Editorial Assistant; Julie Yardley, Developmental Project Manager; Diane Weckenbach, Executive Marketing Manager; and Kim Adams, Production Manager.

Lois Fichner-Rathus

To the memory of my mother

Dedication

Lois Fichner-Rathus

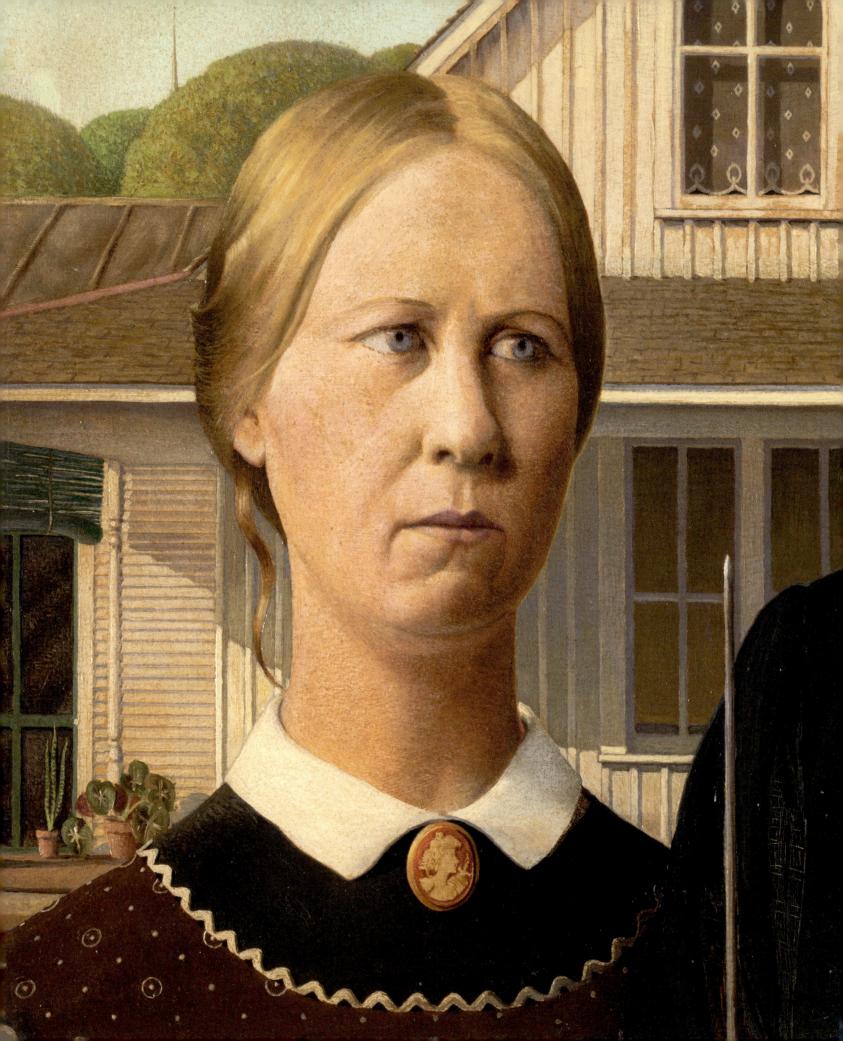

INTRODUCTION

"What does art history have to do with art?" Imagine yourself a student, interviewing an artist for the first time—the artist on whom you would focus your entire program of research for the next several years. Imagine your excitement at meeting face-to-face, your desire to convey your seriousness of purpose, your respect, and your admiration for the artist's work. Then, after some cursory though friendly dialogue, imagine being challenged with this disconcerting question: "What does art history have to do with art?"

C onsider art and history. On the face of it, it would seem that they don't go together. Art is a concrete thing. You can touch it, hold it, see it, walk through it (as in architecture) or around it. Art can be experienced in the here and now, whether it dates back 5000 years or was just completed a week ago. History, on the other hand, is a record and analysis of events that occurred at a specific point in time. We can look back on events in our lifetime that already have been enshrined in history, or, by reading history, we can be transported to the more distant past. History, by definition though, cannot be experienced in the here and now. It's looking *back*, not looking *at*. And when someone walks into a museum and looks at a painting, or studies the sculpture inside a cathedral, or gazes up into the vast spaces of a building interior, the experience is their own. After all is said and done, history is a story written by someone else. Thus, it is legitimate to ask, "What does art history have to do with art?" Do art historians tell a story at the expense of a viewer's distinct, direct experience of the work of art itself?

Jack Tworkov was the artist and I was the student. As an Abstract Expressionist who morphed into a trailblazer in geometric abstraction and served as Chair of the Yale School of Art, Tworkov was not an artist with an aversion for speaking and writing about art—his or anyone else's. On the contrary, he was an articulate spokesperson for contemporary art, a theoretician, a savvy critic, a brilliant teacher. Why, then, the question? Did it serve as a classic cautionary tale? That is, be wary always of allowing the explanation to take precedence over the art, to take on a life of its own. The art is where you start. Pablo Picasso admonished "everyone" for needing to "understand art." On the other hand, he warned, "it is not sufficient to know an artist's works—it is also necessary to know when he did them, why, how, under what circumstances." Keeping a balance between the two ends of the spectrum lies at the heart of these artists' concerns, and mine in presenting the material in this book to you-art and its history.

WHAT IS ART HISTORY?

Art history, at its most concrete, is a story of art that stretches back to the earliest forms of visual expression by humans. That art can be in the form of an object or a building. It can consist of a monumental mural glorifying a wealthy Renaissance pope or a Stone Age cave painting that was likely never even viewed as art by its makers.

Art historians examine works of art from many different angles—the historical and cultural contexts in which art comes into being, artistic or period styles, the manipulation of materials, the subject matter with its overt or hidden meanings. I tell my students that art history is the most interdisciplinary of disciplines. In order to comprehend the complex circumstances that give birth to a work of art, art historians reach into history, philosophy and religion, sociology and psychology, cultural studies, literary criticism, gender studies, and other scholarly disciplines.

Art in Context

The core of the discipline of art history is the investigation of art in its context. When was it made? Where? What was its original, intended location and function? What was going on at the time and in the place where it was made? For whom was it made? Who paid for it? Anyone can appreciate a work of art for the response it might stimulate. You can like something or think it's awful. You can admire it on many levels having nothing to do with the context in which it was created. But your experience of the work, historians would argue, will be enhanced by the knowledge of its context.

Jack Tworkov, who at one time shared a studio with another Abstract Expressionist, Willem de Kooning, essentially stopped working during the World War II years in order to participate in the war effort. In so doing, he removed himself from the core of the New York art scene at its most propitious moment. One might ask how that decision affected his art and, indeed, the rest of his career? Tworkov also worked on the Fine Arts Project of Franklin Roosevelt's Works Progress Administration (WPA). One might ask how that experience affected the artists who participated or the works of art that they produced under the program.

STYLE

Style is at once the most concrete and intangible of all of the components of an artwork. It is the signature look of an artist's work—that something that enables us to differentiate between a Rubens and a Rembrandt, a Picasso and a Pollock. It is the distinctive mode of expression that results from an individual's manipulation of the elements and principles of art and design. Artists' styles might be consistent over time, change in an internally consistent manner, or move in radically different directions. "How can you say one style is better than another?" asked Pop artist Andy Warhol. "You ought to be able to be an Abstract-Expressionist next week, or a Pop artist, or a realist, without feeling you've given up something."

Tworkov's early work exhibits a certain realism or naturalism along with a fluid hand (Fig. 1-1). By the mid-1940s and 1950s, though, he was working in the abstract expressionist idiom, combining broad gestural brushstrokes with a mixed palette (Fig. 1-2). These works, however, were not without structure; they had an architectural look, so to speak. When Tworkov moved toward geometric abstraction, he relied on mathematical relationships to organize his pictorial space (Fig. 1-3). His transitional paintings were just that—in between. He introduced a geometric architecture to his canvases—a precise mathematical grid—and filled the spaces with a loose "handwriting" of small, painterly strokes.

Artists can be said to work more broadly in a **linear style**, a **painterly style**, a **realistic style**, or an **abstract style**. This use of the word *style* describes the relationship between the artist's concepts and approach to the medium. Style also refers to a recurrence of artistic or pictorial 1-1 JACK TWORKOV

Untitled (Study for View of Bay, Provincetown) (ca. 1931). Watercolor and ink on paper, $10^{3}/4'' \times 16^{1}/8''$. © Estate of Jack Tworkov, courtesy of Mitchell Innes & Nash, New York.

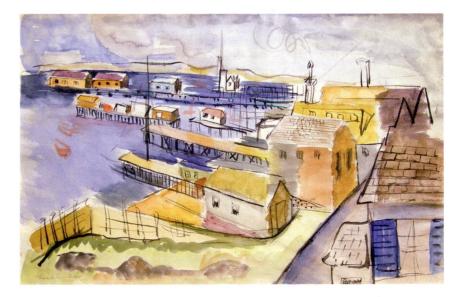

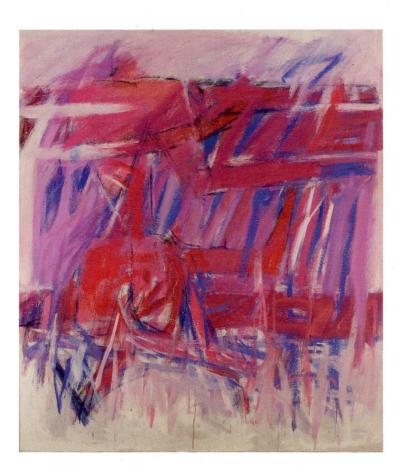

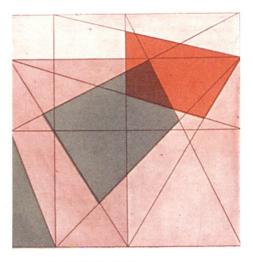

1-3 JACK TWORKOV *L-SF-ES-#2* (1979). Hardground etching, aquatint, 16.25" × 16".
© Estate of Jack Tworkov, courtesy Landfall Press, Santa Fe, NM.

 1-2 JACK TWORKOV Watergame (1955). Oil on canvas, 69" × 59".
 © Estate of Jack Tworkov, courtesy Christie's Images.

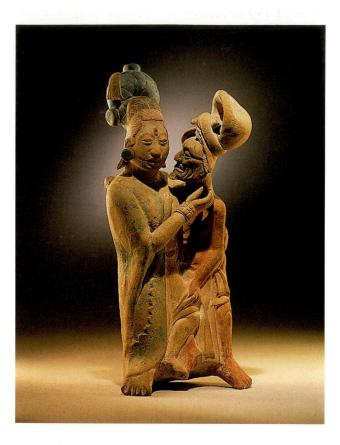

Amorous Couple (Mayan, Late Classic, 700–900 CE). Polychromed ceramic. H: 9³/4". Copyright Detroit Institute of the Arts, Detroit, MI. Sounders Society Purchase, Katherine Margaret Kay Bequest Fund and New Endowment Fund.

1 - 4

similarities among artists working within a group or during a specific historical timeframe. The style of the Impressionist school of painting, for example, is characterized by subjects of leisure life rendered in daubs of color replicating the effects of light and atmosphere on images and objects. Painters working in the typical baroque style used a brilliant palette of reds and golds, employed dramatic lighting, organized their compositions along diagonal lines, and were drawn to theatrical subjects.

One of the best ways to illustrate stylistic differences is to choose a group of works with a common theme (such as those illustrated in Figures 1-4 through 1-11) and challenge ourselves to articulate the similarities and differences among them. The first and seemingly obvious connection is that all of the works represent couples. Yet immediately we are struck by the differences among them, both in terms of the stories they imply and the style in which they are rendered. To begin with, the images demand that we get beyond the conventional definition of "couple," for not all couples are composed of a male and a female. What is really striking,

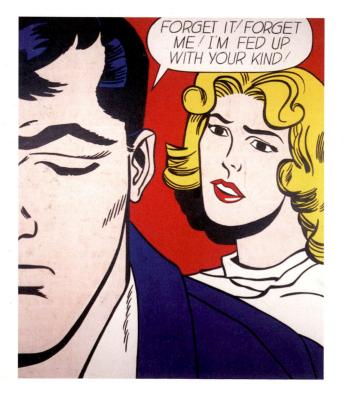

1-5 ROY LICHTENSTEIN.
 Forget It, Forget Me! (1962).
 Magna and oil on canvas. 79⁷/8" × 68".
 Rose Art Museum, Brandeis University,

Waltham, MA. Gevirtz-Minuchin Purchase Fund 1962. Copyright Estate of Roy Lichtenstein. however, are the variations in style, sometimes linked to the use of different media and sometimes connected to diverse cultural contexts, but always indicative of the characteristic approach of the artist to the subject.

The garments, hairstyles, and facial features of the Mayan ceramic couple (Fig. 1-4), for example, link it to the life and times of the Yucatan people before the onslaught of the Europeans. Similar telltale attributes connect Roy Lichtenstein's *Forget It! Forget Me!* (Fig. 1-5) to the United States of the sixties. Henri de Toulouse-Lautrec's *The Two Girlfriends* (Fig. 1-6) transports us to the demimonde of late nineteenth-century Paris. The weather-worn faces and postcard-perfect surroundings of Grant Wood's *American Gothic* (Fig. 1-7) suggest the duality of farm life in early twentieth-century America—hardship and serenity whereas Robert Mapplethorpe drew the world attention to what it was like to be gay and living in America toward the latter part of the twentieth century (Fig. 1-8). The tumult of Germany in the years leading up to World War I can be felt in the dark palette, whirling brushstrokes, and existentialist expressions in Oskar Kokoschka's *The Tempest* (Fig. 1-9). Constantin Brancusi's *The Kiss* (Fig. 1-10) could be said to transcend context in the simple accessibility and readability of its subject. Barbara Hepworth's *Two Figures* (Fig. 1-11) is more difficult to decipher. Hepworth disconnected her work from a specific context by reducing her figures to their most common denominators—organic vertical shapes punctuated by softly modeled voids.

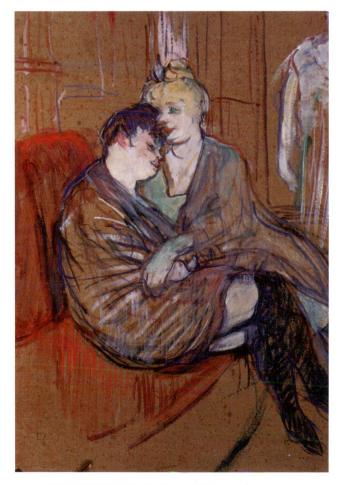

 1-6 HENRI DE TOULOUSE-LAUTREC. The Two Girlfriends (1894). Oil on cardboard. 48 cm × 34.5 cm. Musée Toulouse-Lautrec, Albi. Copyright Corbis.

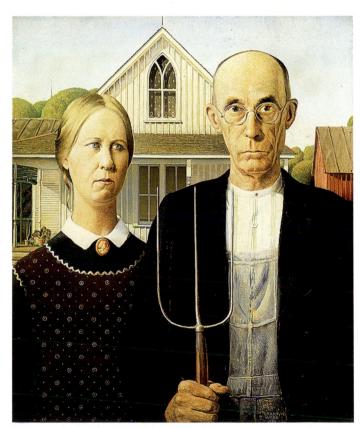

 1-7 GRANT WOOD. American Gothic (1930). Oil on beaverboard. 29⁷/s" × 24⁷/s".
 Art Institute of Chicago. Friends of the American Art Collection. All rights reserved by the Art Institute of Chicago. Licensed by VAGA, New York.

5

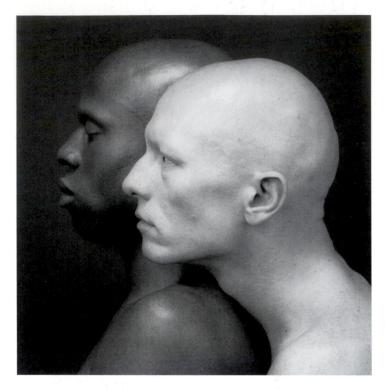

 1-8 ROBERT MAPPLETHORPE. Ken Moody and Robert Sherman (1984). Photograph. Copyright The Estate of Robert Mapplethorpe. Courtesy Art and Commerce Anthology.

Styles in art are numerous, ever changing, and ever new. The vocabulary we use to discuss style, however, has been fairly standard for a long time. The Mayan couple and paintings by Lichtenstein and Toulouse-Lautrec are **representational**. Representational art, often synonymous with **figurative** art, is defined as art that portrays, however altered or distorted, things perceived in the visible world. *American Gothic* is an excellent example of a **realistic**

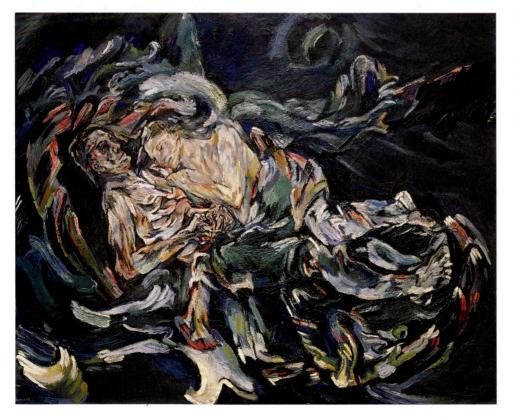

1-9 OSKAR KOKOSCHKA. The Tempest (1914). Oil on canvas. $71^{1}/{2''} \times 86^{1}/{2''}$. Kunstmuseum Basel, Switzerland. Copyright Edimedia. Copyright 2007 Artists Rights Society (ARS), New York/

Pro Litteris, Zürich.

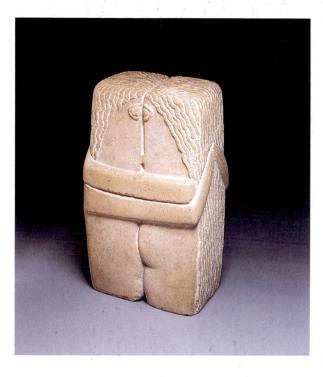

approach to style, portraying people and things as they are seen by the eye or really thought to be, without idealization or distortion. Kokoschka's painting is **expressionistic**, marked by frenzied brushstrokes that mirror the torment of his inner life. Expressionist works are emotional, often combining distortions of color or shape or line to more accurately communicate the inner life or personal vision of the artist. **Abstract** art is characterized by a simplified or distorted rendering of an object that references the essential nature of that object, as in Brancusi's *The Kiss.* **Nonobjective** art, on the other hand, makes no reference to visible reality. By this definition, we would characterize Hepworth's piece as nonobjective. Yet curiously, when we view *Two Figures* in the context of this grouping of couples, it seems to belong, to have the same subject, rather than none at all.

1-10 CONSTANTIN BRANCUSI. The Kiss (c. 1912). Limestone. H: 23"; W: 13"; D: 10".
Philadelphia Museum of Art. Louise and Walter Arensberg Collection. Copyright 2007 Artists Rights Society (ARS), New York/ADAGP, Paris.

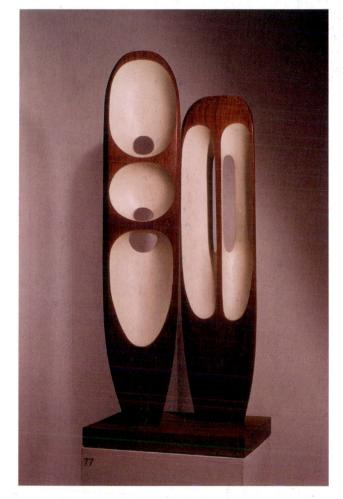

 1-11 BARBARA HEPWORTH (1903–1975). Two Figures (Menhirs) (1954–1955). Teak. H: 54". Art Institute of Chicago. Bridgeman Art Library.

Copyright Bowness, Hepworth Estate.

7

David's The Oath of the Horatii with Kruger's Untitled (We Don't Need Another Hero)

The Oath of the Horatii (Fig. 1-12), by Jacques-Louis David, is one of the most readily recognizable works of the nine-teenth century—indeed, the whole of the history of art. It is a landmark composition—symbolically and pictorially.

David worked for the king of France in the days before the French Revolution. Ironically, although the *Oath* was painted for Louis XVI, who along with his wife, Marie Antoinette, would lose his head to the guillotine, the painting became an almost instant symbol of the Revolution. The loyalty, courage, and sacrifice it portrayed were an inspiration to the downtrodden masses in their uprising against the French monarchy. David, because of his position, was imprisoned along with the members of the court and other French aristocracy, only to be—as it were—"bailed out" by another who could use his services as a painter. Thus David, court painter to the French king, would become painter to Napoleon Bonaparte, who would eventually crown himself emperor. Pictorially, the work is also groundbreaking. It compresses space and forces us to concentrate on the meticulously rendered figures in the foreground. This treatment of space would open the door to the flattening of space in Modernist paintings. The tradition of treating the picture frame as a window frame through which

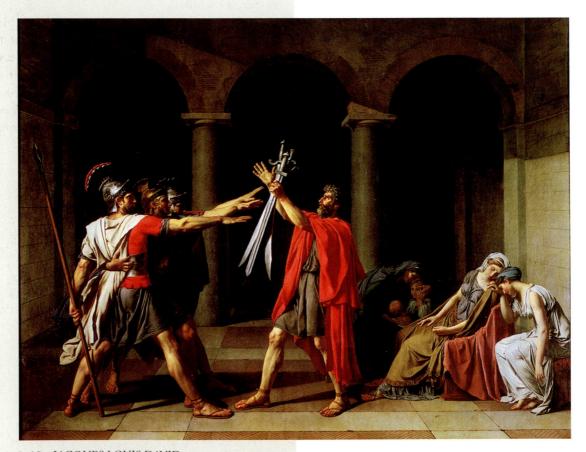

¹⁻¹² JACQUES LOUIS DAVID. The Oath of the Horatii (1784).
Oil on canvas. 11' × 14'.
Louvre Museum, Paris/RMN/Art Resource, New York.

one peers into the infinite distance would be abandoned by many artists in favor of the two-dimensionality of the canvas.

Knowing something of the historical circumstances under which *The Oath of the Horatii* was created, and understanding what is new about it in terms of style and composition, helps us appreciate its significance. But our full comprehension and appreciation of the work can only occur with our consideration and interpretation of the subject matter.

The subject of David's The Oath of the Horatii is, on the face of things, fairly easy to read. Three brothers-the Horatii-swear their allegiance to Rome on swords held high by their father. They pledge to come back victorious or not come back at all. Their forward thrusting and stable stance convey strength, commitment, bravery. And there is something else-something that has been referred to by feminist critics and scholars as a subtext, or additional level of content in the work. David's Oath is also a painting about the ideology of gender differences. The women in the painting collapse in the background, terrified at the prospect of the death of the brothers. To make matters worse, one of the Horatii sisters is engaged to be married to one of the enemy. She might lose her brother to the hands of her fiancé, or vice versa. The women's posture, in opposition to the men's, represents, according to historian Linda Nochlin, "the clear-cut opposition between masculine strength and feminine weakness offered

by the ideological discourse of the period." Whatever else the content of this painting is about, it is also about the relationship of the sexes and gender-role stereotypes.

A number of contemporary feminist artists have challenged the traditional discourse of gender ideology as damaging both to men and women. Barbara Kruger's Untitled (We Don't Need Another Hero) (Fig. 1-13) can be interpreted as an "answer" to David's Oath. In appropriating a Norman Rockwell illustration to depict the "innocence" of gender ideology—in this case, the requisite fawning of a little girl over the budding muscles of her male counterpart—Kruger violates the innocuous vignette with a cautionary band blazing the words We don't need another hero. The representation of the opposition between strength and weakness—male and female—is confronted and replaced with the gender discourse of a more socially aware era. The subject matter of these works is strangely related, oddly linked. Visually, the works could not be more dissimilar.

In David's composition, the subtext of gender ideology exits simultaneously with the main narrative — that of the soldiers preparing for battle. In Kruger's work, by contrast, the main narrative *is* gender ideology — and how to counteract it. In both, however, the essential nature of evaluating the content, or subject matter of the works we view, is underscored. They are, after all, really about the same thing, aren't they?

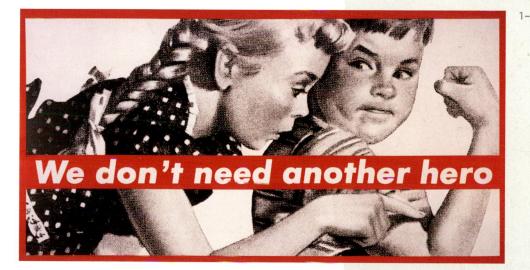

1-13 Barbara Kruger. Untitled (We Don't Need Another Hero) (1987).
Photographic silkscreen, vinyl lettering on Plexiglas. 109 " × 210 ". Collection of Emily Fisher Landau, New York. Courtesy of Mary Boone Gallery, New York.

SUBJECT MATTER, FORM, CONTENT, ICONOGRAPHY

Works of art comprise a good deal, only some of which meets the eye: subject matter, form, content, and iconography.

Subject Matter

On the most basic level, the **subject matter** is the story that the work is telling, or the scene that it depicts, or the figures or objects it represents in visual terms. The subject is the *what* of a work of art. It can include portraits, landscapes, still life paintings of flowers or fruits, historical events, biblical or mythological stories, the human figure, and more. On the other hand, some works of art—like abstract paintings or sculptures—do not have subjects, or stories, per se. Their content is described in terms of their elements, design principles, the artistic process, and composition.

Form

If subject matter is the *what* in a work of art, form is the *how*. Think of **form** as the all-encompassing framework of artistic

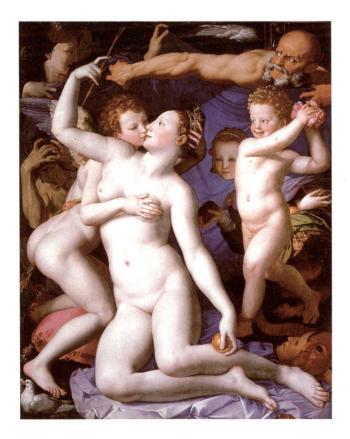

expression. It is the general structure and overall organization of a composition. It signifies the totality of technical means and materials employed by the artist, as well as all of the visual strategies and pictorial devices used to express and communicate. It is, simply, the work of art as a whole.

Content

Content comes close to being the *why* of a work of art in that it includes what we might consider the *reasons* behind its appearance. Content implies subject matter, but is a much bigger concept. Content contains the idea, the cultural and artistic contexts, and the meaning of a work of art. Symbols are a key component of its content, even if they are unapparent to many, even most, viewers. The study of such symbols is called iconography, literally the "writing of images." Symbols are images that stand for ideas underlying that which is actually seen.

Iconography

Iconography is the study of the themes and symbols in the visual arts—the figures and images that lend works their

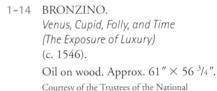

Gallery, London.

10 INTRODUCTION

underlying meanings. Bronzino's sixteenth-century painting Venus, Cupid, Folly, and Time (The Exposure of Luxury) (Fig. 1-14) is a classic example of works in which there is much more than meets the eye. The painting weaves an intricate allegory, with many actors, many symbols. Venus, undraped by Time and spread in a languorous diagonal across the front plane, is fondled by her son Cupid. Folly prepares to toss a handful of rose petals on the couple, while Envy and Inconstancy (with two left hands) lurk in the background. Masks, symbolizing deceit and falseness, and other objects, meanings known or unknown, complete the scene. Works such as these offer an intricate iconographic puzzle. Is Bronzino saying that love in an environment of hatred and that inconstancy is foolish or doomed? Is something being suggested about incest? Self-love? Can one fully appreciate Bronzino's painting without being aware of its iconography? Is it sufficient to respond to the elements and composition, to the figure of a woman being openly fondled before an unlikely array of onlookers? No simple answer is possible, and a Mannerist artist such as Bronzino would have intended this ambiguity. Certainly one could appreciate the composition and the subject mat-

ter for their own sake, but awareness of the symbolism enriches the viewing experience.

Whereas Bronzino's painting illustrates a complex allegory, the symbolism of which would seem relevant only to the initiated, Willie Bester's Semekazi (Migrant Miseries) (Fig. 1-15) uses images and objects to communicate a tragic story to anyone who will listen. Bester is an artist who was classified as "colored" under South African apartheid rule and thus, as with most nonwhite artists, was deprived of opportunities for formal training in art. Collages such as Semekazi combine painting with found objects in a densely covered surface that seems, in its lack of space and air, to reflect the squalid living conditions among black Africans. The many images and objects serve as symbols of rampant oppression and deprivation affecting a whole people, while a single portrait of a worker in the center of the composition-peering from under bedsprings-serves as a single case study.

The paintings by Bronzino and Bester, as far apart in time, tenor, and experience as can be imagined, both supply the viewer with clear, familiar images intended to communicate certain underlying themes.

1–15 WILLIE BESTER. Semekazi (Migrant Miseries)

(1993). Oil, enamel paint, and mixed media on board. $49^{1}/4'' \times 49^{1}/4''$. By courtesy of Sotheby's Picture Library. Copyright 2005 Willie Bester.

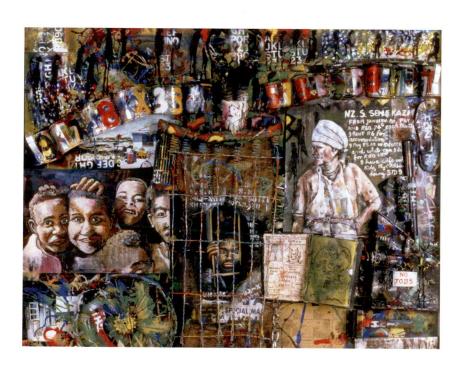

THE VOCABULARY OF ART

The basic components of a work of art (subject matter, form, and content) do not, for the most part, exist—much less communicate the artist's message—absent the elements of art, design principles, mediums, techniques, and style. These are the basic *ingredients* of art.

Visual Elements

The **visual elements** of art consist of line, shape, value, color, texture, space, and time and motion. *Line* serves as an essential building block of art, but can serve as the content itself of a work of art, or be manipulated to evoke an emotional or intellectual response from a viewer. *Shapes*, in twodimensional art, are distinct areas within a composition that have boundaries separating them from what surrounds them. In sculpture and other three-dimensional forms of art, *shape* is the essential visual element. *Value* refers to the blacks and whites and grays in a works of art, as well as to the contrasts between lights and darks.

Color helps to define images or areas in a work of art. It can be used to replicate that which is seen by the human eye or to suggest the artist's emotional response to a subject. The wavelength of light determines its color, or **hue**.

1–16 A color wheel.

The color wheel bends the colors of the visible spectrum into a circle and adds a few missing hues to complete the circle.

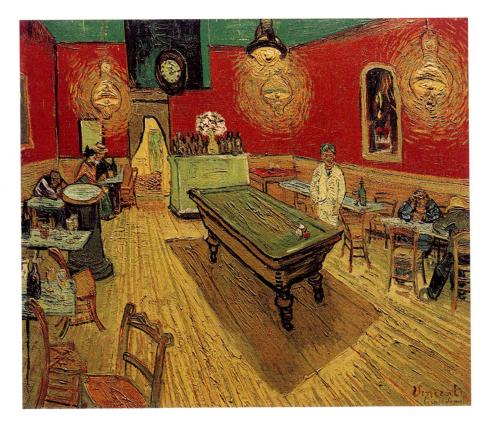

1-17 VINCENT VAN GOGH. *The Night Cofé* (1888). Oil on canvas, 27¹/2" × 35". Yale University Art Gallery, New Haven, CT. Bequest of Stephen C. Clark, B.A., 1903. The visible spectrum consists of the colors red, orange, yellow, green, blue, indigo, and violet, which can be wrapped around into a wheel (Fig. 1-16). The colors on the green–blue side of the color wheel are considered **cool** in "temperature," whereas the colors on the yellow–orange–red side are considered **warm.** On a canvas, warm colors seem to advance toward the picture plane. Cool colors, on the other hand, seem to recede. The saturation of a color is its pureness. Pure hues have the greatest intensity, or brightness. The **saturation**, and hence the intensity, decrease when another hue or black, gray, or white is added. Artists produce **shades** of a given hue by adding black, and **tints** by adding white.

Color can be used realistically, to describe that which the artist sees, or expressively, as in Postimpressionist painter Vincent van Gogh's *The Night Café* (Fig. 1-17), to depict what the artist is feeling. When artists use colors next to one another on the color wheel, they create a harmonious effect. Van Gogh chose reds and greens across the wheel from one another, creating a harsh, clashing effect.

Texture is often used to heighten the sense of realism in a work. It can also create psychological links to our sense of touch; smooth textures attract while rough textures repel. In *Object* (Fig. 1-18), **Surrealist** artist Meret Oppenheim lines her cup, saucer, and spoon with fur. Teacups are usually connected with civilized and refined settings and occasions. The coarse primal fur subverts these associations, possibly challenging the viewer the violence that has enabled civilization to grow and endure.

The creation of the illusion of depth or space is for artists an age-old challenge. Some painters have recreated, on a two-dimensional surface, vistas that appear to recede from the **picture plane** many miles—perhaps infinitely into the distance. Others have denied such illusionism, working with respect to the flattened space of the twodimensional canvas.

When we discuss sculpture or architecture, we refer to objects that either exist in space or encompass it. A sculpturein-the-round or free-standing sculpture is one that you can walk round and view from different angles. It is threedimensional. A relief sculpture, on the other hand, is twodimensional and generally describes the carving of on a slab of stone or wood. Reliefs can also be made of bronze or other metal, in which case they are usually cast from a mold rather than carved, but they are still considered two-dimensional works. If we talk about space in a relief sculpture, it isn't the space it occupies but rather the space that it might depict. As in paintings, artists may use several devices to create the illusion of three-dimensional space on a two-dimensional surface.

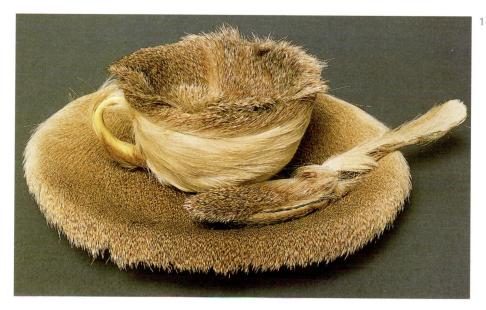

 1–18 MERET OPPENHEIM. Object (1936). Fur-covered cup, saucer, and spoon. Overall height: 2⁷/8". Copyright The Museum of Modern Art, New York. Purchase. Licensed by SCALA/Art Resource, New York. Copyright 2007 Artists Right Society (ARS), New York/ProLitteris, Zürich. Although exercises in perspective (methods to create this illusion) date back to antiquity, artists of the Renaissance were the first to canonize perspective techniques in theory and in practice. Leonardo da Vinci, the acclaimed painter and investigator of all things mathematical, scientific, and artistic, was fascinated by the challenge of creating the illusion of space in his paintings. His *Madonna of the Rocks* (Fig. 1-19) serves as a veritable textbook of perspective devices.

One method artists use is overlapping, based on the observation that when nearby objects are placed in front of more distant objects, they obscure part or all of the distant objects. Overlapping is one of the reasons that, in Madonna of the Rocks, the figure in red is perceived as kneeling behind the baby in the right foreground, and why the grotto seems well behind the group. Leonardo also used atmospheric perspective, in which the illusion of depth is enhanced by techniques such as texture gradient, brightness gradient, color saturation, and the manipulation of warm and cool colors. Texture gradient relies on the fact that closer objects are perceived as having rougher or more detailed surfaces. The effect of a brightness gradient is due to the lesser intensity of distant objects. The foreground of Madonna of the Rocks contains such botanical detail that the painting could serve as a scientific record of the species indigenous to the region. But as landscape recedes into the distance, the plants and rocks become less textured and the colors become less saturated.

The figures themselves also appear three-dimensional due to Leonardo's use of **chiaroscuro**. This technique, perfected by him, employed contrasts of light and shadow through subtle gradations of tone to suggest a roundness of form. Think of a ball in sunlight. Where the light hits, the surface is bright. But as it curves away from the sun's rays, it is in shadow. The areas of shadow closest to the lit surface are brighter than the part of the ball that is 180 degrees away from the light. Applying this observation to drawing or painting on a two-dimensional surface will create the illusion that the figures or objects are three-dimensional.

The farther objects are from us, the smaller they appear to the eye. To re-create this visual phenomenon, artists employ techniques such as **relative size** and **linear perspective**. Leonardo also employed linear perspective, in which the lines in a composition converge at one, two, or three **vanishing points** on an imaginary **horizon** line (the line that is at eye level to the viewer). This technique, seen in Leonardo's *Last Supper* (see Fig. 5-17) and Raphael's *School of Athens* (see Fig. 5-20), is based on the observation that parallel lines appear to converge as they move into the distance away from a fixed point—like a person looking at railroad tracks.

Motion occurs through *time*—the fourth dimension as well as space. Many artists have implied or suggested movement in static works, whereas others—like kinetic artists—have built motion into their works.

Principles of Design

Principles of design refer to the visual strategies used by artists, in conjunction with the elements of art, for expressive purposes. They include unity and variety, emphasis and focal point, balance and rhythm, and scale and proportion. Unity has the effect of gathering parts of a composition into a harmonious whole. Variety, the counterpoint of unity, adds visual interest to a composition. Artists use emphasis and focal point to draw and hold the viewer's eye on certain parts of a work. Balance brings visual stability to a work of art; rhythm conveys a sense of orderly progression among the parts of a work. Predictable rhythms have a calming effect, while sudden changes in rhythm can be disconcerting. The scale of a work is its size in relation to us-the viewers. Scale within a work refers to the size relationships of images and objects represented therein. The proportions of a work have to do with how parts relate to the whole.

Mediums

The **medium** in which an artist works—the plural, *mediums* or *media*—refers to the materials used in the artmaking process and this list is only as long as one's imagination. We usually speak of working in two-dimensional media or three-dimensional mediums, yet artists have sought ways to suggest the fourth dimension of time in their works or have done so literally by creating compositions that change before the viewer's eyes as time passes. Conceptual artists on the other hand argue that the work of art actually exists in the mind of the artist. How do we attach "dimensionality" to that definition of art? Artistic *techniques* are methods—the vehicles by which media are controlled and applied.

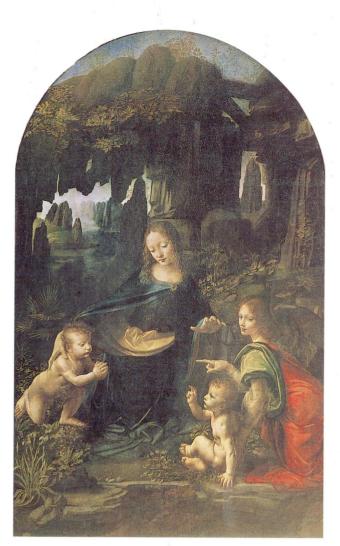

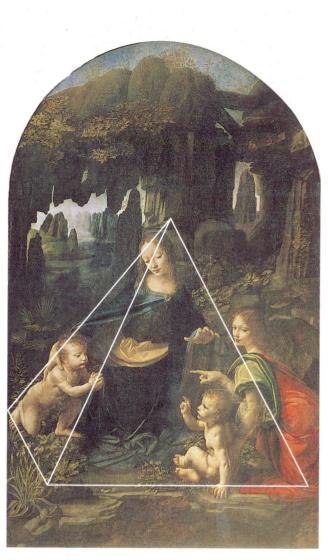

The pyramidal structure of the Madonna of the Rocks.

1-19 LEONARDO DA VINCI. Madonna of the Rocks (c. 1483).
Oil on panel, transferred to canvas. 78¹/₂ " × 48 ". Louvre Museum, Paris/Réunion des Musées Nationaux/Art Resource, New York.

Artists thus use the visual elements of art in compositions that employ various principles of design. In the following chapters, we will see that their compositions are usually created within—or to challenge—certain historic styles. The totality of the form of their works—all we see in

them — also has certain subject matter or content, which may exist on several levels. That content is influenced by the context of the work as well as the individual purposes of the artist.

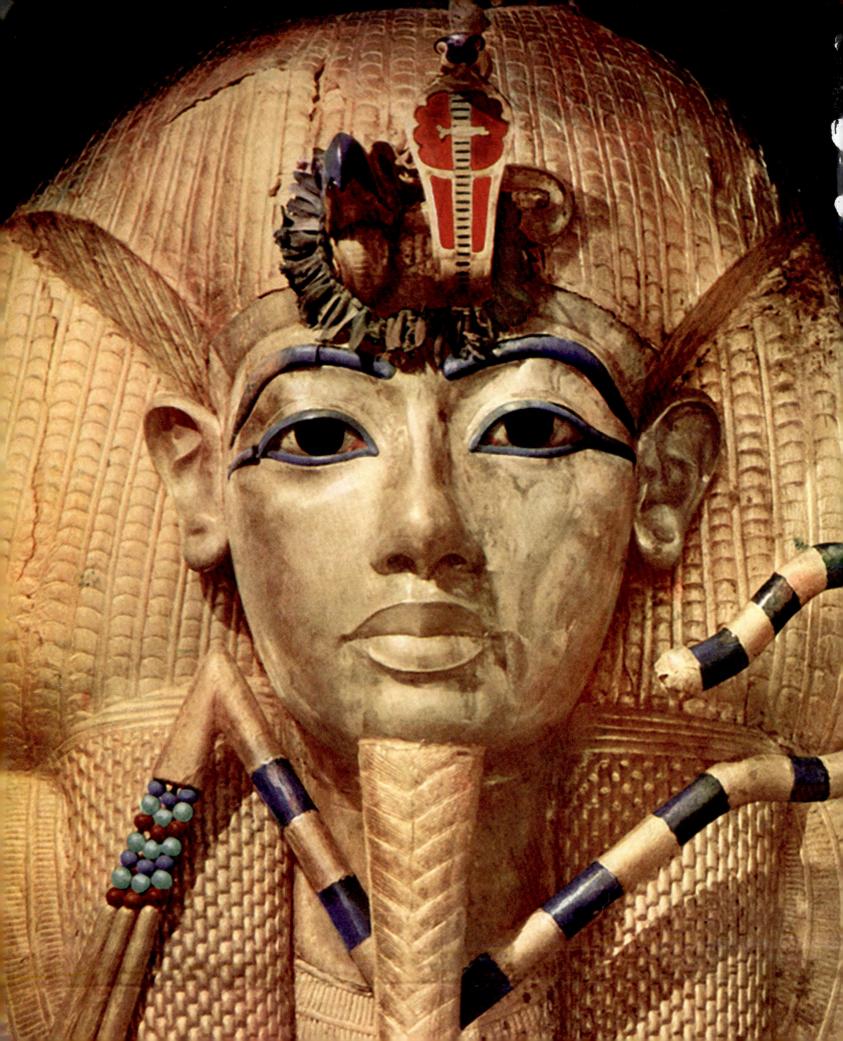

THE ART OF THE ANCIENTS

Art is exalted above religion and race. Not a single solitary soul these days believes in the religion of the Assyrians, the Egyptians, or the Greeks. . . . Only their art, whenever it was beautiful, stands proud and exalted, rising above all time.

-Emil Nolde

The phrase "Stone Age" often conjures an image of men and women dressed in skins, huddling before a fire in a cave, while the world around them—the elements and the animals—threatens their survival. We do not generally envision prehistoric humankind as intelligent and reflective, as having needs beyond food, shelter, and reproduction, as performing religious rituals or as creating art objects. Yet these aspects of life were perhaps as essential to their survival as warmth, nourishment, and progeny.

As the Stone Age progressed from the Paleolithic to the Neolithic periods, humans began to lead more stable lives. They settled in villages and shifted from hunting wild animals and gathering food to herding domesticated animals and farming. They also fashioned tools of stone and bone and created pottery and woven textiles. Most important for our purposes, they became image makers, capturing forms and figures on cave walls with the use of primitive artistic implements. Archeological exploration of Stone Age sites in France and Spain reveals the existence of shelters, tools, and an impressive array of sculptures and paintings in which humans and animals are represented. The sheer quantity of these art objects, although they are not works of art by the usual definition, would suggest a principal role for images and symbols in the struggle for human survival. As with much ancient art, we cannot know for certain what the reasons were for creating these works. But evidence suggests that Stone Age people forged links between religion and life, life and art, and art and religion. They faced intimidating and unknown forces in their confrontation with nature. Perhaps their "art" was an attempt to record and to control.

PREHISTORIC ART

Prehistoric art is divided into three phases that correspond to the periods of Stone Age culture: **Paleolithic** (the late years of the Old Stone Age), **Mesolithic** (Middle Stone Age), and **Neolithic** (New Stone Age). These periods span roughly the years 14,000 to 2000 BCE.

Works of art from the Stone Age include cave paintings, reliefs, and sculpture of stone, ivory, and bone. The subjects consist mainly of animals, although some abstract human figures have been found. There is no surviving architecture as such. Many Stone Age dwellings consisted of caves and rock shelters. Some impressive monuments such as Stonehenge exist, but their functions remain a mystery.

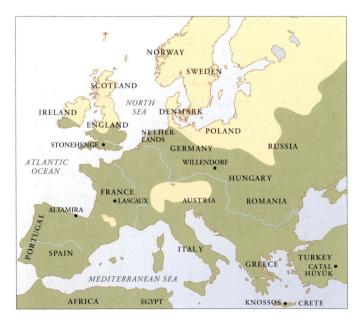

Map 2-1 Prehistoric Europe.

Paleolithic Art

Paleolithic art is the art of the last Ice Age, during which time glaciers covered large areas of northern Europe and North America. As the climate got colder, people retreated into the protective warmth of caves, and it is here that we find their first attempts at artistic creation.

The great cave paintings of the Stone Age were discovered by accident in northern Spain and southwestern France. At Lascaux, France (Map 2-1), two boys whose dog chased a ball into a hole followed the animal and discovered beautiful paintings of bison, horses, and cattle that are estimated to be more than 15,000 years old. At first, because of the crispness and realistic detail of the paintings, they were thought to be forgeries. But in time, geological methods proved their authenticity.

One of the most splendid examples of Stone Age painting, the so-called Hall of Bulls (Fig. 2-1), is found in a cave at Lascaux. Here, superimposed upon one another, are realistic images of horses, bulls, and reindeer that appear to be stampeding in all directions. With one glance, we can understand the early skepticism concerning their authenticity. So fresh, lively, and purely sketched are the forms that they seem to have been rendered yesterday.

In their attempt at **naturalism**, the artists captured the images of the beasts by first confidently outlining the contours of their bodies. They then filled in these dark outlines with details and colored them with shades of ocher and red. The artists seem to have used a variety of techniques ranging from drawing with chunks of raw pigment to applying pigment with fingers and sticks. They also seem to have used an early "spray painting" technique in which dried, ground pigments were blown through a hollowed-out bone or reed. Although the tools were primitive, the techniques and results were not. They used **foreshortening** and contrasts of light and shadow to create the illusion of three-dimensional forms. They strove to achieve a most convincing likeness of the animal.

Why did prehistoric people sketch these forms? Did they create these murals out of a desire to delight the eye, or did they have other reasons? We cannot know for certain. However, it is unlikely that the paintings were merely ornamental, because they were confined to the deepest recesses of the cave, far from the areas that were inhabited, and were not easily reached. Also, new figures were painted over earlier ones with no apparent regard for composition. It is believed that successive artists added to the drawings, respecting the sacredness of the figures that already existed. It is further believed that the paintings covered the walls and

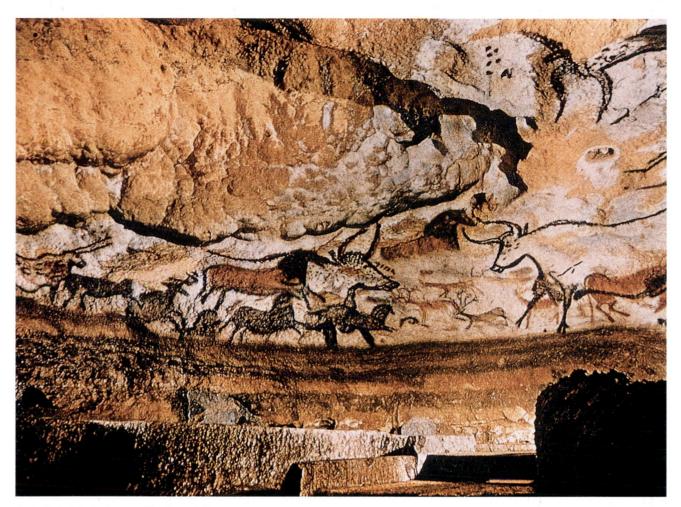

2–1 Hall of Bulls, Lascaux (Dordogne), France (Upper Paleolithic, c. 15,000–10,000 BCE). Photo by P. Buckley.

ceilings of a kind of inner sanctuary where religious rituals concerning the capture of prey were performed. Some have suggested that by "capturing" these animals in art, Stone Age hunters believed that they would be guaranteed success in capturing them in life. This theory, as others, is unproven.

The prehistoric artist also created sculptures, called **Venuses** by the archaeologists who first found them. The most famous is the Venus of Willendorf (Fig. 2-2), named after the site at which she was unearthed. The tiny figurine is carved of stone and is just over four inches high. As with all sculptures of this type, the female form is highly abstracted, and the emphasis is placed on the anatomical parts associated with fertility: the oversized breasts, round abdomen, and enlarged hips. Other parts of the body, like the thin arms resting on the breasts, are subordinated to those related to

reproduction. Does this suggest a concern for survival of the species? Or was this figure of a fertile woman created and carried around as a talisman for fertility of the earth itself—abundance in the food supply? In either, or any other case, people created their images, and perhaps their religion, as a way of coping with these concerns.

 2-2 Venus of Willendorf (Upper Paleolithic) (c. 25,000 BCE).
 Stone. H: 4³/₈".
 Naturhistorisches Museum, Vienna/ Erich Lessing/Art Resource, New York.

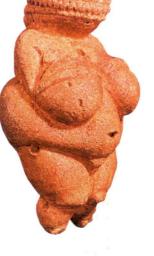

- 2-3 Cormorant or Duck (c. 33,000-30,000 BCE). Ivory. L: approx. 1". Hilde Jensen, University of Tubingen/ Nature Magazine/AP Wide World Photos.
- 2-4 Ritual Dance (c. 10,000 BCE). Rock engraving. Cave of Addaura, Monte Pellegrino (Palermo), Italy. Soprintendenza Beni Culturali Ambientali, Palermo. Copyright Canali Photobank, Milan, Superstock.

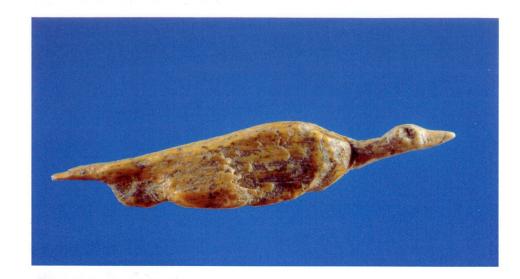

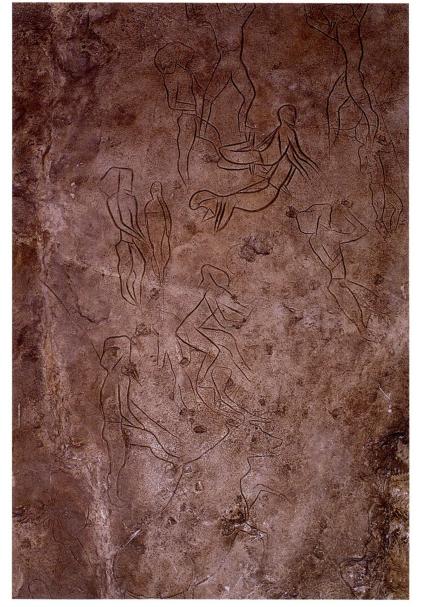

Discoveries of small figurines continue to build our impressions of the nature of artistic skills and expression among the earliest humans. The ivory piece illustrated in Fig. 2-3, resembling a cormorant or a duck, is the oldest-known representation of a bird. Under one inch in length, it has a highly polished surface—as if it had been constantly handled. Archeologists have conjectured that figurines of this size, and in the shapes of animals or half-human half-animals, were likely personal possessions that expressed common aspects of humans and animals. What is perhaps most surprising about such pieces is their artistic quality, despite the probability that art—as we know it—was never the goal.

Mesolithic Art

The Middle Stone Age began with the final retreat of the glaciers. The climate became milder, and people began to adjust to the new ecological conditions by experimenting with different food-gathering techniques. They established fishing settlements along riverbanks and lived in rock shelters. In the realm of art, a dramatic change took place. Whereas Paleolithic artists emphasized animal forms, Mesolithic artists concentrated on the human figure.

The human figure was simplified, and the subjects ranged from warriors to ceremonial dancers. Of the many wall paintings and stone carvings that survive, perhaps none is more appealing to the modern eye than the Ritual Dance (Fig. 2-4). Fluid yet concise outlines describe the frenzied movement From a medieval poem about Stonehenge:

The stones are great And magic power they have Men that are sick Fare to that stone And they wash that stone And with that water bathe away their sickness

—Layamon, 1200 CE

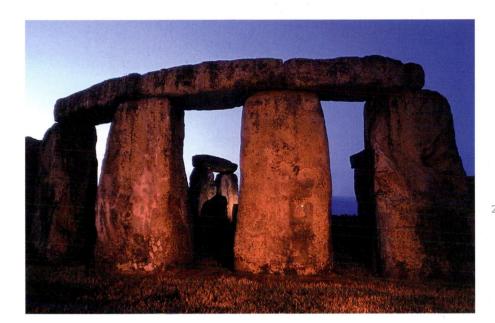

2-5 Stonehenge, Salisbury Plain, Wiltshire, England (Neolithic, c. 1800–1400 BCE). Diameter of circle: 97'. Height of stones aboveground: approx. 24'. NGS Image Collection, Richard T. Nowitz.

of human figures dancing and diving in the presence of animals. These simple and expressive contours call to mind the languid nudes of twentieth-century artists such as Henri Matisse. Whatever the function of a Mesolithic work such as this might have been, it is clear that human beings were beginning to assert their identities as a more self-sufficient species.

Neolithic Art

During the New Stone Age, life became more stable and predictable. People domesticated plants and animals, and food production took the place of food gathering. Toward the end of the Neolithic period in some areas, crops such as maize, squash, and beans were cultivated, metal implements were fashioned, and writing appeared. About 4000 BCE, significant architectural monuments were erected. The most famous of these monuments is Stonehenge (Fig. 2-5) in southern England. It consists of two concentric rings of stones surrounding others placed in a horseshoe shape. Some of these large stones, or **megaliths**, weigh several tons. They are called *megaliths*, from Greek, meaning "large stones." The purpose of Stonehenge remains a mystery. At one time it was believed to have been a druid temple, or the work of Merlin, King Arthur's magician. Lately, some astronomers have suggested that the monument served as a complex calendar that charted the movements of the sun and moon, as well as eclipses. Whatever the meaning or function, the fact that it was undertaken at all is perhaps its most fascinating aspect.

The Neolithic period probably began about 8000 BCE and spread throughout the world's major river valleys between 6000 and 2000 BCE—the Nile in Egypt, the Tigris and Euphrates in Mesopotamia, the Indus in India, and the Yellow in China. In the next section we examine the birth of the great Mesopotamian civilizations.

ART OF THE ANCIENT NEAR EAST

Historic (as opposed to prehistoric) societies are marked by a written language, advanced social organization, and developments in the areas of government, science, and art. They are also often linked with the development of agriculture. Historic civilizations began toward the end of the Neolithic period. In this section we will discuss the art of the Mesopotamian civilizations of Sumer, Akkad, Babylonia, Assyria, and Persia. We will begin with Sumer, which flourished in the river valley of the Tigris and Euphrates about 3000 BCE.

Sumer

The Tigris and Euphrates rivers flow through what is now Syria and Iraq, join in their southernmost section, and empty into the Persian Gulf (Map 2-2). The major civilizations of ancient Mesopotamia lay along one or the other of these rivers, and the first to rise to prominence was Sumer.

Sumer was located in the Euphrates River valley in southern Mesopotamia. The origin of its people is unknown, although they may have come from Iran or India. The earliest Sumerian villages date back to prehistoric times. By about 3000 BCE, however, there was a thriving agricultural civilization in Sumer. The Sumerians constructed sophisticated irrigation systems, controlled river flooding, and worked with metals such as copper, silver, and gold. They had a government based on independently ruled city-states, and they developed a system of writing called **cuneiform**, from the Latin *cuneus*, meaning "wedge"; the characters in cuneiform writing are wedge shaped.

Excavations at major Sumerian cities have revealed sculpture, craft art, and monumental architecture that seems to have been created for worship. Thus, the Sumerian people may have been among the first to establish a formal religion.

One of the most impressive testimonies to the Sumerians' religion-based society is the **ziggurat**, a monumental platform for a temple also seen in the Babylonian and Assyrian civilizations of later years. The ziggurat was the focal point of the Sumerian city, towering high above the fields and dwellings. Typically, the ziggurat was a multilevel structure consisting of a core of sunbaked mud bricks faced with fired brick, sometimes of bright colors. Access to the **temple**, on the uppermost level of the ziggurat, was gained by stairs or a series of ramps leading from one level to the next, or in some instances, by a spiral ramp that rose continuously from ground to summit.

The White Temple at Uruk (Fig. 2-6a and Fig. 2-6b), and ziggurat, so called because of its white-washed walls, are among the earliest and best preserved in the region. The ziggurat, the corners of which are oriented toward the compass points, is some 40 feet high, but pales in comparison to the scale of later ziggurats. The ziggurat known to the Hebrews as the Tower of Babel, a symbol of mortal pride, was some 270 feet high.

The Sumerian gods were primarily deifications of nature. Anu was the god of the sky, Nannu the god of the moon, Abu, the god of vegetation. Votive sculptures found beneath the floor of a temple to Abu in Tell Asmar (Fig. 2-7) reinforce the essential role of religion in Sumerian society. These works

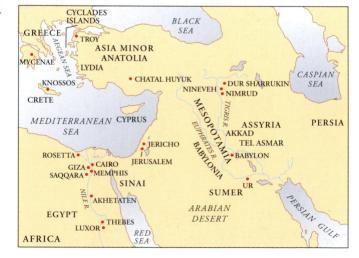

Map 2–2 The Ancient Near East.

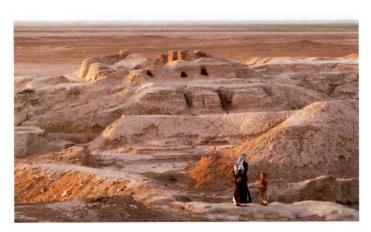

2-6a White Temple at Uruk and Ziggurat (Sumerian, c. 3200–3000 BCE). Sun-dried brick. Nik Wheeler/Corbis.

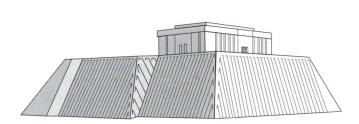

2-6b Reconstruction of White Temple and Ziggurat From E.S. Piggott, Ed.,: *The Dawn of Civilization*, London, Thames and Hudson, 1961, pg. 70.

functioned as "stand-ins," as it were, for donor-worshippers who, in their absence, wished to continue to offer prayers to a specific deity. They range in height from under twelve to over thirty inches and are carved from gypsum with alert inlaid eyes of shell and black limestone. The figures are cylindrical and all stand erect with hands clasped at their chests around now missing flasks. Distinctions are made between males and females. The men have long, stylized beards and hair and wear knee-length skirts decorated with incised lines describing fringe at the hem. The women wear dresses with one shoulder bared and the other draped with a shawl. These sculptures are gypsum, a soft mineral found in rock. The Sumerians, however, worked primarily in clay because of its abundance. They were expert ceramists and, as we have seen, were capable of building monumental structures with brick while their Egyptian contemporaries were using stone. It is believed that the Sumerians traded crops for metal, wood, and stone and used these materials to enlarge their repertory of art objects.

The Sumerian repertory of subjects included fantastic creatures such as music-making animals, bearded bulls, and composite man-beasts with bull heads or scorpion bodies.

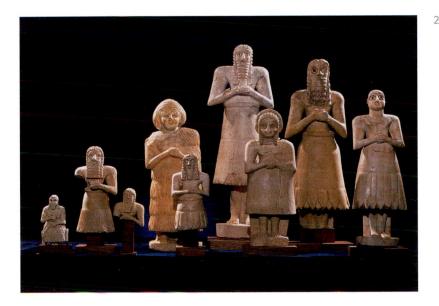

2-7 Statues from Abu Temple, Tel Asmar (Sumerian, Early Dynasty period, c. 2900–2600 BCE). Marble with shell and black limestone inlay. Height of tallest figures: 30". The Oriental Institute Museum, University of Chicago. These were depicted in lavishly decorated objects of hammered gold inlaid with **lapis lazuli**. Found among the remains of Sumerian royal tombs, they are believed by some scholars to have been linked to funerary rituals.

For a long time the Sumerians were the principal force in Mesopotamia, but they were not alone. Semitic peoples to the north became increasingly strong, and eventually they established an empire that ruled all of Mesopotamia and assimilated the Sumerian culture.

Akkad

Akkad, located north of Sumer, centered around the valley of the Tigris River. Its government, too, was based on independent city-states, which, along with those of Sumer, eventually came under the influence of the Akkadian ruler Sargon. It was under Sargon and his successors that the civilization of Akkad flourished.

Akkadian art exhibits distinct differences from that of Sumer. It commemorates rulers and warriors instead of offering homage to the gods. It is an art of violence instead of prayer. Also, although artistic conventions are present, they are coupled with a naturalism that was absent from Sumerian art.

Of the little extant Akkadian art, the Stele of Naram Sin (Fig. 2-8) shines as one of the most significant works. This relief sculpture commemorates the military exploits of Sargon's grandson and successor, Naram Sin. The king, represented somewhat larger in scale than the other figures, ascends a mountain, trampling his enemies underfoot. He is accompanied by a group of marching soldiers, spears erect, whose positions contrast strongly with those of the fallen enemy. One wrestles to pull a spear out of his neck, another pleads for mercy, and another falls headfirst off the mountain. The chaos on the right side of the composition is opposed by the rigid advancement on the left. All takes place under the watchful celestial bodies of Ishtar and Shamash, the gods of fertility and justice.

The king and his men are represented in a conceptual manner. That is, the artist rendered the human body in all of its parts as they are known to be, not as they appear at any given moment to the human eye. This method resulted in figures that are a combination of frontal and profile views. Naturalism was reserved for the enemy, whose figures fall in a variety of contorted positions. It may be that the convention of conceptual representation was maintained as a sign of respect. On the other hand, the conceptual manner complements the upright positions of the victorious, whereas the naturalism echoes the disintegration of the enemy camp.

The Akkadian Empire eventually declined, for reasons that are not clear. Historians have traditionally attributed its collapse to invading tribes. However, recent archeological research has led to the theory that it was not human violence that put an end to Akkadian supremacy but rather a severe and unrelenting drought that gripped the region for 300 years.

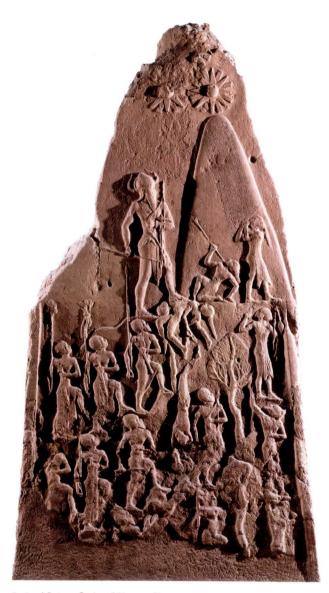

 Victory Stele of Naram Sin (Akkadian, c. 2300–2200 BCE).
 Stone. H: 6'6".
 Louvre Museum, Paris. Copyright Bridgeman Art Library.

When Anu the Sublime, King of the Anunaki, and Bel, the lord of Heaven and earth, who decreed the fate of the land, assigned to Marduk, the over-ruling son of Ea, God of righteousness, dominion over earthly man, and made him great among the Igigi, they called Babylon by his illustrious name, made it great on earth, and founded an everlasting kingdom in it, whose foundations are laid so solidly as those of heaven and earth; then Anu and Bel called by name me, Hammurabi, the exalted prince, who feared God, to bring about the rule of righteousness in the land, to destroy the wicked and the evil-doers; so that the strong should not harm the weak; so that I should rule . . . and enlighten the land, to further the well-being of mankind.

-Preamble to Hammurabi's Code of Laws, translated by L. W. King

With the end of the drought the Sumerians regained power for a while with a Neo-Sumerian state ruled by the kings of Ur, but they, too, were eventually overtaken by fierce warring tribes. Mesopotamia remained in a state of chaos until the rise of Babylon under the great lawmaker and ruler, Hammurabi.

Babylonia

During the eighteenth century BCE the Babylonian Empire, under Hammurabi, rose to power and dominated Mesopotamia. Hammurabi's major contribution to civilization was the codification of Mesopotamian laws. Laws had become cloudy and conflicting after the division of Mesopotamia into independent cities.

This code of law was inscribed on the Stele of Hammurabi (Fig. 2-9), a relief sculpture of basalt over seven feet high. The lower portion of the stele is inscribed with the code itself, written in the Akkadian language with cuneiform characters. Above the code is a relief depicting Hammurabi and the sun-god Shamash. Hammurabi gestures in respect and Shamash reciprocates by handing over to him a rod and ring, symbols of authority. The observer is led to believe, through this interaction, that Hammurabi's authority is god-given and thus, not to be challenged. The sculptor of the stele engaged in some conventions for representation, combining frontal and profile views as we have already seen in the Stele of Naram Sin. However, in the Hammurabi stele there are some new attempts at naturalism. The artist has turned the figure of Shamash toward the viewer a bit and has rendered the lines in his beard as diagonals (rather than strict horizontals, as in the Sumerian votive figures), suggesting an experiment in foreshortening.

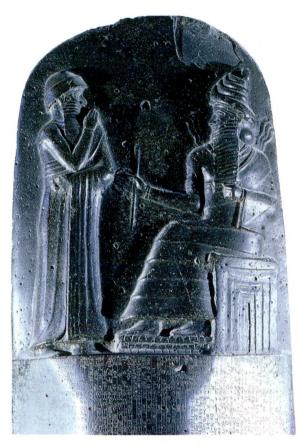

2-9 Stele (upper portion) inscribed with the *Law Code* of Hammurabi, at Susa (Babylonian, c. 1760 BCE). Diorite. H: 7'4" (225 cm).
Louvre Museum, Paris. Copyright Art Resource, New York.

After the death of Hammurabi, Mesopotamia was torn apart by invasions. It eventually came under the influence of the Assyrians, a warring people to the north who had had their eyes on the region for hundreds of years.

Assyria

The ancient empire of Assyria developed along the upper Tigris River. For centuries the Assyrians fought with their neighbors, earning a deserved reputation as a fierce, bloodthirsty people. They eventually overtook the Babylonians, and from about 900 to 600 BCE they controlled all of Mesopotamia.

The Assyrians were influenced by Babylonian art, culture, and religion. But unlike Babylonia, Assyria was an empire built on military conquests and campaigns. Their obsession with war eventually depleted their resources, overtook their economy, and undermined their social structure. The Assyrian rulers ignored agricultural development, forcing the society to import most of its food. Their preoccupation with

 2-10 The Dying Lioness, from Nineveh (Assyrian, 660 BCE). Limestone. H: 13³/4".
 British Museum, London. Copyright Heritage Image Partnership (HIP), heritage-images.com.

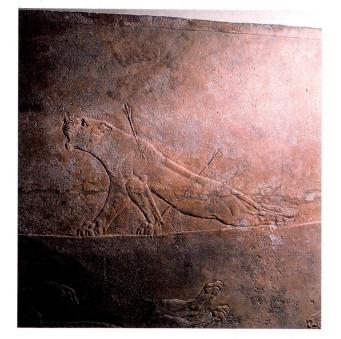

violence and power rather than stability and production eventually led to their demise.

Assyrian architecture consists of sprawling palaces and fortified citadels, and its extensive sculptural decorationrendered in relief-reflects the power and might of the kings. The two most common subjects of these relief sculptures are the king's military exploits and brutal hunts that were staged and tightly controlled to safely showcase the strength of the ruler. One of the most touching and sensitive works of ancient art records a scene from one of King Ashurbanipal's hunting expeditions. The Dying Lioness (Fig. 2-10) is a limestone relief that depicts carnage for the sake of royal sport. A lioness, bleeding profusely from arrow wounds, seems to emit a pathetic, helpless roar as she drags her hindquarters, paralyzed in the assault. Her musculature is clearly defined, and the incised details are painfully realistic. The naturalism in this relief differs significantly from the way in which kings and members of their entourage were depicted. Artists adhered to rigid and stylized conventions for human forms.

Assyria waged almost constant warfare to protect its sovereignty in the area. Ashurbanipal's successors eventually lost control of the empire to Neo-Babylonian kings, the most famous of which was the biblical King Nebuchadnezzar. They remained in power until the conquest of the Persians.

Persia

As Persia, led by King Cyrus, marched toward empire, Babylon was but one of a growing list of casualties. By the sixth century BCE, the Persians had conquered Egypt and, less than a century later, were poised to subsume Greece into their far-reaching realm. The Persian Empire stretched from South Asia to northeastern Europe and would have included southeastern Europe were the Greeks not victorious over the Persians in a decisive battle at Salamis in 480 BCE. Cyrus's successors grew the empire until the defeat of Darius II by Alexander the Great in 330 BCE.

The art of Persia consists of sprawling palaces of grand dimensions and sculpture that is almost totally abstract in its simplicity of design. Favorite subjects included animal forms, such as birds and **ibexes**, translated into decorative column capitals or elegant vessels of precious metals. A capital from the Royal Audience Hall of the palace of King Artaxerxes II (Fig. 2-11) illustrates the Persian combination of decorative motifs and stylization. The upper part of the capital consists

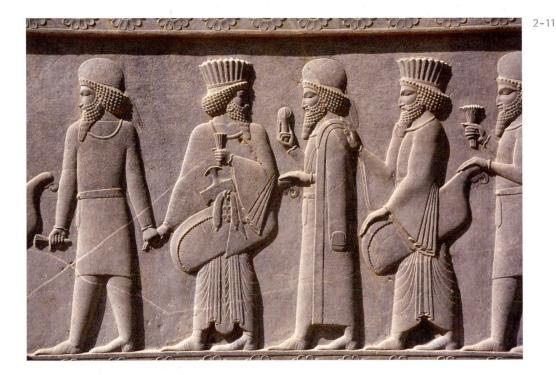

Processional Frieze (detail) from the royal audience hall, Persepolis. (Persian, c. 521–465 BCE). David Poole/Robert Harding Picture Library.

of beautifully carved back-to-back bulls sharing hindquarters. They rest on intricately carved **volutes** that resemble fronds of vegetation. This stylization leads to the perception of the animals as abstract patterns rather than naturalistic forms and is characteristic of Persian art in general.

In 525 BCE Persia conquered the kingdom of Egypt. But civilization in Egypt had begun some 3,000 years earlier. In the next section we will trace its art from the early post-Neolithic period to the reign of the boy-king Tut in the fourteenth century BCE.

EGYPTIAN ART

The lush land that lay between the Tigris and Euphrates rivers, providing sustenance for the Mesopotamian civilizations, is called the **Fertile Crescent.** Its counterpart in Egypt, called the **Fertile Ribbon**, hugs the banks of the Nile River, which flows north from Africa and empties into the Mediterranean Sea (Map 2-2). Like the rivers of the Fertile Crescent, the Nile was an indispensable part of Egyptian life. Without it, Egyptian life would not have existed. For this reason, it also had spiritual significance; the Nile was perceived as a god. Like Sumerian art, Egyptian art was religious. There are three aspects of Egyptian art and life that stand as unique: their link to *religion*, their link to *death*, and their ongoing use of strict *conventionalism* in the arts that affords a sense of permanence.

The art and culture of Egypt are divided into three periods. The Old Kingdom dates from 2680 to 2258 BCE, the Middle Kingdom from 2000 to 1786 BCE, and the New Kingdom from 1570 to 1342 BCE. Art styles proceed from the Old to the New Kingdom with very few variations.

A break in this pattern occurred between 1372 and 1350 BCE, during the Amarna Revolution under the unorthodox leadership of the pharaoh Akhenaton. After his death, Egypt retreated to the old order.

Old Kingdom

Egyptian religion was bound closely to the afterlife. Happiness in the afterlife was believed to be ensured through the continuation of certain aspects of earthly life. Thus, tombs were decorated with everyday objects and scenes depicting common earthly activities. Sculptures of the deceased were placed in the tombs, along with likenesses of the people who surrounded them in life.

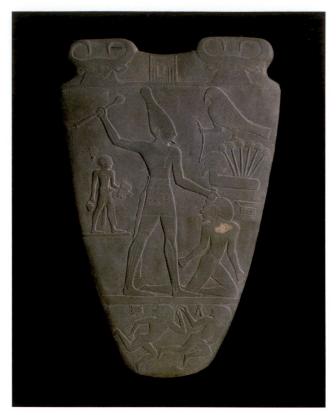

2-12 Narmer Palette (Egyptian, Old Kingdom, c. 3200 BCE).
 Front (left) and back (right) views.
 Slate. H: 25".
 Egyptian Museum, Cairo. Copyright Scala/Art Resource, New York.

In the years prior to the dawn of the Old Kingdom, art consisted of funerary offerings of one type or another, including small, sculpted figures, ivory carvings, pottery, and slate palettes used to mix eye makeup. Toward the end of this period, called the Predynastic period, Egyptian stonecutters begain to create the large limestone works for which Egypt became famous.

Sculpture

Old Kingdom artists initiated a manner of representation that lasted thousands of years, a conceptual approach to the rendering of the human figure that we also encountered in Mesopotamian relief sculpture. In Egyptian reliefs, the head, pelvis, and legs are presented in profile, whereas the upper torso and eye are shown from a frontal view. The figures tend to be flat, and they are situated in a shallow space with no use of foreshortening. No attempt was made to give the illusion of forms that exist in three-dimensional space. Wall decoration was carved in very low relief with a great deal of **incised** detail. Sculpture in the round closely adhered to the block form. Color was applied at times but was not used widely because of the relative impermanence of the material. These basic characteristics were duplicated, with few exceptions, by artists during all periods of Egyptian art. There are instances in which a certain naturalism was sought, but the artist rarely strayed from the inherited stylistic conventions.

Art historian Erwin Panofsky stated that this Egyptian method of working clearly reflected their artistic intention, "directed not toward the variable, but toward the constant, not toward the symbolization of the vital present, but toward the realization of a timeless eternity." One of the most important sculptures from the Old Kingdom period, the Narmer Palette (Fig. 2-12), illustrates these conventions. The Narmer Palette is an example of a type of **cosmetic palette** found in Egypt (Egyptians applied dark colors around their eyes to deflect the sun's glare as football players do), but its symbolism supercedes its function. The Narmer Palette commemorates the unification of Upper Egypt and Lower Egypt, an event that Egyptians marked as the beginning of their civilization.

The back of the palette depicts King Narmer in the crown of Upper Egypt (a bowling pin shape) slaying an enemy. Beneath his feet, on the lowest part of the palette, lie two more dead enemy warriors. To the right a falcon—the god Horus—is perched on a cluster of papyrus stalks that sprout from an object with a man's head. The papyrus is a symbol for Lower Egypt, and Horus's placement would appear to sanction Narmer's takeover of that territory. The top of the palette is sculpted on both sides with two bull-shaped heads with human features. They represent the goddess Hathor, who traditionally symbolized love and joy.

The king is rendered in the typical conventional manner. He is larger than the people surrounding him, symbolizing his royal status. His head, hips, and legs are carved in low relief and in profile, and his eye and upper torso are shown in full frontal view. The musculature is defined with incised lines that appear more as stylized patterns than realistic details. The artist has chosen convention over naturalism and, in the process, created a timeless image, at least as far as Egyptian history is concerned.

The front of the palette is divided into horizontal segments, or **registers**, that are crowded with figures. A hollowedout well in the center of the palette held eye paint, and it is emphasized by the long, entwined necks of lionlike figures tamed by two men with leashes. The top register depicts King Narmer once again, reviewing the captured and deceased enemy. He is now shown wearing the crown of Lower Egypt and holding instruments that symbolize his power. To his right are stacks of decapitated bodies. This is not the first time that we have seen such a monument to a royal conquest, complete with gory details. We witnessed it in the Akkadian victory Stele of Naram Sin (Fig. 2-8). In both works the kings are shown in commanding positions, larger than the surrounding figures, but in the Narmer Palette the king is also depicted as a god. This concept of the ruler of Egypt, along with the strict conventions of his representation, would last some 3,000 years.

Egyptian tomb sculpture included large-scale figures carved in the round, usually from very hard materials that were likely to endure. Permanence was essential, as sculptures like Khafre (Fig. 2-13) were created for the purpose of housing the Ka, or soul, if the mummified remains of the deceased disintegrated. Ka sculptures were not portraits. The artists utilized stylistic conventions, including idealism. Regardless of the age of the deceased, the ka figure emblemized the individual in the prime of life. The statue of Khafre

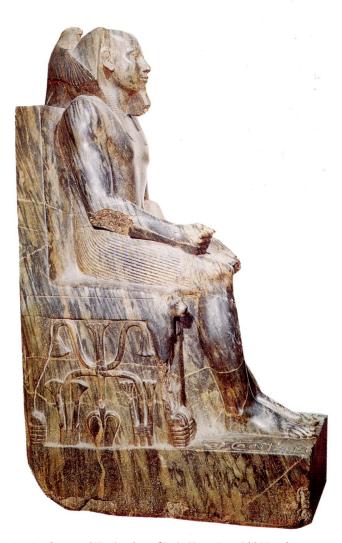

 2-13 Statue of Khafre, from Gizeh (Egyptian, Old Kingdom, c. 2500 BCE).
 Dorite. H: 66".
 Egyptian Museum, Cairo. Copyright Hirmer Archives/Art Resource, New York. 2-14 Great Pyramids at Gizeh
(Egyptian, Old Kingdom,
c. 2570-2500 BCE).
Copyright Topfoto/The Image Works.

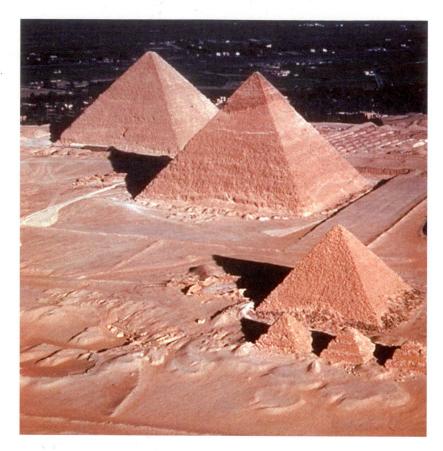

30 THE ART OF THE ANCIENTS

(Fig. 2-13), an Old Kingdom pharaoh, is typical. Carved in diorite, a gray green rock, it shows the pharaoh seated on a throne ornamented with the lotus blossoms and papyrus that symbolize Upper and Lower Egypt. He sits rigidly, and his frontal gaze is reminiscent of the staring eyes of the Mesopotamian votive figures. Khafre is shown with the conventional attributes of the pharaoh: a finely pleated kilt, a linen headdress gracing the shoulders, and a long, thin beard (present on the carved faces of both male and female pharaohs), part of which has broken off. The sun god Horus, represented again as a falcon, sits behind the pharoah's head and spreads his wings protectively around it. The artist confined his figure to the block of stone from which it was carved instead of allowing it to stand freely in space. The legs and torso appear molded to the throne, and the arms and fists are attached to the body. The sense of the solidity of the uncarved block is maintained and, with that, a certain confidence that the sculpture would remain intact. There were few, if any, pieces that were likely to break off. Khafre was rendered according to a specific canon of proportions relating different anatomical parts to one another. The forms rely on predetermined rules and not on optical fact. Naturalism was intermittent in Egyptian art, and more evident in the Middle Kingdom and the Amarna period.

Architecture

The most spectacular remains of Old Kingdom Egypt, and the most famous, are the Great Pyramids at Gizeh (Fig. 2-14). Constructed as tombs, they provided a resting place for the pharaoh, underscored his status as a deity, and lived after him as a monument to his accomplishments. They stand today as haunting images of a civilization long gone, isolated as coarse jewels in an arid wasteland.

The pyramids are massive. The largest has a base that is about 775 feet on a side and is 450 feet high. It is constructed of 2,300,000 limestone blocks that weigh about 2.5 tons each. The stone for the pyramids was quarried from a nearby plateau and moved by workers to the site using wooden rollers and sled-like apparatuses. Stonecutters on the site carved the blocks more finely, after which they were stacked on top of one another in rows, using systems of ropes and pulleys. Artisans finished the surfaces of the pyramid with fine limestone, creating a flawless, smooth and gleaming sheath.

The interiors of the pyramids consist of a network of chambers, galleries, and air shafts. Ostentatious and conspicuous as the pyramids were, thieves wasted no time in plundering them. During the Middle Kingdom, Egyptians designed less easily penetrated dwelling places for their spirits.

Middle Kingdom

The Middle Kingdom witnessed a change in the political hierarchy of Egypt, as the power of the pharaohs was threatened by powerful landowners. During the early years of the Middle Kingdom, the development of art was stunted by internal strife. Egypt was finally brought back on track, reorganized, and reunited under King Mentuhotep, and art flourished once again.

Middle Kingdom art carried the Old Kingdom style forward, although there was some experimentation outside the mainstream of strict conventionalism. We find this experimentation in sensitive portrait sculptures and freely drawn fresco paintings.

A striking aspect of Middle Kingdom architecture was the rock-cut tombs (Fig. 2.15), which may have been designed to prevent robberies. They were carved out of the **living rock**, and their entranceways were marked by columned **porticoes** of post-and-lintel construction. These porticoes led to a columned entrance hall, followed by a chamber along the same axis. The walls of the hall and tomb chamber were richly decorated with relief sculpture and painting, much of which had a sense of liveliness not found in Old Kingdom art.

New Kingdom

The Middle Kingdom also collapsed, and Egypt fell under the rule of an Asiatic tribe called the Hyskos. They introduced Bronze Age weapons to Egypt, as well as the horse. Eventually the Egyptians overthrew them, and the New Kingdom was launched. It proved to be one of the most vital periods in Egyptian history, marked by expansionism, increased wealth, and economic and political stability.

The art of the New Kingdom combined characteristics of the Old and Middle Kingdom periods. The monumental forms of the earliest centuries were coupled with the freedom of expression of the Middle Kingdom years. A certain vitality appeared in two-dimensional works like painting and relief sculpture, although sculpture in the round retained its concentration on solidity and permanence with few stylistic changes.

Egyptian society embraced a death cult, and some of its most significant monuments continued to be linked with death or worship of the dead. During the New Kingdom period, a new architectural form was created—the **mortuary temple.** Mortuary temples were carved out of the living rock, as were the rock-cut tombs of the Middle Kingdom, but their function was quite different. They did not house

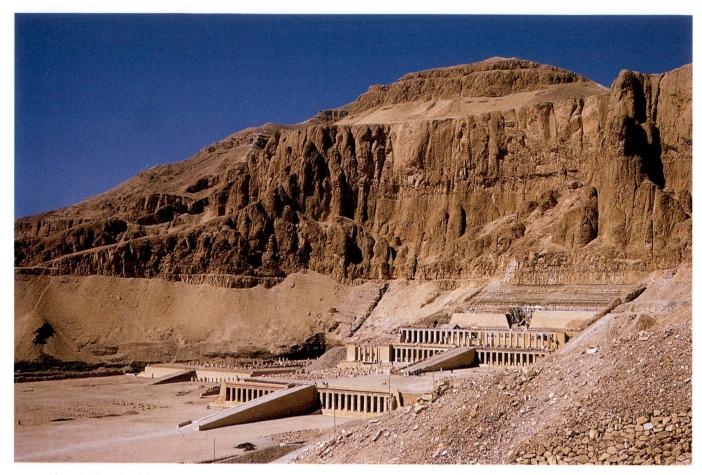

2-16 Mortuary Temple of Queen Hatshepsut, Thebes
 (Egyptian, New Kingdom, c. 1480 BCE).
 Copyright Edimedia/Corbis.

the mummified remains of the pharaohs but rather served as their place for worship during life, and a place at which they could be worshiped after death.

One of the most impressive mortuary temples of the New Kingdom is that of a female pharaoh, Queen Hatshepsut (Fig. 2-16). The temple backs into imposing cliffs and is divided into three terraces, which are approached by long ramps that rise from the floor of the valley to the top of pillared **colonnades.** Although the terraces are now as barren as the surrounding country, during Hatshepsut's time they were covered with exotic vegetation. The interior of the temple was just as lavishly decorated, with some 200 large sculptures as well as painted relief carvings.

As the civilization of Egypt became more advanced and powerful, there was a tendency to build and sculpt on a monumental scale. Statues and temples reached gigantic proportions. The delicacy and refinement of earlier Egyptian art fell by the wayside in favor of works that reflected the inflated Egyptian ego. Throughout the New Kingdom period, conventionalism was, for the most part, maintained. During the reign of Akhenaton, however, Egypt was offered a brief respite from stylistic rigidity.

The Amarna Revolution: The Reign of Akhenaton and Nefertiti

During the fourteenth century BCE a king by the name of Amenhotep IV rose to power. His reign marked a revolution in both religion and the arts. Amenhotep IV, named for the god Amen, changed his name to Akhenaton in honor of the sun god, Aton, and he declared that Aton was the only god. In his monotheistic fury, Akhenaton spent his life tearing down monuments to the old gods and erecting new ones to Aton.

A CLOSER LOOK

King Tut: The Face That Launched a Thousand High-Res Images

The Valley of the Kings, Luxor, Egypt; the fifth of January, 2005. Nearly 3,300 years after his death, the leathery mummy of the legendary boy-king was ever so delicately removed from its tomb and guided into a portable CT-what we call "cat"-scanner. It was not the first time that modern technology was employed to feed the curiosity of scientists, archeologists, and museum officials over the mysteries surrounding the reign and death of Tut. More than three decades earlier the mummy was X-rayed twice, in part to try to solve the mystery of the young pharaoh's death; Tutankhamen was crowned at the age of eight and died only 10 years later. These early X-rays revealed a hole at the base of Tut's cranium, leading to the suspicion that he was murdered. This time around, the focus-and the conclusions-changed. Dr. Zahi Hawass, secretary general of the Supreme Council of Antiquities in Cairo, said, "No one hit Tut on the back of the head." Scientists instead concluded that the damage noted in earlier X-rays was probably due to the rough removal of the golden burial mask by the tomb's discoverers. But they found something else: a puncture in Tut's skin over a severe break in the youth's left thigh. As it is known that this accident took place just days before his death, some experts on the scanning team conjectured that this break, and the puncture caused by it, may have led to a serious infection and Tut's consequent death. Otherwise, the young pharaoh was the picture of health-no signs of malnutrition or disease, with strong bones and teeth, and probably five and a half feet tall.

In all, scientists (including experts in anatomy, pathology, and radiology) spent two months analyzing more than 1,700 three-dimensional, high-resolution images taken with computed tomography (CT) scans. Then artists and scholars took a turn. Three independent teams, one each from Egypt, France, and the United States, came up with their own versions of what Tut might very well have looked like in life: a bit of an elongated skull (normal, they say), large lips, a receding chin, and a pronounced overbite that seems to have run in the family (Fig. 2-17). It was the first time—but certainly not the last—that CT scans would be used to reconstruct the faces of the Egyptian celebrity dead.

Although the price tag on this endeavor was most certainly steep, the Egyptian government stood to gain financially from the images. Their release

was timed to coincide with the launch of the world-traveling exhibition *Tutankhamen and the Golden Age of the Pharaohs.* Along with the scans and reconstruction images, the exhibit would feature King Tut's diamond crown and gold coffin, along with a total of almost 200 objects from his and various other noteworthy tombs. If history were any predictor of the insatiable thirst for things Egyptian, this, like the original exhibition of treasures from Tut's tomb, would attract millions of visitors. This time, however, it was hoped that the \$10 million rental fee for each museum venue would bring in desperately needed funding for a museum being planned beside the pyramids in Gizeh. As in many parts of the world, antiquities are crumbling. "There are no free meals anymore," Hawass said. "We have a task. These monuments will be gone in 100 years if we don't raise the money to restore them."

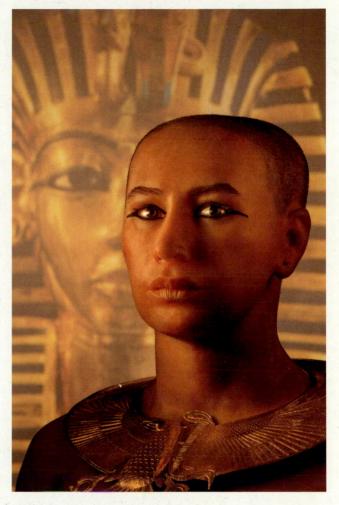

17 Reconstruction of face of King Tut. Kenneth Garrett, Supreme Council of Antiquities and The National Geographic Society.

The art of Akhenaton's reign, or that of the *Amarna period* (so named because the pharaoh moved the capital of Egypt to Tell el-Amarna), was as revolutionary as his approach to religion. The wedge-shaped stylizations that stood as a rigid canon for the representations of the human body were replaced by curving lines and full-bodied forms. The statue of Akhenaton (Fig. 2-18) could not differ more from its precedents in the Old and Middle Kingdoms. The fluid contours of the body contrast strongly with those in earlier sculptures of pharaohs, as do the elongated jaw, thick lips, and thick-lidded eyes. These characteristics suggest that the artist was attempting to create a naturalistic likeness of the pharaoh, "warts and all," as the saying goes.

Aside from being at odds stylistically with other Egyptian sculptures, the very concept of the work is different. Throughout the previous centuries, adherence to a stylistic formality had been maintained, especially in the sculptures of revered pharaohs. If naturalism was present at all, it was reserved for lesser works depicting lesser figures. During the Amarna period it was used in monumental statues depicting members of the royal family as well.

One of the most beautiful works of art from this period is the bust of Akhenaton's wife, Queen Nefertiti (Fig. 2-19). The classic profile reiterates the linear patterns found in the pharaoh's sculpture. An almost topheavy crowned head extends gracefully on a long and sensuous neck. The realism of the portrait is enhanced by the paint that is applied to the limestone.

The naturalism of the works of the Amarna period was short-lived. Subsequent pharaohs returned to the more rigid styles of the earlier dynasties. Just as Akhenaton destroyed the images and shrines of gods favored by earlier pharaohs, so did his successors destroy his temples to Aton.

With Akhenaton's death came the death of monotheism—for the time being. Some have suggested that Akhenaton's loyalty to a single god may have set a monotheistic example for other religions.

Akhenaton's immediate successor was Tutankhamen the famed King Tut. Called the boy-king, Tut died at about the age of 18. His tomb was not discovered until 1922, when British archeologists led by Howard Carter unearthed a treasure trove of gold artworks, many inlaid with semiprecious stones. By far, the most spectacular find was the young pharaoh's coffin (Fig. 2-20), made of solid gold and weighing almost 250 pounds. Within this, the last of three nesting coffins, lay the body of the king, wrapped in linen, his face covered with an astounding gold mask. The lid of the coffin was fashioned out of sheet gold, with eyes of aragonite (a semihard mineral) and obsidian (black volcanic

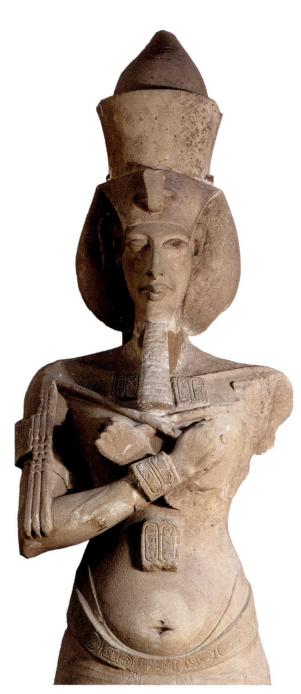

 2-18 Pillar statue of Akhenaton from Temple of Amen-Re, Karnak (Egyptian, New Kingdom, c. 1356 BCE). Sandstone, painted.
 Egyptian Museum, Cairo. Copyright Art Resource, New York. And the Heiress, Great in the Palace, Fair of Face, Adorned with the Double Plumes, Mistress of Happiness, Endowed with Favours, at hearing whose voice the King rejoices, the Chief Wife of the King, his beloved, the Lady of the Two Lands, Neferneferuaten-Nefertiti, May she live for Ever and Always.

-Cyril Aldred, in Akhenaton, King of Egypt

The-beautiful-one-is-come.

-Translation of Nefertiti

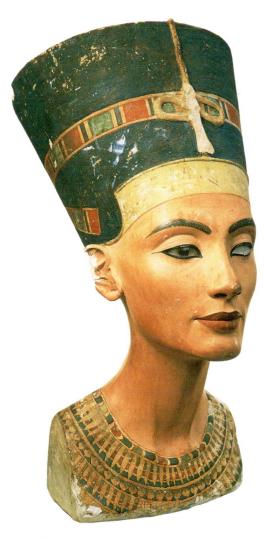

2-19 Bust of Queen Nefertiti (Egyptian, New Kingdom, c. 1344 BCE).Limestone. H: approx. 20".Agyptisches Museum State Museums, Berlin/Edimedia/Corbis.

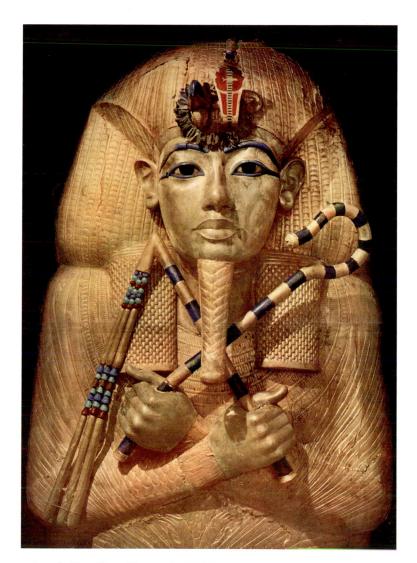

2–20 Coffin of Tutankhamen (c. 1323 BCE). Gold. Time & Life Pictures/Getty Images.

glass) and eyebrows inlaid with lapis lazuli. The hands of Tut's effigy cross over the chest and clutch the royal symbols of the crook and the flail, encrusted in deep blue faience-a signature Egytian opaque glazed earthenware. Carter, upon viewing the revelation of the coffin, described the sense of marvel at the sight: "And as the last was removed a gasp of wonderment escaped our lips, so gorgeous was the sight that met our eye: a golden effigy of the young boy king, of most magnificent workmanship, filled the whole of the interior of the sarcophagus." Although Tut's coffin and mask are characteristically stylized, Carter observed an element of realism in the fashioning of the face. In fact, some residual stylistic effects of the Amarna period are evident in several works from Tut's reign-curvilinear forms not unlike those seen in the statue of Akhenaton, a certain naturalism and tenderness in representations of the boy and his queen.

After Akhenaton's death, Egypt returned to "normal." That is, the worship of Amen was resumed and art reverted to the rigid stylization of the earlier stages. The divergence that had taken place with Akhenaton and been carried forward briefly by his successor soon disappeared. Instead, the permanence that was so valued by this people endured for another 1,000 years virtually unchanged despite the kingdom's gradual decline.

AEGEAN ART

The Tigris and Euphrates valleys and the Nile River banks provided the climate and conditions for the survival of Mesopotamia and Egypt. Other ancient civilizations also flourished because of their geography. Those of the Aegean— Crete in particular—developed and thrived because of their island location. As maritime powers, they maintained contact with distant cultures with whom they traded—including those of Egypt and Asia Minor.

Until about 1870 CE, the Aegean civilizations that had been sung by Greece's epic poet, Homer, in the *Iliad* and the *Odyssey* were viewed as fancy rather than fact. But during the last decades of the nineteenth century, the German archeologist Heinrich Schliemann followed the very words of Homer and unearthed some of the ancient sites, including Mycenae, on the Greek mainland (Map 2-3). Following in Schliemann's footsteps, Sir Arthur Evans excavated on the island of Crete and uncovered remains of the Minoan civilization also cited by Homer. The Bronze Age civilizations of **pre-Hellenic** Greece comprised these cultures and that of the Cyclades Islands.

The Cyclades

The Cyclades Islands are part of an archipelago in the Aegean Sea off the southeastern coast of mainland Greece. They are six in number and include Melos, the site where the famed Venus de Milo (see Fig. 3-16) was found; and Paros, one of the chief quarries for marble used in ancient Greece. The Cycladic culture flourished on these six islands during the Early Bronze Age, from roughly 2500 to 2000 BCE.

The art that survives has been culled mostly from tombs and includes pottery and small marble figurines of women (Fig. 2-21) and male musicians. It is not clear what

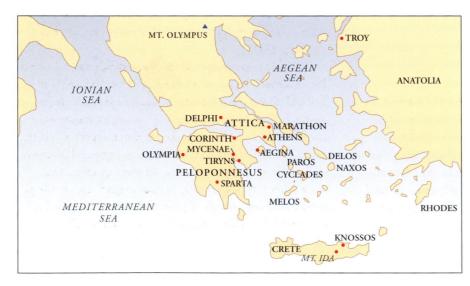

Map 2–3 Greece (5th century BCE).

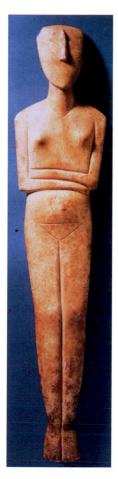

 2-21 Cycladic idol, from Amorgos (c. 2500–1100 BCE). Marble. H: 30".
 Ashmolean Museum, Oxford, England.

purpose the small female figures served. Some say they represent goddesses and others argue for a link to fertility. They are, in a way, pareddown, geometric versions of the Venus of Willendorf (Fig. 2-2); that is, the breasts, abdomen, and pubic area are more defined than the limbs and head. Because they were found in tombs, it would seem likely that they served a funerary function.

The figures range in height from a few inches to well over one foot, although some are life-size. They are essentially flat, with oval or wedgeshaped heads, squared torsos, and attenuated limbs. The smooth planes

of the faces generally bear only one feature—a nose. Some traces of paint have been found. Male figures are typically seated and are playing stylized musical instruments. They were also found in tombs and their function and identity are also open to speculation.

Crete

The civilization that developed on the island of Crete was one of the most remarkable in the ancient world, rich in painting, sculpture, and elaborate architecture. It also brought us names like King Minos (Crete's culture is known as Minoan, after the king) and creatures like the Minotaur. Homer spoke of youths sent to a Cretan labyrinth for sacrifice to the notorious man-beast, and of the hero Theseus, who slayed the Minotaur. Assuming that myths have some basis in fact, we might conclude that the extensive labyrinth that was part of the sprawling palace at Knossos—home to King Minos—inspired Homer's poetic narrative. Homeric descriptions of this island civilization were viewed as literary rather than historical. But as with Schliemann and Troy, the archaeologist Sir Arthur Evan's excavations revealed Crete to have been an advanced and bustling civilization.

Evans divided the history of Minoan civilization into three parts: the Early Minoan period, known as the pre-Palace period, from which survive some small sculptures and pottery; the Middle Minoan period, or the period of the Old Palaces, which began around 2000 BCE and ended three centuries later with what was probably a devastating earthquake; and the Late Minoan period, during which these palaces were reconstructed, which began during the sixteenth century BCE and ended probably in about 1400 BCE. It was at that time that the stronghold of Western civilization shifted from the Aegean to the Greek mainland.

During the Middle Minoan period, the great palaces, including the most famous one at Knossos, were constructed. A form of writing based on **pictographs**, called Linear A, was developed. Refined articles of ivory, metal, and pottery were also produced.

Unlike those of Mesopotamia and Egypt, Minoan architectural projects did not consist of tombs, mortuary temples, or shrines. Instead, the Minoans constructed lavish palaces for their kings and the royal entourage. Not much is known of the old palaces, except for those that were subsequently built on their ruins. Toward the end of the Middle Minoan period, the palace at Knossos was reduced to rubble either by an earthquake or by invaders. About a century after its destruction, however, it was rebuilt on a grander scale. Also during the Late Minoan period, a type of writing called Linear B was developed. This system, finally deciphered in 1953, turned out to be an early form of Greek. The script, found on clay tablets, perhaps indicates the presence of a Greek-speaking people—the Mycenaeans—on Crete during this period.

The most spectacular of the restored palaces on Crete is that at Knossos. It was so sprawling that one can easily understand how the myth of the Minotaur arose. The adjective *labyrinthine* certainly describes it. A variety of rooms were set off major corridors and arranged about a spacious central court. The rooms included the king's and queen's bedrooms, a throne room, reception rooms, servants' quarters, and many other spaces, including rows of **magazines**, or storage areas, where large vessels of grain and wine were embedded in the earth for safekeeping and natural cooling. The palace was three stories high, and the upper floors were reached by well-lit staircases. Beneath the palace were the makings of an impressive water-supply system of terra-cotta pipes that would have provided running water for bathrooms.

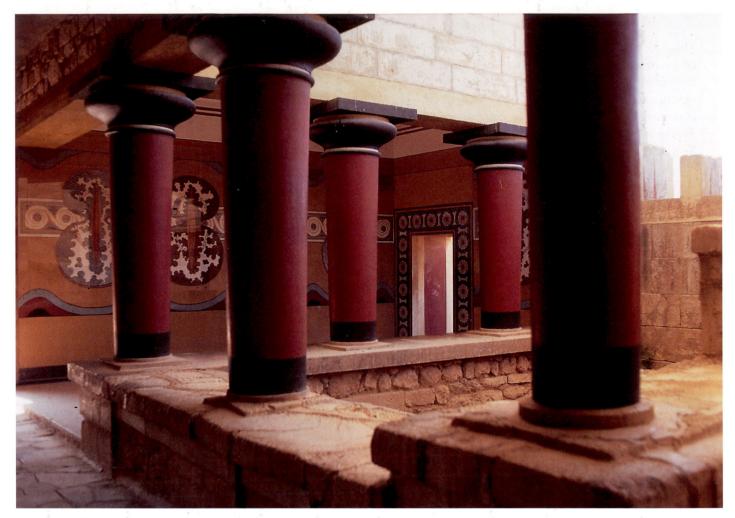

2–22 Queen's bedroom in Palace at Knossos (Late Minoan, c. 1500 BCE). Copyright Art Resource, New York.

Some of the most interesting decorative aspects of the palace at Knossos—seen in the queen's bedroom (Fig. 2-22) are its unique columns and its vibrant fresco paintings. The columns, carved of stone, are narrower at the base than at the top. This proportion is the reverse of that of the standard columns found in Mesopotamia, Egypt, and later, in Greece. The columns are crowned by cushion-shaped capitals that loom large over the curious stem of the column shaft, often painted bright red or blue.

The rooms were also adorned with painted panels of plant and animal life. Stylized **rosettes** accent doorways, and delicately painted dolphins swim across the surface of the walls, giving one the impression of looking into a vast aquarium. This fascination with fish, sea mammals, and coastal plants in wall paintings and on pottery of the Late Minoan period reflects life on an island. The scale and complexity of the architecture reflects Crete as an impressive maritime power.

The palace at Knossos and all the other palaces on Crete were again destroyed sometime in the fifteenth century BCE. At this point the Mycenaeans of the Greek mainland may have moved in and occupied the island. However, their stay was short-lived. Knossos, and the Minoan civilization, had been finally destroyed by the year 1200 BCE.

Mycenae

Although the origins of the Mycenaean people are uncertain, we know that they came to the Greek mainland as early as 2000 BCE. They were a Greek-speaking people, sophisticated in forging bronze weaponry as well as versatile in the arts of ceramics, metalwork, and architecture. The Minoans clearly influenced their art and culture, even though by about 1600 BCE Mycenae was by far the more powerful of the two civilizations. Mycenaeans occupied Crete after the palaces were destroyed. The peak of Mycenaean supremacy lasted about two centuries, from 1400 to 1200 BCE. At the end of that period, invaders from the north—the fierce and undaunted Dorians gained control of mainland Greece. They intermingled with the Mycenaeans to form the beginnings of the peoples of ancient Greece.

Lacking the natural defense of a surrounding sea that was to Crete's advantage, the Mycenaeans were constantly facing threats from land invaders. They met these threats with strong fortifications, such as the citadels in the major cities of Mycenae and Tiryns. Much of the architecture and art of the Mycenaean civilization reflects the preoccupation with defense.

Architecture

For the Mycenaeans, the need for impenetrable fortification did not preclude aesthetic solutions to architectural challenges. Even though the construction methods employed in palaces, tombs, and fortification walls are their most impressive attributes, citadels were embellished with frescoes and sculpture. One of the most famous carved pieces in Mycenae is the Lion Gate (Fig. 2-23), one of the entranceways to the citadel of that city. The actual gateway consists of a heavy **lintel** that rests on two massive vertical pillars another example of post-and-lintel construction. Additional large stones were piled in rows, or courses, above the lintel and **beveled** to form an open triangle. A relief sculpture

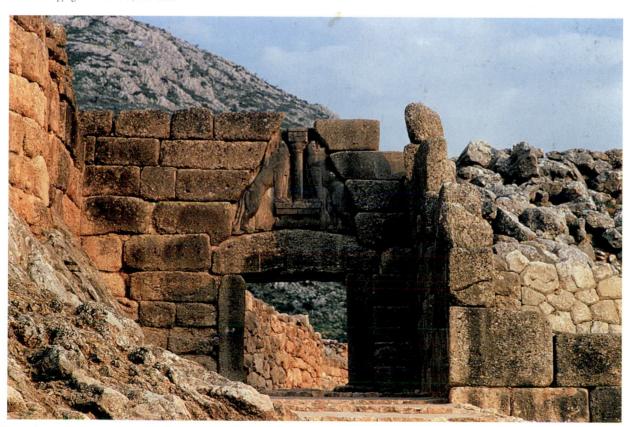

²⁻²³ Lion Gate at Mycenae (c. 1300 BCE). Height of sculpture above lintel: 9'6¹/₂". Copyright Art Resource, New York.

of two lions flanking a Minoan-style column fills the space. The heads of the beasts, now gone, were carved of separate pieces of stone and fitted into place. Although the animal figures are not intact, their prominent and realistic musculature, carved in high relief, is an awesome sight, one that signified to intruders the strength of the army within the walls.

Another contribution of the Mycenaean architect was the tholos, or beehive tomb. During the early phases of the Mycenaean civilization, members of the royal family were buried in so-called shaft graves. These were no more than pits in the ground, lined with stones, and marked by a stele, or headstone, set above the entrance to the grave. As time went on, however, tombs for the wealthy became more ambitious.

The Treasury of Atreus (Fig. 2-24), a tomb so named by Schliemann because he believed it to have been the tomb of the mythological ancient Greek king Atreus, is typical of such constructions. The Treasury consists of two parts: the dromos, or narrow passageway leading to the tomb proper; and the tho-

2-24 The Treasury of Atreus (Mycenaean, c. 1300-1250 BCE).

Copyright Art Resource, New York.

los, or beehive-shaped tomb chamber. The entire structure was covered by earth and has the appearance of a simple mound from the exterior. The interior walls were constructed of hundreds of stones laid on top of one another in concentric rings of diminishing size. The Treasury rose to a height of some 40 feet and enclosed a vast amount of space, an architectural feat not to be duplicated until the domed ceilings of ancient Rome were constructed.

Gold Work

Homer's epithet for Mycenae was "rich in gold." Archeologists came to uphold that description with the discovery of extraordinary quantities of finely wrought gold objects in graves throughout Mycenae although the tholos tombs, like the pyramids before them in Egypt, were plundered well before the modern excavations. One such find is a gold death mask (Fig. 2-25). Made from a sheet of hammered gold, it was intended to be placed over the face of the deceased. Although stylization is evident in the coffee bean eyes and curly-shaped ears, it is noteworthy that the artists attempted

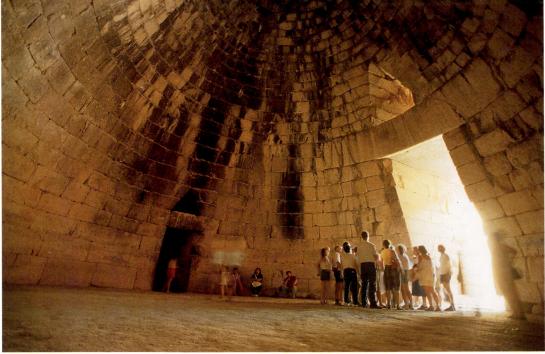

to differentiate one person's physical characteristics from another's. The funerary mask shown here was believed by Schliemann, erroneously, to have been that of Agamemnon, the Mycenaean king who led the Greek army against the Trojans. This mask was created approximately 300 years before he was born. Other craft art was found in Mycenean tombs, including weapons such as inlaid daggers and spectacular gold vessels.

But even the cyclopean walls of the Mycenaean citadels could not ward off enemies for long. After roughly 1200 BCE, the Mycenaean civilization collapsed at the hands of better-equipped warriors—the Dorians. The period following the Dorian invasions of the Greek mainland witnessed no significant developments in art and architecture. But the peoples of this area formed the seeds of one of the world's most influential and magnificent civilizations—that of ancient Greece.

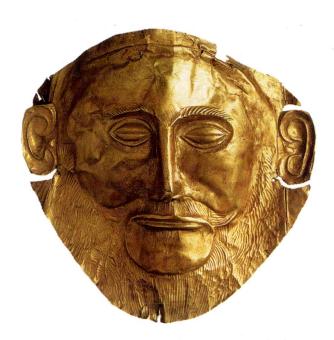

2-25 Funerary mask, from Grave Circle A, Mycenae, Greece (c. 1600–1500 BCE). Beaten gold. H: 12".

National Archaeological Museum, Athens. Copyright Art Resource, New York.

ART TOUR Jerusalem

erusalem-a city set in history, a city beset by current Jevents. Jerusalem—a city at once pluralistic and, more than once, intolerant. Jerusalem-spiritually, the home of three of the world's great religions and, emotionally, a house too often divided.

Over its 3,000-year history, Jerusalem and the Holy Land have been coveted territory. The ancient Egyptians battled the Canaanites in the coastal plains around the Dead Sea, bringing them under the rule of the pharaoh. And although the Hebrew tribes that coalesced into the entity known as Israel around 1200 to 1000 BCE came to dominate the region, they met continual violent struggles with such peoples as the Philistines, Assyrians, and Babylonians (who captured Jerusalem in 586 BCE, destroyed Solomon's Temple, and drove the Jews into exile). When the Jews returned to Jerusalem from Babylonian captivity, they built a new temple on the site of the old, ushering in the period of the "Second Temple." Yet even during this era, they were not selfgoverned; the Persians remained dominant over the region until they themselves were conquered by Alexander the Great.

From that point forward, the lewish nation met a series of enemies. None were more formidable than ancient Rome, whose legions first took the city of Jerusalem in 63 BCE. For almost 100 years, clashes between the Jews and the Romans were constant, and this, according to the Christian Bible, was the state of affairs into which Jesus was born. Bloody skirmishes led to full-scale war in 66 CE. After four years, the Romans were finally victorious, capturing Jerusalem and destroying the city and the Second Temple. But the subjugation of the Jewish people did not occur until three years later, after a test of wills and military might at the fortress of Masada. It was a subjugation that would not last. A second war was fought from 132 to 135 CE, with Rome victorious once again. This time the Jews were driven from the city of Jerusalem, scattering in what is known as the Diaspora.

Other religions entered the region as watershed historical events took place. When the Roman emperor Constantine converted to Christianity and granted freedom of worship to early Christians in the year 313 CE, the doors to the Holy Land were opened to pilgrims of the new faith, who built churches on sites connected to events in the life of Christ. By the late fourth century, Christianity became the official religion of the Holy Land. A little more than three centuries later, Muslims—followers of Islam and its prophet, Muhammad-became the new rulers of the Holy Land. Muslims maintain, as do Jews and Christians, that Jerusalem is holy to their religion; they believe that Muhammad ascended into heaven from the same rock in Jerusalem on which, according to the Hebrew Bible, Abraham was about to sacrifice his son Isaac. The Dome of the Rock stands over this site, on which the lews had originally built their temples. The coming and going of pilgrims to the Holy Land contin-

ued for some time, until lerusalem fell to the Turks in 1071 and Christians were forbidden access to their religious sites. This event led to the Crusades, the military effort to take back the Holy City of Jerusalem and biblical sites.

It is against this historical backdrop that we can make sense of the presentday composition of the Old City of Jerusalem and the

THE DOME OF THE ROCK. Copyright Royalty-Free/Corbis. nature of its historic sites. Within the walls are four delineated sections: the Christian guarter, the Jewish guarter, the Muslim guarter, and the Armenian guarter. Just outside the

fortress walls are the Mount of Olives (on which can be found the Garden of Gethsemane, where the apostle Judas was said to have betrayed Jesus to the Roman authorities) and Mount Zion (the place where it was believed the Last Supper took place.)

The Muslim quarter is the largest and most densely populated of the sections of the Old City and is physically dominated by one of the most extraordinary works of Islamic architecture in the worldthe Dome of the Rock. Built in 688-691 CE, the mosque-shrine represents the epitome of Islamic

THE GARDEN OF GETHSEMANE. Copyright Richard T. Nowitz/ Corbis.

architectural design, from the mathematical relationships of the individual parts to the building as a whole to the supremely ornamented tiles and mosaics of its interior.

Because the Islamic faith traditionally proscribed the rendering of the human figure, the walls and dome contain complex, decorative organic and abstract patterns, sometimes interlaced with Koranic verses and other inscriptions rendered in Arabic calligraphy. The Muslim quarter also includes the El-Aqsa Mosque, several well-known gates to the Old City (such as the Damascus Gate and Herod's Gate), a museum of Islamic art, and the Central Souk, a covered marketplace selling spices, clothes, and souvenirs. The Muslim quarter is also the site of the Via Dolorosa, venerated as the route taken by Jesus on the way to his Crucifixion.

The spiritual heart of the Jewish quarter of the Old City is the Western Wall—a section of the retaining wall of the Temple Mount that is the only part of the Second Temple complex that survives to this day. Since the sixteenth century it has been Judaism's holiest site, having been reconstructed after Israeli troops gained control of the Jewish quarter during the 1967 war. Jewish pilgrims from all over the world (non-Jews are also allowed to approach the wall) come to what is also known as the Wailing Wall to lament the destruction of the temple and to pray. Many leave

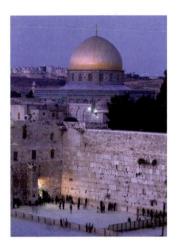

THE WESTERN WALL WITH THE DOME OF THE ROCK ABOVE.

Copyright Richard T. Nowitz/Corbis.

prayers inscribed on the smallest bits of paper, tucked into the cracks between the huge stone blocks that make up the wall.

Today the Jewish quarter is a mixture of historic sites and contemporary places of business serving the local community as well as tourists. Here, as in the other quarters, souvenir shops abound. Several fascinating excavations have been undertaken in the Jewish quarter, including the Cardo—one of Jerusalem's oldest main thoroughfares. During the era of the Crusades, the Cardo became a covered marketplace; today it remains an exclusive shopping arcade, full of

galleries and boutiques. The quarter has several synagogues and archeological museums, of which the Wohl Museum is perhaps best known. It is alive with bustling streets, such as Tiferet Yisrael Street, and squares that are the social centers of the contemporary Jewish quarter. Lovely homes built around courtyards are constructed—by decree of the British military governor in 1917—only of Jerusalem stone, a local material ranging from soft beige to pale rose in color.

Many of the common architectural elements and motifs of the three religious traditions are present even in these residential buildings, particularly the arch and the dome. The Christian quarter of Jerusalem took shape in the shadows of the domes of its most sacred site, the Church of the Holy Sepulchre. Within the walls of this vast structure are two of Christendom's most important monuments: Golgotha, or Calvary (the rock venerated as the site of Christ's Crucifixion), and Christ's tomb (a marble slab that covers the rock on which lesus' body is believed to have been laid). Flanking the main entrance are a bell tower and many chapels that, together with many small churches, hospices, and souvenir shops, obscure the overall exterior plan of the church. Over centuries, bitter disputes over who "owns" the church would arise until an Ottoman decree in 1852, known as the Status Quo, divided custody of the structure and its holy sites among the Roman Catholics, Copts, Armenians, Greeks, Ethiopians, and Syrians. Every day, a Muslim "key holder," a neutral intermediary, unlocks the doors of the church.

INTERIOR OF THE CHURCH OF THE HOLY SEPULCHRE, SHOWING CALVARY.

Copyright Carmen Redondo/Corbis.

Just within the walls of the Christian quarter, the Citadel of the Old City (most likely the place of Christ's trial and condemnation) now houses the Tower of David Museum of the History of Jerusalem. The museum contains specific routes that offer panoramic views of the city, a close look at archeological remains, and displays and dioramas focused on the three cultural-religious traditions of Jerusalem.

The story of the Armenians in Jerusalem begins in the time of Constantine (the kingdom of Armenia was the first to declare Christianity as its state religion after the emperor's edict of 313) and continues through the early twentieth century, when a large number of Armenian citizens fled to Jerusalem to escape the genocide by the Turks. Although their numbers have dwindled significantly over the decades, the Armenian Church still maintains jurisdiction over such sites as the Church of the Holy Sepulchre, the Mosque of the Ascension, and the Tomb of the Virgin on the Temple Mount. Armenian works of ceramic, mosaic, and manuscript illumination can be seen in the library of St. James Cathedral and in the Mardigian Museum in the Armenian quarter.

Modern Jerusalem is as bustling and magnificent a city as one will ever lay eyes on—fashionable hotels, ornate synagogues and mosques, gardens, fountains, upscale shopping districts, colorful markets, important museums. One of the most poignant aspects of this art tour is the recognition that for many, because of the continuing unrest, instability, and violence that grip the city, it is only what lies on these pages that will bring them to Jerusalem.

To continue your tour and learn more about Jerusalem, go to our website.

CLASSICAL ART: GREECE AND ROME

. . . the glory that was Greece And the grandeur that was Rome.

-Edgar Allan Poe

No other culture has had as far-reaching or lasting an influence on art and civilization as that of ancient Greece. It has been said that "nothing moves in the world which is not Greek in origin." To this day, the Greek influence can be felt in science, mathematics, law, politics, and art. Unlike some cultures that flourished, declined, and left barely an imprint on the pages of history, that of Greece has asserted itself time and again over the 3,000 years since its birth. During the fifteenth century, there was a revival of Greek art and culture called the Renaissance, and on the eve of the French Revolution of 1789, artists of the Neoclassical period again turned to the style and subjects of ancient Greece. Our founders looked to Greek architectural styles for the buildings of our nation's capital, and nearly every small town in America has a bank, post office, or library constructed in the Greek Revival style.

To claim that we can get along without study of the antique and the classics is either madness or laziness.

-Jean-Auguste-Dominique Ingres

Despite its cultural and artistic achievements, ancient Greece was conquered and absorbed by Rome—one of history's strongest and largest empires. Although Greece's political power waned, its influence as a culture did not. It was assimilated by the admiring Romans. The spirit of **Hellenism** lived on in the glorious days of the Roman Empire.

In contrast to the Greeks' intellectual and creative achievements, Rome's cultural contributions lay in the areas of building, city planning, government, and law. Although sometimes thought of as uncultured and crude, the Romans civilized much of the ancient world following military campaigns that are still studied in military academies.

Despite its awesome might, the Roman Empire also fell. It was replaced by a force whose ideals differed greatly and whose kingdom was not of this world—Christianity. In this chapter we shall examine the artistic legacy of Greece and Rome. This legacy—called **Classical art**—has influenced almost all of Western art, from Early Christian mosaics to contemporary Manhattan skyscrapers.

GREECE

Humanity, reason, and nature were central preoccupations of the Greek mind, together formulating their attitude toward life. The Greeks considered human beings the center of the universe—the "measure of all things." This concept is called **humanism**. The value the Greeks placed on the individual led to the development of democracy as a system of government among independent city-states throughout Greece and defined the character of Greek art, literature, and philosophy. To reach one's full potential, to be both physically and mentally fit, was an individual imperative. Perfection for the Greeks was the balance between elements: mind and body, emotion and intellect. Their love of reason and admiration for intellectual pursuits led to the development of **rationalism**, a philosophy in which knowledge is assumed to come from reason alone, without input from the senses. The Greeks also had a passion and respect for nature and viewed human beings as a reflection of its perfect order. Naturalism, or truth to reality based on a keen observation of nature, guided the representation of the human figure. When what nature dispensed fell short of the Greek concept of perfection, **idealism** (the representation of forms according to an accepted standard of beauty) held sway. Humanism, rationalism, naturalism, idealism—these are the elements of Greek art and architecture.

From ancient Greece come the names of the dramatists Aeschylus, Aristophanes, and Sophocles; the poets Homer and Hesiod; the philosophers Aristotle, Socrates, and Plato; scientists like Archimedes and mathematicians like Euclid; the historian Herodotus. It has given us gods like Zeus and Apollo, Athena and Aphrodite, and heroic figures named Achilles and Odysseus and Penelope. Even more astonishing, although Greek culture spans almost 1,000 years, its "Golden Age," or period of greatest achievement, lasted no more than 80 years. As with many civilizations, the development of Greece occurred over a cycle of birth, maturation, perfection, and decline. These points in the cycle correspond to the four periods of Greek art that we will examine in this chapter: Geometric, Archaic, Classical, and Hellenistic.

Geometric Period

The **Geometric period** spanned approximately two centuries, from about 900 to 700 BCE. The period prior to this time is sometimes called the Dark Age of Greece because of a virtual collapse of civilization. Greece was gripped by chaos and poverty, the arts were lost, and its society was cut off from the outside world. During the eighth century, trade resumed, the economic situation improved, and with these, first steps were taken to regenerate the arts. The geometric period is so called because of the predominance of geometric shapes and patterns in works of art. As in Egyptian art, the representation of the human figure was conceptual rather than optical, and usually reduced to a combination of geometric forms such as circles and triangles.

The Dipylon Vase (Fig. 3-1), a large krater used as a grave marker and found in the Dipylon cemetery in Athens, is an early example of the Geometric style. Except for its base, most of the vessel is decorated with geometric motifs, some of which may have been inspired by the patterns of woven baskets. Two thicker bands around the body of the vase feature a funeral procession comprised of stylized, geometric figures. Distinctions are made between males and females, but overall, they march along with the same rigidity of the geometric patterns. The figures are a familiar combination of frontal, wedge-shaped torsos, profile legs and arms, and a profile head with a frontal eye. In the center of one of the bands, the deceased rests on a bier. Below, figures of warriors with apple core-shaped shields and teams of chariots are in attendance. The deceased was likely a Greek soldier.

These geometric elements can also be seen in small bronze sculptures of the period, but the stylistic development is most evident in the art of vase painting.

Archaic Period

The **Archaic period** spanned roughly the years from 660 to 480 BCE, but the change from the Geometric style to the Archaic style in art was gradual. As Greece expanded its trade with Eastern countries, it was influenced by their art. Flowing forms and fantastic animals inspired by Mesopotamian art appeared on Greek pottery. There was a growing emphasis on the human figure, which replaced geometric motifs.

3-1 Dipylon Vase with funerary scene (Greek, 8th century BCE). Terra-cotta. H: 42⁵/8".
The Metropolitan Museum of Art, New York. Rogers Fund, 1914 (14.130.14). Copyright 1995 The Metropolitan Museum of Art, New York.

AND A DESCRIPTION OF THE OWNER OF

The Women Weavers of Ancient Greece

There are no names of important women artists recorded in ancient Greece. Yet there is plenty of evidence that women did have outlets for creative expression in the mediums of pottery, basketry, and particularly, weaving. It was typical for wealthy women as well as for common women and slaves to weave either as a pastime or to earn a living. Athena, the most important female god in the Greek pantheon, was the patron goddess of weavers and potters, although Athena is better known as the goddess of war and of wisdom.

Stories of women weaving come down to us from Homer in The Iliad and The Odyssey. Helen of Troy weaves in The Iliad. In The Odyssey, the saga of the wanderings of Odysseus throughout the Mediterranean following the sacking of Troy, Penelope, Odysseus's wife, ruled Ithaca in her husband's absence and was beset by many suitors who wished her to ac-

cept her husband's absence as evidence of his death and to marry one of them. Penelope evaded the suitors through a deception that involved weaving. She promised her suitors that she would marry one of them when she had finished a shroud for Odysseus's father, Laertes. Penelope spent her days weaving the shroud and her nights unraveling it.

The importance of the craft is suggested in a black-figure vase attributed to the Amasis Painter (Fig. 3-2). A large central panel on the body of the vessel contains the images of women working on looms and attending to other tasks in the production of cloth. Some art historians have suggested an even more widespread influence of women's weaving by connecting the patterns of geometric vase painting (Fig. 3-1) with those of Dorian wool fabrics.

> The tradition of weaving is thus an early one, but it is one that continues throughout the centuries. In the Middle Ages, for example, noblewomen, nuns, and commoners alike were taught the skills of weaving and embroidery. The most remarkable tapestries of this era were certainly created by women.

3-2 ATTRIBUTED TO THE AMASIS PAINTER. ATTIC LEKYTHOS. Women Working Wool on a Loom (Greek, c. 540 BCE). Terra-cotta. H: 63/4". Said to have been found in Attica. The Metropolitan Museum of Art, New York. Fletcher Fund, 1931 (31.11.10). Copyright 1999 The Metropolitan Museum of Art, New York.

Vase Painting

During the Archaic period, Eastern patterns and forms gradually disappeared. During the Geometric period the human figure was subordinated to decorative motifs, but in the Archaic period it became the preferred subject. In the François Vase (Fig. 3-3), for example, geometric patterns are restricted to a few areas. The entire body of the vessel, a volute krater, is divided into six wide bands, or registers, featuring the exploits of Greek heroes and legends including Achilles and Theseus. Even though the drawing is somewhat stilted, the figures of men and animals have substance and an attempt at naturalistic gestures has been made. Unlike the figures of the Dipylon Vase, those of the François Vase are not static. In fact, the movement of the battling humans and the prancing horses is quite lively. This energetic mood is echoed in the curling shapes of the volute handles.

The François Vase is a masterpiece of Archaic vase painting. No doubt, the potter and painter were proud of their work, because the vessel is signed twice by each of them. The Francois Vase, named after the archaeologist who found it, is an example of **black-figure painting.** The combination of black figures on a reddish background was achieved through a three-stage, kiln firing process. The figures were painted on a clay pot using a brush and a **slip**, a liquid of sifted clay, and then introduced to the kiln. The first stage of the firing process was called the **oxidizing phase** because oxygen was allowed into the kiln. Firing under these conditions turned both the pot and the painted slip decoration red.

In the second phase of firing, called the reducing phase, oxygen was eliminated from the kiln, and the vase and the slip both turned black. In the third and final phase, called the reoxidizing phase, oxygen was again introduced into the kiln. The coarser material of the pot turned red, and the fine clay of the slip remained black. The result was a vase with black figures silhouetted against a red ground. The finer details of the figures were incised with sharp instruments that scraped away portions of the black to expose the red clay underneath or highlighted with touches of red and purple pigment. Although this technique was fairly versatile, the black figures were ultimately too visually heavy for Greek artists. Around 530 BCE, a reversal of the black-figure process was developed, enabling painters to create lighter, more realistic red figures on a black ground.

orses unl-

> 3-3 KLEITIAS. François Vase. Attic volute krater (Greek, c. 570 BCE). Ceramic. H: 26". Archaeological Museum, Florence. Copyright Art Resource, New York.

Architecture

Some of the greatest accomplishments of the Greeks are witnessed in their architecture. Although their personal dwellings were simple, the temples for their gods were fantastic monuments. During the Archaic period, an architectural format was developed that provided the basis for temple architecture throughout the history and territories of ancient Greece. It consisted of a central room (derived in shape from the Mycenaean **megaron**) surrounded by a single or double row of columns. This room, called the **cella**, usually housed the cult statue of the god or goddess to whom the temple was dedicated. The overall shape of the temple was rectangular, and it had a pitched roof.

There were three styles, or orders, in Greek architecture: the **Doric, Ionic,** and **Corinthian.** The Doric order, which originated on the Greek mainland, was the earliest, simplest, and most commonly used. The more ornate Ionic order was introduced by architects from Asia Minor and

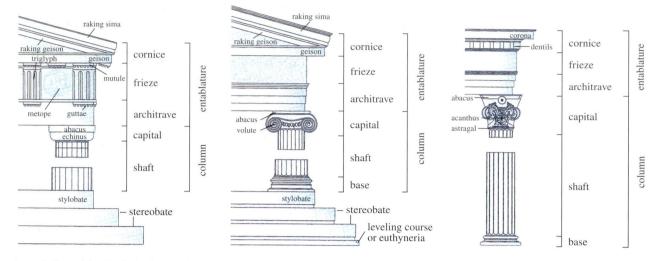

3-4 Left to right: Doric, Ionic, and Corinthian orders.

was generally reserved for smaller temples. The Corinthian order, differentiated from the Ionic by its intricate column capital, was not used widely in Greece but became a favorite design of Roman architects, who adopted it in the second century BCE. Figure 3-4 compares the Doric, Ionic, and Corinthian orders and illustrates the basic parts of the temple facade. The major weight-bearing elements of the temple are cylindrical columns composed of drums stacked on top of one another and fitted with dowels. They sit on either a platform (stylobate) or a base and helped to support the roof. The main vertical body, or shaft, of the column is crowned by a capital that marks a transition from the shaft to a horizontal member (the entablature) that directly bears the weight of the roof. In the Doric order, the capital is simple and cushionlike. In the Ionic order it consists of a scroll or volute similar to those seen on the François Vase (Fig. 3-3). The Corinthian capital is by far the most elaborate, consisting of an all-around carving of overlapping acanthus leaves. The columns directly support the entablature, which is divided into three parts: the architrave, frieze, and cornice. The architrave of the Doric order is a solid, undecorated horizontal band, whereas those of the Ionic and Corinthian orders are subdivided into three narrower horizontal bands. The frieze, which sits directly above the architrave, is typically carved with relief sculpture.

The Doric frieze is divided into sections called **triglyphs** and **metopes.** The triglyphs are carved panels consisting of three vertical elements. These alternate with panels that were filled with figurative sculpture carved in

relief. The Ionic and Corinthian friezes, by contrast, were carved with a continuous band of figures or—particularly in the Corinthian order—repetitive, stylized motifs.

The Ionic order liberated sculptors from the constraints of the square spaces that defined the Doric frieze, allowing the figures and the narrative to flow more freely. The topmost element of the entablature is called a **cornice** and, together with the diagonals of the **raking cornice**, it forms a frame for the **pediment**. The triangular spaces of the pediments, formed by the slope of the roof lines at the short ends of the temple, was also decorated with figurative sculpture.

The Doric order originated in the Archaic period, but it attained perfection in the buildings of the Classical period. In some buildings, like the Parthenon, the Doric and Ionic orders are combined. The Corinthian order, although developed by the Greeks, was used more universally by the Romans.

Sculpture

In the Archaic period, sculpture emerged as a principal art form. In addition to sculptural decoration for buildings, freestanding, life-size, and larger-than-life-size statues were created. Such monumental sculpture was probably inspired by Egyptian figures that Greek travelers would have seen during the early Archaic period.

In Greek temples, the nonstructural members of the building were often ornamented with sculpture. These included the frieze and pediment. Because early Archaic sculptors were forced to work within relatively tight spaces, the figures from this period are often cramped and cumbersome. However, toward the end of the Archaic period, artists compensated for the irregularity of the spaces by arranging figures in poses that corresponded to the peculiarities of the architectural element. For example, the *Dying Warrior* (Fig. 3-5) from the Temple of Aphaia at Aegina was positioned to fit into one of the angles of its west pediment. The figure is based somewhat on the observation of nature, although conventions dominate—the thick-lidded eyes and stylized hair, overly defined lips that purse in an artificial "smile," and linear patterns that define musculature.

Building projects like the Temple of Aphaia took years to complete, and the hands of artists of different styles were involved. Compare the warrior from the west pediment with one from the east pediment of the same building (Fig. 3-6). This warrior's feet would have been wedged into the left corner of the pediment; his body fans out toward the shield, corresponding to the dimensions of the angle. Some conventions remain, like the thick-lidded eyes, subtle "smile," and unnaturally pointed beard. The body may not be wholly realistic, but the patterns that play over the surface of the warrior in the west pediment have been virtually eliminated as the artist aims for a convincing representation of muscles, bones, and tendons. The work reveals a marvelous attention to detail, both physical and psychological. It is, after all, a pitiful sight. The warrior, wounded in battle, crashes down upon the field with his shield in hand. He struggles to lift himself with his right arm, but to no avail. The hopelessness of the situation is echoed in the helplessness of the left arm, which remains trapped in the grasp of the

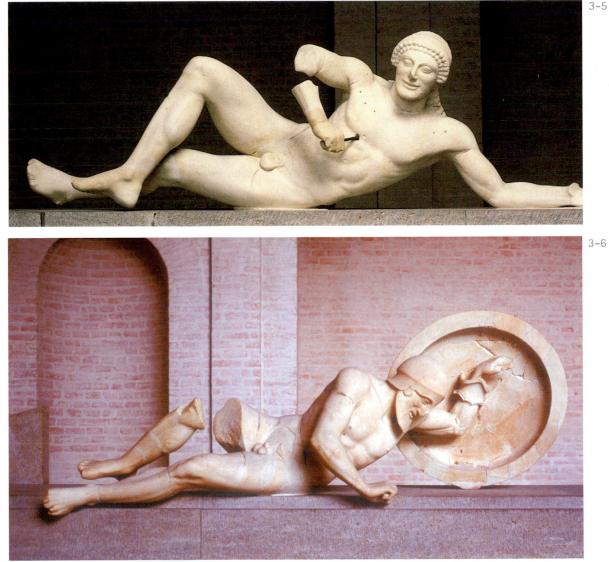

- Dying Warrior, from the west pediment of the Temple of Aphaia at Aegina, Greece (500 – 490 BCE). Marble. Approx. 5' 2¹/2" long. Saskia Ltd. Cultural Documentation.
- -6 Fallen Warrior, from the east pediment of the Temple of Aphaia at Aegina, Greece (490 – 480 BCE). Marble. Approx. 6'1" long. Staatliche Antikensammlungen und Glypothek, Munich. Copyright C. M. Dixon. Copyright Heritage Image Partnership (HIP),

heritage-images.com.

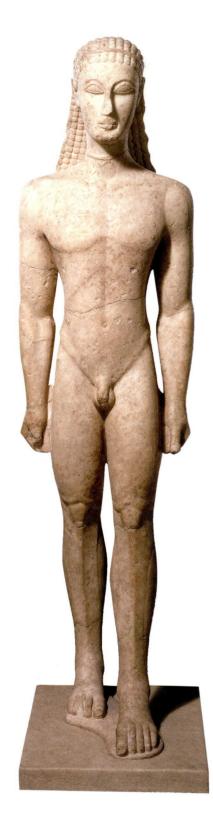

3-7 Kouros figure (Greek, Archaic, c. 600 BCE). Marble. H: 6'4".

The Metropolitan Museum of Art, New York. Fletcher Fund, 1932 (32.11.10). Copyright 1997 The Metropolitan Museum of Art, New York.

cumbersome shield. It hangs there useless, the band of the shield restricting its flow of blood. It is an emotionally wrenching scene, in spite of (or perhaps because of) the fact that the trauma is not revealed in the face of the warrior. It remains mask-like, bound to the restraining conventions of the Archaic style.

The Fallen Warrior from Aegina was created during the last years of the Archaic period and represents a stylistic transition to the Classical era. The history of Archaic Greek sculpture, however, began more than a century earlier, about 600 BCE, with large, freestanding figures. Some of the earliest of these are called kouros figures, devotional or funerary statues of young men. Figure 3-7 is typical of these figures. As in Egyptian sculptures, the arms lie close to the body, the fists are clenched, and one leg advances slightly. But the kouroi are different in a principal way: the stone was carved away from the body, releasing it from the block. These male figures are also depicted in the nude. The musculature is full and thick, and emphasized by harsh, patterned lines. The kneecaps, groin muscles, rib cage, and pectoral muscles are all flexed unrealistically. The head has also been treated according to the artistic conventions of the day. The hair is stylized and intricate in pattern. The eyes are thick lidded and stare directly forward. The youth has very high cheekbones and clearly defined lips that appear to curl upward in a smile. This facial expression, which we also saw on the warriors of the Temple of Aphaia, seems to have been an Archaic convention and thus is called an "Archaic smile." Kouroi (plural) were found in cemeteries, where they replaced large vases as grave markers. They were also used as votive sculptures (recall the votive figures of Tell Asmar, Fig. 2-7). In their stately repose and grand presence, these figures might impress us as gods rather than mortals. One is reminded of the oft-repeated statement, "The Greeks made their gods into men and their men into gods."

The female counterpart to the kouros is the **kore**. Unlike the kouros, the kore is clothed and often embellished with intricate carved detail. The *Peplos Kore* (Fig. 3-8)—so 3-8 Peplos Kore (Greek, Archaic, c. 530 BCE). Marble. H: 48". Acropolis Museum, Athens. Copyright Art Resource, New York.

named because the garment the model wears is a **peplos**, or heavy woolen wrap—is one of the most enchanting images in Greek art, partly because touches of paint remain on the sculpture, giving it a lifelike gaze and sensitive expression. We tend to think of Greek architecture and sculpture as pristine and glistening in their pure white surfaces. Yet most sculpture was painted with subtle colors. Architectural sculpture was embellished with red, blue, yellow, green, black, and sometimes gold pigments. None of this painted decoration remains on temple sculpture. However, statues and wooden panels were painted with encaustic, a more durable and permanent medium combining pigment and wax.

The beauty of the *Peplos Kore* lies in its simplicity. The woman's body is composed of graceful columnar lines echoed in the delicate play of the long braids that grace her shoulders. As with kouroi, she remains close to, but not strictly bound to the marble block from which she was carved. Her right arm is attached to her side at the wrist, but the left arm, now missing, extended outward and probably held a symbolic offering. Although the function of the kore figures is uncertain, they have been interpreted as votive sculptures because many have been found among the ruins of temples.

These architectural and freestanding sculptures were all made of marble. Although expensive, it was readily available and some of the finest marble in the world came from quarries near Athens.

The late Archaic period produced significant works of art and architecture against the backdrop of brutal war with the Persians. We encountered the might of the Persian empire in Chapter 2. By the late fifth century BCE, it appeared as if that empire would consume all of Greece. After horrible, violent losses, the Greeks defeated the Persians in a decisive battle on the plain of Marathon and captured a naval victory at Salamis. Greek pride surged and a Western identity was formed—one that stood in self-conscious opposition to the perceived barbarism of the Persians and their Asian civilization.

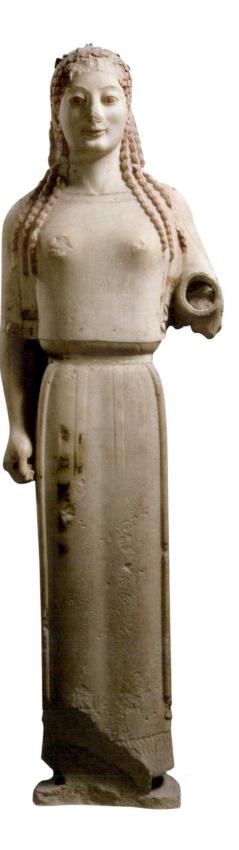

3-9 MYRON.

Diskobolos (Discus Thrower) (c. 450 BCE). Roman marble copy after bronze original. Life-size.

Palazzo Vecchio, Florence. Copyright Edimedia/Corbis.

Early Classical Art

The change from the Archaic to the Classical period coincided with the Greek victory over the Persians at Salamis in 480 BCE. The Greek mood was elevated after this feat, and a new sense of unity among the city-states prevailed, propelling the country into its "Golden Age." Athens, which was sacked by the Persians, became the center for all important postwar activity and the revival of the arts. The style of Early Classical art is marked by a power and austerity that reflected what were seen as Greek traits responsible for the defeat of the Persians. Although Early Classical sculpture developed beyond Archaic stylizations, some of the rigidity of the earlier period remains. The Early Classical style is therefore sometimes referred to as the Severe style.

Sculpture

The most significant development in Early

Classical art was the introduction of implied movement in figurative sculpture. This went hand in hand with the artist's keener observation of nature. One of the most widely copied works of this period, which encompasses these new elements, is the Diskobolos (Fig. 3-9), or Discus Thrower, by Myron. Like most Greek monumental sculpture, it survives only in a marble Roman copy after the bronze original. The life-size statue depicts an event from the Olympic Gamesthe discus throw. The athlete, a young man in his prime, is caught by the artist at the moment when the arm stops its swing backward and prepares to sling forward to release the discus. His muscles are tensed as he reaches for the strength to release the object. His torso intersects the arc of his extended arms, resembling an arrow pulled taut on a bow. It is an image of pent-up energy at the moment before release. As in most of Greek Classical art, there is a balance between motion and stability, between emotion and restraint.

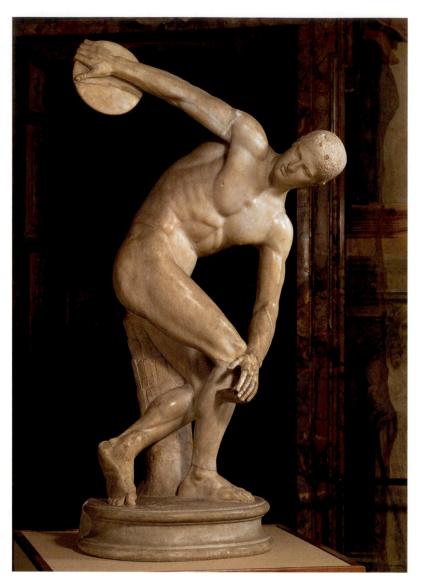

Classical Art

Greek sculpture and architecture reached their height of perfection during the Classical period. Greece embarked upon a period of peace—albeit short-lived—and turned its attention to rebuilding its monuments and advancing art, drama, and music. The dominating force behind these accomplishments in Athens was the dynamic statesman Pericles. His reputation was recounted centuries after his death by the Greek historian Plutarch. On the one hand, Plutarch described the anger of the Greek city-states at Pericles' use of funds set aside for mutual protection to pay for his ambitious Athenian building program. On the other hand, Plutarch wrote glowingly about post-war Athens: ". . . in its beauty, each work was, even at that time, ancient, and yet, in Raphael is a great master. Velázquez is a great master. El Greco is a great master, but the secret of plastic beauty is located at a greater distance: in the Greeks at the time of Pericles.

-Pablo Picasso

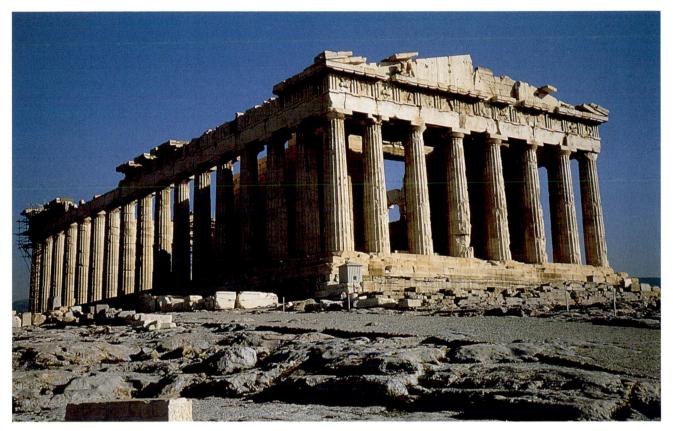

 3-10 ICTINOS AND CALLICRATES. The Parthenon on the Acropolis, Athens (448–432 BCE). Copyright Getty/Image Bank.

its perfection, each looks even at the present time as if it were fresh and newly built. . . . It is as if some ever-flowering life and unaging spirit had been infused into the creation of these works."

Architecture

After the Persians destroyed the Acropolis, the Athenians refused to rebuild their shrines with the fallen stones that the enemy had desecrated. What followed was a massive building campaign under the direction of Pericles. Work began first on the temple that was sacred to the goddess **Athena**, protector of Athens. This temple, the Parthenon (Fig. 3-10), became one of the most influential buildings in the history of architecture. Constructed by the architects Ictinos and Callicrates, the Parthenon stands as the most accomplished representative of the Doric order, although it does include some Ionic elements. A single row of Doric columns, now gracefully proportioned, surrounds a two-roomed cella that housed a treasury and a 40-foot-high statue of Athena made of ivory and gold. At first glance, the architecture appears austere, with its rigid progression of vertical elements crowned by the strong horizontal of its entablature. Yet few of the building's lines are strictly vertical or horizontal. For example, the stylobate, or top step of the platform from which the columns rise, is not straight, but curves downward toward the ends. This convex shape is echoed in the entablature. The columns are not exactly vertical, but rather tilt inward. They are not evenly spaced; the intervals between the corner columns are narrower. The shafts of the columns themselves also differ from one another. The corner columns have a wider diameter, for example. In addition, the shaft of each column swells in diameter as it rises from the base, narrowing once again before reaching the capital. This swelling is called **entasis**.

The reasons for these variations are not known for certain, although there have been several hypotheses. Some art historians have suggested that the change from straight to curved lines is functional. A convex stylobate, for example, might make drainage easier. Others have suggested that the variations are meant to compensate for perceptual distortions on the part of the viewer that would make straight lines look curved from a distance. Regardless of the actual motive, we can assume that the designers of the Parthenon sought an integrated and organic look to their building. The wide base and relatively narrower roof give the appearance of a structure that is anchored firmly to the ground yet growing dramatically from it. Although it has a grandeur based on a kind of austerity, it also has a lively plasticity. It appears as if the Greeks conceived their architecture as large, freestanding sculpture.

The subsequent history of the Parthenon is interesting and shocking. It was used as a Byzantine church, a Roman Catholic church, and a mosque. The Parthenon survived more or less intact, although altered by these successive functions, until the seventeenth century, when the Turks

 3-11 The Three Goddesses, from east pediment of the Parthenon (c. 438-431 BCE). Marble. Height of center figure: 4'7".
 British Museum, London. Copyright Heritage Image Partnership (HIP), heritage-images.com. used it as an ammunition dump in their war against the Venetians. Venetian rockets hit the bull's eye, and the center portion of the temple was blown out in the explosion. The cella still lies in ruins, although fortunately the exterior columns and entablatures were not beyond repair.

Sculpture

The sculptor Phidias was commissioned by Pericles to oversee the entire sculptural program of the Parthenon. Although he concentrated his own efforts on creating the ivory and gold statue of Athena, his assistants followed his style closely. The Phidian style is characterized by a lightness of touch, attention to realistic detail, contrast of textures, and fluidity and spontaneity of line and movement.

As on other Doric temples, the sculpted surfaces of the Parthenon were confined to the friezes and the pediments. The subjects of the Doric frieze were battles between the Lapiths and the Centaurs, the Greeks and the Amazons, and the gods and the giants. In addition, the Parthenon had a continuous, inner Ionic frieze. This was carved with scenes from the Panathenaic procession, an event that took place every four years when the peplos of the statue of Athena was changed. The pediments depicted the birth of Athena and the contest between Athena and Poseidon for the city of Athens.

The *Three Goddesses* (Fig. 3-11), a figural group from the corner of the east pediment, is typical of the Phidian

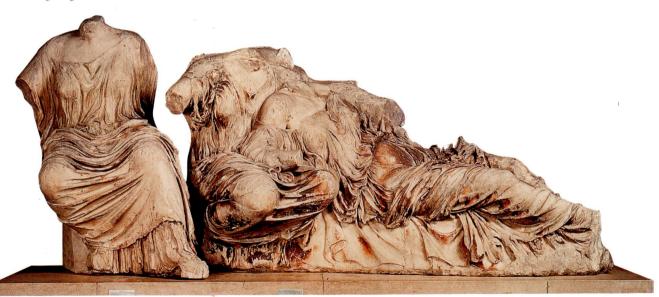

style. The bodies of the goddesses are weighty and wellarticulated and their poses and gestures are naturalistic. The drapery falls over the bodies in realistic folds, and there is a marvelous contrast of textures between the heavier cloth that wraps around the legs and the more diaphanous fabric covering the upper torsos. The thinner drapery clings to the body as if wet, following the contours of the flesh. The intricate play of the linear folds renders a tactile quality not seen in art before this time. The lines both gently envelop the individual figures and integrate them in a dynamically flowing composition.

As mentioned above, Greece had at one time come under Turkish rule. Some of the Parthenon sculptures were taken down by Lord Elgin between 1801 and 1803 while he was British ambassador to Constantinople. He sold them the British government, who put them on display at the British Museum. Although there has been prolonged controversy concerning their return to Greece, there is no doubt that Lord Elgin saved the marbles from utter destruction.

Some of the greatest freestanding sculpture of the Classical period was created by a rival of Phidias named Polykleitos. His favorite medium was bronze and his preferred subject was athletes. As with most Greek sculpture, we know his work primarily from marble Roman copies of the bronze originals.

Polykleitos's work differed markedly from that of Phidias. Whereas the Parthenon sculptor emphasized the reality of appearances and aimed to delight the senses through textural contrasts, Polykleitos's statues were based upon reason and intellect. Rather than mimic nature, he tried to perfect nature by developing a canon of proportions from which he would derive his "ideal" figures.

Polykleitos's most famous sculpture is the Doryphoros (Fig. 3-12), or Spear Bearer. The artist has "idealized" the athletic figure-that is, made it more perfect and more beautiful-by imposing on it a set of laws relating part to part (for example, the entire body is equal in height to eight heads). Although some of Phidias's spontaneity is lost, the result is an almost godlike image of grandeur and strength. One of the most significant elements of Polykleitos's style is the weight-shift principle. The athlete rests his weight on the right leg, which is planted firmly on the ground. It forms a strong vertical that is echoed in the vertical of the relaxed arm. These are counterbalanced by a relaxed left leg bent at the knee and a tensed left arm bent at the elbow. Tension and relaxation of the limbs are balanced across the body *diagonally*. The relaxed arm opposes the relaxed leg, and the tensed arm is opposite the tensed, weight-bearing leg. The weight-shift principle lends naturalism to the figure.

3-12 POLYKLEITOS.

Doryphoros (Spear Bearer) (c. 450–440 BCE). Marble. Roman copy after Greek original. H: 6'6". National Museum, Naples. Copyright Art Resource, New York.

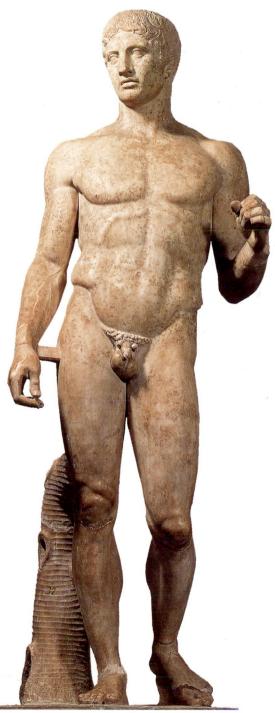

Rather than face forward in a rigid pose, as do the kouroi, the *Doryphoros* stands comfortably at rest. The ease and naturalism, however, were derived from a compulsive balancing of opposing parts.

Vase Painting

The weight-shift principle and the naturalistic use of implied movement can also be seen in Classical vase painting such as the Argonaut Krater (Fig. 3-13), a red-figure vase by the so-called Niobid Painter. In the Dipylon krater and the François Vase, the human figures were confined to registers (see Figs. 3-1 and 3-3). On later vases, these registers were eliminated, making the broad field of the vase available for the portrayal of the human figure in a variety of positions. Until the Classical period, though, the figures were placed in a frieze-like arrangement. That is, all of the heads were pretty much on one level and depth was limited. The Niobid Painter, by contrast, attempted to create a sense of three-dimensional space by outlining a foreground, middle ground, and background. This was a noble attempt at realism, based on optical perception; but ultimately it fails because the artist did not shrink the sizes of the background figures to suggest distance. The ability to arrange figures in space convincingly came later with the development of perspective.

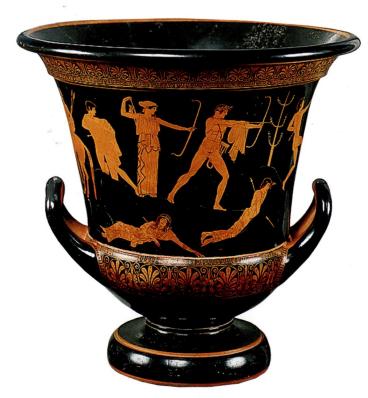

 3-13 NIOBID PAINTER. Argonaut Krater, Attic red-figure krater (Greek, c. 460 BCE). Ceramic. H: 24¹/4". Louvre Museum, Paris. Copyright Art Resource, New York. Vase painting was not the only two-dimensional art form in ancient Greece. There was also wall, or **mural painting**, none of which has survived. It is believed, however, that the Romans copied Greek wall painting, as they did sculpture, and it is thus possible to conjecture what Greek painting looked like by examining surviving Roman wall painting (Fig. 3-21).

Late Classical Art

Sculpture

The Late Classical period brought a more humanistic and naturalistic style, with emphasis on the expression of emotion. The stocky muscularity of the Polykleitan ideal was replaced by a more languid sensuality and graceful proportions. One of the major proponents of this new style was Praxiteles. His works show a lively spirit that was lacking in some of the more austere sculptures of the Classical period.

The Hermes and Dionysos of Praxiteles (Fig. 3-14), interestingly, is the only undisputed original work we have by the Greek masters of the Classical era. Unlike most other sculptors who favored bronze, Praxiteles excelled in carving. His ability to translate harsh stone surfaces into subtly modeled flesh was unsurpassed. We need only compare his figural group with the Doryphoros to witness the changes that had taken place since the Classical period. Hermes is delicately carved and his musculature is realistically depicted, suggesting the preference of nature as a model over adherence to a rigid, pre-defined canon. The messenger-god holds the infant Dionysos, the god of wine, in his left arm, which is propped up by a tree trunk covered with a drape. His right arm is broken above the elbow but reaches out in front of him. It has been suggested that Hermes once held a bunch of grapes toward which the infant was reaching.

Praxiteles' skill in depicting variations in texture was extraordinary. Note, for example, the differences between the solid, toned muscles of the man and the soft, cuddly flesh of the child; or rough, curly hair against the flawless, ivory skin; or the deeply carved, billowing drapery alongside the subtly modeled flesh. The easy grace of the sculpture comes from applying a double weight-shift principle. Hermes shifts his weight from the right leg to the left arm, resting it on the tree. This position causes a sway which is called an **S curve**, because the contours of the body form an S shape around an imaginary vertical axis.

Perhaps most remarkable is the emotional content of the sculpture. The aloof quality of Classical statuary is replaced with a touching scene between the two gods. Hermes' facial expression as he teases the child is one of pride and amusement. Dionysos, on the other hand, exhibits typical infant

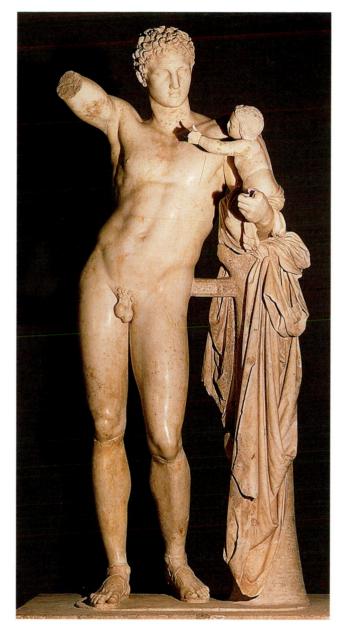

behavior—he is all hands and reaching impatiently for something to eat. There remains a certain restraint to the movement and to the expressiveness, but it is definitely on the wane. In the Hellenistic period, that classical balance will no longer pertain, and the emotion present in Praxiteles' sculpture will reach new peaks.

The most important and innovative sculptor to follow Praxiteles was Lysippos. He introduced a new canon of proportions that resulted in more slender and graceful figures, departing from the stockiness of Polykleitos and assuming the fluidity of Praxiteles. Most important, however, was his new concept of the motion of figure in space. All of the sculptures that we have seen so far have had a two-dimensional perspective. That is, the whole of the work can be viewed 3-14 PRAXITELES. Hermes and Dionysos (c. 330–320 BCE). Marble. H: 7'1". Museum, Olympia. Copyright Art Resource, New York.

3-15 LYSIPPOS.

Apoxyomenos (c. 330 BCE). Roman marble copy after a bronze original. H: 6'6³/4". Vatican Museums, Rome. Copyright Art Resource, New York.

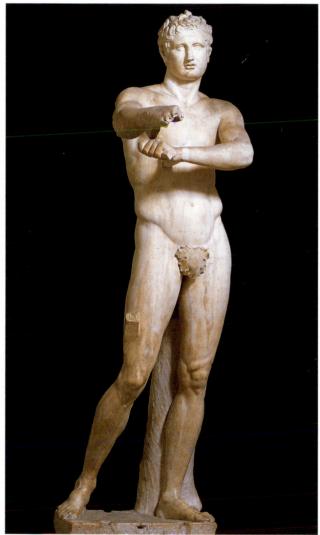

from a single point of view, standing in front of the sculpture. This is not the case in works such as the *Apoxyomenos* (Fig. 3-15) by Lysippos. The figure's arms envelop the surrounding space. The athlete is scraping oil and grime from his body with a dull knife-like implement. This stance forces the viewer to walk around the sculpture to appreciate its details. Rather than adhere to a single plane, as even the

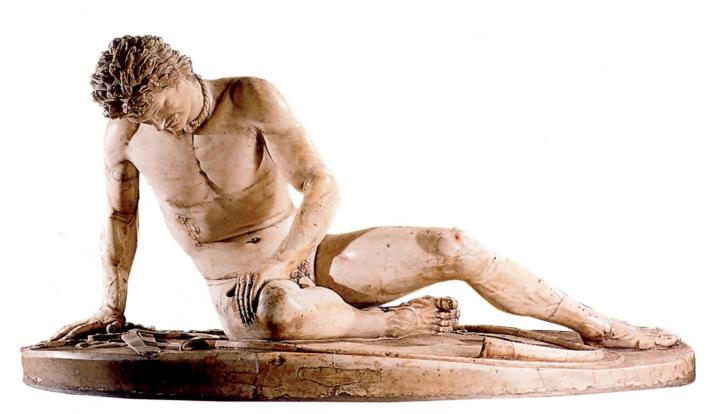

3-16 *The Dying Gaul* (Hellenistic, c. 240–200 BCE). Roman marble copy after a bronze original. Life-size. Capitoline Museum, Rome. Copyright Art Resource, New York.

S-curve figure of *Hermes* does, the *Apoxyomenos* seems to spiral around a vertical axis.

Lysippos's reputation was almost unsurpassed. In fact, so highly thought of was his work that Alexander the Great, the Macedonian king who spread Greek culture throughout the Near East, chose him as his court sculptor. It is said that Lysippos was the only sculptor permitted to execute portraits of Alexander. Years after the *Apoxyomenos* was created, it was still seen as a magnificent work of art. Pliny, a Roman writer on the arts, recounted an amusing story about the sculpture:

Lysippos made more statues than any other artist, being, as we said, very prolific in the art; among them was a youth scraping himself with a strigil, which Marcus Agrippa dedicated in front of his baths and which the Emperor Tiberius was astonishingly fond of. [Tiberius] was, in fact, unable to restrain himself in this case . . . and had it moved to his own bedroom, substituting another statue in its place. When, however, the indignation of the Roman people was so great that it demanded, by an uproar . . . that the Apoxyomenos be replaced, the Emperor, although he had fallen in love with it, put it back.¹

Hellenistic Art

Greece entered the Hellenistic period under the reign of Alexander the Great. His father had conquered the democratic city-states, and Alexander had been raised amid the art and culture of Greece. When he ascended the throne, he conquered Persia, Egypt, and the entire Near East, bringing with him his beloved Greek culture, or Hellenism. With the vastness of Alexander's empire, the significance of the city of Athens as an artistic and cultural center waned.

Hellenistic art is characterized by excessive, almost theatrical emotion and the use of illusionistic effects to heighten realism. In three-dimensional art, the space surrounding the figures is treated as an extension of the viewer's space, at times narrowing the fine line between art and reality.

Sculpture

The Dying Gaul (Fig. 3-16) illustrates the Hellenistic artist's preoccupation with high drama and unleashed passion. Unlike the *Fallen Warrior* (Fig. 3-6), in which the viewer has to extract the emotion by piecing together scattered realistic details that suggest a narrative, *The Dying Gaul* presents all of the elements that communicate the pathos of the work. Bleeding

¹J. J. Pollitt, *The Art of Greece 1400–31 BCE: Sources and Documents* (Englewood Cliffs, NJ: Prentice-Hall, 1965), 144.

from a large wound in his side, the fallen "barbarian" attempts to sustain his weight on a weakened right arm. His head, rendered with coarse, disheveled hair, hangs down hopelessly. He has lost his battle and is now about to lose his life. Strength seems to drain out of his body and into the ground, even as we watch. Our perspective is that of a theatergoer; the Gaul seems to be sitting on a stage. Although the artist intended to evoke pity and emotion from the viewer, the figure's melodramatic pose and his placement on a stage-like platform detach the viewer from the event. We tend to see the scene as well-acted drama rather than cruel reality.

Hellenistic artists were often drawn to dramatic subjects. They did not focus on a balance between emotion and restraint but portrayed human excess. In the midst of this theatricality, however, there was another trend in Hellenistic art that reflected the simplicity and idealism of the Classical period. The harsh realism and passionate emotion of the Hellenistic artist could not be further in spirit from the serene and idealized form of the *Aphrodite of Melos* (Fig. 3-17), often called the *Venus de Milo*. This contradictory style owes more to the artistic legacy of Praxiteles than to the contemporary illusionism of the sculptor of the *Dying Gaul*.

In 146 BCE, the Romans sacked Corinth, a Greek city on the Peloponnesus, after which Greek power waned. Both the territory and the culture of Greece were assimilated by the powerful and growing Roman state. It has been said that "all roads lead to Rome," and so will this chapter. First, however, let us examine the art of the Etruscans, a civilization on the Italian peninsula that predated that of the Romans.

THE ETRUSCANS

The center of power of the Roman state was the peninsula of Italy, but the Romans did not gain supremacy over this area until the fourth century BCE, when they began to conquer the **Etruscans.** The Italian peninsula was inhabited by many peoples, but the Etruscan civilization was the most significant one before that of ancient Rome. The Etruscans had a long and interesting history, dating back to around 700 BCE, the period of transition from the Geometric to the Archaic period in Greece. They were not an indigenous peoples but are believed to have come from Asia Minor. This link may explain some similarities between Etruscan art and culture and that of Eastern countries.

Etruria and Greece had some things in common. Both were great sea powers. Both were divided into independent city-states. The Etruscans even borrowed motifs and styles from the art of Greece. There is one more similarity between the two civilizations: Etruria also fell prey to the 3-17 Aphrodite of Melos (Venus de Milo) (Hellenistic, 2nd century BCE).
 Marble. Larger than life-size.
 Louvre Museum, Paris. Copyright Edimedia/Corbis.

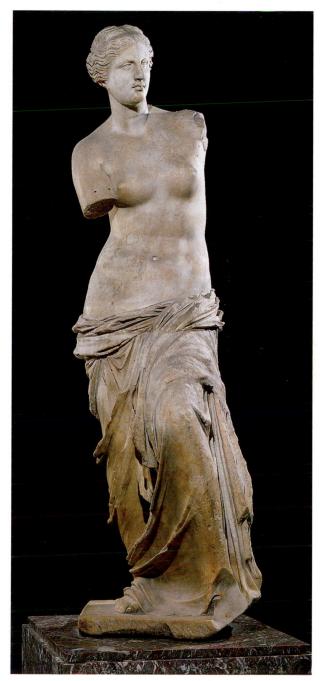

Romans. They were no match for Roman organization, especially because neighboring city-states never came to one another's aid in a time of crisis. By 88 BCE, the Romans had vanquished the last of the Etruscans.

Architecture

Although the Etruscans constructed temples, none survive beyond their foundations because they were constructed of impermanent materials such as wood and mud brick. Yet in what almost seems a throwback to ancient Egypt, underground tombs, carved out of bedrock, suggest the lives and habits of the Etruscan people. The interiors were constructed to resemble those of domestic dwellings. The walls were covered with hundreds of everyday items carved in low relief, including such things as kitchen utensils and weapons. Like the Egyptians, and unlike the Greeks, the Etruscans apparently wanted to duplicate their earthly environments in their funerary monuments.

Sculpture

Much sculpture of bronze and clay has survived from these Etruscan tombs, and we have learned a great deal about the Etruscan people from these finds. For example, even though no architecture survives, we know what the exterior of domestic dwellings looked like from the clay models of homes that served as **cinerary urns**. We have also been able to gain insight into the personalities of the Etruscan people through their figurative sculpture, particularly that found on the lids of their **sarcophagi**. The Sarcophagus from Cerveteri (Fig. 3-18) is a translation into terra-cotta of the banquet scenes of which the Etruscans were so fond. A man and wife are represented reclining on a lounge and appear to be enjoying the dinner entertainment. Their gestures are animated and naturalistic, even though their facial features and hair are rigidly stylized. These stylizations, especially the thick-lidded eyes, resemble Greek sculpture of the Archaic period and were most likely influenced by it. However, the serenity and severity of Archaic Greek art are absent. The Etruscans appear to be as relaxed, happy, and fun loving in death as they were in life.

ROME

In about 500 BCE the Roman Republic was established, and it would last some four centuries. The Roman arm of strength reached into northern Italy, conquering the Etruscans, and eventually stretched in all directions, gaining supremacy over Greece, western Europe, northern Africa, and parts of the Near East (Map 3-1). No longer was this the republican city of Rome flexing its muscles—this was the Roman Empire.

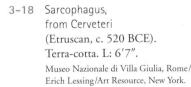

Ancient art was the tyrant of Egypt, the mistress of Greece, and the servant of Rome.

-Henry Fuseli

Roman art combined native talent, needs, and styles with other artistic sources, particularly those of Greece. The art that followed the absorption of Greece into the Roman Empire is thus often called Greco-Roman. It was fashionable for Romans to own-or at the very least, have copies of-Greek works of art. This tendency gave the Romans a reputation as mere imitators of Greek art, a simplistic view laid waste by scholars of Roman art history. A marvelous, unabashed eclecticism pervaded much of Roman art, resulting in vigorous and sometimes unpredictable combinations of motifs. The Romans were also fond of a harsh, almost trompe l'oeil, realism in their portrait sculpture, which had not been seen prior to their time. They were master builders (the inventors of concrete!) who created some of the grandest monuments in the history of architecture. Because of the vast expanse of the empire, these structures, or their remains, can be seen today almost everywhere.

The Republican Period

The ancient city of Rome was built on seven hills to the east of the Tiber River and served as the central Italian base from which the Romans would come to control most of the

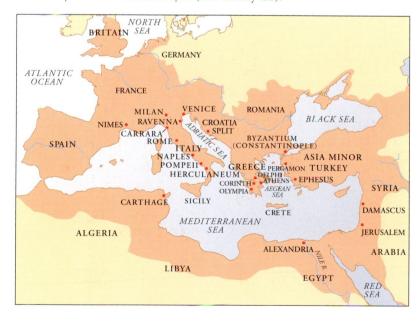

Map 3–1 The Roman Empire (2nd century CE).

known world in the West. Their illustrious beginnings are traced to the **Republican period**, which followed upon the heels of their final victories over the Etruscans and lasted until the death of Julius Caesar in 44 BCE. The Roman system of government during this time was based on two parties, although the distribution of power was not equitable. The patricians ruled the country and could be likened to an aristocratic class. They came from important Roman families and later were characterized as nobility. The majority of the Roman population, however, belonged to the plebeian class. Members of this class were common folk and had less say in running the government. They were, however, permitted to elect their patrician representatives. It was during the Republican period that the famed Roman senate became the governing body of Rome. The rulings of the senate were responsible for the numerous Roman conquests that would expand its borders into a seemingly boundless empire.

By virtue of its construction, however, the republic was doomed to crumble. It was never a true democracy. The patricians became richer and more powerful as a result of the plundering of vanquished nations. The lower classes, on the other hand, demanded more and more privileges and resented the wealth and influence of the aristocracy.

After a series of successful military campaigns and the quelling of internal strife in the republic, Julius Caesar emerged as dictator of the Roman Empire. Under Caesar

> important territories were accumulated, and Roman culture reached a peak of refinement. The language of Greece, its literature, and religion were adopted along with its artistic styles.

On March 15 (the ides of March) in 44 BCE, Julius Caesar was assassinated by members of the senate. With his death came the absolute end of the Roman Republic and the beginnings of the Roman Empire under his successor, Augustus.

Sculpture

Although much Roman art is derived in style from that of Greece, its portrait sculpture originated in a tradition that was wholly Italian. It is in this sculpture that we witness Rome's unique contribution to the arts—that of realism. With the Greeks there's always an aesthetic element. I prefer the virile realism of Rome, which doesn't embellish. The truthfulness of Roman art—it's like their buildings, but all the more beautiful in their genuine simplicity.

-Pablo Picasso

 3-19 Head of a Roman (Republican period, 1st century BCE). Marble. H: 14³/8".
 The Metropolitan Museum of Art, New York. Rogers Fund, 1912 (12.233). Photograph, all rights reserved, copyright The Metropolitan Museum of Art, New York.

It was customary for Romans to make wax death masks of their loved ones and to keep them around the house, as we do photographs. At times, the wax masks were translated into a more permanent medium, such as bronze or terracotta. The process of making a death mask produced intricately detailed images that recorded every ripple and crevice of the face. Because these sculptures were made from the actual faces and heads of the subjects, their realism is unsurpassed. The *Head of a Roman* (Fig. 3-19) records the facial features of an old man, from his bald head and protruding ears to his furrowed brow and almost cavernous cheeks. No attempt has been made by the artist to idealize the figure. Nor does one get the sense, on the other hand, that the artist emphasized the hideousness of the character. Rather, it serves more as an unimpassioned and uninvolved record of the existence of one man.

Architecture

Rome's greatest contribution lay in architecture, although the most significant buildings, monuments, and civic structures were constructed during the Empire period. Architecture of the Republican period can be stylistically linked to both Greek and Etruscan precedents, as can be seen in the Temple of Fortuna Virilis (Fig. 3-20). From the Greeks, the Romans adopted the Ionic order and post-and-lintel construction. From the Etruscans, they adopted the podium on which the temple stands, as well as the general plan of a wide cella extending to the side columns and a free portico in front. But there are Roman innovations as well. The column shafts, for example, are monolithic instead of being composed of drums stacked one on top of one another. The columns along the sides of the temple are not freestanding but are engaged, or attached. Also, the frieze has no relief sculpture. The most marked difference between the temples of Greece and of Rome is the feeling that the Romans did not treat their buildings as sculpture. Instead, they designed them straightforwardly, emphasizing the relationship between form and function.

Painting

The walls of Roman domestic dwellings were profusely decorated with frescoes and mosaics, some of which have survived the ravages of time. These murals are significant in themselves, but they also provide a missing stylistic link in the artistic remains of Greece. That country, you will recall, was prolific in mural painting, but none of it has survived. 3–20 Temple of Fortuna Virilis, Rome (Republican period, late 2nd century BCE). Copyright Canali Photobank, Milan, Superstock.

Roman wall painting passed through several phases, beginning in about 200 BCE and ending with the destruction of Pompeii by the eruption of Mount Vesuvius in 79 CE. The phases have been divided into four overlapping styles.

Ulysses in the Land of the Lestrygonians (Fig. 3-21) is an example of the Architectural Style in which the illusion of retreating space is achieved through various pictorial devices. It is as if viewer were looking through a window and into the distance. In a loosely sketched and liberally painted landscape, the artist recounts a scene from *The Odyssey*, in which Ulysses' men were devoured by

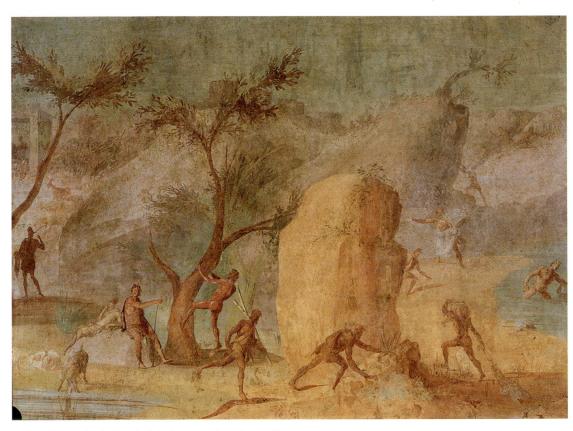

3-21 Ulysses in the Land of the Lestrygonians, from a Roman patrician house (50-40 BCE).
 Fresco. H: 60".
 Vatican Library, Rome. Copyright Edimedia/Corbis.

a race of giant cannibals. The figures rush through the landscape in a variety of poses and gestures, their forms defined by contrasts of light and shade. They are portrayed convincingly in three-dimensional space through the use of **herringbone perspective**, a system whereby **orthogonals** vanish to a specific point along a vertical line that divides the canvas. It is believed that Greek wall painting was similar to the Roman Architectural Style.

With the death of Julius Caesar, a dictator, Rome entered its **Empire period** under the rule of Octavian Caesar—later called Augustus. This period marks the beginning of the Roman Empire, Roman rule by emperor, and the Pax Romana, a 200-year period of peace.

The Early Empire

With the birth of the empire there emerged a desire to glorify the power of Rome by erecting splendid buildings and civic monuments. It was believed that art should be created in the service of the state. Although Roman expansionism left a wake of death and destruction, it was responsible for the construction of cities and the provision of basic human services in the conquered areas.

To their subject peoples, the Roman conquerors brought the benefits of urban planning, including apartment buildings, roads, and bridges. They also provided police and fire protection, water systems, sanitation, and food. They even built recreation facilities for the inhabitants, including gymnasiums, public baths, and theaters. Thus, even in defeat, many peoples reaped benefits because of the Roman desire to glorify the empire through visible contributions.

Architecture

Although the Romans adopted structural systems and certain motifs from Greek architecture, they introduced several innovations in building design. The most significant of these was the arch, and after the second century, the use of concrete to replace cut stone. The combination of these two elements resulted in domed and vaulted structures that were not part of the Greek repertory.

One of the most outstanding Roman civic projects is the **aqueduct**, which carried water over long distances. The Pont du Gard (Fig. 3-22) in southern France carried water more than 30 miles and furnished each recipient with some 100 gallons of water per day. Constructed of three levels of arches, the largest of which spans about 82 feet, the aqueduct is some 900 feet long and 160 feet high. It had to slope down gradually over the long distance in order for gravity to carry the flow of water from the source.

Although the aqueduct's reason for existence is purely functional, the Roman architect did not neglect design. The Pont du Gard has long been admired for both its simplicity and its grandeur. The two lower tiers of wide arches, for example, anchor the weighty structure to the

3-22 Pont du Gard, Nîmes, France (Early Empire, c. 14 CE).L: 900'; H: 160'.Spencer A. Rathus. All rights reserved.

The series of triumphal arches in Rome is a prototype of the billboard. . . . The triumphal arches in the Roman Forum were spatial markers channeling processional paths within a complex urban landscape. On Route 66... the billboards perform a similar formal-spatial function.

—Robert Venturi

earth, whereas the quickened pace of the smaller arches complements the rush of water along the top level. In works such as the Pont du Gard, form *follows* function.

One of the most impressive and famous monuments of ancient Rome is the Colosseum (see Fig. 3-24 in the "Compare and Contrast" feature). Dedicated in 80 CE, the structure consists of two back-to-back **amphitheaters** forming an oval arena, around which are tiers of marble bleachers.

Even in its present condition, having suffered years of pillaging and several earthquakes, the Colosseum is a spectacular sight. The structure is composed of three tiers of arches separated by engaged columns. (This combination of arch and column can also be seen in another type of Roman architectural monument—the triumphal arch (Fig. 3-23). The Colosseum's lowest level, whose arches provided easy access and exit for the spectators, is punctuated by Doric columns. This order is the weightiest in appearance of the three architectural styles and thus visually anchors the structure to the ground. The second level features the Ionic order, and the third level the Corinthian. This combination produces a sense of lightness as one's eye moves from the bottom to the top tier. Thick entablatures rest on top of the rings of columns, firmly delineating the stories. The uppermost level is almost all solid masonry, except for a few regularly spaced rectangular openings. It is ornamented with Corinthian pilasters and crowned by a heavy cornice.

The exterior of the Colosseum was composed of masonry blocks held in place by metal dowels. These dowels were removed over the years when metal became scarce, and thus gravity keeps the structure intact.

3–23 Arch of Constantine, Rome (312–315 CE). Copyright Canali Photobank, Milan, Superstock.

C O M P A R E + C O N T R A S T

Stadium Designs: Thumbs-Up or Thumbs-Down

The sports stadium has become an inextricable part of our global landscape and our global culture. Just as diehard U.S. fans root for their football teams in the Louisiana Superdome, Olympic spectators half a world away cheer their country's athletes on to victory under a *super* dome likely erected just

for the occasion. A city's bid for host of the Olympic Games can hinge entirely on the stadium it has to offer. These megastructures are not only functional—housing anticipated thousands—but they tend to become symbols of the cities, the teams, or now, the corporations who fund them. There's

3-24 Colosseum, Rome (Early Empire, 80 CE). Concrete (originally faced with marble).
H: 160'; D: 620' and 513'. Copyright Topfoto/The Image Works.

something about a space like this. The passion of friends and strangers and "fors and againsts" alike creates an odd sense of uniformity regardless of diversity. And it is this very observation that has led some of history's political leaders to use—and abuse—the phenomenon of the stadium for their own propagandistic purposes.

The Colosseum (Fig. 3-24) represented Rome at its best, but it also stood for Rome at its worst. A major feat of architectural engineering coupled with practical design, this vast stadium accommodated as many as 55,000 spectators who—thanks to 80 numbered entrances and stairways—could get from the street to their designated

3-25 WERNER MARCH. Olympic Stadium, Berlin (1936). Harf Zimmermann/Contact Press Images.

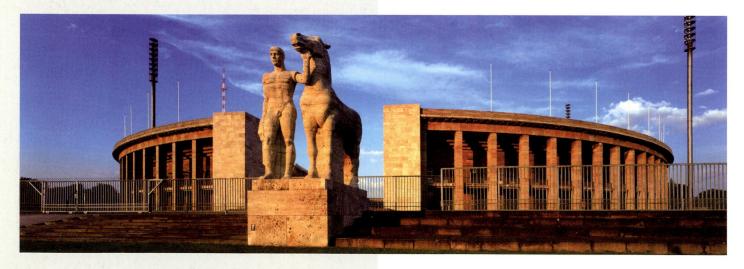

seats within 10 minutes. In rain or under blazing sun conditions, a gargantuan canvas could be hoisted from the arena up over the top of the stadium.

Although the Colosseum was built for entertainment and festivals, its most notorious events ranged from sadistic contests between animals and men and grueling battles to the death between pairs of gladiators. If one combatant emerged alive but badly wounded, survival might depend on whether the emperor (or the crowd) gave the "thumbs-up" or the "thumbs-down." As in much architecture, form can follow function and reflect and create meaning. In 1936, Adolph Hitler commissioned Germany's Olympic Stadium in Berlin (Fig. 3-25). Intended to showcase Aryan superiority (even though Jesse Owens, an African American, took four gold medals in track and field as Hitler watched), designer Werner March's stadium is the physical embodiment of Nazi ideals: order, authority, and the nononsense power of the state.

How different the message, noted critic Nicolai Ourussoff, when an architect uses design to cast off the shackles of "nationalist pretensions" and "notions of social conformity" in an effort to imbue the structure—and the country—with a sense of the future. Created in 1960 by Pier Luigi Nervi, the Palazzo dello Sport (Fig. 3-26) in Rome symbolized an emerging internationalism in the wake of World War II. The unadorned and unforgiving pillars of March's Berlin stadium seem of a distant and rejected past. Nervi's innovative, interlacing concrete roof beams define delicacy and seem to defy gravity.

In 2008, China will host the Olympic Games in the city of Beijing. A doughnut-shaped shell crisscrossed with lines of steel as if it were a precious package wrapped in string, the stadium (Fig. 3-27) will house 100,000 spectators and is projected to cost \$500 million. But beyond these staggering numbers, and like the Colosseum and the Berlin Stadium, it stands to symbolize the transformation of its city—and its country—into a major political and cultural force of its time.

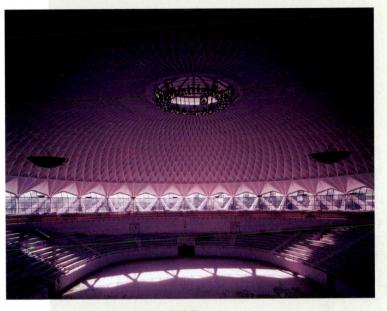

3-26 PIER LUIGI NERVI. Palazzo dello Sport, Rome (1960). David Lees/CORBIS.

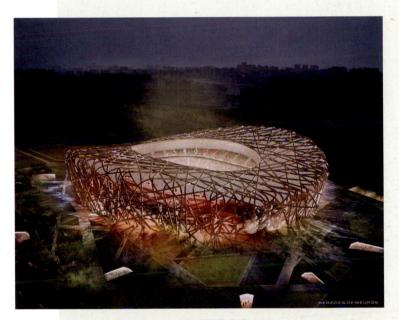

3-27 HERZOG & DE MEURON. Beijing Stadium for the 2008 Olympic Games (2005). Rendering by Herzog & de Meuron Company/China Architecture Design Institute.

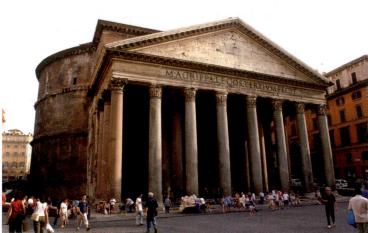

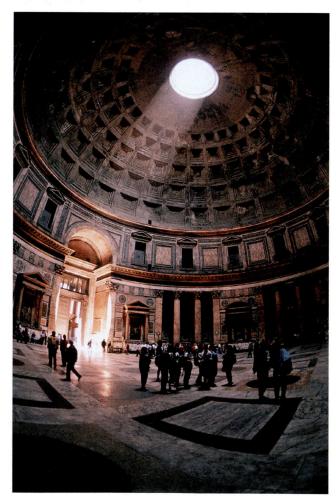

3–29 The Pantheon, Rome (Early Empire, 117–125 CE). Interior view. Copyright Getty Images/STONE/Paul Chesley.

3–28 The Pantheon, Rome (Early Empire, 117–125 CE). Exterior view. allOver Photography/Alamy.

Roman engineering genius can be seen most clearly in the Pantheon (Figs. 3-28 and 3-29), a brick and concrete structure originally erected to house sculptures of the Roman gods. Although the building no longer contains these statues, its function remains religious. Since the year 609 CE, it has been a Christian church.

The Pantheon's design combines the simple geometric elements of a circle and a rectangle. The entrance consists of a rectangular portico, complete with Corinthian columns and pediment. The main body of the building, to which the portico is attached, is circular. It is 144 feet in diameter and spanned by a dome equal in height to the diameter. Supporting the massive dome are 20-footthick walls pierced with deep niches, which in turn are vaulted in order to accept the downward thrust of the dome and distribute its weight to the solid wall. These deep niches alternate with shallow niches in which sculptures were placed.

The dome itself consists of a rather thin concrete shell that thickens toward the base. The interior of the dome is **coffered**, or carved with recessed squares that physically and visually lighten the structure. The ceiling was once painted blue, with a bronze rosette in the center of each square. The sole source of light in the Pantheon is the **oculus**, a circular opening in the top of the dome, 30 feet in diameter.

The interior was lavishly decorated with marble slabs and granite columns that glistened in the spotlight of the sun as it filtered through the opening, moving its focus at different times of the day.

It has been said that Roman architecture differs from other ancient architecture in that it emphasizes space rather than form. In other words, rather than constructing buildings from the point of view of solid shapes, the Romans conceptualized a certain space and then proceeded to enframe it. Their methods of harnessing this space were unique in the ancient world and served as a vital precedent for future architecture.

Sculpture

During the Empire period, Roman sculpture took on a different flavor. The pure realism of the Republican period portrait busts was joined to Greek idealism. The result,

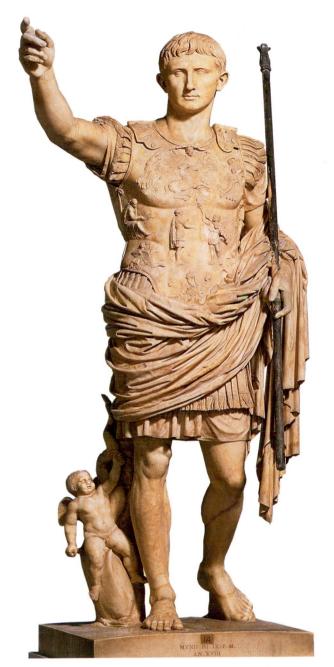

 3-30 Augustus of Primaporta (Roman, c. 20 BCE). Marble. H: 6'8".
 Varican Museums, Rome/Scala/Art Resource, New York.

evident in *Augustus of Primaporta* (Fig. 3-30), was often a curious juxtaposition of individualized heads with idealized, anatomically perfect bodies in Classical poses. The head of Augustus is somewhat idealized and serene, but his unique facial features are recognizable as those that appeared on empire coins. Augustus adopts an authoritative pose not unlike that of Polykleitos's *Doryphoros* (Fig. 3-12). Attired in

military parade armor, he proclaims a diplomatic victory to the masses. His officer's cloak is draped about his hips, and his ceremonial armor is embellished with reliefs that portray both historic events and allegorical figures.

As the first emperor, Augustus was determined to construct monuments reflecting the glory, power, and influence of Rome on the Western world. One of the most famous of these monuments is the *Ara Pacis*, or Altar of Peace, created to celebrate the empire-wide peace that Augustus was able to achieve. The *Ara Pacis* is composed of four walls surrounding a sacrificial altar. These walls are adorned with relief sculptures of figures and delicately carved floral motifs.

Panels such as *The Imperial Procession* (Fig. 3-31) exhibit, once again, a blend of Greek and Roman devices. The right-to-left procession of individuals, unified by the flowing lines of their drapery, clearly refers to the frieze sculptures of the Parthenon. Yet the sculpture differs from its Greek prototype in several respects: The individuals are rendered in portrait likenesses, the relief commemorates a specific event with specific persons present, and these figures are set within a shallow, though very convincing, three-dimensional space. By working in high and low relief, the artist creates the sense of a crowd; fully three rows of people are compressed into this space. They actively turn, gesture, and seem to converse. Despite a noble grandness that gives the panel an idealistic cast, the participants in the procession look and act like real people.

As time went on, the Roman desire to accurately record a person's features gave way to a more introspective portrayal of the personality of the sitter. Although portrait busts

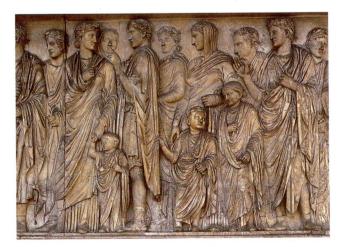

 3-31 Imperial Procession, from the Ara Pacis Augustae, Rome. Marble relief.
 Copyright Canali Photobank, Milan, Superstock.

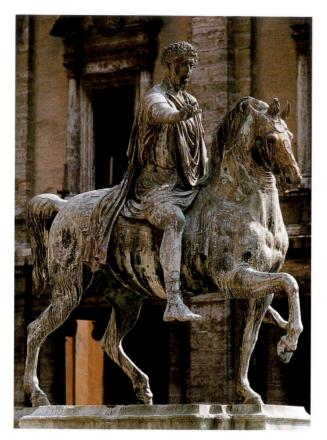

 3-32 Marcus Aurelius on Horseback, Capitoline Hill, Rome (Early Empire, c. 165 CE).
 Bronze. Larger than life-size.
 Copyright Canali Photobank, Milan, Superstock.

remained a favorite genre for Roman sculptors, their repertory also included relief sculpture, full-length statuary, and a new design—the **equestrian portrait.**

The bronze sculpture of Marcus Aurelius (Fig. 3-32) depicts the emperor on a sprightly horse, as if caught in the action of gesturing to his troops or recognizing the applause of his people. The sculpture combines the Roman love of realism with the later concern for psychologically penetrating portraits. The commanding presence of the horse is rendered through pronounced musculature, a confident and lively stride, and a vivacious head with snarling mouth, flared nostrils, and protruding veins. In contrast to this image of brute strength is a rather serene image of imperial authority. Marcus Aurelius, clothed in flowing robes, sits erectly on his horse and gestures rather passively. His facial expression is calm and reserved, reflecting his adherence to Stoic philosophy. Stoicism advocated an indifference to emotion and things of this world, maintaining that virtue was the most important goal in life.

The equestrian portrait of Marcus Aurelius survives because of a case of mistaken identity. During the Middle Ages, objects of all kinds were melted down because of a severe shortage of metals, and ancient sculptures that portrayed pagan idols were not spared. This statue of Marcus Aurelius was saved because it was mistakenly believed to be a portrait of Constantine, the first Roman emperor to recognize Christianity. The death of Marcus Aurelius brings us to the last years of the Empire period, which were riddled with internal strife. The days of the great Roman Empire were numbered.

The Late Empire

During its late years, the Roman Empire was torn from within. A series of emperors seized the reigns of power only to meet violent deaths, some at the hands of their own soldiers. By the end of the third century, the situation was so unwieldy that the empire was divided into eastern and western sections, with separate rulers for each. When Constantine ascended the throne, he returned to the oneruler system, but the damage had already been done—the empire had become divided against itself. Constantine then dealt the empire its final blow by dividing its territory among his sons and moving the capital to Constantinople (present-day Istanbul). Thus, imperial power was shifted to the eastern empire, leaving Rome and the western empire vulnerable. These were decisions from which the empire would never recover.

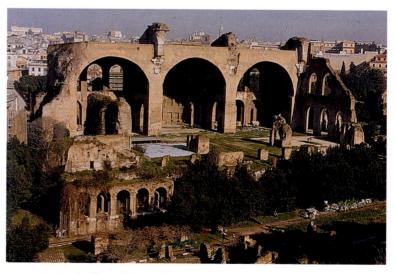

3-33 Basilica of Maxentius and Constantine, Rome (Late Empire, c. 310–320 CE).
300' × 215'.
Copyright Canali Photobank, Milan, Superstock.

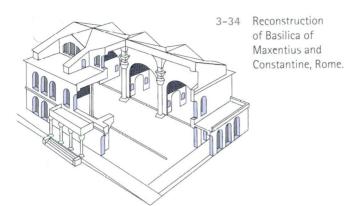

Architecture

Although the empire was crumbling around him, Constantine continued to erect monuments to glorify it. Before moving to the East, he completed a basilica begun by his predecessor Maxentius (Fig. 3-33) that bespoke the grandeur that had been Rome. In ancient Rome, basilicas were large public meeting halls that were usually built around or near the **forums.** The basilica of Maxentius and Constantine was a huge structure, measuring some 300 by 215 feet. It was

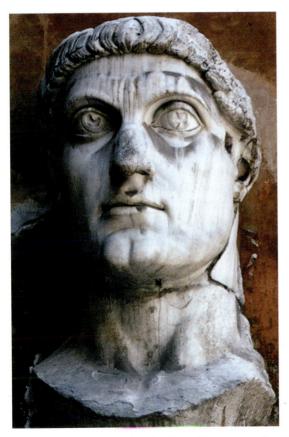

 3-35 Head of Constantine the Great (Roman, Late Empire, early 4th century CE).
 Capitoline Museum, Rome. Courtesy of Spencer A. Rathus. All rights reserved. divided into three rectangular sections, or aisles, the center one reaching a height of 114 feet (Fig. 3-34). The central aisle, called a nave, was covered by a groin vault, a ceiling structure very popular in buildings of such a vast scale. Little remains of the basilica today, but it survived long enough to set a precedent for Christian church architecture. It would serve as the basic plan for basilicas and cathedrals for centuries to come.

Sculpture

Some 300 years before Constantine's reign, a new force began to gnaw at the frayed edges of the Roman Empire-Christianity. The followers of Jesus of Nazareth were persecuted by the Romans for centuries after his death until the emperor Constantine proclaimed tolerance for the faith and accepted the mantle of Christianity himself. These events influenced artistic styles, as can be seen in the Head of Constantine the Great (Fig. 3-35). The literalness and materialism of Roman art and life gave way to a new spirituality and otherworldliness in art. The Head of Constantine the Great was part of a mammoth sculpture of the emperor, consisting of a wooden torso covered with bronze and a head and limbs sculpted from marble. The head is over eight feet high and weighs more than eight tons. The realism and idealism that we witnessed in Roman sculpture were replaced by an almost archaic rendition of the emperor, complete with an austere expression and thick-lidded, wide-staring eyes. The artist elaborated the pensive, passive rigidity of form that we sensed in the portrait of Marcus Aurelius. Constantine's face seems both resigned to the fall of his empire and reflective of the Christian emphasis on a kingdom that is not of this world.

ART TOUR Rome

Everything about Rome is colossal—from the Colosseum itself (Rome's greatest amphitheater) (Fig. 3-24) to the colossal head of Constantine (Fig. 3-35), which is more than eight feet high. As the center of two of the great powers of the Western world—the Roman Empire and the Catholic Church—the city is rife with symbols that trumpeted their status in the times of their glory. A week of travel to Rome would barely do justice to this treasure trove of art and architecture.

It was said that "all roads lead to Rome," and, in truth, any road the visitor might take would lead to something wonderful. Starting with the Capitol, or the southern summit of Capitoline Hill, you will be in what has been called the symbolic center of the Roman world—its citadel as well as the location of three of its most important temples, including the Temple of Jupiter, where triumphal processions giving thanks for victory reached their climax. In the sixteenth century, Michelangelo, the Florentine artist otherwise famous for his sculpture of *David* (Fig. 5-26) and murals for the ceiling of the Sistine Chapel (Figs. 5-21–5-23), designed the geometric patterns of the elliptical plaza as well as the

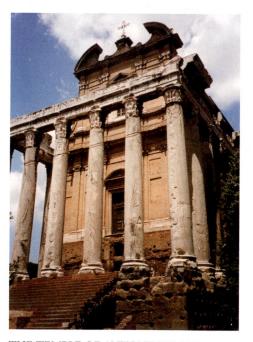

THE TEMPLE OF ANTONINUS AND FAUSTINA IN THE FORUM. Photo courtesy of Spencer A. Rathus. All rights reserved.

facades of the buildings that flank it on three sides. In the center stands a replica of the equestrian portrait of Emperor Marcus Aurelius (Fig. 3-31); the real thing can be found just steps away in one of the Capitoline museums, along with an extensive collection of painting and sculpture, including Caravaggio's unusual Baroque portrayal of St. John the Baptist, the *Dying Gaul*, and the excessively large head and assorted limbs from the statue of Constantine.

If you duck around the back of the museums, you'll come to a wonderful view of the Roman forum below. It's good to linger here awhile to get the "lay of the land" before descending to wander among the ruins (miraculously "restored" by way of computer-generated imagery for the film Gladiator). The forum was the religious, political, and commercial center of the ancient city-the site of temples, courts of law, and the Senate house, along with food stores and brothels teeming with customers. For the contemporary visitor, even the summer tourist crowds might pale in comparison to the hubbub of the forum at the height of the empire. Of particular interest are the central courtyard of the House of the Vestal Virgins (girls from noble families that served as priestesses tending an eternal flame in the Temple of Vesta), the triumphal arches of the emperors Septimius Severus and Titus, and the monumental barrel vaults that remain from the Basilica of Constantine and Maxentius. One of the most curious, composite structures along the Via Sacra (or sacred way) is the ancient Temple of Antoninus and Faustina, now incorporated into a Catholic church, San Lorenzo in Miranda.

Down in the area of the forum, where cats creep and sleep among the ruins, the visitor will also come upon the Arch of Constantine (a popular backdrop for wedding photos) as well as the spectacular and notorious Colosseum. Built during the reign of Emperor Vespasian in 72 CE, the amphitheater was the site of deadly clashes between gladiators and wild beasts staged as sport and theater for the Roman citizenry by the emperors and upper classes. Stadium seating accommodated up to 55,000 spectators, who, on opening day, witnessed the slaughter of more than 9,000

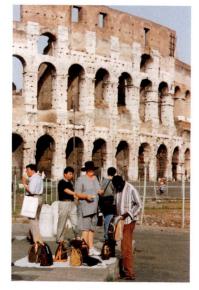

TOURISTS BUYING SOUVENIRS IN FRONT OF THE COLOSSEUM. Photo courtesy of Spencer A. Rathus. All rights reserved.

74

HUNDREDS OF CATS LIVE IN THE FORUM, THE COLOSSEUM, AND OTHER ANCIENT SITES. WOMEN VOLUNTEERS CALLED *LE GATTARE* FEED AND CARE FOR THEM. Photo courtesy of Spencer A. Rathus. All rights reserved.

wild animals in addition to a mock naval battle. The tiers of the Colosseum, bearing columns in all three orders, or styles—Doric, lonic, and Corinthian—served as inspiration for architects during the Renaissance. The artistic and architectural sources for the rebirth of Classicism in Italy were not, as it happened, so far from home.

You can ride the 81 bus from the Colosseum to witness the influence of Roman architecture on the grandest cathedral in Christendom, the Basilica of St. Peter's. Its rhythmic colonnades, imposing temple-front facade, and expansive hemispherical dome epitomize the Renaissance relationship to antiquity. St. Peter's (Fig. 6-3) is the emblem of Roman Catholicism and the centerpiece of the Vatican, the world's

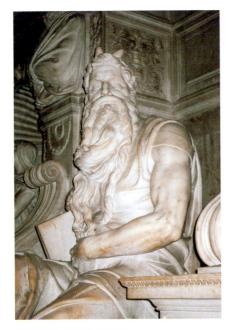

MICHELANGELO, *Moses.* Photo courtesy of Spencer A. Rathus. All rights reserved.

smallest sovereign state, nestled within the city of Rome and ruled by the pope. The current, commanding building is constructed on the ruins of an earlier basilica erected by Constantine, who believed the site to be that in which the apostle Peter was buried. In another part of town, Michelangelo's Mosespart of the tomb of Pope Julius II-overlooks the shackles believed to have been used to imprison Peter before his execution.

Today St. Peter's itself is also the backdrop for magnificent works by Michelangelo (the *Pietà*—protected by

glass since an attack on the sculpture in 1972—and the glorious dome over the main altar, the largest in the world) and by Gianlorenzo Bernini (the Baldacchino, or bronze canopy over the main altar, and several tombs and sculptures throughout the basilica, in addition to the design for the

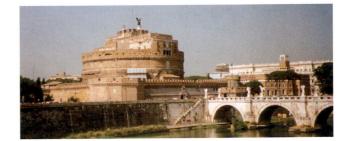

CASTLE SANT'ANGELO. Photo courtesy of Spencer A. Rathus. All rights reserved.

piazza and colonnades that grace the exterior). Visitors to St. Peter's should be aware that proper attire is required for entry to the cathedral; even in the oppressive heat of a Roman summer day, shorts and sleeveless shirts are forbidden.

The wealth of the popes is even more evident in the sublime collections and treasures of the Vatican Museums (the Hellenistic Belvedere Torso and Laocoön reside here) and the rooms of the Vatican Palace—including Michelangelo's paintings of the Sistine Chapel ceiling and Raphael's fresco for the Stanze della Segnatura (Fig. 5-20) in the papal apartments. A grand boulevard—the Via della Conciliazone—leads the traveler from the steps of St. Peter's along the Tevere River toward the Castel Sant'Angelo. Constructed in 139 CE as a mausoleum for Emperor Hadrian, it went on to serve as a medieval citadel and prison, as well as a safe haven for popes (it was connected to the Vatican by an escape corridor). If you continue on foot along this broad avenue, you will eventually wind up in the area of the Roman Pantheon (Figs. 3-28 and 3-29), the great domed temple-turned-Christian-church, initially devoted to the gods and emperors of Rome. Raphael is buried here.

From its romantic fountains and lush gardens to its endless trattorias and pizzerias, museums and monuments, Rome is and has always been a cosmopolitan city on the go. It is a cacophonous mix of old and new (every youthful Roman seems to have a motor scooter and a cell phone), a vast city whose center is so small that a good map and, even better, pair of running shoes—will take you everywhere.

To continue your tour and learn more about Rome, go to our website.

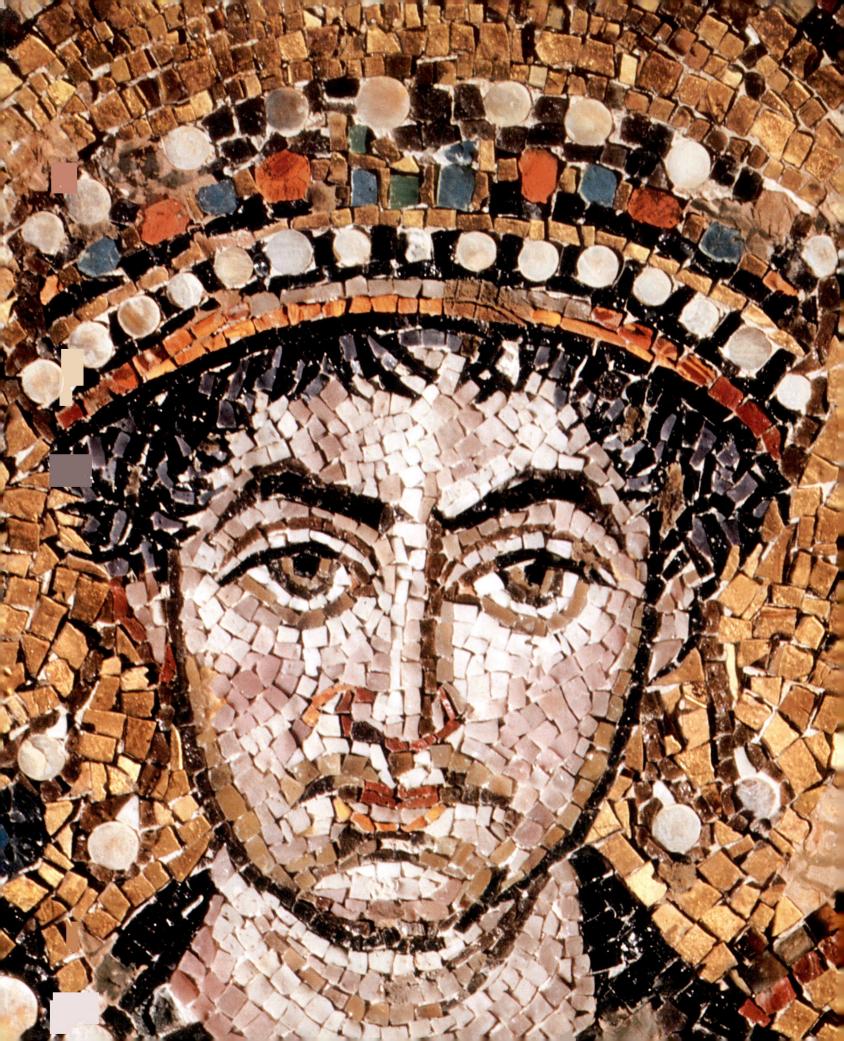

CHRISTIAN ART: FROM CATACOMBS TO CATHEDRALS

Cathedrals are an unassailable witness to human passion. Using what demented calculation could an animal build such places? I think we know. An animal with a gorgeous genius for hope.

-Lionel Tiger

t has been said that the glorious Roman Empire fell to its knees before one mortal man. While such a statement simplifies the historic events leading to Rome's demise and glorifies the impact of Jesus of Nazareth and his teachings on the citizens of the empire, it does capture the reality of Christianity's far-reaching effects. Among the world's religions, Christianity ranks first in terms of followers—over two billion in number.

Historical information about Jesus is scant, although in recent years scholars have attempted to piece together a biography. Christians rely, rather, on the literary sources of the Gospels of the New Testament or Christian Bible, for their sense of Jesus' life and times and activities. These have been attributed to Saints Matthew, Luke, John, and Mark, whom Christians refer to as the Four Evangelists.

Christianity in its most rudimentary form began around 27 CE and had relatively few adherents for the first few centuries. Most early Christians were among the poorest in society and they suffered brutal persecution at the hands of the Roman emperors. It wasn't until Constantine assumed the mantle of Christianity for himself and declared tolerance for Christianity in the Edict of Milan that followers were able to worship more freely and begin to develop the imagery and the architecture that would dominate the history of art for centuries. Representations of Jesus changed dramatically over time, from that of a teacher and shepherd tending his flock to a king enthroned with royal attributes. Likewise, places of worship grew from underground chapels to grand structures that rivaled the basilicas of the Roman empire.

EARLY CHRISTIAN ART

Christianity spread among the ruins of the Roman Empire, even if it did not cause it to collapse. Over many centuries Christianity, too, had its internal and external problems, but unlike the Roman Empire, it survived. In fact, the concept of survival is central to the understanding of Christianity and its art during the first centuries after the death of Jesus.

To be a Christian before Emperor Constantine's proclamation of religious tolerance, one had to endure persecution. Under the emperors Nero, Trajan, Domitian, and Diocletian, Christians were slain for their beliefs. The Romans saw them as mad cult members and barbaric subversives who refused to acknowledge the emperor as a god, or any other Roman gods for that matter.

Constantine's edict brought an official end to persecution and opened the door to establishing Christianity as the religion of the Roman Empire. Early Christian art can be divided into two phases: the Period of Persecution, before Constantine's proclamation, and then the Period of Recognition which followed.

The Period of Persecution

During the Period of Persecution, Christians worshiped in secret, using private homes as well as chapels in catacombs. The **catacombs** were underground burial places, primarily for Christians, outside city walls. The network of galleries and burial chambers in the catacombs was extensive. Some, like those in Rome, go on for up to 90 miles and accommodated almost 6 million bodies (Fig. 4-1). The galleries, or passageways, were dug out of porous stone, and the walls were pierced, waffle-like, with niches into which bodies were placed. Chambers called cubicula served as small chapels where early Christians worshipped and prayed for their dead. These chapels ranged from simple to relatively elaborate in decoration such as in the catacomb of Saints Peter and Marcellinus (Fig. 4-2).

The ceiling of the subterranean chapel features a cross inscribed in a circle, symbols for the Christian faith and for eternity. The arms of the cross radiate from a central circle in which Jesus is shown as the Good Shepherd, and terminate in **lunettes** depicting scenes from the Old Testament story of Jonah and the whale. Figures with arms outstretched in an attitude of prayer stand between the lunettes. They are called **orans,** from the Latin *orare,* meaning "to pray." The figures are reminiscent of those found in vase and wall painting from Greece and Rome. The poses and proportions are realistic, and the drapery falls over the body in a naturalistic way. Early Christians shared the art and culture of Rome, if not its religion. There were bound to be similarities in style.

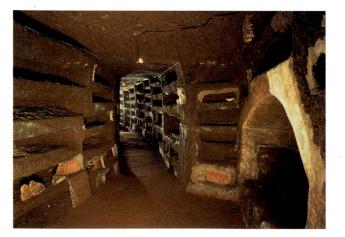

4–1 Catacomb di Priscilla, Rome. Copyright Scala/Art Resource, New York.

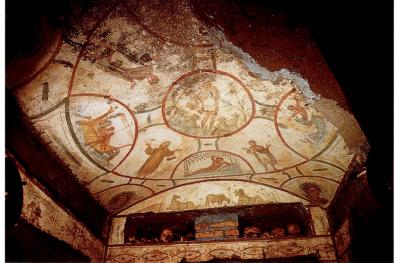

 4-2 The Good Shepherd in the Catacomb of Saints Pietro and Marcellino, Rome (Early Christian, early 4th century CE).
 Fresco Pontifica Commissione di Architettura Sacra, Vatican City. Copyright Art Resource, New York.

Not all catacomb frescoes were as accomplished as the one of Saints Pietro and Marcellino. The lighting was poor in the catacombs, and the artists probably worked swiftly. Yet, a certain iconography was developing within Christian art, based on a mixture of pagan symbols, Jewish subjects, and events from the life of Jesus. Returning to the fresco in the catacomb of Saints Peter and Marcellinus, we find Jesus represented as the Good Shepherd, carrying a lost sheep on his shoulders. It is a visual image based on a literary reference in the gospel of John in which Jesus is quoted: "I am the good shepherd; the good shepherd gives his life for his sheep." Some have suggested, however, that the shepherd image may hark to the Greek (pagan) prototype of the calfbearer, a male figure with an animal draped over his shoulders being carried to sacrifice. The figures in the lunettes reenact scenes from the Old Testament story of Jonah, who cast himself overboard in a violent storm to appease God and was swallowed by a whale. After three days and three nights, Jonah was spat out, prefiguring the resurrection of Jesus Christ after his crucifixion.

The Period of Recognition

After Constantine's edict, persecution of Christianity was officially forbidden and its followers were no longer forced to worship in secret. They poured their energies into constructing houses of worship, many of which were erected on the land on top of the catacombs. In terms of design, it is not surprising that Christians turned to what they already knew—Roman architecture.

One of the first and most important buildings of the Early Christian period was St. Peter's Cathedral. Built by Constantine and based essentially on the design of a Roman basilica, it became the blueprint for most Christian cathedrals for centuries to come. The plan of Old St. Peter's (Fig. 4-3) consisted of seven parts. Unlike the Roman basilica, it was entered from one of the short sides, through a kind of gateway called the propylaeum. Passing through this gateway, the worshiper entered a open large courtyard, or atrium. These two elements of the plan appeared in cathedral designs thereafter, but not with any regularity. Not so with the other parts of the Old St. Peter's plan. The worshiper gains access to the heart of the basilica through the narthex, a series of portals leading to the interior. The long central aisle of the church is called the nave, and it is usually flanked by side aisles. As worshipers walk away from the narthex and up the nave, they approach an altar positioned in the apse. The apse is generally constructed at the easternmost end of the structure and is preceded by the transept, a crossing arm that intersects the nave and side aisles and is

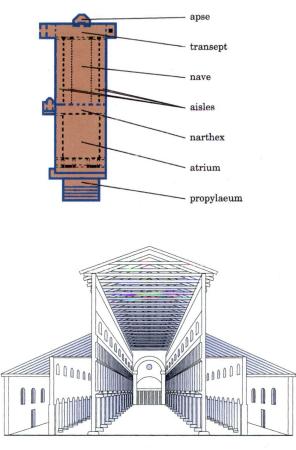

4-3 Plan and section of Old St. Peter's in Rome (Early Christian, first half of the 4th century CE).

parallel to the narthex. The transept often extends beyond the boundaries of the side aisles, resembling the arms of a cross. This plan is often called a **Latin cross plan;** it is also referred to as a **longitudinal plan.**

The longitudinal plan was most prominent in western Europe. Small circular buildings with **central plans** were popular in the East and were occasionally used for ancillary buildings (such as a baptistery) in the West.

Old St. Peter's was decorated lavishly with inlaid marble and **mosaics**, none of which survive. The art of mosaic, many classical in style, was adopted from the Romans and comprised most of the ornamentation in Early Christian churches. Artists of the Period of Recognition also illuminated manuscripts and created some sculpture and small carvings. Their style, like that of the mosaics, can best be described as Late Roman.

BYZANTINE ART

The term **Byzantine** comes from the town of ancient Byzantium, the site of Constantine's capital, Constantinople.

The art called "Byzantine" was produced after the Early Christian era in Byzantium, but also in Ravenna, Venice, Sicily, Greece, Russia, and other Eastern countries. We may describe the difference between Early Christian and Byzantine art as a transfer from an earthbound realism to a more spiritual, otherworldly style. Byzantine figures appear to be weightless; they are placed in an undefined space. Byzantine art features a great deal of symbolism and is far more decorative in detail than Early Christian art.

San Vitale, Ravenna

The city of Ravenna, on the Adriatic coast of Italy, was initially settled by the ruler of the western Roman Empire who was trying to escape invaders by moving his capital out of Rome. As it turned out, the move was timely; only eight years later, that city was sacked. The early history of Ravenna was riddled with strife; its leadership changed hands often. It was not until the age of Emperor Justinian that Ravenna attained some stability and that the arts truly flourished.

During Justinian's reign, the church of San Vitale (Fig. 4-4), one of the most elaborate buildings decorated in the Byzantine style, was erected. San Vitale was designed as a central plan church, with an octagonal perimeter and a narthex set off axis to the apse. When you look at the plan, you can see that it is dominated by a central circle. This circle indicates a dome, which from the exterior appears as another octagon stacked wedding-cake fashion on the first. This circle is surrounded by eight massive piers, between which are semicircular niches that extend into a surrounding aisle, or **ambulatory**, like petals of a flower. The "stem" of this flower is a sanctuary that intersects the ambulatory and culminates in a multisided, or polygonal apse. Unlike the

rigid axial alignment of the Latin Cross churches that follow a basilican plan, San Vitale has an organic quality. Soft, curving forms press into the spaces of the church and are juxtaposed by geometric shapes that seem to complement their fluidity rather than restrain it. The space flows freely and the disparate forms are unified.

This vital, organic quality can also be seen in the details of the church interior. Columns are crowned by capitals carved with complex, interlacing designs. Decorative mosaic borders, inspired by plant life, comprise repetitive stylized patterns.

This stylized treatment of forms can also be seen in the representation of human figures in San Vitale's mosaics. Justinian and Attendants (Fig. 4-5), an apse mosaic, represents the Byzantine style at its peak of perfection in this medium. The mosaic commemorates Justinian's victory over the Goths and proclaims him ruler of Ravenna and the western half of the Roman empire. His authority is symbolized by the military and clerical representatives in his entourage. The figures form a strong, friezelike horizontal band that communicates unity. Although they are placed in groups, some slightly in front of others, the heads present as points in a single line. Thickly lidded eyes stare outward. The heavily draped bodies have no evident substance, as if garments hang on invisible frames and the physical gestures of the men are unnatural. Space is tentatively suggested by a grassy ground line, but the placement of the figures on this line and within this space is uncertain. Notice how the feet seem to hover rather than to support, like Colorforms stuck to a tableau background. These characteristics contrast strongly with the Classicism of Early Christian art and point the way toward a manner of representation in which the corporeality of the body is less significant than the soul.

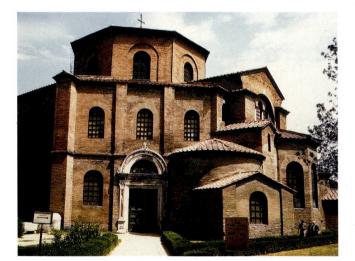

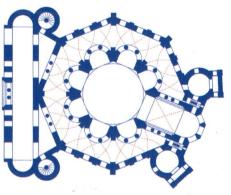

Church of San Vitale, Ravenna 4-4 (Byzantine, 526-547 CE). Exterior and plan. Copyright Art Resource, New York.

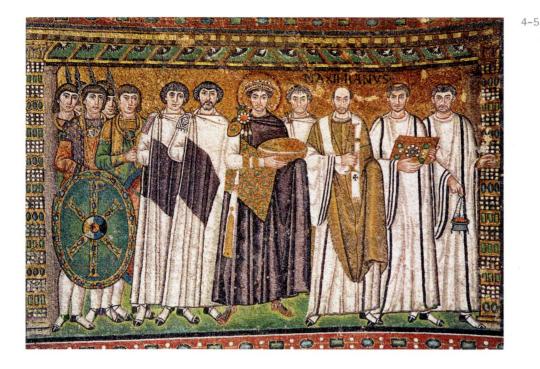

5 Justinian and Attendants (Byzantine, c. 547 CE). Mosaic. Church of San Vitale, Ravenna. Copyright Art Resource, New York.

Hagia Sophia, Constantinople

Even though Ravenna was the capital of the western empire, Justinian's most important public building was erected in Constantinople. Centuries earlier, Constantine had moved the capital of the Roman Empire to the ancient city of Byzantium and renamed it after himself. After his death, the empire was divided into eastern and western halves, and the eastern part remained in Constantinople. It is in this Turkish city—present-day Istanbul—that Justinian built his Church of the Holy Wisdom, or Hagia Sophia (Fig. 4-6). It is a fantastic structure that has served at one time or other in its history as an **Eastern Orthodox** church, an Islamic mosque, and a museum. The most striking aspects of Hagia Sophia are its overall dimensions and the size of its dome. Its floor plan is approximately 240 by 270 feet (Constantine's basilica in Rome was 300 by 215 feet). The dome is about 108 feet across and rises almost 180 feet above the church floor (the dome of the Pantheon, by contrast, is 144 feet high).

The grand proportions of Hagia Sophia put it on a par with the great architectural monuments of Roman times. Its architects, Anthemius of Tralles and Isidorus of Miletus,

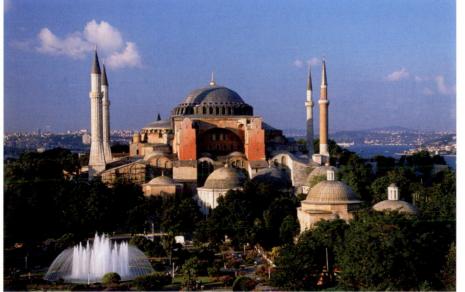

4-6 ANTHEMIUS OF TRALLES AND ISIDORUS OF MILETUS. Hagia Sophia, Constantinople (modern-day Istanbul), Turkey (532–537 CE). Exterior view. The four minarets were added following the Ottoman conquest of 1453 when the church was converted to an Islamic mosque. Richard T. Nowitz/CORBIS.

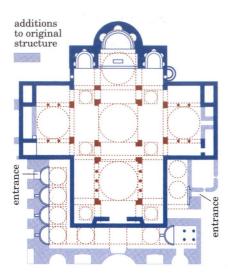

4-7 St. Mark's, Venice (begun 1063 CE).Plan and interior view looking toward the apse.Copyright Topfoto/ The Image Works.

used four triangular surfaces called **pendentives** to support the dome on a square base. Pendentives transfer the load from the base of the dome to the piers at the corners of the square beneath. Although massive, the dome appears light and graceful due to the placement of a ring of arched windows at its base. The light filtering through these windows can create the impression that the dome is hovering above a ring of light, further emphasizing the building's spaciousness.

Like most Byzantine churches, the relatively plain exterior of Hagia Sophia contrasts strongly with the interior wall surfaces, which are decorated lavishly with inlaid marble and mosaic.

Later Byzantine Art

Byzantine church architecture continued to flourish until about the twelfth century, varying between central and longitudinal plans. One interesting variation of the central plan, called a **Greek cross plan**, was used in St. Mark's

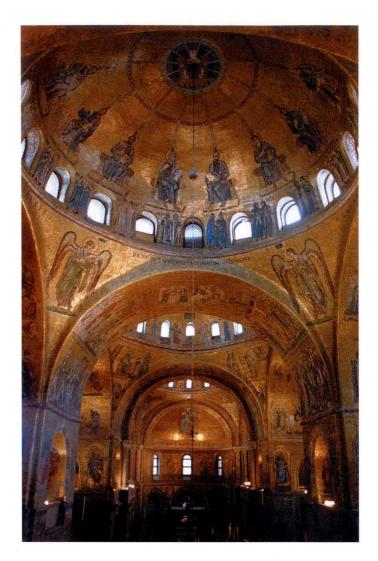

Cathedral in Venice (Fig. 4-7). In this plan, the "arms" of the cross are of equal length, and the focus of the interior is a centrally placed dome that rises above the intersection of these elements. The interior of St. Mark's is likewise covered with gold and brightly colored mosaics.

EARLY MEDIEVAL ART

The 1,000 years between 400 CE and 1400 CE have been called the **Middle Ages** or the "Dark Ages." Some historians considered this millennium a holding pattern between the era of Classical Rome and the rebirth of its art and culture in the Renaissance of the fifteenth century. Some viewed these 1,000 years as a time when the light of Classicism was temporarily extinguished, replaced by a way of life that was crude and superstitious and an art that was primitive and lacking. This negative attitude toward the life and art of the Middle Ages shifted as awareness of the era's contributions

Fine craftsmanship is all about you, but you might not notice it. Look more keenly at it and you . . . will make out intricacies, so delicate and subtle, so exact and compact, so full of knots and links, with colors so fresh and vivid, that you might say that all this was the work of an angel, and not of a man.

-Giraldus Cambrensis, c. 1185

to economics, religion, scholarship, architecture, and the fine arts increased. Even so, "Middle" and "Dark" and "Medieval" have not been replaced by words that better describe the era. As Rome's power declined, non-Roman peoples (like the Huns, Vandals, Franks, Goths, and others once collectively called "barbarian tribes") gained control of parts of Europe. Many works of Christian art from the Early Middle Ages have characteristics similar to those that appear in the small carvings and metalwork of these tribes who migrated across Eurasia for centuries. A carpet page from the Lindisfarne Gospels, so-called for its resemblance to intricate textiles (Fig. 4-8), depicts a stylized cross inscribed with meandering, multicolored scrolls. Surrounding the cross are repetitive linear patterns that can be decoded as fantastic, intertwined snakes devouring themselves. This imagery is derived from the stylized human-animal forms seen frequently in the art of non-Roman peoples from the North.

During the period of migrations, interlacing motifs ornamented surfaces from ship prows to church portals to intricately wrought gold and enamel jewelry. The convoluted shapes in the carpet page find their counterpart in a gold plaque from Siberia (Fig. 4-9). It is a highly compact scene of violence and destruction in which an eagle, wolf, tiger, and colt tear one another to the death. Yet the violent content reads second to a swirl of pleasing lines and patterns. As is often the case in migration art, the overall richness and complexity of the design override the content of the work.

I-9 Scythian plaque with animal interlace, Altai Mountains, Siberia. Gold. $5^{1}/8'' \times 7^{3}/4''$. The State Hermitage Museum, St. Petersburg.

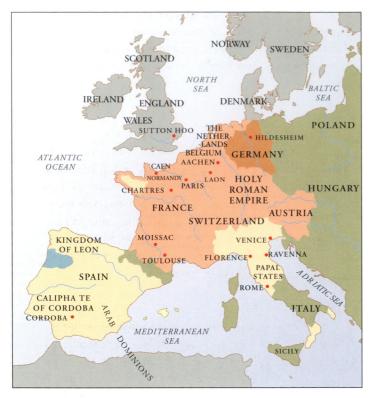

Map 4-1 Europe (c. 800 CE).

4–10 Palatine Chapel of Charlemagne at Aachen (Carolingian, 792–805 CE). Interior and plan. Copyright Art Resource, New York.

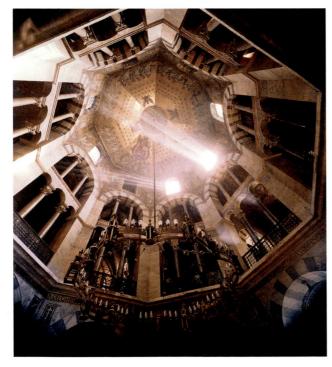

Such motifs became central to western European decoration during the Early Middle Ages.

Carolingian Art

The most important name linked to medieval art and culture during the period immediately following the migrations is that of Charlemagne (Charles the Great). This powerful ruler tried to unify the warring factions of Europe under the aegis of Christianity, and modeling his campaign on those of Roman emperors, he succeeded in doing so. In the year 800, Charlemagne was crowned Holy Roman Emperor by the pope, thus establishing a bond among the countries of western Europe that lasted more than a millennium (see Map 4-1).

The period of Charlemagne's supremacy is called the **Carolingian** period. He established his court at Aachen, a western German city on the border of present-day Belgium, and imported the most significant intellectuals and artists of Europe and the Eastern countries.

The Palatine Chapel of Charlemagne

Charlemagne constructed his **Palatine Chapel** (palace chapel) with two architectural styles in mind (Fig. 4-10). He sought to emulate Roman architecture but was probably also influenced by the central plan church of San Vitale, erected under Emperor Justinian. Like San Vitale, the Palatine Chapel is a central plan with an ambulatory and an octagonal dome. However, this is where the similarity ends. The perimeter of Charlemagne's chapel is polygonal, with almost

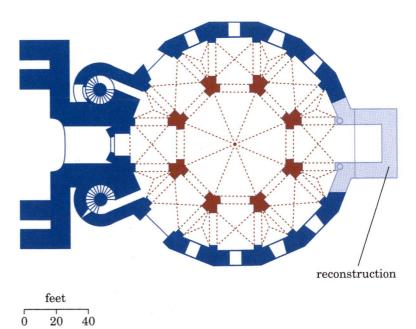

16 facets instead of San Vitale's 8. There is also greater axial symmetry in the Palatine Chapel due to the more logical placement of the narthex.

The interior is also different from San Vitale. The semicircular niches that alternated with columns and pressed into the space of the Ravenna ambulatory have been eliminated at Aachen. There is more definition in the ambulatory between the central domed area and the building's perimeter. This clear articulation of parts is a hallmark of Roman design and stands in contrast to the fluid, organic character of some Byzantine architecture. The walls of the Palatine Chapel are divided into three distinct levels, and each level is divided by classically inspired archways or series of arches. Structural elements, architectural motifs, and a general blockiness of form point both back and forward: to Roman architecture of the classical past and to the development of Romanesque architecture during the eleventh century.

Manuscript Illumination

Charlemagne's court was an intellectual and artistic hub, and it was his love of knowledge and pursuit of truth that

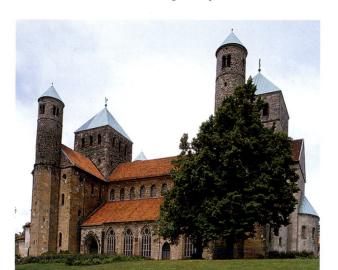

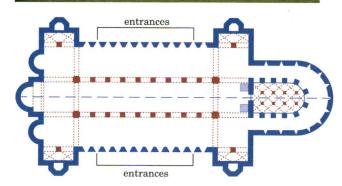

helped keep the flame of scholarship flickering during the Early Middle Ages. His best-known project was the decipherment of the true biblical text which, over decades, had suffered countless errors at the hands of careless scribes.

Ottonian Art

Following Charlemagne's death, internal and external strife threatened the existence of the Holy Roman Empire. It was torn apart on several occasions, only to be consolidated time and again under various rulers. The most significant of these were three German emperors, each named Otto, who succeeded one another in what is now called the Ottonian period. In many respects their reigns symbolized an extension of Carolingian ideals, including the architectural and artistic styles that dominated Charlemagne's era.

Architecture

The most important architectural achievement of the Ottonian period was the construction of the abbey church of St. Michael in Hildesheim, Germany (Fig. 4-11).

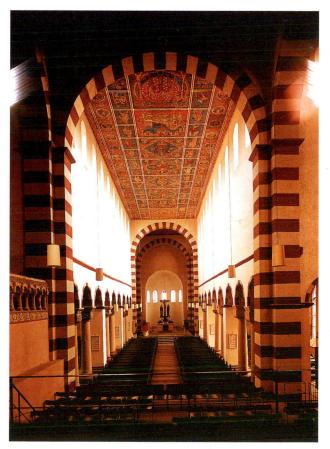

4-11 Abbey Church of St. Michael at Hildesheim, Germany (Ottonian, c. 1001–1031 CE). Restored. -Exterior (above); interior (right); and plan (bottom). Dom-Museum, Hildesheim (Frank Tomio).

Savoldo's St. Matthew with Two Carolingian St. Matthews

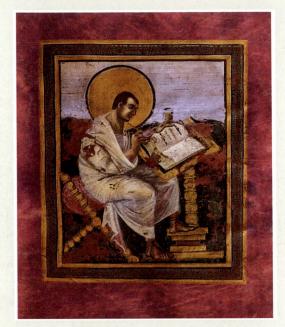

4-12 Saint Matthew, folio 15 recto of the *Coronation Gospels (Gospel Book of Charlemagne)*, from Aachen, Germany, c. 800–810. Ink and tempera on vellum, $1'^{3}/4'' \times 10''$. Schatzkammer, Kunsthistorisches Museum, Vienna.

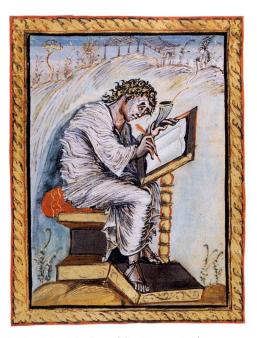

4–13 Saint Matthew, folio 18 verso in the *Ebbo Gospels* (*Gospel Book of Archbishop Ebbo of Reims*), from Hautvillers (near Reims), France, c. 816 – 835. Ink and tempera on vellum, $10^{1}/4'' \times 8^{3}/4''$. Bibliothèque Municipale, Épernay/Art Resource, New York.

The style of Charlemagne's own gospel book, called the *Coronation Gospels* (Fig. 4-12), reflects his love of classical art. Matthew, an evangelist who is believed to have written the first gospel, is represented as an educated Roman writer diligently at work. Only the halo surrounding his head suggests his sacred identity. He does not appear as an otherworldly weightless figure awaiting a bolt of divine inspiration. His attitude is calm, pensive, deliberate. His body has substance, it is seated firmly, and the folds of his garment fall naturally over his limbs. The artist uses painterly strokes and a contrast of light and shade to define his forms much in the way that the wall painters of ancient Rome had done (see Fig. 3-20).

Although classicism was the preferred style of the Holy Roman emperor, it was not the only style pursued during the Carolingian period. *The Gospel Book of Archbishop Ebbo of Reims* (Fig. 4-13) was created only five to ten years after the Coronation Gospels and yet, in terms of style, it could not be more different. The classical balance of emotion and restraint evident in Charlemagne's gospel book has been replaced by a display of passion and energy in Ebbo's evangelist. Both figures sit within a landscape, at work before their writing tables. Charlemagne's Matthew, however, appears to rely on his own intellect to set forth the gospel, whereas Ebbo's evangelist, scroll in hand, rushes to jot down every word being uttered by

86

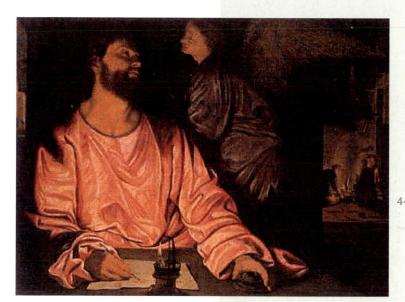

4-14 GIROLAMO SAVOLDO Saint Matthew and the Angel (c. 1535).

Oil on canvas, $36^{3}/4''$ H 49". The Metropolitan Museum of Art, N.Y. Marquand Fund. 1912 (12.14) Photograph © 1984 The Metropolitan Museum of Art.

an angel of God hovering in the upper right corner. He seems to be feverishly trying to keep up. His brow is furrowed, and his hands and feet cramp under the strain of the task.

The mood in the paintings also differs drastically. The calm classical landscape and soft folds of Matthew's drapery create a dignified, intellectual atmosphere in the Coronation Gospels. By contrast, the restless drapery, disheveled hair, facial contortions, and heaving landscape in the Archbishop Ebbo Gospels create an air of dramatic, frantic energy. It is this emotionally charged style that will be most influential in Romanesque art. The naturalism of the Coronation Gospels will not appear again with any regularity until the birth of Early Renaissance art in the fourteenth century. Girolamo Savoldo's *St. Matthew* (Fig. 4-14), painted about 700 years later, is front-lit by a small flame. He leans back from his manuscript into the darkness where an angel whispers to him. Figures in the background of the painting suggest that Matthew has stolen away to a hidden chamber to seek divine inspiration.

What do the three St. Matthew paintings suggest about each artist's views of the relationship between God and humanity? How does each artist use lighting, brushwork, and elements such as the background to convey these views?

4-15 Adam and Eve Reproached by the Lord (Ottonian, 1015 CE).
Panel of bronze doors. 23" × 43".
St. Mary's Cathedral, Hildesheim, Germany/ Erich Lessing /Art Resource, New York.

St. Michael's offers us our first glimpse at a modified Roman basilican plan that will serve as a basis for Romanesque architecture.

The abbey church does not retain the propylaeum or atrium of Old St. Peter's, and it reverts to the lateral entrances of Roman basilicas. But all the other elements of a typical Christian cathedral are present: narthex, nave, side aisles, transept, and a much enlarged apse surrounded by an ambulatory. Most significant for the future of Romanesque and Gothic architecture is the use of the crossing square as a template for other spaces within the church. The crossing square is the area of overlap formed by the intersection of the nave and the transept. In the plan of St. Michael's, the nave consists of three consecutive modules that are equal in dimensions to the crossing square and marked off by square pillars. This design is an early example of square schematism, in which the crossing square (or a fraction or multiple thereof) determines the dimensions of the entire structure.

St. Michael's also uses an **alternate support system** in the walls of its nave. In such a system, alternating structural elements (in this case, pillars and columns) bear the weight of the walls and ultimately the load of the ceiling. The alternating elements in St. Michael's read as pillar-columncolumn-pillar; its alternate support system is then classified as a-b-b-a in terms of repetition of the supporting elements ("a" is assigned to a pillar and "b" is assigned to a column). An alternate support system of one kind or another will be a constant in Romanesque architecture.

As with Old St. Peter's, the exterior of St. Michael's reflects the character of its interior. Nave, side aisles, and other elements of the plan are clearly articulated in the blocky forms of the exterior. The exterior wall surfaces remain unadorned, as were those of the Early Christian and Byzantine churches. However, the art of sculpture, which had not thrived since the fall of Rome, was reborn in St. Michael's.

Sculpture

Adam and Eve Reproached by the Lord (Fig. 4-15), a panel from the bronze doors of St. Mary's Cathedral in Hildesheim (originally commissioned for the Monastery of St. Michael by Bishop Bernward in the eleventh century), represents the first sculpture cast in one piece during the Middle Ages. It closely resembles the manuscript illumination of the period and in mood and style is similar to the Matthew page of the Archbishop Ebbo gospels (See Fig. 4-13). It, too, is an emotionally charged work, in which God points his finger accusingly at the pathetic figures of Adam and Eve. They, in turn, try to deflect the blame; Adam points to Eve and Eve gestures toward Satan, who is in the guise of a fantastic dragon-like animal crouched on the ground. These are not Classical figures who bear themselves proudly under stress. Rather, they are pitiful, wasted images that cower and try frantically to escape punishment. In this work, as well as in that of the Romanesque period, God is shown as a merciless judge, and human beings as quivering creatures who must beware of his wrath.

ROMANESQUE ART

The Romanesque style appeared in the closing decades of the eleventh century among dramatic changes in all aspects of European life. Dynasties, such as those of the Carolingian and Ottonian periods, no longer existed. Individual monarchies ruled areas of Europe, rivaling one another for land and power. After the non-Roman peoples stopped invading [After the] year of the millennium, which is now about three years past, there occurred throughout the world, especially in Italy and Gaul, a rebuilding of church basilicas... [Each] Christian people strove against the others to erect nobler ones. It was as if the whole earth, having cast off the old by shaking itself, were clothing itself everywhere in the white robe of the church.

-Raoul Glaber, c. 1003

and started settling, feudalism began to structure Europe, with monarchies at the head.

St. Sernin

Feudalism was not the only force in medieval life of the Romanesque period. Monasticism also gained in importance. Monasteries during this time were structured communities that emphasized work and study, including manual labor (tending gardens, running bakeries, clearing tracts of wilderness, even building roads in some cases), reading and copying of sacred texts, and memorizing music for chanting. Monasteries paved the way in education as monks became teachers. Salvation in the afterlife was a great preoccupation of the Middle Ages and served as the common denominator among classes. Nobility, clergy, and peasantry all directed their spiritual efforts toward this goal. Two phenomena reflect this obsession: the Crusades and the great pilgrimages.

The Crusades were holy wars waged in the name of recovering the Holy Land from the Muslims, who had taken it over in the seventh century. The pilgrimages were lengthy personal journeys undertaken to worship at sacred shrines or the tombs of saints. Participating in the Crusades and making pilgrimages were seen as holy acts that would help tip the scale in one's favor on Judgment Day. The pilgrims' need of a grand place to worship at journey's end gave impetus to church construction during the Romanesque period.

Architecture

In the Romanesque cathedral, there is a clear articulation of parts, with the exterior forms reflecting the interior spaces. The interiors consist of five major areas, with variations on this basic plan evident in different regions of Europe. We can add two Romanesque criteria to this basic format: spaciousness and fireproofing. The large crowds drawn by the pilgrimage fever required larger structures with interior spaces that would not restrict the flow of movement. After hostile invasions left churches in flames, it was also deemed necessary to fireproof the buildings by eliminating wooden roofs and covering the structures with cut stone.

The church of St. Sernin (Fig. 4-16) in Toulouse, France, met all the requirements for a Romanesque cathedral. An aerial view of the exterior shows the blocky forms that outline a nave, side aisles, narthex to the west, a prominent transept crowned by a multilevel spire above the crossing square, and an apse at the eastern end from whose ambulatory extend five radiating chapels. In the plan of St. Sernin (Fig. 4-17A), the outermost side aisle continues around the outer borders of the transept arm and runs into the ambulatory around the apse. Along the eastern face of the transept, and around the ambulatory, there is a series of chapels that radiate, or extend, from the aisle. These spaces provided extra room for the crowds of pilgrims and offered free movement around the church, preventing interference with worship in the nave or the celebration of Mass in the apse. Square schematism has been employed in this plan; each rectangular bay measures one-half of the crossing square, and the dimensions of each square in the side aisles measures one-fourth of the main module.

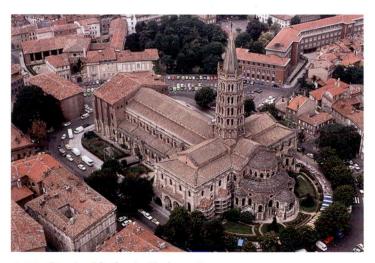

4–16 Church of St. Sernin, Toulouse, France (Romanesque, c. 1080–1120 CE). Copyright Jean Dieuzaide.

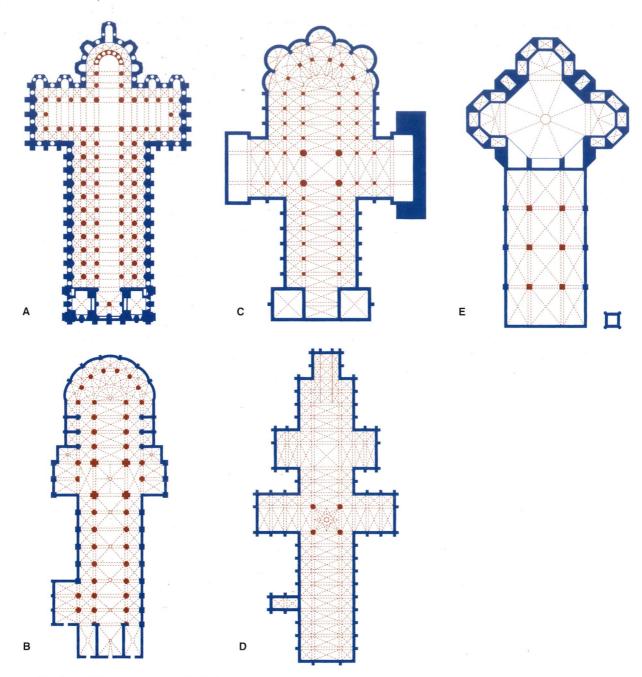

4–17 Basic differences among cathedral plans of the Romanesque and Gothic periods. Copyright Lois Fichner-Rathus.

In St. Sernin, a shift was made from the flat wooden ceiling characteristic of the Roman basilica to a stone vault less vulnerable to fire. The ceiling structure, called a barrel vault, resembles a semicircular barrel punctuated by arches that spring from engaged (attached) columns in the nave to define each bay. The massive weight of the vault is partially supported by the nave walls and partially by the side aisles that accept a share of the downward thrust. This is somewhat alleviated by the **tribune gallery**, which, in effect, reduces the drop-off from the barrel vault to the lower side aisles. The tribune gallery also provided extra space for worshipers.

Because the barrel vault rests directly on top of the tribune gallery, and because fenestration would weaken the structure of the vault, there is little light in the interior of the cathedral. Lack of light was considered a major problem, and solving it would be the primary concern of future Romanesque architects. The history of Romanesque architecture can be written as the history of vaulting techniques, and the need for light provided the incentive for their development.

St. Étienne

The builders of the cathedral of St. Étienne in Normandy contributed significantly to the future of Romanesque and Gothic architecture in their design of its ceiling vault (Fig. 4-17B). Instead of using a barrel vault that tunnels its way from narthex to apse, they divided the nave of St. Étienne into four distinct modules that reflect the shape of the crossing square. Each of these modules in turn is divided into six parts by ribs that spring from engaged columns and compound piers in the nave walls. Some of these ribs connect the midpoints of opposing sides of the squares; they are called transverse ribs. Other ribs intersect the space of the module diagonally, as seen in the plan; these are called diagonal ribs. An alternate a-b-a-b support system is used, with every other engaged column sending up a supporting rib that crosses the vault as a transverse arch. These engaged columns are distinguished from other nonsupporting members by their attachment to pilasters. The vault of St. Étienne is one of the first true rib vaults in that the combination of diagonal and transverse ribs functions as a skeleton that bears some of the weight of the ceiling. In later buildings the role of ribs as support elements will be increased, and reliance on the massiveness of nave walls will be somewhat decreased.

Even though the nave walls of St. Étienne are still quite thick when compared with those of later Romanesque churches, the interior has a sense of lightness that does not exist in St. Sernin. The development of the rib vault made it possible to pierce the walls directly above the tribune gallery with windows. This series of windows that appears cut into the slightly domed modules of the ceiling is called a clerestory. The clerestory became a standard element of the Gothic cathedral plan. The facade of St. Étienne (Fig. 4-18) also served as a model for Gothic architecture. It is divided vertically into three sections by thick buttresses, reflecting the nave and side aisles of the interior, and horizontally into three bands, pierced by portals on the entrance floor and arched windows on the upper levels. Two bell towers complete the facade, each of which is also divided into three parts (the spires were later additions). This two-tower, tripartite facade appeared again and again in Gothic structures, although the walls were pierced by more carving and fenestration and are thus lighter in appearance. The symmetry

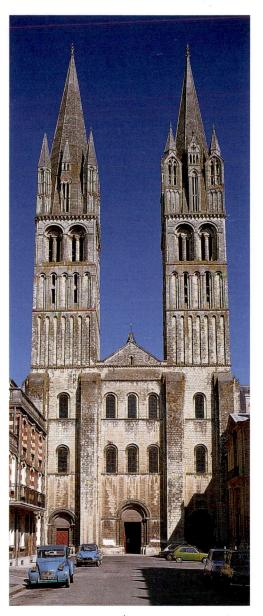

4–18 Cathedral of St. Étienne, Caen, France (Romanesque, 1067–1087 CE). Copyright John Elk III.

and predictability of the St. Étienne design, on the other hand, were maintained.

Sculpture

Although we occasionally find freestanding sculpture from the Romanesque and Gothic periods, it was far more common for sculpture to be restricted to architectural decoration around the portals. Some of the most important and elaborate sculptural decoration is found in the **tympanum**— a semicircular space above the doors to a cathedral—such as 4–19 Cathedral of Saint-Lazare, Autun. West portal. Detail of Last Judgment tympanum, *Weighing of Souls.* Copyright Archivio Iconografico, S.A./CORBIS.

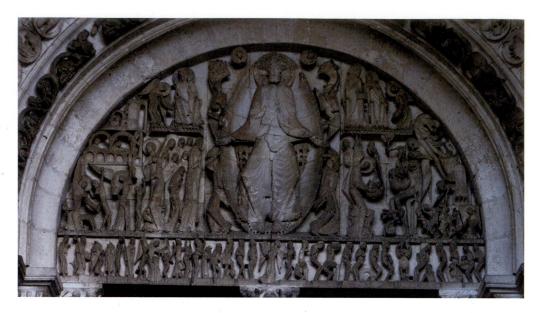

that of the cathedral at Autun in Burgundy (Fig. 4-19). The carved portals of cathedrals bore scenes and symbols that acted as harsh reminders of fate in the afterlife. They were intended to communicate pictorially a profound message, if not direct warning, to the potential, primarily illiterate sinner that repentance through prayer and action was necessary for salvation.

At Autun, the scene depicted is that of the Last Judgment. The tympanum rests on a lintel carved with small figures representing the dead. The archangel Michael stands in the center, dividing the horizontal band of figures into two groups. The naked dead on the left gaze upward, hopeful of achieving eternal reward in heaven, while those to the right look downward in despair. Above the lintel, Jesus is depicted as an evenhanded judge. To his left, tall, thin figures representing the apostles observe the scene while some angels lift bodies into heaven. To Jesus' right, by contrast, is a gruesome event. The dead are snatched up from their graves, and their souls are being weighed on a scale by an angel on the left and a devil-serpent on the right. The devil cheats by adding a little weight, and some of his companions stand ready to grab the souls and fling them into hell.

As in the bronze doors of St. Michael's, humankind is shown as a pitiful, defenseless race, no match for the wiles of Satan. The figures crouch in terror of their surroundings, in strong contrast to the serenity of their impartial judge.

The Romanesque sculptor sought stylistic inspiration in Roman works, the small carvings of the pre-Romanesque era, and especially manuscript illumination. In the early phase of Romanesque art, naturalism was not a concern. Artists turned to art rather than to nature for models, and thus their figures are at least twice, and perhaps 100 times, removed from the original source. It is no wonder, then, that they appear as dolls or marionettes. The figure of Jesus is squashed within a large oval, and his limbs bend in sharp angles in order to fit the frame. Although his drapery seems to correspond broadly to the body beneath, the folds are reduced to stylized patterns of concentric arcs that play across a relatively flat surface. Realism is not the goal. The sculptor is focused on conveying his frightful message with the details and emotions that will have the most dramatic impact on the worshiper or penitent sinner.

Manuscript Illumination

The relationship between Romanesque sculpture and manuscript **illumination** can be seen in *The Annunciation to the Shepherds* (Fig. 4-20), a page from *The Lectionary of Henry II*. As with the figure of Jesus in the Autun tympanum, the long and gangling limbs of the figures join their torsos at odd angles. Drapery falls at harsh, unnatural angles. Sent by God, the angel Gabriel alights on a hilltop to announce the birth of the Christ-child to shepherds tending their flocks. The angel towers over the rocky mound and appears to be almost twice the size of the shepherds. The shepherds, in turn, are portrayed as unnaturally large in relation to the animals. The animals along the bottom edge of the picture stand little more than ankle high. The use of **hierarchical scaling** implies that humans are less significant than celestial beings and that

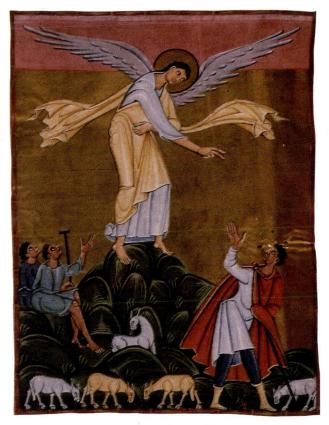

4-20 The Annunciation to the Shepherds, from the Lectionary of Henry II (1002–1014 CE). Approx. 17" × 13". Bayerische Staatsbibliothek, Munich.

animals are lower than humans. The symbols in the scene take precedence over truth; reality fades in their wake.

Toward the end of the Romanesque period there was a significant increase in naturalism. Drapery falls softly rather than in sharp angles, and the body begins to acquire more substance. The gestures are less frantic, and a balance between emotion and restraint begins to reappear. These elements reached their peak during the Gothic period and pointed to a full-scale revival of Classicism during the Renaissance of the fifteenth century.

Tapestry

Although the tasks of copying sacred texts and embellishing them with manuscript illuminations were sometimes assumed by women, the art form remained primarily a male preserve. Not so with the medium of tapestry. In the Middle Ages, weaving and embroidery were taught to women of all social classes and walks of life. Noblewomen and nuns would weave and decorate elaborate tapestries, clothing, and liturgical vestments, using the finest linens, wools, gold and silver thread, pearls, and other gems.

One of the most famous surviving tapestries, the *Bayeux Tapestry* (Fig. 4-21), was almost certainly created by a team of women at the commission of Odo, the bishop of Bayeux. The tapestry describes the invasion of England by William the Conqueror in a continuous narrative. Although the tapestry is less than 2 feet in height, it originally measured in excess of 230 running feet and was meant to run clockwise around the entire nave of the Cathedral of Bayeux. In this way, the narrative functioned much in the same way as the continuous narrative of the Ionic frieze of the Parthenon.

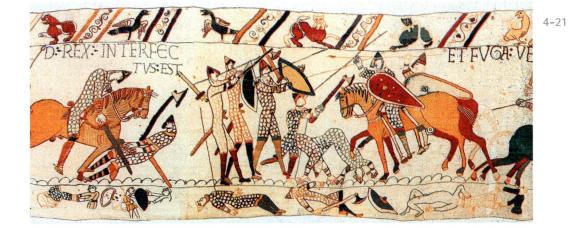

Bayeux Tapestry

(Romanesque,
c. 1073–1083 CE).

Detail.
Wool embroidery on

linen. H: 20"; L: 230'.

Musée de la Tapisserie, Bayeux,

France. Copyright Edimedia/
Corbis.

Hildegard of Bingen

During the Middle Ages, the production and illustration of sacred books took place, for the most part, in the monastery and the abbey, with the greatest percentage of scribes and painters being men. Yet some upper-class women looking for an alternative to marriage and eager to follow these and other intellectual and aesthetic pursuits entered the contemplative life of the nunnery.

One such woman was the German abbess Hildegard of Bingen (1098–1179). Hildegard was a mystic whose visions of otherworldly phenomena began during childhood and led to a life of scholarship elucidating her extraordinary experiences. She wrote books on medicine and history, composed music, debated political and religious issues, and designed illustrations to accompany written records of her visions. Hildegard also devised a secret language. Her most valuable work is the *Liber Scivias*, a text built around images of light and darkness. Sun, stars, moon, and flaming orbs struggle against dragons, demons, and other denizens of darkness.

Figure 4-22 is a twelfth-century copy of Hildegard's Vision of the Ball of Fire, an illustration no doubt designed by the abbess and most likely executed by her nuns. An elaborately patterned orb floats in the center of a simpler rectangular frame. Its central symbols are surrounded by a field of star-flowers spreading outward toward a wreath of flames. Here and there one can spot demons spewing forth fire. The neatness of the execution bears similarity to the fine needlepoint and embroidery techniques characteristic of medieval tapestries. Here follows Hildegard's vision on which the painting was based:

Then I saw a huge image, round and shadowy. It was pointed at the top, like an egg. . . . Its outermost layer was of bright fire. Within lay a dark membrane. Suspended in the bright flames was a burning ball of fire, so large that the entire image received its light. Three more lights burned in a row above it. They gave it support through their glow, so that the light would never be extinguished.

4-22 HILDEGARD OF BINGEN. Vision of the Ball of Fire. Illumination from the Liber Scivias (12th century CE). Rupertberg, Germany (original destroyed).

GOTHIC ART

Art and architecture of the twelfth and thirteenth centuries is called Gothic. The term *Gothic* originated among historians who believed that the Goths were responsible for the style of this period. Because critics believed that the Gothic style only further buried the light of Classicism, and because the Goths were "barbarians," "Gothic" was used disparagingly. For many years, the most positive criticism of Gothic art was that it was a step forward from the Romanesque. "Gothic" is no longer a term of derision, and the Romanesque and Gothic styles are seen as distinct and as responsive to the unique tempers of their times.

Architecture

In the history of art it is rare indeed to be able to trace the development of a particular style to a single work, or the beginning of a movement to a specific date. However, it is generally agreed that the Gothic style of architecture began in 1140 with the construction of the choir of the church of St. Denis near Paris. The vaults of the choir consisted of weight-bearing ribs that formed the skeleton of the ceiling structure. The spaces between the ribs were then filled in with cut stone. At St. Denis the pointed arch is used in the structural skeleton rather than the rounded arches of the Romanesque style. This vault construction also permitted the use of larger areas of stained glass, dissolving the massiveness of the Romanesque wall.

Laon Cathedral

Although Laon Cathedral is considered an Early Gothic building, its plan resembles those of Romanesque churches. For example, the ceiling is a sexpartite rib vault supported by groups of columns in an alternate a-b-a-b rhythm (Fig. 4-23). Yet there were important innovations at Laon. The interior displays a change in wall elevation from three to four levels. A series of arches, or triforium, was added above the tribune gallery to pierce further the solid surfaces of the nave walls. The obsession with reducing the appearance of heaviness in the walls can also be seen on the exterior (Fig. 4-24). If we compare the facade of St. Étienne with that of Laon, we see a change from a massive, fortress-like appearance to one that seems lighter and more organic. The facade of Laon Cathedral is divided into three levels, although there is less distinction between them than in a Romanesque facade. The portals jut forward from the plane of the facade, creating a tunnel-like entrance. The stone is pierced by arched windows, arcades, and a large rose window in the center, and the twin bell towers seem to be constructed of voids rather than solids.

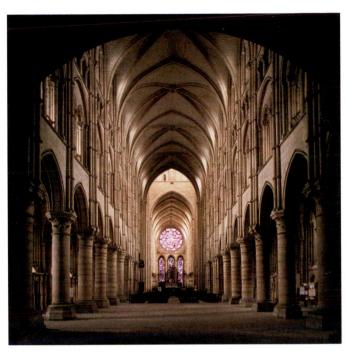

4-23 Interior of Laon Cathedral, view facing east, Laon, France (begun c. 1190 CE).Copyright Ruggero Vanni/Corbis.

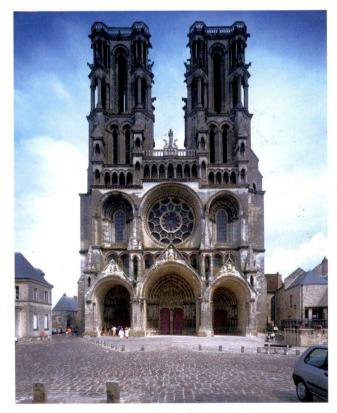

 4-24 Exterior of Laon Cathedral, west facade, Laon, France (begun c. 1190 CE).
 Copyright Angelo Hornak/Corbis.

As the Gothic period progressed, all efforts were directed toward the dissolution of stone surfaces. The walls were penetrated by greater expanses of glass, nave elevations rose to new heights, and carved details became more complex and delicate. There was a mystical quality to these buildings in the way they seemed exempt from the laws of gravity.

Notre-Dame

One of the most famous buildings in the history of architecture is the Cathedral of Notre-Dame de Paris (Fig. 4-25). Perched on the banks of the Seine, it has enchanted visitors ever since its construction. Notre-Dame is a curious mixture of old and new elements. It retains a sexpartite rib vault and was originally planned to have an Early Gothic four-level wall elevation. It was begun in 1163 and was not completed until almost a century later, undergoing extensive modifications between 1225 and 1250. Some of these changes reflected the development of the High Gothic style, including the elimination of the triforium and the use of flying buttresses to support the nave walls. The exterior of the building also reveals this combination of early and late styles. Although the facade is far more massive than that of Laon Cathedral, the north and south elevations look light and airy due to their fenestration and the lacy buttressing.

Chartres Cathedral

Chartres Cathedral is generally considered to be the first High Gothic church. Unlike Notre-Dame, Chartres was planned from the beginning to have a three-level wall elevation and flying buttresses. The three-part wall elevation allowed for larger windows in the clerestory, admitting more

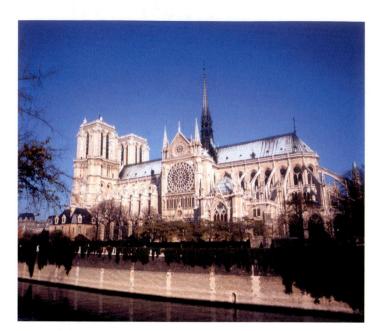

4-25 Cathedral of Notre-Dame de Paris (Gothic, begun 1163 CE, completed 1250 CE). Copyright Topfoto/The Image Works.

light into the interior (Fig. 4-26). The use of large windows in the clerestory was in turn made possible by the development of the flying buttress.

In the High Gothic period there is a change from square schematism to a **rectangular bay system** (Fig. 4-17C). In the latter, each rectangular bay has its own cross rib vault, and only one side aisle square flanks each rectangular bay. Thus, the need for an alternate support system is eliminated. The interior of a High Gothic cathedral presents several dramatic vistas. There is a continuous sweep of space

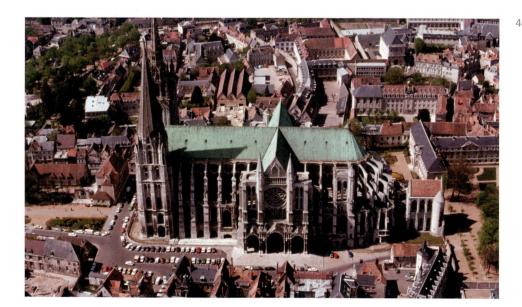

 4–26 Aerial view from the northwest of Chartres Cathedral, Chartres, France (begun 1134 CE, rebuilt after 1194 CE).
 Copyright Marc Garanger/Corbis. from the narthex to the apse along a nave that is uninterrupted by alternating supports. There is also a strong vertical thrust from floor to vaults that is enhanced by the elimination of the triforium and the increased heights of the arches in the nave arcade and clerestory windows. The solid wall surfaces are further dissolved by quantities of stained glass that flood the interior with spectacular patterns of soft colored light. The architects directed all of their efforts toward creating a spiritual escape to another world. They did so by effectively defying the properties of matter: creating the illusion of weightlessness in stone and dissolving solid surfaces with mesmerizing streams of colored light.

Gothic Architecture outside France

The cathedrals that we have examined thus far were built in France, where the Gothic style flourished. Variations on the French Gothic style can also be seen elsewhere in northern Europe, although in some English and German cathedrals

the general "blockiness" of Romanesque architecture persisted. The plan of Salisbury Cathedral (Fig. 4-17D) in England illustrates some differences between English and French architecture of the Gothic period, as seen in the double transept and the unique square apse. The profile of Salisbury Cathedral also differs from that of a French church in that the bell towers on the western end are level with the rest of the facade, and a tall tower rises above the crossing square. Still, the remaining characteristics of the cathedral, including the rectangular bay system, bear close relationship to the French Gothic style. In Italy, on the other hand, there was no strict adherence to the French style, as is seen in the Florence Cathedral (Fig. 4-27). The most striking features of its exterior are the sharp, geometric patterns of green and white marble and the horizontality, or earthbound quality of its profile.

These contrast with the vertical lines of the French Gothic cathedral that seem to reach for heaven. The French

Copyright Scala/Art Resource, New York.

4-27 Florence Cathedral (Gothic, begun 1368 CE).

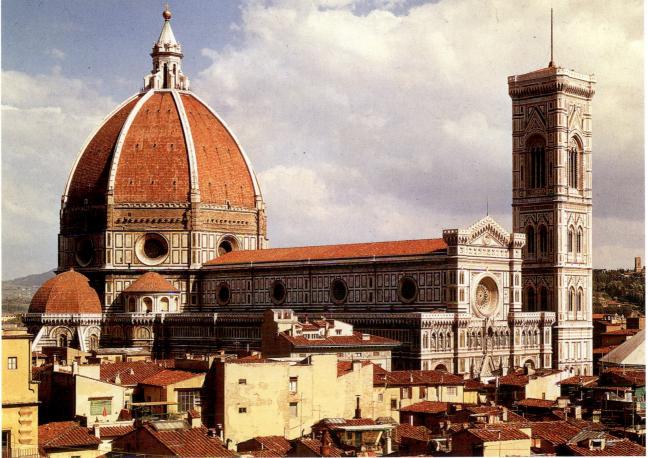

were obsessed with the visual disintegration of massive stone walls. The Italians, on the other hand, preserved the **mural quality** of the structure. In the cathedral of Florence, there are no flying buttresses. The wall elevation has been reduced to two levels, with a minimum of fenestration.

The Florence Cathedral is also different in plan (Fig. 4-17E) from French cathedrals. A huge octagonal dome overrides the structure. The nave consists of four large and clearly defined modules, flanked by rectangular bays in the side aisles. There is only one bell tower in the Italian cathedral, and it is detached from the facade.

Why would this Italian Gothic cathedral differ so markedly from those of the French? Given its strong roots in Classical Rome, it may be that Italy never succumbed wholeheartedly to Gothicism. Perhaps for this reason Italy would be the birthplace of the revival of Classicism during the Renaissance. We shall discuss the Florence Cathedral further in the following chapter because the designer of its dome was one of the principal architects of the Renaissance.

Sculpture

Sculpture during the Gothic period reveals a change in mood from that of the Romanesque. The iconography is one of redemption rather than damnation. The horrible scenes of Judgment Day that threatened the worshiper upon entering the cathedral were replaced by scenes from the life of Jesus or visions of the **apocalypse.** The Virgin Mary also assumed a primary role. Carved tympanums, whole sculptural programs, even cathedrals themselves (for example, Notre-Dame, which means "Our Lady") were dedicated to her.

Gothic sculpture was still pretty much confined to decoration of cathedral portals. Every square inch of the tympanums, lintels, and **archivolts** of most Gothic cathedrals was carved with a dazzling array of figures and ornamental motifs. However, some of the most advanced full-scale sculpture is to be found adorning the **jambs**, such as those flanking the portals of Chartres Cathedral (Fig. 4-28). The figures are rigid in their poses, confined by the columns to which they are attached. The drapery falls in predictable stylized folds reminiscent of those seen in manuscript illumination. Yet there is a certain weight to the bodies and the "hinged" treatment of the limbs is eliminated, heralding change from the Romanesque. During the High Gothic period, these simple elements led to a naturalism that was not witnessed since Classical times. The jamb figures of Reims Cathedral (Fig. 4-29) illustrate an interesting combination of styles. No doubt the individual figures were carved by different artists. The detail of the central portal of the facade illustrates two groups of figures. To the left is an **Annunciation** scene with the angel Gabriel and the Virgin Mary, and to the right is a **Visitation** scene depicting the Virgin Mary and Saint Elizabeth. All the figures are detached from columns and instead occupy the spaces between them. Although they have been carved for these specific niches and are perched on small pedestals, they suggest a freedom of movement not found in the jamb figures at Chartres.

The Virgin Mary of the Annunciation group is the least advanced in technique of the four figures. Her stance is the most rigid, and her gestures and facial expression are the most stylized. Yet her body has substance, and anatomical details are revealed beneath a drapery that responds realistically to the movement of her limbs.

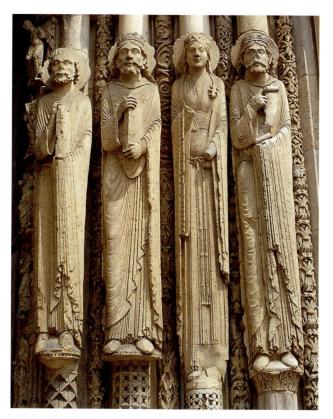

4–28 Jamb figures, west portals, Chartres Cathedral (Gothic, c. 1140–1150 CE).
 Copyright Scala/Art Resource, New York.

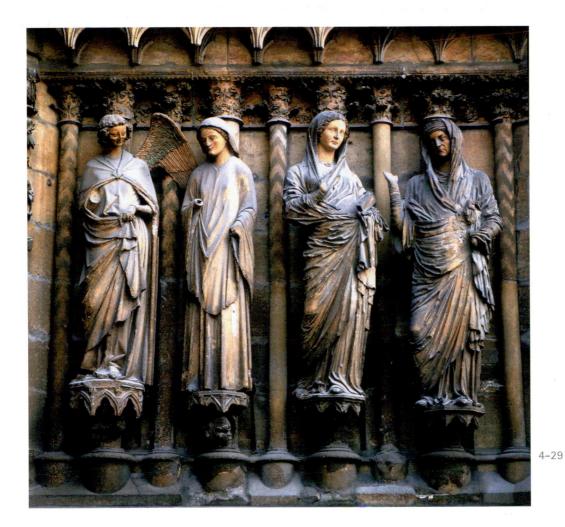

29 Jamb figures, west portals, Reims Cathedral (Gothic, begun 1210 CE). Copyright Art Resource, New York.

The figure of Gabriel contrasts strongly in style with that of the Virgin Mary. He seems relatively tall and lanky. His head is small and delicate, and his facial features are refined. His body has a subtle sway that is accented by the flowing lines of his drapery. Stateliness and sweetness characterize this courtly style; it will be carried forward into the Early Renaissance period in the **International Gothic style**.

Yet Classicism will be the major style of the Renaissance, and in the Visitation group of the Reims portals we have a fascinating introduction to it. The weighty figures of Mary and Elizabeth are placed in a **contrapposto** stance. The folds of drapery articulate the movement of the bodies beneath with a realism that we have not seen since Classical times. Even the facial features and hairstyles are reminiscent of Greek and Roman sculpture. Although we have linked the reappearance of naturalism to the Gothic artist's increased awareness of nature, we must speculate that the sculptor of the Visitation group was looking directly to Classical statues for inspiration. The similarities are too strong to be coincidental. With his small and isolated attempt to revive Classicism, this unknown artist stands as a transitional figure between the spiritualism of the medieval world and the rationalism and humanism of the Renaissance.

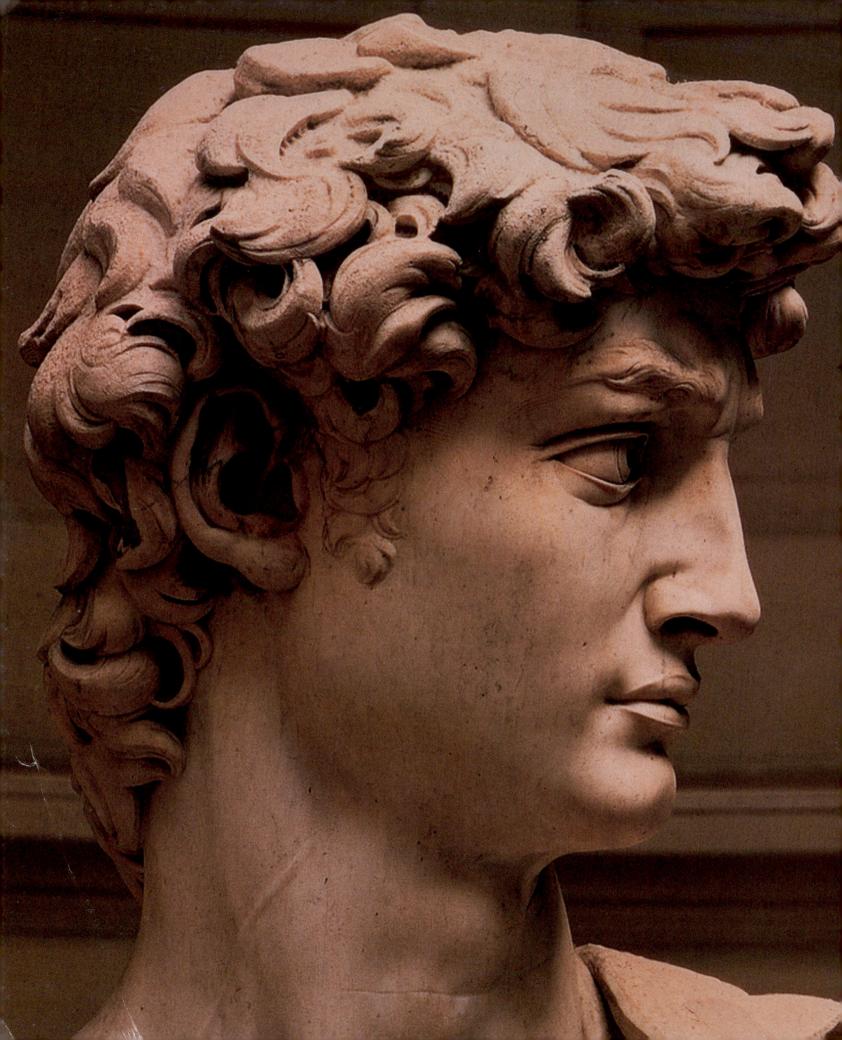

THE RENAISSANCE

The fundamental principle will be that all steps of learning should be sought from Nature; the means of perfecting our art will be found in diligence, study, and application.

—Leone Battista Alberti

While Columbus brought his ships to New World in 1492, a 17-year-old Michelangelo Buonarroti was perfecting his skill at rendering human features from blocks of marble. In 1564, the year that Shakespeare was born, Michelangelo died.

These are two of the marker dates of the **Renaissance**. *Renaissance* is a French word meaning "rebirth," and the Renaissance in Europe was a period of significant historical, social, and economic events. The old feudal system that had organized Europe during the Middle Ages fell to a system of government based on independent city-states with powerful kings and princes at their helms. The economic face of Europe changed, aided by an expansion of trade and commerce with Eastern countries. The cultural base of Europe shifted from Gothic France to Italy. A plague wiped out the populations of entire cities in Europe and Asia. Speculation on the world beyond, which had so preoccupied the medieval mind, was counterbalanced by a scientific observation of the world at hand. Although Copernicus proclaimed

that the sun and not Earth was at the center of the solar system, humanity, and not heaven, became the center of all things.

THE RENAISSANCE

The Renaissance spans roughly the fourteenth through the sixteenth centuries and is seen by some as the beginning of modern history. During this period we witness a revival of Classical themes in art and literature, a return to the realistic depiction of nature through keen observation, and the revitalization of the Greek philosophy of humanism, in which human dignity, ideas, and capabilities are of central importance.

Changes, artistic and otherwise, took root all over Europe, but Italy and Flanders (present-day Belgium and the Netherlands) developed into world-class economic and cultural centers in the fifteenth century (see Map 5-1). Given its Classical roots, Italy never quite succumbed to Gothicism and readily introduced elements of Greek and Roman art into its art and architecture. But Flanders was steeped in the medieval tradition of northern Europe and continued to concern itself with the spiritualism of the Gothic era, enriching it with a supreme realism. (It is worth noting that because the word "renaissance" generally refers to the artistic and cultural revival of Classical sources, some art historians no longer use it to describe northern art of this period.) The difference in attitudes was summed up during the later Renaissance years by one of Italy's great artists, Michelangelo Buonarroti, not entirely without prejudice:

Flemish painting will, generally speaking, please the devout better than any painting in Italy, which will never cause him to shed a tear, whereas that of Flanders will cause him to shed many... In Flanders they paint with a view to external exactness or such things as may cheer you and of which you cannot speak ill, as for example saints and prophets. They paint stuffs and masonry, the green grass of the fields, the shadows of trees, and rivers and bridges.¹

Thus, the subject matter of northern artists remained more consistently religious, although their manner of representation was that of an exact, trompe l'oeil rendition of things of this world. They used the "trick-the-eye" technique to portray mystical religious phenomena in a realistic manner. The exactness of representation of which Michelangelo spoke originated in **manuscript illumination**, where complicated imagery was reduced to a minute scale. Because this imagery illustrated texts, it was often laden with symbolic meaning. Symbolism was carried into **panel paintings**, where it was fused with a keen observation of nature.

FIFTEENTH-CENTURY NORTHERN PAINTING

Flemish Painting: From Page to Panel

A certain degree of naturalism appeared in the work of the northern book illustrator during the Gothic period. The

¹Robert Goldwater and Marco Treves, eds., *Artists on Art* (New York: Pantheon Books, 1972), 68.

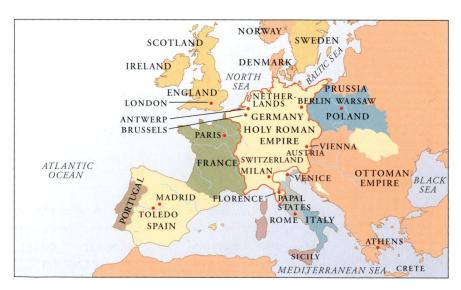

Map 5–1 Renaissance Europe (c. 16th century).

manuscript illuminator *illuminated* literary passages with visual imagery. As the art of manuscript illumination progressed, these thumbnail sketches were enlarged to fill greater portions of the manuscript page, eventually covering it entirely. As the text pages became less able to contain this imagery, the northern Renaissance artist shifted to painting in tempera on wood panels.

The Limbourg Brothers

One of the most dazzling texts available to illustrate this transfer from minute to more substantial imagery is Les Très Riches Heures du Duc de Berry, a Book of Hours illustrated by the Limbourg brothers (born after 1385, died by 1416) during the opening decades of the fifteenth century. Books of Hours were used by nobility as prayer books and included psalms and litanies to a variety of saints. As did most Books of Hours, Les Très Riches Heures contained calendar pages that illustrated domestic tasks and social events of the 12 months of the year. In "May" (Fig. 5-1), one of the calendar pages, we witness a parade of aristocratic gentlemen and ladies who have come in their bejeweled costumes of pastel hues to celebrate the first day of May. Complete with glittering regalia and festive song, the entourage romps through a woodland clearing on carousel-like horses. In the background looms a spectacular castle complex, the chateau of Riom.

The calendar pages of *Les Très Riches Heures* are rendered in the **International style**, a manner of painting common throughout Europe during the late fourteenth and early fifteenth centuries. This style is characterized by ornate costumes embellished with gold leaf and by subject matter literally fit for a king, including courtly scenes and splendid processions. The refinement of technique and attention to detail in these calendar pages recall earlier manuscript illumination. These qualities, and a keen observation of the human response to the environment—or in this case the merrymaking—bring to mind Michelangelo's assessment of northern painting as obsessed with representation of the real world through the painstaking rendition of its everyday objects and occurrences.

Although these calendar pages illustrated a holy book, the themes were secular. Fifteenth-century artists tried to reconcile religious subjects with scenes and objects from everyday life, and northern artists accomplished this by using symbolism. Artists would populate ordinary interiors with objects that might bear some spiritual significance. Many, if

5-1 LIMBOURG BROTHERS.
 "May" from Les Très Riches Heures du Duc de Berry (1416).
 Illumination. 8⁷/₈" × 5³/₈".
 Musée Conde, Chantilly, France. Copyright Art Resource, New York.

not most, of the commonplace items might be invested with a special religious meaning. You might ask how you, the casual observer, are supposed to decipher the cryptic meaning lurking behind an ordinary kettle. Chances are that you would be unable to do so without a specialized background. Yet you can enjoy the warm feeling of being invited into All [Flemish] life was saturated with religion to such an extent that the people were in constant danger of losing sight of the distinction between things spiritual and things temporal.

—Johan Huizinga

someone's home when you look at a northern Renaissance interior and be all the more enriched by the knowledge that there really is something more there than meets the eye.

Robert Campin, the Master of Flémalle

Attention to detail and the use of commonplace settings were carried forward in the soberly realistic religious figures painted by Robert Campin, the Master of Flémalle (c. 1378–1444). His *Merode Altarpiece* (Fig. 5-2) is a triptych whose three panels, from left to right, contain the kneeling donors of the altarpiece; an Annunciation scene with the Virgin Mary and the angel Gabriel; and Joseph, the foster father of Jesus, at work in his carpentry shop. The architectural setting is a typical contemporary Flemish dwelling. The donors kneel by the doorstep in a garden thick with grass and wildflowers, each of which has special symbolic significance regarding the Virgin Mary. Although the door is ajar, it is not clear whether they are witnessing the event inside or whether Campin has used the open door as a compositional device to lead the spectator's eye into the central panel of the triptych.

In any event, we are visually and psychologically coaxed into viewing this most atypical Annunciation. Mary is depicted as a prim and proper middle-class Flemish woman surrounded by the trappings of a typical Flemish household, all rendered in exacting detail. Just as the closed outdoor garden symbolizes the holiness and purity of the Virgin Mary, the items within also possess symbolic meaning. For example, the bronze kettle hanging in the Gothic niche on the back wall symbolizes the Virgin's body—it will be the

5-2 ROBERT CAMPIN.

Merode Altarpiece: The Annunciation with Donors and St. Joseph (c. 1425–1428). Oil on wood. Center: $24^{1}/4'' \times 24^{7}/8''$; Wings: each $25^{3}/8'' \times 10^{7}/8''$. The Metropolitan Museum of Art, The Cloisters, New York. Purchase, 1956 (56.70). Copyright 1996 The Metropolitan Museum of Art, New York.

immaculate container of the redeemer of the Christian world. More obvious symbols of her purity include the spotless room and the vase of lilies on the table. In the upper left corner of the central panel a small child can be seen, bearing a cross and riding streams of "divine light." The wooden table situated between Mary and Gabriel and the room divider between Mary and Joseph guarantee that the light accomplished the deed. Typically, Joseph is shown as a man too old to have been the biological father of Jesus, although Campin's depiction does not quite follow this tradition. He is gray, but by no means ancient. Jesus' earthly father is busy preparing mousetraps—one on the table and one on the windowsill—commonplace objects that symbolize the belief that Christ was the bait with which Satan would be trapped.

The symbolism in the altarpiece presents a fascinating web for the observer to untangle and interpret. Yet it does not overpower the hard-core realism of the ordinary people and objects. With the exceptions of the slight inconsistency of size and the tilting of planes toward the viewer, Campin offers us a continuous realism that sweeps the three panels. There is no distinction between saintly and common folk; the facial types of the heavenly beings are as individual as the portraits of the donors. Although fifteenth-century viewers would have been aware of the symbolism and the sacredness of the event, they would have also been permitted to become "a part" of the scene, so to speak, and to react to it as if the people in the painting were their peers and just happened to find themselves in extraordinary circumstances.

Jan van Eyck

We might say that Campin "humanized" his Mary and Joseph in the *Merode Altarpiece*. As religious subjects became more secular in nature and the figures themselves became rendered as "human," an interest in ordinary, secular subject matter sprang up. During the fifteenth century in northern Europe we have the development of what is known as **genre painting**, painting that depicts ordinary people engaged in run-of-the-mill activities. These paintings make little or no reference to religion; they exist almost as art for art's sake. Yet they are no less devoid of symbolism.

Giovanni Arnolfini and His Bride (Fig. 5-3) was executed by one of the most prominent and significant Flemish painters of the fifteenth century, Jan van Eyck (c. 1395– 1441). This unique double portrait was commissioned by an Italian businessman working in Bruges to serve as a kind of marriage contract, or record of the couple's taking of marriage vows in the presence of two witnesses. The significance of such a document—in this case a visual one—is emphasized by the art historian Erwin Panofsky: According to

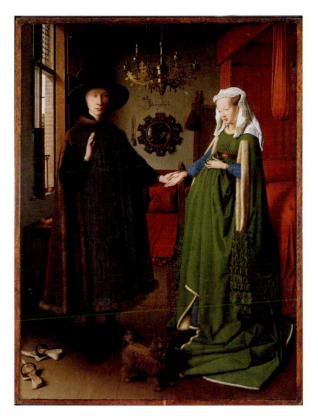

5-3 JAN VAN EYCK. Giovanni Arnolfini and His Bride (1434). Oil on wood. 33" × 22¹/2". Reproduced by Courtesy of the Trustees, The National Gallery, London. Copyright Edimedia/Corbis.

Catholic dogma, the sacrament of matrimony is "immediately accomplished by the mutual consent of the persons to be married when this consent is expressed by words and actions" in the presence of two or three witnesses. Records of the marriage were necessary to avoid lawsuits in which "the validity of the marriage could be neither proved nor disproved for want of reliable witnesses."²

Once again we see the northern artist's striking realism and fidelity to detail offering us exact records of the facial features of the wedding couple. The figures of the two witnesses are reflected in the convex mirror behind the Arnolfinis. Believe it or not, they are Jan van Eyck and his wife, a fact corroborated by the inscription above the mirror: "Jan van Eyck was here." As in most Flemish paintings, the items scattered about are invested with symbolism relevant to the occasion. The furry dog in the foreground symbolizes fidelity, and the oranges on the windowsill may symbolize victory over death. Giovanni himself has kicked off his shoes

² Erwin Panofsky, "Jan van Eyck's 'Arnolfini' Portrait," *Burlington Magazine* 64 (1934): 117–27.

out of respect for the holiness of the ground on which this sacrament takes place. Finally, the finial on the bedpost is an image of St. Margaret, the patroness of childbirth, and around her wooden waist is slung a small whisk broom, a symbol of domesticity. It would seem that Giovanni had his bride's career all mapped out. With Jan van Eyck, Flemish painting reached the height of symbolic realism in both religious and secular subject matter. No one ever quite followed in his footsteps.

German Art

Northern Renaissance painting is not confined to the region of Flanders, and indeed, some of the most emotionally striking work of this period was created by German artists. Their work contains less symbolism and less detail than that of Flemish artists, but their message is often more powerful.

Matthias Grünewald

These characteristics of German Renaissance art can clearly be seen in the *Isenheim Altarpiece* (Fig. 5-4) by Matthias Grünewald (c. 1480–1528), painted more than three-

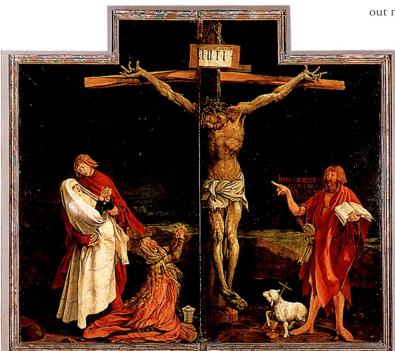

5-4 MATTHIAS GRÜNEWALD.
The Crucifixion, center panel of The Isenheim Altarpiece (exterior) (completed 1515).
Oil on panel. 8'10" × 10'1".
Musée d'Unterlinden, Colmar, France. Copyright Edimedia/Corbis. quarters of a century after Jan van Eyck's Arnolfini portrait. The central panel of the German altarpiece is occupied by a tormented representation of the Crucifixion, one of the most dramatic in the history of art. The dead Christ is flanked by his mother, Mary, the apostle John, and Mary Magdalene to the left, and John the Baptist and a sacrificial lamb to the right. These figures exhibit a bodily tension in their arched backs, clenched hands, and rigidly pointing fingers, creating a melodramatic, anxious tone. The crucified Christ is shown with a deadly pallor. His skin appears cancerous, and his chest is sunken with his last breath. His gnarled hands reach painfully upward, stretching for salvation from the blackened sky. We do not find such impassioned portrayals outside Germany during the Renaissance.

Albrecht Dürer

We appropriately close our discussion of northern Renaissance art with the Italianate master Albrecht Dürer (1471– 1528). His passion for the Classical in art stimulated extensive travel in Italy, where he copied the works of the Italian masters, who were also enthralled with the Classical style. The development of the printing press made it possible for him to disseminate the works of the Italian masters throughout northern Europe.

> Dürer's Adam and Eve (Fig. 5-5) conveys his admiration for the Classical style. In contrast to other German and Flemish artists who rendered figures, Dürer emphasized the idealized beauty of the human body. His Adam and Eve are not everyday figures of the sort Campin depicted in his Virgin Mary. Instead, the images arise from Greek and Roman prototypes. Adam's young muscular body could have been drawn from a live model or from Classical statuary. Eve represents a standard of beauty different from that of other northern artists. The familiar slight build and refined facial features have given way to a more substantial and wellrounded woman. She is reminiscent of a fifthcentury BCE Venus in her features and her pose. The symbols associated with the event—the Tree of Knowledge and the Serpent (Satan)-play a secondary role. In Adam and Eve, Dürer has chosen to emphasize the profound beauty of the human body. Instead of focusing on the consequences of the event preceding the taking of the fruit as an admonition against sin, we delight in the couple's beauty for its own sake. Indeed, this notion is central to the art of Renaissance Italy.

I hold that the more nearly and accurately a figure is made to resemble man, so much better the work will be. If the best parts, chosen from many well-formed men, are fitly united in one figure, it will be worthy of praise.

—Albrecht Dürer

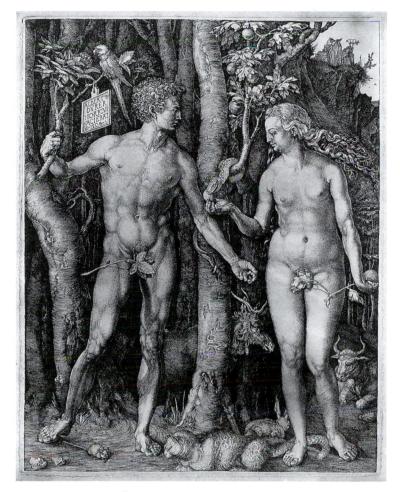

5-5 ALBRECHT DÜRER. Adam and Eve (1504). Engraving, 4th state. 9⁷/₈" × 7⁵/₈". The Metropolitan Museum of Art, New York. Fletcher Fund, 1919 (19.73.1). All rights reserved, The Metropolitan Museum of Art, New York.

THE RENAISSANCE IN ITALY

The Early Renaissance

Not only was there a marked difference between northern and Italian Renaissance art but there were notable differences in the art of various sections of Italy itself. Florence and Rome witnessed a resurgence of Classicism as Roman ruins were excavated in ancient sites, hillsides, and people's backyards. In Siena, on the other hand, the International style lingered, and in Venice a Byzantine influence remained strong. There may be several reasons for this diversity, but the most obvious is that of geography. For example, whereas the Roman artist's stylistic roads led to that ancient city, the trade routes in the northeast brought an Eastern influence to works of art and architecture.

The Italian Renaissance took root and flourished most successfully in Florence. The development of this city's painting, sculpture, and architecture parallels that of the Renaissance in all of Italy. Throughout the Renaissance, as Florence went, so went the country.

Cimabue and Giotto

Some of the earliest changes from a medieval to a Classical style can be perceived in the painting of Florence during the late thirteenth and early fourteenth centuries, the prime exponents being Cimabue and Giotto. So significant were these artists that Dante Alighieri, the fourteenth-century poet, mentioned both of them in his *Purgatory* of *The Divine Comedy:*

O gifted men, vainglorious for first place, how short a time the laurel crown stays green unless the age that follows lacks all grace! Once Cimabue thought to hold the field in painting, and now Giotto has the cry so that the other's fame, grown dim, must yield.³

Who were these artists? Apparently they were rivals, although Cimabue (c. 1240-c. 1302) was older than Giotto

³From *The Divine Comedy* by Dante Alighieri, trans. John Ciardi. Copyright 1954, 1957, 1959, 1960, 1961, 1965, 1967, 1970 by the Ciardi Family Publishing Trust. Used by permission of W. W. Norton & Company, Inc.

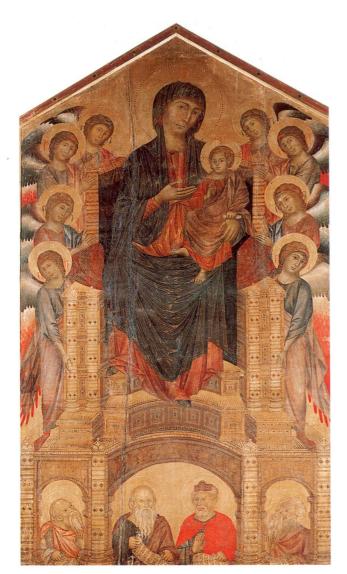

5-6 CIMABUE.
 Madonna Enthroned (c. 1280–1290).
 Tempera on wood panel. 12'7" × 7'4".
 Uffizi Gallery, Florence/Alinari/Art Resource, New York.

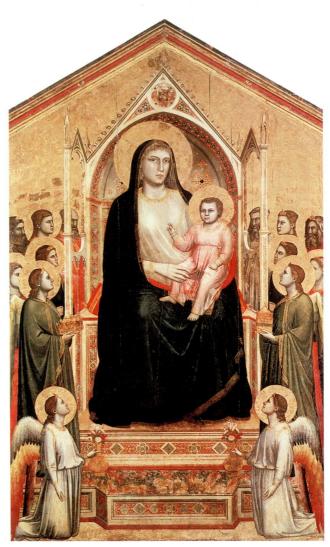

5-7 GIOTTO.
 Madonna Enthroned (c. 1310).
 Tempera on wood panel. 10'8" × 6'8".
 Uffizi Gallery, Florence/Scala/Art Resource, New York.

(c. 1276 - c. 1337) and probably had a formative influence on the latter, who would ultimately steal the limelight.

The similarities and differences between the works of Cimabue and Giotto can be seen in two tempera paintings on wood panels depicting the Madonna and Child enthroned. A curious combination of Late Gothic and Early Renaissance styles betrays Cimabue's composition as a transitional work (Fig. 5-6). The massive throne of the Madonna is Roman in inspiration, with column and arch forms embellished with **intarsia**. The Madonna has a corporeal presence that sets her apart from "floating" medieval figures, but the effect is compromised by the unsureness with which she is placed on the throne. She does not sit solidly; her limbs are not firmly "planted." Rather, the legs resemble the "hinged" appendages of Romanesque figures. This characteristic placement of the knees causes the drapery to fall in predictable folds—concentric arcs reminiscent of a more stylized technique. The angels supporting the throne rise parallel to it, their glances forming an abstract zigzag pattern. The resultant lyrical arabesque, the flickering color patterns of the wings, and the lineup of unobstructed heads recall the Byzantine tradition, particularly the Ravenna mosaics (see Fig. 14-5).

Giotto's rendition of the same theme offers some dramatic differences (Fig. 5-7). The overall impression of the Madonna Enthroned is one of stability and corporeality instead of instability and weightlessness. Giotto's Madonna sits firmly on her throne, the outlines of her body and drapery forming a solid triangular shape. Although the throne is lighter in appearance than Cimabue's Roman throne-and is, in fact, Gothic, with pointed arches-it, too, seems more firmly planted on the earth. Giotto's genius is also evident in his conception of the forms in three-dimensional space. They not only have height and width, as do those of Cimabue, but they also have depth and mass. This is particularly noticeable in the treatment of the angels. Their location in space is from front to rear rather than atop one another as in Cimabue's composition. The halos of the foreground angels obscure the faces of the background attendants, because they have mass and occupy space.

The Renaissance Begins, and So Does the Competition

With Cimabue and Giotto we witness strides toward an art that was very different from that of the Middle Ages. But artists, like all of us, must walk before they can run, and those very "strides" that express such a stylistic advance from the "cutout dolls" of the Ravenna mosaics and the "hinged marionettes" of the Romanesque era will look primitive in another half century. Because the art of Cimabue and Giotto contains vestiges of Gothicism, their style is often termed proto-Renaissance. But at the dawn of the fifteenth century in Florence, the Early Renaissance began—with a competition.

Imagine workshops and artists abuzz with news of one of the hottest projects in memory up for grabs. Think of one of the most prestigious architectural sites in Florence. Savor the possibility of being known as *the* artist who had cast, in gleaming bronze, the massive doors of the Baptistery of Florence. This landmark competition was held in 1401. There were countless entries, but only two panels have come down to us. The artists had been given a scene from the Old Testament to translate into bronze—the sacrifice of Isaac by his father, Abraham. There were specifications, naturally, but the most obvious is the **quatrefoil** format. Within this space, a certain cast of characters was mandated, including Abraham, Isaac, an angel, and two "extras" who appear to have little or nothing to do with the scene. The event takes place out of doors, where God has commanded Abraham to take his only son and sacrifice him. When they arrive on the scene, Abraham, in loyalty to God, turns the blade to Isaac's throat. At this moment, God sends an angel to stop Abraham from completing the deed.

Filippo Brunelleschi and Lorenzo Ghiberti

The two extant panels were executed by Filippo Brunelleschi (c. 1377-1446) and Lorenzo Ghiberti (1378-1455). The obligatory characters, bushes, animals, and altar are present in both, but the placement of these elements, the artistic style, and the emotional energy within each work differ considerably. Brunelleschi's panel (Fig. 5-8) is divided into sections by strong vertical and horizontal elements, each section filled with objects and figures. In contrast to the rigidity of the format, a ferocious energy bordering on violence pervades the composition. Isaac's neck and body are distorted by his father's grasping fist, and Abraham himself lunges viciously toward his son's throat with a knife. With similar passion, an angel flies in from the left to grasp Abraham's arm. But this intense drama and seemingly boundless energy are weakened by the introduction of ancillary figures that are given more prominence than the scene requires. The donkey, for example, detracts from Isaac's plight by being placed broadside and practically dead center. Also, one is struck by the staccato movement throughout. Although this choppiness complements the anxiety in the work, it compromises the successful flow of space and tires the eye.

In Lorenzo Ghiberti's panel (Fig. 5-9), the space is divided along a diagonal rock formation that separates the main characters from the lesser ones. Space flows along this diagonal, exposing the figural group of Abraham and Isaac and embracing the shepherd boys and their donkey. The boys and donkey are appropriately subordinated to the main characters but not sidestepped stylistically. Abraham's lower body parallels the rock formation and then lunges expressively away from it in a dynamic counterthrust. Isaac, in turn, pulls firmly away from his father's forward motion. The forms move rhythmically together in a continuous flow of space. Although Ghiberti's emotion is not quite as intense as Brunelleschi's, and his portrayal of the sacrifice is not quite as graphic, the impact of Ghiberti's narrative is as strong.

It is interesting to note the inclusion of Classicizing elements in both panels. Brunelleschi, in one of his peasants, adapted the Classical sculpture of a boy removing a thorn from his foot, and Ghiberti rendered his Isaac in the manner of the fifth-century sculptor. Isaac's torso, in fact, may be the first nude in this style since Classical times.

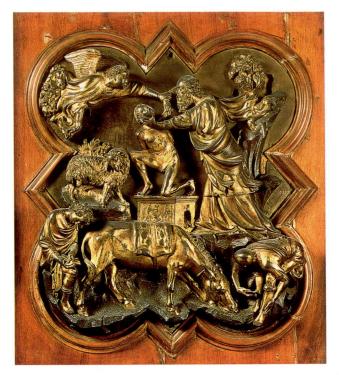

5-8 FILIPPO BRUNELLESCHI.
Sacrifice of Isaac (1401–1402).
Gilt bronze. 21" × 17¹/₂".
Museo Nazionale del Bargello, Florence. Copyright Edimedia/Corbis.

Oh, yes—Ghiberti won the competition and Brunelleschi went home with his chisel. The latter never devoted himself to sculpture again but went on to become the first great Renaissance architect. Ghiberti himself was not particularly modest about his triumph:

To me was conceded the palm of victory by all the experts and by all . . . who had competed with me. To me the honor was conceded universally and with no exception. To all it seemed that I had at that time surpassed the others without exception, as was recognized by a great council and an investigation of learned men . . . highly skilled from the painters and sculptors of gold, silver, and marble.⁴

Donatello

If Brunelleschi and Ghiberti were among the last sculptors to harbor vestiges of the International style, Donatello (c. 1386–1466), the Florentine master, was surely among the first to create sculptures that combined Classicism with realism. In his *David* (Fig. 5-10), the first life-size nude statue since Classical times, Donatello struck a balance between the two styles by presenting a very real image of an Italian peasant boy in the guise of a Classical nude figure.

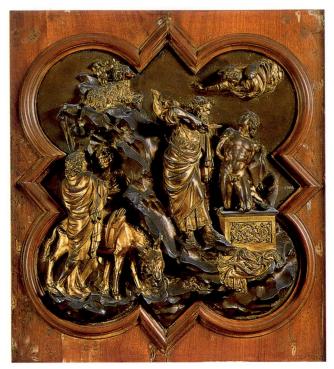

5–9 LORENZO GHIBERTI. Sacrifice of Isaac (1401–1402). Gilt bronze. $21'' \times 17^{1/2}''$. Museo Nazionale del Bargello, Florence. Copyright Edimedia/Corbis.

David, destined to be the second king of Israel, slew the Philistine giant Goliath with a stone and a sling. Even though Donatello was inspired by Classical statuary, notice that he did not choose a Greek youth in his prime as a prototype for his David. Instead, he chose a barely developed adolescent boy, his hair still unclipped and his arms flaccid for lack of manly musculature. After decapitating Goliath, whose head lies at David's feet, his sword rests at his sidealmost too heavy for him to handle. Can such a youth have accomplished such a forbidding task? Herein lies the power of Donatello's statement. We are amazed, from the appearance of this young boy, that he could have done such a deed, much as David himself seems incredulous as he glances down toward his body. What David lacks in stature he has made up in intellect, faith, and courage. His fate was in his own hands-one of the ideals of the Renaissance man.

Masaccio

The Early Renaissance painters shared most of the stylistic concerns of the sculptors. However, included in their attempts at realism was the added difficulty of projecting a naturalistic sense of three-dimensional space on a twodimensional surface. In addition to copying from nature and Classical models, these painters developed rules of perspec-

⁴E. G. Holt, ed., *Literary Sources of Art History* (Princeton, NJ: Princeton University Press, 1947), 87–88.

The works made before [Masaccio's] day can be said to be painted, while his are living, real, and natural.

—Giorgio Vasari

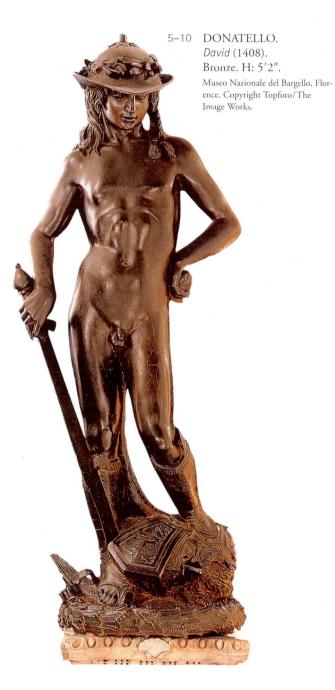

tive to depict images in the round on flat walls, panels, and canvases. One of the pioneers in developing systematic laws of one-point linear perspective was Brunelleschi, of Baptistery doors near fame.

Masaccio's *Holy Trinity* (Fig. 5-11) uses these laws of perspective. In this chapel fresco, Masaccio (1401–1428)

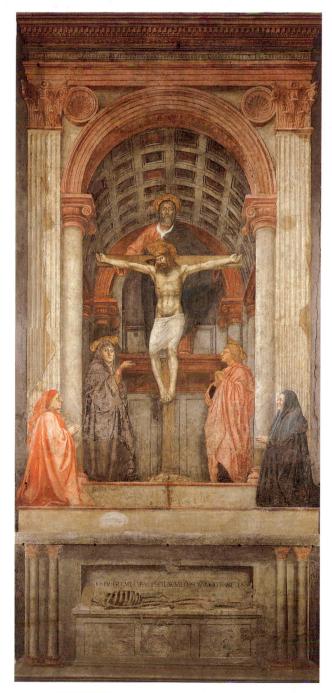

5-11 MASACCIO. Holy Trinity, Santa Maria Novella, Florence (c. 1428). Fresco. $21' \times 10'5''$. Erich Lessing/Art Resource, New York. creates the illusion of an extension of the architectural space of the church by painting a barrel-vaulted "chapel" housing a variety of holy and common figures. God the Father supports the cross that bears his crucified son while the Virgin Mary and the apostle John attend. Outside the columns and pilasters of the realistic, Roman-inspired chapel kneel the donors, who are invited to observe the scene. Aside from the trompe l'oeil rendition of the architecture, the realism in the fresco is enhanced by the donors, who are given importance equal to that of the "principal" characters, similar to Campin's treatment of the donors in the *Merode Altarpiece* (Fig. 5-2). The architecture appears to extend our physical space, and the donors appear as extensions of ourselves.

Filippo Brunelleschi

The revival of Classicism was even more marked in the architecture of the Renaissance. Some 20 years after Brunelleschi's unsuccessful bid for the Baptistery doors project in Florence, he was commissioned to cover the crossing square of the cathedral of Florence with a dome. Interestingly, Ghiberti worked with him at the outset but soon bowed out, and Brunelleschi was left to complete the work alone. It was quite an engineering feat, involving a doubleshell dome constructed around 24 ribs (Fig. 5-12). Eight of these ribs rise upward to a crowning lantern on the exterior of the dome. You might wonder why Brunelleschi, whose architectural models were essentially Classical, would have constructed a somewhat pointed dome reminiscent of the Middle Ages. The fact is that the architect might have preferred a more rounded or hemispherical structure, but the engineering problem required an ogival, or pointed, section, which is inherently more stable. The dome was a compromise between a somewhat Classical style and traditional Gothic building principles.

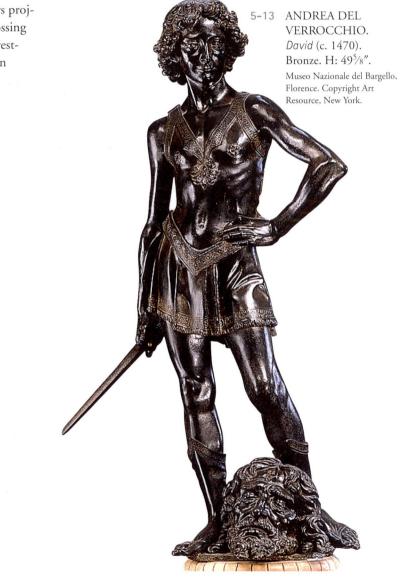

5–12 FILIPPO BRUNELLESCHI. Construction of the cathedral dome, Florence (1420–1436).

Renaissance Art at Midcentury and Beyond

Andrea del Verrocchio

As we progress into the middle of the fifteenth century, the most important and innovative sculptor is Andrea del Verrocchio (1435 –1488). An extremely versatile artist who was trained as a goldsmith, Verrocchio ran an active shop that attracted many young artists, including Leonardo da Vinci. We see in Verrocchio's bronze *David* (Fig. 5-13), commissioned by the Medici family, a strong contrast to Donatello's handling of the same subject. The Medici also owned the Donatello *David*, and Verrocchio probably wanted to outshine his predecessor. Although both artists chose to represent David as an adolescent, Verrocchio's hero appears somewhat older and exudes pride and self-confidence rather than a dreamy gaze of disbelief. Whereas Donatello reconciled re-

alistic elements with an almost idealized, Classically inspired torso, Verrocchio's goal was supreme realism in minute details, including orientalizing motifs on the boy's doublet that would have made him look like a Middle Easterner. The sculptures differ considerably also in terms of technique. Donatello's David is essentially a closed-form sculpture with objects and limbs centered around an S curve stance; Verrocchio's sculpture is more open, as is evidenced by the bared sword and elbow jutting away from the central core. Donatello's graceful pose has been replaced, in the Verrocchio, by a jaunty contrapposto that enhances David's image of self-confidence.

 5-14 PIERO DELLA FRANCESCA. *Resurrection* (c. late 1450s). Fresco. 7'5" × 6'6¹/2". Town Hall, Borgo San Sepolcro, Italy/ Scala/Art Resource, New York.

Piero della Francesca

The artists of the Renaissance, along with the philosophers and scientists, tended to share the sense of the universe as an orderly place that was governed by natural law and capable of being expressed in mathematical and geometric terms. Piero della Francesca (c. 1420–1492) was trained in mathematics and geometry and is credited with writing the first theoretical treatise on the construction of systematic perspective in art. Piero's art, like his scientific thought, was based on an intensely rational construction of forms and space.

His *Resurrection* fresco (Fig. 5-14) for the town hall of Borgo San Sepolcro reveals the artist's obsessions with order and geometry. Christ ascends vertical and triumphant, like a monumental column, above the "entablature" of his tomb, which serves visually as the pedestal of a statue. Christ and the other figures are constructed from the cones, cylinders, spheres, and rectangular solids that define the theoretical

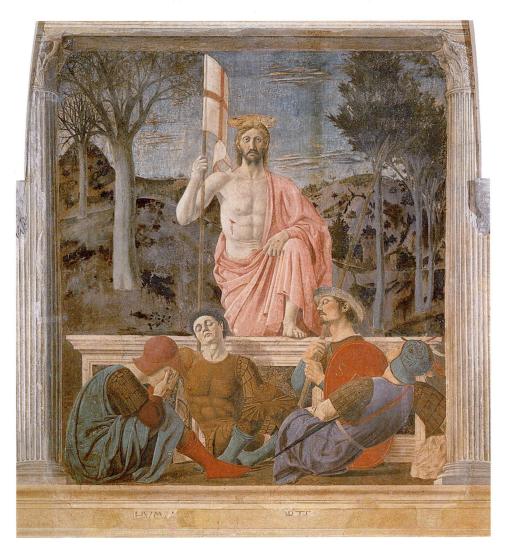

world of the artist. There is a tendency here toward the simplification of forms—not only of people, but also of natural features such as trees and hills. All the figures in the painting are contained within a triangle—what would become a major compositional device in Renaissance painting—with Christ at the apex. The sleeping figures and the marble sarcophagus provide a strong and stable base for the upper two-thirds of the composition. Regimented trees rise in procession behind Christ, as they never do when nature asserts its random jests; Piero's trees are swept back by the rigid cultivation of scientific perspective. They crown, as ordered, just above the crests of rounded hills. The artist of the Renaissance was not only in awe of nature but also commanded it fully.

Sandro Botticelli

During the latter years of the fifteenth century, we come upon an artistic personality whose style is somewhat in opposition to the prevailing trends. Since the time of Giotto, painters had relied on chiaroscuro, or the contrast of light

5-15 SANDRO BOTTICELLI. *The Birth of Venus* (c. 1486). Tempera on canvas. 5'8⁷/₈" × 9'1⁷/₈". Uffizi Gallery, Florence. Copyright Edimedia/Corbis. and shade to create a sense of roundness and mass in their figures and objects, in an effort to render a realistic impression of three-dimensional forms in space. Sandro Botticelli (c. 1444–1510), however, constructed his compositions with line instead of tonal contrasts. His art relied primarily on drawing. Yet when it came to subject matter, his heart lay with his Renaissance peers, for, above all else, he loved to paint mythological themes. Along with other artists and men of letters, his mania for these subjects was fed and perhaps cultivated by the Medici prince Lorenzo the Magnificent, who surrounded himself with Neoplatonists, or those who followed the philosophy of Plato.

One of Botticelli's most famous paintings is *The Birth* of Venus (Fig. 5-15), or, as some art historians would have it, "Venus on the Half-Shell." The model for this Venus was Simonetta Vespucci, a cousin of Amerigo Vespucci, the navigator and explorer after whom America was named. The composition presents Venus, born of the foam of the sea, floating to the shores of her sacred island on a large scallop shell, aided in its drifting by the sweet breaths of entwined

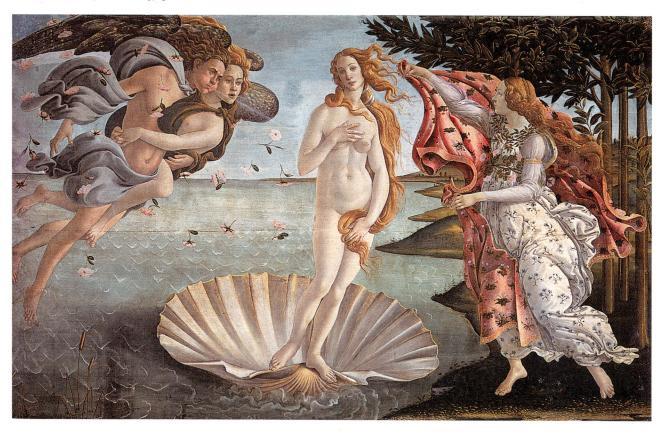

zephyrs. The nymph Pomona awaits her with an ornate mantle and is herself dressed in a billowing, flowered gown. Botticelli's interest in Classicism is evident also in his choice of models for the Venus. She is a direct adaptation of an antique sculpture of this goddess in the collection of the Medici family. Notice how the graceful movement in the composition is evoked through a combination of different lines. A firm horizon line and regimented verticals in the trees contrast with the subtle curves and vigorous arabesques that caress the mythological figures. The line moves from image to image and then doubles back to lead your eye once again. Shading is confined to areas within the harsh, linear, sculptural contours of the figures. Botticelli's genius lay in his ability to utilize the differing qualities of line to his advantage; with this formal element he created the most delicate of compositions.

Leon Battista Alberti

You could never accuse Leon Battista Alberti (1404 –1472) of false modesty, or of any modesty at all. Like so many other artists of the Renaissance, including Ghiberti, Michelangelo, and Leonardo—and unlike the anonymous European artists of the Middle Ages—he sought fame with conscious conviction.

Some of the purest examples of Renaissance Classicism lie in the buildings Alberti designed. Alberti was among the first to study treatises written by Roman architects, the most famous of whom was Vitruvius, and he combined his Classical knowledge with innovative ideas in his grand opus, Ten Books on Architecture. One of his most visually satisfying buildings in the great Classical tradition is the Palazzo Rucellai (Fig. 5-16) in Florence. The building is divided by prominent horizontal string courses into three stories, crowned by a heavy cornice. Within each story are apertures enframed by pilasters of different orders. The first-floor pilasters are of the Tuscan order, which resembles the Doric order in its simplicity; the second story uses a composite capital of volutes and acanthus leaves, seen in the Ionic and Corinthian orders, respectively; and the top-floor pilasters are crowned by capitals of the Corinthian order. As in the Colosseum (see Fig. 3-24), this combination of orders gives an impression of increasing lightness as we rise from the lower to the upper stories. This effect is enhanced in Alberti's building by a variation in the masonry. Although the texture remains the same, the upper stories are faced with lighter-appearing smaller blocks in greater numbers. The palazzo's design, with its clear articulation of parts, overall balance of forms, and rhythmic placement of elements in horizontals across the facade, shows a clear understanding

5–16 LEON BATTISTA ALBERTI. Palazzo Rucellai, Florence (1446–1451). Copyright Scala/Art Resource, New York.

of Classical design adapted successfully to the contemporary nobleman's needs.

The High Renaissance

The High Renaissance ushered in a new era for some artists—one of respect, influence, fame, and, most important, the power to shape their circumstances. Here is an example: Sometime in 1542, Julius II and Michelangelo Buonarroti were in conflict, and the artist was feeling the brunt of the pope's behavior. As if backing out of his tomb commission and refusing to pay for materials were not enough, the pope laid the last straw by having Michelangelo removed from the Vatican when the artist sought to redress his grievances. Michelangelo let his outrage be known: I can make armored cars, safe and unassailable, which will enter the . . . ranks of the enemy with their artillery, and there is no company of men at arms so great that they will not break it. And behind these the infantry will be able to follow quite unharmed and without any opposition. . . . If need shall arise, I can make cannon, mortars, and light ordnance, of very beautiful and useful shapes, quite different from those in common use. . . . Also I can execute sculpture in marble, bronze, and clay, and also painting, in which my work will stand comparison with that of anyone else, who ever he may be.

-Leonardo da Vinci (from a letter of application for a job)

A man paints with his brains and not with his hands, and if he cannot have his brains clear he will come to grief. Therefore I shall be able to do nothing well until justice has been done me. . . . As soon as the Pope [carries] out his obligations towards me I (will) return, otherwise he need never expect to see me again.

All the disagreements that arose between Pope Julius and myself were due to the jealousy of Bramante and of Raffaelo da Urbino; it was because of them that he did not proceed with the tomb, . . . and they brought this about in order that I might thereby be ruined. Yet Raffaello was quite right to be jealous of me, for all he knew of art he learned from me.⁵

Although this is only one side of the story (Michelangelo might also have been somewhat jealous of Raphael), this passage offers us a good look at the personality of an artist of the High Renaissance. He was independent yet indispensable—arrogant, aggressive, and competitive.

From the second half of the fifteenth century onward, a refinement of the stylistic principles and techniques associated with the Renaissance can be observed. Most of this significant, progressive work was being done in Florence, where the Medici family played an important role in supporting the arts. At the close of the decade, however, Rome was the place to be, as the popes began to assume the grand role of patron. The three artists who were in most demand-the great masters of the High Renaissance in Italy-were Leonardo da Vinci, a painter, scientist, inventor, and musician; Raphael, the Classical painter thought to have rivaled the works of the ancients; and Michelangelo, the painter, sculptor, architect, poet, and enfant terrible. Donato Bramante is deemed to have made the most significant architectural contributions of this period. These are the stars of the Renaissance, the artistic descendants of the Giottos, Donatellos, and Albertis, who, because of their earlier

place in the historical sequence of artistic development, are sometimes portrayed as but stepping-stones to the greatness of the sixteenth-century artists rather than as masters in their own right.

Leonardo da Vinci

If the Italians of the High Renaissance could have nominated a counterpart to the Classical Greek's "four-square man," it most assuredly would have been Leonardo da Vinci (1452–1519). His capabilities in engineering, the natural sciences, music, and the arts seemed unlimited, as he excelled in everything from solving drainage problems (a project he undertook in France just before his death), to designing prototypes for airplanes and submarines, to creating some of the most memorable Renaissance paintings.

The Last Supper (Figs. 5-17 and 5-18), a fresco painting executed for the dining hall of a Milan monastery, stands as one of Leonardo's greatest works. The condition of the work is poor, because of Leonardo's experimental fresco technique—although the steaming of pasta for centuries on the other side of the wall may also have played a role. Nonetheless, we can still observe the Renaissance ideals of Classicism, humanism, and technical perfection, now coming to full fruition. The composition is organized through the use of one-point linear perspective. Solid volumes are constructed from a masterful contrast of light and shadow. A hairline balance is struck between emotion and restraint.

The viewer is first attracted to the central triangular form of Jesus sitting among his apostles by orthogonals that converge at his head. His figure is silhouetted against a triple window that symbolizes the Holy Trinity and pierces the otherwise dark back wall. One's attention is held at this center point by the Christ-figure's isolation that results from the leaning away of the apostles. Leonardo has chosen to depict the moment when Jesus says, "One of you will betray me." The apostles fall back reflexively at this accusation; they ges-

⁵Robert Goldwater and Marco Treves, eds., *Artists on Art* (New York: Pantheon Books, 1972), 63.

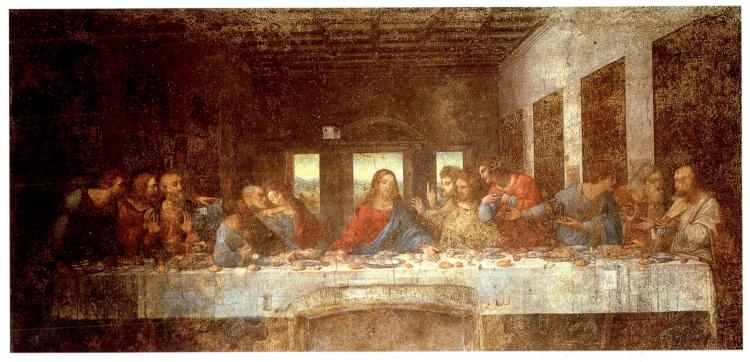

5-17 LEONARDO DA VINCI. *The Last Supper* (1495–1498). Fresco (oil and tempera on plaster). 13'9" × 29'10". Refectory, Santa Maria delle Grazie, Milan. Copyright Edimedia/Corbis.

ture expressively, deny personal responsibility, and ask, "Who can this be?" The guilty one, of course, is Judas, who is shown clutching a bag of silver pieces at Jesus' left, with his elbow on the table. The two groups of apostles, who sweep dramatically away from Jesus along a horizontal line, are subdivided into four smaller groups of three that tend to moderate the rush of the eye out from the center. The viewer's eye is wafted outward and then coaxed back inward through the "parenthetic" poses of the apostles at either end. Leonardo's use of strict rules of perspective and his graceful balance of motion and restraint underscore the artistic philosophy and style of the Renaissance.

Although Leonardo does not allow excessive emotion in his *Last Supper*, the reactions of the apostles seem genuinely human. This spirit is also captured in *Madonna of the Rocks* (see Fig. 1-19). Mary is no longer portrayed as the queen of heaven, but as a mother. She is human; she is "real."

The soft, hazy atmosphere and dreamy landscape of *Madonna of the Rocks*, and the chiaroscuro that so realistically defines the form of the subtly smiling Virgin Mary, were still in Leonardo's pictorial repertory when he created

5–18 LEONARDO DA VINCI. *The Lost Supper* (detail). Refectory, Santa Maria delle Grazie, Milan/Scala/Art Resource, New York.

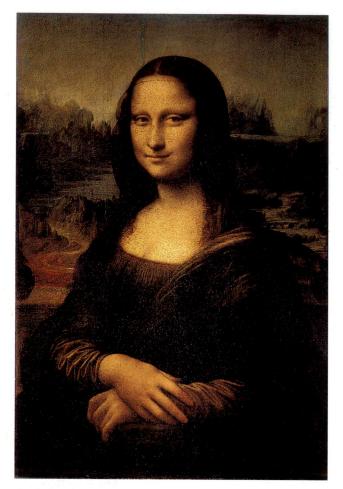

5-19 LEONARDO DA VINCI. Mona Lisa (c. 1503 – 1505).
Oil on wood panel. 30¹/4" × 21". Louvre Museum, Paris/Réunion des Musées Nationaux/Art Resource, New York.

what is arguably the most famous portrait in the history of art—the *Mona Lisa* (Fig. 5-19). An air of mystery pervades the work—from her entrancing smile and intense gaze to her real identity and the location of the landscape behind her. With the *Mona Lisa*, Leonardo altered the nature of portrait painting for centuries, replacing the standard profile view of a sitter to one in which a visual dialogue could be established between the subject and the observer.

Raphael Sanzio

A younger artist who assimilated the lessons offered by Leonardo, especially on the humanistic portrayal of the Madonna, was Raphael Sanzio (1483-1520). As a matter of fact, Michelangelo was not far off base in his accusation that Raphael copied from him, for the younger artist freely adopted whatever suited his purposes. Raphael truly shone in his ability to combine the techniques of other masters with an almost instinctive feel for Classical art. He rendered countless canvases depicting the Madonna and Child along the lines of Leonardo's Madonna of the Rocks. Raphael was also sought after as a muralist. Some of his most impressive Classical compositions, in fact, were executed for the papal apartments in the Vatican. The commission, of course, came from Pope Julius, and to add fuel to Michelangelo's fire, was executed at the same time Michelangelo was at work on the Sistine Chapel ceiling. For the Stanza della Segnatura, the room in which the highest papal tribunal was held, Raphael painted The School of Athens (Fig. 5-20), one of four frescoes designed within a semicircular frame. In what could be a textbook exercise of one-point linear perspective, Raphael crowded a veritable "who's who" of Classical Greece convening beneath a series of barrel-vaulted archways. The figures symbolize philosophy, one of the four subjects deemed most valuable for a pope's education. (The others were law, theology, and poetry.) The members of the gathering are divided into two camps representing opposing philosophies and are led, on the right, by Aristotle and on the left, by his mentor, Plato. Corresponding to these leaders are the Platonists, whose concerns are the more lofty realm of Ideas (notice Plato pointing upward), and the Aristotelians, who are more in touch with matters of the Earth, such as natural science. Some of the figures have been identified: Diogenes, the Cynic philosopher, sprawls out on the steps, and Herakleitos, a founder of Greek metaphysics, sits pensively just left of center. Of more interest is the fact that Raphael included a portrait of himself, staring out toward the viewer, in the far right foreground. He is shown in a group surrounding the geometrician Euclid. Raphael clearly saw himself as important enough to be commemorated in a Vatican mural as an ally of the Aristotelian camp.

As in *The Last Supper* by Leonardo, our attention is drawn to the two main figures by **orthogonals** leading directly to where they are silhouetted against the sky breaking through the archways. The diagonals that lead toward a single horizon point are balanced by strong horizontals and verticals in the architecture and figural groupings, lending a feeling of Classical stability and predictability. Stylistically,

5-20 RAPHAEL.

The School of Athens (1510–1511). Fresco. $26' \times 18'$. Stanza della Segnatura, Vatican, Rome. Copyright Art Resource, New York.

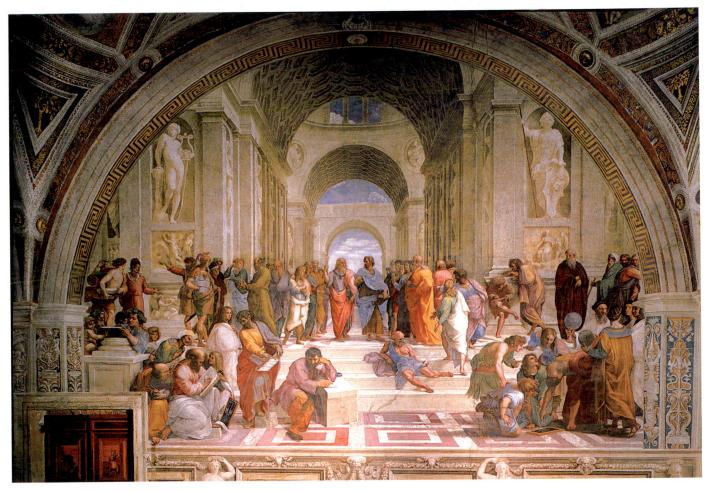

as well as iconographically, Raphael has managed to balance opposites in a perfectly graceful and logical composition.

Michelangelo Buonarroti

Of the three great Renaissance masters, Michelangelo (1475–1564) is probably most familiar to us. During the 1964 World's Fair in New York City, hundreds of thousands of culture seekers and devout pilgrims were trucked along a conveyor belt for a brief glimpse of his *Pietà* at the Vatican Pavilion. A year later, actor Charlton Heston (who seems to bear a striking resemblance to the artist) reprised the tumultuous relationship between artist and patron and the traumatic physical experience surrounding the painting of the Sistine ceiling in the Hollywood film, *The Agony and the* *Ecstasy.* These two works stand as symbols of the breadth and depth of Michelangelo's talents as an artist.

That famed ceiling is the vault of the chapel of Pope Sixtus IV, known as the Sistine Chapel. The ceiling is some 5,800 square feet and is almost 70 feet above the floor. The decorative fresco cycle was commissioned by Pope Julius II, but the iconographic scheme was Michelangelo's. The artist had agreed to the project in order to pacify the temperamental Julius in the hope that the pontiff would eventually allow him to complete work on his mammoth tomb. For whatever reason, we are indeed fortunate to have this painted work from the sculptor's hand. After much anguish and early attempts to populate the vault with a variety of religious figures (eventually more than 300 in all), Michelangelo settled on a division of the ceiling into geometrical "frames" (Figs. 5-21 and 5-22) housing biblical prophets, mythological soothsayers, and Old Testament scenes from Genesis to Noah's flood.

The most famous of these scenes is *The Creation of Adam* (Fig. 5-23). As Leonardo had done in *The Last Supper*, Michelangelo chose to communicate the event's most dramatic moment. Adam lies on the Earth, listless for lack of a soul, while God the Father rushes toward him amidst a host of angels, who enwrap him in a billowing cloak. The contrasting figures lean toward the left, separated by an illuminated diagonal that provides a backdrop for the Creation. Amidst an atmosphere of sheer electricity, the hand of God reaches out to spark spiritual life into Adam—but does not touch him! In some of the most dramatic negative space in the history of art, Michelangelo has left it to the spectator to

5–21 MICHELANGELO. The Sistine Chapel in the Vatican, Rome (1508–1512). 5,800 sq. ft.

Vatican Museum, Rome. Copyright Canali Photobank, Milan. Nippon Television Network Corporation, Tokyo/Superstock/Vatican Museum, Rome. complete the act. In terms of style, Michelangelo integrated chiaroscuro with Botticelli's extensive use of line. His figures are harshly drawn and muscular with almost marble-like flesh. In translating his sculptural techniques to a twodimensional surface, the artist has conceived his figures in the round and has used the tightest, most expeditious line and modeling possible to render them in paint.

It is clear that Michelangelo saw himself more as a sculptor than as a painter. The "sculptural" drawing and modeling in *The Creation of Adam* attest to this. When Michelangelo painted the Sistine Chapel ceiling, he was all

5-22 MICHELANGELO.

The ceiling of the Sistine Chapel in the Vatican, Rome (1508–1512).

5,800 sq. ft.

Vatican Museum, Rome. Copyright Canali Photobank, Milan. Nippon Television Network Corporation, Tokyo/Superstock/Vatican Museum, Rome.

5-23 MICHELANGELO.

The Creation of Adam (1508–1512). Detail from the ceiling of the Sistine Chapel in the Vatican, Rome. Vatican Museum, Rome. Copyright Canali Photobank, Milan. Nippon Television Network Corporation, Tokyo/Superstock/Vatican Museum, Rome.

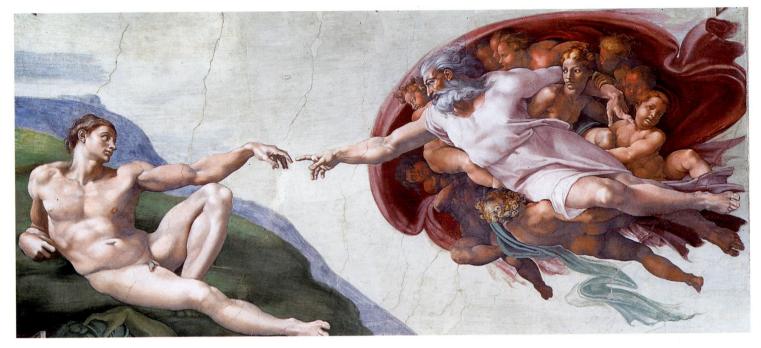

of 33 years old, but he began his career some 20 years earlier as an apprentice to the painter Domenico Ghirlandaio (1449-1494). His reputation as a sculptor, however, was established when, at the age of 27, he carved the 131.2-foothigh David (Fig. 5-26) from a single piece of almost unworkable marble. Unlike the Davids of Donatello and Verrocchio, Michelangelo's hero is not shown after conquering his foe. Rather, David is portrayed as a most beautiful animal preparing to kill-not by savagery and brute force but by intellect and skill. Upon close inspection, the tensed muscles and the furrowed brow negate the first impression that this is a figure at rest. David's sling is cast over his shoulder, and the stone is grasped in the right hand, the veins prominent in anticipation of the fight. Michelangelo's David is part of the Classical tradition of the "ideal youth" who has just reached manhood and is capable of great physical and intellectual feats. Like Donatello's David, Michelangelo's sculpture is closed in form. All of the elements move tightly around a central axis. Michelangelo has been said to have sculpted by first conceptualizing the mass of the work and then carefully extracting all of the marble that was not part of the image. Indeed, in the *David*, it appears that he worked from front to back instead of from all four sides of the marble block, allowing the figure, as it were, to "step out of" the stone. The identification of the figure with the marble block provides a dynamic tension in Michelangelo's work, as the forms try at once to free themselves from and succumb to the binding dimensions.

High and Late Renaissance in Venice

The artists who lived and worked in the city of Venice were the first in Italy to perfect the medium of oil painting that we witnessed with van Eyck in Flanders. Perhaps influenced

The "Davids" of Donatello, Verrocchio, Michelangelo, and Bernini

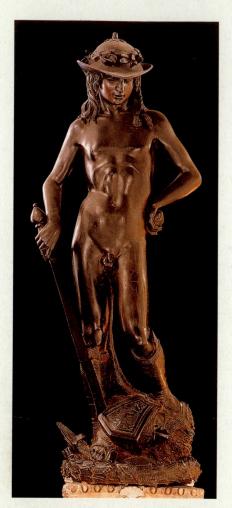

5-24 DONATELLO. David (1408). Bronze. H: 5'2". Museo Nazionale del Bargello, Florence/ Scala/Art Resource, New York.

Sometime soon after the year 1430, a bronze statue of David (Fig. 5-24) stood in the courtyard of the house of the Medici. The work was commissioned of Donatello by Cosimo de' Medici himself, the founding father of the Republic of Florence. It was the first freestanding, life-size nude since Classical antiquity, poised in the same contrapposto stance as the victorious athletes of Greece and Rome. But soft, and somehow oddly unheroic. And the incongruity of the heads: David's boyish, expressionless face, framed by soft tendrils of hair and shaded by a laurel-crowned peasant's hat; Goliath's tragic, contorted expression, made sharper by the pentagonal helmet and coarse, disheveled beard. Innocence and evil. The weak triumphing over the strong. The city of Florence triumphing over the aggressive dukes of Milan? "David" as a civic-public monument.

In the year 1469, Ser Piero from the Tuscan town of Vinci moved to Florence to become a notary. He rented a house on the Piazza San Firenze, not far from the Palazzo Vecchio. His son, who was a mere 17 years old upon their arrival, began an apprenticeship in the Florentine studio of the wellknown artist Andrea Verrocchio. At that time, Verrocchio was at work on a bronze sculpture of the young David (Fig. 5-25). Might the head of this fine piece be a portrait of the young Leonardo da Vinci?

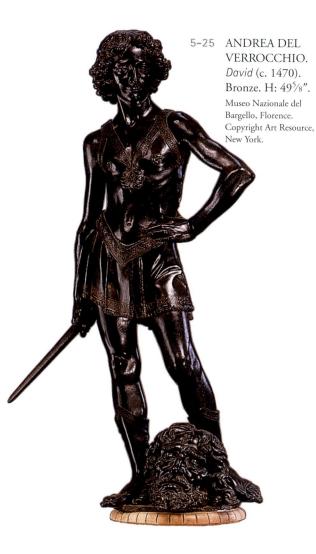

COMPARE + CONTRAST

⁵⁻²⁶ MICHELANGELO. David (1501–1504). Marble. H: 13¹/2'. Galleria dell'Accademia, Florence/Scala/Art Resource, New York.

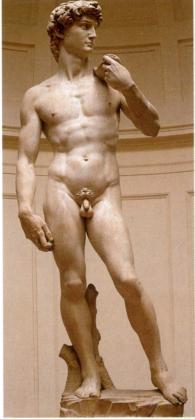

For many years a block of marble lay untouched, tossed aside as unusable, irretrievable evidence of a botched attempt to carve a human form. It was 18 feet high. A 26-year-old sculptor, riding high after the enormous success of his figure of the Virgin Mary holding the dead Christ, decided to ask for the piece. The wardens of the city in charge of such things let the artist have it. What did they have to lose? Getting anything out of it was better than nothing. So this young sculptor named Michelangelo measured and calculated. He made a wax model of David with a sling in his hand. And he worked on his David (Fig. 5-26) continuously for some three years until, a man named Vasari tells us, he brought it to perfect completion. Without letting anyone see it.

A century later, a 25-year-old sculptor stares into a mirror at his steeled jaw and determined brow. A contemporary source tells us that on this day, perhaps, the mirror is being held by Cardinal Maffeo Barberini while Bernini transfers what he sees in himself to the face of his David (Fig. 5- 27). Gianlorenzo Bernini: sculptor and architect, painter, dramatist, composer. Bernini, who centuries later would be called the undisputed monarch of the Roman High Baroque, identifying with David, whose adversary is seen only by him.

The great transformation in style that occurred between the Early Renaissance and the Baroque can be followed in the evolution of David. Look at them: A boy of 12, perhaps, looking down incredulously at the physical self that felled an unconquerable enemy; a boy of 14 or 15, confident and reckless, with enough adrenaline pumping to take on an army; an adolescent on the brink of adulthood, captured at that moment when, the Greeks say, sound mind and sound body are one; and another full-grown youth at the threshold of his destiny as king.

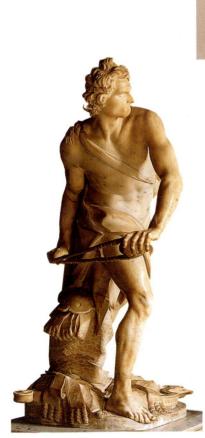

5-27 GIANLORENZO BERNINI. David (1623). Marble. H: 6'7".
Borghese Gallery, Rome/Scala/Art Resource, New York. [Titian] made the promise of a figure appear in four brushstrokes. [Then] he used to turn his pictures to the wall and leave them there without looking at them, sometimes for several months. When he wanted to apply his brush again, he would examine them . . . to see if he could find any faults. . . . In this way, working on the figures and revising them, he brought them to the most perfect symmetry that the beauty of art and nature can reveal.
[So] he gradually covered those essential forms with living flesh, bringing them . . . to a state in which they lacked only the breath of life.

-Palma il Giovane, contemporary of Titian

by the mosaics in St. Mark's Cathedral, perhaps intrigued by the dazzling colors of imports from Eastern countries into this maritime province, the Venetian artists sought the same clarity of hue and lushness of surface in their oil-on-canvas works. In the sixteenth century, Venice would come to figure as prominently in the arts as Florence had in the fifteenth.

Titian

Although he died in 1576, almost a quarter century before the birth of the Baroque era, the Venetian master Tiziano Vecellio (b. 1477)—called Titian—had more in common with the artists who would follow him than with his Renaissance contemporaries in Florence and Rome. Titian's picto-

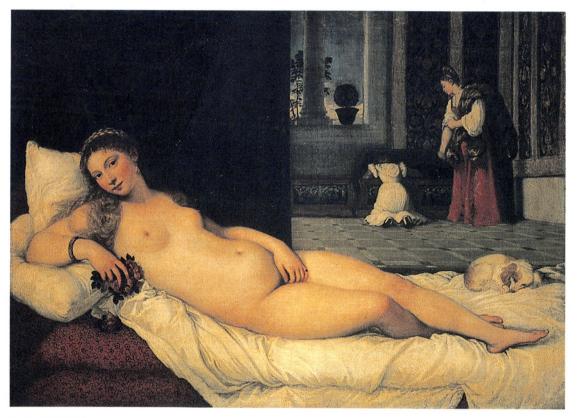

5–28 TITIAN. Venus of Urbino (1538). Oil on canvas. $47'' \times 65''$. Uffizi Gallery, Florence/Scala/Art Resource, New York. rial method differed from those of Leonardo, Raphael, and Michelangelo in that he was foremost a painter and colorist rather than a draftsman or sculptural artist. He constructed his compositions by means of colors and strokes of paint and layers of varnish rather than by line and chiaroscuro. A shift from painting on wood panels to painting on canvas occurred at this time, and with it a change from tempera to oil paint as the preferred medium. The versatility and lushness of oil painting served Titian well, with its vibrant, intense hues and its more subtle, semitransparent glazes.

Titian's Venus of Urbino (Fig. 5-28) is one of the most beautiful examples of the glazing technique. The composition was painted for the duke of Urbino, from which its title derives. Titian adopted the figure of the reclining Venus from his teacher Giorgione, and it has served as a model for many compositions since that time. In the foreground, a nude Venus pudica rests on voluptuous pillows and sumptuous sheets spread over a red brocade couch. Her golden hair, complemented by the delicate flowers she grasps loosely in her right hand, falls gently over her shoulder. A partial drape hangs in the middle ground, providing a backdrop for her upper torso and revealing a view of her boudoir. The background of the composition includes two women looking into a trunk-presumably handmaidensand a more distant view of a sunset through a columned veranda. Rich, soft tapestries contrast with the harsh Classicism of the stone columns and inlaid marble floor. Titian appears to have been interested in the interaction of colors and the contrast of textures. The creamy white sheet complements the radiant golden tones of the body of Venus, built up through countless applications of glazes over fleshtoned pigment. Her sumptuous roundness is created by extremely subtle gradations of tones in these glazes rather than the harshly sculptural chiaroscuro that Leonardo or Raphael might have used. The forms evolve from applications of color instead of line or shadow. Titian's virtuoso brushwork allows him to define different textures: the firm yet silken flesh, the delicate folds of drapery, the servant's heavy cloth dress, the dog's soft fur. The pictorial dominance of these colors and textures sets the work apart from so many examples of Florentine and Roman painting. It appeals primarily to the senses rather than to the intellect.

Titian's use of color as a compositional device is significant. We have already noted the drape, whose dark color forces our attention on the most important part of the composition—Venus's face and upper torso. It also blocks out the left background, encouraging viewers to narrow their focus on the vista in the right background. The forceful diagonal formed by the looming body of Venus is balanced by three elements opposite her: the little dog at her feet and the two handmaidens in the distance. They do not detract from her because they are engaged in activities that do not concern her or the spectator. The diagonal of her body is also balanced by an intersecting diagonal that can be visualized by integrating the red areas in the lower left and upper right corners. Titian thus subtly balances the composition in his placement of objects and color areas.

Tintoretto

Perhaps no other Venetian artist anticipated the Baroque style so strongly as Jacopo Robusti, called Tintoretto, or "little dyer," after the profession of his father. Supposedly a pupil of Titian, Tintoretto (1518–1594) emulated the master's love of color, although he combined it with a more linear approach to constructing forms. This interest in draftsmanship was culled from Michelangelo, but the younger artist's compositional devices went far beyond those of the Florentine and Venetian masters. His dynamic structure and passionate application of pigment provide a sweeping, almost frantic, energy within compositions of huge dimensions.

Tintoretto's painting technique was indeed unique. He arranged doll-like figures on small stages and hung his flying figures by wires in order to copy them in correct perspective on sheets of paper. He then used a grid to transcribe the figures onto much larger canvases.

Tintoretto primed the entire canvas with dark colors. Then he quickly painted in the lighter sections. Thus, many of his paintings appear very dark, except for bright patches of radiant light. The artist painted extremely quickly, using broad areas of loosely swathed paint. John Ruskin, a nineteenth-century art critic, is said to have suggested that Tintoretto painted with a broom.⁶ Although this is unlikely, Tintoretto had certainly come a long way from the sculptural, at times marble-like, figures of the High Renaissance and the painstaking finish of Titian's glazed *Venus of Urbino*. This loose brushwork and dramatic white spotlighting on a dark ground anticipate the Baroque style.

⁶Frederick Hartt, *History of Italian Renaissance Art*, 2nd ed. (Englewood Cliffs, NJ: Prentice-Hall; New York: Harry N. Abrams, 1979), 615.

5-29 TINTORETTO.

The Last Supper (1592–1594).

Oil on canvas. $12' \times 18'8''$.

San Giorgio Maggiore, Venice/Cameraphoto/Art Resource, New York.

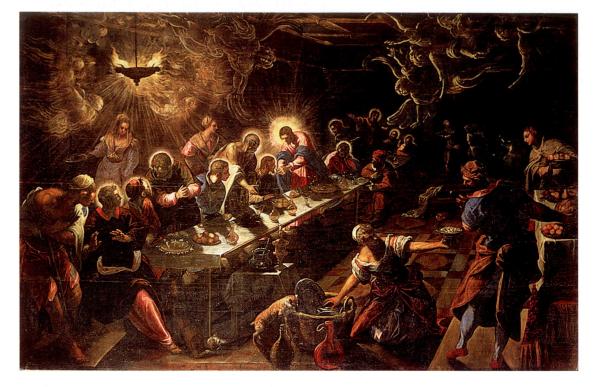

The Last Supper (Fig. 5-29) seals his relationship to the later period. A comparison of this composition with Leonardo's *The Last Supper* (Fig. 5-17) will illustrate the dramatic changes that had taken place in both art and the concept of art over almost a century. The interests in motion, space, and time; the dramatic use of light; and the theatrical presentation of subject matter are all present in Tintoretto's *The Last Supper*. We are first impressed by the movement. Everything and everyone are set into motion: people lean, rise up out of their seats, stretch, and walk. Angels fly and animals dig for food. The space, sliced by a sharp, rushing diagonal that goes from lower left toward upper right, seems barely able to contain all of this commotion; but this "cluttered" effect enhances the energy of the event.

Leonardo's obsession with symmetry, along with his balance between emotion and restraint, yields a composition that appears static in comparison to the asymmetry and overpowering emotion in Tintoretto's canvas. Leonardo's apostles seem posed for the occasion when contrasted with Tintoretto's spontaneously gesturing figures. A particular moment is captured. We feel that if we were to look away for a fraction of a second, the figures would have changed position by the time we looked back! The timelessness of Leonardo's figural poses has given way to a seemingly temporary placement of characters. The moment that Tintoretto has chosen to depict also differs from Leonardo's. The Renaissance master chose the point at which Jesus announced that one of his apostles would betray him. Tintoretto, on the other hand, chose the moment when Jesus shared bread, which symbolized his body as the wine stood for his blood. This moment is commemorated to this day during the celebration of Mass in the Roman Catholic faith. Leonardo chose a moment signifying death, Tintoretto a moment signifying life, depicted within an atmosphere that is teeming with life.

HIGH AND LATE RENAISSANCE OUTSIDE ITALY

El Greco

The Late Renaissance outside Italy brought us many different styles, and Spain is no exception. Spanish art polarized into two stylistic groups of religious painting: the mystical and the realistic. One painter was able to pull these opposing trends together in a unique pictorial method. El Greco (1541–1614), born Domeniko Theotokopoulos in Crete, integrated many styles in his work. As a young man he traveled to Italy, where he encountered the works of the Florentine and Roman masters, and he was for a time affiliated with Titian's workshop. The colors that El Greco incorporated in his paintings suggest a Venetian influence, and the distortion of his figures and use of an ambiguous space speak for his interest in Mannerism, which is discussed later.

These pictorial elements can clearly be seen in one of El Greco's most famous works, The Burial of Count Orgaz (Fig. 5-30). In this single work, El Greco combines mysticism and realism. The canvas is divided into two halves by a horizontal line of white-collared heads, separating "heaven" and "earth." The figures in the lower half of the composition are somewhat elongated, but well within the bounds of realism. The heavenly figures, by contrast, are extremely attenuated and seem to move under the influence of a sweeping, dynamic atmosphere. It has been suggested that the distorted figures in El Greco's paintings might have been the result of astigmatism in the artist's eyes, but there is no convincing proof of this. For example, at times El Greco's figures appear no more distorted than those of other Mannerists. Heaven and earth are disconnected psychologically but joined convincingly in terms of composition. At the center of the rigid, horizontal row of heads that separates the two worlds, a man's upward glance creates a path for the viewer into the upper realm. This compositional device is complemented by a sweeping drape that riscs into the upper half of the canvas from above his head, continuing to lead the eye between the two groups of figures, left and right, up toward the image of the resurrected Christ. El Greco's color scheme also complements the worldly and celestial habitats. The colors used in the costumes of the earthly figures are realistic and vibrantly Venetian, but the colors of the upper half of the composition are of discordant hues, highlighting the otherworldly nature of the upper canvas. The emotion is high-pitched and exaggerated by the tumultuous

- 5-30 EL GRECO.
 - The Burial of Count Orgaz (1586). Oil on canvas. $16' \times 11'10''$. Santo Tome, Toledo, Spain. Copyright Edimedia/Corbis.

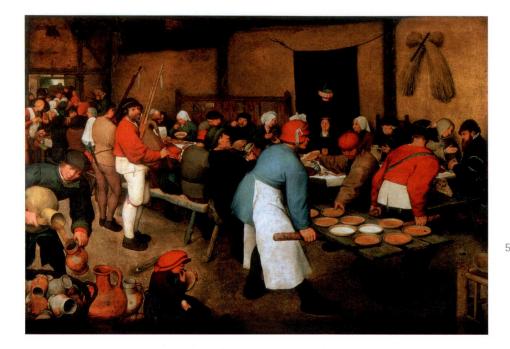

5-31 PIETER BRUEGHEL THE ELDER. The Peasant Wedding (1568). Oil on wood. 45" × 64¹/₂". Kunsthistorisches Museum, Vienna, Austria. Copyright Art Resource, New York.

atmosphere. This emphasis on emotionalism links El Greco to the onset of the Baroque era. His work contains a dramatic, theatrical flair, one of the hallmarks of the seventeenth century.

Pieter Bruegel the Elder

During the second half of the sixteenth century in the Netherlands, changes in the subject matter of painting were taking place that would affect the themes of artists working in northern Europe during the Baroque period. Scenes of everyday life involving ordinary people were becoming more popular. One of the masters of this genre painting was Pieter Bruegel the Elder (c. 1520-1569), whose compositions focused on human beings in relation to nature and the life and times of plain Netherlandish folk. The Peasant Wedding (Fig. 5-31) is a good example of Bruegel's "slice-of-life" canvases. The painting transports us to a boisterous hall, where food and drink flow in abundance and music and merriment raise the rafters. The viewer's experience of this event relies on the degree to which the artist conveys the sense of noise, of laughter, of celebration. The circular rims of soup bowls are echoed in the spherical caps of the peasants and the mouths of the stacked, earthenware pitchers. In a sea of confusion, this simple repetitive element provides visual unity and guides the path of the eye. There is no hidden message here, no religious fervor, no battle between mythological giants. Human activities are presented as sincere and viable subject matter. There are few examples of such painting before this time, but genre painting will play a

principal role in the works of Netherlandish artists during the Baroque period.

MANNERISM

During the Renaissance, the rule of the day was to observe and emulate nature. Toward the end of the Renaissance and before the beginning of the seventeenth century, this rule was suspended for a while, during a period of art that historians have named Mannerism. Mannerist artists abandoned copying directly from nature and copied art instead. Works thus became "secondhand" views of nature. Line, volume, and color no longer duplicated what the eye saw but were derived instead from what other artists had already seen. Several characteristics separate **Mannerist art** from the art of the Renaissance and the Baroque periods: distortion and elongation of figures; flattened, almost two-dimensional space; lack of a defined focal point; and the use of discordant pastel hues.

Jacopo Pontormo

A representative of early Mannerism, Jacopo Pontormo (1494–1557) used most of its stylistic principles. In *Entombment* (Fig. 5-32), we witness a strong shift in direction from High Renaissance art, even though the painting was executed during Michelangelo's lifetime. The weighty sculptural figures of Michelangelo, Leonardo, and Raphael have given way to less substantial, almost weightless, forms that

balance on thin toes and ankles. The limbs are long and slender in proportion to the torsos, and the heads are dwarfed by billowing robes. There is a certain innocent beauty in the arched eyebrows of the haunted faces and in the nervous glances that dart this way and that past the boundaries of the canvas. The figures are pressed against the picture plane, moving within a very limited space. Their weight seems to be thrust outward toward the edges of the composition and away from the almost void center. The figures' robes are composed of odd hues, departing drastically in their soft pastel tones from the vibrant primary colors of the Renaissance masters. The weightlessness, distortion, and ambiguity of space create an almost otherworldly feeling in the composition, a world in which objects and people do not come under an earthly gravitational force. The artist accepts this "strangeness" and makes no apologies for it to the viewer. The ambiguities are taken in stride. For example, note that the character in a turban behind the head of the dead Jesus does not appear to have a body-there is really no room for it in the composition. And even though a squatting figure in the center foreground appears to be balancing Christ's torso on his shoulders after having taken him down from the cross a moment before, there is no cross in sight! Pontormo seems to have been most interested in elegantly rendering the high-pitched emotion of the scene. Iconographic details and logical figural stances are irrelevant.

The artists from the second half of the sixteenth century through the beginning of the seventeenth century all broke away from the Renaissance tradition in one way or another. Some were opposed to the stylistic characteristics of the Renaissance and turned them around in an original but ultimately uninfluential style called Mannerism. Others, such as Titian and Tintoretto, emphasized the painting *process*, constructing their compositions by means of stroke and color rather than line and shadow. Still others combined an implied movement and sense of time in their compositions, foreshadowing some of the concerns of the artist in the Baroque period. The High and Late Renaissance witnessed artists of intense originality who provide a fascinating transition between the grand Renaissance and the dynamic Baroque.

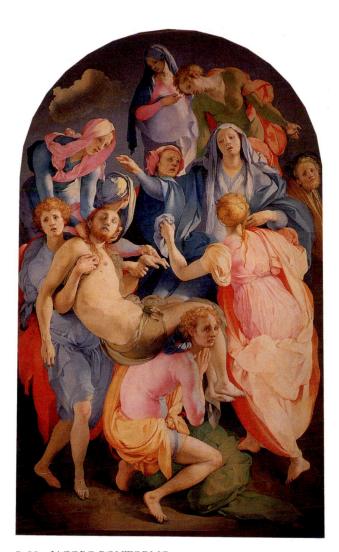

5-32 JACOPO PONTORMO. Entombment (1525−1528). Oil on panel. 10'3" × 6'4". Capponi Chapel, Santa Felicità, Florence/ Scala/Art Resource, New York.

ART TOUR *Florence*

Leaf through the pages of the chapter on Renaissance Art and survey the figure captions accompanying the illustrations of Italian Renaissance art and architecture. Surprised at how many are in Florence? The fact is, Florence commanded Europe in the fourteenth and fifteenth centuries—in the worlds of finance, patronage, arts, and culture. Dante Alighieri (author of *The Divine Comedy*); Michelangelo Buonarroti (sculptor of the *David*, painter of the *Sistine Chapel*, architect of *St. Peter's Basilica*); Niccolo Machiavelli (political philosopher, advisor, and author of *The Prince*); Galileo Galilei (astronomer and mathematician, author of the heliocentric theory of the universe)—all were born in or lived in the city of Florence at this pivotal moment in history.

Florence began during Roman times when Julius Caesar passed a law providing land there for retired war veterans. The walls around the city were extended and fortified against the invasions of the Ostrogoths during the Byzantine era, but the territory was lost to the Lombards, along with all of Tuscany, by 570 CE. It was Charlemagne who "rescued" Florence from the "barbarians," incorporating the city into the Holy Roman Empire. From that point forward, it was ruled by princes and ... the Medicis.

By far the dominant name associated with Renaissance Florence is Medici—a family renowned for their politics and patronage. Evidence of their money and taste seems ubiquitous in Florence, as every building they owned or were somehow connected to bears their coat of arms (a shield with round balls—pills—that signify the family's trade as apothecaries). Works of art and architecture that were commissioned by the Medici comprise the core of Florence's artistic legacy, bequeathed to the city by the last in the Medici family line—Anna Maria Luisa. The Galleria degli Uffizi is home to a large number of works from the Medici art collection, and the art institution that is a "don't miss" for any traveler to Florence. (Make that every traveler to Florence.) Arrive early in the morning or a couple of hours before closing to avoid the outrageous lines,

GALLERIA DEGLI UFFIZI WITH PALAZZO VECCHIO IN THE BACKGROUND Hubert Stadler/Corbis.

PIAZZA DELLA SIGNORIA WITH THE PALAZZO VECCHIO Dennis Degnan/Corbis.

and start with this extraordinary monument to get a feel of the historic significance of the city. It stands on one side of a public square—the Piazza della Signoria—which was the political center of Florence and site of things glorious and inglorious (Michelangelo's *David* once stood there; Savonarola, the would-be reformer-monk, was burned at the stake there). The piazza is also the site of the Palazzo Vecchio, which has served as Florence's Town Hall since the fourteenth century and has a spectacular interior. While you are in the square, check out Florence's best source for postcards—the Sorbi newspaper kiosk—and sample what many rank as the best gelato (Italian ice cream) place in Florence—Perché No! ("Why not!").

FLORENTINE GELATO Alantide Photo Travel/Corbis.

Florence is an extremely walkable city, with an expansive pedestrian-only area that encompasses many of its highlights, including the Piazza della Signoria, the Duomo, the Ponte Vecchio, and Santa Croce.

If there is one symbol of Florence (like the Eiffel Tower in Paris or Big Ben in London), it is the Duomo. Literally the Italian word for "dome," the Duomo is the affectionate name for the cathedral of Santa Maria del Fiori. Looking at the skyline of the city, it is easy to understand its status as an icon. The dome, covered with reddish terracotta tiles and accented with eight white ribs, dominates its surroundings. It was constructed by Filippo Brunelleschi after he won a competition for the commission. Lorenzo Ghiberti, whose bronze reliefs for the doors of the nearby Baptistery are among Florence's greatest treasures, lost. Many tourists climb the 463 steps of the dome to the lantern on top to get an unsurpassed view of the city and surrounding hills. My advice is this: if you want to climb, go up

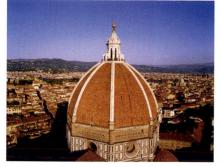

THE DUOMO AND CITY OF FLORENCE AS SEEN FROM THE CAMPANILE Free Agents Limited/ Corbis.

into the cathedral's bell tower (the Campanile) instead. Not only do you get a great view of Florence, but the best view of the dome to boot. And it's a mere 414 steps to the top. The cathedral, Baptistery, and bell tower are all faced with polychrome marble—white from Carrara, green from Prato, and pink from the Maremma area of southern Tuscany. The combination of light and dark marbles, in particular, characterize many of Florence's buildings—including the churches of Santa Maria Novella and Santa Croce.

Santa Croce lies to the east of the Piazza della Signoria and is the burial place of Florence's famous—including Michelangelo, Machiavelli, Galileo, and the composer Gioacchino Rossini (*The Barber of Seville*). There is also a memorial to Dante, although he isn't buried there. Santa Croce is filled with important frescoes by artists like Taddeo Gaddi and Giotto and a relief sculpture by Donatello. While there, look for the tide mark on the pillars and walls—evidence of a devastating flood that gripped the city in 1966.

While many of the art and architectural treasures of Florence were imperiled by the flood, the Old Bridge, or Ponte Vecchio, somehow survived the onslaught of water and silt when the river Arno rose over its banks. It was not the first time that floodwaters threatened the bridge; it had to be rebuilt in the fourteenth century after a flood. The Ponte Vecchio has a long history. At one time it was the only bridge across the river, and it was the only bridge that the Germans did not destroy during World War II. The Ponte Vecchio looks a bit odd, with shops lining both sides of a walkway across the bridge and a corridor on top of the buildings on one side. The Medici family built the corridor so they could walk across the bridge and not have to run into any real people. The bridge was always-dating back to the thirteenth century, at least—a place to shop, and since 1593, exclusive home to goldsmiths and jewelers. You can purchase Florentine gold on the Ponte Vecchio, although the prices can be significantly higher than in other shops around town. In addition to its gold (usually sold by weight), Florence is known for its leather goods, linens, ceramics, and marble-paper. You'll also find no shortage of plastic Davids and Duomos.

These highlights are clustered in the pedestrian area in the core of the city, but Florence has innumerable other sites within walking distance from one another. The Palazzos Pitti and Medici-Riccardi (Renaissance palaces that were at one time or another occupied by the Medici family); San Lorenzo (parish church and burial place of the Medici, and homage to their patronage of the arts); The Bargello (where all of the glorious sculpture is kept); the Galleria dell'Accademia (where Michelangelo's *David* now resides, along with the *Slaves* that the artist carved for the original design of the tomb of Pope Julius II); and the Boboli Gardens (an inner-city oasis of green behind the Palazzo Pitti to which travelers escape when they've had enough).

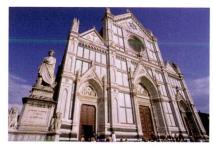

CHURCH OF SANTA CROCE Tibor Bognar/Corbis.

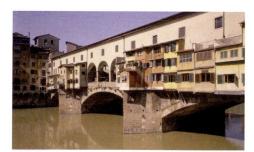

THE PONTE VECCHIO Alinari Archives/Corbis.

The Renaissance in Italy was a tale of two cities: Florence and Rome. The fourteenth and fifteenth centuries belonged to Florence. No other city in Europe had her impact on art and

culture. During the High Renaissance, as the money moved, so did the artists to papal Rome. At 15 million visitors per year, though, the city of Florence has never lost its premier place in the history of art.

BOBOLI GARDENS Massimo Listri/Corbis.

To continue your tour and learn more about Florence, go to our Premium Companion website.

THE AGE OF BAROQUE

Nature, and Nature's laws lay hid in night. God said: "Let Newton be!" and all was Light!

-Alexander Pope

The Baroque period spans roughly the years from 1600 to 1750. Like the Renaissance, which preceded it, the Baroque period was an age of genius in many fields of endeavor. Sir Isaac Newton derived laws of motion and of gravity that have only recently been modified by the discoveries of Einstein. The achievements of Galileo and Kepler in astronomy brought the vast expanses of outer space into sharper focus. The Pilgrims also showed an interest in motion when, in 1620, they put to sea and landed in what is now Massachusetts. Our founders had a certain concern for space as well—they wanted as much as possible between themselves and their English oppressors.

The Baroque period in Europe included a number of post-Renaissance styles that do not have all that much in common. On the one hand, there was a continuation of the Classicism and naturalism of the Renaissance. On the other, a far more colorful, ornate, painterly, and dynamic style was born. If one name had to be applied to describe these different directions, it is just as well that that name is **Baroque**—for the word is believed to derive from the Portuguese *barroco*, meaning "irregularly shaped pearl." The Baroque period was indeed irregular in its stylistic tendencies, and it also gave birth to some of the most treasured pearls of Western art.

Motion and *space* were major concerns of the Baroque artists, as they were of the scientists of the period. The concept of *time*, a dramatic use of *light*, and a passionate *theatricality* complete the list of the five most important characteristics of Baroque art, as we shall see throughout this chapter.

THE BAROQUE PERIOD IN ITALY

The Baroque era was born in Rome, some say in reaction to the spread of Protestantism resulting from the **Reformation**.

Even though many areas of Europe were affected by the new post-Renaissance spirit (Map 6-1), it was more alive and well and influential in Italy than elsewhere—partly because of the strengthening of the papacy in religion, politics, and patronage of the arts. During the Renaissance, the principal patron of the arts was the infamous Pope Julius II. However, during the Baroque era, a series of powerful popes—Paul V, Urban VIII, Innocent X, and Alexander VII—assumed this role. The Baroque period has been called the Age of Expansion, following the Renaissance Age of Discovery, and this expansion is felt keenly in the arts.

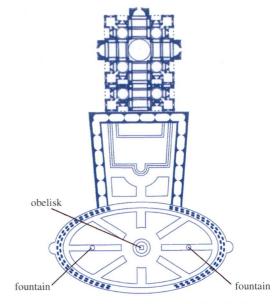

6-1 Plan of St. Peter's Cathedral, Rome (1605-1613).

St. Peter's

The expansion and renovation of St. Peter's Cathedral in Rome (Fig. 6-1) is an excellent project with which to begin our discussion of the Baroque in Italy, for three reasons: The building expresses the ideals of the Renaissance, stands as a hallmark of the Baroque style, and brings together work by the finest artists of both periods—Michelangelo and Bernini.

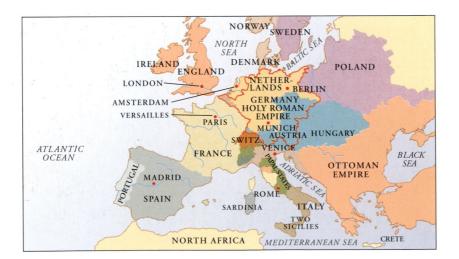

Map 6-1 Europe (mid-18th century).

The major change in the structure of St. Peter's was from the central Greek cross plans of Bramante and Michelangelo to a longitudinal Latin cross plan. Thus, three bays were added to the nave between the domed crossing and the facade. The architect Carlo Maderno was responsible for this task as well as the design for the new facade, but the job of completing the project fell into the hands of the most significant sculptor of the day, Gianlorenzo Bernini.

Gianlorenzo Bernini

Gianlorenzo Bernini (1598–1680) made an extensive contribution to St. Peter's as we see it today, both to the exterior and the interior. In his design for the **piazza** of St. Peter's, visible in the aerial view (Fig. 6-2), Bernini had constructed two expansive arcades extending from the facade of the church and culminating in semicircular "arms" enclosing an oval space. This space, the piazza, was divided into trapezoidal "pie sections," in the center of which rises an Egyptian obelisk. The Classical arcades, true in details to the arts that inspired them, stretch outward into the surrounding city, as if to welcome worshipers and cradle them in spiritual comfort. The curving arms, or arcades, are composed of two double rows of columns with a path between, ending in Classical pedimented "temple fronts." In the interior of the cathedral, beneath Michelangelo's great dome, Bernini designed a bronze canopy to cover the main altar. In the apse, Bernini combined architecture, sculpture, and stained glass

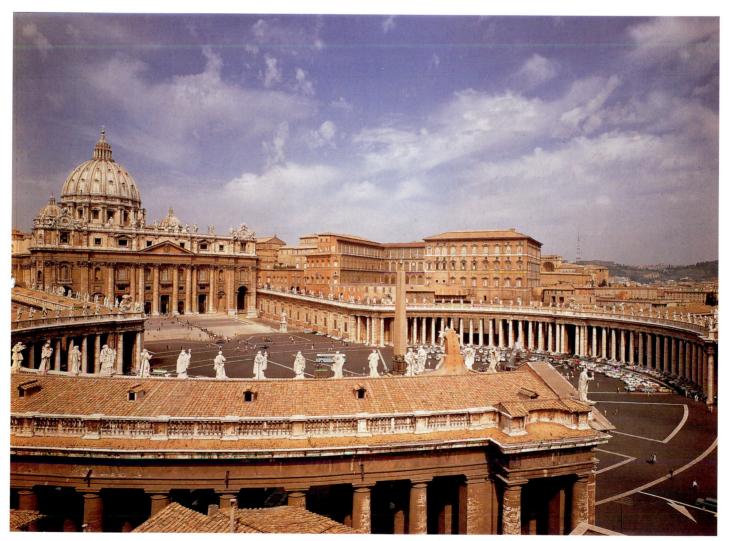

6-2 GIANLORENZO BERNINI. Piazza of St. Peter's (St. Peter's Square, Vatican State). Copyright Art Resource, New York.

Art Meets History: The Funeral of a Pope

Karol Wojtyla died in his Vatican apartment on April 2, 2005. He was 84 years old and reigned over the Catholic Church as Pope John Paul II for 26 years—the second longest papacy in history. His death set into motion a series of rituals that had been fixed for centuries, from the destruction of his papal ring to the sequestering of the cardinals who would, in secrecy, elect his successor. The world bore witness to many if not most of these traditions as they unfolded before dignitaries, pilgrims, and the international media. And as an art appreciation and art history professor, I told all of my students, "Watch as much as you can." History was being made against the backdrop of the very art and architecture that they were studying—what *you* are studying in your Renaissance and Baroque chapters. For the most part, in our classes, we look at art outside its actual context, analyzing projected images that have the same dimensions regardless of the actual size of the actual art. We view photographs of works of architecture vast in scale with no sense whatsoever of what it might be like to *be* in those spaces. Regardless of one's religious beliefs, regardless of one's views on the teachings and actions of this particular pope, this meeting of history and art provided an opportunity to see—in context and on-site and in scale—some of the most spectacular treasures of Rome and the Vatican.

This brief portfolio of images was chosen to illustrate things that a student would not ordinarily see, even on a trip to Rome. We may study the design of Bernini's colonnades, extending from Maderno's facade and scooping around his elliptical piazza (Fig. 6-3). But how much better did we grasp Bernini's concept of the arms of the church extending to embrace its fold when we saw throngs of pilgrims cradled in that space as they paid final respects to their beloved pope? The elaborate frescoes of the Clementine Hall (Fig. 6-4) became for us more than disembodied slides. What's more, they are works rarely if ever seen by the public, for the hall—part of the Papal Palace near St. Peter's Basilica—is used only by the pope for formal ceremonies and private receptions . . . and for the private viewing of his body in death before it is moved to St. Peter's.

And how to comprehend the vastness of the interior of St. Peter's Basilica itself? As we viewed the tens upon tens of thousands of diminutive mourners solemnly filing past the funeral

 GIANLORENZO BERNINI.
 Piazza of St. Peter's Cathedral, Rome (1605–1613).
 Bernini's piazza and colonnades of

> St. Peter's with crowds assembling for funeral Mass for Pope John Paul II, April 8, 2005. Maderno's facade and Michelangelo's dome can also be seen. © Peter Turnley/Corbis.

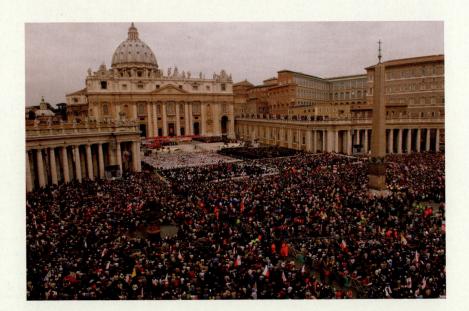

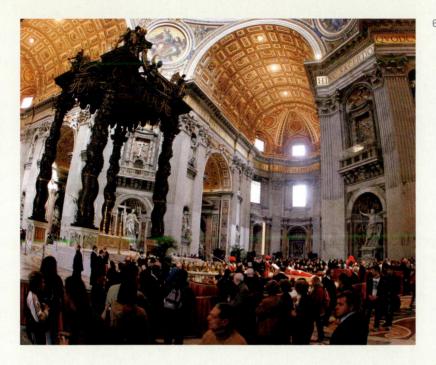

bier at the foot of Bernini's colossal bronze canopy; as we looked upward to Michelangelo's expansive, enveloping dome and around the altar at the towering sculptures of saints standing watch (Fig. 6-5); as we took in the sweep of the seemingly endless nave—only then did we grasp the relationship between the magnitude of the event and the monumentality of the setting.

And as the reign of John Paul II ended and the election of his successor proceeded, the world's attention shifted to one of the Vatican's most beloved landmarks—the Sistine Chapel (see Fig. 5-21). The vastness of St. Peter's was supplanted by the intimacy of the Sistine. It was there that the College of Cardinals spent hours in prayer and reflection as they elected the next pope through a series of secret ballots. Isolated from the outside world and surrounded by Michelangelo's scenes from the Bible and his terrifying Last Judgment, it was within the walls of one of art history's most treasured monuments that these men themselves judged who would be the next among them to make history (Fig. 6-6). 6-4 St. Peter's Basilica, Rome.
Pope John Paul II lying in state at the foot of Bernini's bronze canopy (left) in the transept of St. Peter's Basilica, April 6, 2005. Bernini's *St. Longinus* can be seen in niche at right.
Claudio Peri/EPA/Landoy.

6-5 Clementine Hall, Papal Palace, Rome. Pope Benedict XVI speaks during an audience with the cardinals in the Clementine Hall in the Vatican, April 22, 2005. Osseratore Romano/EPA/Landov.

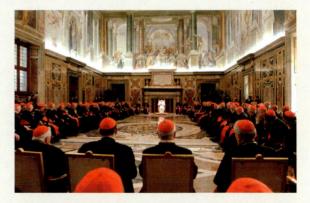

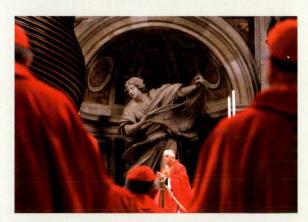

6-6 Cardinal Joseph Ratzinger leading Mass in the transept of St. Peter's Basilica. Mass held April 18, 2005, before cardinals sequestered

themselves for their conclave. In the background is Francesco Mochi's sculpture *Saint Veronica* (1629). Photo by Pier Paolo Cito/Associated Press.

GIANLORENZO BERNINI. *The Ecstasy of St. Theresa* (1645–1652). Marble. Height of group: approx. 11'6". Cornaro Chapel, Santa Maria della Vittoria, Rome. Copyright Canali Photobank, Milan.

in a brilliantly golden display for the Cathedra Petri, or Throne of St. Peter. Through his many other sculptural contributions to St. Peter's, commissioned by various popes, Bernini's reputation as a master is solidified.

Bernini's *David* (see Fig. 5-27) testifies to the artist's genius and illustrates the dazzling characteristics of Baroque sculpture. This David is remarkably different from those of Donatello, Verrocchio, and Michelangelo. Three of the five characteristics of Baroque art are present in Bernini's sculpture: motion (in this case, implied), a different way of looking at space, and the introduction of the concept of time. The Davids by Donatello and Verrocchio were figures at rest after having slain their Goliaths. Michelangelo, by contrast, presented David before the encounter, with the tension and emotion evident in every vein and muscle, bound to the block of marble that had surrounded the figure. Bernini does not offer David before or after the fight, but instead in the process of the fight. He has introduced an element of time in his work. As in The Last Supper by Tintoretto (see Fig. 5-29), we sense that David would have used his weapon if we were to look away and then back. We, the viewers, are forced to complete the action that David has begun for us.

A new concept of space comes into play with David's positioning. The figure no longer remains still in a Classical contrapposto stance but rather extends *into* the surrounding space away from a vertical axis. This movement outward from a central core forces the viewer to take into account both solids and voids—that is, both the form and the spaces between and surrounding the forms—in order to appreciate the complete composition. We must move around the work in order to understand it fully, and as we move, the views of the work change radically.

We may compare the difference between Michelangelo's *David* and Bernini's *David* to the difference between Classical

and Hellenistic Greek sculpture. The movement out of Classical art into Hellenistic art was marked by an extension of the figure into the surrounding space, a sense of implied movement, and a large degree of theatricality. The timehonored balance between emotion and restraint coveted by the Classical Greek artist as well as the Renaissance master had given way in the Hellenistic and Baroque periods to unleashed passion.

Uncontrollable passion and theatrical drama might best describe Bernini's *The Ecstasy of St. Theresa* (Fig. 6-7), a sculptural group executed for the chapel of the Cornaro family in the church of Santa Maria della Vittoria in Rome. The sculpture commemorates a mystical event involving

It's pure mockery of realism. It's a lie. It's a stage setting. The same as . . . in films. Put me a spotlight to the right and another on the left.

-Pablo Picasso, when asked whether Caravaggio was a realist

St. Theresa, a Carmelite nun who believed that a pain in her side was caused by an angel of God stabbing her repeatedly with a fire-tipped arrow. Her response combined pain and pleasure, as conveyed by the sculpture's submissive swoon and impassioned facial expression. Bernini summoned all of his sculptural powers to execute these figures and combined the arts of architecture, sculpture, and painting to achieve his desired theatrical effect. Notice the way in which Bernini described vastly different textures with his sculptural tools: the roughly textured clouds, the heavy folds of St. Theresa's woolen garment, the diaphanous "wet-look" drapery of the angel. "Divine" rays of glimmering bronzeilluminated by a hidden window-shower down on the figures, as if emanating from the painted ceiling of the chapel. Bernini enhanced this self-conscious theatrical effect by including marble sculptures in the likenesses of members of the Cornaro family in theater boxes to the left and right. They observe, gesture, and discuss the scene animatedly as would theatergoers. The fine line between the rational and the spiritual that so interested the Baroque artist was presented by Bernini in a tactile yet illusionary masterpiece of sculpture.

Caravaggio

This theatrical drama and passion had its counterpart in Baroque painting, as can be

seen in the work of Michelangelo de Merisi, called Caravaggio (1573–1610). Unlike Bernini's somewhat idealized facial and figural types, the models for Caravaggio came directly from those around him. Whereas Bernini could move in the company of popes and princes, Caravaggio was more comfortable with the outcasts of society. In a way he was one of them, having a police record for violent assaults himself. Caravaggio chose lower-class models for his shocking painting *The Conversion of St. Paul* (Fig. 6-8). The artist marked the dramatic moment when Paul, persecuting Christians in

6-8 CARAVAGGIO. *The Conversion of St. Paul* (1600–1601). Oil on canvas. 90" × 69". Santa Maria del Popolo, Rome/Scala/Art Resource, New York. the name of the Roman Empire, was confronted with his actions and, in response, changed the course of his life. Thrown from his horse and blinded by a bright light, Paul professed to have heard a voice asking why he engaged in murderous persecution. The voice, that of Jesus according to Paul, directed him to proceed to Damascus, where he was cured of his blindness and began to preach the tenets of Christianity. Very much in the Baroque spirit, Caravaggio chose to focus on the exact moment when Paul was thrown from his horse. He lies flat on his back, evelids shut, arms groping in the darkness of his blindness. Paul looks as if he might be trampled by his horse, except for the rugged yet calming hands of a man nearby. A piercing light flashes upon the scene, spotlighting certain parts and casting others into the night, resulting in an exaggerated chiaroscuro called tenebrism. Tenebrism, translated as "dark manner," is characterized by an often small and concentrated light source within the painting or what appears to be an external "spotlight" directed at specific points in the composition. The effect is harsh and theatrical, as if the events were playing out onstage and being lit from above. The lighting technique of tenebrism was used broadly by Italian Baroque painters but is seen throughout European painting at this time.

Artemisia Gentileschi

One of Caravaggio's foremost contemporaries was Artemisia Gentileschi (1593–c. 1652). Her father, the painter Orazio Gentileschi, who himself enjoyed much success in Rome, Genoa, and London, recognized and supported Artemisia's talents. Although one of her father's choices for her ended in

 6–9 CARAVAGGIO.
 Judith and Holofernes (c. 1598).
 Oil on canvas. Approx. 56³/₄" × 76³/₄".
 Galleria Nazionale d'Arte Antica, Palazzo Barberini, Rome/Scala/ Art Resource, New York. disaster—an apprenticeship with a man who ultimately raped her—Artemisia came to develop a personal, dramatic, and impassioned Baroque style. Her work bears similarities to that of Caravaggio, her own father, and others working in Italy at this moment, but it often stands apart in the emphatic rendering of its content or in its reconsideration and revision of subjects commonly represented by sixteenth- and seventeenth-century artists.

Consider, for example, the roughly contemporary paintings of *Judith and Holofernes* by Caravaggio (Fig. 6-9) and *Judith Decapitating Holofernes by* Gentileschi (Fig. 6-10). Both works reference a biblical story of the heroine Judith, who rescues her oppressed people by decapitating the tyrannical Assyrian general Holofernes. She steals into his tent under the cover of night and pretends to respond to his seductive overtures. When he is besotted, with her and with drink, she uses his own sword to cut off his head. Both paintings are prime examples of the Baroque style—vibrant palette, dramatic lighting, an impassioned subject heightened to excess by our coming face-to-terrified-face with a man at the precise moment of his bloody execution. But

 6-10 ARTEMISIA GENTILESCHI. Judith Decapitating Holofernes (c. 1620). Oil on canvas. 72¹/₂" × 55³/₄". Uffizi Gallery, Florence/Scala/Art Resource, New York.

6-11 BACICCIO.

Triumph of the Sacred Name of Jesus (1676–1679). Ceiling fresco. Il Gesu, Rome. Copyright Art Resource, New York.

consider the differences. How would you compare Gentileschi's image of Judith with Caravaggio's? Look at the delicacy of Judith's demeanor and the disgust in her facial expression. Now observe Gentileschi's Judith-determined, strong, physically and emotionally committed to the task. In Caravaggio's painting, Holofernes is caught unaware and falls victim in his compromised, drunken state. Gentileschi's tyrant snaps out of his wine-induced stupor and struggles for his life. He pushes and fights and is ultimately overpowered by a righteous woman. What, if any, gender differences can you interpret in these renderings?

Gentileschi's Judith Decapitating Holofernes is one of her most studied and violent paintings. She returned to the subject repeatedly in many different versions, leading some historians to suggest that her seeming obsession with the story signified her personal struggle in the wake of her rape and subsequent trial of her accuser, during which *she* was tortured in an attempt to verify the truth of her testimony. Do you think that this context is essential to understanding Gentileschi's work?

Baroque Ceiling Decoration

The Baroque interest in combining the arts of painting, sculpture, and architecture found its home in the naves and domes of churches and cathedrals, as artists used the three media to create an unsurpassed illusionistic effect. Unlike Renaissance ceiling painting, as exemplified by Michelangelo's decoration for the Sistine Chapel, the space was not divided into "frames" with individual scenes. Rather, the Baroque artist created the illusion of a ceiling vault open to the heavens with figures flying freely in and out of the church. Baciccio's *Triumph of the Sacred Name of Jesus* (Fig. 6-11) is an

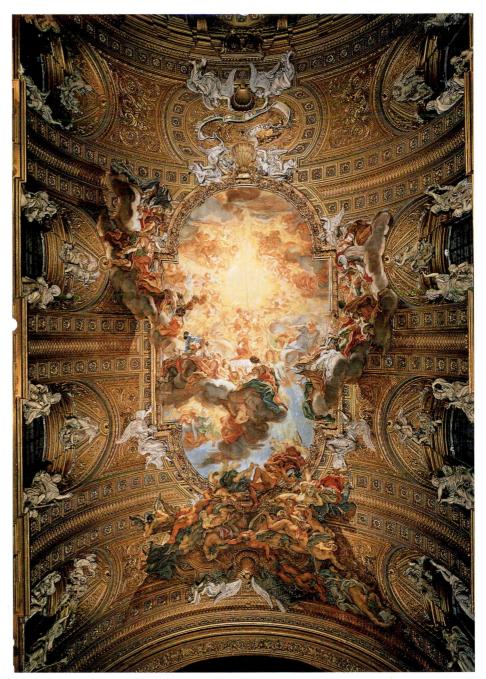

energetic display of figures painted on plaster that spill out beyond the gilded frame of the ceiling's illusionistic opening. The trompe l'oeil effect is achieved by combining these painted figures with white stucco-modeled sculptures and a gilded stucco ceiling. Attention to detail is remarkable, from the blinding light of the heavens to the deep shadows that would be cast on the ceiling by the painted forms. Saints and angels fly upward toward the light while sinners are banished from the heavens to the floor of the church. Artists like Baciccio and their patrons spared no illusionistic device to create a total, mystical atmosphere.

C O M P A R E + C O N T R A S T

Susannah and the Elders by Tintoretto and Gentileschi

Artemisia Gentileschi once said, in reaction to being cheated out of a potentially lucrative commission, "If I were a man, I can't imagine it would have turned out this way." How particularly apt a statement to keep in mind as we consider these works on the subject of Susannah and the Elders.

The story of Susannah can be found in the book of Daniel in the Old Testament, or Hebrew Bible. Susannah was the wife of Joachim, a wealthy Babylonian Jew whose home was frequently visited by judges and elders of the community. Susannah was as pious as she was enchantingly beautiful, and when she rejected the sexual advances of two such elders, they accused her of committing adultery in order to retaliate. Indeed, Susannah was put on trial for these fictitious accusations, was found guilty, and would have been stoned to death were it not for the appearance in the court of Daniel himself. God had answered Susannah's prayers and sent her a lawyer of sorts. Daniel cross-examined the elders individually, poking holes in their contrived testimony. The tables turned: Susannah was saved and the elders were put to death for bearing false witness.

With these details in mind, how would Tintoretto and Gentileschi tell this story pictorially? The choices they made are very different, and they are illuminating. Tintoretto's rendering of Susannah (Fig. 6-12) befits her status. Her beauty and sensuality are enhanced by a show of precious possessions—perfume bottles, jewels and pearls, silken cloth. Bathing

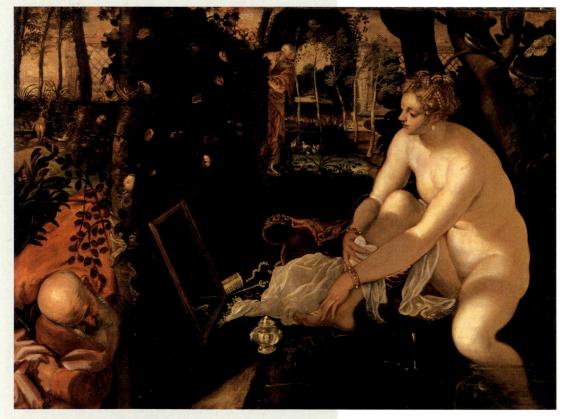

6–12 JACOPO TINTORETTO. Susannah and the Elders (1555–1556). Oil on canvas. 146.6 × 193.6 cm. Kunsthistorisches Museum, Vienna, Austria/Erich Lessing/Art Resource, New York. in the surrounds of a sumptuous, fertile garden, Susannah admires herself in a mirror propped up against a screen covered in vines and flowers. Our focus is entirely on her, as are the prying eyes of one of the elders whose bald head pokes around the screen in the lower left. Susannah, *pious?* Would we ever read that attribute in Tintoretto's image? Is Tintoretto suggesting that Susannah played some role in her seduction? Is he turning us, the spectators, into voyeurs such as those who menaced her?

Gentileschi's *Susannah and the Elders* (Fig. 6-13) tells the same story, but how? Tintoretto's deep, lush, garden setting, where Susannah lounges at her leisure, has been replaced by a compressed space in which she twists and turns her body to fend off the threatening, sleazy elders. There is nothing sensual about her contorted face and her nakedness against the harsh, cold stone. As one of the men gestures "Shhhhhh! You better not say a word!" Susannah finds herself trapped in a claustrophobic space—between her seducers, the stone, and us. If our eyes focus on Susannah, they focus on her anguish.

Faced with a narrative to be rendered, artists always make choices. Ask yourselves: What are those choices? Why, in my opinion, did the artist make them? Aside from the story, or *text* of the work of art, is there some other message that the artist is trying to convey (that is, a *subtext*)? What do these choices say about the artist, or the patron, or the gender ideologies in place in the society that produced the work?

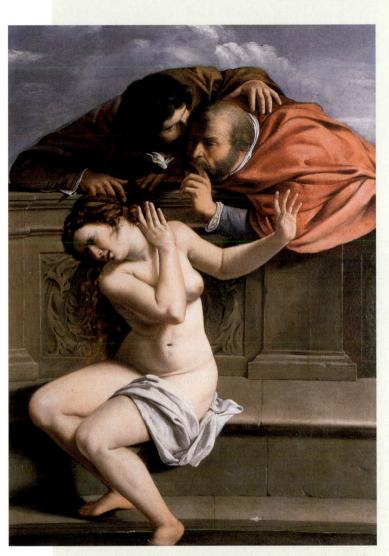

6-13 ARTEMISIA GENTILESCHI. Susannah and the Elders (1610). Oil on canvas. 66⁷/8" × 46⁷/8". Kunstsammlungen Graf von Schonborn, Wiesentheid.

Francesco Borromini

Although it is hard to imagine an architect incorporating the Baroque elements of motion, space, and light in buildings, this was accomplished by the great seventeenth-century architect Francesco Borromini (1599–1667). His San Carlo alle Quattro Fontane (Fig. 6-14) shows that the change from Renaissance to Baroque architecture was one from the static to the organic. Borromini's facade undulates in implied movement complemented by the concave entablatures of the bell towers on the roof. Light plays across the plane of the facade, bouncing off the engaged columns while leaving the recessed areas in darkness. The stone seems to breathe be-

6–14 FRANCESCO BORROMINI. San Carlo alle Quatro Fontane, Rome (1665–1667). Copyright Canali Photobank, Milan.

cause of the **plasticity** of the design and the innovative use of light and shadow. The interior is equally alive, consisting of a large oval space surrounded by rippling concave and convex walls. For the first time since we examined the Parthenon (see Fig. 3-9), we appreciate a building first as sculpture and only second as architecture.

THE BAROQUE PERIOD OUTSIDE ITALY

Baroque characteristics were found in the art of other areas of Europe also. Artists of Spain and Flanders adopted the Venetian love of color, and with their application of paint in loosely brushed swaths, they created an energetic motion in their compositions. Northern artists had always been interested in realism, and during the Baroque period they carried this emphasis to an extreme and used innovative pictorial methods to that end. Paintings of everyday life and activities became the favorite subjects of Dutch artists, who followed in Bruegel's footsteps and perfected the art of genre painting. The Baroque movement also extended into France and England, but there it often manifested itself in a strict adherence to Classicism. The irregularity of styles suggested by the term *baroque* is again apparent.

Spain

Spain was one of the wealthiest countries in Europe during the Baroque era—partly because of the influx of riches from the New World—and the Spanish court was lavish in its support of the arts. Painters and sculptors were imported from different parts of Europe for royal commissions, and native talent was cultivated and treasured.

Diego Velázquez

Diego Velázquez (1599–1660) was born in Spain and rose to the position of court painter and confidant of King Philip IV. Although Velázquez relied on Baroque techniques in his use of Venetian colors, highly contrasting lights and darks, and a deep, illusionistic space, he had contempt for the idealized images that accompanied these elements in the Italian art of the period. Like Caravaggio, Velázquez preferred to use common folk as models to assert a harsh realism in his canvases. Velázquez brought many a mythological subject down to earth by portraying ordinary facial types and naturalistic attitudes in his principal characters. Nor did he restrict this preference to paintings of the masses. Velázquez adopted the same genre format in works involving the royal

Las Meninas, what a picture! What realism! There you have the true painter of reality.

-Pablo Picasso

family, such as the famous *Las Meninas* (Fig. 6-15). The huge canvas is crowded with figures engaged in different tasks. *Las meninas*, "the maids of honor," are attending the little princess Margarita, who seems dressed for a portrait-painting session. She is being entertained by the favorite members of her entourage, including two dwarfs and an oversized dog. We suspect that they are keeping her company while the artist, Velázquez, paints before his oversized canvas.

Is Velázquez, in fact, supposed to be painting exactly what we see before us? Some have interpreted the work in

6-15 DIEGO VELÁZQUEZ. Las Meninas (The Maids of Honor) (1656). Oil on canvas. 10'5" × 9'³/4".
Prado Museum, Madrid. Copyright Edimedia/Corbis. this way. Others have noted that Velázquez would not be standing behind the princess and her attendants if he were painting them. Moreover, on the back wall of his studio, we see the mirror images of the king and queen standing next to one another with a red drape falling behind. Because we do not actually see them in the flesh, we may assume that they are standing in the viewer's position, before the canvas and the artist. Is the princess being given a few finishing touches before joining her parents in a family portrait? We cannot know for sure. The reality of the scene has been left a mystery by Velázquez, just as has the identity of the gentleman observing the scene from an open door in the rear of the room. It is interesting to note the prominence of the artist in this painting of royalty. It makes us aware of his importance to the court and to the king in particular. Recall

the portrait of Raphael in *The School of Athens* (see Fig. 5-20). Raphael's persona is almost furtive by comparison.

Velázquez pursued realism in technique as well as in subject matter. Building upon the Venetian method of painting, Velázquez constructed his forms from a myriad of strokes that capture light exactly as it plays over a variety of surface textures. Upon close examination of his paintings (Fig. 6-16), we find small distinct

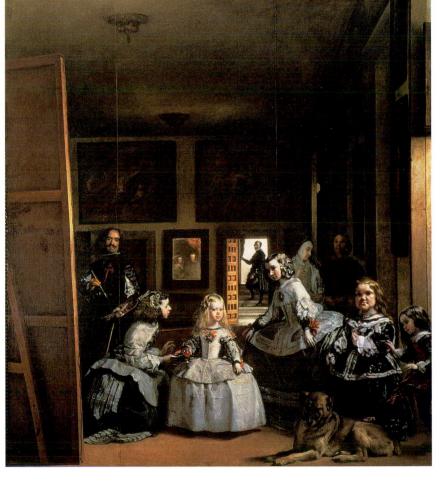

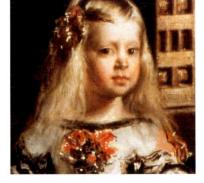

6–16 DIEGO VELÁZQUEZ. Las Meninas (detail). Museo del Prado, Madrid, Spain/ Scala/Art Resource, New York.

strokes that hover on the surface of the canvas, divorced from the very forms they are meant to describe. Yet from a few feet away, the myriad brushstrokes evoke an overall *impression* of silk or fur or flowers. Velázquez's method of dissolving forms into small, roughly textured brushstrokes that re-create the play of light over surfaces would be the foundation of a movement called **Impressionism** some two centuries later. In his pursuit of realism, Velázquez truly was an artist before his time.

Flanders

After the dust of Martin Luther's Reformation had settled, the region of Flanders was divided. The northern sections, now called the Dutch Republic (present-day Holland), accepted Protestantism, whereas the southern sections, still called Flanders (present-day Belgium), remained Catholic. This separation more or less dictated the subjects that artists rendered in their works. Dutch artists painted scenes of daily life, carrying forward the tradition of Bruegel, whereas Flemish artists continued painting the religious and mythological scenes already familiar to us from Italy and Spain. were seized by the twin sons of Zeus, Castor and Pollux. The action in the composition is described by the intersection of strong diagonals and verticals that stabilize the otherwise unstable composition. Capitalizing on the Baroque "stop-action" technique, which depicts a single moment in an event, Rubens placed his struggling, massive forms within a diamond-shaped structure that rests in the foreground on a single point—the toes of a single man and woman. Visually, we grasp that all this energy cannot be

6–17 PETER PAUL RUBENS. The Rape of the Daughters of Leucippus (1617). Oil on canvas. $7'3'' \times 6'10''$. Alte Pinakothek, Munich. Copyright Bridgeman Art Library.

Peter Paul Rubens

Even the great power and prestige held by Velázquez were exceeded by the Flemish artist Peter Paul Rubens (1577–1640). One of the most sought-after artists of his time, Rubens was an ambassador, diplomat, and court painter to dukes and kings. He ran a bustling workshop with numerous assistants to help him complete commissions. Rubens's style combined the sculptural qualities of Michelangelo's figures with the painterliness and coloration of the Venetians. He also emulated the dramatic chiaroscuro and theatrical presentation of subject matter we found in the Italian Baroque masters. Much as had Dürer, Rubens admired and adopted from his southern colleagues. Although Rubens painted portraits, religious subjects, and mythological themes, as well as scenes of adventure, his canvases were always imbued with the dynamic energy and unleashed passion we link to the Baroque era.

In *The Rape of the Daughters of Leucippus* (Fig. 6-17), Rubens recounted a tale from Greek mythology in which two mortal women

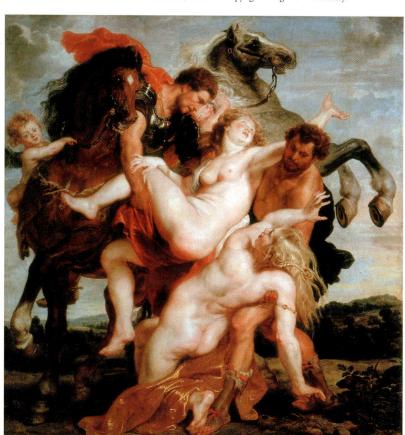

supported on a single point, so we infer continuous movement. The action has been pushed up to the picture plane, where the viewer is confronted with the intense emotion and brute strength of the scene. Along with these Baroque devices, Rubens used color and texture much in the way the Venetians used it. The virile sun-tanned arms of the abductors contrast strongly with the delicately colored flesh of the women. The soft blond braids that flow outward under the influence of all of this commotion correspond to the soft, flowing manes of the overpowering horses.

Holland

The grandiose compositional schemes and themes of action executed by Rubens could not have been further removed from the concerns and sensibilities of most seventeenthcentury Dutch artists. Whereas mysticism and religious naturalism flourished in Italy, Flanders, and Spain amidst the rejection of Protestantism and the invigorated revival of Catholicism, artists of the Low Countries turned to secular art, abiding by the Protestant mandate that humans not create "false idols." Not only did artists turn to scenes of everyday life but the collectors of art were themselves everyday folk. In the Dutch quest for the establishment of a middle class, aristocratic patronage was lost and artists were forced to "peddle" their wares in the free market. Landscapes, still lifes, and genre paintings were the favored canvases, and realism was the word of the day. Although the subject matter of Dutch artists differed radically from that of their colleagues elsewhere in Europe, the spirit of the Baroque, with many, if not most, of its artistic characteristics, was present in their work.

Rembrandt van Rijn

The golden-toned, subtly lit canvases of Rembrandt van Rijn (1606 –1669) possess a certain degree of timelessness. Rembrandt concentrates on the personality of the sitter or the psychology of a particular situation rather than on surface characteristics. This introspection is evident in all of Rembrandt's works, whether religious or secular in subject, landscapes or portraits, drawings, paintings, or prints.

Rembrandt painted a great number of self-portraits that offer us an insight into his life and personality. In a selfportrait at the age of 46 (Fig. 6-18), Rembrandt paints an image of himself as a self-confident, well-respected, and sought-after artist who stares almost impatiently out toward the viewer. It is as if he had been caught in the midst of working and has but a moment for us. It is a powerful image, with piercing eyes, thoughtful brow, and determined jaw that betray a productive man who is more than satisfied with his position in life. All of this may seem obvious, but notice how few clues he gives us to reach these conclusions about his personality. He stands in an undefined space with no props that reveal his identity. The figure itself is cast into darkness; we can hardly discern his torso and hands resting in the sash around his waist. The penetrating light in the canvas is reserved for just a portion of the artist's face. Rembrandt gives us a minute fragment with which he beckons us to complete the whole. It is at once a mysterious and revealing portrayal that relies on a mysterious and revealing light.

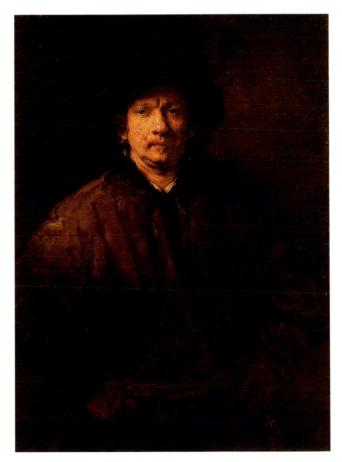

6–18 REMBRANDT VAN RIJN. Self-Portrait (1652). Oil on canvas. 45" × 32". Kunsthistorisches Museum, Vienna. Copyright Art Resource, New York.

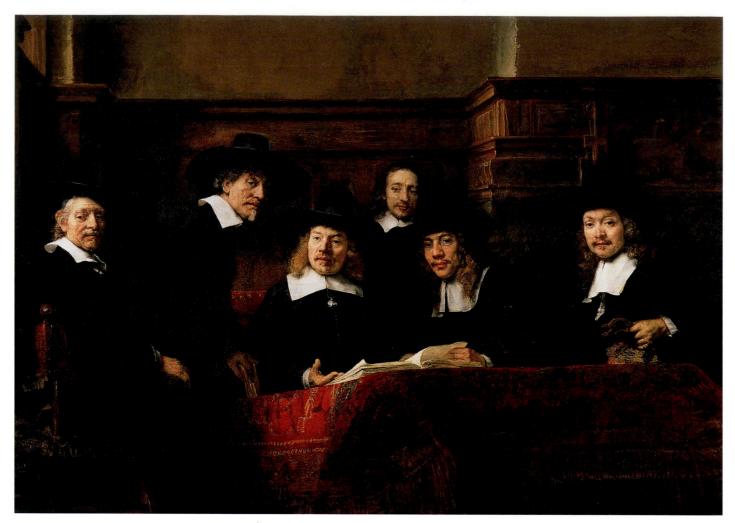

6–19 REMBRANDT VAN RIJN. Syndics of the Drapers' Guild (1661–1662). Oil on canvas. 72⁷/8" × 107¹/8". Rijksmuseum, Amsterdam. Copyright Rijksmuseum, Amsterdam.

Rembrandt also painted large group portraits. In his *Syndics of the Drapers' Guild* (Fig. 6-19), which you may recognize from the cover of Dutch Masters' cigar boxes, we, the viewers, become part of a scene involving Dutch businessmen. Bathed in the warm light of a fading sun that enters the room through a hidden window to the left, the men appear to be reacting to the entrance of another person. Some rise in acknowledgment. Others seem to smile. Still others gesture to a ledger as if to explain that they are gathering to "go over the books." Even though the group operates as a whole, the portraits are highly individualized and themselves complete. As in his self-portrait, Rembrandt concentrates his

light on the heads of the sitters, from which we, the viewers, gain insight into their personalities. The haziness that surrounds Rembrandt's figures is born from his brushstrokes and his use of light. Rembrandt's strokes are heavily loaded with pigment and applied in thick impasto. As we saw in the painterly technique of Velázquez, Rembrandt's images are more easily discerned from afar than from up close. As a matter of fact, Rembrandt is reputed to have warned viewers to keep their "nose" out of his painting because the smell of paint was bad for them. We can take this to mean that the technical devices Rembrandt used to create certain illusions of realism are all too evident from the perspective of a few I'd give the whole of Italian painting for Vermeer of Delft. There's a painter who simply said what he had to say without bothering about anything else. None of these mementos of antiquity for him.

-Pablo Picasso

inches. Above all, Rembrandt was capable of manipulating light. His is a light that alternately constructs and destructs, that alternately bathes and hides from view. It is a light that can be focused as unpredictably, and that shifts as subtly, as the light we find in nature. Although Rembrandt was sought after as an artist for a good many years and was granted many important commissions, he fell victim to the whims of the free market. The grand master of the Dutch Baroque died at the age of 63, out of fashion and penniless.

Jan Vermeer

If there is a single artist who typifies the Dutch interest in painting scenes of daily life, the commonplace narratives of middle-class men and women, it is Jan Vermeer (1632–1675). Although he did not paint many pictures and never strayed from his native Delft, his precisely sketched and pleasantly colored compositions made him well respected and influential in later centuries.

Young Woman with a Water Jug (Fig. 6-20) exemplifies Vermeer's subject matter and technique. In a tastefully under-furnished corner of a room in a typical middle-class household, a woman stands next to a rug-covered table, grasping a water jug with one hand and, with the other, opening a stained-glass window. A blue cloth has been thrown over a brass and leather chair, a curious metal box sits on the table, and a map adorns the wall. At once we are presented with opulence and simplicity. The elements in the composition are perfectly placed. One senses that their position could not be moved even a fraction of an inch without disturbing the composition. Pure colors and crisp lines grace the space in the painting rather than interrupt it. Every item in the painting is of a simple, almost timeless form and corresponds to the timeless serenity of the porcelain-like image of the woman. Her simple dress and starched collar and bonnet epitomize grace and serenity. We might not see this as a Baroque composition if it were not for three things: a single source of light bathing the elements in the composition, the genre subject, and a bit of mystery surrounding the moment

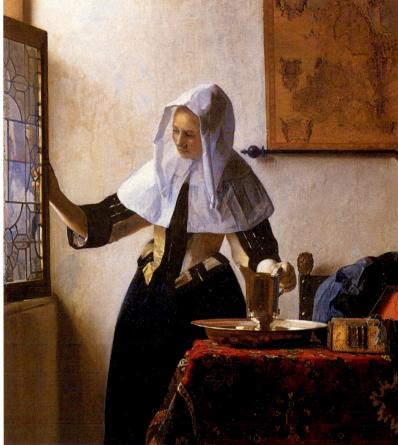

6-20 JAN VERMEER. Young Woman with a Water Jug (c. 1665). Oil on canvas. 18" × 16". The Metropolitan Museum of Art, New York. Henry G. Marquand, 1889. Marquand Collection (89.15.21). Copyright 1993 The Metropolitan Museum of Art, New York.

captured by Vermeer. What is the woman doing? She has opened the window and taken a jug into her hand at the same time, but we will never know for what purpose. Some have said that she may intend to water flowers at a window box. Perhaps she was in the midst of doing something else and paused to investigate a noise in the street. Vermeer gives us a curious combination of the momentary and the eternal in this almost photographic glimpse of everyday Dutch life.

France

During the Baroque period, France, under the reign of the "sun king," Louis XIV, began to replace Rome as the center of the art world. The king preferred Classicism. Thus did the country, and painters, sculptors, and architects alike created works in this vein. Louis XIV guaranteed adherence to Classicism by forming academies of art that perpetuated this style. These academies were art schools of sorts, run by the state, whose faculties were populated by leading proponents of the Classical style.

When we examine European art during the Baroque period, we thus perceive a strong stylistic polarity. On the one hand, we have the exuberant painterliness and high drama of Rubens and Bernini, and on the other, a reserved Classicism that hearkens back to Raphael.

Nicolas Poussin

The principal exponent of the Classical style in French painting was Nicolas Poussin (1594–1665). Although he was born in France, Poussin spent much of his life in Rome, where he studied the works of the Italian masters, particularly Raphael and Titian. Although his *Rape of the Sabine Women* (Fig. 6-21) was painted four years before he was summoned back to France by the king, it illustrates the Baroque Classicism that Poussin would bring to his native country. The flashy dynamism of Bernini and Rubens gives way to a more static, almost staged motion in the work of Poussin. Harshly sculptural, Raphaelesque figures thrust in various directions, forming a complex series of intersecting diagonals and verticals. The initial impression is one of chaos, of unrestrained movement and human anguish. But as was the case with the Classical Greek sculptors and Italian

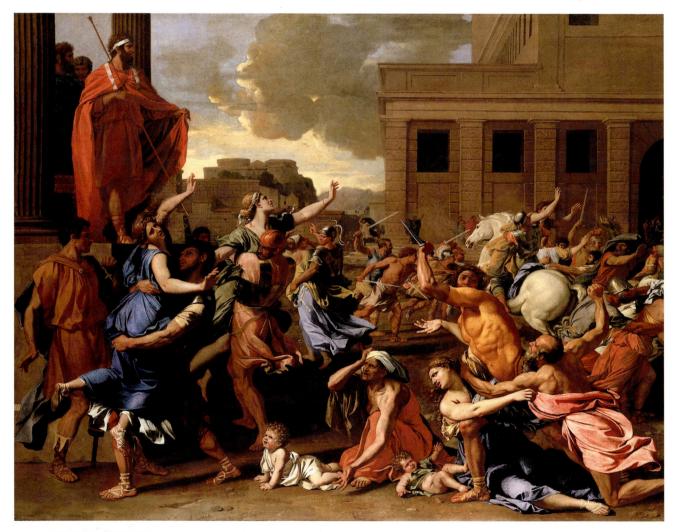

6-21 NICOLAS POUSSIN. The Rape of the Sabine Women (c. 1636–1637). Oil on canvas. 60⁷/₈" × 82⁵/₈". The Metropolitan Museum of Art, New York. Harris Brisbane Dick Fund, 1946 (46.160). Copyright 1992 The Metropolitan Museum of Art, New York. The subject or topic should be great, such as battles, heroic actions, and divine matters.

-Nicolas Poussin

Renaissance artists, emotion is always balanced carefully with restraint. For example, the pitiful scene of the old woman in the foreground, flanked by crying children, forms part of the base of a compositional triangle that stabilizes the work and counters excessive emotion. If one draws a vertical line from the top of her head upward to the top border of the canvas, one encounters the apex of this triangle, formed by the swords of two Roman abductors. The sides of the triangle, then, are formed by the diagonally thrusting torso of the muscular Roman in the right foreground, and the arms of the Sabine women on the left, reaching hopelessly into the sky. This compositional triangle, along with the Roman temple in the right background that prevents a radically receding space, are Renaissance techniques for structuring a balanced composition. Poussin used these, along with a stage-like, theatrical presentation of his subjects, to reconcile the divergent styles of the harsh Classical and the vibrant Baroque.

Polar opposites in style occur in other movements throughout the history of art. It will be important to remember this aspect of the Baroque, because in later centuries we will encounter the polarity again, among artists who divide themselves into the camps Poussiniste and Rubeniste.

Versailles

The king's taste for the Classical extended to architecture, as seen in the Palace at Versailles (Fig. 6-22). Originally the site of the king's hunting lodge, the palace and surrounding area just outside Paris were converted by a host of artists, architects, and landscape designers into one of the grandest monuments to the French Baroque. In their tribute to Classicism, the architects Louis Le Vau (1612-1670) and Jules Hardouin-Mansart (1646-1708) divided the horizontal sweep of the facades into three stories. The structure was then divided vertically into three major sections, and these were in turn subdivided into three additional sections. The windows march along the facade in a rhythmic beat accompanied by rigid pilasters that are wedged between the strong horizontal bands that delineate the floors. A balustrade tops the palace, further emphasizing the horizontal sweep while restraining any upward movement suggested by the building's vertical members. The divisions into Classically balanced threes and the almost obsessive emphasis on the horizontal echo the buildings of Renaissance architects. The French had come a long way from the towering spires of their glorious Gothic cathedrals!

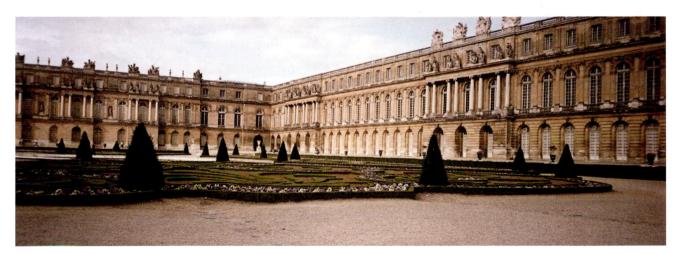

6–22 LOUIS LE VAU AND JULES HARDOUIN-MANSART. Palace of Versailles, as seen from the garden (1669–1685). Copyright Spencer A. Rathus. All rights reserved.

England

The Baroque in England had a different flavor from that is the European continent, in part because it was not dominated by an absolute monarchy as it was, for example, in France. Instead, England's Common Law and Parliament coexisted with a limited monarchy. Also, unlike other countries, England was also home to a variety of religious groups—including Anglicans and other Protestants, and Catholics. As in Holland, the Baroque era in England witnessed a burgeoning of trade, made possible by the nation's status as a maritime power.

England's most significant contribution to the arts in the seventeenth and early eighteenth centuries was in the realm of architecture. Two architects in particular-Inigo Jones (1573-1652) and Sir Christopher Wren (1632-1723)were responsible for the architectural profile of London in its Baroque years. Both were heavily influenced by Italian Baroque architecture, which combined the regimentation and clarity of classical elements with occasional, unpredictable shapes or rhythms. Jones's Banqueting House at Whitehall (Fig. 6-23) in London illustrates a certain symmetry and repetition of classical elements (for example, regularly spaced windows separated by engaged columns and an overall balance of horizontal and vertical lines). But the rigidity of the design scheme is subtly challenged by the use of pilasters in a different rhythm at the corners, and the mix-up of architectural orders- Ionic capitals on the lower floor and more ornate, Corinthian-style capitals on the second floor.

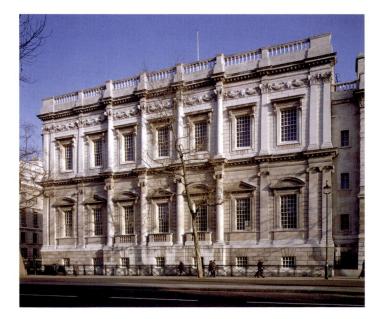

6–23 INIGO JONES.
Banqueting House at Whitehall, London, England. (1619–1622).
© Angelo Hornak/Corbis.

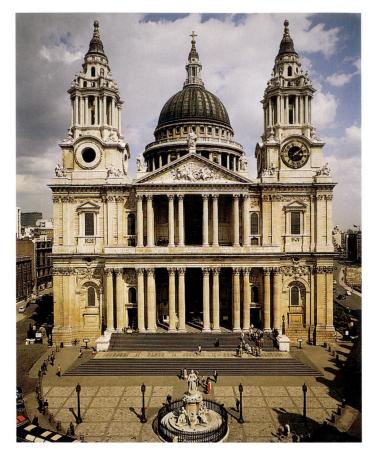

 6-24 SIR CHRISTOPHER WREN. New Saint Paul's Cathedral, London, England. (1675 – 1710). A.E. Kersting.

The alternating pattern of vertical elements is not unlike that of the façade of St. Peter's in Rome.

Sir Christopher Wren began his career at the age of 25although not as an architect. He was an engineer and professor of astronomy, whose developing interest in mathematics led him to architecture. Solicited by King Charles II to renovate St. Paul's Cathedral—a Gothic structure—his plans for the project were in place when the devastating fire of London in 1666 consumed the old building. The new St. Paul's (Fig. 6-24) stands as Wren's masterpiece and the most beloved structure in London. Influenced by Italian and French Baroque architecture, Wren reconciled the problematic relationship of the classical pedimented façade to hemispherical dome that we first encountered in the Baroque expansion of St. Peter's in Rome. He did this by placing tall bell towers on either side of the façade to soften the visual transition from the horizontal emphasis of the two-storied elevation to the vertical rise of the massive dome a nave'slength away. Wren's design stands midway between the organic, flowing designs of the Italian Baroque and the strict

classicism of the French Baroque architects, integrating both in a reserved, but not rigid, composition. The double-columned, two-tiered portico is French Baroque in style (see the Palace of Versailles, Fig. 6-22), and the upper level of the bell towers (topped by pineapples—symbols of peace and prosperity) are similar to those found on Borromini's churches, such as San Carlo alle Quattro Fontane (see Fig. 6-14) in Rome.

The dome of St. Paul's is the world's second-highest at 361 feet (St. Peter's is higher). Inside the dome is the socalled Whispering Gallery; visitors who whisper against its walls can be heard on the opposite side of the dome. The interior is richly embellished with marble inlays, frescoes, mosaics, and wrought-iron. Aside from its stature as an architectural masterpiece, St. Paul's holds a valuable place in British memory. Winston Churchill took extraordinary measures to protect the church from the Nazi bombing raids—the Blitz—of World War II. It survived amidst a virtually ruined city.

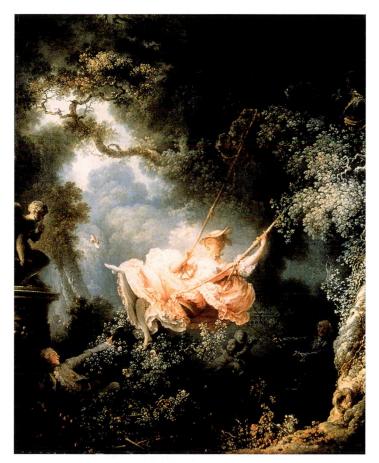

6–25 JEAN-HONORÉ FRAGONARD. Happy Accidents of the Swing (1767). Oil on canvas. 31⁷/₈" × 25³/₈". Reproduced by permission of the Trustees, The Wallace Collection, London. Copyright Art Resource, New York.

THE ROCOCO

We have roughly dated the Baroque period from 1600 to 1750. However, art historians have recognized a more distinct style within the Baroque that began shortly after the dawn of the eighteenth century. This **Rococo** style strayed further from Classical principles than did the Baroque. It is more ornate and characterized by sweetness, gaiety, and light. The courtly pomp and reserved Classicism of Louis XIV were replaced with a more delicate and sprightly representation of the leisure activities of the upper class.

The early Rococo style appears as a refinement of the painterly Baroque in which Classical subjects are often rendered in wispy brushstrokes that rely heavily on the Venetian or Rubensian palette of luscious golds and reds. The later Rococo period, following mid-century, is more frivolous in its choice of subjects (that of love among the very rich), palette (that of the softest pastel hues), and brushwork (the most delicate and painterly strokes).

Jean-Honoré Fragonard

Jean-Honoré Fragonard (1732–1806) is one of the finest representatives of the Rococo style, and his painting Happy Accidents of the Swing (Fig. 6-25) is a prime example of the aims and accomplishments of the Rococo artist. In the midst of a lush green park, whose opulent foliage was no doubt inspired by the Baroque, we are offered a glimpse of the "love games" of the leisure class. A young, though notso-innocent, maiden, with petticoats billowing beneath her sumptuous pink dress, is being swung by an unsuspecting bishop high over the head of her reclining gentleman friend, who seems delighted with the view. The subjects' diminutive forms and rosy cheeks make them doll-like, an image reinforced by the idyllic setting. This is eighteenth-century life at its best-pampered by subtle hues, embraced by lush textures, and bathed by the softest of lights. Unfortunately, this was all a mask for life at its worst. As the ruling class continued to ignore the needs of the common people, the latter were preparing to rebel.

Élisabeth Vigée-Lebrun

Whereas Rembrandt epitomizes the artists who achieve recognition after death, Élisabeth Vigée-Lebrun (1755–1842) was a complete success during her lifetime. The daughter of a portrait painter, she received instruction and encouragement from her father and his colleagues from an early age. As a youngster she also studied paintings in the Louvre and was particularly drawn to the works of Rubens. By the time she reached her early twenties, she commanded high prices for her portraits and was made an official portrait painter for

6-26 ÉLISABETH VIGÉE-LEBRUN. Marie Antoinette and Her Children (1781). Oil on canvas. 8'8" × 6'10". Palace of Versailles, Versailles, France. Copyright Art Resource, New York.

Marie Antoinette, the Austrian wife of Louis XVI. Neither Marie Antoinette nor her husband survived the French Revolution, but Vigée-Lebrun's fame spread throughout Europe, and by the end of her career she had created some 800 paintings.

Marie Antoinette and Her Children (Fig. 6-26) was painted nearly a decade after Vigée-Lebrun had begun to paint the royal family. In this work she was commissioned to counter the antimonarchist sentiments spreading throughout the land by portraying the queen as, first and foremost, a loving mother. True, the queen is set within the imposing Salon de la Paix at Versailles, with the famous Hall of Mirrors to the left and the royal crown atop the cabinet on the right. True, the queen's enormous hat and voluminous skirts create a richness and monumentality to which the common person could not reasonably aspire. But the triangular composition and the child on the lap are reminiscent of Renaissance images of the Madonna and child (see Chapter 5), at once creating a sympathetic portrait of a mother and her children and, subliminally, asserting their divine right. Even amid the opulence at Versailles, Marie Antoinette displays her children as her real jewels. The young dauphin to the right, set apart as the future king, points to an empty cradle that might have originally contained the queen's fourth child, an infant who died two months before the painting was scheduled for exhibition.

The French populace, of course, was not persuaded by this portrait or by other public relations efforts to paint the royal family as accessible and sympathetic. The artist, in fact, did not exhibit her painting as scheduled for fear that the public might destroy it. Two years after the painting was completed, the convulsions of the French Revolution shook Europe and the world. The royal family was imprisoned and then executed. More than the royal family had passed into history, and more than democracy was about to be born. Modern art was also to be ushered into this brave new world.

Enlightenment, Revolution, the Scientific, and the Natural

The aristocratic culture reflected in the Rococo style may symbolize the late eighteenth century in France, but it was not the only game in town. Enlightenment views and philosophies, which rejected the stranglehold of religion and superstition and promoted scientific inquiry and critical thinking about the world and the human condition, went hand-in-hand with revolutions in France and America. Many historical personalities are associated with the Enlightenment—France's Rene Descartes, England's Isaac Newton and John Locke, America's Benjamin Franklin and Thomas Jefferson. But the opposing viewpoints of the Enlightenment—the "scientific" versus "the natural"—are represented by, respectively, Voltaire (1694–1778) and Jean-Jacques Rousseau (1712–1778). Voltaire held that science and rationalism held the key to the improvement of the human condition, whereas Rousseau believed that feeling and emotions trumped reason and that the return to the natural, or the "primitive state" would lead to the salvation of humankind. Rousseau's philosophy was translated into the pictorial arts in England and America in works by painters such as Thomas Gainsborough (1727–1788) and John Singleton Copley (1738–1815). It also contributed to the demise of the Rococo, which represented an "artificial" rather than a "natural" state of being.

Gainsborough bridged the gap between the Rococo and the new naturalism as one of the most renowned portraitists in eighteenth-century England. One of the initiators of socalled Grand Manner portraiture (see Fig. 6-27), Gainsborough created an air of elegance and importance to his sitters by using a number of pictorial devices—a deep, lush landscape, relatively large-scale figure, simple pose, and dignified gaze. Soft, feathery strokes define both figure and background and a pastel-colored light bathes the whole composition. These are two characteristics you also saw in Rococo art.

Gainsborough's style was also seen in American art particularly history paintings on a grand scale. But America offered a new twist in portraiture, perhaps best represented by John Singleton Copley of Massachusetts. Whereas Gainsborough combined naturalism with elements of French Rococo, Copley combined English naturalism with an Ameri-

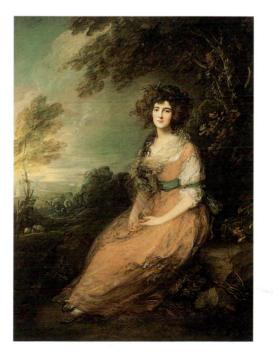

6-27 THOMAS GAINSBOROUGH. Mrs. Richard Brinsley Sheridan (1787). Oil on canvas, approx. 7' 2⁵/₈" × 5' ⁵/₈". © 1999 National Gallery of Art, Washington, Andrew W. Mellon Collection.

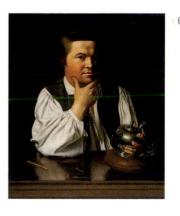

6-28 JOHN SINGLETON COPLEY. *Portrait of Paul Revere* (c. 1968 – 1770). Oil on canvas, 2' 11¹/s" × 2' 4". Museum of Fine Arts, Boston. Gift of Joseph W., William B., and Edward H. R. Revere. All Rights Reserved.

can taste for realism and simplicity. His Portrait of Paul Revere (Fig. 6-28), the silversmith-turned-revolutionary hero, has a directness of expression and unpretentious gaze that is markedly different from Gainsborough's sitter. Mrs. Richard Brinsley Sheridan's dreamy, introspective air contrasts sharply with Revere's assertive, visual dialogue with the viewer. Tools at hand, he ponders the teapot on which he is working and raises his head momentarily from the task to acknowledge the visitor, the patron, the observer. Gainsborough's painterly touch contrasts with Copley's harsh linear style. The lighting is dramatic rather than subtle and the textures, softly blended in Gainsborough's portrait, are purposefully distinct and different from one another (the soft folds of Revere's shirtsleeves against his sculptural arms; the warm wood surface of his worktable against the gleaming metal of his teapot). It is tempting to read Copley's approach as one that reflects American values and sensibilities. Like some other Americanborn artists of his generation, however, he moved to London, where he adapted his style to the British taste.

Chapters 2 through 6 have focused on art and the Western heritage. Yet "the West" comprises but a fraction of the world's population and a particular historical, cultural, and aesthetic approach to art. Art beyond the West is incredibly diverse. It is not united by a common history or by common ideas as to what art is, who will produce it, or what place art will occupy in people's lives. Even in the same general region, such as sub-Saharan Africa, there are diverse peoples and diverse approaches to art. The next chapter will bring us into contact with art that lies beyond the Western tradition, art that often requires a different critical vocabulary to be described, art that must be viewed in an altogether different context to be understood. For most Westerners, the art and culture of "the non-West" is "the other." In order to fully appreciate the meaning and function of art of cultures beyond the West, it is necessary, and immensely rewarding, to "think otherly"-to "reframe" your frame of reference to be something other than that which is familiar to you.

ART TOUR London

Europe's largest city cashes in big on tourism from the "colonies across the pond." There is a natural affinity between the United States and Britain for all sorts of reasons, ranging from a common language and common political causes to imports and exports such as Elvis and The Beatles. Even London's idiosyncratic phone booths have entered the popular culture with Austin Powers movies. Because of the ease of travel (it takes no longer to jet from New York to London than it does to fly from New York to Los Angeles) and the ease of communicating, London is a natural first-tripabroad destination for students. It also serves as a logical jumping-off point for other cities worldwide, many of which can be reached by booking discounted student and youth fares with local London travel agents. The center of London is easily explored on foot, and almost all of the city is acces-

SIGNATURE LONDON TELEPHONE BOOTHS. Photo courtesy of Lois Fichner-Rathus. All rights reserved.

sible by an inexpensive and highly efficient subway system.

A good place to start is at the symbolic heart of the city of London—St. Paul's Cathedral. The building as you see it today is the reincarnation—in Classical dress—of the original medieval church that was brought to ruin during the Great Fire of London in 1666. No stranger itself to destruction, the St. Paul's of today was literally kept standing by the "Watch," a team of volunteers who kept nightly vigil over the cathedral

during the Blitz—the Nazi bombing raids on London in 1940 and 1941 that caused devastation all over the city. The cathedral is viewed as the masterpiece of the architect Sir Christopher Wren, who borrowed porticoes and pediments from Greek temple architecture and whose Classical vision dominates some of the more medieval aspects of the cathedral plan, such as the cross shape of the nave and transept. The most spectacular feature of St. Paul's is the dome, whose inner and outer shells rival one another for beauty. It is the second-largest dome in the world, after St. Peter's in Rome (designed by Michelangelo). It features an exterior, circular stone gallery, which offers the non-

BIG BEN. Photo courtesy of Lois Fichner-Rathus. All rights reserved.

acrophobic a panoramic view of the city, and a pendant interior gallery—the so-called Whispering Gallery—from which you can hear whispers echoing from across the dome. St. Paul's is also a British monument that pays homage throughout to the United States for its unwavering devotion and support during World War II. The American visitor, while circling the apse, will come upon the American Memorial Chapel behind the high altar. St. Paul's has been the site of funerals (Sir Winston Churchill's) and weddings (Prince Charles and Lady Diana Spencer's) of the rich and famous and houses many memorials to popular heroes and historical figures from Lawrence of Arabia to Lord Nelson. Many more individuals who figure prominently in Britain's cultural history—from Darwin to Chaucer—can be found entombed or enshrined in Westminster Abbey. But keep walking ...

From St. Paul's, you can luxuriate in a walk down to the Thames, that long and serpentine body of water on which you can take a circular cruise to view some of London's most famous (and infamous) sights: the Houses of Parliament (with the bell tower, Big Ben); the Tower Bridge; and Traitors' Gate, the creepy river entrance to the Tower of London, used for prisoners fresh from their trials in Westminster Hall. If you've chosen not to take this detour, continue across the new Millennium Bridge directly to the sensational Tate Modern, one of the world's premier collections of twentiethcentury art, now housed in the vast, old Bankside Power Station. Upon entering the building, visitors proceed down a ramp into an enormous hall that contained turbines in former days and is now brought to life with large-scale works of art. From this level, escalators lead up to three large suites of galleries arranged more or less chronologically to give some sense of a history of modern art. Interspersed among the many works by British artists in the museum are a large number of well-known international works, including Picasso's Three Dancers and Warhol's Marilyn Diptych. The Tate Modern also offers some of the best views of the city from across the river in its glass-enclosed top floors, one of which includes a restaurant.

Continuing west along the river, the visitor will reach the world's tallest observation wheel, the British Airways London Eye, constructed to celebrate the new millennium. On a clear day you can see forever (or maybe about 40 miles) from this overgrown Ferris wheel. As you can imagine, the lines are insufferably long, no matter the weather. Back across the river, a walk east and then north will bring you to the Covent Garden plazza and Central Market, where performers of all kinds command the square and where you can eat just about anything cheaply. From here, find your way to Leicester Square and the half-price ticket booth, which offers theater tickets for same-day performances in legendary theaters such as the Palladium. When in London, do as the Londoners do—at least one play per visit in one of the city's famous theaters is a must.

You can ask directions (in English!) to the queen's "intown" residence, Buckingham Palace, and try to catch the wellknown changing of the guard. During the height of the tourist season, this event takes place at 11:30 a.m. daily; the rest of the year it's every other day. Near the palace you can take a stroll through one of the most beautiful green spots in London, St. James Park. A route through the park will bring you eventually to Westminster Abbey, the site of the coronation chair and the final resting place for the kings and queens of England for centuries. In contrast to the Classical perfection and serenity of St. Paul's, Westminster Abbey is one of the most glorious examples of medieval architecture in London, if not in all of Europe. From its splendid west front towers and the massive flying buttresses to the vaulted ceiling of the Lady Chapel and the magnificent tiles of the octagonal Chapter House, the abbey does not disappoint the dense throngs who visit this "half national church-half national museum." Negotiating the many transepts and chapels will reveal some of the abbey's finest memorials to musicians, poets, and artists.

Even if your trip to London is brief and much of your "art tour" seems to be taking place outdoors, you will not want to miss the extraordinary British Museum. Wandering amidst the world's greatest collection of Mesopotamian, Egyptian, and Greek and Roman antiquities, even the most jaded or museum-fatigued among us will marvel at the Rosetta Stone—the slab we learned about in sixth grade,

WESTMINSTER ABBEY. Copyright Angelo Hornak/Corbis.

THE BRITISH MUSEUM. Photo courtesy of Lois Fichner-Rathus. All rights reserved.

which unlocked the mysterious code of Egyptian hieroglyphs—or the Parthenon (Fig. 3-10) marbles—removed from the temple by the British diplomat Lord Elgin between 1801 and 1804 and sold to the British nation in 1816. (In fact, Greece wants them back.) Admission to the British Museum and other wonderful art places, such as the National Gallery and National Portrait Gallery in Trafalgar Square, the Tate Modern, and the Tate Britain, is free.

 \bigcirc

To continue your tour go to our Premium Companion website.

ART BEYOND THE WEST

The map is open and connectable in all of its dimensions.

-Gilles Deleuze and Felix Guattari

he world is shrinking." "The Global Village." "The Global Stage." "The Era of Globalization." As citizens of the world in the new millennium, we are connected to one another like never before. We travel to remote sites—across actual space (thanks to modern-day transportation) and cyberspace (thanks to the Internet). Money, goods, and services flow quickly from one part of the world to another. Information is more available to ordinary people as access to modes of international communication has become the rule for the many rather than the exception for the few. Although "globalization" is a term most often linked to the current state of global business and politics, the concept has expanded to include historical and cultural studies. While investment bankers, corporate businesses, and entrepreneurs have developed mutually beneficial relationships with countries around the globe, which have only recently begun to tap into their rich economic potential, new groups of individuals—such as research academicians (sociologists, anthropologists, historians, political scientists) have begun to investigate social, historical, cultural, and artistic phenomena of regions that are now within reach.

Map 7-1 Art beyond the Western tradition.

As citizens of the world, we also share an extensive and varied heritage. Western culture and the Western tradition in art—that which solidified in ancient Greece and developed in Western Europe and later, the United States—may be more familiar to most of us than the art of other cultures and traditions that lie "beyond the West" (Map 7-1). But those traditions are rich and varied and represent other ways of seeing and knowing that enable us to expand our understanding of ourselves in relation to the world.

Ancient African sculpture and the masquerade, intricately carved catamarans of the Oceanic islanders, colossal stone heads from pre-Columbian Mexico, the South American metropolises, Native American cliff palaces—these are but a handful of examples of art that embody ways of life that have developed along their own courses. They often reflect societal organizations based on the village or the tribe that are rural and self-sufficient and continue from generation to generation with little change. The art of such societies serves to express the values and beliefs of a people and plays a pivotal role in the continuation of customs and traditions in societies dependent on oral rather than written history.

Europeans who colonized these territories between the sixteenth and twentieth centuries did not think much of the fetishes, idols, and other curiosities upon which they gazed. Today this art is avidly collected throughout the world, including the Western world. Islamic art or Chinese and Japanese art may be somewhat more familiar to the Western eye than the arts of Africa, Oceania, and Native America. As sacred spaces, the great mosques of the world of Islam, the cathedrals of Christian Europe, and synagogues around the world have some elements in common. Persian carpets are popular, and the Western eye need not be especially schooled to appreciate them. Some of the great works of the Indian subcontinent, such as the Taj Mahal, are also familiar, and the influence of China and Japan on Western art has been felt since the explorations and beginnings of trade, for many hundreds of years. The refined ceramics of the

Chinese, for example, were known to European potters, and the perspective techniques and delicacy of Japanese drawings and paintings influenced many modern artists of the nineteenth century.

In this chapter we shall explore the world of art beyond the West. The breadth of the material precludes detailed discussion of the historical aspects of this work but need not preclude an appreciation for the widely diverse styles of these cultures and the significance of their art to their societies.

AFRICAN ART

African art is as varied as the cultures that have populated that continent. The earliest African art, like the earliest art of Europe and North America, consists of rock paintings and engravings that date to the Neolithic period. In tropical Africa—the central portion of the continent—the lost-wax technique was developed to cast small bronze sculptures as early as the ninth century.

The kingdom of Benin, which during the fourteenth through nineteenth centuries occupied what is now Nigeria, was rich in sculptures of many media, including iron, bronze, wood, ivory, and terra-cotta. Works such as the Altar of the Hand (Fig. 7-1) illustrate the skill with which the Benin manipulated bronze, as well as the importance of symbolism to their art. The many figures that are cast in relief around the circumference of this small work are meant to venerate the king and glorify his divine office. The king is the central figure in both the relief and in the freestanding figures on top of the altar. He holds the staffs of his office in his hands, and his head is larger than those of his attendants. This purposeful distortion signifies the head as the center of being and source of intelligence and power. The king's importance is further underscored by his placement within a triangular frame of sorts, his head at the apex. The entire altar is cast with symbolic forms or incised with decorative motifs, all arranged in a symmetrical pattern. The monuOne of the first principles of art . . . is truth to material. . . . Wood has a stringy, fibrous consistency and [the African sculptor could carve it] into thin forms without breaking [it]. Much [African] carving . . . has pathos, a static patience and resignation to unknown mysterious powers; it is religious and, in movement, upward and vertical like the tree it was made from, but in its heavy bent legs is rooted in the earth.

—Henry Moore

mentality that this altar achieves in its mere 17 inches or so is remarkable and impressive.

This penchant for ornament can also be seen in more recent tribal art from Nigeria, such as that of the Yoruba. The carved wooden doors in Figure 7-2 depict scenes of tribal life and ritual. The figures are angular and stylized;

 7-1 Altar of the Hand, Benin, Nigeria (17th-18th centuries?). Bronze. H: 17¹/2".
 British Museum, London. Heritage Image Partnership (HIP), heritage-images.com.

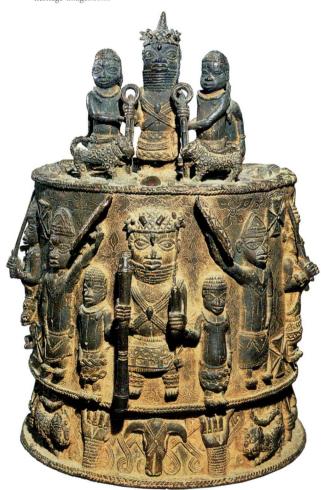

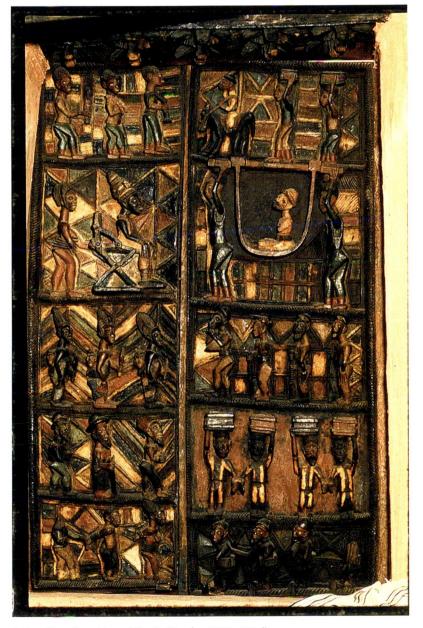

Door from Iderre, Nigeria (Yoruba, 1910–1914).
 Wood. H: 6'.
 British Museum, London. Copyright Art Resource, New York.

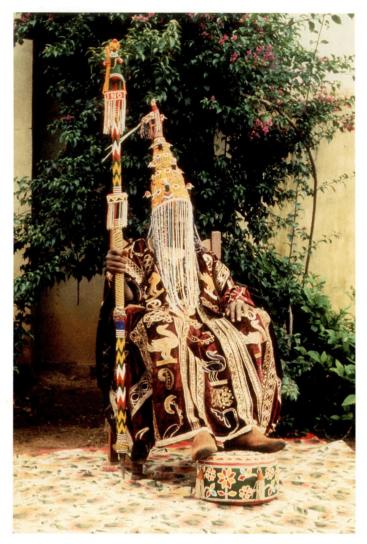

7-3 The ruler of Orangun-Ila, Airowayoye I, with a beaded scepter, crown, veil, and footstool. Nigeria (Yoruba, 1977). Copyright Jack Pemberton.

as in the *Altar of the Hand*, the king, who is seated on a throne, is shown larger than his attendants. The work reads rather like a comic strip, with parts of the narrative confined to small compartments. In most sections, a geometricpatterned background adds a rich, tapestry-like quality to the work. These doors continue artistic traditions established in much older works.

The Yoruba are famous for their mix of the old and the modern in fanciful objects crafted for ceremonial or ritualistic purposes. Masks and headdresses are used in performances called masquerades. They incorporate music, dance, and elaborate costuming in a combination of theater and ritual that often involves social criticism. The beadwork evident in headdresses similar to the crown that is worn by the royal Yoruba ruler in Figure 7-3 is created by a guild of artisans who pass their techniques down from generation to generation. In the ruler's costume, a veil composed of strands of beads covers the face, protecting onlookers from the power of the ruler's eyes. The height of the crown emphasizes the head as the center of power and often contains ritual medicines and potions to enhance that power.

Masks and headdresses are found in other regions of Africa as well, and their symbolism is as widely varied as their style. The simplest of these, such as the Etoumba mask (Fig. 7-5), have facial features resolved into abstract geometric shapes. They are also sometimes punched and slashed with markings intended to represent body scarification. More intricate pieces such as the *mboom* helmet mask from the Kuba people of Zaire (Fig. 7-4) might be embellished with brass, shells, beads, seeds, feathers, and furs. These contrasting textures, along with the protruding chin and prominent forehead, are symbols of royalty. The mask itself represents a primordial ancestor that oversees the passage of boys into adulthood.

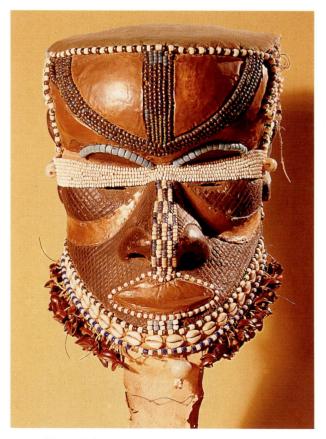

Mboom helmet mask, Zaire (Kuba, 19th–20th centuries).
 Wood, brass, cowrie shells, beads, seeds. H: 13".
 Royal Museum for Central Africa, Tervuren, Belgium.

R S С P R F 0 Ν А 0 M Т

Picasso's Nude with Drapery with an Etoumba Mask

In the early years of the twentieth century, painter Pablo Picasso saw two large exhibitions in Paris. One was of ancient sculpture from his native Spain, carved by the Iberians before their conquest by the Romans; the other was of the native art of African peoples. Both would have a lasting impression on his art.

with those of an African mask like the ones he may have seen at the Musée de l'Homme in Paris (Fig. 7-5). What lines and shapes has Picasso adopted? What other conventions or stylizations of African art has he used? How has the painter captured the simplicity and strength of the traditional mask in his painting?

as he came to understand more fully the importance of the sa-

Compare the facial features of Picasso's painting (Fig. 7-6)

Picasso was enamored of the aesthetic of African art. But

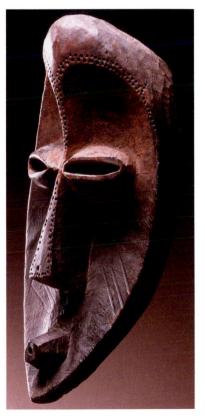

Mask, Etoumba region, Brazzaville, Zaire. 7-5 Wood. H: 13". Copyright abm archives Barbier-Müller, Geneva. Photograph by Pierre-Alain Ferrazzini.

cred and mystical powers of that art to its society, he began to see his own art and perhaps art in general as "a form of magic designed to be a mediator between this strange, hostile world and us, a way of seizing the power by giving form to our terrors as well as our desires."

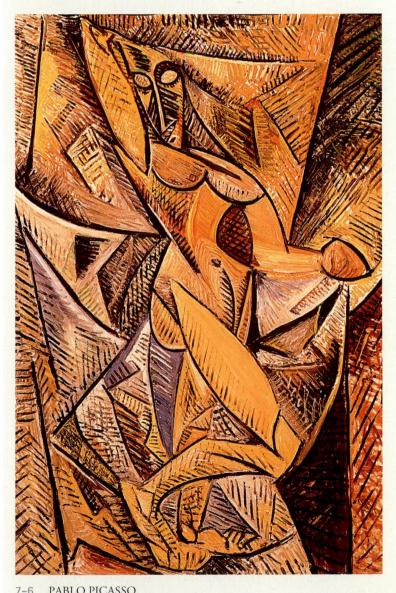

PABLO PICASSO. Nude with Drapery (1907). Oil on canvas. The Hermitage, St. Petersburg. Copyright 2007 Estate of Pablo Picasso/ Artists Rights Society (ARS), New York.

7-7 Ancestral figure, Zaire (Kongo, 19th–20th centuries).
 Wood and brass. H: 16".
 Royal Museum for Central Africa, Tervuren, Belgium.

Other work from Zaire is more conventional in form. A so-called ancestral or power image from the Kongo peoples (Fig. 7-7) is a delicate wood carving of a mother and child, most likely intended as a repository of the soul of a deceased noblewoman (recall the Ka figures of Old Kingdom Egypt). The function of the sculpture was probably to receive prayers for the woman's continuing guardianship and care of the community, but other such figures served to channel ancestral powers from "medicines" placed within or on the sculptures to those in need—warriors in battle, farmers planting crops, or people trying to cure disease.

In many Western societies, Christians light votive candles to request favors from God, to seek the intervention of saints on their behalf, and to thank them for help. In a 7-8 Nkisi nkondi (hunter figure), the Democratic Republic of Congo (collected 1905).
 Wood, metal, glass, and mixed media. H: 38".
 Copyright abm archives Barbier-Müller, Geneva. Photograph by Pierre-Alain Ferrazzini.

number of African societies, priests have hammered nails into carved, wooden **fetish figures** (Fig. 7-8) to seek help from the gods, to ward off evil, to vanquish enemies, or solve problems in their villages. By driving nails into the figure, the villagers believe that wrongdoers will suffer pain. Once the social problem has been solved, the nails may be removed from the figure. Sometimes such fetish figures have human forms, but some are wild animals connected to ancestral spirits. In either case, these figures represent a vehicle for mediation between the living and the dead.

The seated primordial couple in Figure 7-9 are characteristic of another well-known style of African art—that of the Dogon people of Mali, in the western part of the continent. Although the Dogon artist often worked in a more natu7-9 Ancestral couple, Mali (Dogon).Wood. H: 28³/4".

The Metropolitan Museum of Art, New York. Gift of Lester Wunderman, 1977 (1977.394.15). Copyright 1982 The Metropolitan Museum of Art, New York.

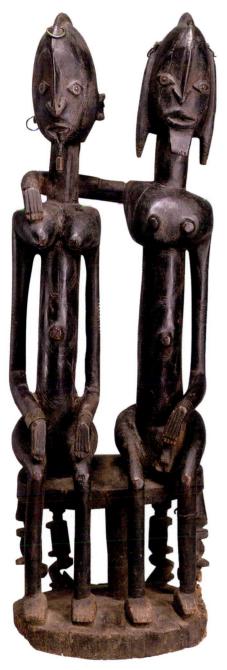

 7-10 The Great Mosque, Djenne, Mali (14th century CE).
 Puddled clay, adobe brick, and wooden poles.
 Copyright Sandro Vannini/CORBIS.

ralistic style, here the artist has opted for a highly stylized, rigid, and elongated figure, incised with overall geometric patterns. This treatment removes the subjects from contemporary reality. The group represents the mythical ancestors of the human race, a kind of Adam and Eve of all of us.

Traders from North Africa brought Islam to Ghana in the eighth century CE, which, because of its wealth, became a vibrant center of Islamic culture. What emerged in terms of religious practice and art was a blend of both traditions. The plan of the Great Mosque at Djenne in Mali (Fig. 7-10), like that of all early mosques, is based on the model of Muhammad's home in Medina. It has a walled courtyard in front of a wall that faces Mecca. Unlike the stone mosques of the Middle East, however, the mosque at Djenne is built of sun-dried bricks and puddled clay. Wooden poles jutting through the clay serve as a kind of scaffold support for workers who replaster the structure yearly to prevent complete erosion of the clay. They also provide a form of exterior "ornamentation," an aspect of a highly decorative aesthetic Muslim art and architecture.

OCEANIC ART

The peoples and art of Oceania are also varied. They span millions of square miles of ocean, ranging from the continent of Australia and large islands of New Guinea and New Zealand to small islands such as the Gilberts, Tahiti, and

 7-11 Great stone figures on Easter Island (Polynesian, 15th century CE).
 H: approx. 30'.
 Copyright George Holton/Photo Researchers, Inc., New York.

> Easter Island. They are divided into the cultures of Polynesia, Melanesia, and Micronesia. We shall discuss works from Polynesia and Melanesia.

Polynesia

The Polynesian artists are known for their figural sculptures, such as the huge stone images of Easter Island (Fig. 7-11). More than 600 of these heads and half-length fig-

ures survive, some of them 60 feet tall. Polynesian art is also known for its massiveness and compactness. Carved between the fifth and seventeenth centuries CE, their jutting, monolithic forms have the abstracted quality of African masks and ancestor figures. Figure after figure has the same angular sweep of nose and chin, the severe pursed lips, and the overbearing brow.

Archeologists have determined that these figures symbolize the power that chieftains were thought to derive from

7-12 Canoe prow (Maori, pre-1935).
Wood. 70⁷/₈" × 29¹/₂".
Musée d'Histoire Naturelle, Ethnographie et Prehistoire, Rouen, France.
Copyright RMN/Art Resource, New York.

the gods and to retain in death through their own deification. Political power in Polynesia was believed to be a reflection of spiritual power. The images of the gods were thought to be combined with those of their descendants in the carvings and other artworks like those on Easter Island.

The Polynesian Maori of New Zealand are known for their wooden relief carvings. The plentiful nature of tough, durable pinewood allowed them to sculpt works with the curvilinear intricacy and vitality of the nearly six-foot-long canoe prow shown in Figure 7-12. The figure at the front of the prow is intended to have an earthy phallic thrust.

The winding snake pattern on the mythic figure and scrollwork of the eighteenth-century canoe prow are like that found on the Maori's tattooed bodies. Body painting and tattooing are governed by tradition and are believed to link the individual to the spirits of ancestors. Ancestor figures are intended to appear menacing to outsiders, but they are perceived as benevolent within the group. Other Maori carvings are found on assembly houses, storehouses, and stockades.

Melanesia

Melanesian art is generally more colorful than that of Polynesia. The cloth masks of New Britain are woven with a certain flair, and the mixed-media ancestral poles of New Guinea (Fig. 7-13) are painted in vivid hues. The intricate poles are carved from single pieces of wood and adorned with palm leaves and paint. Space flows around and through the ancestral poles as it could not pass through the figures at Easter Island. The expressionistically elongated and attenu[Mexican sculpture's] "stoniness," by which I mean its tremendous power without loss of sensitiveness, its astonishing variety and fertility of form-invention, and its approach to a full, three-dimensional concept of form, make it unsurpassed in my opinion by any other period of stone sculpture.

-Henry Moore

ated bodies again represent ancestors. The openwork banners are phallic symbols, intended to give courage to community men in ceremonies before combat with other tribes.

Practical, ceremonial, and decorative uses of art swept across the Pacific into the New World. Many historians and archeologists believe, in fact, that the Americas were first populated many thousands of years ago by migrations across the Pacific.

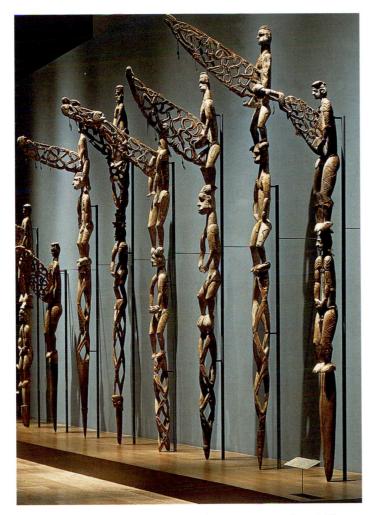

7-13 Ancestor poles, New Guinea (Melanesian, Amsat tribe, 1960).
 Wood, paint, and fiber. Height of tallest pole: 17'11".
 The Metropolitan Museum of Art. The Michael C. Rockefeller Collection.
 Photograph copyright 1982 The Metropolitan Museum of Art, New York.

NATIVE ART OF THE AMERICAS

The art of the Americas was rich and varied before the arrival of European culture. We shall explore the native arts of North America and Peru.

Native Arts of Mexico

Some of the earliest, and certainly the most massive, art of the Americas was produced by the Olmecs in southern Mexico long before the Golden Age of Greece. In addition to huge heads such as that in Figure 7-14, the Olmecs produced small stone carvings, including reliefs.

More than a dozen great heads up to 12 feet in height have been found at Olmec ceremonial centers. The hard

7–14 Colossal head, Villahermosa, Mexico (Olmec culture, c. 500 BCE–200 CE).
 Basalt. H: 8'.
 Copyright Comstock.

 7–15 Effigy vessel, girl on swing, from Remojadas region, Veracruz, Mexico (300–900 CE). Ceramic: 9¼".

The Metropolitan Museum of Art, New York. The Michael C. Rockefeller Memorial Collection. Bequest of Nelson A. Rockefeller, 1979 (1979.206.574). Copyright 1991 The Metropolitan Museum of Art, New York.

basalt and jadeite from which they were carved had to be carted nearly 100 miles. The difficulty of working this material with primitive tools may to some degree account for the works' close adherence to the original monoliths. The heads share the same tight-fitting helmets, broad noses, full lips, and wide cheeks. Whether these colossal heads represent gods or earthly rulers is unknown, but there can be no doubting the power they project.

Henry Moore stated that Mexican sculpture is known for its massiveness. But contrast the Olmec heads with the sprightliness of the kinetic sculpture of the swinging girl (Fig. 7-15). This small piece is actually a whistle. The swinging girl was created many hundreds of years after the Olmec heads and was found in the same region of southern Mexico. We can find a continuity of tradition in the oversized head, but note the delicacy of the curved body. The entire length of the body is nothing but a spread-eagled, draped abstraction.

The Mayans, whose civilization reached its height in the Yucatán region of Mexico and the highlands of Guatemala from about 300 to 600 CE, built many huge limestone structures with **corbelled** vaults. Mayan temples were highly ornamented with figural relief carvings that represent rulers and gods and with commemorative and allegorical murals. The temple discovered at Bonampak in 1947 is decorated with murals of vivid hues such as that in Figure 7-16, in which

prisoners are being presented for sacrifice.

The placement of the reasonably realistic figures along the receding steps symbolizes the social hierarchy. At the bottom are the common people. On the upper platform are noblemen and priests in richly embellished headdresses, as well as their personal attendants, and symbols of the heavens. The prisoners sit and kneel on various levels, visually without a home, whereas the Mayans are rigidly erect in their ascendance. There is no perspective; the figures on the upper registers are not smaller, even though they are farther away. The eye is drawn upward to the center of the composition by the pyramidal shape formed by the scattered prisoners. The figures face the center of the composition,

 7-16 Mural from Mayan temple at Bonampak, Mexico (c. 6th century CE). Watercolor copy by Antonio Tejeda. Copyright Peabody Museum, Harvard University.

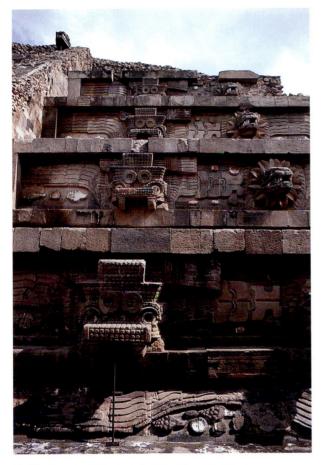

 7–17 Temple of Quetzalcóatl, Teotihuacán, Mexico (300–700 CE).
 Copyright Erich Lessing/Art Resource, New York.

providing symmetry, and the rhythm of the steps provides unity. The subject of human sacrifice is repugnant to us, and well it should be. The composition of the mural, however, shows a classical refinement.

While the Mayans were reaching the height of their power in lower Mexico, the population of the agricultural civilization of Teotihuacán may have reached 100,000. The temples of Teotihuacán, harmoniously grouped in the fertile valley to the north of modern-day Mexico City, include the massive 250-foot-high Pyramid of the Sun and the smaller Temple of Quetzalcóatl (Fig. 7-17). The god Quetzalcóatl was believed to be a feathered serpent. The high-relief head of Quetzalcóatl projects repeatedly from the terraced sculptural panels of the temple, alternating with the squarebrimmed geometric abstractions of Tlaloc, the rain god. Bas-reliefs of abstracted serpent scales and feathers follow sinuous paths on the panels in between.

The warlike Aztecs were a small group of poor nomads until they established their capital, Tenochtitlán, in about 1325 CE on the site of modern Mexico City. Once estab-

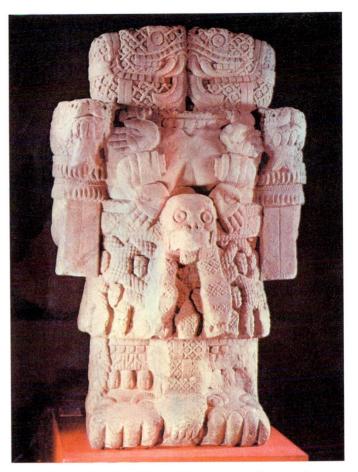

 7-18 Statue of Coatlicue (Aztec, Toltec culture, 15th century). Stone. H: 99".
 National Museum of Anthropology, Mexico City.

lished in Tenochtitlán, the Aztecs made great advances in art and architecture, as well as in mathematics and engineering. But they also cruelly subjugated peoples from surrounding tribes. Prisoners of war were used for human sacrifice in order to compensate the sun god, who was believed to have sacrificed himself in the creation of the human race. It is not surprising that in the early part of the sixteenth century the invading Spaniards found many neighbors of the Aztecs more than eager to help them in their conquest of Mexico. The Aztecs also helped seal their own fate by initially treating the Spaniards, who they believed were descended from Quetzalcóatl, with great hospitality. The Spaniards, needless to say, did not rush to disabuse their hosts of this notion and were thus able to creep into the hearts of the Aztecs within the Trojan Horse of mistaken identity.

Coatlicue was the Aztec goddess of earth and death. In the compact, monumental stone effigy shown in Figure 7-18, Coatlicue takes the form of a composite beast that never was. Her head consists of facing snakes. Her hands are also snakes, her fingers fangs. Hands, hearts, and

A CLOSER LOOK

⁷⁻¹⁹ Bargueño (18th century). Inlaid wood.
17¹/₄" × 28" × 16¹/₄". Collection of Michael Haskell, Santa Barbara, CA.

7-20 MIGUEL CABRERA. Castas (Depiction of Racial Mixtures) (1763). Oil on canvas. 52" × 40¹/₂". Private collection.

Cambios: The Clash of Cultures and the Artistic Fallout

In the year 1492, the king and queen of Spain funded Columbus's trip to the New World. The day after he left Spain's shores, Jews were expelled from the country by decree. Some 27 years later, the Spaniard Hernán Cortez sailed to Mexico and conquered the Aztec Empire. His cam-

paign was brilliant; the empire fell to only 500 Spanish soldiers. The Aztec capital was vanquished in a bloody siege, and much of the Native Mexican population eventually succumbed to smallpox, a virus that the Spaniards introduced and to which the Native Mexicans had not developed immunity. The picture of Spain in the sixteenth century is one of sharp contrasts. It was a country in its "Golden Age," marked by feats of exploration and cultural masterworks, and at the same time, marked by prejudice, savage domination, and the infliction of pain.

The culture of Mexico survived, albeit in a transformed state. And the works of art that emerged during the Spanish Colonial period in Mexico, Central America, and South America bear evidence as well of artistic transformation. These works were the subject of a 1993 exhibition at the Santa Barbara Museum of Art in California—"Cambios: The Spirit of Transformation in Spanish Colonial Art." Cultural clash almost always leaves in its wake fascinating artistic imagery; perhaps in no other encounter of peoples has the interaction and reconciliation of disparate motifs been more well-defined than in the clash of the Spanish and Meso-American cultures.

The exhibition focused on how indigenous art forms, motifs, and techniques were integrated with European influences. In a review of the show in *Latin American Art*, Leslie Westbrook noted that the exhibit illustrated the great diversity of design influences as well as the willingness of artists to combine vocabularies from different cultures and contexts to create a "new world order" on the palette, so to speak.* Some examples of motifs include the Meso-American jaguar, flower-filled jars, leaf patterns, and elaborate borders (Fig. 7-19) reconciled with the lion image, a European formal symmetry, and of course, Christian subject matter. Of special interest is a newly attributed work by Miguel Cabrera entitled *Castas* (Depiction of Racial Mixtures) (Fig. 7-20). It represents the *mestizo*— the child born of the union of a European and a Native American. These children bear the physical characteristics of the two peoples and as such symbolize the "marriage" of two cultures.

The "Cambios" exhibition brought together remnants of a sometimes cruel history, where, as the reviewer remarked, one civilization superseded and dominated another. Yet nothing directly spoke of the cruel and devastating effects of Spanish domination. Instead, a freewheeling creativity—one of absorption, reconciliation, and ancestral legacy—dominated the show, a testimony to the resilience of the human spirit.

^{*}Leslie A. Westbrook, "Cambios: The Spirit of Transformation in Spanish Colonial Art," *Latin American Art* 5, no. 1: 54–57.

skull compose her necklace. Coiled human figures hang from her midsection.

Native Arts of Peru

The native arts of Peru include pyramid-shaped structures that form supports for temples, as in Mexico; stone carvings, mostly in the form of ornamental reliefs on ceremonial architecture; ceramic wares; and astounding feats of engineering.

The ceramic portrait jar shown in Figure 7-21 was created in about the fifth or sixth century CE by the Mochica culture along the Pacific coast of northern Peru. It has a typical flat bottom and stirrup-shaped spout. Other jars show entire human or animal figures, some of them caught in erotic poses.

Figure 7-22 shows the grand ruins of Machu Picchu, the fortress that straddled the Peruvian Andes. This structure, built by the Incas in about 1500 CE, shows an engineering genius that has been compared to the feats of the Romans. The tight fit of the dry masonry walls seems to reflect the tightness of the totalitarian fist with which the In-

can nobility regulated the lives of their own masses and subjugated peoples from Ecuador and Chile.

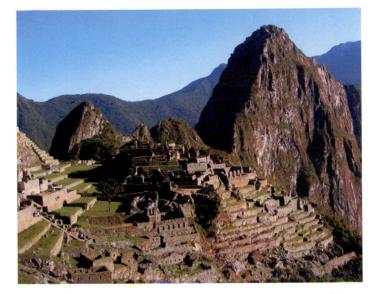

 7–22 Fortress of Machu Picchu, Urubamba Valley, Peru (Incan, 1490–1530).
 Topfoto/The Image Works.

The conquering Spaniards were amazed by the great Incan "Royal Road of the Mountains." Thirty feet wide and walled for its entire 3,750 miles, it had no parallel in Europe.

 7-21 Ceramic portrait jar from Peru (Mochica culture, c. 500 CE). Terra-cotta with paint. Copyright Scala/Art Resource, New York.

7-23 Eskimo mask representing a moon goddess (before 1900).
 Phoebe A. Hearst Museum of Anthropology.
 The University of California at Berkeley.

7–24 Kwakiutl headdress from Vancouver Island, British Columbia, Canada (c. 1895–1900). Wood and muslin. $52'' \times 46''$. Courtesy of the National Museum of the American Indian, Smithsonian Institution, Washington, DC.

Native Arts of the United States and Canada

Some native art objects in the United States and Canada date back nearly 12,000 years. As with African art, much of it is practical craft, much is ceremonial, and all is richly varied. Eskimo, or Inuit, sculpture exhibits a simplicity of form and elegant refinement in both its realistic and abstract designs.

It can also be highly imaginative, as in a mask representing a moon goddess (Fig. 7-23). Such masks, worn by shamans in ritual ceremonies, were carved of ivory or wood and often had movable parts that added to the drama and realism of the object.

Prehistoric sites in what is now the United States also have yielded many interesting works. One of the larger ceremonial sculptures to survive is an earthwork called the Serpent Mound, a snakelike form of molded earth that meanders some 1,440 feet in the Ohio countryside. Pyramidal temple platforms reminiscent of those of Mexico and South America have also been unearthed.

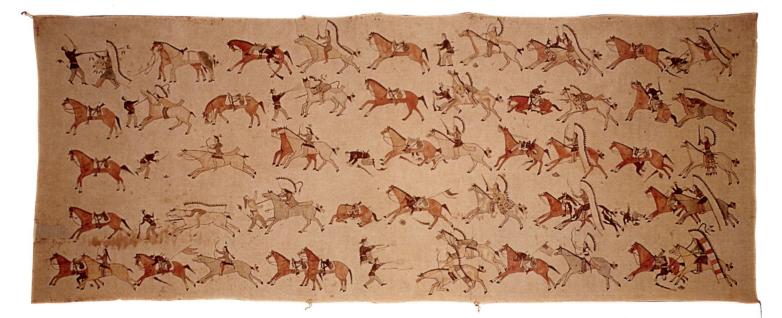

7-25 Custer's Last Stand (Plains culture, late 19th century).
 Teepee lining. Painted muslin. 35" × 85".
 National Museum of Natural History, Department of Anthropology, Smithsonian Institution, Washington, DC.

What I know of Islam is that tolerance, compassion and love are at its very heart.

—Salman Rushdie

Among Native Americans, the Navajos of the Southwest are particularly noted for their fiber artistry and stylized sand paintings that portray the gods and mythic figures. Some of these works are believed to be empowered to heal.

Peoples of the Northwest Coast have produced masks used by shamans in healing rituals, totem poles not unlike the ancestor poles of Oceania, bowls, clothing, and canoes and houses that are embellished with carving and painted ornamentation. The wood and muslin of a four-foot-high Kwakiutl headdress from British Columbia (Fig. 7-24) is vividly painted with abstracted human and animal forms. Like the Inuit moon goddess mask, it too has movable parts. When the string hanging from the inner mask is pulled, the two profiles to the sides are drawn together, forming another mask. The symbols represent the sun and other spirits. It is an extraordinary composition, balanced by the circular flow of fabric above the heads and by the bilateral symmetry in the placement of the shapes. As is often the case in ethnographic art, the embellishment of the work reflects traditional body decoration, such as painting, tattooing, or scarification.

The nomadic tribes of the Great Plains poured their artistic energies into embellishing portable items, such as garments and teepees. The muslin teepee lining of the Crow peoples of the Plains (Fig. 7-25) is a multihued and fairly realistic portrayal of nineteenth-century warfare with the U.S. cavalry. In this symbolic collection of events, Crow warriors advance rhythmically from the right. Many chieftains sport splendid feather headdresses. The cavalry is largely unhorsed and apparently unable to stop the implied momentum of the charge, which is very much like the sequence of frames in a motion picture.

ISLAMIC ART

The era of Islam was founded in Arabia by Muhammad in 622 CE. Within a century, the Islamic—also known as Muslim—faith had been spread by conquering armies westward across North Africa to the Atlantic Ocean. It also spread to the east. So it is that many of the great monuments of Islamic art and architecture are found as far west as Spain and as far east as Agra in India. Muslims look upon the Old and New Testaments as well as the Koran as holy scriptures, and they number Abraham, Moses, and Jesus among their prophets. The Great Mosque at Samarra, Iraq (Fig. 7-26), was constructed between 848 and 852 CE. Once the largest mosque in the world of Islam, it now lies in ruins. Its most striking feature is the spiral minaret, from which a crier known as a **muezzin** called followers to prayer at certain hours. Mosques avoid symbols, and early mosques in particular do not show ornamentation. Nor is there the clerical hierarchy in Islam that is found in many Christian religions. The leader of gatherings for worship, called the **imam**, stands on a pulpit in the mosque, near the wall that faces Mecca, the spiritual capital of Islam.

The mosque at Samarra was a simple building, 800 feet long and 520 feet wide, covered in part by a wooden roof, with a great open courtyard. The roof was supported by the **hypostyle** system of multiple rows of columns that could be expanded in any direction as the population of the

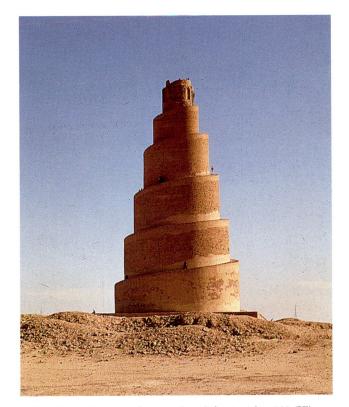

7–26 Great Mosque at Samarra, Iraq (Islamic, 848–852 CE). Copyright Scala/Art Resource, New York.

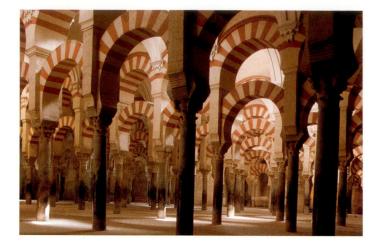

 7–27 Sanctuary of the Mosque at Córdoba, Spain (Islamic) (786–987 CE). Interior view.
 Adam Woolfitt/Corbis.

> congregation grew. By bowing toward Mecca in the same yard, worshipers were granted equal psychological access to Allah, the Islamic name of God.

The interior of the mosque at Córdoba, Spain (Fig. 7-27) shows the system of arches that spans the distances between columns in the hypostyle system. A series of vaults, supported by heavier piers, overspreads the arches. There is no grand open space as in the Western cathedral; rather, air and light flow as through a forest of high-crowned trees. The interiors of mosques have traditionally been decorated with finely

7–29 Taj Mahal, Agra, India (Islamic, 1630–1648).Copyright Photo Researchers, Inc./Koch.

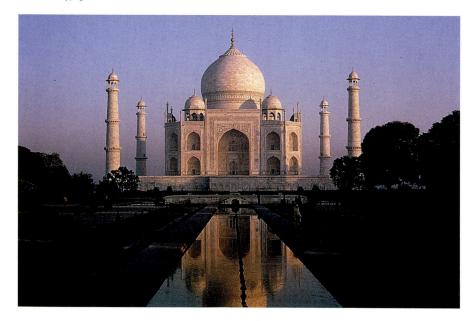

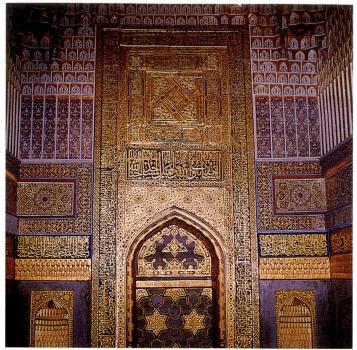

7–28 Mihrab, Mosque at Isfahan, Iran (1617). Copyright Art Resource, New York.

detailed mosaics, as seen in a mosque in Isfahan, Iran (Figure 7-28). Our photograph shows the **mihrab**, a niche in the wall facing Mecca that provides a focus of worship.

The Taj Mahal at Agra (Fig. 7-29) is a mausoleum built by Shah Jahan in the seventeenth century in memory of his wife. In sharp contrast to the plainness of early Islamic architecture, tree-lined pools reflect a refined elegance. The

> three-quarters sphere of the dome is a stunning feat of engineering. Open archways, with their ever-changing play of light and shade, slender minarets, and spires give the marble structure a look of weightlessness. Creamy marble seems to melt in the perfect order.

INDIAN ART

Indian art, like that of the Americas, shows a history of thousands of years, and it too has been influenced by different cultures. Stone sculptures and **seals** that date to the second or third millennium BCE have been discovered. In low relief, the seals portray sensuous, rounded native animals and humanoid figures that presage the chief Hindu god, **Shiva.** India once encompassed present-day Pakistan, Bangladesh, and the buffer states between modern India and China. Many religious traditions have conflicted and sometimes peacefully coexisted in India, among them the Vedic religion, Hinduism, Buddhism, and Islam. Today Islam is the dominant religion of Pakistan, and Hinduism predominates in India. Indian art, like Islamic art, is found in many parts of Asia where Indian cultural influence once reigned, as in Indochina.

Buddhism flowered from earlier Indian traditions in the sixth century BCE, largely as a result of the example set by a prince named Siddhartha. In his later years Siddhartha renounced his birthright and earthly luxuries to become a Buddha, or enlightened being. Through meditation and selfdenial, he is believed to have reached a comprehension of the universe that Buddhists call nirvana. After his death, Buddha's cremated remains were supposedly placed in stupas in eight different locations in India. These sites became places of worship and devotion for his followers. The Great Stupa at Sanchi (Fig. 7-30) was completed in the first century CE. The stupa is crowned by a large dome that symbolizes the sky. The dome is visually separated from the base of the structure by a stone railing or fence-known as the vedika-echoing the separation of the heavenly and earthly spheres. Pilgrims circumnavigate the mound in a clockwise

7-30 The Great Stupa, Sanchi, India (Shunga and Early Andhra periods, 3rd century BCE–early 1st century CE).
 H: 65'.
 Copyright Adam Woolfitt/CORBIS.

direction, as if tracing the path of the sun across the sky. The worshipers' relationship to the monument concentrates on the exterior rather than the interior as, for example, in the case of the Christian church.

The bracket figure (Fig. 7-31) on a gateway to the Great Stupa is a *yakshia*—pre-Buddhist goddess who was believed to embody the generative forces of nature. She appears to be nude, but a hemline reveals that she wears a diaphanous garment. Her ample breasts and sex organs symbolize the force of her productive powers. The voluptuousness of such figures stands in contrast to the often ascetic figures we find in Western religious art.

For many hundreds of years there were no images of the Buddha, but sculptures and other representations began to appear in the second century CE. Some sculpted Buddhas show a Western influence that can be traced to the conquest of northwestern India by Alexander the Great in 327 BCE. Others have a sensuous, rounded look that recalls the ancient seals and is decidedly Indian. The slender

 7-31 Yakshi bracket figure from the east gate of the Great Stupa at Sanchi, India (Early Andhra period, 1st century BCE).
 Stone. H: approx 60".
 Copyright Charles and Josette Lenars/CORBIS.

7-32 Buddha Calling on the Earth to Witness, India (Bengal Pala period, 9th century CE).
Black chlorite. H: 99 cm.
Copyright The Cleveland Museum of Art. Dudley P. Allen Fund, 1935.

chlorite Buddha (Fig. 7-32) shows delicate fingers and gauzelike, revealing drapery. The face exhibits a pleasant cast that is as inscrutable as the expression of La Gioconda in Leonardo's *Mona Lisa* (see Fig. 5-19).

Let us briefly travel west of India to view the colossal Buddha carved out of living rock at Bamiyan, Afghanistan (Fig. 7-33). The statue portrays the eternal form of Buddha in the belief that his earthly form was purely transient. The concept of eternity is expressed in part through scale. This Buddha, 180 feet tall, and its somewhat smaller companion, 120 feet tall, commanded the surrounding landscape and was so well-known that tiny replicas were carved for visitors as souvenirs that they carried back to their home countries.

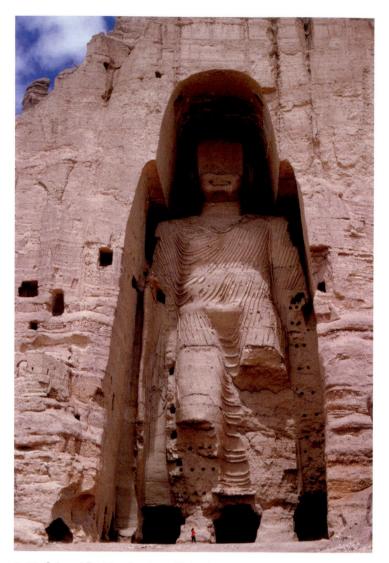

 7-33 Colossal Buddha, Bamiyan, Afghanistan (2nd-5th centuries CE). Destroyed in 2001. Stone. H: 180'.
 Copyright Charles and Josette Lenars/CORBIS.

Even though the photograph seems to suggest a rather rough-hewn rendering of Buddha, it is quite possible that it was gilded and had applications of plaster and pigment. The Taliban destroyed these figures in 2001 despite pleas by other nations who offered to remove and preserve them at their own expense.

In the sixth and seventh centuries CE, Hinduism rose to prominence in India, perhaps because it permitted more paths for reaching nirvana, including the simple carrying out of one's daily duties. Another reason for the popularity of Hinduism may be its frank appreciation of eroticism. Western religions impose a distinction between the body or flesh, on the one hand, and the soul or mind, on the other.

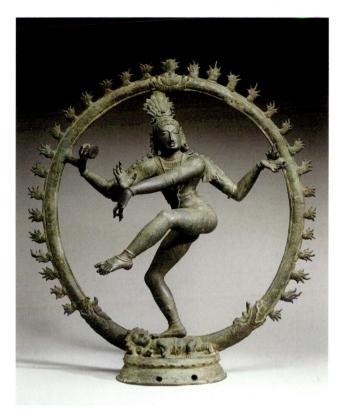

- 7-34 Nataraja: Shiva as King of Dance, South India (Chola period, 11th century CE).
 Bronze. H: 43⁷/₈"; W: 40".
 Copyright 2000 The Cleveland Museum of Art. Purchase from the J. H. Wade Fund (1930.331).
- 7–35 Kandariya Mahadeva Temple, Khajuraho, India (10th–11th centuries CE). Copyright George Holton/Photo Researchers, Inc., New York.

As a consequence, sex is often seen as being at odds with religious purity. Hinduism considers sexual expression to be one legitimate path to virtue. Explicit sexual acts in high reliefs adorn temple walls and amaze Western visitors.

There are many Hindu gods, including Shiva, the Lord of Lords and god of creation and destruction, which, in Hindu philosophy, are one. Figure 7-34 shows Shiva as Nataraja, the King of Dance. With one foot on the Demon of Ignorance, this eleventh-century bronze figure dances within a symbolically splendid fiery aura. The limbs are sensuous, even erotic. The small figure to the right side of his head is Ganga, the river goddess. This periodic dance destroys the universe, which is then reborn. So, in Hindu belief, is the human spirit reborn after death, its new form reflecting the sum of the virtues of its previous existences.

Hindu temples are considered to be the dwelling places of the gods, not houses of worship. The proportions of the famous Kandariya Mahadeva Temple at Khajuraho (Fig. 7-35) symbolize cosmic rhythms. The gradual unfolding of spaces within is highlighted by the sculptural procession of exterior forms. The organic, natural shapes of the multiple roofs are in most sections separated from the horizontal registers of the base by sweeping cornices. The main tower is an abstracted mountain peak, reached visually by ascending what appear to be architectural and natural hurdles. All this can be seen as representing human paths to oneness with the universe. The registers of the base are populated by high reliefs of gods, allegorical scenes, and idealized men and women in erotic positions.

Other Hindu temples are even more intricate. Vast pyramidal bases contain forests of towers and spires, corniced

> at the edges as they ascend from level to fanciful level. They are thick with low and high reliefs. In the Buddhist temples of Indochina, the giant face of Buddha looms from the walls of imposing towers and gazes in many directions. Indian art, including Indian painting—of which little, sad to say, survives-teaches us again how different the content of the visual arts can be. Still, techniques such as that of stone carving and bronze casting, as well as elements of composition, seem to possess a universal validity.

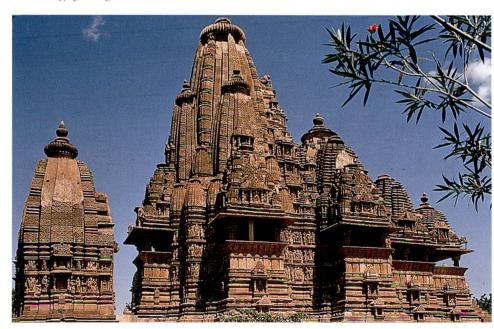

7–36 Ceremonial vessel (Guang), from a royal tomb at Anyang, Henan (Shang dynasty, 12th century BCE). Bronze. L: 12¹/4". Courtesy of the Freer Gallery of Art, Smithsonian Institution, Washington, DC.

CHINESE ART

China houses more than a billion people in a country not quite as large as the United States. Nearly 4,000 years ago, inhabitants of China were producing primitive crafts. Beautiful bronze vessels embellished with stylized animal imagery were cast during the second millennium BCE, such as the one shown in Figure 7-36. During the feudal period of the Late Chou dynasty, which was contemporaneous with the Golden Age of Greece, royal metalworks were inlaid with gold, silver, and polished mirrors. Elegant carvings of fine jade were buried with their noble owners.

Confucianism ascended as the major Chinese way of life during the second century BCE. It is based on the moral principles of Confucius, which argue that social behavior must be derived from sympathy for one's fellows. Paintings and reliefs of this period show the conceptual space of Egyptian painting and create the illusion of depth by means of overlapping. Missionaries from India successfully introduced Buddhism to China during the second century CE, and many Chinese artists imitated Indian models for a few centuries afterward. But by the sixth century, Chinese art was again Chinese. Landscape paintings transported viewers to unfamiliar, magical realms. It was believed by many that artist and work of art were united by a great moving spirit. Centuries after the introduction of Buddhism, Confucianism again emerged. The present-day Peoples Republic of China is officially atheistic, but many Chinese still follow the precepts of Confucius.

Fan K'uan's *Travelers among Mountains and Streams* (Fig. 7-37) was painted on a silk scroll during the early part

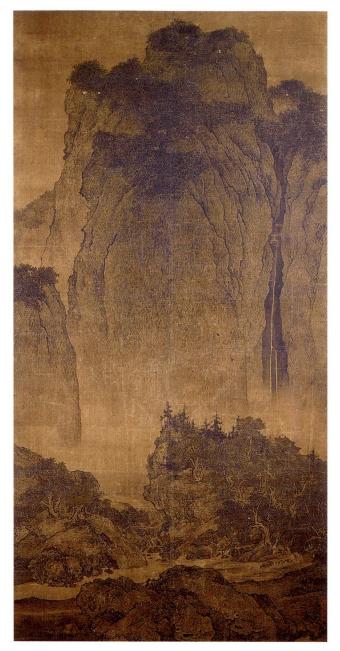

7-37 FAN K'UAN.

Travelers among Mountains and Streams (c. 1000 CE). Hanging scroll, ink and colors on silk. H: 81³/4". Collection of the National Palace Museum, Taiwan.

of the eleventh century. Years of political turmoil had reinforced the artistic escape into imaginary landscapes. It is executed in the so-called Monumental style. Rocks in the foreground create a visual barrier that prevents the viewer from being drawn suddenly into the painting. Rounded forms rise in orderly, rhythmic fashion from foreground through background. Sharp brushstrokes clearly delineate conifers, deciduous trees, and small temples on the cliff in the middle

A Chinese poem:

To what can our life on earth be likened? To a flock of geese, alighting on the snow. Sometimes leaving a trace of their passage.

—Su Dongpo, 11th century CE

ground. The waterfall down the high cliffs to the right is balanced by the cleft to the left. A high contrast in values picks out the waterfall from the cliffs. Distant mountains dwarf human figures. In contrast to the perspective typical of Western landscapes, there is no single vanishing point or set of vanishing points. The perspective shifts, offering the viewer a freer journey back across the many paths and bridges.

The blue and white porcelain vase from the Ming dynasty (Fig. 7-38) speaks eloquently of the refinement of Chinese ceramics. The crafting of vases such as these was a hereditary art, passed on from father to son over many generations. Labor was also frequently divided so that one craftsman made the vase and others glazed and decorated it. The vase has a blue underglaze decoration—that is, a decoration molded or incised beneath rather than on top of the glaze. Transparent glazing increases the brilliance of the piece. In many instances the incising or molding was so subtle that it amounted to "secret" decoration.

Li K'an's fourteenth-century ink painting, *Bamboo* (Fig. 7-39), possesses an almost unbearable beauty. The entire composition consists of minor variations in line and tone. On one level it is a realistic representation of bamboo leaves, with texture gradient providing a powerful illusion of depth. On another level, it is a nonobjective symphony of

7–38 Vase (Ming dynasty, 1368–1644 CE). Porcelain. Musée Guimet, Paris/RMN/ Art Resource, New York.

7-39 LI K'AN.

Bamboo (1308 CE). Detail of 1st section. Hand scroll. Ink on paper. $14^{3}/4'' \times 93^{1}/2''$. The Nelson-Atkins Museum of Art, Kansas City, MO. Purchase Nelson Trust.

calligraphic brushstrokes. The mass of white paper showing in the background is a symbolic statement of purity, not a realistic rendering of natural elements such as haze.

In much of Chinese art there is a non-Western type of reverence for nature in which people are seen as integral parts of the order of nature, neither its rulers nor its victims. In moments of enlightenment, we understand how we create and are of this order, very much in the way Li K'an must have felt that his spirit had both created and been derived from these leaves of bamboo and the natural order that they represent.

How can we hope to have spoken meaningfully about the depth and beauty of Chinese philosophies and Chinese arts in but a few sentences? Our words are mean strokes, indeed, but perhaps they point in the right direction.

JAPANESE ART

Japan is an island country off the eastern coast of Asia, holding more than 120 million people in an area not quite as large as California. The islands were originally formed from porous volcanic rock, and thus they are devoid of hard stone suitable for sculpture and building. Therefore, Japan's sculpture tradition has focused on clay modeling and bronze casting, and its structures have been built from wood.

The Japanese tradition, like the Western tradition, has various periods and styles. In Japanese art, as in Western art, we find a developing technology, the effect of native materials, indigenous and foreign influences, a mix of religious traditions, and disagreement as to what art is intended to portray. Despite its vast differences from Western art, Japanese art shows similar meanings and functions. Japanese artists also use the same elements of art, in their own fashion, to shape brilliant compositions.

Ceramic figures and vessels date to the fourth millennium BCE. Over the past 2,000 years, Japanese art has been intermittently influenced by the arts of nearby China and Korea. In the fifth and sixth centuries CE, the Japanese produced **haniwa**, hollow ceramic figures with tubular limbs modeled from slabs of clay. Haniwa were placed around burial plots, but their function is unknown.

By the beginning of the seventh century, Buddhism had been exported from China and established as the state religion in Japan. Many sculptors produced wooden and bronze effigies of the Buddha, and Buddhist temples reflected the Chinese style. Shinto, the native religion of Japan, teaches love of nature and the existence of many beneficent gods, who are never symbolized in art or any other visual form.

7-40 Kumano Mandala, Japan (Kamakura period, c. 1300 CE).
 Hanging scroll. Color on silk. 53³/₄" × 24³/₈".
 The Cleveland Museum of Art. John L. Severance Fund.

A Japanese poem:

Temple bells die out. The fragrant blossoms remain. A perfect evening!

—Matsuō Bash, 17th century CE

For nearly 2,000 years, wooden Shinto shrines, such as those shown in Figure 7-40, have been razed every 20 years and replaced by duplicates. The landscapes, portraits, and narrative scrolls produced by the Japanese during the Kamakura period, which spanned the late twelfth through the early fourteenth centuries CE, are highly original and Japanese in character. Some of them express the contemplative life of Buddhism, others express the active life of the warrior, and still others express the aesthetic life made possible by love of nature.

The Kumano Mandala (Fig. 7-40), a scroll executed at the beginning of the fourteenth century, represents three **Shinto** shrines. These are actually several miles apart in mountainous terrain, but the artist collapsed the space between them to permit the viewer an easier visual pilgrimage. The scroll pays homage to the unique Japanese landscape in its vivid color and rich detail. The several small figures of the seated Buddha portrayed within testify to the Japanese reconciliation of disparate spiritual influences. The repetition of forms within the shrines and the procession of the shrines themselves afford the composition a wonderful rhythm and unity. A **mandala** is a religious symbol of the design of the universe. It seems as though the universe of the shrines of the Kumano Mandala must carry on forever, as, indeed, it did in the minds of the Japanese.

Some periods of Japanese art have given rise to an extraordinary realism, as in the thirteenth-century wood sculpture of *The Sage Kuya Invoking the Amida Buddha* (Fig. 7-41). From the stance of the figure and the keen observation of every drapery fold, to the crystal used to create the illusion of actual eyes, this sculptor's effort to reproduce reality knew no bounds. The artist even went as far as to attempt to render speech: Six tiny images of Buddha come forth from the sage's mouth, representing the syllables of a prayer that repeats the name of Buddha. A remarkable balance between the earthly and the spiritual is achieved through the use of extreme realism to portray a subject that refers to religion.

7-41 The Sage Kuya Invoking the Amida Buddha (Kamakura period, 13th century CE).
Painted wood. H: approx. 46".
Copyright Pacific Press, Tokyo.

Some three centuries later, Hasegawa Tohaku painted his masterful Pine Wood (Fig. 7-42) on a pair of screens. It is reminiscent of Li K'an's study of bamboo in that the plant life stands alone. No rocks or figures occupy the foreground. No mountains press the skies in the background. Like Bamboo, it is also monochromatic. The illusion of depth-and, indeed, the illusion of dreamy mists-is evoked by subtle gradations in tone and texture. Overlapping and relative size also play their roles in the provision of perspective. Without foreground and background, there is no point of reference from which we can infer the scale of the trees. Their monumentality is implied by the power of the artist's brushstrokes. The groupings of trees to the left have a soft sculptural quality and the overall form of delicate ceramic wares. The groupings of trees within each screen balance one another, and the overall composition is suggestive of the infinite directional strivings of nature to find form and express itself.

We noted that Picasso was strongly influenced by the art of Africa. Many Western artists of the nineteenth century were influenced by the art of the East, particularly prints from Japan, which were being imported to Paris and other

7-42 HASEGAWA TOHAKU.
 Pine Wood (1539–1610 CE). Detail from a pair of sixfold screens.
 Ink on paper. H: 61".
 Tokyo National Museum/DNPArchives.com.

7-43 ANDO HIROSHIGE.
 Rain Shower on Ohashi Bridge (1857).
 Color woodblock on paper. 13⁷/₈" × 9¹/₈".
 The Cleveland Museum of Art. Gift of J. J. Wade.

Western cultural centers. The French Impressionist Edgar Degas, in fact, hung a print by Torii Kiyonaga in his bedroom. Modern artists were intrigued by the flatness of space, the decorative patterns, brilliant palette, and off-center compositions in Japanese woodcuts, such as Hiroshige's *Rain Shower on Ohashi Bridge* (Fig. 7-43). Vincent van Gogh, in fact, made an oil-on-canvas painting of this print, adding a decorative frame, complete with calligraphic patterns (Fig. 7-44). The ordinariness of Japanese subjects also struck a chord among the Modernists who were trying to escape the grip of mythological and historical painting.

The opening of trade between Japan and the West in the mid-nineteenth century revealed new artistic worlds to the painters in Western Europe. Van Gogh wasn't the only artist of his time to copy or reinterpret the masterworks of Japanese painters, printmakers, and porcelain artists. Copying, as we have seen, has always been a way to come to

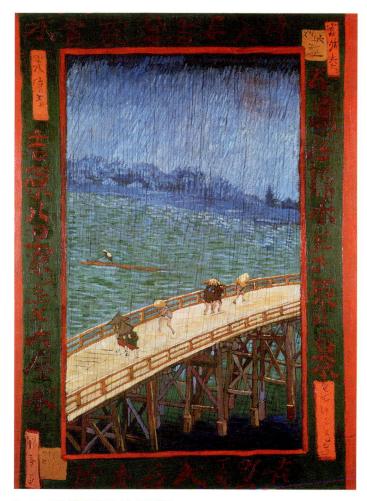

 7-45 SILVIA REINSTEIN. Untitled. Acrylic on paper with painted frame. 26" × 20". Courtesy K. S. Art, New York.

7-44 VINCENT VAN GOGH. Bridge in the Rain, copy after Ando Hiroshige (1887). Oil on canvas. $28^{3}/4'' \times 18^{1}/4''$. Van Gogh Museum, Amsterdam. Copyright Corbis.

understand—and to know deeply—the process and the product of art. But according to art critic Lyle Rexer, for some self-taught, "outsider" artists (see Chapter 1), it has also been a way to experience times and places that would otherwise remain unreachable. Although never intended to hang anywhere nor appear in any compendium of art history, Silvia Reinstein's untitled acrylic work on paper, embellished by a painted gold frame (Fig. 7-45), bears the same hallmark of inspiration by Japanese prints as the works of her "insider," Impressionist predecessors.

The ability to represent nature with exacting realism was a goal that united most Western artists through the ages. There were occasional deviations, as among the Christian artists of the Middle Ages, for whom representing the physicality of the figure was unimportant. Their choice was not based on an inability to mirror nature, but on the belief that the soul—and not the body—was a more relevant and intimate part of God's celestial plan. During the Renaissance, Western artists—including those who portrayed religious subjects—devised perspective to master the illusion of reality. As humanism took hold, the figure in sculpture and painting also appeared "more human."

Mimesis—imitation in representation—was never as much a goal for artists beyond the West, not because of lack of skill but because their artistic goals were not the same. Once art entered the modern era in the West, and artists had reached the height of their ability to represent nature with utmost accuracy, some, to be sure, continued in the realistic tradition, but others found it meaningless. After all, early enough in the nineteenth century, the camera would be able to do that for them. It was when art no longer needed to be consonant with realism that art beyond the West spoke most cogently to these artists. It was the exploration of art beyond the West that steered Western modernism on a different course.

MODERN ART

Most painting in the European tradition was painting the mask. Modern art rejected all that. Our subject matter was the person behind the mask. —Robert Motherwell

istorians of modern art have repeatedly posed the question, "When did modern art begin?" Some link the beginnings of modern painting to the French Revolution in 1789. Others have chosen 1863, the year of a landmark exhibition of "modern" painting in Paris.

Another issue of interest has been "Just what is modern about modern art?" The artists of the mid-fifteenth century looked upon their art as modern. They chose new subjects, materials, and techniques that signaled a radical change from a medieval past. Their development of one-point linear perspective altered the face of painting completely. From our perspective, modern art begins with the changes in the representation of space as introduced by artists of the late eighteenth century. Unlike the Renaissance masters, who sought to open up endless vistas within the canvas, the artists of the latter 1700s thrust all of the imagery toward the **picture plane**. The flatness or two-dimensionality of the canvas surface was asserted by the use of **planar recession** rather than **linear recession**. Not all artists of the eighteenth centuries abided by this novel treatment of space, but with this innovation the die was cast for the future of painting.

In short, what was *modern* about the modern art of the eighteenth century in France was its concept of space. In a very real sense, the history of modern art is the history of two differing perceptions and renderings of that space.

As we shall see in this chapter, the flattening of pictorial space begins in the late eighteenth century with Jacques-Louis David and Neoclassicism. Romanticism followed closely in its wake, at times displaying stylistic continuity with its predecessor and at times diametrically opposed to it. We shall discuss the survival of Academic painting in the nineteenth century and consider the relationship between art, politics, and social consciousness. In the mid-nineteenth century, change was everywhere. Realist artists rejected the content of Academic art and took to the subjects of life around them. The Impressionists rejected the isolation of the artist's studio and took to the outdoors to paint, recording the fleeting optical impressions of light and atmosphere. The new medium of photography experienced technical strides, and its growing familiarity had a marked influence on later-nineteenth-century painting. Paris had become the center of the art world.

NEOCLASSICISM

Modern art declared its opposition to the whimsy of the late Rococo style with **Neoclassical art.** The Neoclassical style is

8–1 JACQUES-LOUIS DAVID. *The Oath of the Horatii* (1784).

Oil on canvas. 14' × 11'. Louvre Museum, Paris/Scala/ Art Resources, New York. characterized by harsh sculptural lines, a subdued palette, and for the most part, planar instead of linear recession into space. The subject matter of Neoclassicism was inspired by the French Revolution and designed to heighten moral standards. The new morality sought to replace the corruption and decadence of Louis XVI's France. The Roman Empire was often chosen as the model to emulate. For this reason, the artists of the Napoleonic era imitated the form and content of Classical works of art. This interest in antiquity was fueled by contemporaneous archeological finds at sites such as Pompeii as well as by numerous excavations in Greece.

Jacques-Louis David

The sterling proponent of the Neoclassical style and official painter of the French Revolution was Jacques-Louis David (1748–1825). David literally gave postrevolutionary France a new look. He designed everything from clothing to coiffures. David also set the course for modern art with a sudden and decisive break from the ornateness and frivolity of the Rococo.

In *The Oath of the Horatii* (Fig. 8-1), David portrayed a dramatic event from Roman history in order to heighten French patriotism and courage. Three brothers prepare to fight an enemy of Rome, swearing an oath to the empire on swords upheld by their father. To the right, their mother and other relatives collapse in despair. They weep for the

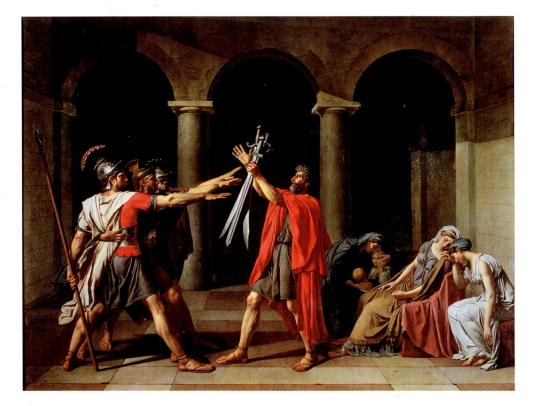

men's safety but are also distraught because one of the enemy men is engaged to a sister of the Horatii. Family is pitted against family in a conflict that no one can win. Such a subject could descend into pathos, but David controlled any tendency toward sentimentality by reviving the Classical balance of emotion and restraint. The emotionality of the theme is countered by David's cool rendition of forms. The elements of the composition further work to harness emotionalism. Harsh sculptural lines define the figures and setting. The palette is reduced to muted blues and grays, with an occasional splash of deep red. Emotional response is barely evident in the idealized Classical faces of the figures.

A number of Classical devices in David's compositional format also function to balance emotion and restraint. The figural groups form a rough triangle. Their apex-the clasped swords of the Horatii—is the most important point of the composition. In the same way that Leonardo used three windows in his Last Supper, David silhouetted his dramatic moment against the central opening of three arches in the background. David further imitated Renaissance canvases by presenting cues for a linear perspective in the patterning of the floor. But unlike sixteenthcentury artists, David led his orthogonals into a flattened space instead of a vanishing point on a horizon line. The closing off of this background space forces the viewer's eye to the front of the picture plane, where it encounters the action of the composition and the canvas surface itself. No longer does the artist desire to trick observers into believing they are looking through a window frame into the distance. Now the reality of the two-dimensionality of the canvas is asserted.

8-2 ANGELICA KAUFFMAN. The Artist in the Character of Design Listening to the Inspiration of Poetry (1782).

Oil on canvas. D: 24". The Iveagh Bequest, Kenwood, London. Copyright Heritage Image Partnership (HIP), heritage-images.com. David was one of the leaders of the French Revolution, and his political life underwent curious turns. Although he painted *The Oath of the Horatii* for Louis XVI, he supported the faction that deposed him. Later he was to find himself painting a work commemorating the coronation of Napoleon. Having struggled against the French monarchy and then living to see it restored, David chose to spend his last years in exile in Brussels.

Angelica Kauffman

Angelica Kauffman (1741–1807) was another leading Neoclassical painter, an exact contemporary of David. Born in Switzerland and educated in the Neoclassical circles in Rome, Kauffman was responsible for the dissemination of the style in England. She is known for her portraiture, history painting, and narrative works such as *The Artist in the Character of Design Listening to the Inspiration of Poetry* (Fig. 8-2). In this The first virtue of a painting is to be a feast for the eyes.

-Eugène Delacroix

allegorical work, Kauffman paints her own features in the person of the muse of design, who is listening attentively with paper and pencil in hand to her companion muse of poetry. Poetry's idealized facial features, along with the severe architecture, classically rendered drapery, and rich palette place the work firmly in the Neoclassical style.

Jean-Auguste-Dominique Ingres

David abstracted space by using planar rather than linear recession. His most prodigious student, Jean-Auguste-Dominique Ingres (1780–1867), created sensuous, though pristinely Classical compositions in which line functions as an abstract element. Above all else, Ingres was a magnificent draftsman.

Ingres's work is a combination of harsh linearity and sculptural smoothness on the one hand, and delicacy and sensuality on the other. His Grande Odalisque (Fig. 8-7 in the nearby Compare and Contrast feature) portrays a Turkish harem mistress in the tradition of the great reclining Venuses of the Venetian Renaissance. Yet how different it is, for example, from Titian's Venus of Urbino! (See the Compare and Contrast feature later in the chapter.) The elongation of her spine, her attenuated limbs, and odd fullness of form recall the distortions and abstractions of Mannerist art. In the Grande Odalisque, Ingres also delights in the differing qualities of line. The articulation of heavy drapery contrasts markedly with the staccato treatment of the bed linens and the languid, sensual lines of the mistress's body. Like David's, Ingres's forms are smooth and sculptural, and his palette is muted. Ingres also flattens space in his composition by placing his imagery in the foreground, as in a relief.

Ingres's exotic nudes were a popular type of imagery in the late eighteenth century, but other artists often rendered such subjects quite differently. There was a popularity of style during this period that was similar to that existing during the Baroque era. On the one hand were artists such as David and Ingres, who represented the linear style. On the other hand were artists whose works were painterly. The foremost proponents of the painterly style were Géricault and Delacroix. The linear artists, called **Poussinistes**, followed in the footsteps of Classicism with their subdued palette and emphasis on draftsmanship and sculptural forms. The painterly artists, termed the **Rubenistes**, adopted the vibrant palette and aggressive brushstroke of the Baroque artist. The two factions argued vehemently about the merits and the shortcomings of their respective styles. No artists were more deeply entrenched in this feud than the leaders of the camps, Ingres and Delacroix.

Neoclassical Sculpture

The principles of Neoclassicism were embraced by sculptors working in France, England, and the United States. It was the style of choice for official portraits, relief sculptures, and monuments of all sorts. Antonio Canova (1757-1822), trained in Italy, wrote of having to "[sweat] day and night over the Greek models, imbibing their style, turning it into one's own blood." He became the sculptor to Napoleon Bonaparte and was responsible for numerous portraits of the Emperor and members of his family, including his sister, Pauline Borghese (Fig. 8-3). Just as Napoleon chose a Zeuslike pose for his coronation painting by Ingres, Pauline had herself portrayed as the goddess of love-Venus. The reclining figure clearly references classical Greek prototypes, although his is a combination of realism and idealism. Pauline's face has the character of a portrait, however modified or improved, and the finely carved details of the elaborate lounge can almost be described as trompe l'oeil.

Neoclassical Architecture

In the late eighteenth and nineteenth centuries, Neoclassicism also dominated architectural design in France, England, and America. The architects and visionaries of the U.S. capital-Thomas Jefferson included-embraced classical models for their aesthetic beauty and simplicity. The reference to ancient Greece also befitted the young democracy. From Pierre L'Enfant's plan for Washington, D.C., with its radiating boulevards, geometric spaces, and vistas culminating in classical monuments, to Benjamin Latrobe's concepts for the U.S. Capitol building (Fig. 8-4), the city was awash in the serenity and monumentality of columns, pediments, and pristine marble facades. Latrobe especially was a stickler for purity of Greek forms. He combined elements of the Ionic order for the Senate chamber and Corinthian capitals for the House of Representatives. Also of interest is Latrobe's contribution to the White Housean oval room with a columned portico that would come to symbolize the hub of presidential power.

 ANTONIO CANOVA.
 Pauline Borghese as Venus (1808).
 Marble, life-size.
 Galleria Borghese, Rome/
 Dagli Orti/The Art Archive.

ROMANTICISM

Both Neoclassicism and **Romanticism** reflected the revolutionary spirit of the times. Neoclassicism emphasized restraint of emotion, purity of form, and subjects that inspired morality, whereas Romantic art sought extremes of emotion enhanced by virtuoso brushwork and a brilliant palette. The two major proponents of the romantic style in France were Théodore Géricault and Eugène Delacroix.

Théodore Géricault

The depiction of nature as unpredictable and uncontrollable—in the words of the French philosopher Denis Diderot, as stunning the soul and imprinting feelings of terror—was a favorite theme of the romantic artist. A number of French and British paintings of the period reveal a particular fascination with the destructive power of nature at sea, perhaps none as intensely as Théodore Géricault's *Raft of the Medusa* (Fig. 8-5). Based on a shipwreck off the coast of West Africa in 1816, during which a makeshift raft laden

with Algerian immigrants was set adrift by the captain and crew of the crippled French ship, *Medusa*, the painting is viewed as Géricault's most controversial and political work.

Like many of his liberal contemporaries, Géricault (1791–1824) opposed the French monarchy and used the tragedy of the *Medusa* to call attention to the mismanagement and ineffectual policies of the French government, as well as the practice of slavery. The plight of the survivors and victims of the *Medusa* became a national scandal, and Géricault's

 8-4 BENJAMIN LATROBE.
 U.S. Capitol Building (1803 – 1807).
 George D. Lepp/CORBIS.

8-5 THÉODORE GÉRICAULT. Raft of the Medusa (1818–1819). Oil on canvas, approx. 16' × 23'. Louvre, Paris/Reunion Musees Nationaux/Art Resource, New York

authentic documentation—based on interviews with the rescued and visits to the morgue—was intended as a direct attack on the government. The powerful composition is full of realistic detail and explores the full gamut of human emotion under extreme hardship and duress. Much of the drama of Géricault's composition occurs along a diagonal configuration of figures, from the corpse in the lower left that will soon slip into the dark abyss of the ocean, upward along a crescendo that culminates in the muscular torso of a black man waving a flag toward a rescue ship barely visible on the horizon. The fractured raft is tossed about mercilessly by the winds and waves; humans battle against nature, and their own, for sheer survival.

Eugène Delacroix

The most famous Rubeniste—and Ingres's archrival—was Eugène Delacroix (1798–1863). Whereas Ingres believed that a painting was nothing without drawing, Delacroix advocated the spontaneity of painting directly on canvas without the tyranny of meticulous preparatory sketches. Ingres believed that color ought to be subordinated to line, but Delacroix maintained that compositions should be constructed of color. Their contrasting approaches to painting can be seen clearly in the *Odalisque* by each artist (Figs. 8-7 and 8-8 in the Compare and Contrast feature), fine examples of the difference between the Neoclassical and Romantic styles.

One of Delacroix's most dynamic statements of the Romantic style occurs in one of his many compositions devoted to the more exciting themes from literary history. *The Death of Sardanapalus* (Fig. 8-6), inspired by a tragedy by Byron, depicts the murder-suicide of an Assyrian king who, rather than surrender to his attackers, set fire to himself and his entourage. All of the monarch's earthly possessions, including concubines, servants, and Arabian stallions, are heaped upon his lavish gold and velvet bed, now turned funeral pyre. The chaos and terror of the event are rendered

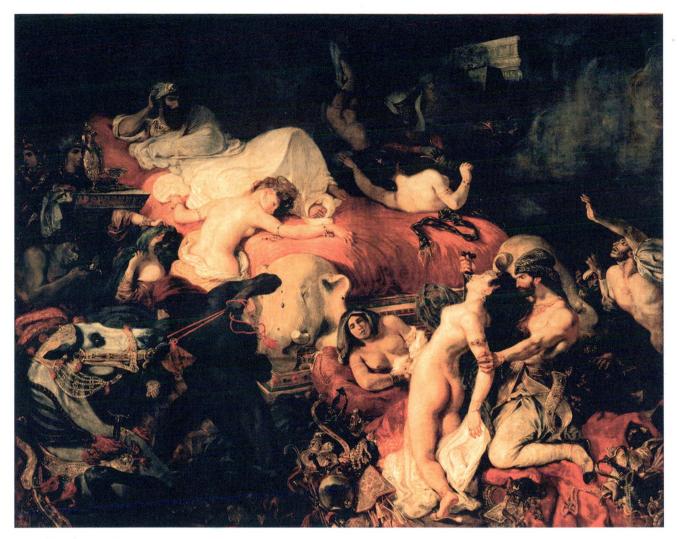

8-6 EUGÈNE DELACROIX. The Death of Sardanapalus (1826). Oil on canvas. 12'11¹/₂" × 16'3". Louvre Museum, Paris. Copyright Edimedia/Corbis.

by Delacroix with all the vigor and passion of a Baroque composition. The explicit contrast between the voluptuous women and the brute strength of the king's executioners brings to mind *The Rape of the Daughters of Leucippus* by Rubens (see Fig. 6-17). Arms reach helplessly in all directions, and backs arch in hopeless defiance or pitiful submission before the passive Sardanapalus. Delacroix's unleashed energy and assaulting palette were strongly criticized by contemporaries who felt that there was no excuse for such a blatant depiction of violence. But his use of bold colors and freely applied pigment, along with the observations on art and nature that he recorded in his journal, were an important influence on the young artists of the nineteenth century who were destined to transform artistic tradition.

Francisco Goya

Ironically, the man considered the greatest painter of the Neoclassical and Romantic periods belonged to neither artistic group. He never visited France, the center of the art world at the time, and was virtually unknown to painters of the late eighteenth and early nineteenth centuries. Yet his paintings and prints foreshadowed the art of the nineteenthcentury Impressionists. Francisco Goya (1746–1828) was born in Spain and, except for an academic excursion to Rome, spent his entire life there. He enjoyed a great reputation in his native country and was awarded many important commissions, including religious frescoes and portraits of Spanish royalty. But Goya is best known for his works with political overtones, ranging from social satire to savage

C O M P A R E + C O N T R A S T

Ingres's Grande Odalisque, Delacroix's Odalisque, Cézanne's A Modern Olympia, and Sleigh's Philip Golub Reclining

Compare-and-contrast exercises are often used to stimulate a student's powers of visual recognition and discrimination, to test the student's ability to characterize and categorize, and to force the student to think critically about the content and context of the work. If put together just right, they ought also to act as a springboard for discussion of issues that push beyond the discipline of art. Tall order? You bet. But somehow these four meet the demands.

You can write paragraphs on the stylistic differences alone between the Odalisque by Ingres (Fig. 8-7) and by Delacroix (Fig. 8-8). They are arch examples of the contrast between a linear and painterly approach to the same subject; they offer clear evidence of the "battle" between the Poussinistes and the Rubenistes during the Romantic period (those whose draftsmanship was inspired by the Classical Baroque artist Nicolas Poussin versus those who "went to school" on the Flemish Baroque painter Peter Paul Rubens). On the other hand, they have one very important thing in common. Both bespeak an enormous fascination with the exotic, with the "Orient," with the other; a seemingly insatiable fascination not only with the trappings of an exotic sensuality-turbans, silken scarves, peacock feathers, opium pipes-but with what was perceived as an unrestrained and exotic sexuality. These two works are in abundant company in nineteenth-century France. Can you do a bit of leg work and find out what circumstances (historical, political, sociological, and so on) prevailed at this moment in time that might have led to a market for such paintings? Why did these very different artists find the same subject so captivating, so fashionable?

Nineteenth-century art historian and feminist scholar Linda Nochlin has suggested that such paintings speak volumes about contemporary ideology and gender discourse— "the ways in which representations of women in art are founded upon and serve to reproduce indisputably accepted assumptions held by society in general, artists in particular, and some artists more than others about men's power over, superiority to, difference from, and necessary control of

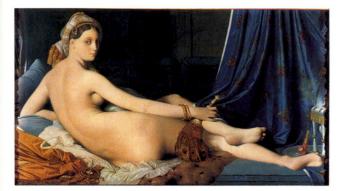

 JEAN-AUGUSTE-DOMINIQUE INGRES. Grande Odalisque (1814).
 Oil on canvas. 35¹/4" × 63³/4".
 Louvre Museum, Paris. Copyright Art Resource, New York.

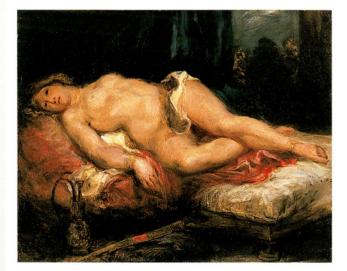

 8-8 EUGÈNE DELACROIX. Odalisque (1845–1850). Oil on canvas. 147.80 3 181. 40. Fitzwilliam Museum, Cambridge, England. Reproduction by permission of the Syndics of the Fitzwilliam Museum.

8-9 PAUL CÉZANNE. A Modern Olympia (1873–1874). Oil on canvas. 18¹/₄" × 21⁷/₈". Musée D'Orsay, Paris. Copyright Erich Lessing/Art Resource, New York.

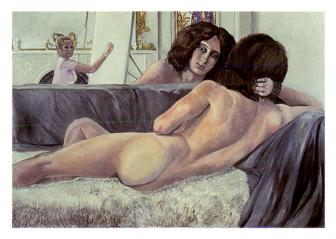

8-10 SYLVIA SLEIGH. *Philip Golub Reclining* (1971). Oil on canvas. $42'' \times 60''$. Courtesy of the artist.

women, assumptions which are manifested in the visual structures as well as the thematic choices of the pictures in question." Among several that Nochlin lists are assumptions about women's weakness and passivity and sexual availability for men's needs.

The works in this feature speak to the tradition of the reclining nude in Western art. In another Compare and Contrast feature in this chapter, you can see some other examples of this tradition and are asked for whose "gaze" you think they were intended. In fact, the concept of the "male gaze" has been central to feminist theory for the past decade. In a landmark article written in 1973, the filmmaker Laura Mulvey explained the roles of the viewer and the viewed in art, literature, and film this way: Men are in the position of looking, and women are "passive, powerless objects of their controlling gaze."

Paul Cézanne's A Modern Olympia (Fig. 8-9) and Sylvia Sleigh's Philip Golub Reclining (Fig. 8-10) seem to address the issue of the "male gaze" straight on, but in ways that could not differ more from one another. Cézanne was surely commenting on Edouard Manet's Olympia, which was painted just 10 years before and had made quite a splash when exhibited. What are the similarities in content? What are the differences? Note, among other things, that Cézanne has placed himself in the picture-owning up, as it were, to the male gaze. Sleigh attacks the issue head on by reversing the "power relationship" in painting. The artist is seen in the background, in mirror reflection, painting the nude torso of Philip Golub from the rear. Does the work raise questions such as "Is this also what women really want to paint?" or "Is this what women want to gaze upon?" Or do you think the purpose of this painting is to call our attention to a tradition in the arts of perpetuating ideological gender attitudes?

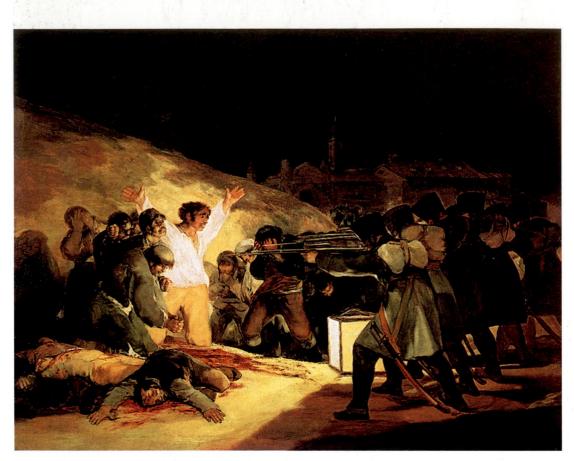

8-11 FRANCISCO GOYA. *The Third of May, 1808* (1814–1815). Oil on canvas. 8'9" × 13'4". Prado, Madrid. Copyright Edimedia/Corbis.

> condemnation of the disasters of war. One of his most famous depictions of war is The Third of May, 1808 (Fig. 8-11). The painting commemorates the massacre of the peasant-citizens of Madrid after the city fell to the French. Reflecting the procedures of Velásquez and Rembrandttwo Baroque masters whom Goya acknowledged as influential in the development of his style-Goya focuses the viewer's attention on a single moment in the violent episode. A Spaniard thrusts his arms upward in surrender to the bayonets of the faceless enemy. The brusqueness of the application of pigment corresponds to the harshness of the subject. The dutiful and regimented procedure of the executioners, dressed in long coats, contrasts visually and psychologically with the expressions of horror, fear, and helplessness on the faces of the ragtag peasants. The emotion is heightened by the use of acerbic tones and by a strong chiaroscuro that illuminates the pitiful victims while relegating all other details to darkness.

Goya devoted much of his life to the graphic representation of man's inhumanity to man. Toward the end of his life he was afflicted with deafness and plagued with bitterness and depression over the atrocities he had witnessed. These feelings were manifested in macabre paintings and lithographs, which presaged the style of the great painters of the nineteenth century.

The Academy

Ingres's paintings spoke of a calm, though exotic Classicism. Delacroix retrieved the dynamism of the Baroque. Goya swathed his canvases with the spirit of revolution. Ironically, the style of painting that had the least impact on the development of modern art was the most popular type of painting in its day. This was **Academic art**, so called because its style and subject matter were derived from conventions established by the Academie Royale de Peinture et de Sculpture in Paris.

Established in 1648, the Academy had maintained a firm grip on artistic production for more than two centuries. Many artists steeped in this tradition were followers rather

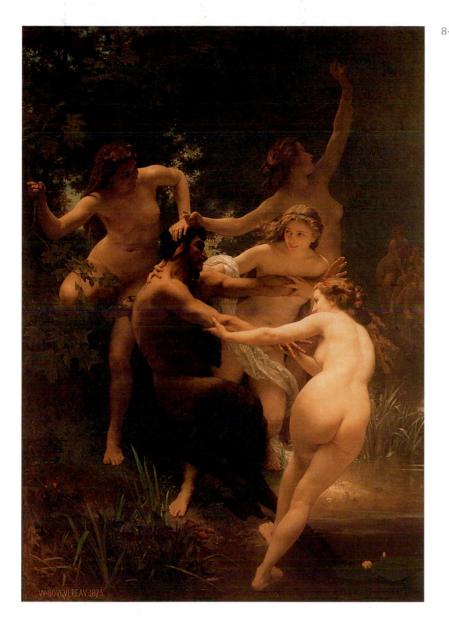

 8-12 ADOLPHE WILLIAM BOUGUEREAU. Nymphs and Satyr (1873). Oil on canvas. 102³/s" × 70⁷/s". Sterling and Francine Clark Art Institute, Williamstown, MA.

than innovators, and the quality of their production left something to be desired. Some, however, like David and Ingres, worked within the confines of a style acceptable to the Academy but rose above the generally rampant mediocrity.

Adolphe William Bouguereau

One of the more popular and accomplished Academic painters was Adolphe William Bouguereau (1825–1905). Included among his oeuvre are religious and historical paintings in a grand Classical manner, although he is most famous for his meticulously painted nudes and mythological subjects. *Nymphs and Satyr* (Fig. 8-12) is nearly photographic in its refined technique and attention to detail. Four sprightly and sensuous wood nymphs corral a hesitant satyr and tug him into the water. Their innocent playfulness would have appealed to the Frenchman on the street, although the saccharine character of the subject matter and the extreme lighthandedness with which the work was painted served only as a model against which the new wave of painters rebelled.

REALISM

The "modern" painters of the nineteenth century objected to Academic art on two levels: The subject matter did not represent life as it really was, and the manner in which the subjects were rendered did not reflect reality as it was observed by the naked eye.

The modern artists chose to depict subjects that were evident in everyday life. The way in which they rendered To record the manners, ideas, and aspects of the age as I myself saw them—to be a man as well as a painter—in short to create a living art—that is my aim.

—Gustave Courbet

these subjects also differed from that of Academic painters. They attempted to render on canvas objects as they saw them—optically—rather than as they knew them to be conceptually. In addition, they respected the reality of the medium they worked with. Instead of using pigment merely as a tool to provide an illusion of three-dimensional reality, they emphasized the two-dimensionality of the canvas and asserted the painting process itself. The physical properties of the pigments were highlighted. Artists who took these ideas to heart were known as the Realists. They include Honoré Daumier and two painters whose work stands on the threshold of the Impressionist movement: Gustave Courbet and Edouard Manet.

Honoré Daumier

Of all of the modern artists of the mid-nineteenth century, Honoré Daumier (1808–1879) was perhaps the most concerned with bringing to light the very real subject of the plight of the masses. Daumier worked as a caricaturist for Parisian journals, and he used his cartoons to convey his disgust with the monarchy and contemporary bourgeois society. His public ridicule of King Louis Philippe landed him in prison for six months.

Daumier is known primarily for his lithographs, which number some 4,000, although he was also an important painter. He brought to his works on canvas the technique and style of a caricaturist. Together, they make for a powerful rendition of his realistic subjects. One of Daumier's most famous compositions is The Third-Class Carriage (Fig. 8-13), an illustration of a crowded third-class compartment of a French train. His caricaturist style is evident in the flowing dark outlines and exaggerated features and gestures, but it also underscores the artist's concern for the working class by advertising their ill fortune. The peasants are crowded into the car, their clothing poor and rumpled, their faces wide and expressionless. They contrast markedly with bourgeois commuters, whose felt top hats tower above the kerchiefed heads. It is a candid-camera depiction of these people. Wrapped up in their own thoughts and disappointments, they live their quite ordinary lives from day to day, without significance and without notice.

8-13 HONORÉ DAUMIER.

The Third-Class Carriage (c. 1862). Oil on canvas. $25^{3}/4'' \times 35^{1}/2''$. The Metropolitan Museum of Art, New York. Bequest of Mrs. H. O. Havemeyer, 1929. The H. O. Havemeyer Collection (29.100.129). Copyright 1985 The Metropolitan Museum of Art, New York.

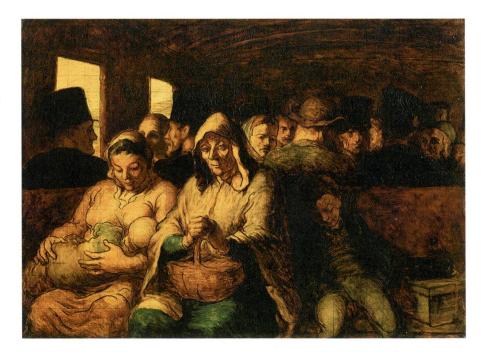

Gustave Courbet

The term "realist," when it applies to art, is synonymous with Gustave Courbet (1819–1877). Considered to be the father of the Realist movement, Courbet used the term "realism" to describe his own work and even issued a manifesto on the subject. As was the case with many artists who broke the mold of the Academic style, Courbet's painting was shunned and decried by contemporary critics. But Courbet proceeded undaunted. After his paintings were rejected by the jurors of the 1855 **Salon**, he set up his own pavilion and exhibited some 40 of his own paintings. Such antics, as well as his commitment to realistic subjects and vigorous application of pigment, served as a strong model for the younger painters at mid-century who were also to rebel against the established Academic tradition in art.

Paintings such as *The Stone-Breakers* (Fig. 8-14) were the objects of public derision. Courbet was moved to paint the work after seeing an old man and a young boy breaking stones on a roadside. So common a subject was naturally criticized by contemporary critics, who favored mythological or idealistic subjects. But Courbet, who was quoted as saying that he couldn't paint an angel because he had never seen one, continued in this vein despite the art world's rejection. It was not only the artist's subject matter, however, that the critics found offensive. They also spurned his painting technique. Although his choice of colors was fairly traditional-muted tones of brown and ocher-their quick application with a palette knife resulted in a coarsely textured surface that could not have been further removed from the glossy finish of an Academic painting. Curiously, although Courbet believed that this type of painting was more realistic than that of the salons, in fact the reverse is closer to the truth. The Academic painter strove for what we would today consider to be an almost photographically exact representation of the figure, whereas Courbet attempted quickly to jot down his impressions of the scene in an often spontaneous flurry of strokes. (For this reason, Courbet can be said to have foreshadowed the Impressionist movement, which we discuss in the next section.) Despite Courbet's advocacy of hard-core realism, the observer of The Stone-Breakers is presented ultimately with the artist's subjective view of the world.

8–14 GUSTAVE COURBET. The Stone-Breakers (1849).

Oil on canvas. $63'' \times 102''$.

Formerly Staatliche Kunstsammlungen, Dresden (destroyed in World War II). Copyright Bridgeman Art Library.

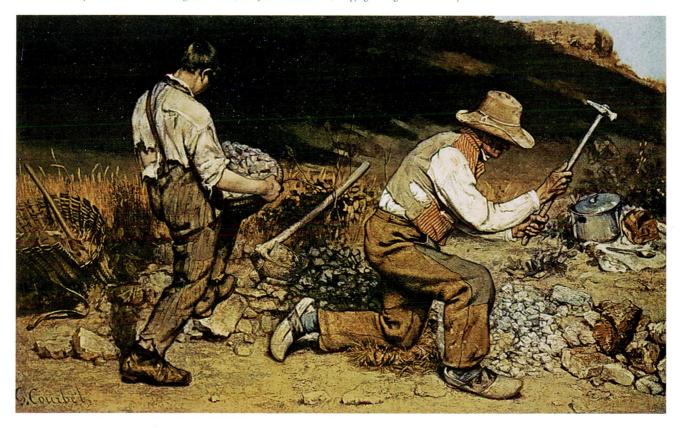

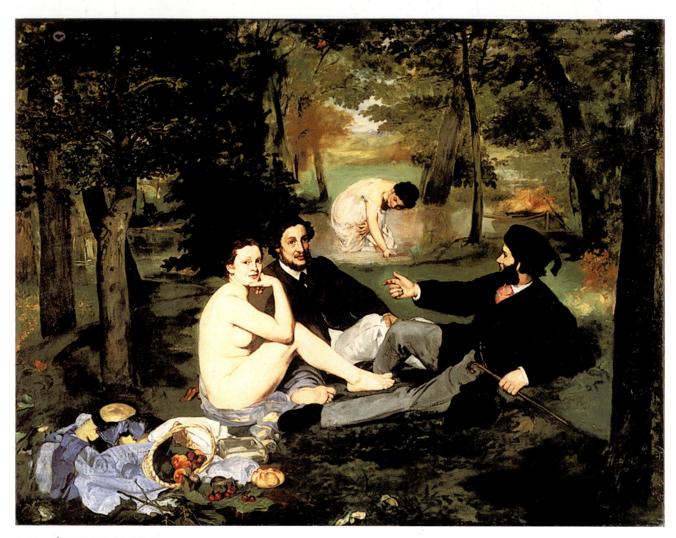

8-15 ÉDOUARD MANET. Le Déjeuner sur L'Herbe (Luncheon on the Grass) (1863).
Oil on canvas. 7' × 8'1". Musée d'Orsay, Galerie Nationale du Jeu de Paume, Paris. Copyright Edimedia/Corbis.

Edouard Manet

Courbet's painting may have laid the groundwork for Impressionism, but he himself was not to be a part of the new wave. His old age brought conservatism, and with it disapproval of the younger generation's painting techniques. One of the targets of Courbet's derision was Edouard Manet (1832–1883). According to some art historians, Manet is the artist most responsible for changing the course of the history of painting.

What was modern about Manet's painting was his technique. Instead of beginning with a dark underpainting and building up to bright highlights—a method used since the Renaissance—Manet began with a white surface and worked to build up dark tones. This approach lent a greater luminosity to the work, one that duplicated sunlight as closely as possible. Manet also did not model his figures with a traditional chiaroscuro. Instead, he applied his pigments flatly and broadly. With these techniques he attempted to capture an impression of a fleeting moment, to duplicate on canvas what the eye would perceive within that collapsed time frame.

All too predictably, these innovations met with disapproval from critics and the public alike. Manet's subjects were found to be equally abrasive. One of his most shocking paintings, *Le Déjeuner sur l'Herbe* (Luncheon on the Grass) (Fig. 8-15), stands as a pivotal work in the rise of the Im-

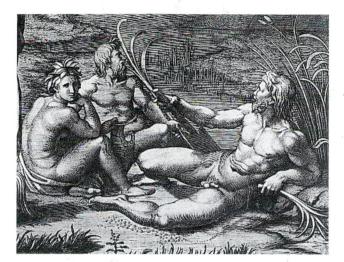

8-16 MARCANTONIO RAIMONDI. Engraving after Raphael's *The Judgment of Paris* (c. 1520). Detail.

The Metropolitan Museum of Art, New York. Rogers Fund, 1919 (19.74.1). All rights reserved by The Metropolitan Museum of Art, New York.

pressionist movement. Manet's luncheon takes place in a lush woodland setting. Its guests are ordinary members of the French middle class. It is culled from a tradition of Venetian Renaissance **pastoral** scenes common to the masters Giorgione and Titian. The composition is rather traditional. The figural group forms a stable pyramidal structure that is set firmly in the middle ground of the canvas. In fact, the group itself is derived from an engraving by Marcantonio Raimondi after a painting by Raphael called *The Judgment of Paris* (Fig. 8-16).

What was so alarming to the Parisian spectator, and remains so to this day, is that there is no explanation for the behavior of the picnickers. Why are the men clothed and the women undraped to varying degrees? Why are the men chatting between themselves, seemingly unaware of the women? The public was quite used to the painting of nudes, but they were not prepared to witness one of their fold—an ordinary citizen—displayed so shamefully on such a grand scale. The painting was further intolerable because the seated woman meets the viewer's stare, as if the viewer had intruded on their gathering in a voyeuristic fashion.

Viewers expecting another pastoral scene replete with nymphs and satyrs got, instead, portraits of Manet's model (Victorine Meurend), his brother, and a sculptor friend. In lieu of a highly polished Academic painting, they found a broadly brushed application of flat, barely modeled hues that sat squarely on the canvas with no regard for illusionism. With this shocking subject and unconventional technique, Modernism was on its way.

Manet submitted the work to the 1863 Salon, and it was categorically rejected. He and other artists whose works were rejected that year rebelled so vehemently that Napoleon III allowed them to exhibit their work in what was known as the *Salon des Réfusés*, or Salon of the Rejected Painters. It was one of the most important gatherings of **avant-garde** painters in the century.

Although Manet was trying to deliver a message to the art world with his *Déjeuner*, it was not his wish to be ostracized. He was just as interested as the next painter in earning recognition and acceptance. Commissions went to artists whose style was sanctioned by the academics, and painting salon pictures was, after all, a livelihood. Fortunately, Manet had the private means by which he could continue painting in the manner he desired.

Manet was perhaps the most important influence on the French Impressionist painters, a group of artists that advocated the direct painting of optical impressions. *Déjeuner* began a decade of exploration of these new ideas that culminated in the first Impressionist exhibition of 1874. Although considered by his followers to be one of the Impressionists, Manet declined to exhibit with that avant-garde group. A quarter of a century later, only 17 years after his death, Manet's works were shown at the prestigious Louvre Museum.

Rosa Bonheur

Rosa Bonheur (1822 –1899) was one of the most successful artists working in the second half of the nineteenth century. In terms of style, she is most closely related to Courbet and the other Realist painters, although for the most part she shunned human subjects in favor of animals—domesticated and wild. She was an artist who insisted on getting close to her subject; she reveled in working "in the trenches." Bonheur was seen in men's clothing and hip boots, plodding through the bloody floors of slaughterhouses in her struggle to understand the anatomy of her subjects.

The Horse Fair (Fig. 8-22) is a panoramic scene of extraordinary power, inspired by the Parthenon's horsemen frieze. The dimensions—more than twice as long as it is high—compel the viewer to perceive the work as just a small portion of a vast scene in which continuation of action beyond the left and right borders of the canvas is implied. The dramatic contrasts of light and dark underscore the struggle between man and beast, while the painterly brushwork heightens the emotional energy in the painting.

C O M P A R E + C O N T R A S T

Titian's Venus of Urbino, Manet's Olympia, Gauguin's Te Arii Vahine, Valadon's The Blue Room, and Eidos Interactive's Lara Croft

"We never encounter the body unmediated by the meanings that cultures give to it." Right out of the starting gate, can you challenge yourself to support or contest this statement with reference to the five works in this exercise? The words are Gayle Rubin's, and they can be found in her essay "Thinking Sex: Notes for a Radical Theory of the Politics of Sexuality." Which of these works, in your view, are about "thinking sex"? Which address the "politics of sexuality"?

Titian's reclining nude (Fig. 8-17) was commissioned by the duke of Urbino for his private quarters. There was a considerable market for erotic paintings in the sixteenth century. Indeed, one point of view maintains that many of the "great nudes" of Western art were, in essence, created for the same purpose as the "pinup." Yet there is also no doubt that this particular reclining nude has had an undisputed place in the canon of "great art." And this much, at least, has been reaffirmed by the reinterpretations and revisions the work has inspired into contemporary times.

One of the first artists to use Titian's *Venus* as a point of departure for his own masterpiece was Edouard Manet. In his *Olympia* (Fig. 8-18), Manet intentionally mimicked the Renaissance composition as a way of challenging the notion that modern art lacked credibility when brought face-to-face with the "old masters." In effect, Manet seemed to be saying, "You want a Venus? I'll give you a Venus." And just where do you find a "Venus" in nineteenth-century Paris? In the bordellos of the Parisian demimonde. What do these paintings have in common? Where do they depart? What details does Titian use to create an air of innocence and vulnerability? What details does Manet use to do just the opposite?

Paul Gauguin, the nineteenth-century French painter who moved to Tahiti, was also inspired by the tradition of the Western reclining nude in the creation of *Te Arii Vahine* (The Noble Woman) (Fig. 8-19). The artist certainly knew Manet's revision of the work; in fact, he had a photograph of *Olympia* tacked on the wall of his hut. How does this Tahitian "Venus" fit into the mix? All three of these works have a sense of selfdisplay. In which do the women solicit our gaze? refuse our gaze? How do the stylistic differences influence our interpretation of the women and our relationship to them? How is the flesh modeled in each work? What overall effects are provided by the different palettes? And the \$64,000 question:

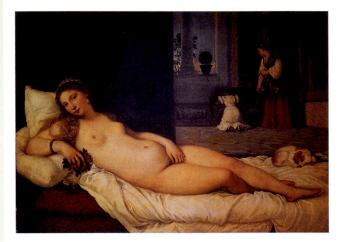

8-17 TITIAN. Venus of Urbino (1538). Oil on canvas. 47" × 65". Uffizi Gallery, Florence. Copyright Edimedia/Corbis.

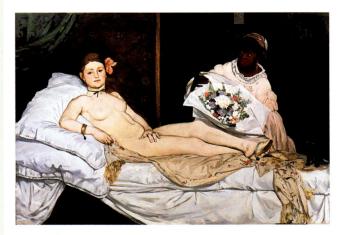

 8-18 ÉDOUARD MANET. Olympia (1863–1865). Oil on canvas. 51³/₈" × 74³/₄". Musée d'Orsay, Paris/Erich Lessing/Art Resource, New York

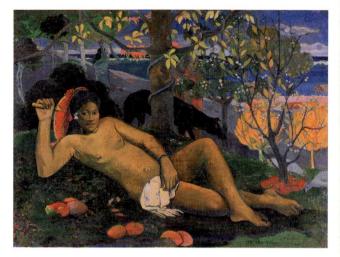

8–19 PAUL GAUGUIN. *Te Arii Vahine* (The Noble Woman) (1896).
Oil on canvas. 97 cm × 130 cm. Pushkin Museum, Moscow. Copyright Erich Lessing/Art Resource, New York.

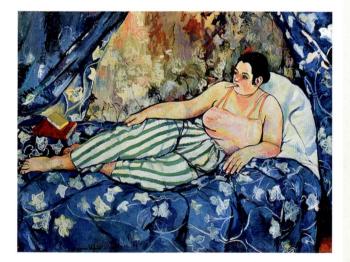

8-20 SUZANNE VALADON. *The Blue Room* (1923). Oil on canvas. 35¹/2" × 45⁵/8". Musée National d'Art Moderne, Centre Georges Pompidou/ Réunion des Musées Nationaux. Copyright CNAC/MNAM/RMN/ Art Resource, New York. Copyright 2007 Artists Rights Society (ARS), New York/ADAGP, Paris.

> 8–21 Lara Croft. Computer-generated drawing. Courtesy of Eidos Interactive.

Are these paintings intended for the "male gaze," "the female gaze," or both?

Suzanne Valadon would probably say that such an image is *not* one that appeals equally to men and women. More to the point, Valadon would argue that the painting of such subjects is not at all of interest to women artists. Perhaps this belief was the incentive behind her own revision of the reclining nude: *The Blue Room* (Fig. 8-20). With this work she seems to be informing the world that when women relax, they really *don't* look like the "Venuses" of Titian, or Manet, or Gauguin. Instead, they get into their loose-fitting clothes, curl up with a good book, and sometimes treat themselves to a bit of tobacco.

The woman in The Blue Room may be real, but the cyberspace character in Figure 8-21 is the stuff of virtual reality. Lara Croft was created in the 1990s by Eidos Interactive as the player's alter ego in the Tomb Raider video games. If in his Olympia Manet was saying, "You want a Venus? I'll give you a Venus," Eidos Interactive seems to have been saying, "You want a Venus? We'll give you a millennium version-tall (5'9"), slim (110 lb.), buffed up, with 'danger' for a middle name." The contemporary Olympia posed in this video game still serves as yet another revision of the enduring tradition of the reclining female figure-albeit one that seems to reverse power relationships. Unlike her art historical counterparts who recline before the male gaze, existing to substantiate "men's power over, superiority to, . . . and necessary control of women," Lara appears to be in control of her viewer-typically an adolescent male. But is she? When male players use Lara to vanquish their computer-generated enemies, do not her powers somehow meld with theirs? And does not the selfsufficient Lara present, on some level, something of the male desire for a superwoman? The vision of Lara Croft may be something quite new to the visual arts, but the issues (and eyebrows) she raises have any number of precedents.

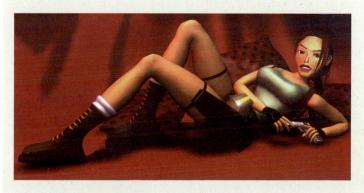

8-22 ROSA BONHEUR.

The Horse Fair (1853). Oil on canvas. $8'^{1}/4'' \times 16'7^{1}/2''$. The Metropolitan Museum of Art, New York. Gift of Cornelius Vanderbilt, 1887 (87.25). Copyright 1997 The Metropolitan Museum of Art, New York.

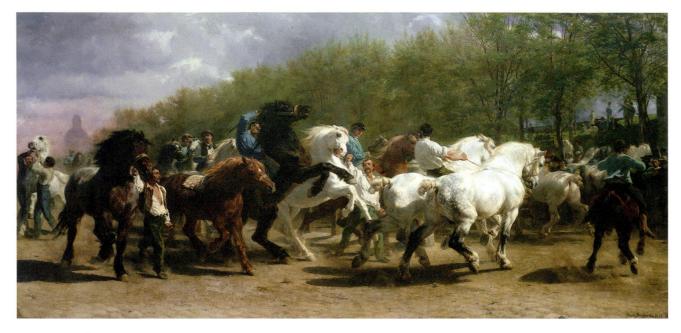

The Horse Fair was an extremely popular work, which was bought widely in engraved reproductions, cementing Bonheur's fame and popularity.

IMPRESSIONISM

While Bonheur won quick acceptance by the Academy, a group of younger artists were banding together against the French art establishment. Suffering from lack of recognition and vicious criticism, many of them lived in abject poverty for lack of commissions. Yet they stand today as some of the most significant and certainly among the most popular artists in the history of art. They were called the *Impressionists*. The very name of their movement was coined by a hostile critic and intended to malign their work. The word *impressionism* suggests a lack of realism, and realistic representation was the standard of the day.

The Impressionist artists had common philosophies about painting, although their styles differed widely. They all reacted against the constraints of the Academic style and subject matter. They advocated painting out-of-doors and chose to render subjects found in nature. They studied the dramatic effects of atmosphere and light on people and objects and, through a varied palette, attempted to duplicate these effects on canvas. Through intensive investigation, they arrived at awareness of certain visual phenomena. When bathed in sunlight, objects are optically reduced to facets of pure color. The actual color—or local color—of these objects is altered by different lighting effects. Solids tend to dissolve into color fields. Shadows are not black or gray but a combination of colors.

Technical discoveries accompanied these revelations. The Impressionists duplicated the glimmering effect of light bouncing off the surface of an object by applying their pigments in short, choppy strokes. They juxtaposed complementary colors such as red and green to reproduce the optical vibrations perceived when one is looking at an object in full sunlight. Toward this end they also juxtaposed primary colors such as red and yellow to produce, in the eye of the spectator, the secondary color orange. We shall discuss the work of the Impressionists Claude Monet, Pierre-Auguste Renoir, Berthe Morisot, and Edgar Degas.

Claude Monet

The most fervent follower of Impressionist techniques was the painter Claude Monet (1840–1926). His canvas *Impression: Sunrise* (Fig. 8-23) inspired the epithet "impressionist" when it was exhibited at the first Impressionist exhibition in 1874. Fishing vessels sail from the port of Le Havre toward I have no other wish than a close fusion with nature, and I desire no other fate than to have worked and lived in harmony with her laws. Beside her grandeur, her power, and her immortality, the human creature seems but a miserable atom.

-Claude Monet

 8-23 CLAUDE MONET. *Impression: Sunrise* (1872). Oil on canvas. 19¹/2" × 25¹/2". Musée Marmottan, Paris. Copyright Scala/ Art Resource, New York.

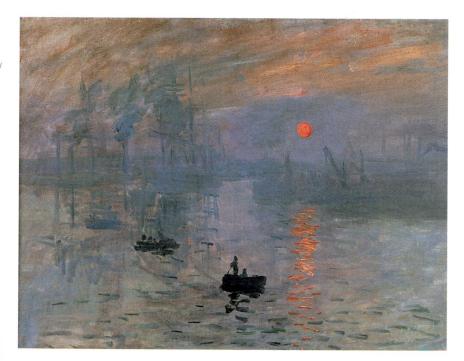

8-24 CLAUDE MONET. Rouen Cathedral (1894).
Oil on canvas. 39¹/4" × 25⁷/8".
The Metropolitan Museum of Art, New York. Theodore M. Davis Collection, 1915 (30.95.250). Copyright 1996 The Metropolitan Museum of Art, New York.

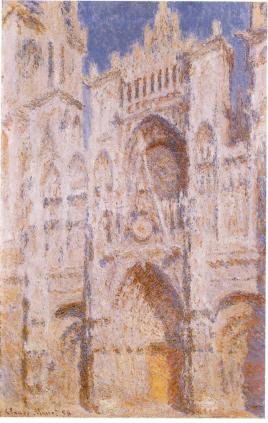

the morning sun, which rises in a foggy sky to cast its copper beams on the choppy, pale blue water. The warm blanket of the atmosphere envelops the figures, their significance having paled in the wake of nature's beauty.

The dissolution of surfaces and the separation of light into its spectral components remain central to Monet's art. They are dramatically evident in a series of canvases depicting *Rouen Cathedral* (Fig. 8-24) from a variety of angles, during different seasons and times of day. The harsh stone facade of the cathedral dissolves in a bath of sunlight, its finer details obscured by the bevy of brushstrokes crowding the surface. Dark shadows have been transformed into patches of bright blue and splashes of yellow and red. With these delicate touches, Monet has recorded for us the feeling of a single moment in time. He offers us his impressions as eyewitness to a set of circumstances that will never be duplicated.

Pierre-Auguste Renoir

Most Impressionists counted among their subject matter landscape scenes or members of the middle class enjoying One morning, one of us, lacking black, used blue: Impressionism was born.

-Pierre-Auguste Renoir

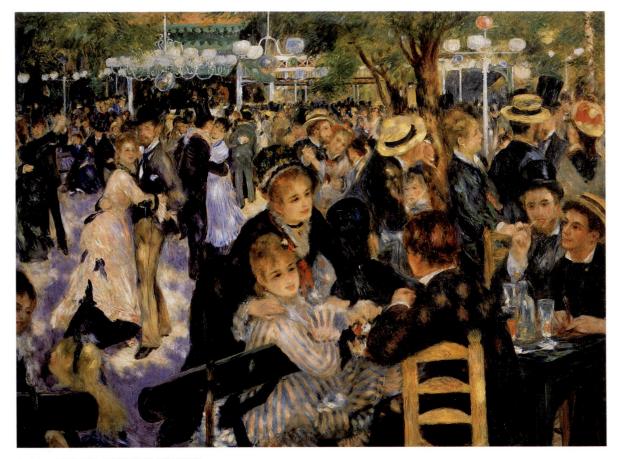

leisure-time activities. Of all the Impressionists, however, Pierre-Auguste Renoir (1841–1919) was perhaps the most significant figure painter. Like his peers, Renoir was interested primarily in the effect of light as it played across the surface of objects. He illustrated his preoccupation in one of the most wonderful paintings of the Impressionist period, *Le Moulin de la Galette* (Fig. 8-25). With characteristic feathery strokes, Renoir communicated all of the charm and gaiety of an afternoon dance. Men and women caress and converse in frocks that are dappled with sunlight filtering through the trees. All of the spirit of the event is as fresh as if it were yesterday. From the billowing skirts and ruffled dresses to the rakish derbies, top hats, and skimmers, Renoir painted all the details that imprint such a scene on the mind forever.

Berthe Morisot

Like a number of other Impressionists, Berthe Morisot (1841–1895) exhibited at the Salon early in her career, but she surrendered the safe path as an expression of her allegiance to the new. Morisot was a granddaughter of the eighteenth-century painter Jean-Honoré Fragonard (see Chapter 16) and the sister-in-law of Edouard Manet. Manet painted her quite often. In fact, Morisot is the seated figure in his painting *The Balcony*. It is very good to copy what one sees; it is much better to draw what you can't see anymore but is in your memory. It is a transformation in which imagination and memory work together. You only reproduce what struck you; that is to say, the necessary.

—Edgar Degas

In Morisot's Young Girl by the Window (Fig. 8-26), surfaces dissolve into an array of loose brushstrokes, applied, it would seem, at a frantic pace. The vigor of these strokes contrasts markedly with the tranquility of the woman's face. The head is strongly modeled, and a number of structural lines, such as the back of the chair, the contour of her right arm, the blue parasol astride her lap, and the vertical edge of drapery to the right, anchor the figure in space. Yet in this, as in most of Morisot's works, we are most impressed by her

 8–26 BERTHE MORISOT. Young Girl by the Window (1878). Oil on canvas. 29¹⁵/16" × 24". Musée Fabre, Montpellier, France. Marie de Montpellier. Copyright Art Resource, New York. ingenious ability to suggest complete forms through a few well-placed strokes of pigment.

Edgar Degas

We can see the vastness of the aegis of Impressionism when we look at the work of Edgar Degas (1834–1917), whose approach to painting differed considerably from that of his peers. Degas, like Morisot, had exhibited at the Salon for many years before joining the movement. He was a superb draftsman who studied under Ingres. While in Italy, he copied the Renaissance masters. He was also intrigued by Japanese prints and the new art of photography.

The Impressionists, beginning with Manet, were strongly influenced by Japanese woodcuts, which were becoming readily available in Europe, and oriental motifs appeared widely in their canvases. They also adopted certain techniques of spatial organization found in Japanese prints, including the use of line to direct the viewer's eye to different sections of the work and to divide areas of the essentially flattened space (see Chapter 9). They found that the patterning and flat forms of oriental woodcuts complemented similar concerns in their own painting. Throughout the Impressionist period and even more so in the Postimpressionist period, the influence of Japanese artists remained strong.

Degas was also strongly influenced by the developing art of photography, and the camera's exclusive visual field served as a model for the way in which he framed his own paintings. The ballet rehearsal (Fig. 8-27) contains elements both of photographs and of Japanese prints. Degas draws us into the composition with an unusual and vast off-center space that curves around from the viewer's space to the background of the canvas. The diagonals of the floorboards carry our eyes briskly from outside the canvas to the points at which the groups of dancers congregate. The imagery is placed at eye level so that we feel we are part of the scene. This feeling is enhanced by the fact that our "seats" at the rehearsal are less than adequate; a spiral staircase to the left blocks our view of the ballerinas. In characteristic camera fashion, the borders of the canvas slice off the forms and

8-27 EDGAR DEGAS. *The Rehearsal (Adagio)* (1877). Oil on canvas. 26" × 39³/8". The Burrell Collection, Glasgow Art Gallery and Museum, Glasgow.

> figures in a seemingly arbitrary manner. Although it appears as if Degas has failed to frame his subject correctly or has accidentally cut off the more important parts of the scene, he carefully planned the placement of his imagery. These techniques are what render his asymmetrical compositions so dynamic and, in the spirit of Impressionism, so immediate.

PHOTOGRAPHY

The influence of the new medium of photography can readily be seen in many examples of impressionist painting. Whereas the earliest developments in photographic technology pre-date impressionism by several decades, the creation of the **daguerreotype** and invention of the negative in the early nineteenth century propelled the progress of the medium. Photography improved rapidly for the next 50 or 60 years thereafter—faster emulsions, glass-plate negatives, better camera lenses—and photographs became more widely available and affordable to the general public. The subject matter and style of early photographs was limited. The concept of a visual record drove portraiture and photojournalism, while "art photography" aimed to replicate the pictorial aspects of painting. The first successful daguerreotype, a still life composition of the artist's studio, was created by Jacques-Mande Daguerre, a landscape painter.

Portraits

By the 1850s, photographic technology and a growing middle class in the wake of the American and French revolutions came together to create a burgeoning business in portrait photography. Having a likeness of oneself was formerly reserved for the wealthy, who could afford to commission painted portraits. Photography became the democratic equalizer. The rich, the famous, and average bourgeois citizens could now preserve their presence for posterity. (It is interesting to recall the realistic sculptures and wax portraits from the Roman Republican era.) Photographic studios

8–28 NADAR.
 Sarah Bernhardt (1859).
 Bibliothèque Nationale, Paris. Copyright Photos 12, Paris.

spread like wildfire, and many photographers, such as Julia Margaret Cameron and Gaspard Felix Tournachon—called "Nadar"—vied for famous clients. Cameron's impressive portfolio included portraits of Charles Dickens; Alfred, Lord Tennyson; and Henry Wadsworth Longfellow. Figure 8-28 is Nadar's 1859 portrait of the actress Sarah Bernhardt. It was printed from a glass plate, which could be used several times to create sharp copies. Early portrait photographers such as Nadar imitated both nature and the arts, using costumes and props that recall Romantic paintings or sculpted busts caressed by flowing drapery. For Bernhardt's portrait, Nadar arranged a mass of voluptuous drapery into a pedestal of sorts for the extraordinary beauty and intellect of the actress. The soft, smooth textures underscore the pensive, brooding countenance associated with her dramatic style

Photojournalism

Prior to the nineteenth century, illustrations in newspapers and magazines were few and primarily derived from engravings or drawings. Photography revolutionized the way that news media brought visual images of events to the public. Pioneers such as Mathew Brady and Alexander Gardner used the camera to record scenes of the U.S. Civil War. The photographers and their crews trudged the roads alongside soldiers, hauling their equipment behind them in horsedrawn wagons. The technology available to Brady and Gardner did not allow for the capture of candid scenes, so there is no direct record of the bloody to and fro of the battle lines, no "action shots" so to speak. Instead, their work focused on staged portraits of officers and soldiers, of daily life in the camps along the lines, and, as in Gardner's *Home of a Rebel Sharpshooter, Gettysburg* (Fig. 8-29), of the harsh evidence of the gruesome death and devastation of war. Whereas Civil War photographers may have enticed soldiers to sit for portraits that might be sent back to their families, or may have taken advantage of the sense of celebrity on the part of the generals to immortalize their faces, it's unlikely that any of them expected that their more graphic images would serve any purpose other than historical record.

Art Photography

Photography as an art form made a significant leap forward with Louis Lumière 's introduction of the "autochrome" color process in 1907. Lumière's autochrome photographs, such as *Young Lady with an Umbrella* (Fig. 8-30), are akin to paintings by Postimpressionist artist Georges Seurat (see Fig. 8-31), an avid student of color theory, as well as to works by other photographers in the pictorial style. Lumière's technology was not replaced until 1932, when Kodak began to produce color film that applied the same principles to more advanced materials.

 8–29 ALEXANDER GARDNER. Home of a Rebel Sharpshooter, Gettysburg (July 1863). Wet-plate photograph. Courtesy of the Chicago Historical Society

 8–30 LOUIS LUMIÈRE. Young Lady with an Umbrella (1906–1910). Autochrome. Société Lumière, Paris.

POSTIMPRESSIONISM

The Impressionists were united in their rejection of many of the styles and subjects of the art that preceded them. These included Academic painting, the emotionalism of Romanticism, and even the depressing subject matter of some of the Realist artists. During the latter years of the nineteenth century, a group of artists that came to be called Postimpressionists were also united in their rebellion against that which came before them—in this case, Impressionism. The Postimpressionists were drawn together by their rebellion against what they considered an excessive concern for fleeting impressions and a disregard for traditional compositional elements. Although they were united in their rejection of Impressionism, their individual styles differed considerably. Postimpressionists fell into two groups that in some ways parallel the stylistic polarities of the Baroque period as well as the Neoclassical-Romantic period. On the one hand, the work of Georges Seurat and Paul Cézanne had at its core a more systematic approach to compositional structure, brushwork, and color. On the other hand, the lavishly brushed canvases of Vincent van Gogh and Paul Gauguin coordinated line and color with symbolism and emotion.

Georges Seurat

At first glance, the paintings by Georges Seurat (1859–1891), such as *A Sunday Afternoon on the Island of La Grande Jatte* (Fig. 8-31), have the feeling of Impressionism "tidied up." The small brushstrokes are there, as are the juxtapositions of complementary colors. The subject matter is entirely acceptable within the framework of Impressionism. However, the spontaneity of direct painting found in Impressionism is relinquished in favor of a more tightly controlled, "scientific" approach to painting.

Seurat's technique has also been called **pointillism**, after his application of pigment in small dabs, or points, of pure color. Upon close inspection, the painting appears to be a collection of dots of vibrant hues—complementary colors abutting one another, primary colors placed side by side. These hues intensify or blend to form yet another color in the eye of the viewer who beholds the canvas from a distance.

Seurat's meticulous color application was derived from the color theories and studies of color contrasts by the scientists Hermann von Helmholtz and Michel-Eugène Chevreul. He used these theories to restore a more intellectual approach to painting that countered nearly two decades of works that focused wholly on optical effects.

8-31 GEORGES SEURAT.

A Sunday Afternoon on the Island of La Grande Jatte (1884–1886). Oil on canvas. $81'' \times 120^3/8''$. The Art Institute of Chicago. Helen Birch Bartlett Memorial Collection/ Topfoto/The Image Works.

The same subject seen from a different angle gives a subject for study of the highest interest and so varied that I think I could be occupied for months without changing my place, simply bending a little more to the right or left.

—Paul Cézanne

8-32 PAUL CÉZANNE. Still Life with Basket of Apples (c. 1895). Oil on canvas. 2'³/8" × 2'7". The Art Institute of Chicago. Helen Birch Bartlett Memorial Collection. Photo courtesy of the Art Institute of Chicago.

Paul Cézanne

From the time of Manet, there was a movement away from a realistic representation of subjects toward one that was abstracted. Early methods of abstraction assumed different forms. Manet used a flatly painted form, Monet a disintegrating light, and Seurat a tightly painted and highly patterned composition. Paul Cézanne (1839–1906), a Postimpressionist who shared with Seurat an intellectual approach to painting, is credited with having led the revolution of abstraction in modern art from those first steps.

Cézanne's method for accomplishing this radical departure from tradition did not disregard the old masters. Although he allied himself originally with the Impressionists and accepted their palette and subject matter, he drew from old masters in the Louvre and desired somehow to reconcile their lessons with the thrust of Modernism, saying, "I want to make of Impressionism something solid and lasting like the art in the museums." Cézanne's innovations include a structural use of color and brushwork that appeals to the intellect, and a solidity of composition enhanced by a fluid application of pigment that delights the senses. Cézanne's most significant stride toward Modernism, however, was a drastic collapsing of space, seen in works such as Still Life with Basket of Apples (Fig. 8-32). All of the imagery is forced to the picture plane. The tabletop is tilted toward us, and we simultaneously view the basket, plate, and wine bottle from front and top angles. Cézanne did not paint the still-life arrangement from one vantage point either. He moved around his subject, painting not only the objects but the relationship among them. He focused on solids as well as on the void spaces between two objects. If you run your finger along the tabletop in the background of the painting, you will see that it is not possible to trace a continuous line. This discontinuity follows from Cézanne's movement around his subject. In spite of this spatial inconsistency, the overall feeling of the composition is one of completeness.

Cézanne's painting technique is also innovative. The sensuously rumpled fabric and lusciously round fruits are constructed of small patches of pigment crowded within dark outlines. The apples look as if they would roll off the table were it not for the supportive facets of the tablecloth.

Cézanne can be seen as advancing the flatness of planar recession begun by David more than a century earlier. Cézanne asserted the flatness of the two-dimensional canvas by eliminating the distinction between foreground and background, and at times merging the two. This was perhaps his most significant contribution to future modern movements.

Vincent van Gogh

One of the most tragic and best-known figures in the history of art is the Dutch Postimpressionist Vincent van Gogh (1853-1890). We associate him with bizarre and painful acts, such as the mutilation of his ear and his suicide. With these events, as well as his tortured, eccentric painting, he typifies the impression of the mad, artistic talent. Van Gogh also epitomizes the cliché of the artist who achieves recognition only after death: just one of his paintings was sold during his lifetime.

"Vincent," as he signed his paintings, decided to become an artist only 10 years before his death. His most beloved canvases were created during his last 29 months. He began his career painting in the dark manner of the Dutch Baroque, only to adopt the Impressionist palette and brushstroke after he settled in Paris with his brother, Theo. Feeling that he was a constant burden on his brother, he left Paris for Arles, where he began to paint his most significant

> Postimpressionist works. Both his life and his compositions from this period were tortured, as Vincent suffered from what may have been bouts of epilepsy and mental illness. He was eventually hospitalized in an asylum at Saint-Rémy, where he painted the famous Starry

VINCENT VAN GOGH. Starry Night (1889). Oil on canvas. $29'' \times 36^{1/4''}$. The Museum of Modern Art, New York. Acquired through the Lillie P. Bliss Bequest. Copyright The Museum of Modern Art, New York/Art Resource, New York,

Night (Fig. 8-33). 8-33

Why Did van Gogh Cut Off His Ear?

Two days before Christmas in the year 1888, the 35-year-old Vincent van Gogh cut off the lower half of his left ear (Fig. 8-34). He took the ear to a brothel, asked for a prostitute by the name of Rachel, and handed it to her. "Keep this object carefully," he said.

How do we account for this extraordinary event? Over the years, many explanations have been advanced. Many of them are psychoanalytic in nature.* That is, they argue that van Gogh fell prey to unconscious primitive impulses.

As you consider the following suggestions, keep in mind that van Gogh's bizarre act occurred many years ago and that we have no way today to determine which, if any, of them is accurate. Perhaps one of them cuts to the core of van Gogh's urgent needs; perhaps several of them contain a kernel of truth. But it could also be that all of them fly far from the mark. In any event, here are a number of explanations suggested in the *Journal of Personality and Social Psychology:*[†]

- 1. Van Gogh was frustrated by his brother's engagement and his failure to establish a close relationship with Gauguin. The aggressive impulses stemming from the frustrations were turned inward and expressed in self-mutilation.
- 2. Van Gogh was punishing himself for experiencing homosexual impulses toward Gauguin.
- 3. Van Gogh identified with his father, toward whom he felt resentment and hatred, and the cutting off of his own ear was a symbolic punishment of his father.
- 4. Van Gogh was influenced by the practice of awarding the bull's ear to the matador after a bullfight. In effect, he was presenting such an "award" to the lady of his choice.
- 5. Van Gogh was influenced by newspaper accounts of Jack the Ripper, who mutilated prostitutes. Van Gogh was imitating the "ripper," but his self-hatred led him to mutilate himself rather than others.
- 6. Van Gogh was seeking his brother's attention.
- 7. Van Gogh was seeking to earn the sympathy of substitute parents. (The mother figure would have been a model he had recently painted rocking a cradle.)
- 8. Van Gogh was expressing his sympathy for prostitutes, with whom he identified as social outcasts.
- 9. Van Gogh was symbolically emasculating himself so that his mother would not perceive him as an unlikable "rough" boy. (Unconsciously, the prostitute was a substitute for his mother.)
- 10. Van Gogh was troubled by auditory hallucinations (hearing things that were not there) as a result of his mental state. He cut off his ear to put an end to disturbing sounds.
- 11. In his troubled mental state, Van Gogh may have been acting out a biblical scene he had been trying to paint. According to the New Testament, Simon Peter cut off the ear of the servant Malchus to protect Christ.
- 12. Van Gogh was acting out the Crucifixion of Jesus, with himself as victim.

* William McKinley Runyan, *Journal of Personality and Social Psychology* (June 1981). [†] Ibid.

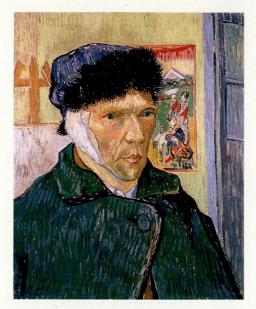

8-34 VINCENT VAN GOGH. Self-Portrait with Bandaged Ear (1889–1890). Oil on canvas. 23⁵/8" × 19¹/4". Courtauld Institute Galleries, London/ Edimedia/Corbis.

Art is either plagiarism or revolution.

-Paul Gauguin

In *Starry Night* an ordinary painted record of a sleepy valley town is transformed into a cosmic display of swirling fireballs that assault the blackened sky and command the hills and cypresses to undulate to their sweeping rhythms. Vincent's palette is laden with vibrant yellows, blues, and greens. His brushstroke is at once restrained and dynamic. His characteristic long, thin strokes define the forms but also create the emotionalism in the work. He presents his subject not as we see it but as he would like us to experience it. His is a feverish application of paint, an ecstatic kind of drawing, reflecting at the same time his joys, hopes, anxieties, and despair. Vincent wrote in a letter to his brother Theo, "I paint as a means to make life bearable. . . . Really we can speak only through our paintings."

Paul Gauguin

Paul Gauguin (1848–1903) shared with van Gogh the desire to express his emotions on canvas. But whereas the Dutchman's brushstroke was the primary means to that end, Gauguin relied on broad areas of intense color to transpose his innermost feelings to canvas.

Gauguin, a stockbroker by profession, began his artistic career as a weekend painter. It was not until the age of 35 that he devoted himself full-time to his art, leaving his wife and five children to do so. Gauguin identified early with the Impressionists, adopting their techniques and participating in their exhibitions. But Gauguin was a restless soul. Soon he decided to leave France for Panama and Martinique,

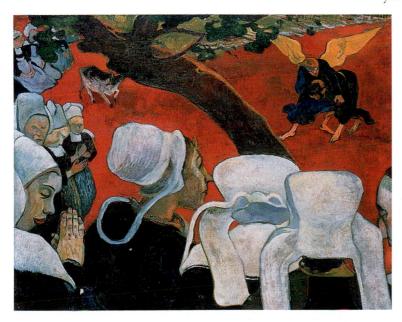

primitive places where he hoped to purge the civilization from his art and life. The years until his death were spent between France and the South Seas, where he finally died of syphilis five years after a failed attempt to take his own life.

Gauguin developed a theory of art called Synthetism, in which he advocated the use of broad areas of unnaturalistic color and primitive or symbolic subject matter. His Vision after the Sermon (Jacob Wrestling with the Angel) (Fig. 8-35), one of the first canvases to illustrate his theory, combines reality with symbolism. After hearing a sermon on the subject, a group of Breton women believed they had a vision of Jacob, ancestor of the Hebrews, wrestling with an angel. In a daring composition that cancels pictorial depth by thrusting all elements to the front of the canvas, Gauguin presented all details of the event, actual and symbolic. An animal in the upper left portion of the canvas walks near a tree that interrupts a bright vermilion field with a slashing diagonal. The Bible tells us that it was on the banks of the Jabbok River in Jordan that Jacob had wrestled with an angel. Caught, then, in a moment of religious fervor, the Breton women may have imagined the animal's four legs to have been those of the wrestling couple, and the tree trunk might have been visually analogous to the river.

Gauguin's contribution to the development of modern art lay largely in his use of color. Writing on the subject, he said, "How does that tree look to you? Green? All right, then use green, the greenest on your palette. And that shadow, a little bluish? Don't be afraid. Paint it as blue as you can." He intensified the colors he observed in nature to

the point where they became unnatural. He exaggerated his lines and patterns until they became abstract. These were the lessons he learned from the primitive surroundings of which he was so fond. They were his legacy to art.

Henri de Toulouse-Lautrec

Henri de Toulouse-Lautrec (1864–1901), along with van Gogh, is one of the best-known nineteenth-century European artists—both for his art and for the troubled aspects of his personal life. Born into a noble French family, Toulouse-Lautrec broke his legs during adolescence and

8-35 PAUL GAUGUIN. Vision after the Sermon (Jacob Wrestling with the Angel) (1888). Oil on canvas. 28³/₄" × 36¹/₂". National Galleries of Scotland, Edinburgh/Edimedia/Corbis. they failed to develop correctly. This deformity resulted in alienation from his family. He turned to painting and took refuge in the demimonde of Paris, at one point taking up residence in a brothel. In this world of social outcasts, Toulouse-Lautrec, the dwarflike scion of a noble family, apparently felt at home.

He used his talents to portray life as it was in this cavalcade of cabarets, theaters, cafes, and bordellos-sort of seamy, but also vibrant and entertaining, and populated by "real" people. He made numerous posters to advertise cabaret acts and numerous paintings of his world of night and artificial light. In At the Moulin Rouge (Fig. 8-36), we find something of the Japanese-inspired oblique perspective we found earlier in his poster work. The extension of the picture to include the balustrade on the bottom and the heavily powdered entertainer on the right is reminiscent of those "poorly cropped snapshots" of Degas, who had influenced Toulouse-Lautrec. The fabric of the entertainer's dress is constructed of fluid Impressionistic brushstrokes, as are the contents of the bottles, the lamps in the background, and the amorphous overall backdrop-lost suddenly in the unlit recesses of the Moulin Rouge. But the strong outlining, as in the entertainer's face, marks the work of a Postimpressionist. The artist's palette is limited and muted, except for a few accents, as found in the hair of the woman in the center of the composition and the bright mouth of the entertainer. The entertainer's face is harshly sculpted by artificial light from beneath, rendering the shadows a grotesque but not ugly green. The green and red mouth clash, of course, as green and red are complementary colors, giving

further intensity to the entertainer's mask-like visage. But despite her powdered harshness, the entertainer remains human—certainly as human as her audience. Toulouse-Lautrec was accepting of all his creatures, just as he hoped that they would be accepting of him. The artist is portrayed within this work as well, his bearded profile facing left, toward the upper part of the composition, just left of center—a part of things, but not at the heart of things, certainly out of the glare of the spotlight. There, so to speak, the artist remained for many of his brief 37 years.

8-36 HENRI DE TOULOUSE-LAUTREC. At the Moulin Rouge (1892). Oil on canvas. 4' × 4'7". The Art Institute of Chicago. Helen Birch Bartlett Memorial Collection. Photo courtesy of the Art Institute of Chicago/Edimedia/Corbis.

EXPRESSIONISM

A polarity existed in Postimpressionism that was like the polarity of the Neoclassical-Romantic period. On the one hand were artists who sought a more scientific or intellectual approach to painting. On the other were artists whose works were more emotional, expressive, and laden with symbolism. The latter trend was exemplified by van Gogh and particularly Gauguin. These artists used color and line to express inner feelings. In their vibrant palettes and bravura brushwork, van Gogh and Gauguin foreshadowed Expressionism.

Edvard Munch

The expressionistic painting of Gauguin was adopted by the Norwegian Edvard Munch (1863–1944), who studied the Frenchman's works in Paris. Munch's early work was Impressionistic, but during the 1890s he abandoned a light palette and lively subject matter in favor of a more somber style that reflected an anguished preoccupation with fear and death.

The Scream (Fig. 8-37) is one of Munch's best-known works. It portrays the pain and isolation that became his central themes. A skeletal figure walks across a bridge toward the viewer, cupping his ears and screaming. Two figures in the background walk in the opposite direction, unaware of or uninterested in the sounds of desperation piercing the atmosphere. Munch transformed the placid landscape into

The sky was suddenly blood-red—I stopped and leaned against the fence, dead tired. I saw the flaming clouds like blood and a sword—the bluish-black fjord and town—my friends walked on—I stood there, trembling with anxiety—and I felt as though Nature were convulsed by a great unending scream.

-Edvard Munch

Where do all the women who have watched so carefully over the lives of their beloved ones get the heroism to send them to face the cannon?

—Käthe Kollwitz

one that echoes in waves the high-pitched tones that emanate from the sunken head. We are reminded of the swirling forms of van Gogh's *Starry Night*, but the intensity and horror pervading Munch's composition speak of his view of humanity as being consumed by an increasingly dehumanized society.

Käthe Kollwitz

It is not often in the history of art that we find two artists whose backgrounds are so similar that we can control for just about every variable except for personality when com-

 8-37 EDVARD MUNCH. The Scream (1893). Casein on paper. 35¹/₂" × 28²/₃". National Gallery, Oslo, Norway/Erich Lessing/Art Resource, New York. paring their work. But such is the case with Edvard Munch and Käthe Kollwitz (1867–1945). They were born and died within a few years of each other. They both lived through two world wars; Kollwitz lost a son in World War I and a grandson in World War II. Both are Expressionist artists. Yet their choice of subjects speaks of their idiosyncratic concerns. Whereas Munch looked for symbols of isolation that would underscore his own sense of loneliness, or themes of violence and perverse sexuality that reflected his own psychological problems, Kollwitz sought universal symbols for inhumanity, injustice, and humankind's destruction of itself.

The Outbreak (Fig. 8-38) is one of a series of seven prints by Kollwitz representing the sixteenth-century Peasants' War. In this print, Black Anna, a woman who led the

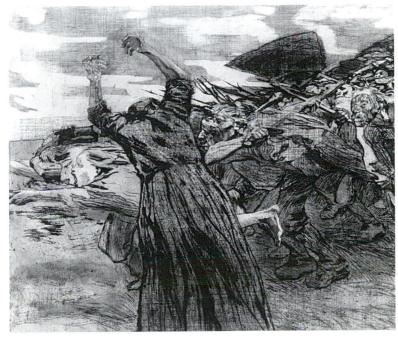

8-38 KÄTHE KOLLWITZ. The Outbreak (1903). Plate no. 5 from The Peasants' War. Library of Congress, Washington, DC. Collection of Ellen and Max Friedman. Copyright 2007 Artists Rights Society (ARS), New York/VG Bild-Kunst, Bonn.

I will not admit that a woman can draw so well.

—Edgar Degas, of Mary Cassatt

Well, not bad, but there are decidedly too many of them, and they are not very well arranged. I would have done it differently.

-James Abbott McNeill Whistler, when asked whether the stars were beautiful one evening

laborers in their struggle against their oppressors, incites an angry throng of peasants to action. Her back is toward us, her head down, as she raises her gnarled hands in inspiration. The peasants rush forward in a torrent, bodies and weapons lunging at Anna's command. Although the work records a specific historical incident, it stands as an inspiration to all those who strive for freedom against the odds. There are few more forceful images in the history of art.

The styles of these early Expressionists would be adopted in the twentieth century by younger German artists who shared their view of the world. Many revived the woodcut medium to complement their expressive subjects. This younger generation of artists worked in various styles, but collectively were known as the Expressionists. We shall examine their work in Chapter 9.

AMERICAN EXPATRIATES

Until the twentieth century, art in the United States remained fairly provincial. Striving artists of the eighteenth and nineteenth centuries would go abroad for extended pilgrimages to study the old masters and mingle with the

avant-garde. In some cases, they immigrated to Europe permanently. These artists, among them Mary Cassatt and James Abbott McNeill Whistler, are called the American Expatriates.

Mary Cassatt

Mary Cassatt (1844 –1926) was born in Pittsburgh but spent most of her life in France, where she was part of the inner circle of Impressionists. The artists Manet and Degas, photog-

8–39 MARY CASSATT. *The Boating Party* (1893–1894). Oil on canvas. 35¹/₂" × 46¹/₈". National Gallery of Art, Washington, DC. Chester Dale Collection. Copyright 2003 Board of Trustees, National Gallery of Art, Washington, DC. raphy, and Japanese prints influenced Cassatt's early career. She was a figure painter whose subjects centered on women and children.

A painting such as *The Boating Party* (Fig. 8-39), with its flat planes, broad areas of color, and bold lines and shapes, illustrates Cassatt's interest and skill in merging French Impressionism with elements of Japanese art. Like many of her contemporaries in Paris, she became aware of Japanese prints and art objects after trade was established between Japan and Europe in the mid-nineteenth century. In their solidly constructed compositions and collapsed space, Cassatt's lithographs, in particular, stand out from the more ethereal images of other Impressionists.

James Abbott McNeill Whistler

In the same year that Monet painted his *Impression: Sunrise* and launched the movement of Impressionism, the American artist James Abbott McNeill Whistler (1834–1903) painted one of the best-known compositions in the history of art. Who among us has not seen "Whistler's Mother," whether on posters, billboards, or television commercials?

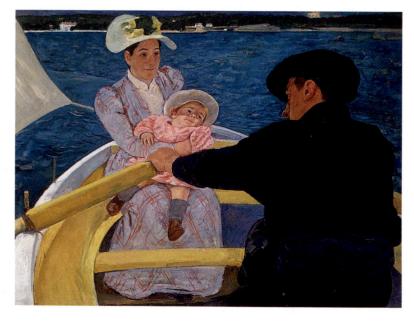

8-40 JAMES ABBOTT MCNEILL WHISTLER. Arrangement in Black and Gray: The Artist's Mother (1871). Oil on canvas. 57" × 64¹/2". Louvre Museum, Paris/Edimedia/Corbis.

and pleasing arrangement of shapes in tones of black, gray, and white that work together in pure harmony.

AMERICANS IN AMERICA

While Whistler and Cassatt were working in Europe, several American artists of note remained at home working in the Realist tradition. This realism can be detected in figure painting and landscape painting, both of which were tinted with Romanticism.

Thomas Eakins

The most important American portrait painter of the nineteenth century was Thomas Eakins (1844–1916). Although his early artistic training took place in the United States, his study in Paris with painters who depicted historical events provided the major influence on his work. The penetrating realism of a work such as *The Gross Clinic* (Fig. 8-41) stems from Eakins's endeavors to become fully acquainted with human anatomy by working from live models and dissecting corpses. Eakins's dedication to these practices met with disapproval from his colleagues and ultimately forced his resignation from a teaching post at the Pennsylvania Academy of Art.

The Gross Clinic—no pun intended—depicts the surgeon Dr. Samuel Gross operating on a young boy at the Jefferson Medical College in Philadelphia. Eakins thrusts the

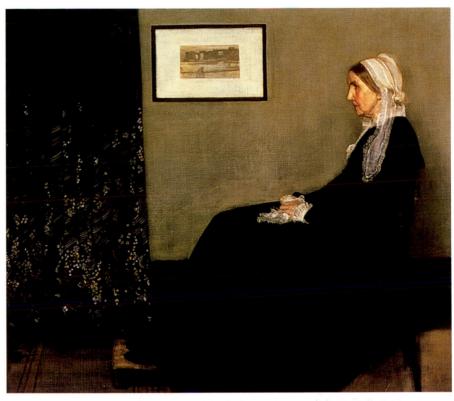

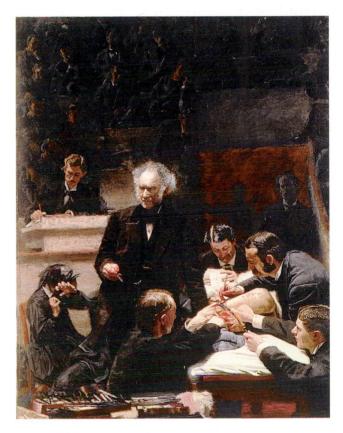

8–41 THOMAS EAKINS. *The Gross Clinic* (1875). Oil on canvas. 96" × 78". Jefferson Medical College of Thomas Jefferson University, Philadelphia. brutal imagery to the foreground of the painting, spotlighting the surgical procedure and Dr. Gross's bloody scalpel while casting the observing medical students in the background into darkness. The painting was deemed so shockingly realistic that it was rejected by the jury for an exhibition. Part of the impact of the work lies in the contrast between the matter-of-fact discourse of the surgeon and the torment of the boy's mother. She sits in the lower left corner of the painting, shielding her eyes with whitened knuckles. In brush technique Eakins is close to the fluidity of Courbet, although his compositional arrangement and dramatic lighting are surely indebted to Rembrandt.

Eakins devoted his career to increasingly realistic portraits. Their haunting veracity often disappointed sitters who would have preferred more flattering renditions. The artist's passion for realism led him to use photography extensively as a point of departure for his paintings as well as an art form in itself. Eakins's style and ideas influenced American artists of the early twentieth century who also worked in a Realist vein.

Thomas Cole

During the nineteenth century, American artists turned, for the first time, from the tradition of portraiture to landscape painting. Inspired by French landscape painting of the Baroque period, these artists fused this style with a pride in the beauty of their native United States and a Romantic vision that was embodied in the writings of James Fenimore Cooper.

One such artist was Thomas Cole (1801–1848). Cole was born in England and immigrated to the United States at the age of 17. Cole was always fond of landscape painting and settled in New York, where there was a ready audience for this genre. Cole became the leader of the **Hudson River School**—a group of artists whose favorite subjects included the scenery of the Hudson River Valley and the Catskill Mountains in New York State.

The Oxbow (Fig. 8-42) is typical of such paintings. It records a natural oxbow formation in the Connecticut River Valley. Cole combines a vast, sun-drenched space with meticulously detailed foliage and farmland. There is a contrast

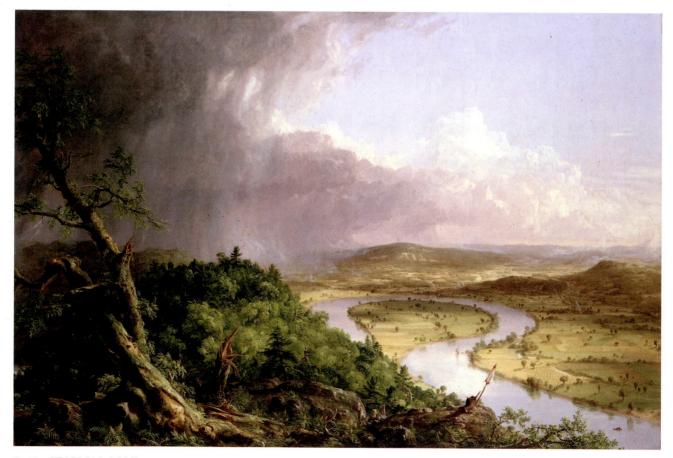

 8-42 THOMAS COLE. The Oxbow (Connecticut River near Northampton) (1836). Oil on canvas. 51¹/₂" × 76". The Metropolitan Museum of Art, New York. Gift of Mrs. Russell Sage, 1908 (08.228). Copyright 1995 The Metropolitan Museum of Art, New York.

Weaving Together Biblical and Personal Stories

In 1859, Harriet Beecher Stowe, renowned author of *Uncle Tom's Cabin*, described the quilting bee:

The day was spent in friendly gossip as they rolled and talked and laughed.... One might have learned in that instructive assembly how best to keep moths out of blankets; how to make fritters of Indian corn undistinguishable from oysters; how to bring up babies by hand; how to mend a cracked teapot; how to take grease from a brocade; how to reconcile absolute decrees with free will; how to make five yards of cloth answer the purpose of six; and how to put down the Democratic party.*

Many years later, an author on quiltmaking quoted her great-grandmother: "My whole life is in that quilt. It scares me sometimes when I look at it. All my joys and all my sorrows are stitched into those little pieces."[†]

The art of quiltmaking was clearly not only an acceptable vehicle for women's artistic expression but also an arena for consciousness raising on the practical and political problems of the day. Beyond this, the object recorded family history, kept memory alive, and ensured the survival of the matriarch/quilter through that historical record.

Toward the end of the nineteenth century, African American quilter Harriet Powers created her *Bible Quilt.* Its 15 squares of cotton appliqué weave together stories from the Bible with significant events from the family and community of the artist (Fig. 8-43). For example, reading left to right, the fourth square is a symbolic depiction of Adam and Eve in the Garden of Eden. A serpent tempts Eve beneath God's all-seeing eye and benevolent hand. In the sixth square, Jonah is swallowed by a whale. The last square is a stylized depiction of the Crucifixion. Amidst

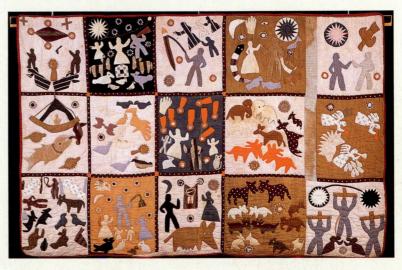

the religious subjects are records of meaningful days. For example, the eleventh square was described by Powers as "Cold Thursday," February 10, 1895. A woman is shown frozen at a gateway while at prayer. Icicles form from the breath of a mule. All bluebirds are killed. The thirteenth square includes an "independent" hog that was said to have run 500 miles from Georgia to Virginia, and the fourteenth square depicts the creation of animals in pairs.

Unity in the quilt is created by a subtle palette of complementary hues and by simple, cutout shapes that define celestial orbs, biblical and familial characters, and biblical and local animals. The quilt has an arresting combination of widely known themes and private events known to the artist and her family. The juxtaposition establishes an equivalence between biblical and personal stories. The work personalizes the religious events and imbues the personal and provincial events with universal meaning.

Because of the hardness of the times, the artist sold the quilt for five dollars.[‡]

[†]Marguerite Ickis, *The Standard Book of Quiltmaking and Collecting* (New York: Dover, 1960).

8-43 HARRIET POWERS. Bible Quilt: The Creation of the Animals (1895–1898). Pieced, appliquéd, and printed cotton embroidered with cotton and metallic yarn. 69" × 105". Bequest of Maxim Karolik. Courtesy Museum of Fine Arts, Boston, MA.

^{*}Harriet Beecher Stowe, The Minister's Wooing (New York: Derby and Jackson, 1859).

[‡]In Mirra Bank, Anonymous Was a Woman (New York: St. Martin's Press, 1979), 118.

in moods between the lazy movement of the river, which meanders diagonally into the distance, and the more vigorous diagonal of the gnarled tree trunk in the left foreground. Half of the canvas space is devoted to the sky, whose storm clouds roll back to reveal rays of intense light. These atmospheric effects, coupled with our "crow's-nest" vantage point, magnify the awesome grandeur of nature and force us to contemplate the relative insignificance of humans.

THE BIRTH OF MODERN SCULPTURE

Some of the most notable characteristics of modern painting include a newfound realism of subject and technique; a more fluid, or impressionistic handling of the medium; and a new treatment of space. Nineteenth-century sculpture, for the most part, continued stylistic traditions that artists saw as complementing the inherent permanence of the medium with which they worked. It would seem that working on a large scale with materials such as marble or bronze was not well suited to the spontaneous technique that captured fleeting impressions. One nineteenth-century artist, however, changed the course of the history of sculpture by applying to his work the very principles on which modern painting was based, including Realism, Symbolism, and Impressionism—Auguste Rodin.

Auguste Rodin

Auguste Rodin (1840–1917) devoted his life almost solely to the representation of the human figure. His figures were imbued with a realism so startlingly intense that he was accused of casting the sculptures from live models. (It is interesting to note that casting of live models is used today without criticism.)

Rodin's *The Burghers of Calais* (Fig. 8-44) represents all of the innovations of Modernism thrust into three dimensions. The work commemorates a historical event in which six prominent citizens of Calais offered their lives to the conquering English so that their fellow townspeople might be spared. They present themselves in coarse robes with nooses around their necks. Their psychological states range from quiet defiance to frantic desperation. The reality of the scene is achieved in part by the odd placement of the figures. They are not a symmetrical or cohesive group. Rather, they are a scattered collection of individuals, who were meant to be seen at street level. Captured as they are, at a particular moment in time, Rodin ensured that spectators would partake of the tragic emotion of the scene for centuries to come.

Rodin preferred modeling soft materials to carving because they enabled him to achieve highly textured surfaces that captured the play of light, much as in an Impressionist painting. As his career progressed, Rodin's sculptures took on an abstract quality. Distinct features were abandoned in favor of solids and voids that, together with light, constructed the image of a human being. Such works were outrageous in their own day—audacious and quite new. Their abstracted features set the stage for yet newer and more audacious art forms that would rise with the dawn of the twentieth century.

ART NOUVEAU

In looking at examples of French, Norwegian, and American art of the nineteenth century, we witnessed a collection of disparate styles that reflected the artists' unique situations or personalities. Given the broad range of circumstances that give rise to a work of art, it would seem unlikely that a crosscultural style could ever evolve. However, as the nineteenth

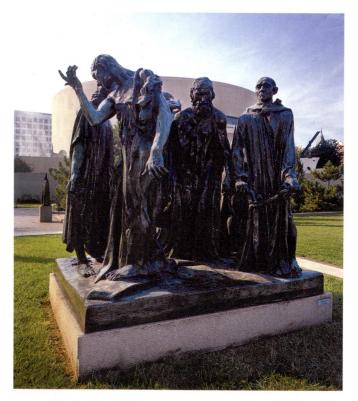

 8-44 AUGUSTE RODIN. The Burghers of Calais (1884–1895). Bronze. 79³/₈" × 80⁷/₈" × 77¹/₈". Copyright Hirshhorn Museum and Sculpture Garden. Gift of Joseph Hirshhorn, 1966.

The only thing is to see.

-Auguste Rodin

century turned to the twentieth, there arose a style called Art Nouveau whose influence extended from Europe to the United States. Its idiosyncratic characteristics could be found in painting and sculpture as well as architecture, furniture, jewelry, fashion, and glassware.

Art Nouveau is marked by a lyrical linearity, the use of symbolism, and rich ornamentation. There is an overriding sense of the organic in all of the arts of this style, with many of the forms, such as those in Victor Horta's (1861–1947) staircase (Fig. 8-45), reminiscent of exotic plant life. Antonio Gaudi's (1852–1926) apartment house in Barcelona, Spain (Fig. 8-46), shows an obsessive avoidance of straight lines and flat surfaces. The material looks as if it had grown in place or hardened in malleable wood forms, as would cement; in actuality, it is cut stone. The rhythmic roof is wavelike, and the chimneys seem dispensed like shaving cream or soft ice cream. Nor are any two rooms on a floor alike. This multistory organic hive is clearly the antithesis of the steel-cage construction that was coming into its own at the same time.

Art Nouveau originated in England. It was part of an arts and crafts movement that arose in rebellion against the pretentiousness of nineteenth-century art. Although it continued into the early years of the twentieth century, the style disappeared with the onset of World War I. At that time art began to reflect the needs and fears of humanity faced with self-destruction.

8–45 VICTOR HORTA.
 Staircase in the Hotel van Eetvelde, Brussels (1895).
 Brussels, Belgium. Copyright Foto Marburg/Art Resource, New York.

8–46 ANTONIO GAUDI. *Casa Mila Apartment House*, Barcelona (1905–1907). Copyright Art Resource, New York.

ARCHITECTURE

Nineteenth-century industrialization enabled **cast iron** and steel to emerge as widely used building materials. They were but two of a number of innovative structural materials that would change the face of architecture. Cast iron was the first material to allow the erection of tall buildings with relatively slender walls. A single 12' column of cast iron could replace a stone wall several feet thick. Iron beams and bolted trusses are also capable of spanning vast interior spaces, freeing them from the forests of columns that would otherwise be required with stone.

At the mid-nineteenth-century Great Exhibition held in Hyde Park, London, Sir Joseph Paxton's Crystal Palace (Fig. 8-47) covered 17 acres. Like subsequent iron buildings, the Crystal Palace was prefabricated, that is, its structural iron components were cast at a factory and sent to the site. An expanding nexus of railways facilitated transportation, and it was a simple matter to assemble the parts at the exhibition—or anywhere else. The structure could be, and was, dismantled and reconstructed at another site. The iron skeleton, with its myriad arches and trusses, framed plateglass panels that served as non-weight-bearing walls. The iron support structure, rather than being hidden, became an integral part of the design. Paxton asserted that "nature" had been his "engineer," explaining that he merely copied the system of longitudinal and transverse supports that one finds in a leaf. The Crystal Palace served as a museum and concert hall until heavily damaged by fire. It was demolished by the English during World War II, after it was discovered that the Germans were using it as a landmark for their pilots on bombing runs.

The Eiffel Tower (Fig. 8-48) was constructed in Paris in 1889 for another World Exposition. Gustave Eiffel's open design, which rejected a standard masonry façade in favor of the glorification of contemporary materials and structural elements, was castigated by critics. Today the tower, with its magnificent exposed iron trusses, has become the single most recognizable symbol of Paris. The pieces of the 1,000foot-tall tower were prefabricated, and the tower was assembled at the site in 17 months by only 150 workers. Castiron structures such as the Crystal Palace and Eiffel Tower presaged steel-cage construction and the development of the skyscraper.

Steel is a strong metal comprised of iron alloyed with small amounts of carbon and a variety of other metals. Steel is harder than iron, and more rust and fire resistant. It is more expensive than other structural materials, but its great strength permits it to be used in relatively small quantities. Light, thin, prefabricated steel beams have great tensile strength. They resist bending in any direction and can be riveted or welded together at the site into skeletal forms called **steel cages** (Fig. 8-49). Facades of materials such as stone, glass, or metal, as well as interior walls, are attached to the skeleton, which supports them with ease.

 8-47 Engraving of Sir Joseph Paxton's Crystal Palace, London (1851).
 Copyright Ann Ronan Picture Library/Heritage Image Partnership (HIP), heritage-images.com.

8–48 GUSTAVE EIFFEL. Eiffel Tower, Paris (1889). Topfoto/The Image Works.

The Wainwright Building (Fig. 8-50), erected in 1890, is an early example of steel-cage construction. Louis Sullivan, one of the fathers of modern American architecture, originated the phrase "form follows function," and his rigid horizontal and vertical processions of the elements of the facade suggest the regularity of the rectangular spaces within. Sullivan, on the other hand, was not averse to ornamentation. The verticality of the building is enhanced by **pilasters** between the windows. Decorative horizontal bands separate most of the windows, and a prominent **cornice** crowns the building. Sullivan's early "skyscraper"—in function, in structure, and in simplified form—was a precursor of the twentieth-century behemoths to follow.

8-49 Steel-cage construction.

8–50 LOUIS SULLIVAN. Wainwright Building, St. Louis, MO (1890). Courtesy Bill Hedrich, Hedrich-Blessing/ Chicago Historical Society.

ART TOUR Paris

Jou could devote your entire life to the pursuit and still not see all the visual delights of Paris. The city itself is one of the most beautiful in the world—a work of art in itself. Its origins, however, are far more humble. When the Romans conquered Paris in 55 BCE, it was a small fishing village on the north ("right") bank of the Seine River. Paris today has spread across the river to the Left Bank, and that tiny fishing village has expanded to hold more than 2 million people. It occupies the center of what is known as the Île-de-France, now home to one-fifth of France's 50 million people. The Île-de-France includes Versailles to the west (site of the glorious palace of King Louis XIV), Chartres with its famed Gothic cathedral (Fig. 4-23) to the southwest, and numerous chateaus, such as Fontainebleau and-my favorite-Chantilly. Twenty miles and a short train or auto ride to the east is Disneyland Paris, and a ride northwest will get you to Giverny and Monet's famous gardens, where the famed Impressionist painted water lilies, a Japanese footbridge, and many other outdoor delights. When in doubt, use the train. The Paris subway, called the Metro, is one of the best in the world, and the high-velocity trains out of town will move you around rapidly.

Take the Metro to the Trocadéro stop to visit the Eiffel Tower. Be captivated by the vista as you walk downhill between the museums on Chaillot Hill (Picasso might never have painted *Les Demoiselles d'Avignon* if he hadn't seen the African masks at the Musée de l'Homme) and across the Seine to the tower, which was built in 1889 for an industrial exhibition. At the

EIFFEL TOWER. Copyright Larry Lee Photography/ Corbis.

time, the architect Gustave Eiffel was castigated by critics for building an open structure that lacked the standard masonry facade. The pieces of the 984-foot- tall tower were prefabricated, and the tower was assembled at the site in 17 months by only 150 workers. Napoleon's tomb and the Rodin Museum are a relatively short walk from the Tower.

Much of Paris is centered around the Place de la Concorde, from which one can look in any direction and find major monuments. This hub features a 3,200year-old Egyptian obelisk that occupies the exact spot where, in the wake of the French Revolution (the Place de la Concorde was once the Place de la Revolution), a guillotine stood and the heads of more than 1,000 people rolled. To the west of the Concorde, along the Champs-Élysées—a wide boulevard where you can shop till you drop—is the Place de l'Étoile. The centerpiece of this star-shaped intersection is the Arc de Triomphe, built by Napoleon to celebrate his victorious military campaigns. It is one of the world's craziest rotaries; motorists enter it without looking anywhere but straight ahead. It is incumbent on the drivers already in the mess to do the watching out.

Just to the east of the Place de la Concorde—heading away from the Arc de Triomphe—is the Jardin (garden) des Tuileries, with lovely paths for strolling, donkey rides, a carousel, and even a Ferris wheel. Along the north side of the Tuileries, you will find the Rue de Rivoli and some of the most expensive shopping in Paris.

Just past the Jardin des Tuileries is the Louvre Museum, which many art historians consider to have the foremost collection of the art in the world. Here you will find Leonardo's *Mona Lisa* (Fig. 5-19), David's *The Oath of the Horatii* (Fig. 8-1), Géricault's *The Raft of the "Medusa"* (Fig. 8-5), Aphrodite of Melos (Venus de Milo, Fig. 3-17), Delacroix's *The Death of Sardanapalus* (Fig. 8-6), Manet's Olympia (Fig. 8-18), Whistler's *Arrangement in Black and Gray: The Artist's Mother* ("Whistler's Mother," Fig. 8-40), and many more famed works from around the world. But the museum itself has become a more noted work of art with I. M. Pei's controversial addition (the traditional first wing of the Palais du Louvre was built by François I in 1527).

The south side of the Jardin des Tuileries runs along the Seine and is connected to the Left Bank by many bridges. Across from the Jardin you will find the Musée d'Orsay. Before its opening in 1986, the building had been the old Gare d'Orsay, the grandest railway station in the city. In its new incarnation, the familiar floriated clock still tells time. Manets, Monets, Renoirs, Courbets, Rodins, and other beloved works from the second half of the nineteenth century and the first

I. M. PEI, Pyramid at the Louvre. Photo by Spencer A. Rathus. All rights reserved.

MUSÉE D'ORSAY. Copyright Stefano Bianchetti/Corbis.

decade of the twentieth populate byways where passengers once rushed. From its roof you can view the church of Sacré Coeur to the north, the Jardin des Tuileries just across the river, and the Louvre just to the right of the Jardin.

On the Right Bank in central Paris you will find a very different museum, one of contemporary art: the Georges Pompidou National Center of Art and Culture, designed by Richard Rogers and Renzo Piano. It could not be more different from the Greek-inspired Classicism of the Louvre, given its trussed steel-cage structure, service ducts, huge escalator, and stacks that remind one of an ocean liner. While in the vicinity of the Pompidou Center, take in some of the street life in the large square in front of the building or relax by the Stravinsky Fountain with its huge red lips and other sculptures, thanks to the contemporary artistry of Niki de Saint Phalle. You will find numerous cafés around the fountain and the square. This is a great place to take a rest.

To the east of the Musée d'Orsay and the Louvre, the majestic cathedral of Notre-Dame rises on an island in the Seine—the Île de la Cité. With the stories of the hunchback of Notre-Dame, and with its perch on the banks of the river, the cathedral is one of the most famous buildings in the history of architecture. Notre-Dame is a curious mixture of old and new elements, begun in 1163 and not completed until almost a century later. While on the Île de la Cité, do not miss seeing Saint-Chapelle, which has been hailed as ethereal, magical, and one of the architectural wonders of the Western world. Multicolored light floods the upper chapel through 15 stained-glass windows.

Behind Notre-Dame—past the flying buttresses, a little park, and across a street usually populated by parked tourist buses—you'll find another park and then a surprising Deportation Memorial (Mémorial des Martyrs et de la Déportation), which is below ground level and against the river. You descend a narrow stairway onto a platform with bars that

NOTRE-DAME. Copyright Yann Arthus-Bertrand/Corbis.

prevent you from reaching the water. No way out. A room off the platform names the Nazi death camps to which Jews and others were deported.

If you head south from the Île de la Cité along Boulevard St. Michel, you'll find outdoor cafés, including the Deux Magots, where Ernest Hemingway and F. Scott Fitzgerald drank and dined. Cross Boulevard Saint-Germain and you're in University of Paris territory. Within a few blocks on the left you'll see the Pantheon, which houses an interesting crypt where Madame Curie, among others, is interred. On the right side you will come to the Luxembourg Gardens, with its hedged trees, palace, and sailboat pond.

Don't pass up Père Lachaise, which is the major cemetery in Paris. You will find graves and fascinating mausoleums for the Romantic painters Eugène Delacroix and Théodore Géricault, the Polish composer Frédéric Chopin, the British writer Oscar Wilde, the French actress Sarah Bernhardt, the French playwright Molière, the American Jim Morrison (lead singer of the Doors), and dozens of others whom you are likely to recognize.

No visit to Paris is complete without a trip to Versailles (see Fig. 6-22). This complex began as a hunting lodge and was rebuilt in 1668 by the Sun King (Louis XIV) into the grandest palace in Europe. The palace is well known for its magnificent Hall of Mirrors and its art collection, but you'll also want to spend time strolling in the gardens. When at Versailles, be sure to visit the Grand Trianon, one of the "outbuildings" of the complex, for its colonnade and sweeping vistas of hedged trees and human-made lakes. Take a boat ride or just wander among the greenery, as did Queen Marie Antoinette in her peasant-girl attire. Sometimes we all need to escape.

To continue your tour and learn more about Paris, go to our Premier Companion website.

THE TWENTIETH CENTURY: THE EARLY YEARS

When people ask me to compare the 20th century to older civilizations, I always say the same thing: "The situation is normal." —Will Durant

t could be said that the art world has been in a state of perpetual turmoil for the last hundred years. All the important movements that were born during the late nineteenth and early twentieth centuries met with the hostile, antiseptic gloves of critical disdain. When Courbet's paintings were rejected by the 1855 Salon, he set up his own Pavilion of Realism and pushed the Realist movement on its way. Just eight years later, rejection by the Salon jury prompted the origin of the Salon des Réfusés, an exhibition of works including those of Manet. These ornery French artists went on to found the influential Impressionist movement. Their very name—*Impressionism*—was coined by a hostile critic who degraded their work as mere "impressions," sort of quick and easy sketches of the painter's view of the world. Impressionism ran counter to the preferred illusionistic realism of Academic painting. The opening years of the twentieth century saw no letup to these scandalous entrees into the world of modern art. In 1905 the **Salon d'Automne**—an independent exhibition so named to distinguish it from the Academic Salons that were traditionally held in the spring—brought together the works of an exuberant group of French avant-garde artists who assaulted the public with a bold palette and distorted forms. One art critic who peeked in on the show saw a Renaissance-type sculpture surrounded by these blasphemous forms. He was sufficiently unnerved by the juxtaposition to exclaim, "Donatello au milieu des fauves!" (that is, "Donatello among the wild beasts!"). With what pleasure, then, the artists adopted as their epithet: "The Fauves." After all, it was a symbol of recognition.

THE FAUVES

In some respects, **Fauvism** was a logical successor to the painting of van Gogh and Gauguin. Like these Postimpressionists, the Fauvists also rejected the subdued palette and delicate brushwork of Impressionism. They chose their color and brushwork on the basis of their emotive qualities. Despite the aggressiveness of their method, however, their subject matter centered on traditional nudes, still lifes, and landscapes.

What set the Fauves apart from their nineteenth-century predecessors was their use of harsh, nondescriptive color; bold linear patterning; and a distorted form of perspective. They saw color as autonomous, a subject in and of itself, not merely an adjunct to nature. Their vigorous brushwork and emphatic line grew out of their desire for a direct form of expression, unencumbered by theory. Their skewed perspective and distorted forms were also inspired by the discovery of ethnographic works of art from Africa, Polynesia, and other ancient cultures.

André Derain

One of the founders of the Fauvist movement was André Derain (1880–1954). In his *London Bridge* (Fig. 9-1) we find the convergence of elements of nineteenth-century styles and the new vision of Fauvism. The outdoor subject matter is reminiscent of Impressionism (Monet, in fact, painted many renditions of Waterloo Bridge in London), and the distinct zones of unnaturalistic color relate the work to Gauguin. But the forceful contrasts of primary colors and the delineation of forms by blocks of thickly applied pigment speak of something new.

Nineteenth-century artists emphasized natural light and created their shadows from color components. Derain and the Fauvists evoked light in their canvases solely with color contrasts. Fauvists tended to negate shadow altogether. Whereas Gauguin used color areas primarily to express emotion, the Fauvist artists used color to construct forms and space. Although Derain used his bold palette and harsh line to render his emotional response to the scene, his bright blocks of pigment also function as building facades. Derain's oblong patches of color define both stone and water. His thickly laden brushstroke constructs the contour of a boat and the silhouette of a fisherman.

Henri Matisse

Along with Derain, Henri Matisse (1869–1954) brought Fauvism to the forefront of critical recognition. Yet Matisse was one of the few major Fauvist artists whose reputation exceeded that of the movement. Matisse started law school at the age of 21, but when an illness interrupted his studies, he began to paint. Soon thereafter he decided to devote himself totally to art. Matisse's early paintings revealed a strong and traditional compositional structure, which he gleaned from his first mentor, Adolphe William Bouguereau (see Fig. 8-12),

9-1 ANDRÉ DERAIN.

London Bridge (1906). Oil on canvas. $26'' \times 39''$. The Museum of Modern Art, New York. Gift of Mr. And Mrs. Charles Zadok. Copyright Scala/Art Resource, New York. Copyright 2007 Artists Rights Society (ARS), New York/ADAGP, Paris.

My choice of colors does not rest on any scientific theory; it is based on observation, on feeling, on the very nature of each experience.

—Henri Matisse

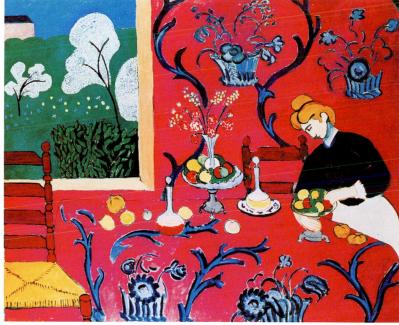

9-2 HENRI MATISSE. *Red Room (Harmony in Red)* (1908–1909). Oil on canvas. 69³/4" × 85⁷/8". The Hermitage, St. Petersburg, Russia. Copyright 2007 Succession H. Matisse, Paris/Artists Rights Society (ARS), New York/Scala/Art Resource, New York.

and from copying old masters in the Louvre. His loose brushwork was reminiscent of Impressionism, and his palette was inspired by the color theories of the Postimpressionists. In 1905 he consolidated these influences and painted a number of Fauvist canvases in which, like Derain, he used primary color as a structural element. These canvases were exhibited with those of other Fauvists at the Salon d'Automne of that year.

In his post-Fauvist works, Matisse used color in a variety of other ways—structurally, decoratively, sensually, and expressively. In his *Red Room (Harmony in Red)* (Fig. 9-2), all of these qualities of color are present. A vibrant palette and curvilinear shapes create the gay mood of the canvas. The lush red of the wallpaper and tablecloth absorb the viewer in their brilliance. The arabesques of the vines create an enticing surface pattern.

A curious contest between flatness and three dimensions in Red Room characterizes much of Matisse's work. He crowds the table and wall with the same patterns. They seem to run together without distinction. This jumbling of patterns propels the background to the picture plane, asserting the flatness of the canvas. The two-dimensionality of the canvas is further underscored by the window in the upper left, which is rendered so flatly that it suggests a painting of a garden scene instead of an actual view of a distant landscape. Yet for all of these attempts to collapse space, Matisse counteracts the effect with a variety of perspective cues: the seat of the ladder-back chair recedes into space, as does the table; and the dishes are somewhat foreshortened, combining frontal and bird's-eye views.

Matisse used line expressively, moving it rhythmically across the canvas to complement the pulsing color. Although the structure of *Red Room* remains assertive, Matisse's foremost concern was to create a pleasing pattern. Matisse insisted that painting ought to be joyous. His choice of palette, his lyrical use of line, and his brightly painted shapes are all means toward that end. He even said of his work that it ought to be devoid of depressing subject matter, that his art ought to be "a mental soother, something like a good armchair in which to rest."¹

Although the colors and forms of Fauvism burst explosively on the modern art scene, the movement did not last very long. For one thing, the styles of the Fauvist artists were very different from one another, so the members never formed a cohesive group. After about five years, the "Fauvist qualities" began to disappear from their works as they pursued other styles. Their disappearance was, in part, prompted by a retrospective exhibition of Cézanne's painting held in 1907, which revitalized an interest in this nineteenthcentury artist's work. His principles of composition and constructive brush technique were at odds with the Fauvist manifesto.

¹Robert Goldwater and Marco Treves, eds., *Artists on Art* (New York: Pantheon Books, 1972), 413.

While Fauvism was descending from its brief colorful flourish in France, related art movements, termed **expressionistic**, were ascending in Germany.

EXPRESSIONISM

Expressionism is the distortion of nature—as opposed to the imitation of nature-in order to achieve a desired emotional effect or representation of inner feelings. According to this definition, we have already seen many examples of this type of painting. The work of van Gogh and Gauguin would be clearly expressionistic, as would the paintings of the Fauves. Even Matisse's Red Room distorts nature or reality in favor of a more intimate portrayal of the artist's subject, colored, as it were, by his emotions. Edvard Munch and Käthe Kollwitz were expressionistic artists who used paintings and prints as vehicles to express anxieties, obsessions, and outrage. Three other movements of the early twentieth century have been termed expressionistic: Die Brücke, Der Blaue Reiter, and The New Objectivity, or Neue Sachlichkeit. Although very different from one another in the forms they took, these movements were reactions against Impressionism and Realism. They also sought to communicate the inner feelings of the artist.

Die Brücke (The Bridge)

Die Brücke (The Bridge) was founded in Dresden, Germany, at the same time that Fauvism was afoot in France. The artists who began the movement chose the name *Die Brücke* because, in theory, they saw their movement as bridging a number of disparate styles. Die Brücke, like Fauvism, was short-lived because of the lack of cohesion among its proponents. Still, Die Brücke artists showed some common interests in techniques and subject matter that ranged from boldly colored landscapes and cityscapes to horrific and violent portraits. Their emotional upheaval may, in part, have reflected the mayhem of World War I.

Emil Nolde

The supreme colorist of the Expressionist movement was Emil Nolde (1867–1956), who joined Die Brücke a year after it was founded. Canvases of his, such as *Dance around the Golden Calf* (Fig. 9-3), are marked by a frenzied brush technique in which clashing colors are applied in lush strokes. The technique complements the nature of the subject—a biblical theme recounting the worshiping of an idol by the Israelites even as their liberator, Moses, was receiving the Ten Commandments on Mount Sinai. In Nolde's characteristic fashion, both ecstasy and anguish are brought to the same uncontrolled, high pitch.

9-3 EMIL NOLDE.

Dance around the Golden Calf (1910). Oil on canvas. 34³/s" × 41". Staatsgalerie Moderner Kunstmuseum, Munich. Copyright Bridgeman Art Library.

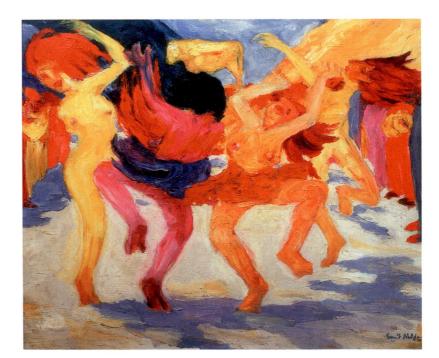

Nolde was also well known for his graphics. He used the idiosyncratic, splintered characteristics of the woodcut—a medium that had not been in vogue for centuries to create ravaged, masklike portraits of pain and suffering.

Der Blaue Reiter (The Blue Rider)

Emotionally charged subject matter, often radically distorted, was the essence of Die Brücke art. **Der Blaue Reiter** (**The Blue Rider**) artists—who took their group name from a painting of that title by Wassily Kandinsky, a major proponent—depended less heavily on content to communicate feelings and evoke an emotional response from the viewer. Their work focused more on the contrasts and combinations of abstract forms and pure colors. In fact, the work of Der Blaue Reiter artists, at times, is completely without subject and can be described as nonobjective, or abstract. Whereas Die Brücke artists always used nature as a point of departure, Der Blaue Reiter art sought to free itself from the shackles of observable reality.

Wassily Kandinsky

One of the founders of Der Blaue Reiter was Wassily Kandinsky (1866–1944), a Russian artist who left a career in law to become an influential abstract painter and art theorist. During numerous visits to Paris early in his career, Kandinsky was immersed in the works of Gauguin and the Fauves and was himself inspired to adopt the Fauvist idiom. The French experience opened his eyes to color's powerful capacity to communicate the artist's inmost psychological and spiritual concerns. In his seminal essay "Concerning the Spiritual in Art," he examined this capability and discussed the psychological effects of color on the viewer. Kandinsky further analyzed the relationship between art and music in this study.

Early experiments with these theories can be seen in works such as *Sketch I for Composition VII* (Fig. 9-4), in which bold colors, lines, and shapes tear dramatically across the canvas in no preconceived fashion. The pictorial elements flow freely and independently throughout the painting, reflecting, Kandinsky believed, the free flow of unconscious thought. *Sketch I for Composition VII* and other works of this series underscore the importance of Kandinsky's early Fauvist contacts in their vibrant palette, broad brushstrokes, and dynamic movement, and they also stand as harbingers of a new art unencumbered by referential subject matter.

For Kandinsky, color, line, and shape were subjects in themselves. They were often rendered with a spontaneity born of the psychological process of free association. At this time free association was also being explored by the founder of psychoanalysis, Sigmund Freud, as a method of mapping the geography of the unconscious mind.

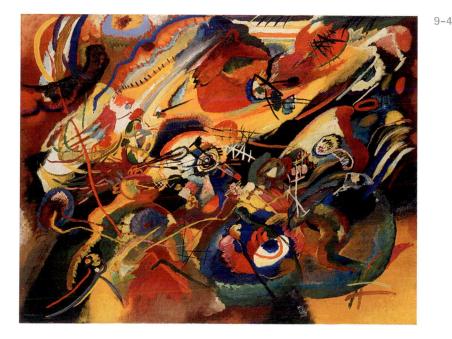

WASSILY KANDINSKY. Sketch I for Composition VII (1913). Oil on canvas. 30³/4" × 39³/8". Photo copyright Sotheby's Picture Library. Copyright 2007 Artists Rights Society (ARS)/ADAGP, Paris.

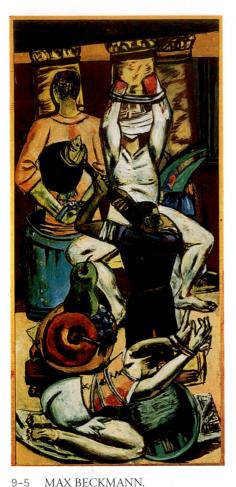

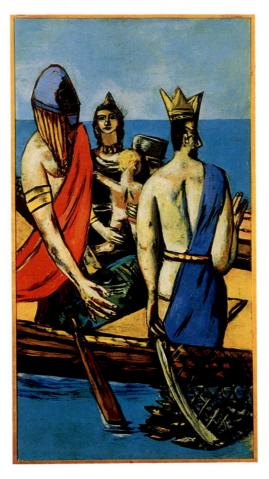

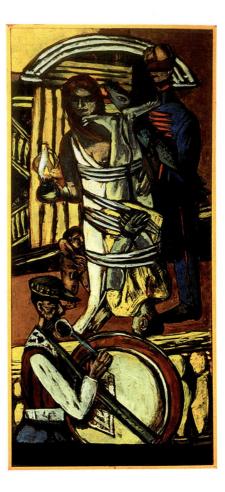

MAX BECKMARIN. Departure (1932–1933). Oil on canvas. Triptych, center panel $7'^{3}/_{4}'' \times 3'^{3}/_{8}''$; side panels each $7'^{3}/_{4}'' \times 3'^{1}/_{4}''$. The Museum of Modern Art, New York. Given anonymously. Copyright Art Resource, New York. Copyright 2007 Artists Rights Society (ARS), New York/VG, Bild-Kunst, Bonn.

The New Objectivity (Neue Sachlichkeit)

As World War I drew to a close and World War II loomed on the horizon, different factions of German Expressionism could be observed. Some artists, such as Max Beckmann (1884–1950), calling themselves **The New Objectivity** (Neue Sachlichkeit), reacted to the horrors and senselessness of wartime suffering with an art that commented bitterly on the bureaucracy and military with ghastly visions of human torture. In *Departure* (Fig. 9-5), a painting whose subject is exile, two panels depicting such torture flank a central canvas in which a king looks back longingly on his homeland. He stands as a universal symbol for all of those who were forced to flee their native lands with Adolf Hitler's rise to power.

CUBISM

The history of art is colored by the tensions of stylistic polarities within given eras, particularly the polarity of an intellectual versus an emotional approach to painting. Fauvism and German Expressionism found their roots in Romanticism and the emotional expressionistic work of Gauguin and van Gogh. The second major art movement of the twentieth century, Cubism, can trace its heritage to Neoclassicism and the analytical and intellectual work of Cézanne. Cubism is like standing at a certain point on a mountain and looking around. If you go higher, things will look different; if you go lower, again they will look different. It is a point of view.

—Jacques Lipchitz

I paint objects as I think them, not as I see them.

-Pablo Picasso

Cubism is an offspring of Cézanne's geometrization of nature and his abandonment of scientific perspective, his rendering of multiple views, and his emphasis on the twodimensional canvas surface. Picasso, the driving force behind the birth of Cubism, and perhaps the most significant artist of the twentieth century, combined the pictorial methods of Cézanne with formal elements from native African, Oceanic, and Iberian sculpture.

Pablo Picasso

Pablo Ruiz y Picasso (1881–1973) was born in Spain, the son of an art teacher. As an adolescent, he enrolled in the Barcelona Academy of Art, where he quickly mastered the illusionistic techniques of the realistic Academic style. By the age of 19, Picasso was off to Paris, where he remained for more than 40 years—introducing, influencing, or reflecting the many styles of modern French art.

Picasso's first major artistic phase has been called his Blue Period. Spanning the years 1901 to 1904, this work is characterized by an overall blue tonality, a distortion of the human body through elongation reminiscent of El Greco and Toulouse-Lautrec, and melancholy subjects consisting of poor and downtrodden individuals engaged in menial tasks or isolated in their loneliness. The Old Guitarist (Fig. 9-6) is but one of these haunting images. A contorted, white-haired man sits hunched over a guitar, consumed by the tones that emanate from what appears to be his only possession. The eyes are sunken in the skeletal head, and the bones and tendons of his hungry frame protrude. We are struck by the ordinariness of poverty, from the unfurnished room and barren window view (or is he on the curb outside?) to the uneventfulness of his activity and the insignificance of his plight. The monochromatic blue palette creates an unrelenting somber mood. Tones of blue eerily echo the ghostlike features of the guitarist.

Picasso's Blue Period was followed by works that were lighter both in palette and in spirit. Subjects from this socalled Rose Period were drawn primarily from circus life and

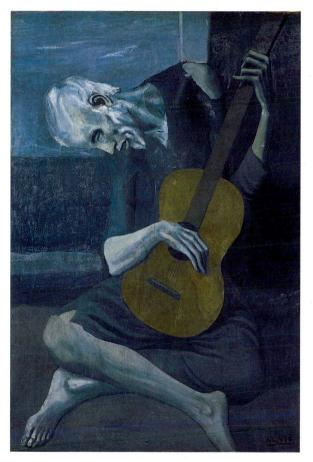

9-6 PABLO PICASSO. *The Old Guitarist* (1903). Oil on canvas. 47³/4" × 32¹/2". The Art Institute of Chicago. Copyright 2007 Estate of Pablo Picasso/Artists Rights Society (ARS), New York.

rendered in tones of pink. During this second period, which dates from 1905 to 1908, Picasso was inspired by two very different art styles. He, like many artists, viewed and was strongly influenced by the Cézanne retrospective exhibition held at the Salon d'Automne in 1907. At about that time,

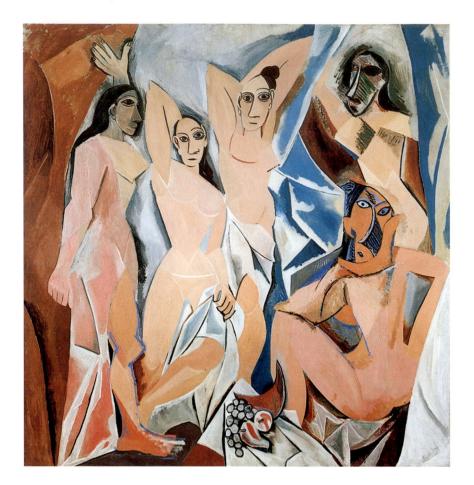

 9-7 PABLO PICASSO. Les Demoiselles d'Avignon (1907). Oil on canvas. 8' × 7'8". The Museum of Modern Art, New York. Acquired through the Lillie P. Bliss Bequest. Copyright Edimedia. Copyright 2007 Estate of Pablo Picasso/Artists Rights Society (ARS), New York.

Picasso also became aware of the formal properties of ethnographic art from Africa, Oceania, and Iberia, which he viewed at the Musée de l'Homme. These two art forms, which at first glance might appear dissimilar, had in common a fragmentation, distortion, and abstraction of form that were adopted by Picasso in works such as *Les Demoiselles d'Avignon* (Fig. 9-7).

This startling, innovative work, still primarily pink in tone, depicts five women from Barcelona's red-light district. They line up for selection by a possible suitor who stands, as it were, in the position of the spectator. The faces of three of the women are primitive masks. The facial features of the other two have been radically simplified by combining frontal and profile views. The thick-lidded eyes stare stage front, calling to mind some of the Mesopotamian votive sculptures we saw in Chapter 2.

The bodies of the women are fractured into geometric forms and set before a background of similarly splintered

drapery. In treating the background and the foreground imagery in the same manner, Picasso collapses the space between the planes and asserts the two-dimensionality of the canvas surface in the manner of Cézanne. In some radical passages, such as the right leg of the leftmost figure, the limb takes on the qualities of drapery, masking the distinction between figure and ground. The extreme faceting of form, the use of multiple views, and the collapsing of space in *Les Demoiselles* together provided the springboard for **Analytic Cubism**, co-founded with the French painter Georges Braque in about 1910.

Analytic Cubism

The term "Cubism," like so many others, was coined by a hostile critic. In this case the critic was responding to the predominance of geometrical forms in the works of Picasso and Braque. Cubism is a limited term in that it does not ad-

Art is meant to disturb.

-Georges Braque

equately describe the appearance of Cubist paintings, and it minimizes the intensity with which Cubist artists analyzed their subject matter. It ignores their most significant contribution—a new treatment of pictorial space that hinged upon the rendering of objects from multiple and radically different views.

The Cubist treatment of space differed significantly from that in use since the Renaissance. Instead of presenting an object from a single view, assumed to have been the complete view, the Cubists, like Cézanne, realized that our visual comprehension of objects consists of many views that we perceive almost at once. They tried to render this visual "information gathering" in their compositions. In their dissection and reconstruction of imagery, they reassessed the notion that painting should reproduce the appearance of reality. Now the very reality of appearances was being questioned. To Cubists, the most basic reality involved consolidating optical vignettes instead of reproducing fixed images with photographic accuracy.

Georges Braque

During the analytic phase of Cubism, which spanned the years from 1909 to 1912, the works of Picasso and Braque were very similar. The early work of Georges Braque (1882–1963) graduated from Impressionism to Fauvism to more structural compositions based on Cézanne. He met Picasso in 1907, and from then until about 1914 the artists worked together toward the same artistic goals.

The theory of Analytic Cubism reached the peak of its expression in 1911 in works such as Braque's *The Portuguese* (Fig. 9-8). Numerous planes intersect and congregate at the center of the canvas to form a barely perceptible triangular human figure, which is alternately constructed from and dissolved into the background. There are only a few concrete signs of its substance: dropped eyelids, a mustache, the circular opening of a stringed instrument. The multifaceted, abstracted form appears to shift position before our eyes, simulating the time lapse that would occur in the visual assimilation of multiple views. The structural lines—sometimes called the *Cubist grid*—that define and fragment the figure are thick and dark. They contrast with the delicately modeled short, choppy brushstrokes of the remainder of the composition. The monochromatic palette, chosen so as not to interfere with the exploration of form, consists of browns, tans, and ochers.

Although the paintings of Picasso and Braque were almost identical at this time, Braque first began to insert words and numbers and to use **trompe l'oeil** effects in portions of his Analytic Cubist compositions. These realistic elements contrasted sharply with the abstraction of the major figures and reintroduced the nagging question, "What is reality and what is illusion in painting?"

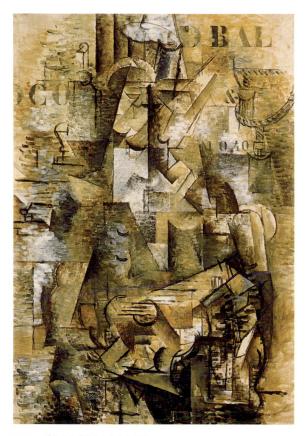

 9-8 GEORGES BRAQUE. The Portuguese (1911). Oil on canvas. 45¹/₂" × 31¹/₂". Oeffentliche Kunstsammlung, Kunstmuseum, Basel. Copyright 2007 Artists Rights Society (ARS), New York/ADAGP, Paris.

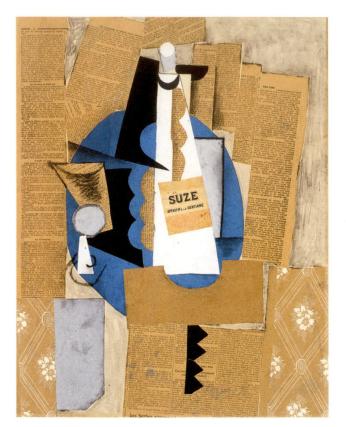

9–9 PABLO PICASSO. *The Bottle of Suze* (1912–1913). Pasted paper with charcoal. 25³/4" × 19³/4". Washington University Gallery of Art, St. Louis. University Purchase, Kende Sale Fund, 1946. Copyright 2007 Estate of Pablo Picasso/ Artists Rights Society (ARS), New York.

Synthetic Cubism

Picasso and Braque did not stop with the inclusion of precisely printed words and numbers in their works. They began to add characters cut from newspapers and magazines, other pieces of paper, and found objects such as labels from wine bottles, calling cards, theater tickets—even swatches of wallpaper and bits of rope. These items were pasted directly onto the canvas in a technique Picasso and Braque called *papier collé*—what we know as **collage**. The use of collage marked the beginning of the synthetic phase of Cubism.

Some Synthetic Cubist compositions, such as Picasso's *The Bottle of Suze* (Fig. 9-9), are constructed entirely of found elements. In this work, newspaper clippings and

opaque pieces of paper function as the shifting planes that hover around the aperitif label and define the bottle and glass. These planes are held together by a sparse linear structure much in the manner of Analytic Cubist works. In contrast to Analytic Cubism, however, the emphasis is on the form of the object and on constructing instead of disintegrating that form. Color reentered the compositions, and much emphasis was placed on texture, design, and movement.

After World War I, Picasso and Braque no longer worked together, and their styles, although often reflective of the Cubist experience they shared, came to differ markedly. Braque, who was severely wounded during the war, went on to create more delicate and lyrical still-life compositions, abandoning the austerity of the early phase of Cubism. Although many of Picasso's later works carried forward the Synthetic Cubist idiom, his artistic genius and versatility became evident after 1920 when he began to move in radically different directions. These new works were rendered in Classical, Expressionist, and Surrealist styles.

When civil war gripped Spain, Picasso protested its brutality and inhumanity through highly emotional works such as Guernica (Fig. 9-10). This mammoth mural, painted for the Spanish Pavilion of the Paris International Exposition of 1937, broadcast to the world the carnage of the German bombing of civilians in the Basque town of Guernica. The painting captures the event in gruesome details such as the frenzied cry of one woman trapped in rubble and fire and the pale fright of another woman who tries in vain to flee the conflagration. A terrorized horse rears over a dismembered body while an anguished mother embraces her dead child and wails futilely. Innocent lives are shattered into Cubist planes that rush and intersect at myriad angles, distorting and fracturing the imagery. Confining himself to a palette of harsh blacks, grays, and whites, Picasso expressed, in his words, the "brutality and darkness" of the age.

Cubist Sculpture

Cubism was born as a two-dimensional art form. Cubist artists attempted to render on canvas the manifold aspects of their subjects as if they were walking around threedimensional forms and recording every angle. The attempt was successful, in part, because they recorded these views with intersecting planes that allowed viewers to perceive the many sides of the figure.

9-10 PABLO PICASSO.

Guernica (1937).

Oil on canvas. $11'6'' \times 25'8''$. Museo Nacional Centro de Arte Reina Sofia, Madrid, Spain/Art Resource, New York. Copyright 2007 Estate of Pablo Picasso/Artists Rights Society (ARS), New York.

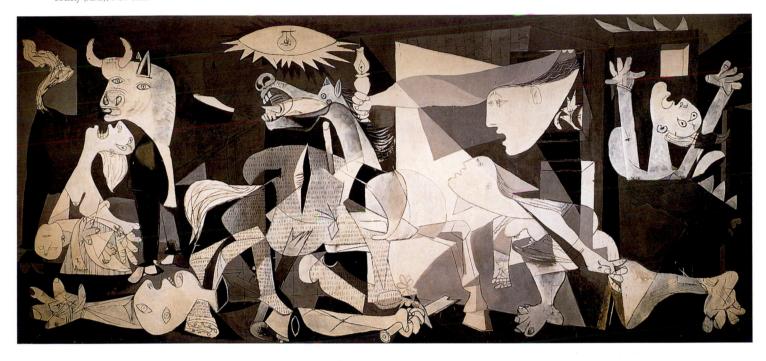

Because Cubist artists were trying to communicate all the visual information available about a particular form, they were handicapped, so to speak, by the two-dimensional surface. In some ways the medium of sculpture was more natural to Cubism, because a viewer could actually walk around a figure to assimilate its many facets. The "transparent" planes that provided a sense of intrigue in Analytical Cubist paintings were often translated as flat solids, as in Jacques Lipchitz's (1891–1964) *Still Life with Musical Instruments* (Fig. 9-11).

Alexander Archipenko

One of the innovations in Cubist sculpture was the threedimensional interpenetration of Cubist planes, as implied in Lipchitz's relief. Another was the use of void space as 9-11 JACQUES LIPCHITZ.

 $\begin{array}{l} \mbox{Still Life with Musical Instruments} \ (1918). \\ \mbox{Stone relief. } 22^{1\!/_2''} \times 28''. \\ \mbox{Copyright Estate of Jacques Lipchitz. Courtesy, Marlborough Gallery, } \\ \mbox{New York.} \end{array}$

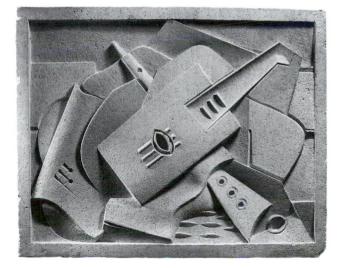

9-12 ALEXANDER ARCHIPENKO.

Walking Woman (1912). Bronze. H: 26¹/2". Copyright 2007 Estate of Alexander Archipenko/Artists Rights Society

solid form, as seen in Walking Woman (Fig. 9-12) by Alexander Archipenko (1887-1964). True to Cubist principles, the figure is fragmented; the contours are broken and dislocated. But what is new here are the open spaces of the torso and head, now as much a part of the whole as the solid forms of the composition. Although there is a good degree of abstract simplification in the figure, the overall impression of the forms prompts recognition of the humanity of the subject.

FUTURISM

Several years after the advent of Cubism, a new movement sprang up in Italy under the leadership of poet Filippo Marinetti (1876–1944). Futurism was introduced angrily by Marinetti in a 1909 manifesto that called for an art of "violence, energy, and boldness" free from the "tyranny of . . . harmony and good taste."2 In theory, Futurist painting and sculpture were to glorify the life of today, "unceasingly and violently transformed by victorious science." In practice, many of the works owed much to Cubism.

Umberto Boccioni

An oft-repeated word in Futurist credo is dynamism, defined as the theory that force or energy is the basic principle of all phenomena. The principle of dynamism is illustrated in Umberto Boccioni's (1882-1916) Dynamism of a Soccer Player (see Fig. 9-17). Irregular, agitated lines communicate the energy of movement. The Futurist obsession with illustrating images in perpetual motion also found a perfect outlet in sculpture. In works such as Unique Forms of Continuity in Space (Fig. 9-13), Boccioni, whose forte was sculpture, sought to convey the elusive surging energy that blurs an image in motion, leaving but an echo of its passage. Although it retains an overall figural silhouette, the sculpture is devoid of any representational details. The flame-like curving surfaces of the striding figure do not exist to define movement; instead, they are a consequence of it.

Giacomo Balla

The Futurists also suggested that their subjects were less important than the portrayal of the "dynamic sensation" of the subjects. This declaration manifests itself fully in Giacomo Balla's (1871–1958) pure Futurist painting, Street Light

²F. T. Marinetti, "The Foundation and Manifesto of Futurism," in *Theories* of Modern Art, ed. Herschel B. Chipp, 284-88 (Berkeley: University of California Press, 1968).

Everything moves, everything runs, everything turns swiftly. The figure in front of us never is still, but ceaselessly appears and disappears. Owing to the persistence of images on the retina, objects in motion are multiplied, distorted, following one another like waves through space. Thus a galloping horse has not four legs; it has twenty.

—Umberto Boccioni

(Fig. 9-14). The light of the lamp pierces the darkness in reverberating circles; V-shaped brushstrokes simultaneously fan outward from the source and point toward it, creating a sense of constant movement. The palette consists of complementary colors that forbid the eye to rest. All is movement; all is sensation.

9-13 UMBERTO BOCCIONI.

Unique Forms of Continuity in Space (1913). Bronze (cast 1931). $43^{7}/8'' \times 34^{7}/8'' \times 15^{3}/4''$. The Museum of Modern Art, New York. Acquired through the Lillie P. Bliss Bequest. Copyright Art Resource, New York.

9-14 GIACOMO BALLA. Street Light (1909). Oil on canvas. 68³/4" × 45¹/4". The Museum of Modern Art, New York. Hillman Periodicals Fund. Copyright The Museum of Modern Art, New York/Licensed by Scala/ Art Resource, New York. Copyright Artists Rights Society (ARS), New York/SIAE, Rome.

A CLOSER LOOK

The Illusion of Motion: Explosions in the Shingle Factory

9-15 THOMAS EAKINS. Man Pole Vaulting (1884). Photograph.

> Metropolitan Museum of Art, New York. Gift of Charles Bregler, 1941 (41.142.11) All rights reserved by The Metropolitan Museum of Art, New York.

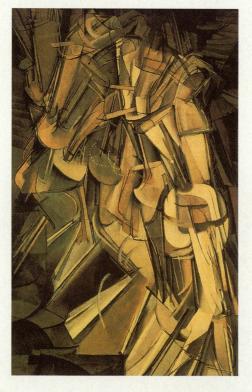

When artists use techniques to suggest that motion is *in the process of occurring*, we say that the works contain the illusion of motion. Early experiments with photography provided an illusion of the figure in motion through the method of rapid multiple exposures. In his *Man Pole Vaulting* (Fig. 9-15), Thomas Eakins—better known for his paintings (see Fig. 8-41)—used photo sequences to study the movement of the human body.

In the wake of these experiments, a number of artists created the illusion of motion by applying the visual results of multiple-exposure photography to their paintings. Marcel Duchamp's *Nude Descending a Staircase #2* (Fig. 9-16) in effect creates multiple exposures of a machine-tooled figure walking down a flight of stairs. The overlapping of shapes and the repetition of linear patterns blur the contours of the figure. Even though an unkind critic labeled the Duchamp painting "an explosion in a shingle factory," it symbolized the dynamism of the modern machine era.

Umberto Boccioni's *Dynamism of a Soccer Player* (Fig. 9-17) reveals the **Futurist** obsession with the dynamism of the modern machine era among a school of artists who worked in

the Italy of nearly a century past. On approaching the painting, one is struck by the sensation of motion long before it becomes possible to decipher the limbs of a running athlete. Spirals, arcs, and what seem to be flame-licked shapes swirl around a core of energy and fan outward, leaving traces of themselves in the surrounding environment. Wedges of sky fall on the figure like so many spotlights, breaking the solids into bits of prismatic color. The soccer player courses, pulsates, and hurtles ahead, cutting through space and time as the viewer is visually drawn into the work by lines and shapes that appear to encircle and ensnare.

The **Op Art** movement of the 1960s and 1970s created optical sensations of movement through the repetition and manipulation of color, shape, and line. In kinetic sculpture, movement is real, whether activated by currents of air or motors. In Op Art, bold and apparently vibrating lines and colors create the il-

 9-16 MARCEL DUCHAMP. *Nude Descending a Staircase #2* (1912). Oil on canvas. 58" × 35". Philadelphia Museum of Art, Louise and Walter Arensberg Collection. Copyright 2007 Artist Rights Society (ARS), New York/ADAGP, Paris/ Succession Marcel Duchamp/Art Resource, New York.

9–17 UMBERTO BOCCIONI. Dynamism of a Soccer Player (1913). Oil on canvas. 6' $4^{1}/8'' \times 6' 7^{1}/8''$. Museum of Modern Art, New York. The Sidney and Harriet Janis Collection. Copyright Art Resource, New York.

lusion of movement. Bridget Riley's *Cataract 3* (Fig. 9-18) is composed of a series of curved lines that change in thickness and proximity to one another. These changes seem to suggest waves, but they also create a powerful illusion of rippling movement. Complementary red

and green colors also contribute to the illusion of vibration. When we look at a color for an extended period of time, we tend to perceive its **afterimage.**

Red is the afterimage of green, and vice versa. Therefore, there seems to be a pulsating in Riley's selection of color as well as in the tendency of the eye to perceive the lines as rippling.

There are many other ways of creating the illusion of motion, including contemporary cinematography and video.

Motion pictures create an illusion of movement so real that it cannot be distinguished from real movement by the naked eye. Motion pictures create the illusion of movement through **stroboscopic motion.** In this method, the viewer is shown from 16 to 24 still pictures per second. Each picture or frame differs slightly from the one that preceded it. The individual who views the frames in rapid succession has the psychological experience—the *illusion*—of seeing moving objects rather than a series of still pictures. It does not matter whether viewers know that they are watching a progression of still images; the illusion of movement is so powerful that it is experienced as real movement. Motion pictures may *capture* real movement, but the way in which they *depict* movement involves illusion.

9-18 BRIDGET RILEY. Cataract 3 (1967). Emulsion on canvas. 5' 10¹/₂" × 5' 10¹/₂". British Council, London. Copyright Bridget Riley. I said to myself—I'll paint what I see—what the flower is to me but I'll paint it big and they will be surprised into taking the time to look at it—I will make even busy New Yorkers take time to see what I see of flowers.

—Georgia O'Keeffe

Cubist and Futurist works of art, regardless of how abstract they might appear, always contain vestiges of representation, whether they be unobtrusive details like an eyelid or mustache, or an object's recognizable contours. Yet with Cubism, the seeds of abstraction were planted. It was just a matter of time until they would find fruition in artists who, like Kandinsky, would seek pure form unencumbered by referential subject matter. American artists who were influenced by the Parisian avantgarde—Picasso, Matisse, and others—in his 291 gallery (at 291 Fifth Avenue in New York). Georgia O'Keeffe was among the artists supported by Stieglitz.

Throughout her long career, Georgia O'Keeffe (1887– 1986) painted many subjects, from flowers to city buildings to the skulls of animals baked white by the sun of the desert Southwest. In each case she captured the essence of her sub-

EARLY TWENTIETH-CENTURY ABSTRACTION IN THE UNITED STATES

The Fauvists and German Expressionists had an impact on art in the United States as well as Europe. Although the years before the First World War in America were marked by an adherence to Realism and subjects from everyday rural and urban life, a strong interest in European Modernism was brewing.

291 Gallery

It was the American photographer Alfred Stieglitz who propounded and supported the development of abstract art in the United States by exhibiting modern European works along with those of

9-19 GEORGIA O'KEEFFE. White Iris (1930).
Oil on canvas. 40" × 30".
Virginia Museum of Fine Arts. Gift of Mr. And Mrs. Bruce Gottwald. Copyright Virginia Museum of Fine Arts. Photo by Ron Jennings. Copyright 2007 The Georgia O'Keeffe Foundation/ Artists Rights Society (ARS), New York.

jects by simplifying their forms. In 1924, the year O'Keeffe married Stieglitz, she began to paint enlarged flower pictures such as White Iris (Fig. 9-19). In these paintings, she magnified and abstracted the details of her botanical subjects, so that often a large canvas was filled with but a fragment of the intersection of petals. These flowers have a yearning, reaching, organic quality, and her botany seems to function as a metaphor for zoology. That is, her plants are animistic; they seem to grow because of will, not merely because of the blind interactions of the unfolding of the genetic code with water, sun, and minerals. And although O'Keeffe denied any attempt to portray sexual imagery in these flowers (those who saw it, she said, were speaking about themselves and not her), the edges of the petals, in their folds and convolutions, are frequently reminiscent of parts of the female body. The sense of will and reaching renders these petals active rather than passive in their implied sexuality, so they seem symbolically to express a feminist polemic. The Georgia O'Keefe Museum is located in Santa Fe, New Mexico. In addition to O'Keefe's works, the building houses American art from 1890 to the present.

The Armory Show

Between 1908 and 1917, Stieglitz brought to 291—and thus to New York City—European Modernists, the likes of Toulouse-Lautrec, Cézanne, Matisse, Braque, and Brancusi.

In 1913 the sensational Armory Show—the International Exhibition of Modern Art held at the 69th Regiment Armory in New York City—assembled works by leading American artists and an impressive array of Europeans ranging from Goya and Delacroix to Manet and the Impressionists; from Van Gogh and Gauguin to Picasso and Kandinsky. There were many more American than European works exhibited, but the latter dominated the show—raising the artistic consciousness of the Americans while, at the same time, raising some eyebrows. The most scandalous of the Parisian works, Marcel Duchamp's *Nude Descending a Staircase #2* (see Fig. 9-16), was dismissed as a "pile of kindling wood." But the message to American artists was clear: Europe was the center of the art world. For now.

In the years following the Armory Show, American artists explored abstraction to new heights, finding ways to maintain a solid sense of subject matter in combination with geometric fragmentation and simplification. Charles Demuth (1883–1935) was one of a group of artists called "Cubo-Realists" or "Precisionists" who overlaid stylistic elements from Cubism and Futurism on authentic American imagery. *My Egypt* (Fig. 9-20) is a precise rendition of a grain elevator in Demuth's hometown of Lancaster, Pennsyl-

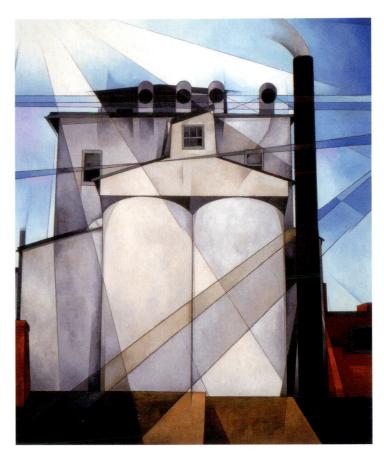

9-20 CHARLES DEMUTH. My Egypt (1927).
Oil on composition board. 35³/4" × 30".
Whitney Museum of American Art, New York.

vania. Diagonal lines—contradictory rays of light and shadow—sweep across the solid surfaces and lessen the intensity of the stone-like appearance of the masses. The shapes in *My Egypt* are reminiscent of limestone monoliths that form the gateways to ancient temple complexes such as that at Karnak in Egypt. The viewer cannot help being drawn to Demuth's title, which acknowledges the association of the architectural forms and, at the same time, asserts a sense of American pride and history in the possessive adjective, "My." It seems to reflect the desire on the part of the American artist to be conversant and current with European style while maintaining a bit of chauvinism about subjects that have meaning to their own time and place.

EARLY TWENTIETH-CENTURY ABSTRACTION IN EUROPE

The second decade of the twentieth century witnessed the rise of many dynamic schools of art in Europe. Two of these—**Constructivism** and **De Stijl**—were dedicated to pure abstraction, or nonobjective art. Nonobjective art differs from the abstraction of Cubism or Futurism in its total lack of representational elements. It does not use nature or visual reality as a point of departure; it has no subject other than that of the forms, colors, and lines that compose it. In nonobjective art, the earlier experiments in abstracting images by Cézanne and then by the Cubists reached their logical conclusion. Kandinsky is recognized as the first painter of pure abstraction, although several artists were creating nonobjective works at about the same time.

Constructivism

Whereas nonobjective painting was the logical outgrowth of Analytic Cubism, Cubist collage gave rise to Constructivist sculpture. Born in Russia, Constructivism challenged the traditional sculptural techniques of carving and casting that emphasized mass rather than space.

Naum Gabo

Naum Gabo (1890-1977), a Constructivist sculptor, challenged the ascendance of mass over space by creating works in which intersecting planes of metal, glass, plastic, or wood defined space. The nonobjective Column (Fig. 9-21) exudes a high-tech feeling. It is somewhat reminiscent of magnetic fields, of things plugged in, or even of the skyscrapers that are being imagined as this page is being written-a theme that would be revisited by the Deconstructivist architects at the end of the twentieth century and the early years of the third millennium. But the subject of the work consists in the constructed forms themselves. The column itself is suggested by intersecting planes that interact with the surrounding space; it does not envelop space, and-true to the Constructivist aesthetic-it denies mass and weight. The beauty of Column is found in the purity of its elements and in the contrasts between horizontal and vertical elements and translucent and opaque elements.

Piet Mondrian

Influenced by Vincent van Gogh, fellow Dutch painter Piet Mondrian (1872–1944) began his career as a painter of Impressionistic landscapes. In 1910 he went to Paris and was immediately drawn to the geometricism of Cubism. During

9–21 NAUM GABO.
 Column (c. 1923).
 Perspex, wood, metal, glass. 41¹/₂" × 29" × 29".
 Copyright Solomon R. Guggenheim Museum, New York.

the war years, when he was back in Holland, his studies of Cubist theory led him to reduce his forms to lines and planes and his palette to the primary colors and black and white. These limitations, Mondrian believed, permitted a more universally comprehensible art.

Mondrian developed his own theories of painting that are readily apparent in works such as *Composition with Red*, *Blue*, *and Yellow* (Fig. 9-22):

Painting occupies a plane surface. The plane surface is integral with the physical and psychological being of the painting. Hence the plane surface must be respected, must be allowed to declare itself, must not be falsified by imitations of volume. Painting must be as flat as the surface it is painted on.³

³Robert Goldwater and Marco Treves, eds., *Artists on Art* (New York: Pantheon Books, 1972), 426.

All painting is composed of line and color. Line and color are the essence of painting. Hence they must be freed from their bondage to the imitation of nature and allowed to exist for themselves.

—Piet Mondrian

9–23 GERRIT RIETVELD. Schroeder House, Utrecht (1924). Copyright Jannes Linders/Copyright 2007 Artists Rights Society (ARS), New York/Beeldrect, Amsterdam.

9-22 PIET MONDRIAN. Composition with Red, Blue, and Yellow, 1930. Oil on canvas. 18¹/8" × 18¹/8" (46 × 46 cm).
© 2007 Mondrian/Holtzman Trust c/o HCR International, Warrenton, VA, USA.

Gerrit Rietveld's De Stijl *Schroeder House* (Fig. 9-23) is to architecture what Mondrian's pure geometric canvases are to painting. Here there is an almost literal translation of geometry and color to architecture. Broad expanses of white concrete intersect to define the strictly rectilinear dwelling, or appear to float in superimposed planes. As in a Mondrian painting, these planes are accented by black verticals and horizontals in supporting posts or window mullions. The surfaces are unadorned, like the color fields of a Mondrian. The living areas have sliding partitions that allow space to flow from one area to another.

Mondrian's obsessive respect for the two-dimensionality of the canvas surface is the culmination of the integration of figure and ground begun with the planar recession of Jacques-Louis David (see Fig. 8-1). No longer was it necessary to tilt tabletops or render figure and ground with the same brushstrokes and palette to accomplish this task. Canvas and painting, figure and ground were one.

Constantin Brancusi

The universality sought by Mondrian through extreme simplification can also be seen in the sculpture of Constantin Brancusi (1876–1957). Yet unlike Mondrian's, Brancusi's works, however abstract they appear, are rooted in the figure.

Brancusi was born in Romania 13 years after the Salon des Réfusés. After an apprenticeship as a cabinetmaker and studies at the Bucharest Academy of Fine Arts, he traveled to Paris to enroll in the famous École des Beaux-Arts. In 1907 Brancusi exhibited at the Salon d'Automne, leaving favorable impressions of his work.

Brancusi's work, heavily indebted to Rodin at this point, did indeed grow in a radically different direction. As early as 1909 he reduced the human head—a favorite theme he would draw upon for years—to an egg-shaped form with sparse indications of facial features. In this, and in other abstractions such as *Bird in Space* (Fig. 9-24), he reached for the essence of the subject by offering the simplest contour that, along with a descriptive title, would fire recognition in the spectator. *Bird in Space* evolved from more representational versions into a refined symbol of the cleanness and solitude of flight.

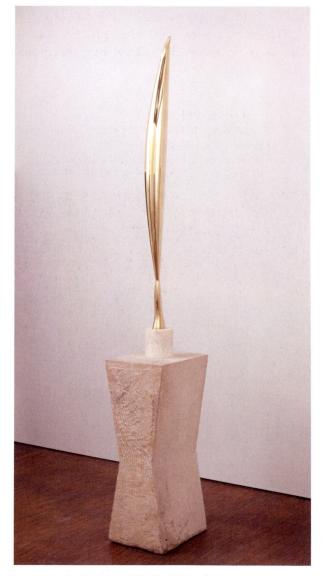

9-24 CONSTANTIN BRANCUSI. Bird in Space (c. 1928). Bronze (unique cast). H: 54".

The Museum of Modern Art, New York. Given anonymously. Copyright The Museum of Modern Art, New York. Licensed by Scala/Art Resource, New York. Copyright 2007 Artists Rights Society (ARS), New York/ ADAGP, Paris.

FANTASY AND DADA

Throughout the history of art, most critics and patrons have seen the accurate representation of visual reality as a noble goal. Those artists who have departed from this goal, who have chosen to depict their personal worlds of dreams or supernatural fantasies, have not had it easy. Before the twentieth century, only isolated examples of what we call **Fantastic art** could be found. The early 1900s, however, saw many artists exploring fanciful imagery and working in styles as varied as their imaginations.

How do we describe Fantastic art? The word *fantastic* derives from the Greek *phantastikos*, meaning "the ability to represent something to the mind" or "to create a mental image." *Fantasy* is further defined as "unreal, odd, seemingly impossible, and strange in appearance." Fantastic art, then, is the representation of incredible images from the artist's mind. At times the images are joyful reminiscences; at times, horrific nightmares. They may be capricious or grotesque.

Paul Klee

One of the most whimsical yet subtly sardonic of the Fantastic artists is Paul Klee (1879–1940). Although influenced early in his career by nineteenth-century artists such as Goya, who touched upon fantasy, Klee received much of his stylistic inspiration from Cézanne. In 1911 he joined Der Blaue Reiter, where his theories about intuitive approaches to painting, growing abstraction, and love of color were well received.

A certain innocence pervades Klee's idiosyncratic style. After abandoning representational elements in his art, Klee turned to ethnographic and children's art, seeking a universality of expression in their extreme simplicity. Many of his works combine a charming naïveté with wry commentary. *Twittering Machine* (Fig. 9-25), for example, offers a humorous contraption composed of four fantastic birds balanced precariously on a wire attached to a crank. The viewer who is motivated to piece together the possible function of this apparatus might assume that turning the crank would result in the twittering suggested by the title.

In this seemingly innocuous painting, Klee perhaps satirizes contemporary technology, in which machines may sometimes seem to do little more than express the whims and ego of the inventor. But why a machine that twitters? Some have suggested a darker interpretation in which the mechanical birds are traps to lure real birds to a makeshift coffin beneath. Such gruesome doings might in turn symbolize the entrapment of humans by their own existence. In

 9–25 PAUL KLEE. *Twittering Machine* (1922). Watercolor, pen and ink. 25¹/₄" × 19". The Museum of Modern Art, New York. Copyright The Museum of Modern Art. Licensed by Scala/Art Resource, New York. Copyright 2007 Artists Rights Society (ARS), New York/VG Bild-Kunst, Bonn.

any event, it is evident that Klee's simple, cartoon-like subjects may carry a mysterious and rich iconography.

Giorgio de Chirico

Equally mysterious are the odd juxtapositions of familiar objects found in the works of Giorgio de Chirico (1888–1978). Unlike Klee's figures, Chirico's are rendered in a realistic manner. Chirico attempted to make the irrational believable. His subjects are often derived from dreams, in which ordinary objects are found in extraordinary situations. The realistic technique tends to heighten the believability of these events and imparts a certain eeriness characteristic of dreams or nightmares. Part of the intrigue of Chirico's subjects lies in their ambiguity and in the uncertainty of the outcome. Often we do not know why we dream what we dream. We do not know how the strange juxtapositions oc-

cur nor how the story will evolve. We may now and then "save" ourselves from danger by awakening.

The intrigues of the dream world are captured by Chirico in works such as *The Mystery and Melancholy of the Street* (Fig. 9-26). Some of his favorite images—the icy arcade, the deserted piazza, the empty boxcar—provide the backdrop for an encounter between two figures at opposite ends of a diagonal strip of sunlight. A young girl, seemingly unaware of the tall dark shadow beyond her, skips at play with stick and hoop. What is she doing there? Why is she alone? Who is the source of the shadow? Is it male or female? What is the spear-like form by the figure? We quickly perceive doom. We wonder what will happen to the girl and

9-26 GIORGIO DE CHIRICO.

The Mystery and Melancholy of the Street (1914). Oil on canvas. $34\frac{1}{4}" \times 28\frac{1}{8}"$. Private collection, U.S.A. Copyright Foundation Giorgio de Chirico/

Copyright 2007 Artists Rights Society (ARS), New York/SIAE, Rome.

C O M P A R E + C O N T R A S T

Leonardo's Mona Lisa, Duchamp's Mona Lisa (L.H.O.O.Q.), Odutokun's Dialogue with Mona Lisa, and Lee's Bona Lisa

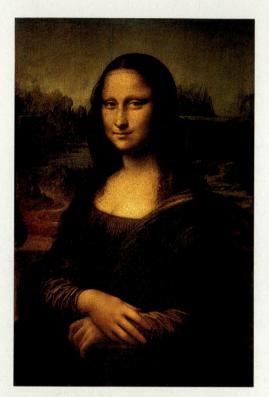

 9-27 LEONARDO DA VINCI. Mona Lisa (c. 1503). Oil on panel. 30¹/₄" × 21". Louvre Museum, Paris/Edimedia/Corbis.

If you were asked to close your eyes and think of the most famous work of art in all of history, what would you say? Odds are that the first piece to come up on your memory screen would be none other than the leadoff work in this exercise. Her portrait has captivated poets and lyricists, museumgoers and, yes, artists, for centuries. Simply put, her face has been everywhere. Why and how did she attain this icon status? The *Mona Lisa* (Fig. 9-27) is a portrait of a banker's wife, worked on by Leonardo for four years and, as was much of his work, left unfinished.

In its own day, though, it was quite an innovative composition. Among other things, Leonardo rejected the traditional profile portrait bust in favor of a three-quarter-turned, half-length figure. The inclusion of the hands in a natural position, for the most part uncharacteristic of earlier portraiture, was essential for Leonardo as a method of exploring and revealing the personality of the sitter: "A good painter has two chief objects to paint, man and the intention of his soul; the former is easy, the latter hard, because he has to represent it by the attitudes and movements of the limbs." A new look at portrait painting, to be sure. But there is still the matter of that enigmatic smile. And those eyes, which many have vouched, follow the viewer's movements across a room. The *Mona Lisa* is a beautiful painting, but does that account for why a visitor in search of the masterpiece in Paris's Louvre Museum need only look for the one painting that cannot be viewed because of the crowd surrounding it?

The selection of images in this exercise represents but a sampling of work that attempts to come to terms with "Mona Lisa: The Icon." One of the earlier revisions of Leonardo's

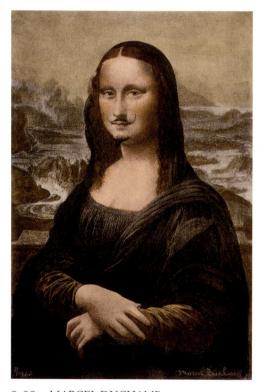

9-28 MARCEL DUCHAMP. *Mona Lisa (L.H.O.O.Q.)* (1919). Rectified readymade; pencil on a reproduction. $7^{3}/4'' \times 4^{7}/8''$.

> Philadelphia Museum of Art. Private collection. Copyright 2007 Artists Rights Society (ARS), New York/ADAGP, Paris/Succession Marcel Duchamp.

 9-29 G. ODUTOKUN. Dialogue with Mona Lisa (1991). Gouache on paper. 30" × 22".
 Private collection. Photo: Visual Arts Library, London. Copyright Art Resource, New York.

painting was assembled by the Dada artist, Marcel Duchamp (Fig. 9-28). Using a reproduction of the original work, Duchamp modified the image-graffiti style-by penciling in a mustache and goatee. Beneath the image of the banker's wife is Duchamp's irreverent explanation of that enigmatic smile: If you read the letters aloud with their French pronunciation, using a slurred, legato style, the sound your ears will hear is "elle a chaud au cul." (Rough PG-13-rated translation: "She is hot in the pants.") Part of the underlying philosophy of the Dada movement was the notion that the museums of the world are filled with "dead art" that should be "destroyed." Why do you imagine Duchamp would have used the image of the Mona Lisa to convey something of this philosophy? Duchamp was certainly a capable enough draftsman to have rendered his own copy of the Mona Lisa. Do you think he used a reproduction simply to expedite completion of the work?

The gouache composition by G. Odutokun (Fig. 9-29) is another clear illustration of the icon status of the *Mona Lisa*. In this work, cultural exchanges are explored through the

interaction between images symbolic of Western and non-Western traditions. What do you think the artist aims to suggest through the title of the work? Look closely at the content of the piece. Who is painting whom; who is sculpting whom? Even though the artist seems to be portraying a cross-cultural encounter, would this work be as relevant to a contemporary European viewer as a contemporary African viewer? What does this composition say about standards of beauty that are culturally defined?

And is the standard of beauty that the *Mona Lisa* has represented for generations one that is gender biased as well as culturally biased? This question is posed in Sadie Lee's revision entitled *Bona Lisa* (Fig. 9-30). At first glance, the portrait seems to be a male version of Leonardo's female sitter. In reality, Lee has represented the banker's wife as a lesbian with close-cropped hair and masculine attire. Edward Lucie-Smith has interpreted this work as an "ironic comment on the popular image of a 'butch' lesbian." From politics and protest to the protest of political correctness, each of the artists we have here observed has understood the significance of attaching his or her message to Leonardo's masterwork. What are your impressions?

9-30 SADIE LEE.
Bona Lisa (1992).
Oil on board. 23" × 19".
Copyright Visual Arts Library, London/Art Resource, New York.

The most important thing about Dada, it seems to me, is that Dadaists despised what is commonly regarded as art, but put the whole universe on the lofty throne of art.

—Jean Arp

imagine the worst. For example, we are not likely to assume that the girl is rushing to her father standing by a flagpole. Viewers must stew in their active imaginations, pondering the simple clues to a mystery that Chirico will not unlock.

Dada

In 1916, during World War I, an international movement arose that declared itself against art. Responding to the absurdity of war and the insanity of a world that gave rise to it, the Dadaists declared that art—a reflection of this sorry state of affairs—was stupid and must be destroyed. Yet in order to communicate their outrage, the Dadaists created works of art! This inherent contradiction spelled the eventual demise of their movement. Despite centers in Paris, Berlin, Cologne, Zurich, and New York City, Dada ended with a whimper in 1922.

The name **Dada** was supposedly chosen at random from a dictionary. It is an apt epithet. The nonsense term describes nonsense art-art that is meaningless, absurd, unpredictable. Although it is questionable whether this catchy label was in truth derived at random, the element of chance was indeed important to the Dada art form. Dada poetry, for example, consisted of nonsense verses of random word combinations. Some works of art, such as the Dada collages, were constructed of materials found by chance and mounted randomly. Yet however meaningless or unpredictable the poets and artists intended their products to be, in reality they were not. In an era dominated by the doctrine of psychoanalysis, the choice of even nonsensical words spoke something at least of the poet. Works of art supposedly constructed in random fashion also frequently betrayed the mark of some design.

Marcel Duchamp

In an effort to advertise their nihilistic views, the Dadaists assaulted the public with irreverence. Not only did they attempt to negate art but they also advocated antisocial and amoral behavior. Marcel Duchamp offered for exhibition a urinal, turned on its back and entitled *Fountain*. Later he summed up the Dada sensibility in works such as *Mona Lisa (L.H.O.O.Q.)* (see Fig. 9-28 in the nearby Compare and Contrast feature), in which he impudently defiled a color

9-31 MAX ERNST. *Two Children Are Threatened by a Nightingale* (1924). Oil on wood with wood construction. 27¹/₂" × 22¹/₂" × 4¹/₂". The Museum of Modern Art, New York. Purchase. Copyright Art Resource, New York. Copyright 2007 Artists Rights Society (ARS),

New York/ADAGP, Paris.

print of Leonardo da Vinci's masterpiece with a mustache and goatee. In *Nude Descending a Staircase #2* (see Fig. 9-16), Duchamp's simulation of the fourth dimension of time through a series of overlapping images added a new element to the experiments of Cubism.

Fortified by growing interest in psychoanalysis, Dada, with some modification, would provide the basis for a movement called Surrealism that began in the early 1920s. Like Max Ernst's Dada composition, *Two Children Are Threatened by a Nightingale* (Fig. 9-31), some Surrealist works offer irrational subjects and the chance juxtaposition of everyday objects. These often menacing paintings also incorporate the Realistic technique and the suggestion of dream imagery found in Fantastic art.

SURREALISM

Surrealism began as a literary movement after World War I. Its adherents based their writings on the nonrational, and thus they were naturally drawn to the Dadaists. Both literary groups engaged in **automatic writing**, in which the mind was to be purged of purposeful thought and a series of free associations were then to be expressed with the pen. Words were not meant to denote their literal meanings but to symbolize the often seething contents of the unconscious mind. Eventually the Surrealist writers broke from the Dadaists, believing that the earlier movement was becoming too academic. Under the leadership of the poet Andre Breton, they defined their movement as follows in a 1924 manifesto:

Surrealism, noun, masc., pure psychic automatism by which it is intended to express either verbally or in writing, the true function of thought. Thought dictated in the absence of all control exerted by reason, and outside all aesthetic or moral preoccupations.

Encycl. Philos. Surrealism is based on the belief in the superior reality of certain forms of association heretofore neglected, in the omnipotence of the drcam, and in the disinterested play of thought. It leads to the permanent destruction of all other psychic mechanisms and to its substitution for them in the solution of the principal problems of life.

From the beginning, Surrealism expounded two very different methods of working. **Illusionistic Surrealism**, exemplified by artists such as Salvador Dalí and Yves Tanguy, rendered the irrational content, absurd juxtapositions, and metamorphoses of the dream state in a highly illusionistic manner. The other, called **Automatist Surrealism**, was a direct outgrowth of automatic writing and was used to divulge mysteries of the unconscious through abstraction. The Automatist phase is typified by Joan Miró and Andre Masson.

Salvador Dalí

Modesty was not his strong suit. One of the few "household names" in the history of art belongs to a leading Surrealist figure, the Spaniard Salvador Dalí (1904–1986). His reputation for leading an unusual—one could say surrealistic—life would seem to precede his art, for many not familiar with his canvases had seen Dalí's outrageous mustache and knew of his shenanigans. Once as a guest on the Ed Sullivan television show, he threw open cans of paint at a huge canvas. Dalí began his painting career, however, in a somewhat more conservative manner, adopting, in turn, Impressionist, Pointillist, and Futurist styles. Following these forays into contemporary styles, he sought academic training at the Academy of Fine Arts in Madrid. This experience steeped him in a tradition of illusionistic realism that he never abandoned.

In what may be Dalí's most famous canvas, *The Persistence of Memory* (Fig. 9-32), the drama of the oneiric imagery is enhanced by his trompe l'oeil technique. Here, in a barren landscape of incongruous forms, time, as all else, has expired. A watch is left crawling with insects like scavengers

9–32 SALVADOR DALÍ.

The Persistence of Memory (1931). $9^{1}/2'' \times 1'1''$. The Museum of Modern Art, New York. Given anonymously. Digital image © The Museum of Modern Art/Licensed by Scala/Art Resource, New York. © 2007 Salvador Dalí/Artists Rights Society (ARS), New York.

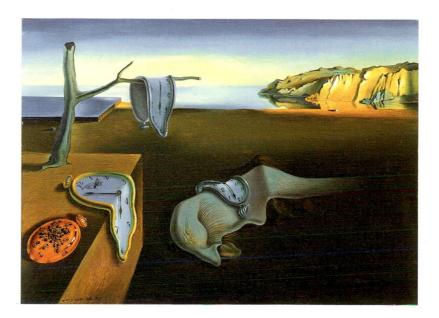

My way is to seize an image that moment it has formed in my mind, to trap it as a bird and to pin it at once to canvas. Afterward I start to tame it, to master it. I bring it under control and I develop it.

—Joan Miró

over carrion; three other watches hang limp and useless over a rectangular block, a dead tree, and a lifeless, amorphous creature that bears a curious resemblance to Dalí. The artist conveys the world of the dream, juxtaposing unrelated objects in an extraordinary situation. But a haunting sense of reality threatens the line between perception and imagination. Dalí's is, in the true definition of the term, a surreality—or reality above and beyond reality.

Joan Miró

Not all of the Surrealists were interested in rendering their enigmatic personal dreams. Some found this highly introspective subject matter meaningless to the observer and sought a more universal form of expression. The Automatist Surrealists believed that the unconscious held such universal imagery, and through spontaneous, or automatic, drawing, they attempted to reach it. Artists of this group, such as Joan Miró (1893–1983), sought to eliminate all thought from their minds and then trace their brushes across the surface of the canvas. The organic shapes derived from intersecting skeins of line were believed to be unadulterated by conscious thought and thus drawn from the unconscious. Once the basic designs had been outlined, a conscious period of work could follow in which the artist intentionally applied his or her craft to render them in their final form. But because no conscious control was to be exerted to determine the early course of the designs, the Automatist method was seen as spontaneous, as employing chance and accident. Needless to say, the works are abstract, although some shapes are amoebic. Miró was born near Barcelona and spent his early years in local schools of art learning how to paint like the French Modernists. He practiced a number of styles ranging from Romanticism to Realism to Impressionism, but Cézanne and van Gogh seem to have influenced him most. In 1919 Miró moved to Paris, where he was receptive to a number of art styles. The work of Matisse and Picasso along with the

9-33 JOAN MIRÓ.

Painting (1933). Oil on canvas. $68^{1/2''} \times 77^{1/4''}$. The Museum of Modern Art, New York. Louis D. Lasker Bequest (by exchange)/ Art Resource, New York/© 2007 Succession Miró/Artists Rights Society (ARS), New York/ADAGP, Paris.

primitive innocence of Rousseau found their way into his canvases. Coupled with a rich native iconography and an inclination toward fantasy, these different elements would shape Miró's unique style.

Miró's need for spontaneity in communicating his subjects was compatible with Automatist Surrealism, although the whimsical nature of most of his subjects often appears at odds with that of other members of the movement. In *Painting* (Fig. 9-33), meandering lines join or intersect to form the contours of clusters of organic figures. Some of these shapes are left void to display a nondescript background of subtly colored squares. Others are filled in with sharply contrasting black, white, and bright red pigment.

In this work, Miró applied Breton's principles of psychic automatism in an aesthetically pleasing, decorative manner. By 1930 Surrealism had developed into an international movement, despite the divorce of many of the first members from the group. New adherents exhibiting radically different styles kept the movement alive. As the decade of the 1930s evolved, however, Adolf Hitler rose to power and war once again threatened Europe. Hitler's ascent drove refugee artists of the highest reputation to the shores of the United States. Among them were the leading figures of Abstraction and Surrealism, two divergent styles that would join to form the basis of an avant-garde American painting. The center of the art world had moved to New York.

ARCHITECTURE

The early years of the twentieth century witnessed many trends in architecture. One of these was the development of the modern skyscraper. As we will see in the Art Tour following this section, perhaps no city has been so intimately associated with the "upward thrust" as Chicago.

9–34 WALTER GROPIUS. Shop Block, The Bauhaus (1925–1926). Vanni/Art Resource, New York.

The Bauhaus

The German architect Walter Gropius (1883–1969) and his followers brought a number of principles to modern architecture, amplifying the concepts that "form follows function" and that "less is more." Gropius relied on basic forms, such as the rectangular solid, and diligently avoided ornamentation and embellishment. For Gropius, an overriding emphasis on simplicity and on the economical use of space and time, materials, and money.

In 1919, Gropius became director of the Weimar School of Arts and Crafts. He renamed the school Das Staatliche Bauhaus, or "Building House of the State," referred to simply as The Bauhaus. Gropius believed that his vision was a doorway to the future of art and architecture, training architects, artists, designers, and craftspersons. Because of political conflicts, Gropius moved his school to Dessau in 1925 and designed its new home (Fig. 9-34). Design and carpentry were integral to the Bauhaus curriculum, and Gropius had students and faculty create the furnishings for the building. Ludwig Miës van der Rohe (1886–1969) became director of the Bauhaus in 1928 and moved the school to Berlin.

The Nazis shut down the Bauhaus in 1933, and some of its faculty fled to the United States, Gropius and Miës van der Roh among them. Gropius became chair of architecture at the Harvard University Graduate School of Design, and Miës chaired the architecture department of the school that would become the Illinois Institute of Technology. During its short life of 15 years, the Bauhaus gave birth

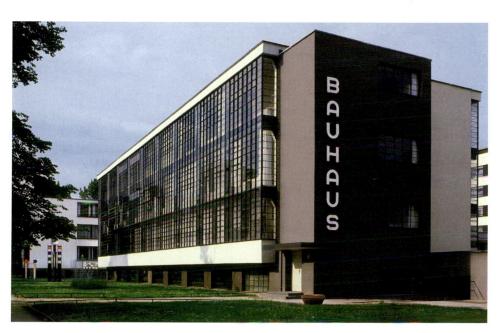

9–35 LUDWIG MIËS VAN DER ROHE. Model for a glass skyscraper (1922). Photo courtesy The Miës Van der Rohe Archive, The Museum of Modern Art, New York/Art Resource, New York.

> to designers and designs that would shape much of the remaining two-thirds of the twentieth century.

In Chapter 10 we will see Miës' Farnsworth House (Fig. 10-65), a single-story residential design, although he also worked "tall." His visionary style can be seen in his model for a glass skyscraper that was never built (Fig. 9-35). Miës' Seagram Building on New York's Park Avenue also has glass curtain walls, but is more compact, less soaring in appearance.

Marcel Breuer's (1902–1981) tubular steel chair (Fig. 9-36) is an example of Bauhaus furniture. Gone are the overstuffed cushions. The sitter is suspended in midair on cloth or leather slings attached to steel tubing. The concept

behind the chair is the use of simple shapes, but the result is actually quite complex. Bauhaus furniture, especially Breuer chairs of various kinds, remain popular to this day and are visible on many web sites. Like Gropius, Breuer also moved to the United States and taught at Harvard University. Breuer would later design New York's Whitney Museum of American Art, which we see in the New York Art Tour.

Frank Lloyd Wright

The design of housing also advanced dramatically during the early years of the twentieth century, and perhaps the most influential architect of the era was Frank Lloyd Wright (1867–1959), a native of Wisconsin who created many of his most important buildings in his studio in the Chicago suburb of Oak Park. We noted that The Bauhaus focused on the aesthetic unity of architecture and arts and crafts such as carpentry, furniture design, and weaving. So did Wright. Many of his houses contain stained glass windows, textile designs, and built-in furniture. Legend has it that he even went so far as to design evening gowns for the occupant of one of his dwellings that coordinated with the surroundings.

Wright's landmark Robie House (see the following Art Tour of Chicago) was completed in 1910 in his so-called **Prairie style,** characterized by horizontal lines that sweep into dramatic overhangs of roofs, windows with artistic de-

 9–36 MARCEL BREUER. Tubular steel chair (1925). Museum of Modern Art/Licensed by SCALA/Art Resource, New York.

FRANK LLOYD WRIGHT 9 - 37Kaufmann House ("Fallingwater"), Bear Run, PA (1936). Scott Frances/ESTO.

signs, and an open floor plan in which the spaces of the living areas would flow into one another.

While Wright's Robie House sits on a suburban street, his Kaufmann House (also called "Fallingwater," Fig. 9-37), is nestled in sylvan surroundings. It too has its sweeping horizontal lines and dramatic overhangs. Cantilevered decks of reinforced concrete rush outward into the landscape from the building's central core, intersecting in strata that parallel the natural rock formations. Wright's **naturalistic style** integrates his building with its site. Stone walls complement the sturdy rock of the Pennsylvania countryside and reinforced concrete elements create a modernist, visual counterpoint. Wright's severe geometry did not preclude organic integration with the site. A small waterfall seems mysteriously to originate beneath the broad white planes of a deck. The irregularity of the structural components—concrete, cut stone, natural stone, and machine-planed surfaces—complements the irregularity of the wooded site. It seems somehow that the Kaufmann House might have always been there. It is right for its setting.

Part of Wright's inventiveness lies in the fact that his early works give little hint of the shifting directions of his own artistic development. As we see in the next chapter, the creator of the Robie House also designed New York's unique spiral-shaped Guggenheim Museum—and at the advanced age of 89. But first enjoy a tour of Chicago, and more of its stunning architecture.

ART TOUR Chicago

Go for the lake and the miles of beaches. Go for the deeppan pizza and hotdogs with the works. Go to cheer for the Chicago Cubs or the Bulls. Go to see Oprah. But while you're in Chicago—for goodness' sake—make time in your day for the most magnificent art and architecture you can imagine.

Situated at the literal crossroads between the East and Midwest, Chicago grew rich on trade opportunities and began to take shape as a major commercial and cultural center in the nineteenth century. The Great Chicago Fire of 1871, however, destroyed most of the downtown buildings in a conflagration that lasted 36 hours. Out of this devastation, after which one-third of the city population was homeless, came one of the greatest building campaigns in U.S. history.

Experiencing Chicago starts with getting to know its neighborhoods—77 in all—and its unique topographic features—such as the Chicago River, which wends its way amidst skyscrapers, or Lake Michigan, which provides 15 miles of recreational beaches. At its heart is the Loop, but the long list contains neighborhoods such as the Magnificent Mile, River North, River West, the Gold Coast, Old Town, Lincoln Park, Wrigleyville, Lakeview, South Loop, and Chinatown.

We all know how good it feels to be "in the loop." But that expression couldn't have more meaning than when it's used to describe the city of Chicago. The Loop in this town refers to the very center of the downtown core and takes its name from the elevated train tracks that encircle the area.

The city of Chicago has always been synonymous with architectural innovation and world-class buildings. **Balloon-frame construction** (still one of the most common residential building types in the United States today, and so called because it was said to be as simple and easy as blowing up a balloon) originated in 1833 with a Chicago developer. Although most structures of this kind went up in flames in the 1871 fire, you can still see a few of them in the North Side area of the city. After the fire, wood was banned as a building material and cast iron and terra-cotta took its place. Those materials—along with steel—made their most significant impact on the city's commercial architecture. It was here that the first skyscraper was built and the Chicago School of architecture—an internationally celebrated style—was born.

One of the weirder structures in the downtown core is the Monadnock Building, the two halves of which represent old-style and new-style architectural design and materials. One half-the northern half-was designed in 1891 by the firm of Burnham and Root. At 16 stories, it was the tallest masonry building ever to have been constructed. Two years later, the other, southern half was constructed, this time of a steel skeleton covered with a sheath of terra-cotta. This design, by the firm of Holabird and Roche, was pivotal for the future of the skyscraper. Other buildings of the era that sought the clouds included the Rookery (1885-1886), the Reliance Building (1894-1895), and the Marquette Building (1894),

THE MONADNOCK BUILDING. (1891–1893) Robert Frerck/Odyssey.

to name a few. All of these can be seen within the downtown core. Keep your eye out for the signature "Chicago windows" on some of these buildings. They were a stylistic by-product of the Chicago School's structural innovations and consist of a wide central glass pane that doesn't open flanked by two thinner windows that do.

Among the sentimental favorites of Chicago architecture are the Marshall Field and Company and the Carson Pirie Scott department stores. Marshall Field's (1885–1887) began as a Renaissance-revival building that ultimately grew to accommodate 800,000 square feet of retail space. Its southern atrium features a spectacular glass mosaic dome whose installation in 1897 was supervised by Louis Comfort Tiffany himself. Louis Sullivan, one of the city's most prolific and beloved architects of the Chicago School, finished the exterior of his steel-frame Carson Pirie Scott building (1899) with white terracotta and graced the first two stories of the entrance with ornamental cast-iron motifs consisting of organic and geometric forms. You can still pick out the initials L.H.S. above the entrance.

Surveying the architectural wonders of Chicago can keep a tourist busy. These historic examples are but the tip of the iceberg. Within the downtown core you'll find Beaux Arts-style gems such as the Chicago Theatre, Neoclassical monuments such as the Chicago Cultural Center and the Art Institute of Chicago (more later on this phenomenal collection), and on the opposite end of the style spectrum, the Sears Tower. Opened in 1974 after three years under construction, the building had, then lost, and then regained the title as the world's tallest building (thanks to the addition of one very tall antenna). Its sky deck offers unparalleled views of the city, Lake Michigan, and beyond.

THE TRIBUNE TOWER. (1925). Copyright John Zich/zrImages/Corbis.

Extending your tour a bit north, you'll come to the Miracle Mile. There you'll get a glimpse of the Wrigley Building (1920-1924), the seat of the chewing gum empire; Marina City's corncob towers (1959–1964), Miës van der Rohe's exposed steel-frame IBM Building (1973), and the Tribune Tower (home to one of the country's most influential newspapers). The Tribune Tower that you see was the winning design in a 1922 international competition calling upon architects to design the

most beautiful office building in the world. The entrance features sculptures of figures from Aesop's fables, and gargoyles abound in the upper reaches of the facade. Most peculiar, perhaps, is the collection of stone fragments from the world's great architectural sites embedded in the outer walls of the building. You'll find pieces from London's Westminster Abbey, the Colosseum in Rome, and the Great Wall of China; a rock from Antarctica and one from the moon. Believe it or not, most of these stones were pilfered by Tribune foreign correspondents at the behest (command?) of one of the paper's early publishers.

Among Chicago's newest additions to its architecture hall of fame is Frank Gehry's music pavilion for Millennium Park, an extension of Grant Park. Gehry's band shell, home to the Grant Park Symphony, is renowned for a sound system that reaches all of its 14,000 audience members.

FRANK GEHRY, Pritzker Pavilion for Millennium Park (1999–2004). Copyright John Zich/Corbis.

Although architecture in Chicago has a way of monopolizing the spotlight, its art collections merit a significant piece of the action. For one thing, the Art Institute of Chicago, a venerable museum of art that was founded in 1879, has what some of us like to call "The Room." This term of

endearment refers to a cluster of spaces featuring some of the best-known examples of Impressionist, Postimpressionist, and early twentieth-century art—Monet haystacks, Degas dancers, a van Gogh self-portrait; Cézanne's *Still Life with Basket of Apples* (Fig. 8-32), Toulouse-Lautrec's *At the Moulin Rouge* (Fig. 8-36), Picasso's *Old Guitarist* (Fig. 9-6), and one of Chicago's most prized possessions—Seurat's *A Sunday Afternoon on the Island of La Grand Jatte* (Fig. 8-31). You will also find Grant Wood's *American Gothic* (Fig. 1-7)—and more. Students remark that their art history textbooks unfold before their eyes as they wander these galleries.

Chicago's museums go far beyond the Institute. The Museum of Contemporary Art has an impressive permanent collection by artists such as Alexander Calder, Andy Warhol, and the photographer Cindy Sherman, mixed with cutting-edge rotating exhibitions by new and established contemporary artists. The Terra Museum of American Art, founded and funded by a man who invented fast-drying ink, is one of the only U.S. collections designed to feature exclusively works by American artists. It includes paintings of the Hudson River School, George Caleb Bingham, and Edward Hopper. The University of Chicago is also the site of both the Oriental Institute (specializing in Middle Eastern antiquities) and the Smart Museum (known for its old master prints, Asian paintings, and postwar Chicago artwork and craft). These museums, and the university, are in Chicago's South Side area, the location also of the famed Frank Lloyd Wright Robie House, designed in 1908 for the bicycle manufacturer-

magnate Frederick Robie and completed in 1910. Wright's signature unity among all of the parts—exterior design, interior function, interior decoration makes this one of the quintessential examples of Wright's Prairie style of architecture.

FRANK LLOYD WRIGHT, ROBIE HOUSE. (1908–1910). Art Resource, NY.

So grab a hotdog (which, in Chicago, has

its own sort of architecture) with ketchup, mustard, relish, onions, and hot peppers and get yourself moving. You still have to meet Sue (the most complete Tyrannosaurus rex anywhere, on display at the Field Museum) before you catch the best jazz and blues in the world.

> To continue your tour and learn more about Chicago, go to the Premium Companion website.

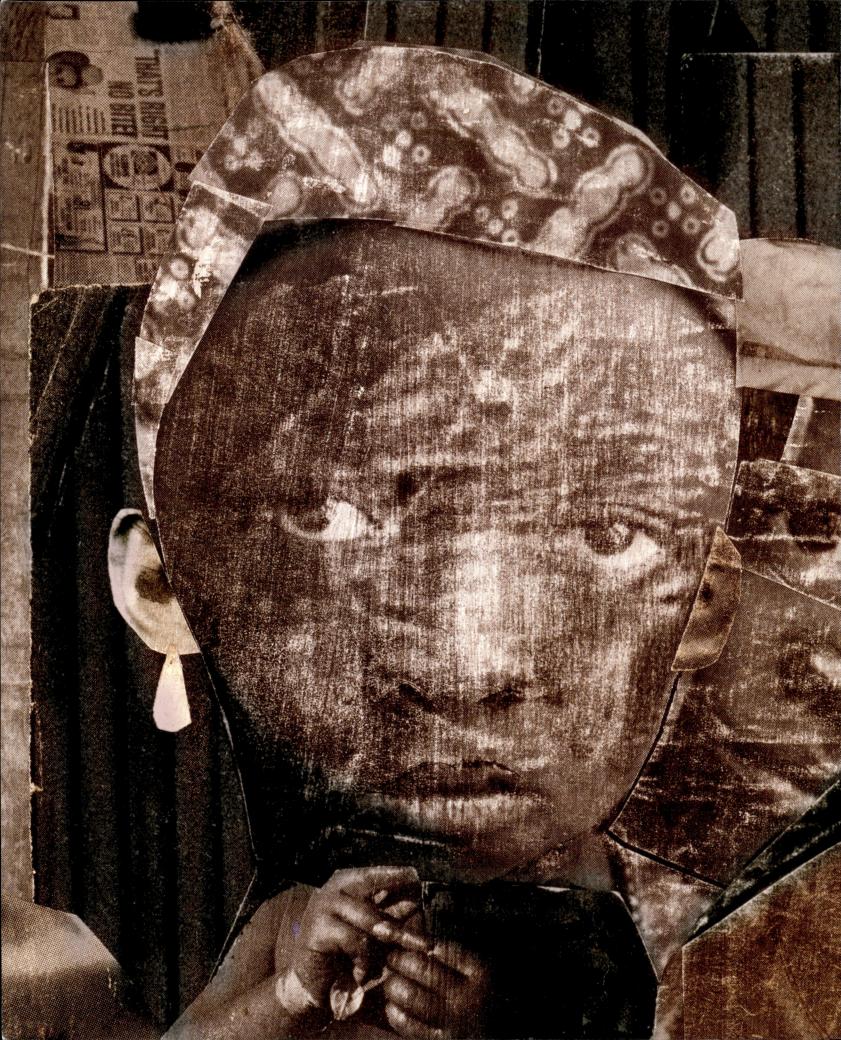

CONTEMPORARY ART

Being an artist now means to question the nature of art.

-Joseph Kosuth

There is a saying, once thought to be a Chinese curse, that reads, "May you live in interesting times." Whatever the origin, it captures the value of stimulation and novelty, even at the expense, perhaps, of tranquility. When it comes to contemporary art, we live in nothing if not interesting times. Louise Bourgeois, who was born in 1911 and continues to work avidly in her nineties, noted that "there are no settled ways"; there is "no fixed approach." Never before in history have artists experimented so freely with so many media, such different styles, such a wealth of content. Never before in history have works of art been so accessible to so many people. Go to "Google Images," and the world of art and artists is a mouseclick away.

CONTEMPORARY ART

In this chapter we discuss painting, sculpture, architecture, and other works that have appeared since the end of World War II-the art of recent times and of today. After the war, the center of the art world shifted to New York following its long tenure in Paris. There were a number of reasons. The wave of immigrant artists who escaped the Nazis had settled largely in New York. Among them were Marcel Duchamp, Fernand Léger, Josef Albers, Hans Hofmann, and others. The Federal Art Project of the WPA (Works Progress Administration) had also nourished the New York artist community during the Great Depression. This group included Arshile Gorky, Willem de Kooning, Jack Tworkov, James Brooks, Philip Guston, and Stuart Davis, among many others. Together these were known as the first-generation New York School. Even the Mexican muralists Diego Rivera and José Clemente Orozco sojourned and taught in the city.

Just before the Great Depression began, Orozco had already argued that the artists of the New World should no longer look to Europe for their inspiration and their models. In January 1929 he wrote: "If new races have appeared upon the lands of the New World, such races have the unavoidable duty to produce a New Art in a new spiritual and physical medium. Any other road is plain cowardice." Despite his devotion to the arts and culture of the Mexican Native Americans, Orozco added: "Already the architecture of Manhattan is a new value, something that has nothing to do with Egyptian pyramids, with the Paris Opera, with the Geralda of Seville, or with Saint Sofia, any more than it has to do with the Maya palaces of Chichen-Itzá or with the pueblos of Arizona."¹

There is no question that the postwar generation produced an art never before seen on the face of the planet. It is a lively art that stirs both adoration and controversy. It is also a fertile art, giving birth to exploration down many branching avenues.

PAINTING

Many vital movements have given shape to contemporary painting. We will begin with painters of the first-generation New York School and their powerful new movement of **Abstract Expressionism.** Then we will consider the work of a younger, second generation of New York School painters, including color-field and hard-edge painters. Finally, we will discuss a number of the other movements in painting that have defined the postwar years, including figurative painting, Pop Art, Photorealism, and Op Art.

THE NEW YORK SCHOOL: THE FIRST GENERATION

At mid-twentieth century the influences of earlier nonobjective painting, the colorful distortions of Expressionism, Cubist design, the supposedly automatist processes of Surrealism, and a host of other factors—even an interest in Zen Buddhism—converged in New York City. From this artistic melting pot, Abstract Expressionism flowered. At first, like other innovative movements in art, it was not universally welcomed by critics. Writing in *The New Yorker* in 1945, Robert M. Coates commented:

[A] new school of painting is developing in this country. It is small as yet, no bigger than a baby's fist, but it is noticeable if you get around to the galleries much. It partakes a little of Surrealism and still more of Expressionism, and although its main current is still muddy and its direction obscure, one can make out bits of Hans Arp and Joan Miró floating in it, together with large chunks of Picasso and occasional fragments of [African American] sculptors. It is more emotional than logical in expression, and you may not like it (I don't either, entirely), but it can't escape attention.²

Abstract Expressionism is characterized by spontaneous execution, large gestural brushstrokes, abstract imagery, and fields of intense color. Many canvases are quite large, lending monumentality to the imagery. The abstract shapes frequently have a calligraphic quality found in the painting of the Far East (see Chapter 7). However, the scope of the brushstrokes of the New York group was vast and muscular compared with the gentle, circumscribed brushstrokes of Chinese and Japanese artists.

Turning the Corner toward an Abstract Expressionism

Before we discuss the work of the major Abstract Expressionists, let us explore the vibrant canvases of two artists whose work, near mid-twentieth century, showed the influ-

¹Robert Goldwater and Marco Treves, eds., *Artists on Art* (New York: Pantheon Books, 1972), 479.

²Robert M. Coates, "The Art Galleries," *The New Yorker*, May 26, 1945, 68.

The vital task was a wedding of abstraction and surrealism. Out of these opposites something new could emerge, and Gorky's work is part of the evidence that this is true.

-Adolph Gottlieb

ence of earlier trends and, in turn, presaged Abstract Expressionism: Arshile Gorky and Hans Hofmann.

Arshile Gorky

Born in Armenia, Arshile Gorky (1905–1948) immigrated to the United States in 1920 and became part of a circle that included Willem de Kooning and Stuart Davis. Some of Gorky's early still lifes show the influence of the nineteenthcentury painter Paul Cézanne. Later abstract works resolve the shapes of the objects of still lifes into sharp-edged planes that recall the works—and the fascination with native forms—of Pablo Picasso and Georges Braque. Abstractions of the late 1940s show the influence of Expressionists such as Wassily Kandinsky and Surrealists such as Joan Miró.

Gorky's *The Liver Is the Cock's Comb* (Fig. 10-1) is six feet high and more than eight feet long. Free, spontaneous lines pick out unstable, organic shapes from a lush molten background of predominantly warm colors: analogous reds, oranges, and yellows.

Many of Gorky's paintings, like those of the Surrealists, are like erotic panoramas. Here and there we can pick out abstracted forms that seem to hark back to dreams of childhood or to the ancestral figures of primitive artists. Transitional works such as this form a logical bridge between early twentieth-century abstraction, Automatist Surrealism, and the gestural painting of Jackson Pollock and Willem de Kooning.

Hans Hofmann

Born in Bavaria, Hans Hofmann (1880–1966) studied in Paris early in the twentieth century. He witnessed at close hand the Fauvists' use of high-keyed colors and the Cubists' resolution of shapes into abstract planes. He immigrated to the United States from Germany in 1932 and established schools of fine art in New York City and in Provincetown, Massachusetts.

Hofmann's early works were figural and expressionistic, showing the influence of Henri Matisse. From the war years

10-1 ARSHILE GORKY. *The Liver Is the Cock's Comb* (1944). Oil on canvas. 72" × 98".

> Albright-Knox Art Gallery, Buffalo, New York. Gift of Seymour H. Knox, 1956. Copyright 2007 Artists Rights Society (ARS), New York.

on, however, his paintings showed a variety of abstract approaches, from lyrically free, curving lines to the depiction of geometrical masses. Hofmann is considered a transitional figure between the Cubists and the Abstract Expressionists. In his abstract paintings, he shows some allegiance to Fauvist coloring and Cubist design, but Hofmann also used color architecturally to define structure.

In *The Golden Wall* (Fig. 10-2), intense fields of complementary and primary colors are pitted against one another in Fauvist fashion, but they compose abstract rectangular forms. The gestural brushstrokes in the color fields of paintings such as these would soon spread through the art world. Hofmann, the analyst and instructor of painting, knew very well that the cool blues and greens in *The Golden Wall* would normally recede and the warm reds and oranges would emerge; but sharp edges and interposition press the blue and green areas forward, creating tension between planes and flattening the canvas. Hofmann saw this tension as symbolic of the push and pull of nature; but the "tension" is purely technical, for the mood of *The Golden Wall*, as of most of his other works, is joyous and elevating.

Later Hofmann would claim that paintings such as these were derived from nature, even though no representational imagery can be found. In their expressionistic use of color and their abstract subject matter, Hofmann's

10-2 HANS HOFMANN. *The Golden Wall* (1961). Oil on canvas. 60" × 72¹/2". Photograph courtesy of The Art Institute of Chicago. Mr. and Mrs. Logan G. Prize Fund. Copyright 2007 Artists Rights Society (ARS), New York.

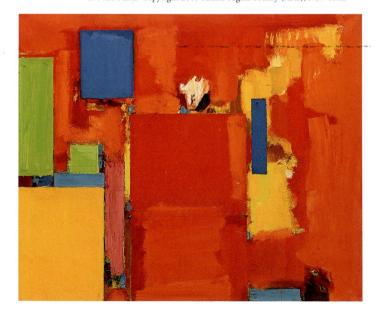

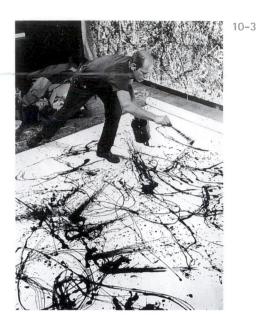

3 Jackson Pollock at work in his Long Island studio (1950). Copyright Hans Namuth, Ltd.

paintings form a clear base for the flowering of Abstract Expressionism.

Focus on Gesture

For some Abstract Expressionists, such as Jackson Pollock and Willem de Kooning, the gestural application of paint seems to be the most important aspect of their work. For others, the structure of the color field seems to predominate.

Jackson Pollock

Pollock's talent is volcanic. It has fire. It is unpredictable. It is undisciplined. It spills itself out in a mineral prodigality not yet crystallized. It is lavish, explosive, untidy. . . . What we need is more young men who paint from inner compulsion without an ear to what the critic or spectator may feel painters who will risk spoiling a canvas to say something in their own way. Pollock is one.³

Jackson Pollock (1912–1956) is probably the best known of the Abstract Expressionists. Photographs or motion pictures of the artist energetically dripping and splashing paint across his huge canvases (Fig. 10-3) are familiar to many. Pollock would walk across the surface of the canvas as if controlled by primitive impulses and unconscious ideas.

³Clement Greenberg, quoted in Introduction to catalog of an exhibition, "Jackson Pollock," Art of This Century Gallery, New York, November 9– 27, 1943.

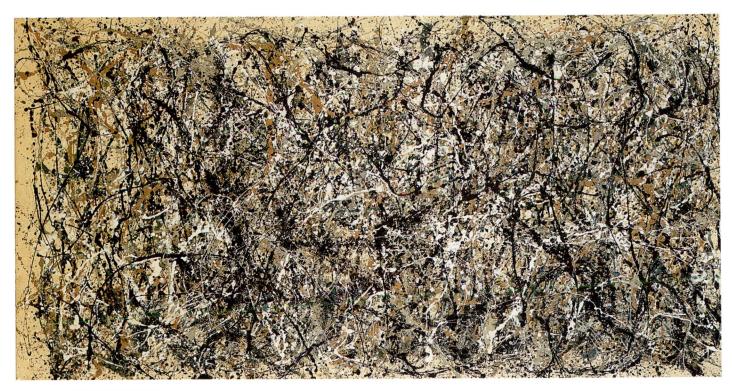

10-4 JACKSON POLLOCK.
 One (Number 31, 1950) (1950).
 Oil and enamel paint on canvas. 8'10" × 17'5⁵/8".

The Museum of Modern Art, New York. Sidney and Harriet Janis Collection Fund by exchange. Digital Image © The Museum of Modern Art. Copyright 2007 The Pollock-Krasner Foundation/Artists Rights Society (ARS), New York.

Accident became a prime compositional element in his painting. Art critic Harold Rosenberg coined the term **action painting** in 1951 to describe the outcome of such a process—a painting whose surface implied a strong sense of activity, as created by the signs of brushing, dripping, or splattering of paint.

Born in Cody, Wyoming, Pollock came to New York to study with Thomas Hart Benton at the Art Students League. The 1943 quote from Clement Greenberg shows the impact that Pollock made at an early exhibition of his work. His paintings of this era frequently depicted actual or implied figures that were reminiscent of the abstractions of Picasso and, at times, of Expressionists and Surrealists.

Aside from their own value as works of art, Pollock's drip paintings of the late 1940s and early 1950s made a number of innovations that would be mirrored and developed in the work of other Abstract Expressionists. Foremost among these was the use of an overall gestural pattern barely contained by the limits of the canvas. In *One* (Fig. 10-4), the surface is an unsectioned, unified field. Overlapping skeins of paint create dynamic webs that project from the picture plane, creating an illusion of infinite depth. In Pollock's best work, these webs seem to be composed of energy that pushes and pulls the monumental tracery of the surface like the architectural shapes of a Hofmann painting.

Pollock was in psychoanalysis at the time he executed his great drip paintings. He believed strongly in the role of the unconscious mind, of accident and spontaneity, in the creation of art. He was influenced not only by the intellectual impact of the Automatist Surrealists but also by what must have been his impression of walking hand in hand with his own unconscious forces through the realms of artistic expression. Before his untimely death in 1956, Pollock had returned to figural paintings that were heavy in impasto and predominantly black. One wonders what might have emerged if the artist had lived a fuller span of years. I merge what I call the organic with what I call abstract.

—Lee Krasner

Lee Krasner

Lee Krasner (1908–1984) was one of only a few women in the mainstream of Abstract Expressionism. Yet, in spite of her originality and strength as a painter, her work, until fairly recently, had taken a critical "back seat" to that of her famous husband—Jackson Pollock. She once noted,

I was not the average woman married to the average painter. I was married to Jackson Pollock. The context is bigger and even if I was not personally dominated by Pollock, the whole art world was.⁴

Krasner had a burning desire to be a painter from the time she was a teenager and received academic training at some of the best art schools in the country. She was influenced by artists of diverse styles, including Hofmann (under whom she studied), Picasso, Mon-

drian, and the Surrealists. Most important, like Pollock and the other members of the Abstract Expressionist school, she was exposed to the work of a number of European émigrés who came to New York in the 1930s and 1940s.

Both Pollock and Krasner experimented with allover compositions around 1945, but the latter's work was smaller in scale and exhibited much more control. Even after 1950, when Krasner's work became much freer and larger, the accidental nature of Pollock's style never took hold of her own. Rather, Krasner's compositions might be termed a synthesis of choice and chance.

Easter Lilies (Fig. 10-5) was painted in 1956, the year of Pollock's fatal accident. The jagged shapes and bold black lines against the muddied greens and ochers render the composition dysphoric; yet in the midst of all that is harsh are the recognizable contours of lilies, whose bright whites offer a kind of hope in a sea of anxiety. Krasner once remarked of her work, "My painting is so autobiographical, if anyone can take the trouble to read it."⁵

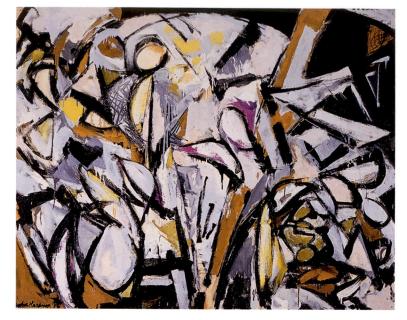

 10-5 LEE KRASNER. Easter Lilies (1956). Oil on cotton duck. 48¹/4" × 60¹/8".
 Private collection. Courtesy of the Robert Miller Gallery, New York. Copyright 2007 The Pollock-Krasner Foundation/Artists Rights Society (ARS), New York.

Willem de Kooning

Born in Rotterdam, Holland, Willem de Kooning (1904 – 1997) immigrated to the United States in 1926, where he joined the circle of Gorky and other forerunners of Abstract Expressionism. Until 1940 de Kooning painted figures and portraits. His first abstractions of the 1940s, like Gorky's, remind one of Picasso's paintings. As the 1940s progressed, de Kooning's compositions began to combine biomorphic, organic shapes with harsh, jagged lines. By mid-twentieth century, his art had developed into a force in Abstract Expressionism.

De Kooning is best known for his series of paintings of women that began in 1950. In contrast to the appealing figurative works of an earlier day, many of his abstracted women are frankly overpowering and repellent. Faces are frequently resolved into skull-like native masks reminiscent of ancient fertility figures; they assault the viewer from a loosely brushed backdrop of tumultuous color. Perhaps they portray what was a major psychoanalytic dilemma during the 1950s—how women could be at once seductive, alluring, and castrating. In our own liberated times, this notion

⁴Lee Krasner, in Roberta Brandes Gratz, "Daily Close-Up—After Pollock," *New York Post*, December 6, 1973.

⁵Lee Krasner, in Cindy Nemser, "A Conversation with Lee Krasner," *Arts Magazine* 47 (April 1973): 48.

[A critic] thought that American painting couldn't be abstract—it wasn't American.

-Willem de Kooning

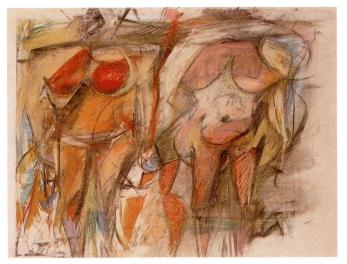

 10-6 WILLEM DE KOONING. *Two Women* (1953). Pastel drawing. 18⁷/s" × 24". Photograph courtesy of The Art Institute of Chicago. Joseph H. Wrenn Memorial Collection. Copyright 2007 The Willem de Kooning Foundation/Artists Rights Society (ARS), New York.

of woman or of eroticism as frightening seems sexist or out of joint. In any event, in some of his other paintings, abstracted women communicate an impression of being unnerved, even vulnerable.

The subjects of *Two Women* (Fig. 10-6) are among the more erotic of the series. Richly curved pastel breasts swell from a sea of spontaneous brushstrokes that here and there violently obscure the imagery. The result is a free-floating eroticism. A primal urge has been cast loose in space, pushing and pulling against the picture plane. But de Kooning is one of the few Abstract Expressionists who never completely surrendered figurative painting. De Kooning's work frequently seems obsessed with the violence and agitation of the "age of anxiety." The abstract backgrounds seem to mirror the rootlessness many of us experience as modern modes of travel and business call us to foreign towns and cities.

Focus on the Color Field

For a number of Abstract Expressionists, the creation of pulsating fields of color was more important than the gestural quality of the brushstroke. These canvases are so large that they seem to envelop the viewer with color, the subtle modulations of which create a vibrating or resonating effect. Artists who subscribed to this manner of painting, such as Mark Rothko and Barnett Newman, had in common the reworking of a theme in an extended series of paintings. Even though the imagery often remains constant, each canvas has a remarkably different effect due to often radical palette adjustments.

Mark Rothko

Mark Rothko (1903–1970) painted lone figures in urban settings in the 1930s and biomorphic surrealistic canvases through the early 1940s. Later in that decade he began to paint the large floating, hazy-edged color fields for which he is renowned. During the 1950s, the color fields consistently assumed the form of rectangles floating above one another in an atmosphere defined by subtle variations in tone and gesture. They alternately loom in front of and recede from the picture plane, as in *Blue, Orange, Red* (Fig. 10-7). The large scale of these canvases absorbs the viewer in color.

10-7 MARK ROTHKO. Blue, Orange, Red (1961). Oil on canvas. $90^{3}/4^{"} \times 81^{"}$.

Hirshhorn Museum and Sculpture Garden, Smithsonian Institution, Washington, DC. Gift of the Hirshhorn Foundation, 1966. Copyright 2007 Artists Rights Society (ARS), New York. Early in his career, Rothko had favored a palette of pale hues. During the 1960s, however, his works grew somber. Reds that earlier had been intense, warm, and sensuous were now awash in deep blacks and browns and took on the appearance of worn cloth. Oranges and yellows were replaced by grays and black. Light that earlier had been reflected was now trapped in his canvases. Despite public acclaim, Rothko suffered from depression during his last years. In 1968 he was diagnosed as having heart disease, and one year later his second marriage was in ruins. He committed suicide the following winter. His paintings of the later years may be an expression of the turmoil and the fading spark within.

Combined Gesture and Color-Field Painting

For some artists of the Abstract Expressionist era, the most original work lay in the bridging of gesture and color field. Artists such as Adolph Gottlieb, Robert Motherwell, and Clifford Still enlarged simple forms and made them the predominant themes of their compositions. Often these forms were set in large expanses of washed color, their contours eroded by the resonating hues.

Adolph Gottlieb

Adolph Gottlieb (1903–1974) is preeminent among those artists who chose to combine the two styles of Abstract Expressionism. He was born in New York and studied under

American Realist painter John Sloan at New York City's Art Students League. During the 1940s and early 1950s, he painted a series of "pictographs" in which the canvases were sectioned into rectangular compartments filled with schematized or abstract forms such as ancestral images, sinuous shapes of reptiles and birds, pure geometric forms, anatomic parts, and complex shapes suggestive of cosmic symbols or microscopic life-forms. He denied that the pictographs had any meaning beyond their interesting shapes, but much of the enjoyment in viewing them stems from trying to decipher the content.

Some of Gottlieb's most successful paintings belong to the *Bursts* series that began in 1957. In the Bursts, there is an implied horizontal division of the canvas. An orb of color pulsates in the upper part of the canvas while broad, gestural strokes burst beneath it against a washed field of color. Visually, the Bursts are studies in contrast between pure closed forms and amorphous open forms. On a symbolic level, they seem to reflect the opposites in human nature.

Green Turbulence (Fig. 10-8), painted in 1968, is a variation on the Bursts theme. Below an implied horizon line, a simple black pictograph floats against a field of green while three pristine orbs hover above. Smaller and less perfectly formed spheres seem to break out of the chaotic, "earthly" zone and await their voyage to the celestial realm. The pictograph is strongly calligraphic, as if the baser history of our species is being broadly recorded in swaths of paint. By comparison, the orbs seem immaculate in conception. These

 10-8 ADOLPH GOTTLIEB. Green Turbulence (1968). Oil on canvas. 94" × 157".

> Photograph courtesy of Adolph and Esther Gottlieb Foundation, Inc., New York. Copyright Adolph and Esther Gottlieb Foundation/Licensed by VAGA, New York.

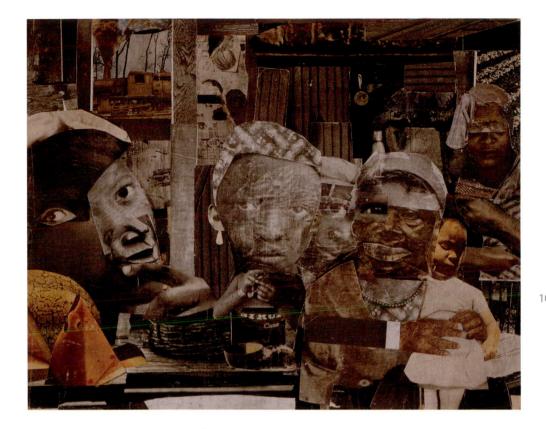

 10-9 ROMARE BEARDEN. Prevalence of Ritual: Mysteries (1964). Collage. 11¹/4" × 14¹/4". Museum of Fine Arts, Boston. Ellen Kelleran Gardner Fund, 1971. Copyright Romare Bearden Foundation/Licensed by VAGA, New York.

pulsating shapes imply a pure but obscure symbol that is close at hand yet unreachable.

Abstract Expressionism may be the major movement in painting of the postwar era, but contemporary painting has been a rich and varied undertaking, with tentative strokes and brilliant bursts of fulfillment in many directions.

Romare Bearden

Abstract Expressionism has been viewed by some critics as an exclusive "club" of white male artists. Indeed, the main figures associated with the movement do not count among them women and artists of color. Yet these artists did experiment with the style of Abstract Expressionism, developing their own artistic voices.

African American artist Romare Bearden (1914–1988) experimented with the Abstract Expressionist style in the 1950s and a decade later enhanced his artistic vocabulary with collage techniques that would become characteristic of his mature style. Although his compositions have a familiar allover design that reflects his interest in Abstract Expressionism, one of the ways in which he departed from their style is his emphasis on imagery that reflected his experiences and memories of life in North Carolina, his birthplace, and in Harlem, where he carried out most of his work. The son of middle-class parents, Bearden attended the Art Students League and New York University in the 1940s. He believed that African Americans should create their own art form, just as they had developed musical styles such as jazz and the blues. In the 1960s he arrived at his signature style, which combined painting and collage. *Prevalence of Ritual: Mysteries* (Fig. 10-9) is constructed of pasted papers that read as flashes of memory. Objects, faces, photos of houses, and swatches of newsprint appear something like a scrapbook of consciousness and experience. The rituals Bearden observed in his early life all seem to blend together—planting, sowing, picking cotton, family meals, river baptisms, "down-home" jazz, or blues. Ralph Ellison wrote of Bearden's art:

Bearden's meaning is identical with his method. His combination of technique is in itself eloquent of the sharp breaks, leaps in consciousness, distortions, paradoxes, reversals, telescoping of time and surreal blending of styles, values, hopes and dreams which characterize much of [African] American history.⁶

⁶ Ralph Ellison, introduction to *Romare Bearden: Paintings and Projections* (Albany, NY, 1968).

THE NEW YORK SCHOOL: THE SECOND GENERATION

Abstract Expressionism was a painterly movement. Contours and colors were loosely defined, edges were frequently blurred, and long brushstrokes trailed off into ripples, streaks, and specks of paint. During the mid-1950s, a number of younger abstract artists, referred to as the "second generation" New York School, began to either build upon or deemphasize this painterly approach; some furthered the staining technique that Pollock used in his last years, whereas others focused increasingly on clarity of line and clearness of edges. Beyond a few common features, their styles were quite different, and they modified and extended in a number of ways the forces that had led to Abstract Expressionism. Some of these artists, such as Morris Louis, Helen Frankenthaler, and Kenneth Noland, became known as color-field painters. Others, such as Ellsworth Kelly, whose work focused on clear geometric shapes with firm contours that separated them from their fields, were known as hard-edge painters. Many of this new crop of abstract painters, Noland and Kelly among them, also pioneered the shaped canvas, which challenges the traditional orientation of a painting and often extends the work into threedimensional space. Some artists in the 1980s would use the shaped canvas exclusively in their works.

built on Pollock's legacy. The canvas is awash in color. Broad expanses of thinned pigment are allowed to seep into the fibers of the canvas, thus softening the edges of the varied shapes. The shapes themselves are interspersed with flowing lines and paint spatters that make reference to Pollock's techniques. The roles of accident and spontaneity are not diminished. *Lorelei* is in many ways a reconciliation between gesture and color-field Abstract Expressionism; yet its uniqueness lies in its combination of a vibrant palette, staining technique, and above all, strong abstract image in a structurally sound composition. Frankenthaler is capable of suggesting space through subtle color modulations. By pouring fields of thinned vibrant color onto unprimed canvas, the resulting central image is open, billowing, and abstract, free of gestural brushing.

Minimal Art

Paintings involving the shaped canvas, color field, and images derived from mathematical systems gave rise to an art form known as **Minimal art**, or simply **Minimalism**. Many

10-10 HELEN FRANKENTHALER. Lorelei (1957). Oil on canvas. 70³/4" × 87". The Brooklyn Museum. Gift of Alan D. Emil. © Helen Frankenthaler.

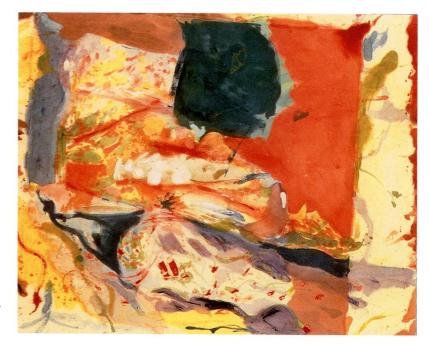

Color-Field Painting

Helen Frankenthaler

Kenneth Noland once said of Helen Frankenthaler (b. 1928), "She was a bridge between Pollock and what was possible." He claimed that it was Frankenthaler who showed him and Morris Louis a way to push beyond Pollock, showed them "a way to think about and use, color."⁷ In fact, it is works like *Lorelei* (Fig. 10-10) that best describe the manner in which Frankenthaler

⁷Kenneth Noland, in James McC. Truitt, "Art-Arid D.C. Harbors Touted 'New' Painters," *Washington Post*, December 21, 1961, A20. My pictures have neither subject nor space nor lines nor anything else—no forms. They are light, and are about fusion and formlessness, about dissolving form.

-Agnes Martin

 10-11 AGNES MARTIN. Untitled (1989). Acrylic and graphite on canvas. 12" × 12". Courtesy of PaceWildenstein Gallery, New York.

artists in the 1960s purified their images and painting processes to reflect their commitment to intellectual theory and mathematics as bases for their compositions. Common to all is the sense of the contradictory: an extraordinary lightness and transience that belies the solidity and permanence of their shapes.

Agnes Martin

Untitled (Fig. 10-11) by Agnes Martin (1912–2004) is a quintessential example of the Minimalist style. A tiny $12'' \times 12''$ canvas provides a luminous backdrop for finely wrought bands of shimmering graphite. The absolute square of the canvas is softened by the delicacy of technique. Martin said of her paintings, "When I cover the square with rectangles, it lightens the weight of the square, destroys its power."⁸

FIGURATIVE PAINTING

Although abstraction has been a driving force in American painting since the years just prior to World War II, a number of figurative painters have remained strong in their commitment to nature, or reality, as a point of departure for their work. De Kooning's *Women* series remains figurative, although he was an active participant in the Abstract Expressionist movement. Other artists have portrayed human and animal figures in any number of styles—realistic, expressionistic, even abstracted. In the thick of Abstract Expressionism, and in the decade following, when artists sought to create new forms of expression within its canon, painters such as Alice Neel and Francis Bacon used the figure, respectively, in compositions of extreme verity and surrealist juxtaposition.

Alice Neel

One of the most dramatic figurative painters of the era was a portrait painter named Alice Neel (1900–1984). The designation "portraitist," however, in no way prepares the viewer for the radical nature of Neel's work. She took no commissions but rather handpicked her sitters from all strata of society and often painted them in the nude, or seminude. The drama, curiously, lies in the very *un*dramatic character of her work—stark, unflinching realism. Neel's sitters were wildly diverse (from painter Andy Warhol to her housekeeper, Carmen), but her harsh style remained constant, as did her belief that she could convey something of a person's inner self through a meticulous rendering of its physical embodiment.

⁸H. H. Arnason, *History of Modern Art*, 3rd ed. (Englewood Cliffs, NJ: Prentice-Hall /Abrams, 1986), 520.

10-12 ALICE NEEL. Pregnant Woman (1971). Oil on canvas. 40" × 60". Courtesy of the Robert Miller Gallery, New York. Copyright The Estate of Alice Neel. Pregnant Woman (Fig. 10-12) is one in a series of canvases devoted to the nude pregnant woman. Although her subject reclines in a pose traditionally reserved for the Renaissance goddess, her facial features prevent us from reading the work as either stereotypical or archetypal. They are specific; they belong to this woman and no one else. Maria does not symbolize maternity or childbirth for all women. This experience is hers alone.

Francis Bacon

Many of the figurative canvases of Francis Bacon (1909– 1992) rework themes by masters such as Giotto, Rembrandt, and van Gogh. But Bacon's personalized interpreta-

> tion of history is expressionistically distorted by what must be a very raw response to the quality of contemporary life.

Head Surrounded by Sides of Beef (Fig. 10-13) is one of a series of paintings from the 1950s in which Bacon reconstructed Velázquez's portrait of Pope Innocent X. The tormented, open-mouthed figure is partially obscured, as if seen through a curtain or veil. The brilliantly composed slabs of beef, which stand like totems richly threaded with silver and gold, replace ornamental metalwork posts that rise from the back corners of the papal throne in the Velázquez portrait. Profiles can be seen in the sides of beef, and a goblet of noble proportions is constructed from the negative space between them. The bloody whisperings shared by the profiles are anybody's guess. Whereas the background of Velázquez's subject was a textured space of indefinite depth, Bacon's seated figure and the sides of beef are set by singlepoint perspective within an abstract black box.

10-13 FRANCIS BACON.

Head Surrounded by Sides of Beef (1954). Oil on canvas. $50^{7}/8'' \times 48''$.

The Art Institute of Chicago. Harriott A. Fox Fund. Copyright The Art Institute of Chicago. Copyright 2007 The Estate of Francis Bacon/Artists Rights Society (ARS), New York/DACS, London.

POP ART

If one were asked to choose the contemporary art movement that was most enticing, surprising, controversial, and also exasperating, one might select Pop Art. The term "Pop" was coined by English critic Lawrence Alloway in 1954 to refer to the universal images of "popular culture," such as movie posters, billboards, magazine and newspaper photographs, and advertisements. Pop Art, by its selection of commonplace and familiar subjects—subjects that are already too much with us—also challenges commonplace conceptions about the meaning of art.

Whereas many artists have strived to portray the beautiful, Pop Art intentionally depicts the mundane. Whereas many artists represent the noble, stirring, or monstrous, Pop Art renders the commonplace, the boring. Whereas other forms of art often elevate their subjects, Pop Art is often matter-of-fact. In fact, one tenet of Pop Art is that the work should be so objective that it does not show the "personal signature" of the artist. This maxim contrasts starkly, for example, with the highly personalized gestural brushstroke found in Abstract Expressionism.

Richard Hamilton

Despite the widespread view that Pop Art is a purely American development, it originated during the 1950s in England. British artist Richard Hamilton (b. 1922), one of its creators, had been influenced by Marcel Duchamp's idea that the mission of art should be to destroy the normal meanings and functions of art.

Hamilton's tiny collage *Just What Is It That Makes Today's Homes So Different, So Appealing?* (Fig. 10-14) is one of the earliest and most revealing Pop Art works. It is a collection of objects and emblems that form our environment. It is easy to read satire and irony into Hamilton's work, but his placement of these objects within the parameters of "art" encourages us to truly *see* them instead of just coexisting with them.

Robert Rauschenberg

American Pop artist Robert Rauschenberg (b. 1925) studied in Paris and then with Josef Albers and others at the famous Black Mountain College in North Carolina. Before developing his own Pop Art style, Rauschenberg experimented with loosely and broadly brushed Abstract Expressionist canvases. He is best known, however, for introducing a construction referred to as the **combine painting**, in which stuffed animals, bottles, articles of clothing and furniture, and scraps of photographs are attached to the canvas.

Rauschenberg's *The Bed* (Fig. 10-15) is a paint-splashed quilt and pillow, mounted upright on a wall as any painting

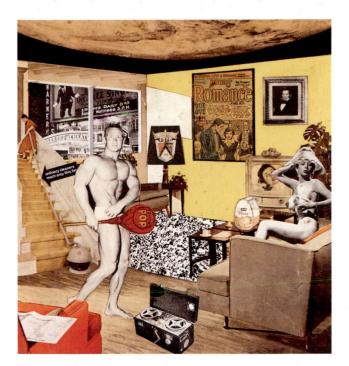

 10-14 RICHARD HAMILTON. Just What Is It That Makes Today's Homes So Different, So Appealing? (1956). Collage. 10¹/4" × 9³/4". Kunsthalle Tübingen, Germany. Collection of G. F. Zundel.

might be. Here the artist toys with the traditional relationships between materials, forms, and content. The content of the work is actually its support; rather than a canvas on a stretcher, the quilt and pillow are the materials on which the painter drips and splashes his pigments. Perhaps even more outrageous is Rauschenberg's famous 1959 work *Monogram*, in which a stuffed ram—an automobile tire wrapped around its middle—is mounted on a horizontal base that consists of scraps of photos and prints and loose, gestural painting.

Jasper Johns

Jasper Johns (b. 1930) was Rauschenberg's classmate at Black Mountain College, and their appearance on the New York art scene was simultaneous. His early work also integrated the overall gestural brushwork of the Abstract Expressionists with the use of found objects, but unlike

10-15 ROBERT RAUSCHENBERG. The Bed (1955). Combine painting: Oil and pencil on pillow, quilt, and sheet on wood supports. $75^{1/4''} \times 31^{1/2''} \times 6^{1/2''}$. The Museum of Modern Art, New York. Gift of Leo Castelli in honor of Alfred H. Bart Jr. Copyright The Museum of Modern Art/Licensed by Scala/Art Resource, New York. Copyright Robert Rauschenberg. Licensed by VAGA, New York.

Rauschenberg, Johns soon made the object central to his compositions. His works frequently portray familiar objects such as numbers, maps, color charts, targets, and flags integrated into a unified field by thick gestural brushwork.

One "tenet" of Pop Art is that imagery is to be presented objectively, that the personal signature of the artist is to be eliminated. That principle must be modified if we are to include as Pop the works of Rauschenberg, Johns, and others, for many of them immediately betray their devotion to expressionistic brushwork.

A work by Johns that adheres more to Pop Art dogma is his *Painted Bronze (Ale Cans)* (Fig. 10-16). In the tradition of Duchamp's readymades, Johns has bronzed two Ballantine beer cans and painted facsimile labels thereon. As with works such as the Dadaist's *Fountain* (see Fig. 1-32) or *Mona Lisa (L.H.O.O.Q.)* (see Fig. 9-24), questions concerning the definition of art are raised: Is it art because the artist chooses the object? because he or she manipulates it? or because the artist says it is art? One difference separates the Dada and Pop aesthetics, however: Whereas Duchamp believed that art should be destroyed, Johns firmly believes in the creative process of art. Whereas it was left for Duchamp to stop making art (he devoted his life to the game of chess), Johns remains first and foremost an artist.

 10-16 JASPER JOHNS.
 Painted Bronze (Ale Cans) (1960).
 Painted bronze. 5¹/₂" × 8" × 4³/₄".
 Kunstmuseum (Ludwig Collection), Basel.
 Copyright Rheinisches Bildarchiv. Copyright Jasper Johns/Licensed by VAGA, NY.

10-17 ANDY WARHOL.

Green Coca-Cola Bottles (1962). Oil on canvas. $82^{1}/4'' \times 57''$.

Collection of Whitney Museum of American Art, New York. Purchased with funds from the Friends of the Whitney Museum of American Art. Copyright 2007 Andy Warhol Foundation for the Visual Arts/Artists Rights Society (ARS), New York.

Andy Warhol

Andy Warhol (1930–1987) once earned a living designing packages and Christmas cards. Today he epitomizes the Pop artist in the public mind. Just as Campbell's soups represent bland, boring nourishment, Andy Warhol's appropriation of hackneyed portraits of celebrities, his Brillo boxes, and his Coca-Cola bottles (Fig. 10-17) elicit comments that contemporary art has become bland and boring and that there is nothing much to be said about it. Warhol also evoked contempt here and there for his underground movies, which have portrayed sleep and explicit eroticism (*Blue Movie*) with equal disinterest. Even his shooting (from which he recovered) by a disenchanted actress seemed to evoke yawns and a "What-can-you- expect?" reaction from the public.

Warhol painted and printed much more than industrial products. During the 1960s he reproduced multiple photographs of disasters from newspapers. He executed a series of portraits of public figures such as Marilyn Monroe and Jackie Kennedy in the 1960s, and he turned to portraits of political leaders such as Mao Ze-dong in the 1970s. Although his silkscreens have at least in their technique met the Pop Art objective of obscuring the personal signature of the artist, his compositions and his expressionistic brushing of areas of his paintings achieved an individual stamp.

It could be argued that other Pop artists owe some of their popularity to the inventiveness of Andy Warhol. Without Warhol, Pop Art might have remained a quiet movement, one that might have escaped the notice of the art historians of the new millennium.

What, then, do we make of Pop Art? Is it a cynical gesture to place expensive but meaningless objects in a gullible marketplace? Is it the sincere expression of deeply felt experience? Is it, perhaps, the only contemporary art movement that is a reflection of its times? Is it an attempt to countermand the unreachable and esoteric in the art of the 1940s and 1950s and provide the public with an art to which it can relate on some level?

HYPERREALISM

Hyperrealism, or the rendering of subjects with sharp, photographic precision, is firmly rooted in the long, realistic tradition in the arts. But as a movement that first gained major recognition during the early 1970s, it also owes some of its impetus to the Pop artist's objective portrayal of familiar images. Photorealism is also in part a reaction to the expressionistic and abstract movements of the twentieth century. That is, hyperrealism permits artists to do something very new to the eye even while they are doing something very old.

Audrey Flack

Audrey Flack (b. 1931) was born in New York and studied at the High School of Music and Art, at Cooper Union, and at Yale University's Graduate School. During the 1950s she showed figure paintings that were largely ignored, in part because of the popularity of Abstract Expressionism, in part because women artists, in general, had not been privy to the

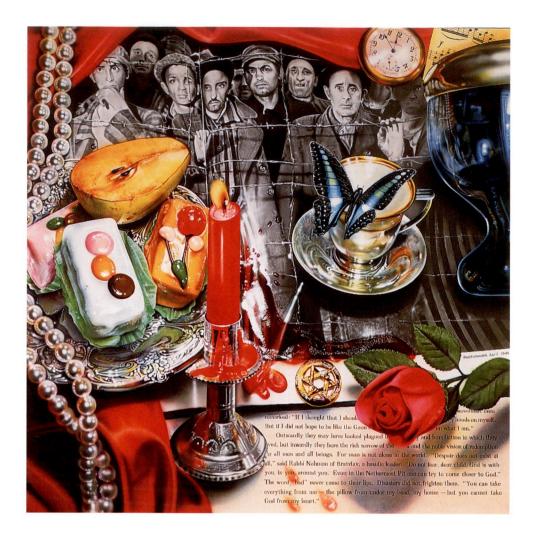

10-18 AUDREY FLACK. World War II (Vanitas) (1976–1977). Oil over acrylic on canvas. 96" × 96". Photograph courtesy of the Louis K. Meisel Gallery, New York. Incorporating a portion of Margaret

Bourke White's photograph "Buchenwald, 1945."

Copyright Time, Inc.

critical attention that their male colleagues had received. Yet throughout these years she persisted in a sharply realistic, or trompe l'oeil style. Her illusionistically real canvases often result from a technique involving the projection of color slides onto her canvases, which she then sketches and paints in detail. Since the 1970s, Flack's focus has largely shifted away from the human figure to richly complex still-life arrangements.

One of Flack's best-known works from the 1970s is World War II (Vanitas) (Fig. 10-18), a painting that combines Margaret Bourke-White's haunting photo The Living Dead of Buchenwald with ordinary objects that teem with life—pastries, fruit, a teacup, candle, a string of pearls. The subtitle of the work, Vanitas, refers to a type of still life frequently found in the sixteenth and seventeenth centuries. The content was selected specifically to encourage the viewer to meditate on death as the inescapable end to human life. Flack's items are all the more poignant in their juxtaposition because they suggest lives cut short—abruptly and drastically—by Hitler's Holocaust. The painting further functions as a memorial to those who perished at the hands of the Nazis and as a tribute to survivors. Flack is fascinated by the ways in which objects reflect light, and in this painting and others she uses an airbrush to create a surface that imitates the textures of these objects. She layers primary colors in transparent glazes to produce the desired hues without obvious brushstrokes. The resulting palette is harsh and highly saturated, and the sense of realism stunning.

OP ART (OPTICAL PAINTING)

In Op Art, also called optical painting, the artist manipulates light or color fields, or repeats patterns of line, in order to produce visual illusions. The effects can sometimes be disorienting. Hungarian-born Victor Vasarely (1906–1997) was perhaps the best-known Op artist to experiment with the illusion of three dimensions on a two-dimensional surface using linear perspective and atmospheric effects. He used relatively few elements in his compositions but worked with many different materials in his paintings and sculptures.

Vasarely's Orion (Fig. 10-19) is an assemblage of paper cut-outs that take on different intensities depending on their backgrounds. Vasarely sought to create optical illusions in many of his works. Warm hues (blues and greens) tend to seem to recede from the viewer, whereas warm colors (reds, oranges, yellows) tend to appear to move toward the picture plane. In *Orion*, the shifts from warm to cool hues cause parts of the arrangement to appear to "push and pull"—to move toward or away from the viewer. The progressions of circles and ellipses within lighter and darker squares also contribute to the pulsating sense of the piece.

NEW IMAGE PAINTING

The decade of the 1970s witnessed a strong presence of realism in the visual arts that was, in part, a virulent reaction against the introspective and subjective abstract tendencies that had gripped American painting since World War II.

Toward the end of that decade—in 1978—New York's Whitney Museum of American Art mounted a controver-

sial, though significant exhibition called "New Image Painting." The participants, including Jennifer Bartlett (b. 1941), Susan Rothenberg (b. 1945), and eight other artists, were doing something very different. They were, in their own way, reconciling the disparate styles of abstraction and representation. The image was central to their compositions, much in the tradition of Realist artists. The images were often so simplified, however, that they conveyed the grandeur of abstract shapes. These images never dominated other aesthetic components of the work, such as color, texture, or even composition. Rather, they cohabited the work in elegant balance.

Orion (1956).
 Paper on paper mounted on wood. 6'10¹/₂"× 6'6³/₄".
 Hirshhorn Museum and Sculpture Garden, Smithsonian Institution, Washington, D.C. Gift of Joseph H. Hirshhorn, 1966.

10-20 JENNIFER BARTLETT. Spiral: An Ordinary Evening in New Haven (1989). Painting: oil on canvas, $108'' \times 192''$; tables: painted wood, $30^{1}/_{2}'' \times 32'' \times 35''$; painted wood with steel base, $39^{1}/_{2}'' \times 41'' \times 35''$; cones: welded steel, $20'' \times 30^{1}/_{4}'' \times 21''$. Courtesy of the artist.

10-21 SUSAN ROTHENBERG.

Diagonal (1975). Acrylic and tempera on canvas. $40'' \times 60''$.

Private collection. Courtesy Sperone Westwater, New York. Copyright Susan Rothenberg/Artists Rights Society (ARS), New York.

Jennifer Bartlett

Jennifer Bartlett's Spiral: An Ordinary Evening in New Haven (Fig. 10-20) combines a painted canvas and several sculptural objects in a virtual maelstrom of imagery that is alternately engulfed by flames and apparently spewed out by the turbulent blaze. In this work, Bartlett includes figurative imagery and explores the use of line and color. The title and the work itself invite the viewer's speculation as to exactly what has happened to cause the conflagration and how it can possibly represent an "ordinary evening" anywhere. This sort of interplay between the verbal and the visual is another hallmark of New Image painting. Bartlett combines narrative, conceptual art, representation, and some abstract process painting of the sort we find in Abstract Expressionism.

Susan Rothenberg

Susan Rothenberg's *Diagonal* (Fig. 10-21) also stands as an example of New Image painting in bringing together representational and abstract art. The highly simplified and sketchy contours of a horse in full gallop barely separate the animal from the lushly painted field. Although the subject is strong and inescapable, its reality is diminished by the unified palette, the bisecting diagonal line, and the structured composition with its repetitive triangles. Rothenberg favored the horse as image in the 1970s, although in the 1980s she turned to the human form. The artist has said of her earlier compositions, "The horse was a way of not doing people, yet it was a symbol of people, a self-portrait, really."⁹

PATTERN PAINTING

Though painted at the same time, it would seem that no two works could be more drastically at odds with one another than Rothenberg's epitome of the "new image" aesthetic and Kim MacConnel's (b. 1946) riotous **pattern painting.** The stylistic and pictorial heritages of these artists are completely different. Whereas Rothenberg's originality lies in her ability to work within and expand the possibilities of representational and abstract constructs, MacConnel allowed his early experiments with rigid geometric forms to be

10-22KIM MACCONNEL.
Le Tour (1979).
Acrylic silkscreen on fabric. $86^{1/2}'' \times 87^{1/2}''$.
Collection of Anita Grossman. Courtesy of the Artist and Holly Solomon Gallery.

subsumed by a vast and more lively array of evocative signs, symbols, and patterns. What had heretofore been a term of degradation in the arts—"decorative"—became the cornerstone of his compositions. *Le Tour* (Fig. 10-22) is composed of patterned strips that are silkscreened onto fabric and stitched together. A remarkable balance and contradictory reserve are achieved through the juxtaposition of simple and complex patterns and the almost architectural placement of the vertical panels. MacConnel's art form attacks all conventions, from the banality of decoration to the materials and methods associated with women's artistic endeavors.

THE SHAPED CANVAS

The art of the 1980s was nothing if not pluralistic. Painters of extraordinary talent and innovation affirmed their love of the medium and put an end to the speculation of the late 1960s and 1970s that "painting was dead." Many artists, including Frank Stella, Judy Pfaff, and Elizabeth Murray, have

⁹Susan Rothenberg, in Grace Glueck, "Susan Rothenberg: New Outlook for a Visionary Artist," *The New York Times Magazine*, July 22, 1984, 20.

10-23 ELIZABETH MURRAY. Sail Baby (1983). Oil on canvas. 126" × 135". Collection of the Walker Art Center, Minneapolis. Walker Special Purchase Fund, 1984.

obscured the lines between painting, sculpture, and installations by radically changing the shapes of their canvases.

Elizabeth Murray

In Elizabeth Murray (b. 1940) we find a painter who has affirmed a belief in abstraction as a viable style, in the midst of trends that find it sterile and unreachable. Coupling clearcut, abstract shapes that nonetheless are suggestive of organic forms, or taking specific objects—such as a teacup or a table—and treating them as isolated abstract shapes, Murray has created an art form that is personal and reachable in spite of its emphasis on formal concerns. *Sail Baby* (Fig. 10-23) comprises three large shaped canvases. Although the somewhat repetitive shapes have strong, separate identities because of their prominent contours, the entire work is unified by the painting of a teacup that traverses all three supports. Beyond the common imagery, Murray has explained that the painting functions as a narrative: "[It is] about my family. It's about myself and my brother and my sister, and I think, it is also about my own three children, even though Daisy (her youngest daughter) wasn't born yet."¹⁰ The individual identities of the separate shapes may, in this context, represent the individuality of the siblings, whereas their interconnectedness is established by the image that overrides them as well as the snakelike green line (an umbilical cord?) that flows from the smallest shape and wends around to the right, behind the largest. Though essentially an abstract work, its references to human experience cannot be ignored or minimized. They are essential to our comprehension of the piece.

NEO-EXPRESSIONISM

The center of the art world moved to New York in the 1940s for historical as well as artistic reasons. The first generation Abstract Expressionists developed a style that was viewed worldwide as highly original and influential. They laid claim to the tenet that the process of painting was a viable alternative to subject matter. In the early 1980s, a group of artists who were born during the Abstract Expressionist era-though on other shores-wholeheartedly revived the gestural manner and experimentation with materials that the Americans had devised four decades earlier, but with an added dimension. These young German and Italian artists, who came to be called Neo-Expressionists, detested painting "about nothing." Born as they were during the darkest years of postwar Europe, when Germany and Italy stood utterly defeated, these artists would mature to portray the bitter ironies and angst of their generation in emotionally fraught images that are rooted in history, literature, and expressionistic art.

Anselm Kiefer

Perhaps the most remarkable of these Neo-Expressionists is Anselm Kiefer (b. 1945). Kiefer has been able to synthesize an expressionistic painterly style with strong abstract elements in a narrative form of painting that makes multivalent references to German history and culture. The casual observer cannot hope to decipher Kiefer's paintings; they are highly intellectual, obscure, and idiosyncratic. But at the same time, they are overpowering in their scale, their largerthan- life subjects, and their textural, encrusted surfaces.

Kiefer's *Dein Goldenes Haar, Margarethe* (Fig. 10-24) serves as an excellent example of the artist's formal and literary concerns. The title of the work, and others of this series, refers to a poem by Paul Celan entitled "Your Golden Hair, Margarethe," which describes the destruction of European

¹⁰*Elizabeth Murray: Paintings and Drawings*, exhibition catalogue organized by Sue Graze and Kathy Halbreich, essay by Roberta Smith (New York: Abrams, in association with the Dallas Museum of Art and the MIT Committee on the Visual Arts, 1987), 64.

10-24 ANSELM KIEFER. Dein Goldenes Haar, Margarethe (1981). Mixed media on paper. 14" × 18³/4". Courtesy of the Marian Goodman Gallery, New York.

Jewry through the images of a golden-haired German woman named Margarethe and a dark-haired Jewish woman, Shulamith. Against a pale gray blue background, Kiefer uses actual straw to suggest the hair of the German woman, contrasting it with thick black paint that lies charred on the upper canvas, to symbolize the hair of her unfortunate counterpart. Between them a German tank presides over this human destruction, isolated against a wasteland of its own creation. Kiefer here, as often, scrawls his titles or other words across the canvas surface, sometimes veiling them with his textured materials. The materials function as content; they become symbols to which we must emotionally and intellectually respond.

Eric Fischl

A number of American painters responded to European Neo-Expressionism with narrative works that have American references. For example, New York painter Eric Fischl (b. 1948) focused on middle-class life in the suburbs, including Levittown, Long Island. Fischl's *A Visit To / A Visit From / The Island* (Fig. 10-25) shifts the locale from big-city

10-25 ERIC FISCHL.

A Visit To / A Visit From / The Island (1983). Oil on canvas. Two panels; each panel: $84'' \times 84''$. Copyright Eric Fischl. Collection of the Whitney Museum of American Art, New York. Purchase, with funds from the Louis and Bessie Adler Foundation, Inc., Seymour M. Klein, President.

10-26 JEAN-MICHEL BASQUIAT. *Melting Point of lce* (1984). Acrylic, oil paintstick, and silkscreen on canvas. 86" × 68". The Broad Art Foundation, Santa Monica, CA. Photo: Douglas Parker Studio. Estate of Jean-Michel Basquiat. Copyright 2007 Artists Rights Society (ARS), New York/ADAGP, Paris.

suburbs to an island vacation setting. While his transported suburbanites blithely bob along in the turquoise waters of the Caribbean, oblivious to anything other than pleasure seeking, their counterparts—native islanders—are drowning in the surf. Fischl is underscoring the bipolar social structure we find in these vacation "paradises"—the affluent tourists versus the poverty-stricken workers. Although Fischl's style can be characterized as a lush realism, in some ways very different from that of the Europeans, he too embraces a narrative format.

Jean-Michel Basquiat

Jean-Michel Basquiat (1960–1988) was a Haitian-Hispanic artist who dropped out of school at 17, rose quickly to fame and fortune in his early twenties, and died at 27 of a drug overdose. He is now considered to have been one of the most talented artists of his generation as well as a symbolic casualty of the cycle of work, success, and burnout that characterized the 1980s in the United States.

Basquiat's origins as an artist were not propitious. The themes, symbols, and strokes for which he is known first ap-

peared on downtown New York City walls as graffiti. With Andy Warhol as a mentor, he brought his own complex form of collage to canvas, combining photocopies, drawing, and painting in intricate and overworked layers. In virtually all of Basquiat's art there is a complex iconography at work. References to the black experience—from slavery and discrimination (Fig. 10-26) to hard-won successes of African Americans like jazz musician Charlie Parker or athlete Jesse Owens—pour across the canvases in images, symbols, and strands of text. As Fischl and other artists of his generation looked back to the Expressionism of Jackson Pollock, Basquiat sought to emphasize the process of painting while never losing focus of the essential role of narrative.

SCULPTURE

True experimentation in the medium of sculpture came with the advent of the twentieth century, and contemporary sculptors owe much to the trail-blazing predecessors who embraced unorthodox materials, techniques, and influences. Style, content, composition, materials, and, from midcentury onward, *scale* were completely up for grabs.

Sculpture at Mid-Twentieth Century

In the middle of the twentieth century, there were two major directions in sculpture: figurative and abstract. Sometimes they are divergent paths. Yet they seamlessly converge with the British artist Henry Moore, whose work encompasses both the figurative and the abstract and who, more than any other individual, epitomizes sculpture in the twentieth century.

Henry Moore

Henry Moore (1898–1986) had a long and prolific career that spanned the seven decades since the 1920s, but we introduce him at this point because, despite his productivity, his influence was not generally felt until after World War II. In the late 1920s, Moore was intrigued by the massiveness of stone. In an early effort to be true to his material, he executed blocky reclining figures reminiscent of the Native American art of Mexico. In the 1930s, Moore turned to bronze and wood and was also influenced by Picasso. His figures became abstracted and more fluid. Voids opened up, and air and space began to flow through his works.

At mid-twentieth century, Moore's works received the attention they deserve. He continued to produce figurative works, but he also executed a series of abstract bronzes in the tradition of his early reclining figures, such as the one at Lincoln Center for the Performing Arts in New York City The sensitive observer of sculpture must . . . learn to feel shape simply as shape, not as description or reminiscence. He must, for example, perceive an egg as a simple single solid shape, quite apart from its significance as food, or from the literary idea that it will become a bird.

—Henry Moore

HENRY MOORE. *Reclining Figure*, Lincoln Center (1963–1965). Bronze. H: 16'; W: 30'. Lincoln Center for the Performing Arts, New York. Photo by Spencer A. Rathus. All rights reserved.

(Fig. 10-27). No longer as concerned about limiting the scope of his expression because of material, he could now let his bronzes assume the massiveness of his earlier stonework. However, his continued exploration of abstract biomorphic shapes and his separation and opening of forms created a lyricism that was lacking in his earlier sculptures.

Contemporary Figurative Sculpture

Figurative art continues to intrigue sculptors as well as painters. Some figurative works are utterly realistic. Others are highly abstract, such as the reclining figures of Henry Moore.

George Segal

George Segal (1926 – 2000) was a student of Hans Hofmann and painted until 1958. During the 1960s he achieved renown as a Pop Art sculptor. In many instances, he cast his figures in plaster from live models and then typically surrounded them with familiar objects — Coke machines, Formica and chrome tables, porcelain sinks and copper pipes, mirrors, neon signs, telephone booths, television sets, park benches. His figures evoke a mood of isolation and detachment, surrounded as they are by ordinary symbols of their day and age.

Segal also made sensuous reliefs of women and still lifes, as in *Cézanne Still Life #5* (Fig. 10-28). The plaster of

10-28 GEORGE SEGAL.

Cézanne Still Life #5 (1982). Painted plaster, wood, and metal. $37'' \times 36'' \times 29''$. Virginia Museum of Fine Arts, Richmond. Gift of Sydney and Francis Lewis Foundation. Copyright George Segal. Licensed by VAGA, New York.

10-29 MARISOL.

Women and Dog (1964).

Fur, leather, plaster, synthetic polymer, and wood. $72'' \times 82'' \times 16''$.

Collection of the Whitney Museum of American Art, New York. Copyright Marisol Escobar/Licensed by VAGA, New York. Purchase, with funds from the Friends of the Whitney Museum of American Art.

the drapery is modeled extensively by the sculptor's fingers in these reliefs, giving large areas an almost gestural quality. In many of his later works, Segal used primary colors, eliminating the ghostlike quality of his earlier works.

Marisol

Venezuelan artist Marisol Escobar (b. 1930), known to the world as Marisol, creates figurative assemblages from plaster, wood, fabric, paint, found objects, photographs, and other sources. As in *Women and Dog* (Fig. 10-29), Marisol frequently repeats images of her own face and body in her work. She has also used these techniques to render satirical portraits of world leaders.

Duane Hanson

Duane Hanson (1925–1996) was reared on a dairy farm in Minnesota. His *Tourists* (Fig. 10-30) is characteristic of the work of a number of contemporary sculptors in that it uses synthetic substances such as liquid polyester resin to closely approximate the visual and tactile qualities of flesh. Such literal surfaces allow the artist no expression of personal signature. In the presence of a Hanson figure, or a John De Andrea nude, viewers watch for the rising and falling of the

 10–30 DUANE HANSON. *Tourists* (1970).
 Polyester resin/fiberglass. Life-size.
 Courtesy of Mrs. Duane Hanson. Copyright Estate of Duane Hanson. Licensed by VAGA, New York.

chest. They do not wish to stare too hard or to say something careless on the off chance that the sculpture is real. There is an electricity in gallery storerooms where these sculptures coexist in waiting. One tries to decipher which ones will get up and walk away.

Duane Hanson's liberal use of off-the-rack apparel and objects such as "stylish" sunglasses, photographic paraphernalia, and shopping bags gave these figures a caustic, satirical edge. But not all of Hanson's sculptures are lighthearted. Like Warhol, Hanson also portrayed disasters, such as death scenes from the conflict in Vietnam. In his later work, the artist focused more on the psychological content of his figures, as expressed by tense postures and grimaces.

Deborah Butterfield

Montana sculptor Deborah Butterfield (b. 1949) has been interested in horses since her childhood in California. Horses, of course, are powerful creatures, and there is a his-

10-31 DEBORAH BUTTERFIELD. Horse #6-82 (1982). Steel, sheet aluminum, wire, and tar. 76" × 108" × 41". Dallas Museum of Art Foundation for the Arts Collection, Edward S. Marcus Fund.

tory of equestrian sculptures that commemorate soldiers. Such horses are usually stallions that are vehicles of war, but Butterfield turns to mares. In this way, like Susan Rothenberg, she uses horses to create something of a symbolic selfportrait:

I first used horse images as a metaphorical substitute for myself—it was a way of doing a self-portrait one step removed from the specificity of Deborah Butterfield. . . . The only horse sculpture I'd ever seen was very masculine. . . . No knight or soldier would ever be caught riding a mare into battle, it was just not done. . . . [What] I wanted to do [was] to make this small reference to the [Vietnam] war [with a] big sculpture that was very powerful and strong, and yet, very feminine and capable of procreation rather than just destruction.¹¹

Horse #6-82 (Fig. 10-31) is constructed from scrap metal derived from a crushed aluminum trailer. Ribbons of shiny metal wrap surfaces splattered with tar, giving form to the animal. Although her horses are figural, Butterfield notes that their meaning "isn't about horses at all."¹²

Contemporary Abstract Sculpture

Abstract sculpture remains vital, ever varied in form and substance. Contemporary abstract sculptures range from the the machined surfaces of David Smith's cubes (see Fig. 10-32) to the mobiles of Alexander Calder (Fig. 10-33), the site-specific works of Robert Smithson (see Fig. 10-49), Judy Pfaff (10-34) and Christo and Jeanne-Claude (see Figs. 10-51 and 10-52), and the anti-art machines of Jean Tinguely (Fig. 10-36).

David Smith

American artist David Smith (1906–1965) moved away from figurative sculpture in the 1940s. His works of the 1950s were compositions of linear steel that crossed back and forth as they swept through space.

Many sculptors of massive works create the designs but then farm out their execution to assistants or to foundries. Smith, however, took pride in constructing his own metal sculptures. Even though Smith's shapes are geometrically pure (Fig. 10-32), his loving burnishing of their highly reflective surfaces grants them the overall gestural quality found in Abstract Expressionist paintings.

10-32 DAVID SMITH.

Cubi Series.

Stainless steel. (Left) *Cubi XVIII* (1964), H: 9'8", Museum of Fine Arts, Boston. (Center) *Cubi XVII* (1963), H: 9', Dallas Museum of Fine Arts. (Right) *Cubi XIX* (1964), H: 9'5", Tate Gallery, London. Copyright Estate of David Smith/Licensed by VAGA, New York.

¹¹Excerpts from Deborah Butterfield in *Deborah Butterfield* (Winston-Salem, NC: Southeastern Center for Contemporary Art, 1983; and Providence: Rhode Island School of Design Museum of Art, 1981).

¹²Deborah Butterfield, in Graham W. J. Beal, "Eight Horsepower," in *Viewpoints: Deborah Butterfield: Sculpture* (Minneapolis: Walker Art Center, 1982).

 10–33 ALEXANDER CALDER. Untitled (1972).
 East Building mobile.
 National Gallery of Art, Washington, DC. Gift of the Collectors Committee. Copyright 2007 Board of Trustees, National Gallery of Art, Washington, DC, 1976. Copyright 2007 Estate of Alexander Calder/Artists Rights Society (ARS), New York.

Alexander Calder

The **mobiles** of Alexander Calder (1898–1976) are some of the most popular examples of kinetic art in the twentieth century. The colossal mobile that hangs in the interior of the East Building of the National Gallery of Art (Fig. 10-33) is composed of wing-like dashes and disks of different sizes that are cantilevered from metal rods such that they can rotate horizontally—in orbits—as currents of air press against them. However, the center of gravity remains stable, so the entire sculpture is hung from a single point. Unlike a painting, the mobile changes according to the movement of air above and the movement of the observer below, who might shift vantage points to create new compositions, new relationships among the shapes and lines.

Judy Pfaff

Another contemporary sculpture form is the **installation**, in which materials from planks of wood to pieces of string and metal are assembled to fit within specific room-sized exhibition spaces. Installations are not necessarily intended to be permanent. In *Dragon* (Fig. 10-34), by Judy Pfaff (b. 1946), the viewer roams around within the elements of the piece, an experience that can be pleasurable and overwhelming among the vibrant colors and assorted textures. Many of the elements of Pfaff's installations hang down around the viewer, creating an atmosphere reminiscent of foliage, sometimes of an underwater landscape.

Nancy Graves

Nancy Graves (b. 1940) has worked both in figural and abstract styles and is comfortable with ignoring the traditional boundary between them. In addition to sculpture, she has also created drawings, prints, paintings, and films. When she was only 29 years old, the Whitney Museum exhibited her life-size, naturalistic camels.

Tarot (Fig. 10-35) is made of traditional bronze but is directly cast such that the original object is destroyed as it is reborn into the metal. In a sense, Graves redoes nature. Much of the innovation of the piece is derived from the juxtapositions and coloration. Graves has focused much of her attention on the development of polychrome (multicolored) patinas with poured acrylic and baked enamel. *Tarot* (the word refers to a set of allegorical cards used in fortunetelling) is an assemblage of sundry human-made and natural

10–34 JUDY PFAFF.
 Dragon (January–April 1981).
 Installation view, Whitney Biennial, The Whitney Museum of American Art, New York.
 Courtesy of the Holly Solomon Gallery.

The only stable thing is movement.

-Jean Tinguely

10-35 NANCY GRAVES. *Tarot* (1984).
Bronze with polychrome patina and enamel. 88" × 49" × 20".
Private collection. Courtesy of M. Knoedler and Company, Inc., New York. Copyright Nancy Graves Foundation/Licensed by VAGA, New York.

elements—strange flowers, lacy plants, noodles, dried fish, lampshades, tools and machinery, even packing materials. With this concoction—or perhaps this history—humankind is cast an eccentric fortune indeed.

Jean Tinguely

Swiss-born kinetic sculptor Jean Tinguely (1925–1991) was an able satirist of the machine age who shares the Dadaist view of art as anti-art. He is best known for his *Homage to New York* (Fig. 10-36), a motorized, mixed-media construction that self-destructed (intentionally) in the garden of the Museum of Modern Art. But an unexpected fire within the machine necessitated the intervention of the New York Fire Department, which provided a spontaneous touch without charge. Tinguely's machines, more than those on which his work comments, frequently fail to perform precisely as intended.

As a further reflection of his philosophy of art, in the 1950s Tinguely introduced kinetic sculptures that served as "painting machines." One of them produced thousands of "Abstract Expressionist" paintings—on whose quality, perhaps, we need not comment.

Jackie Winsor

Canadian-born Jackie Winsor (b. 1941), like many of her contemporaries, is taken with the primal aesthetics of simple geometric forms. Yet unlike the machined smoothness employed by David Smith, her works are more likely to have a weathered organic, handmade look. Winsor's works are a while in the making, and though she has the resources to

10-36 JEAN TINGUELY.
Fragment from *Homage to New York* (1960).
Painted metal. 6'8¹/4" × 29⁵/8" × 7'3⁷/8".
The Museum of Modern Art, New York. Gift of the artist. Digital image © The Museum of Modern Art, New York/Licensed by Scala/Art Resource, New York. Copyright 2007 Artists Rights Society (ARS), New York/ADAGP, Paris.

C O M P A R E + C O N T R A S T

Delacroix's Liberty Leading the People, Kollwitz's Outbreak, Catlett's Harriet, and Goya's And They Are Like Wild Beasts

The evolution of feminist art finds its parallel in the evolution of feminist art history. The dust jacket of a text entitled *Women, Art, and Power and Other Essays* by the nineteenthcentury-art scholar Linda Nochlin, bears a detail of Eugene Delacroix's *Liberty Leading the People* (Fig. 10-37). At its center is the allegory of Liberty—a fast-striding woman bearing the tricolor in one hand and a bayonet in the other—looking, for all the world, like an Amazon of ancient Greece. An archetypal figure set within an archetypal setting of an archetypal revolution. So, where's the rub?

Nochlin, who also explored the uncharted territory of feminist issues in art history and criticism, notes in her text: "Delacroix's powerful figure of Liberty is, like almost all feminine embodiments of human virtue-Justice, Truth, Temperance, Victory—an allegory rather than a concrete historical woman, an example of what Simone de Beauvoir (French existential philosopher and author of The Second Sex) has called Woman-as-Other." By contrast, the forceful figure who inspires courage and motivates action in Kollwitz's The Outbreak (Fig. 10-38) is a historically documented leader of the sixteenth-century German Peasants' War. She was known as Black Anna. Delacroix's Liberty does not portray the role of women in the French Revolution but rather embodies the intangible spirit that fueled the burning desire for freedom. Kollwitz's Anna is at the front. It is through her exampleher indomitable spirit at the cost of her own life-that we experience, firsthand, the quest for justice.

A striking visual parallel can be seen in Elizabeth Catlett's *Harriet* (Fig. 10-39), a linoleum block print that records the actions of Harriet Tubman, one of the "conductors" of the Underground Railroad, who led more than 300 slaves to

10–38 KÄTHE KOLLWITZ. The Outbreak (1903).

Plate #5 from *The Peasants' War*. Etching and aquatint. Library of Congress, Washington, DC. Courtesy of The Library of Congress, Washington, DC. Copyright 2007 Artists Rights Society (ARS), New York/VG Bild-Kunst, Bonn.

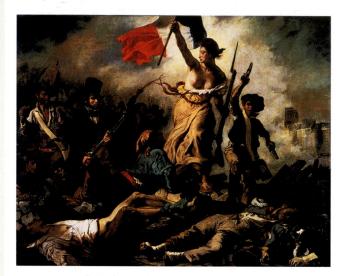

10-37 EUGÈNE DELACROIX.
Liberty Leading the People (1830).
Oil on canvas. 8'6" × 10'10".
Louvre Museum, Paris/Erich Lessing/Art Resource, New York.

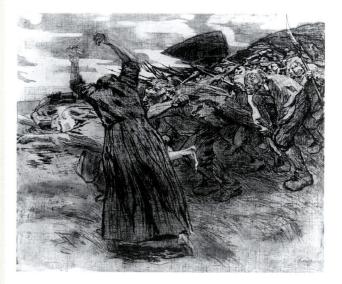

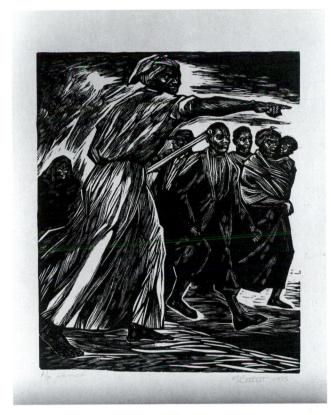

10-39 ELIZABETH CATLETT. Harriet (1975). Linoleum block print. $12^{1/2}'' \times 10^{1/8}''$. Courtesy Sragow Gallery. Copyright Elizabeth Catlett. Licensed by VAGA, New York. freedom. Like Kollwitz's Anna, Harriet is a historic figure who loomed larger than life and is so depicted through her relative size.

The Spanish artist Francisco Goya also turned his attention to the subject of women and aggression (Fig. 10-40) in one of a suite of prints entitled *Disasters of War*. At first glance we observe a group of women, one with an infant astride her hip, defending themselves with rocks and sticks against the swords and guns of male soldiers. Theirs is a valiant effort, inspired by raw courage and maternal instinct. And yet, if we make note of the title of the work, we come to understand that Goya equates this desperate attempt to protect themselves and their children with the animal instincts of "wild beasts."

In all four works, we witness the images of women astride or in the midst of chaos and destruction. How does each artist use vantage point in the composition (frontal, profile, rear) to involve the observer in the action of the scene? What is our relationship to the female figures, and indeed to the action as a whole, in each of these works? Are we observers? participants? Stylistically, how does each artist use the medium to enhance the subject of the work? How do the use of perspective and compositional arrangement intensify the narrative? Can you speculate as to the gender ideologies reflected in or reaffirmed by the artists of each of these compositions?

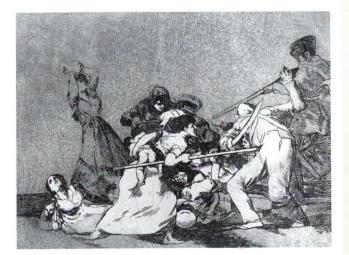

10-40 FRANCISCO GOYA Y LUCIENTES. And They Are Like Wild Beasts (Y son Fieras). From Disasters of War (1808–1820). Etching and aquatint. 15.5 cm × 20.1 cm.
1951 Purchase Fund. Courtesy Museum of Fine Arts, Boston. Copyright 1997 Museum of Fine Arts, Boston. All rights reserved.

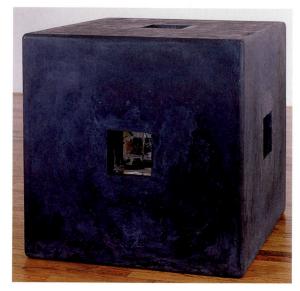

10-41 JACKIE WINSOR. Exploded Piece (before and after) (1980–1982). Wood, reinforced concrete, plaster, gold leaf, and explosive residue. 34¹/₂" × 34¹/₂" × 34¹/₂". Private collection. Photos courtesy of Paula Cooper Gallery, New York.

have others construct them from her design, hers is an art of the hand as well as of the heart and the mind.

Exploded Piece (Fig. 10-41) is one of the sculptures that Winsor also sees as a performance piece. Winsor is not destructive in the mold of Tinguely. (In fact, the culmination of the "performance" was her reconstruction of the exploded parts into a perfect whole.) Rather, she seems preoccupied with the nature and the potentials of her materials. Another work, *Burnt Piece*, seemed to pose and answer the question, "What will happen to a half-concrete, half-wood cube when it is set afire?" *Exploded Piece*, similarly, explores the results of detonating an explosive charge within a cube made of wood, reinforced concrete, and other materials.

It seems appropriate to leave the section on abstract sculpture with a bang.

FEMINIST ART

If it were customary to send little girls to school and to teach them the same subjects as are taught to boys, they would learn just as fully and would understand the subtleties of all arts and sciences.

- Christine de Pisan, Cité des Dames, 1405

While on the East Coast Pop Art was on the wane and Photorealism on the rise, happenings on the West Coast were about to change the course of women's art, history, and criticism forever.

Judy Chicago

In 1970, a midwestern artist named Judy Gerowitz (b. 1939)—who would soon call herself Judy Chicago—initiated a feminist studio art course at Fresno State College in California. One year later, she collaborated with artist Miriam Schapiro (b. 1923) on a feminist art program at the California Institute of Arts in Valencia. Their interests and efforts culminated in another California project—a communal installation in Hollywood called *Womanhouse*.

Womanhouse

Teaming up with students from the University of California, Chicago and Schapiro refurbished each room of a dilapidated mansion in a theme built around women's experiences: The "Kitchen," by Robin Weltsch, was covered with breast-shaped eggs; a "Menstruation Bathroom," by Chicago, included the waste products of female menstruation cycles. Another room housed a child-sized dollhouse, in which Schapiro and Sherry Brody juxtaposed mundane and

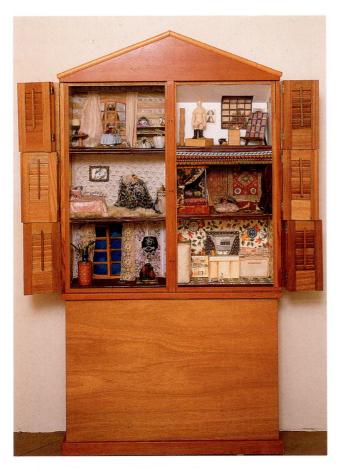

10-42 MIRIAM SCHAPIRO, in collaboration with SHERRY BRODY. *The Doll House* (1972). Mixed media. 84" × 40" × 41". Collection of the artist. National American Art Museum, Smithsonian Institution, Washington, DC/Art Resource/New York.

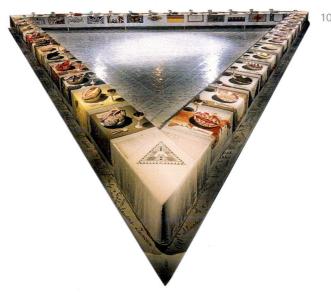

frightening objects to effect a kind of black humor (Fig. 10-42). The now-famous installation became a much-needed hub for area women's groups and was itself the impetus for the founding a year later of the Los Angeles Women's Building, still active today.

Womanhouse called attention to women artists, their wants, their needs. It some ways it was an expression of anger toward injustice of art-world politics that many women artists experienced—lack of attention by critics, curators, and historians; pressure to work in canonical styles. It announced to the world, through shock and exaggeration, that men's subjects are not necessarily of interest to women; that women's experiences, although not heroic, are significant. And perhaps of most importance, particularly in light of the subsequent careers of its participants, the exhibition exalted women's ways of working.

Following her collaboration on Womanhouse, Chicago created her renowned installation *The Dinner Party* (Fig. 10-43), which dissolves the lines between life and death, between place and time. A fantastic dinner party honors and immortalizes history's notable women, who meet before place settings designed to reflect their personalities and accomplishments. Chicago and numerous other women artists have devoted a good portion of their careers to educating the public on the significant role of women in the arts and society.

10-43 JUDY CHICAGO

The Dinner Party (1974–1979). Painted porcelain and needlework. $48' \times 48' \times 48' \times 3'$. Copyright 2007 Judy Chicago, ACA Galleries, New York. Copyright 2007 Artists Rights Society (ARS), New York.

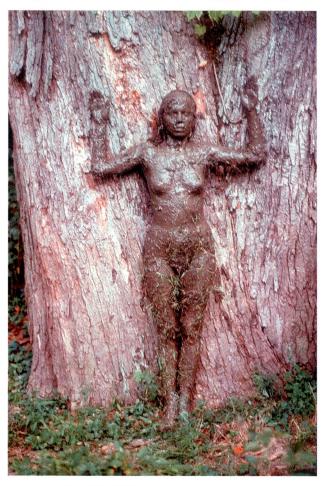

10-44 ANA MENDIETA. *Arbol de la Vida*, no. 294, from the *Arbol de la Vida / Silueta* (Tree of Life / Silhouette) series (1977). Color photograph. $20'' \times 13^{1/4''}$. Documentation of earth–body sculpture with artist, tree

trunk, and mud, at Old Man's Creek, Iowa City, IA. Copyright the Estate of Ana Mendieta and Galerie LeLong. Collection Ignacio C. Mendieta. Courtesy of The Estate of Ana Mendieta and Galerie LeLong, New York.

Ana Mendieta

Much of the impact of *Arbol de la Vida* (Tree of Life), no. 294 (Fig. 10-44), is related to the shock value of its extraordinary contrasts of texture. In this performance piece, feminist artist Ana Mendieta (1948–1985) presented her own body, draped in mud (an "earth–body sculpture"), against the craggy bark of a tree. Like some women artists, she shunned painting, especially abstract painting, as historically inundated with male values. Mendieta tied her flesh and blood, instead, across time and cultures, to the ancient myths of the earth mother goddesses.

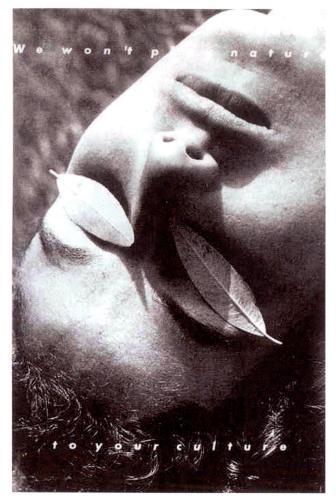

10–45 BARBARA KRUGER We Won't Play Nature to Your Culture (1983). Collection of the artist. Copyright 2007 Artists Rights Society (ARS), New York.

Barbara Kruger

Many women artists have tried to call attention to stereotypes that influence the way women are perceived. Laurie Simmons's "Stepford Wife" in her *Red Library* shows a woman locked into the compulsive care of her home, to the exclusion of more worthwhile and rewarding activity. Barbara Kruger's (b. 1945), in *Untitled (We Don't Need Another Hero)* (see Fig. 1-13), confronts her male and female viewers with stereotypical epithets for the "dominant sex," seeming to criticize females for feeding male expectations as much as males for having them. Kruger's juxtaposition of images and text, tabloid-like in their visual attraction, cause the viewer to reconsider the ideological hold that words and pictures and familiar phrases have on us. *We Won't Play Nature to Your Culture* (Fig. 10-45) forces us to define those words and to come to terms with the way that women have been relegated to "nature" (motherhood, domesticity, the literal or figurative sequestering in the home) while men have had the privilege of participating in "culture" (the world of ideas, of thinking, talking, sharing, and acting). As in many of Kruger's works, her medium is the message—a call to action.

Joan Snyder

Like Chicago's *The Dinner Party*, Joan Snyder's *Small Symphony for Women #1* (Fig. 10-46) draws attention to women's accomplishments. From the early 1970s onward, Snyder focused on women's issues in her work, unifying her narrative content with lush brushwork and an often dramatic palette. *Small Symphony* is broken into three sections, or variations on a theme. The first square presents, according to Snyder, "political ideas, dreams, colors, materials, angers, rage" that are written, scratched out, or emphatically boxed. The center square offers a kind of directory of Snyder's signature images, words and brushstrokes; the third is a resolution or consolidation of the other two sections. The painting, three times as long as it is high, reads from left to

right like a codified narrative. It is at once unique and universal, telling something of woman's plight as well as Snyder's private view of the world.

SITE-SPECIFIC WORK

Site-specific works are distinguished from other artworks that are typically created in a studio with no particular spatial context in mind. Site-specific art is produced in one location and—in theory, at least—cannot be relocated. The work is in and of its site, and often the content and meaning of the work is inextricably bound to it.

Site-specific art consists of many types, goals, and styles. The earliest examples, dating to the 1960s and '70s, were earthworks or earth art. Much of it was environmentally conscious and fiercely anti-commercial; some of it exists well after its creation while other pieces survive only in documentary photographs.

Ephemeral art is short-lived or fleeting and not intended to be permanent. Ephemeral art may be constructed for the duration of an exhibition, or, as in the works of Christo and Jeanne-Claude, for a specific period of time.

Earthworks included great trenches and drawings in the desert, collections of rocks, shoveled rings in ice and snow, and even installations of mounds of dirt on floors of

10-46 JOAN SNYDER.

Small Symphony for Women #1 (1974). Oil and acrylic on canvas. Three parts: each $24'' \times 24''$; $24'' \times 72''$ overall. Collection Suellen Snyder. Courtesy of the artist.

Guerrilla Girl Warfare

THE ADVANTAGES OF BEING A WOMAN ARTIST:

Working without the pressure of succes Not having to be in chows with men.

Noting an escape from the art world in your 4 free-lance jobs. Knowing your career might pick up after you're eighty. Being reassured that whatever kind of art you make it will be labeled feminine. Not being steck in a tenured teaching position. Sooing your ideas live on in the work of others. Having the opportunity to choose between career and metherhood. Not having the choice on these big cigars or paint in Italian suits. Having more time to work after your mate dumps you for someone younger. Being included in revised versions of art history. Not having to endergo the embarrassment of being celled a genius. Gotting your picture in the art magazines wearing a gorilla suit.

lease send \$ and comments to: GUERRILLA GIRLS CONSCIENCE OF THE ART WORLD

WHEN RACISM & SEXISM ARE NO LONGER FASHIONABLE, WHAT WILL YOUR ART COLLECTION BE WORTH?

The art market won't bestow mega-buck prices on the work of a few white males forever. For the 17.7 million you just spent on a single Jasper Johns painting, you could have bought at least one work by all of these women and artists of color:

Bernice Abbott	Elaine de Kooning	Dorothea Lange	Sarah Peale
	Lavinia Fontana	Marie Laurencin	Liubova Popova
Anni Albers			Olga Rosanova
Sofonisba Anguisolla	Meta Warwick Fuller	Edmonia Lewis	
Diane Arbus	Artemisia Gentileschi	Judith Leyster	Nellie Mae Rowe
Vanessa Bell	Marguérite Gérard	Barbara Longhi	Rachel Ruysch
Isabel Bishop	Natalia Goncharova	Dora Maar	Kay Sage
Rosa Bonheur	Kate Greenaway	Lee Miller	Augusta Savage
Elizabeth Bougereou	Barbara Hepworth	Lisette Model	Vavara Stepanova
Margaret Bourke-White	Eva Hesse	Paula Modersohn-Becker	Florine Stettheimer
Romaine Brooks	Hannah Hoch	Ting Modotti	Sophie Taeuber-Arp
Julia Margaret Comeron	Anna Huntingdon	Berthe Morisot	Alma Thomas
Emily Corr	May Howard Jackson	Grandma Moses	Marietta Robusti Tintore
Rosalba Carriera	Frida Kahlo	Gabriele Münter	Suzanne Valadon
Mary Cassatt	Angelica Kauffmann	Alice Neel	Remedios Varo
Constance Marie Charpentier	Hilma of Klimt	Louise Nevelson	Elizabeth Vigée Le Brun
		Georgia O'Keeffe	Loura Wheeling Waring
Imogen Cunningham	Kathe Kollwitz		Lourd wheeling woring
Sonia Delaunay	Lee Krasner	Meret Oppenheim	
Information constant of C	bustia's Sotheby's Mover's Internation	al Austina Records and Leanard's Annual Pr	co Index of Auctions

Please send & and comments to: GUERRILLA GIRLS CONSCIENCE OF THE ART WORLD

10-47 Guerrilla Girls (c. 1987). Poster. Guerrilla Girls, 13-40-88-438.

> 10-48 Arnold Glimcher and His Art World All-Stars. Used on the cover of *New York Times Magazine* (October 3, 1993). © NYTPictures

During the 1980s something of a backlash against inclusion of women and ethnic minorities in the arts could be observed.* For example, a 1981 London exhibition, *The New Spirit in Painting*, included no women artists. A 1982 Berlin exhibition, *Zeitgeist*, represented 40 artists, but only 1 was a woman. The 1984 inaugural exhibition of the Museum of Modern Art's remodeled galleries, *An International Survey of Recent Painting and Sculpture*, showed the works of 165 artists, only 14 of whom were women. The New York exhibition *The Expressionist Image: American Art from Pollock to Now* included the works of 24 artists, only 2 of whom were women. And so it goes.

To combat this disturbing trend, an anonymous group of women artists banded together as the Guerrilla Girls. The group appeared in public with gorilla masks and proclaimed themselves to be the "conscience of the art world." They mounted posters on buildings in Manhattan's SoHo district, one of the most active centers in the art world today. They took out ads of protest.

Figure 10-47 shows one of the Guerrilla Girls' posters. This particular poster sardonically notes the "advantages" of being a woman artist in an art world that, despite the "liberating" trends of the postfeminist era, continues to be dominated by men. It also calls attention to the blatant injustice of the relative price tags on works by women and men. Note that at this writing, the inequity persists. A 1993 cover story for the *New York Times Magazine* pictures the "art world all-stars" of dealer Arnold Glimcher (Fig. 10-48). Women artists and artists of color are conspicuous by their absence.

*Whitney Chadwick, Women, Art, and Society (London and New York: Thames and Hudson, 1990).

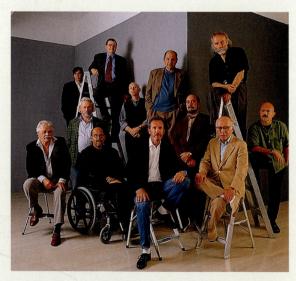

10-49 ROBERT SMITHSON. Spiral Jetty, Great Salt Lake, Utah (1970).
Black rocks, salt, earth, water, and algae.
L: 1500'; W: 15'.
Copyright Estate of Robert Smithson. Licensed by VAGA, New York.

10-50 MARCO EVARISTTI. *The Ice Cube Project* (2004). Red dye and seawater, Greenland coast. EPA/HO/Landov.

the urban galleries. Robert Smithson's *Spiral Jetty* (Fig. 10-49) is composed of rocks and earth bulldozed into a spiral formation in Utah's Great Salt Lake. Over time, salt deposits and algae have accumulated on the jetty, which is still visible decades after its creation.

Art that "makes marks" in nature is often temporary, however. In March of 2004, Danish artist Marco Evaristti set sail in two icebreaker-boats to find the perfect "frozen canvas" among the icebergs off the coast of Greenland. For two hours, a crew of twenty sprayed 780 gallons of red dye onto an almost 10,000 square foot-iceberg (Fig. 10-50). The dye, diluted with sea water, was the same that is used for tinting meat. Evaristti's work can be found—for the time being, at least—near Ilullissat (which means icebergs in the Greenlandic language), a town of 4,000 that is popular among tourists for its spectacular and *artistic* scenery.

Christo and Jeanne-Claude: The Gates, Project for Central Park, New York, 1979–2005

As if intentionally timed to shake New York City out of its winter doldrums, 7,500 sensuous saffron panels were gradually released from the tops of 16-foot-tall gates along 23 miles of foot-paths throughout Central Park. It was the morning of February 12, 2005—a date that marked the end of artists Christo and Jeanne-Claude's 26-year-long odyssey to bring a major project to their adopted city. For a brief 16 days, the billowy nylon fabric fluttered and snapped and obscured and enframed our favorite park perspectives. Olmsted's and Vaux's majestic plan of ups and downs, of lazy loops and serpentine curves, was being seen or re-seen for the first time as we—the participants—wove our walks according to the patterns of the gates. The artists have said that "the temporary quality of their projects is an aesthetic decision," that it "endows the works of art with a feeling of urgency to be seen." For a brief 16 days, it was clear from the crowds in a winter park, from the constant cluster of buses at the 72nd Street entrance, and from the rubbernecking traffic on the streets and avenues bordering the park, that the urgency of which Christo and Jeanne-Claude speak was very real.

As with all of artists Christo and Jeanne-Claude's works of environmental art, every aspect of *The Gates* project was financed and fought for by the artists themselves. They developed the concept for *The Gates* back in 1979, but their first proposal to the city in 1981 was rejected. Mayor Michael R. Bloomberg granted permission for the 2005 version of the project on January 22, 2003. The "vital statistics" of *The Gates, Project for Central Park, New York* are staggering. Placed at 12- to 15-foot intervals, 7,500 vinyl gates, 16 feet high, varying in width from 5 feet 6 inches to 18 feet, covered 23 miles of footpaths. The free-hanging, saffron-colored

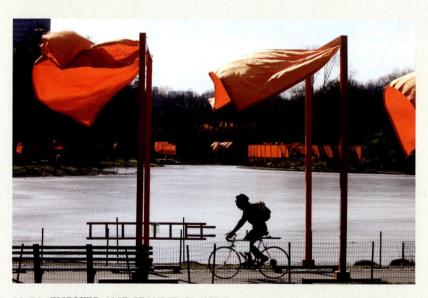

10-51 CHRISTO AND JEANNE-CLAUDE. The Gates, Central Park, New York City (1979–2005). Andrew Gombert/EPA/Landov.

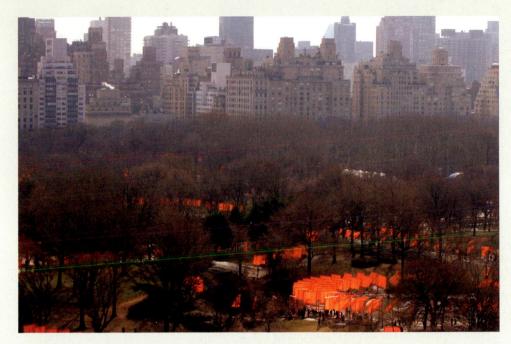

10–52 Aerial view of *The Gates* in Central Park with Manhattan skyline. Photograph by Andrea Mohin/The New York Times.

fabric panels dropped from the top of each rectangular vinyl gate to 7 feet above the ground—just low enough for small children on their fathers' shoulders to sneak a touch. The project required more than 1 million square feet of vinyl and 5,300 tons of steel. Hundreds of paid volunteers assembled, installed, maintained, and removed the work and most of the materials were to be recycled. The estimated cost of the project—borne by the artists alone—was 20 million dollars.

The artists finance their environmental sculptures, which have included Wrapped Reichstag, Berlin, 1971–95; Surrounded Islands, Biscayne Bay, Greater Miami, Florida, 1980–83; and Running Fence, Sonoma and Marin Counties, California, 1972–76; and others, by selling preparatory drawings and early works by Christo. Much of the funds thus accumulated have been used to cover the cost of the materials used in the project, to pay workers, and, when necessary, for legal fees to combat suits brought by concerned environmentalists (as was the case with the Running Fence project).

The environmental art projects of artists Christo and Jeanne-Claude have been seen by millions who have been enticed to experience their familiar surroundings with a heightened sensibility. Like the artists, I too live in New York City. I walked *The Gates* many times over 16 days, with each group of family members and friends who made the pilgrimage. As I read the artists' response to the question: Why was it so important to realize this work in Central Park? ("When our son was a little boy, we used to take him to Central Park every day—he loved to climb the beautiful rocks. Central Park was a part of our life."), I thought of my own daughter, whose school holds gym class on the park's Great Lawn. The Central Park that she will remember as a part of her life growing up in New York will forever include the 16 days when, in clear and in cold and a glorious snowfall, a "golden river" snaked through a barren winter scene, lighting the landscape with flashes of color.

VIDEO ART

Commercial television is most often used to transmit news, sporting events, staged events, and films to viewers. But fine artists have appropriated video as their medium in the creation of works of art—video art.

Nam June Paik's *Global Groove* (Fig. 10-53) flashes fragmented segments of Japanese Pepsi commercials, Korean drummers, a videotaped theater group, poet Allen Ginsberg reading from his work, women tap dancers, and a musical piece in which a cellist draws her bow across a man's back. The stream of consciousness is somewhat surrealistic, but the imagery provides a reasonably recognizable pastiche of television worldwide.

In *Three Mountains* (Fig. 10-54), Japanese artist Shigeko Kubota incorporates video into a pyramidal sculptural piece, a combination intended to re-create the experience of the open western landscape. Video monitors are installed in a plywood base—the cut-outs lined with mirrors. The mixed-media work confronts the viewer with multiple images of the Grand Canyon, as seen from a helicopter; a drive along Echo Cliff, Arizona; a Taos, New Mexico sunset; and a Teton sunset. Kubota commented:

My mountains exist in fractured and extended time and space. My vanishing point is reversed, located behind your brain. Then, distorted by mirrors and angles, it vanishes in many points at once. Lines of perspective stretch on and on, crossing at steep angles, sharp, like cold thin mountain air.¹³

¹³Shigeko Kubota, *Video Sculptures* (Berlin: Daadgalerie; Essen: Museum Folkwang: Zurich: Kunsthaus, 1982), 37.

 10-53 NAM JUNE PAIK. Global Groove (1973). Video still. Courtesy Electronic Arts Intermix (EAI), New York.

Dara Birnbaum's provocative videotapes and multimedia installations contribute to the contemporary discourse on art, television, and feminism. Her works appropriate and subvert the power of mass media images to comment on the myths and stereotypes of our culture. Her installation *PM Magazine* (Fig. 10-55) appropriated and modified footage from the former network magazine-format show to reveal how news and entertainment formats can exploit women. (How many older, unglamourous female TV news anchors

10-54 SHIGEKO KUBOTA.

Three Mountains (1976-1979).

Four-channel video installation with 3 mountains, constructed of plywood and plastic mirrors, containing 7 monitors; Mountain I: $38'' \times 17''$ at top and $59'' \times 59''$ at base; Mountains II and III: $67'' \times 21''$ at top and $100'' \times 60''$ at base; 4 color videotapes, each 30 minutes. Collection of the artist. Courtesy Electronic Arts Intermix, New York.

296 CONTEMPORARY ART

and reporters do we see? How many "important" stories involve bizarre incidents of sex and violence?)

Bill Viola's The Crossing (Fig. 10-56) is a video/sound installation that engulfs the senses and attempts to transport the viewer into a spiritual realm. In this piece the artist simultaneously projects two video channels on separate 16foot-high screens or on the back and front of the same screen. In each video a man enveloped in darkness appears and approaches until he fills the screen. On one channel, a fire breaks out at his feet and grows until the man is apparently consumed in flames (the content is not what we would call graphic or disturbing, however). On the other channel, the one shown here, drops of water fall onto the man's head, develop into rivulets, and then inundate him. The sound tracks accompany the screenings with audio images of torrential rain and of a raging inferno. The dual videos wash over the viewer with their contrasts of cool and hot colors and their encompassing sound. Critics speak about the spiri-

10-55 DARA BIRNBAUM.

PM Magazine (1982). Installation at San Francisco Museum of Modern Art, May 9–September 16, 1997; five-channel color video and sound installation. Installation panel 6' \times 8'. San Francisco Museum of Modern Art. Purchased through a gift of Rena Bransten and the Accessions Committee Fund. Gift of Collectors Forum, Doris and Donald G. Fisher, Evelyn and Walter Haas Jr., Byron R. Meyer, and Norah and Norman Stone.

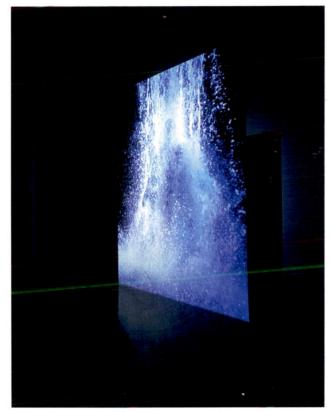

10–56 BILL VIOLA. The Crossing (1996).

Two-channel color video and stereo-sound installation, continuous loop. $192'' \times 330'' \times 684''$ (487.7 cm × 838.2 cm × 1,737.4 cm).

Solomon R. Guggenheim Museum, New York. Gift, The Bohen Foundation (2000.2000.61). Photograph by Sally Ritts. © The Solomon R. Guggenheim Foundation, New York.

tual nature of Viola's work, but it is also about the here-andnow reality of the sensory experiences created by his artform.

In *Getaway #2* (Fig. 10-57) Tony Oursler projects a videotape with a sound track onto the cloth face of a lifesize doll "hiding" adolescent-like beneath a mattress. A critic described his experiences as he and a companion observed another couple viewing the work in Williamstown, Massachusetts:

We followed a couple into the gallery, and I saw one of them later taking great pains to get down on the ground to better see a piece consisting of a life-size doll whose head is underneath a mattress. The doll's projected face is yelling, "Hey, you! Get outta here!," plus various obscenities and epithets; and the aforementioned viewer, upon a heroic struggle to get up again after that better look, exclaimed, "Whew! I almost became part of that piece!"¹⁴

¹⁴Devon Damonte, "Vital Video in Williamstown: Personal reflections on some new musuum exhibits in Western Mass," September 1999.

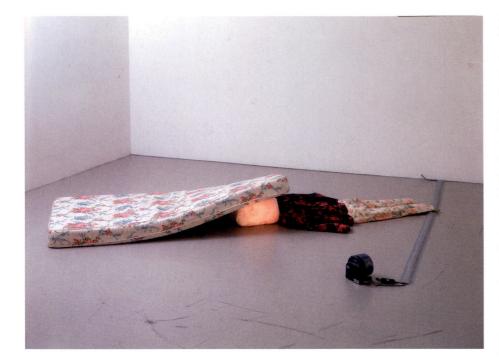

10-57TONY OURSLER.
Getaway #2 (1994).
Mattress, cloth, LCD projector, VCR, videotape.
 $16'' \times 117^{1/2''} \times 86''$ overall.
Whitney Museum of American Art, New York.
Purchased with funds from the Contemporary Painting and Sculpture
Committee.

The message of many of Oursler's video works seems to be that people are unusually receptive to video images. They absorb them and then spout them. Television creates some of the most salient of the images we share in our culture both video and audio—and as with any effort to define or describe the individual, we must wonder where the person's "individuality" leaves off and cultural influences begin. Perhaps they become so enmeshed that it is impossible to define the borders. Oursler seems to be saying that the border is porous.

DIGITAL ART

Most readers have undoubtedly toyed with computer programs like Microsoft's *Paint* or *Paintbrush*. Software like this, typically part of the computer manufacturer's standard package, enables the user—artistic or otherwise—to create illustrations by manipulating stock shapes, drawing "free hand," "spray painting" color fields, or enhancing the images with a variety of textural patterns—all of which are selected by directing the mouse to a menu of techniques and design elements. The resultant shapes or drawings can be flipped and rotated or stretched in any direction. Even wordprocessing programs like Word and WordPerfect can be used to distort and otherwise play with images. The userartist needn't have the talent to draw a straight line, simply the ability to point and click. For most of us, the results are literally "child's play," but career artists who have sealed their reputations in other media have also been tempted by the computer as an artistic tool. Keith Haring, the infamous subway graffitistturned-mainstream-artist, created Untitled (Fig. 10-58) on the Images paint system of the New York Institute of Technology. Haring's paintings are characterized by animated, mostly featureless figures bounded by thick, signature outlines, and his computergenerated image bears a close resemblance to his other work. Drawing on a computer screen must have seemed a

natural segue for Haring. An experimenter by nature, and an artist who challenged and pushed the limits, his exploration of the possibilities of the computer as tool is not surprising. Yet when Haring created *Untitled* in 1983, he probably could only have imagined the directions that computer art would take in the coming decades.

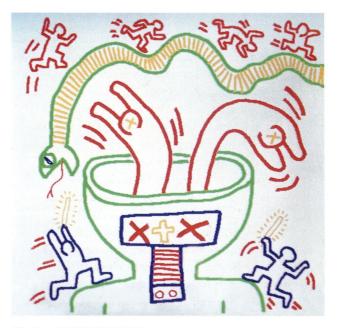

10-58 KEITH HARING.

Untitled (1983).

35 mm slide of work created on the New York Institute of Technology's Images paint system. Courtesy of the New York Institute of Technology. © Estate of Keith

Haring.

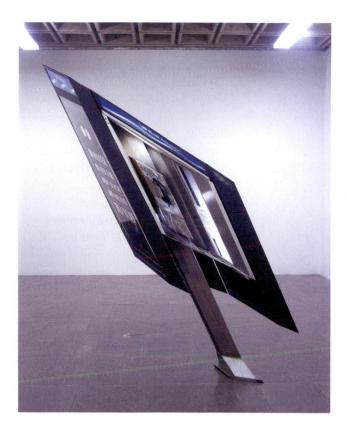

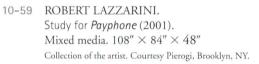

Only within the last century have the horizons of artists been expanded by technological advances encompassing anything and everything from the development of quickdrying acrylic paints to the advent of film and video. The computer has greatly expanded what can be achieved in these media and others. Today computer graphics software programs offer palettes of more than thirty-two million colors, which can be selected and produced on the monitor almost instantaneously. Compositions can be recolored in seconds. Effects of light and shade and simulated textured surfaces can be produced with the point and click of a mouse. Software programs enable artists to create threedimensional representations with such astounding realism that they cannot be distinguished from photos or films of real objects in space. They can be viewed from any vantage point and in any perspective. Images can be saved or stored in any stage of their development, brought back into the computer's memory at will, and modified as desired, without touching the original image. It is difficult to believe that these images are stored in computers as series of zeroes and ones, and not as pictures, but they are.

10-60 YAEL KARANEK. Digital landscape in the sunset/sunrise desert terrain of *World of Awe* (2000). Courtesy of the artist.

Figure 10-58 is an example of **digital art.** Broadly speaking, digital art is the production of images by artists with the assistance of the computer. Just as artists have adapted the technical possibilities of photography, film, and video, so too have they appropriated the computer.

Digital artists can distort the commonplace according to meticulous mathematical formulas. Robert Lazzarini uses the computer to alter everyday objects, like the payphones we find along the streets of cities (Fig. 10-59), and then he builds sculptures based on the modified images. The sculptures are fabricated from the materials used in the actual objects. The viewer might try to get a visual handle on such works by viewing them from the "proper" angle, but no vantage point will "straighten out" these objects. The viewer is compelled to take a new look at the familiar, a goal of art for millennia.

Yael Karanek's digital landscape in *World of Awe* (Fig. 10-60) is a screenshot of an interactive digital "journal" that was purportedly found on a laptop computer in Silicon Canyon. The "traveler" who enters this virtual world will find love letters, travel logs, and a variety of navigation tools that can be used to find a "treasure." The work builds on the notion of "interfaces" (to use a nice digital term) between travel, storytelling, creation, and technology.

Visual artists as well as commercial filmmakers use digital techniques to modify and embellish ordinary imagery. In the storyboard from *Winchester* (Fig. 10-61), Jeremy Blake combines film, drawings, and computer-generated imagery to narrate what he imagines to be the psychological state of Sarah Winchester, the widow of the founder of the Winchester rifle company, who believed that she was being

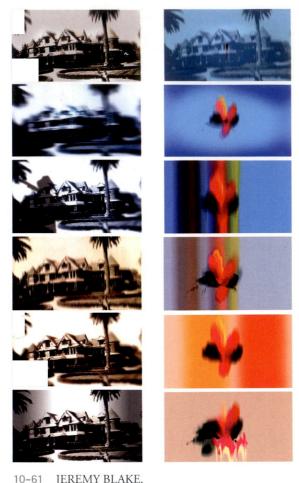

Winchester (2002). Sequence from DVD with sound for plasma or projection, 18-minute continuous loop. Courtesy Feigen Contemporary, New York. pursued by the ghosts of people who had been killed with her husband's rifles. Over a span of 38 years, she added numerous rooms to her San Jose home, shown here in a spongy space-time continuum, to house friendly apparitions and ward off hostile spirits with noisy construction. The unreality of the resultant DVD reflects the unreality of this peculiar home environment.

Artists not only appropriate the technology of the day, they also appropriate images that have special meaning within a culture. Lynn Hershman's *Digital Venus* (Fig. 10-62) starts with Titian's well-known Renaissance painting, the *Venus of Urbino* (see Fig. 5-28), and substitutes digital imagery for the sumptuous glazes that defined the body. Many of Hershman's works comment on the voyeurism we find in the video medium, and *Digital Venus* is a way of showing how frequently the images that affect us are composed of pixels—microscopically small bits of digital information that fool our senses into believing we are somehow connecting with a corporeal reality. And like the work of Dara Birnbaum, it addresses feminist issues pertaining to the male gaze and the exploitation of women.

ARCHITECTURE

After World War II, architecture moved in many directions. Some of these were technological advances that allowed architects to literally achieve greater heights, as in the skyscraper, and to create more sculptural forms, as in Le Corbusier's Chapel of Notre-Dame-du-Haut (see Figs. 10-64 and 10-65). Millions of soldiers returned from Europe and the Pacific and established new families, giving birth not only to what we now call the baby-boomers, but also vast

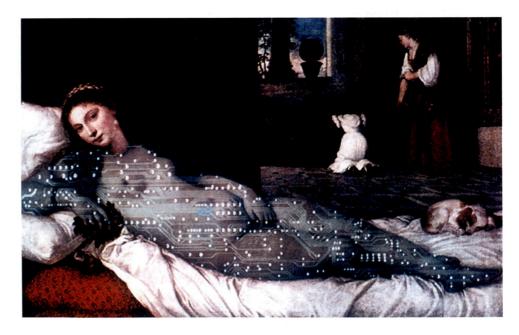

10–62 LYNN HERSHMAN. *Digital Venus* (1996). Iris print. 102 cm × 152 cm. Courtesy of the artist. Hotwire Productions.

housing tracts like Levittown (Fig. 10-63) that dotted suburbs that had earlier been farms, small towns, or wilderness. All these and more were examples of modern architecture.

Modern Architecture

Modern architecture rejected the ideals and principles of the classical tradition in favor of the experimental forms of expression that characterized many styles of art and literature from the 1860s to the 1970s. *Modernism* also refers to approaches that are ahead of their time. "Modern" suggests, in general, an approach that overturns the past and by that definition, every era of artists doing something completely new can be considered modern in their time.

Modernism is a concept of art-making built on the urge to depict contemporary life and events rather than history. Modernism was a response to industrialization, urbanization, and the growth of capitalism and democracy. Modern architects, like modern artists, felt free to explore new styles inspired by technology and science, psychology, politics, economics, and social consciousness.

As we see in the differences among Le Corbusier's work, Levittown, Miës van der Rohe's Farnsworth House (Fig 10-67) and Gordon Bunshaft's Lever House (Fig. 10-68), modernism in architecture never comprised just one style. Rather, it serves as an umbrella term that encompasses the many architectural visions, including those of Frank Lloyd Wright (see Fig. 9-37), Le Corbusier, van der Rohe, Gordon Bunshaft, and many others.

Levittown was more than a collection of houses. It was a socio-aesthetic comment on the need for mass housing. William Levitt built 17,000 houses almost exactly like those shown in Figure 10-63 on 60- by 100-foot lots that were carved out from potato fields. In what was to become neigh-

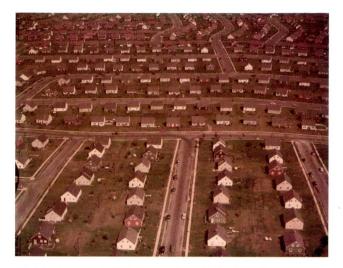

 10-63 Cape Cod–Style Houses Built By Levitt & Sons, Levittown, NY (C. 1947–1951).
 Hulton Archive/Getty Images.

borhood after neighborhood, bulldozers smoothed already flat terrain and concrete slabs were poured. Wooden frames were erected, sided, and roofed. Trees were planted; grass was sown. The houses had an eat-in kitchen, living room, two tiny bedrooms, and one bath on the first floor, and an expansion attic. Despite the tedium of the repetition, the original Levittown house achieved a sort of architectural integrity, providing living space, the pride of ownership, and an unornamented facade for a modest price. Driving through Levittown today, it seems that successive generations of owners personalized their dwellings, as families grew, with random additions in random directions.

Le Corbusier's chapel of Notre-Dame-du-Haut (Figs. 10-64 and 10-65) is an example of the modern movement called "brutalism," derived from the French *brut*, meaning

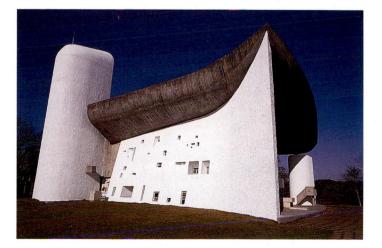

10–64 LE CORBUSIER. Chapel of Notre-Dame-du-Haut, Ronchamp, France (1950–1954). Copyright 2007 Artists Rights Society (ARS), New York/ADAGP, Paris /FLC.

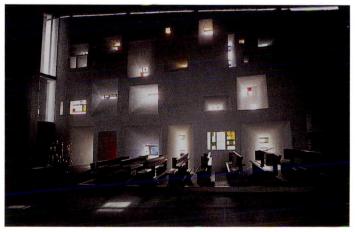

10–65 LE CORBUSIER. Interior, south wall, Chapel of Notre-Dame-du-Haut. Copyright 2007 Artists Rights Society (ARS), New York/ADAGP, Paris / FLC.

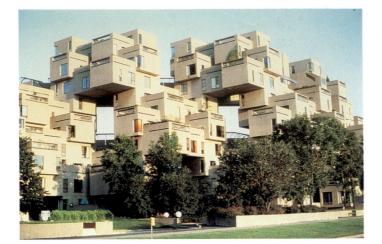

10–66 MOSHE SAFDIE. Habitat, Expo 67, Montreal (1967). Copyright Magma Photo, Quebec.

rough, uncut, or raw. To create his sculptural walls, the architect spun a web of steel, surrounded it with wooden forms whose inner surfaces had the shapes of the walls he desired, poured concrete within, and removed the wooden forms after the concrete hardened, leaving their rough marks on the concrete surfaces. The white walls, dark roof, and white towers are plain, except for the texture of the curving reinforced concrete slabs. In places the walls are very thick. Windows of various shapes and sizes expand from small slits and rectangles to form mysterious light tunnels; not so much illuminating the interior as drawing the observer outward. The massive voids of the window apertures recall the huge stone blocks of prehistoric religious structures. Reinforced concrete freed the modern architect to think freely and sculpturally.

Moshe Safdie's Habitat (Fig. 10-66) is another expression of the versatility of concrete. Habitat was erected for Expo 67 in Montreal as one solution to the housing problems of the future. Rugged, prefabricated units were stacked like blocks about a common utility core at the site, so that the roof of one unit would provide a private deck for another. Only a couple of Safdie-style "apartment houses" have actually been erected, so today Safdie's beautiful sculptural assemblage evokes more nostalgia than hope for the future. Its unique brand of rugged, blocky excitement is, unfortunately, rarely found in mass housing.

A rhythmic procession of white steel columns suspends Miës van der Rohe's Farnsworth House (Fig. 10-67) above the Illinois countryside. In its perfect technological elegance, it is in many ways visually remote from its site. Why steel? Less expensive wood could have supported this house of one story and short spans, and wood might have appeared more natural on this sylvan site. The architect's choices, of course, may be read as a symbol of our contemporary remoteness from our feral past. If so, the architect seems to believe that the powerful

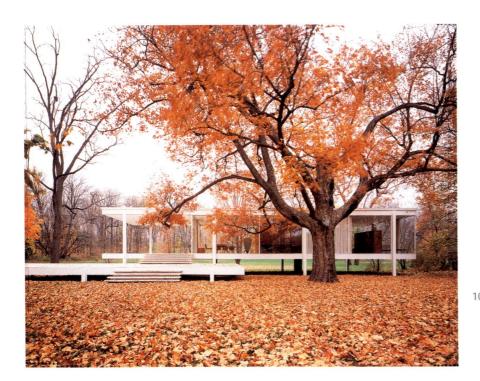

10-67 LUDWIG MIËS VAN DER ROHE. Farnsworth House, Fox River, Plano, IL (1950). Courtesy Hedrich-Blessing. Copyright 2007 Artists Rights Society (ARS), New York/ VG Bild-Kunst, Bonn.

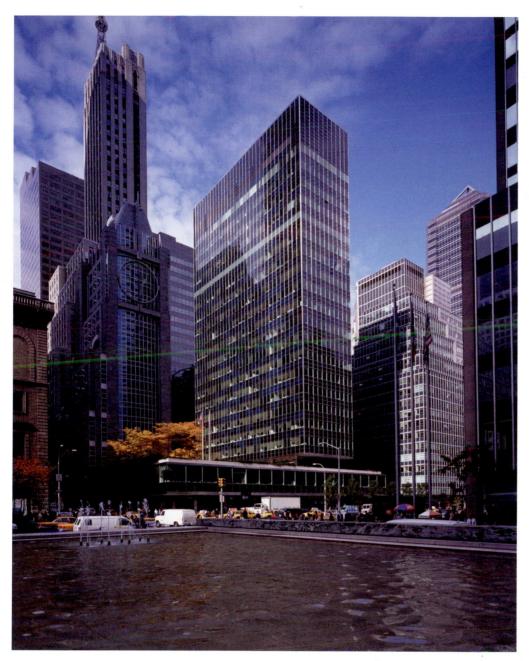

10–68 GORDON BUNSHAFT. Lever House, New York (1951–1952). Copyright Angelo Homak/CORBIS.

> technology that has freed us is to the good, for the house is as beautiful as it is austere in ornamentation. The Farnsworth House has platforms, steps, and a glass curtain wall that allows the environment to flow through. The steps and platforms provide access to a less well-ordered world below.

> New York City's Lever House (Fig. 10-68) was designed by Gordon Bunshaft of Skidmore, Owings, and Mer

rill, a firm that quickly became known for its "minimalist" rectangular solids with their "curtain walls" of glass. The clean, austere profile of Lever House, and its public, open plaza that prevented the behemoth shaft from overwhelming its site were exciting innovations. Hundreds of skyscrapers across the nation mimicked Lever House, including the towers of the World Trade Center, destroyed by Al Qaeda in 2001.

Postmodern Architecture

By the mid-1970s, the clean Modernist look of buildings such as Lever House was overwhelming the urban cityscape. A few buildings of the kind—even a few dozen buildings of the kind—would have been most welcome, but now architectural critics were arguing that a national proliferation of steel-cage rectangular solids was threatening to bury the nation's cities in boredom. Said John Perrault in 1979, "We are sick to death of cold plazas and 'curtain wall' skyscrapers."

By the end of the 1970s, a new steel-cage monster was being bred throughout the land—one that utilized contemporary technology but drew freely from past styles of ornamentation. These **Postmodernist** structures reject the formal simplicity and immaculate finish of Modernist architecture in favor of whimsical shapes, colors, and patterns. Postmodern architects revived the concept of the decorative in architecture, an absolute "no-no" for decades in the twentieth century.

One of most interesting aspects of Postmodern architecture is its appropriation of historical motifs; Philip Johnson's and John Burgee's AT&T Building in New York City (subsequently sold to Sony) (Fig. 10-69) is one of the earliest examples. The massive tower sits on a forest of columns, reminiscent—to Johnson—of an Egyptian **hypostyle** hall. Its pale pink facade is punctuated with fenestration, although the prominent stone grid lines regulate the pace of the upward sweep. The building is crowned with a broken roof pediment referencing the Chippendale style that originated with the eighteenth-century British cabinetmaker, Thomas Chippendale. Beneath the ornamentation lies a steel cage structure, now visually all but disguised.

Deconstructivist Architecture

What we have known as modern architecture is no longer "modern," at least not in the sense of relating to the *present*. It's not even Postmodern, if we want to pigeonhole style. As we move forward in the third millennium, the world of architecture seems completely enmeshed in a movement called *Deconstructivism*.

The Deconstructivist movement originated in the 1960s with the ideas of the French philosopher Jacques Derrida. He argued, in part, that literary texts can be read in different ways and that it is absurd to believe that there can be only one proper interpretation. Similarly, in Deconstructivist architectural design, the whole is less important than the parts. In fact, buildings are meant to be seen in bits and pieces. The familiar elements of traditional architecture are taken apart, discarded, or disguised so that what remains seems randomly assembled.

Deconstructivist architects deny the modern maxim that form should follow function. Instead, they tend to reduce their structures to purer geometric forms made possible by contemporary materials, and they make liberal use of color to express emotion. An early (1988) exhibition of Deconstructivist works at the Museum of Modern Art connected Deconstructivist architecture with Cubism and with

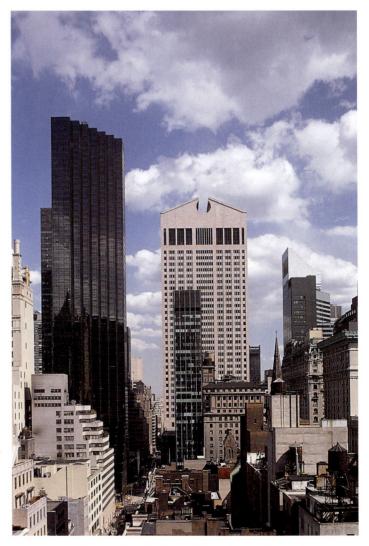

10-69 BURGEE ARCHITECTS WITH PHILIP JOHNSON. Sony Plaza (formerly AT&T Building), New York (1984). Photo courtesy of Norman McGrath.

the Constructivist Russian painting and sculpture of the 1920s (see Naum Gabo's *Column*, Fig. 9-21). American architect Philip Johnson contributed to that exhibition at the age of 82, and he was the only architect of note to have been a driving force in the Modern, Postmodern, and Deconstructivist movements.

Frank Gehry

Frank Gehry, the architect of the Guggenheim Museum in Bilbao, Spain (Fig. 10-70), refers to his deconstructivist work as a "metallic flower." Others have found the billowing, curvilinear shapes to be reminiscent of ships, linking the machine-tooled structure that is perched on the water's edge to the history of Bilbao as an international seaport. It is as if free-floating geometric shapes have collided on this site, and on another day, they might have assumed a different configuration. There are no pediments or architraves in this museum, no steel cages, no industrial anonymity, no Chippendale motifs. And there is no overriding sense of a whole. Shapes, textures, and colors seem to exist purely for their own sake, the uniqueness of their "personalities" to be savored by the viewer.

You will find that most architecture going up around you is *not* Deconstructivist. Most new office buildings are variations on Modern and Postmodern themes. Most residential and civic architecture in the United States is traditional. Architectural clients typically want familiar-looking buildings, and most architects are in business to supply them. It is the exception to the rule that surprises and titillates. The Guggenheim Museums have always been on the cutting edge of design, beginning with Frank Lloyd Wright's unique spiralshaped monument on New York City's Fifth Avenue across from Central Park (see the ArtTourTM at the end of the chapter). Frank Gehry designed the no-less-remarkable Guggenheim Museum Bilbao, which brings many thousands of tourists to that industrial Spanish city each year.

Daniel Libeskind

Although Daniel Libeskind seems to have taken Deconstructivism as a point of departure in his design for the

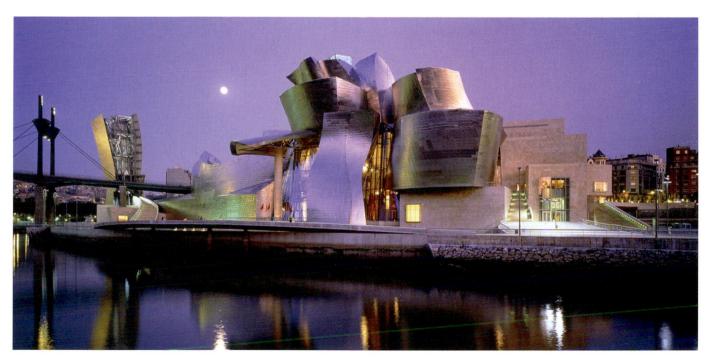

10–70 FRANK GEHRY. Guggenheim Museum, Bilbao, Spain (1997). Copyright E. Streichan/ZEFA/CORBIS.

The void is one of the organizing features of the building. . . . It is the cut through German history, Jewish history. It is the extermination of Jews and the deportation of Jews not only from this city but from Germany and from Europe. —Daniel Libeskind

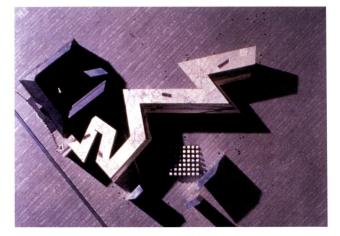

10–71 DANIEL LIBESKIND. Extension of the Berlin Museum (1989–1996). Copyright Studio Daniel Libeskind.

Jewish Museum Department of the Berlin Museum (Fig. 10-71), he invested its parts with profound symbolism. The addition is intended to

10–72 REM KOOLHAAS. Central Library, Seattle (2004). © Lara Swimmer/ESTO.

communicate the vastness and also the legacy of things that are not completely visible. Contrary to public opinion the flesh of architecture is not cladding, insulation and structure, but the substance of the individual in society and history; a figuration of the inorganic, the body and the soul.

The zigzag, or lightning-bolt shape of the building, resembles a broken Star of David. It was derived mathematically by plotting the Berlin addresses of Jewish writers, artists, and composers who were killed during the Holocaust. The overall design is punctuated by voids that symbolize the absence of Jewish people and culture in Berlin.

The zinc exterior of the museum is slashed by a linear pattern of windows that was determined by connecting the addresses of German and Jewish Berliners on a map of the museum's neighborhood. The visitor cannot help being struck by the overwhelming sense that every structural, design, and symbolic element—each of which attracts and holds interest—has been informed by the historic circumstances that gave rise to the building.

Rem Koolhaas

Herbert Muschamp, the architectural critic for the *New York Times*, said in his article on the Central Library (Fig. 10-72) in Seattle, Washington, that "there's never been a great building without a strong client in the history of the world, and Ms. [Deborah L.] Jacobs [Seattle's city librarian] is now up there with popes and princes as an instigator of fabulous cities." The accolades for the design of this extraordinary building go to Dutch architect Rem Koolhaas, but the laurels for making it happen go to Ms. Jacobs.

Koolhaas's name has become synonymous with Deconstructivist architecture. The library's exterior is faceted into folded planes of glass and steel supported by a diagonal grid of light blue metal. True to this aesthetic, the angles and shapes seem almost arbitrary, and the essential structure of the building is hard to decipher from the outside looking in. But within the building, Koolhaas's love of distinct parts and his tendency to subvert their traditional placement can be seen everywhere—from the bright red grand staircase and spiral ramp of book stacks to the "Mixing Chamber" at the heart of the building where librarians greet and help readers. Muschamp sees the Central Library as "a series of It's art; it's fashion. It's good; it's bad. It's sexist; it's not. It's Vanessa Beecroft's performance art.

-http://www.designboom.com/portrait/beecroft.html

episodes in urban space." He also sees it as "where architecture is going."

Santiago Calatrava

In the meantime, Spaniard Santiago Calatrava's architecture seems to be going up everywhere: a symphony center in Atlanta; a total of 30 bridges including 3 that will span the Trinity River in Dallas; a \$2 billion transportation hub for Ground Zero (the World Trade Center site); and a residential tower composed of 12 cubes cantilevered from a concrete core overlooking the East River in New York City (Fig. 10-73). *Time* magazine named him one of the 100 most influential

10–73 SANTIAGO CALATRAVA. Residential Tower on South Street, New York. Santiago Calatrava, S.A./© David Sundberg/ESTO.

people of 2005, and the American Institute of Architects awarded him their coveted gold medal in the same year.

The inspiration for the tower came from a series of cubed sculptures made by Calatrava decades ago. He has said that he considers architecture "the greatest of all arts" because it embraces all of the others, including music, painting, and sculpture. Calatrava believes that he "couldn't be an architect without doing those things." Indeed, his cross-disciplinary focus has yielded designs that seem sculptural, even painterly at times. His client for the transportation station called him "the da Vinci of our time . . . [an artist who] combined light and air and structural elegance with strength."

A PORTFOLIO OF ART IN THE NEW MILLENNIUM

We have traveled thousands of years together, observing the ebb and flow of style in architecture and art. Where are we going? What is new? Can we label the trends?

We can make some generalizations, but the specifics are countless. The inclination to question the nature of art mentioned at the outset of the chapter—remains central. You will have no trouble recognizing much of the art on the following pages as *art*, but the performances of Vanessa Beecroft and William Pope.L may leave you puzzled. The integration of audio and visual mediums—film and electronic—is firmly in place, as you will see in the works of Matthew Barney, Shirin Neshat, and Lorna Simpson. Software and microchips are a new set of artist tools, as we see in Ken Feingold's talking heads. Installations maintain their popularity and, in fact, enhance the opportunities for interactivity between the work and the spectator. Although new media appear to be taking center stage, painting seems to be reasserting itself with the help of influential collectors.

As your experience with art continues and grows, you will encounter artists who use pastels and paint, marble and bronze alongside those using video and film, their own bodies and those of others. You will see things that today you cannot even imagine.

Here, then, is a portfolio of art as we enter the new millennium. It represents the tip of the iceberg when it comes to the things that are happening in the art world today.

Matthew Barney

Stephen Holden, the *New York Times* film critic, considers Matthew Barney (b. 1967) to be "the most important American artist of his generation." Contemporary artists continue to challenge the use of traditional media, and Barney is no exception, having sculpted dumbbells of tapioca

10-74 MATTHEW BARNEY. Cremaster 2 (1999), from the Cremaster film series (1994–2002).

Silkscreened digital videodisc, tooled saddle leather, sterling silver, beeswax, polycarbonate honeycomb, acrylic, and nylon vitrine, with 35 mm print; digital video transferred to film with audio, 1:19:00, vitrine: $38^3/8'' \times 40'' \times 46^5/8''$. Edition 8/10. Copyright 1999 Matthew Barney. Courtesy of the Gagosian Gallery, New York. Photo by Michael James O'Brien. Courtesy, Barbara Gladstone.

pudding and an exercise bench of petroleum jelly. But Barney is best known for his *Cremaster* series of five films. The characters in the films include androgynous nymphs, satyrs, and other legendary figures who are, or are not, what they seem to be. The narratives, enhanced with eclectic sound tracks, circle around various ritual masculine athletic challenges and a good deal of symbolic pagan pageantry. Much of *Cremaster 2* takes place in the wide-open spaces of the "Wild West," accompanied by folk songs, the Mormon Tabernacle Choir, and other music. One scene transports the viewer to the 1893 Columbia International Exhibition in which the novelist Norman Mailer impersonates the escape artist Harry Houdini (Fig. 10-74), standing next to the artist in the guise of a bizarrely attired Gary Gilmore. Mailer's book *The Executioner's Song* was about convicted murderer Gary Gilmore, who was executed by a firing squad in 1977. Gilmore, unlike Houdini, did not escape.

Vanessa Beecroft

Performance is alive and well in the new millennium, taking on any number of shapes and forms. Italian-born Vanessa Beecroft (b. 1969), who lives and works in the United States, has staged numerous performances of nearly nude women in museums and galleries the world over. The women have included models, actresses, and individuals encountered by the artist in chance meetings. The women have been variously clad-string bikinis, strappy high-heel shoes and khaki uniform caps, cowboy hats and pantyhose. In one piece, completely nude women whose heads were covered with smooth, oval, flesh-covered masks, pranced around a gallery installation amidst ordinary spectators. They sat, stood motionless, and every so often moved ever so slightly, oddly reminiscent of the poseable wooden models used in drawing studios. Figure 10-75 is a close-up photograph of one of the women in VB43 (signifying Vanessa Beecroft's forty-third performance), held at London's Gagosian Gallery for one evening on May 9, 2000. Critics noted that although the art world is quite familiar with the subject of the female nude, the presentation of multiple nudes doing nothing more than simultaneously occupying space in a gallery is an experience that compels viewers to reconsider the mutual roles of nude subject and clothed spec-

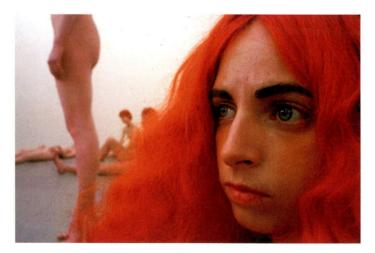

 10-75 VANESSA BEECROFT. VB43 (2000). Digital c-print. 75" × 52". Courtesy of the Gagosian Gallery, New York.

I wanted them to look like replacement parts being shipped from the factory which had suddenly gotten up and begun a kind of existential dialogue right there on the assembly line.

—Ken Feingold

tator. The viewers are forced into the position of voyeur, never fully comfortable, and like the performers, never fully sure of what they should be doing or how they should be reacting. The women do not talk. They do not interact with gallery-goers. They exist in space as "living sculptures," or, as some have described them, "portraits in three dimensions."

Ken Feingold

Multimedia works employing computerized systems have become familiar artistic fare in the new millennium. Ken Feingold's (b. 1952) *If / Then* (Fig. 10-76), exhibited in the Whitney Biennial 2002, is composed of what have become the artist's signature puppets, robots, and talking heads. Two disembodied, mannequin-like heads constructed of silicone, fiberglass, and steel are nestled in a Styrofoam-filled carton in such a position as to facilitate dialogue between the two. And converse they do—to the tune of some 50,000 "thought units" available to them through their custom software. The title of the piece, *If / Then*, reflects the basis of deductive logic, in which a conclusion is derived from a premise. Yet the logic of the thought units occurs in a human vacuum. The heads seem to be unaware of their humble origins and unaware of their complete ensnarement. They go on and on as if the platitudes they utter had some actual meaning. Their identical features give the lie to their sense of individuality. One cannot escape the feeling that our own use of logic is ultimately meaningless in the broad scheme of things and that our senses of individuality and freedom may be no more than illusions.

Sarah Lucas

Much of British-born Sarah Lucas's (b. 1962) work comments on male-female relationships in life and in art. She has been profoundly interested in the political issues surrounding the "male gaze" and the woman as the stereotypical object of desire. One of her best-known works, *Au Naturel*, features an old mattress with a cucumber, pieces of fruit, and a bucket as stand-ins for male and female body

10-76 KEN FEINGOLD. *lf/Then* (2001).
Silicone, pigment, fiberglass, steel, and electronics.
24" × 28" × 24".
Courtesy of the artist. Courtesy, Postmasters Gallery, New York.

Jacques-Louis David on a Brooklyn Tennis Court

Jacques-Louis David's *Intervention of the Sabine Women* (Fig. 10-77), in all of its Classical idealization, patriotism, and heroism, hangs among other prized examples of Neoclassicism in a quiet, stately gallery in the Louvre Museum in Paris. But on a raw, wintery day in 2005, the myth that gave birth to one of David's most symbolic works was revisited—reenacted—on a tennis court in Brooklyn, New York. Video artist Eve Sussman was once again exploring the "pictorial evolution of a masterpiece." In Sussman's version, the men wore suits (in David's painting, they are in their birthday suits). The women were not in chic retro Roman attire; they wore vintage 1960s couture.

We have already studied Nicolas Poussin's *The Rape of the Sabine Women* (see Fig. 6-21), which recounts the subject of the Romans' abduction of their neighbors' (the Sabines) women for the dubious purpose of growing their city's population. David's painting is, in effect, a follow-up to the story. Three years after the attack by Romulus (Rome's founder) and his men, the Sabine men organized a counterattack to reclaim their women. When they arrive, the Sabine-turned-Roman women intervene! For the first time in David's career as a history painter, he placed a woman at the center of the action. She is Hersilia, daughter of the Sabine Tatius and wife of Romulus himself. And she's not going back. Hersilia and other now-Roman women stand between the warriors and their children and, through their gestures, appeal for a peaceful solution to the crisis. As in most examples of the Neoclassical style, there is balance

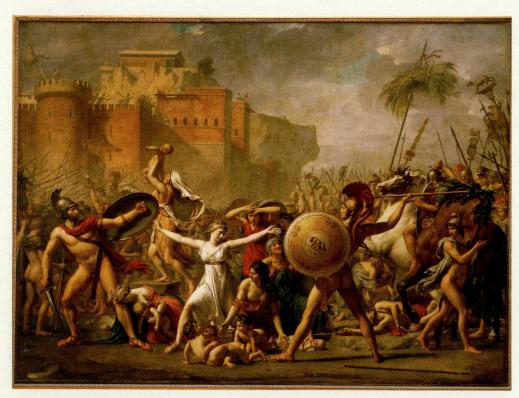

between action and restraint. The flailing arms and emotional expressions of the women contrast with the firmly planted stances of the fighting men. The movement seems controlled, even frozen, in spite of the overall sense of violence and chaos.

Enter Eve Sussman. Lights . . . camera . . . smoke machine. "Just walk around," her choreographer told the actors. "O.K., now find somebody in the group and lock eyes with them, like they are a magnet pulling you together. Now lean your body against theirs." From these first, tentative movements, a full-scale battle scene ensued (Fig. 10-78). Clothes were ripped off, people bumped, grinded, and fell over one another. The women screamed,

10-77 JACQUES-LOUIS DAVID. The Intervention of the Sabine Women (1799).
Oil on canvas.
385 cm × 522 cm.
Louvre Museum, Paris/RMN/Art Resource, New York. cried, and desperately held children up in the air. Figures moved through the mist stepping over the carnage, surveying the destruction. Cut.

The scene thus shot may or may not be used in Sussman's video-opera project, Raptus, a piece in progress that is based on the myth of the Sabine women (raptus, in ancient Rome, meant "carrying off by force" and was a crime of property theft). It follows a similar successful work based on Diego Velázquez's Las Meninas (see Fig. 6-15) called 89 Seconds at Alcázar (Fig. 10-79). The video and film stills visualize imagined moments before and after the scene that Velázquez chose to represent. Sussman said of her thought process in generating the idea for 89 Seconds at Alcázar, "[The painting] has the feeling of a snapshot . . . as if the Enfanta could walk out and come back again. And you think, if this is a film still, then there is a still that came before, and one that came after." Unlike 89 Seconds at Alcázar, which involved sets and elaborate costumes replicating the interior backdrop of Velázquez's famous portrait, Raptus is far more loosely based on the David prototype. The artist admits to making it up as she and the actors go along. Working with a loose outline rather than a complete script, the collaborators are coming up with their own version of the myth, based on interpretation, interaction, and reaction. "We know we want a fight involving the Sabine women, and other than that we don't have a clue."

10–78 EVE SUSSMAN. Footage for *Raptus* (2005). Performance video. Michael Nagle/The New York Times.

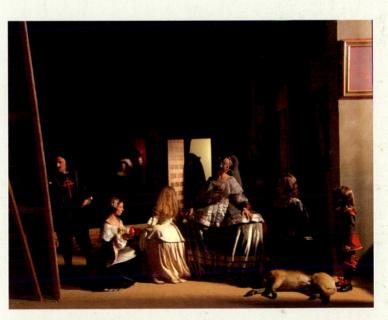

10-79 EVE SUSSMAN.
 Screen grab from 89 Seconds at Alcázar.
 © 2004 by the artist/Whitney Museum of American Art, New York.

You have to think twice about everything I say, no matter whether I mean it seriously or jokingly. That is provocative.

 10-80 SARAH LUCAS. *The Fag Show* (2000). Installation view, Sadie Coles HQ, London. Copyright Sarah Lucas. Courtesy Sadie Coles HQ. London.

parts. *The Fag Show* (Fig. 10-80) was inspired by Lucas's conquest of her addiction to tobacco. (*Fag* is the slang word in Britain for cigarette.) The outer skins of the objects in the installation, including vacuum cleaners and Disneyesque dwarves, consist of swirling linear patterns of cigarettes. Much of Lucas's work focuses on blatant sexual imagery and the stuff of self-destruction and death.

Shirin Neshat

Shirin Neshat's (b. 1957) films are obsessed with gender roles in Islamic society. Although men in Iran can reveal their individual faces to the world, women share a collective cultural identity that seems to be defined by the chador, the required head-to-toe covering, that serves both as a symbol of repression and of female identity. Her film *Passage* (Fig. 10-81), commissioned by the composer Philip Glass, follows the ritual of passage from this world to the next as men carry a shrouded body, women prepare a grave with their bare hands, and a little girl sets a fire that comes to circum-

—Sarah Lucas

scribe the scene. During one of the film's most abstract and intensely visual passages, Glass's pulsating score juxtaposed with a close-up of the women's thrumming chadors creates a sense of oil bubbling from the desert ground. The ingredients are natural and elemental—sticks, stones, fire, smoke, sand, and dust—and the repetitive movements, chanting, and music form a circle of life, death, and perhaps, rebirth.

William Pope.L

William Pope.L's (b. 1956) business card proclaims himself "The friendliest Black artist in America"—a descriptor that also serves as the title of an MIT Press book on the artist. William Pope.L, a professor at Bates College in Maine, paints, sculpts, and produces some of the most intriguing and witty performance art in the United States. Pope.L's reputation soared when the chairman of the National Endowment for

81 SHIRIN NESHAT. Still from Passage (2001). Color video installation with sound, 00:11:40, dimensions vary with installation. Edition 5/6. Solomon R. Guggenheim Museum, New York. Purchased with funds contributed by the International Director's Council and Executive Committee Members. 2001.70. Copyright The Solomon R. Guggenheim Museum, New York. Photograph courtesy of the artist. the Arts overturned the recommendation of his advisory panel and denied support for Pope.L's retrospective exhibition, *eRacism.* Given this notoriety, Pope.L became a cause célèbre and was featured in newspapers across the nation. Many of Pope.L's performances take place on "the street." He has publicly eaten (and thrown up) copies of *The Wall Street Journal*, handed out (rather than solicited) cash from a bank door, and walked Harlem's 125th Street sporting a 12-foot cardboard phallus. *Training Crawl, Lewiston, ME* (Fig. 10-82) is one of his many signature "crawls" in which he usually appears in a city, unannounced, dressed in athletic wear or a business suit, and inches along public streets until he is exhausted. It shows Pope.L training for a 22-mile crawl up Broadway, which he expects will take five years to complete—despite the Superman costume.

David Salle

Oklahoma-born David Salle (b. 1952) is best known for his use of *pastiche*—that is, the appropriation of images from other sources. His thought-provoking compositions juxtapose images culled from his own photographs, art historical icons (e.g., Velázquez, Bernini, Cézanne, Giacometti,

10-83 DAVID SALLE.

Angel (2000). Oil and acrylic on canvas and linen (two panels).

 $72'' \times 96''$.

Courtesy Mary Boone Gallery, New York. Copyright David Salle. Licensed by VAGA, New York.

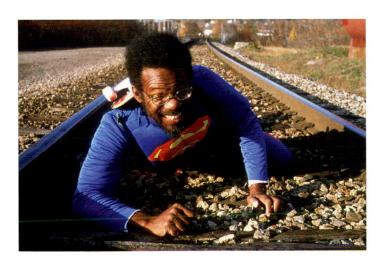

10-82 WILLIAM POPE.L.Training Crawl, Lewiston, ME (Fall 2001).William Pope.L trains for The Great White

William Pope.L trains for *The Great White Way*, his marathon five-year crawl up Broadway in Manhattan. Photograph courtesy of the artist.

Magritte, Jasper Johns), print ads, "how-to-draw" manuals, even pornographic magazines. Salle is one of the most successful proponents of Neo-Expressionism, and his work has inspired a revival of large-scale, figurative painting. *Angel* (Fig. 10-83) is one of Salle's "pastoral" paintings, which art critic David Kuspit characterizes as highly learned, even scholarly. Here we find a portrait of the artist and his muse in baroque costume. Their relationship is intriguing sophisticated, formal, yet exhibiting an underlying sexual tension. Questions arise as to the artist's creativity, originality, potency. In any case, Salle is not afraid to reconfirm the appeal of solid figurative painting.

Damien Hirst

A perceived resurgence in the interest in painting can perhaps be symbolized by Damien Hirst's (b. 1965) own foray into the medium after a long association with anything but. Hirst established his reputation as one of the YBAs (young British artists) making conceptual art that seemed to challenge ethics, morality, and plain good taste. He is perhaps best known for his infamous installation of a dismembered shark suspended in formaldehyde (*The Physical Impossibility*) We are all working so hard to change people's attitudes about race, but it's like handling a wet eel.

—Kara Walker

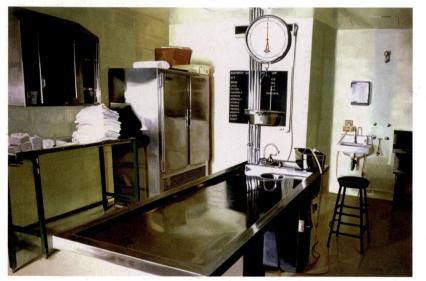

10–84 DAMIEN HIRST. Mortuary (2003–2004). Photograph courtesy of the Gagosian Gallery, New York.

of Death in the Mind of Someone Living, 1991), but Hirst's latest paintings consist of often no less difficult imagery rendered, however, in a Photorealist style (Fig. 10-84).

Hirst's patron and promoter, the influential British collector Charles Saatchi, sold the so-called pickled shark for a reputed \$13 million. Saatchi seems to have found a new passion for contemporary painting, focusing his efforts (and his financial support) on a series of exhibitions featuring 56 artists working exclusively in the medium. Saatchi labeled it "The Triumph of Painting."

Lorna Simpson

Lorna Simpson (b. 1960) often combines black-and-white photography and text to address racial issues in her work, but for the most part indirectly. She has been particularly concerned with the place of African American women in the United States, portraying them variously as victims, protagonists, and survivors. The use of fragmentation as a device for communicating the line between the individuality and anonymity of her subjects has also been a persistent visual construct and is evident here in the film *Easy to Remember* (Fig. 10-85). A grid of 15 mouths—15 African American jazz singers—hum along to the Rodgers and Hart song *Easy to Remember*, rendered as a lilting ballad by the saxophonist John Coltrane. Although the singing is mostly in unison, slight variations are evident in individual rendition. The title of the work and the song resonate with meaning for the artist, recalling memories from her childhood. The work was selected for the Whitney Biennial 2002.

Kara Walker

As an African American woman, Kara Walker (b. 1969) has experienced much of her life in terms of black and white and now, like Lorna Simpson, produces much of her art in this dichotomous palette. She has worked in many media, but her life-size paper cutouts, which are used to silhouette her comments on the often brutal history of race relations in the United States, have captured the attention of the art world. Her figures are twodimensional—often black figures pasted onto

white gallery walls—and their flatness seems to echo the stereotyping that prevents people of one background from seeing people of other backgrounds in their full vitality and individualism.

Insurrection! (Our Tools Were Rudimentary, Yet We Pressed On) (Fig. 10-86) recounts some grisly events taken from the history of slavery in the United States. A nude slave is propositioned by a plantation owner. A woman with a

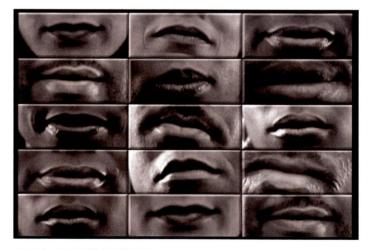

10-85 LORNA SIMPSON.
Still from *Easy to Remember* (2001).
16 mm film transferred to DVD, sound; 2¹/₂ minutes.
Courtesy of the Sean Kelly Gallery, New York.

baby barely escapes being lynched. Elsewhere a group tortures a victim. The piece fills the walls of a large room where additional shapes are projected onto the walls, and visitors find their own shadows projected among them. Viewers are thus integrated into the haunting works, as if they share in culpability or victimhood. Walker's installations are haunting in their disconnect between the lyrical shadow-puppet display and the dark content of the narrative.

Sam Taylor-Wood

Edward Steichen wrote, "Every other artist begins [with] a blank canvas, a piece of paper . . . the photographer begins with the finished product." Implicit in Steichen's statement is the reality of the planning and selection that permits the instantaneous creation of an image to be a "finished product." The contemporary images of Sam Taylor-Wood (b. 1967), who lives and works in England, are created with extensive forethought and with knowledge of, and reverence for, the history of art.

Taylor-Wood has become known for her roomencompassing video installations and 360-degree photographic panoramas, accompanied by sound tracks, that

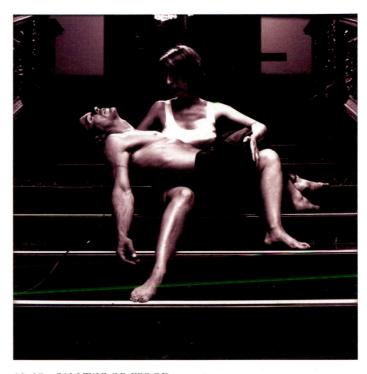

10-87 SAM TAYLOR-WOOD.
 Self-Pietà (2001).
 C-print. 53" square.
 Courtesy Jay Jopling/White Cube, London.

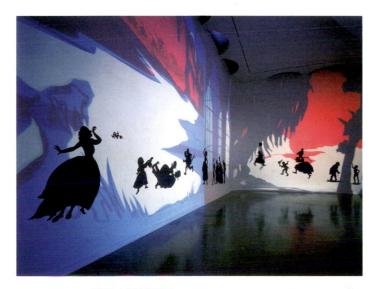

10-86 KARA WALKER. Insurrection! (Our Tools Were Rudimentary, Yet We Pressed On) (2000). Installation view. Cut paper silhouettes and light projections, site-specific dimensions.

Solomon R. Guggenheim Museum of Art, New York. Purchased with funds contributed by the International Director's Council and Executive Committee Members. 2000.68. Copyright The Solomon R. Guggenheim Museum. Courtesy, Brent Sikkema, New York. Photograph by Ellen Labenski. depict people in the midst of personal dramas and fantasies. Although the actors in her dramas may be visually attractive, something about them is awkward and vulnerable, out of place. Even though some are involved in sexual activity, they appear to be emotionally isolated. Taylor-Wood's photographs are often structured like multi-paneled Renaissance altarpieces, replete with art-historical references. In her Soliloquy III, for example, a reclining nude mimics the pose of Velázquez's Rokeby Venus (1650). Her grand-scale Self-Pietà (Fig. 10-87) mimics Michelangelo's Pietà, in which the Virgin Mary holds her dead son in her lap. In Taylor-Wood's photo, the artist herself holds a motionless male, an icon, as it were, that threatens to slip from her hands. Although there is a sense of contemporary alienation in Taylor-Wood's work, it is rooted in the art-historical past. Although the art of today is exploding in many directions, it explodes not in a vacuum but from a past with identifiable traditions.

Where the explosions will take us, we cannot say. But just as scientists study the origins of the universe in the stars of their own sphere of study, so the art historians and critics of the future will see the origins of the works before them in the art of our past and today.

ART TOUR New York

When we look at New York and the arts, the Big Apple is the big show. For the performing arts—theater and music and dance—there's nothing like Broadway and Lincoln Center.

In terms of the visual arts, New York is renowned, and rightly so, for its museums and architecture, and for its public art, including Central Park and statues popping up everywhere. The Metropolitan Museum of Art houses one of the greatest and broadest collections in the world, including Egyptian, Greek and Roman, Asian, Islamic, Pacific Island, European, American, and contemporary art (which, of course, comes from anywhere and everywhere).

Even the most reluctant museumgoer will be charmed by the nineteenth-century European collection, which includes great paintings by the likes of Cézanne, Monet, Manet, Renoir, Degas, and van Gogh, and sculpture by Rodin. In the contemporary wing, you'll find paintings by Jackson Pollock, Georgia O'Keeffe, and Andy Warhol, for example. During the summer months, the roof of the Met is an outdoor sculpture garden. Take the elevator up for the art and for grand views of Central Park and the city. The main museum sits on Fifth Avenue, within Central Park, in the lower 80s. The Cloisters, which is part of the Met, is devoted to European medieval art and architecture and is located in northern Manhattan's Fort Tryon Park, which seems like a Manhattan island untouched by civilization.

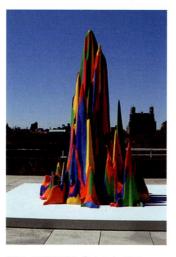

SOL LEWITT, *Splotch #15*, on the roof at the Met. © 2007 Sol LeWitt /Artists Rights Society (ARS), New York.

Frank Lloyd Wright's Solomon R. Guggenheim Museum sits across Fifth Avenue from Central Park, about 10 blocks up from the Met, in New York's "Museum Mile." The main exhibition hall houses transient exhibitions. Marcel Breuer's Whitney Museum of American Art is found on Madison Avenue, which parallels Fifth Avenue, one block east, at 75th Street.

The Whitney is devoted to American art, and its exhibitions include some of the

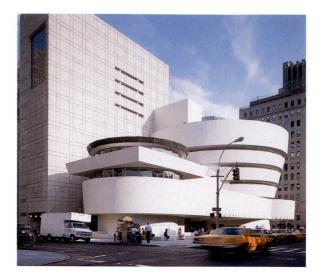

FRANK LLOYD WRIGHT, Guggenheim Museum. Rafael Macia/PR.

edgiest and most controversial art in New York. My youngest daughter was captivated by Tony Oursler's *Getaway #2*, which was lying on the floor, repeatedly asking "Are you lookin' at me?" and cursing museum-goers. You can catch lunch in any of these museums.

The Museum of Modern Art (MOMA) has recently undergone a major renovation. The collection of the MOMA contains many familiar and beloved works, works not to be missed: van Gogh's *Starry Night* (Fig. 8-33), Derain's *London Bridge* (Fig. 9-1), Picasso's *Les Demoiselles d'Avignon* (Fig. 9-7), Boccioni's *Unique Forms of Continuity in Space* (Fig. 9-13), Balla's *Street Light* (Fig. 9-14), Brancusi's *Bird in Space* (Fig. 9-24), Ernst's *Two Children Are Threatened by a Nightingale* (Fig. 9-31), Dalí 's *The Persistence of Memory* (Fig. 9-32), Pollocks, Monets, and . . . the list is, for all practical purposes, endless.

There are almost too many other museums and art galleries to mention. The Morgan Library on Madison Avenue in midtown contains one of the few remaining copies of the Gutenberg Bible (dated 1455). When visiting Harlem, check out the exhibitions at the Studio Museum on 125th Street. The Museo del Barrio is on Fifth Avenue in the 100s (don't forget the charming garden within Central Park across from the Museo). As you're heading back down Fifth Avenue toward the 90s and the Museum Mile, you will find it worthwhile to visit the Jewish Museum and the Cooper-Hewitt National Design Museum. Down in the 70s, past the Met, you'll find the Frick Collection. New York is also an architecture buff's dream. The Guggenheim and Whitney Museums are to be appreciated as works of art themselves, not just as houses for art. Some of the churches of the city are, well, divine, including the Cathedral of St. John the Divine, on Am-

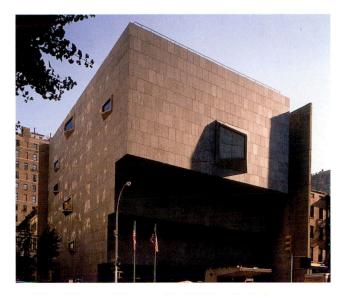

THE WHITNEY MUSEUM OF AMERICAN ART. Jeff Goldbert/Esto.

sterdam Avenue at 112th Street. This is the largest cathedral in the world (really), and St. Patrick's Cathedral, on Fifth Avenue at 50th Street, is the largest Catholic cathedral in the United States. The Cathedral of St. John the Divine was begun in 1892 and is about two-thirds finished.

When (and if) sufficient funds are raised, completion will require only about another half century. It is a very people- and environment-oriented cathedral, with chapels containing children's art and fish tanks that illustrate the ecology of the Hudson River.

New York is looking up. That is, visitors to New York are always looking up. Look for the Art Deco stainless steel spire of the Chrysler Building (Lexington Avenue at 42nd Street), which resembles the grille of a car of the 1920s (its gargoyles resemble hood ornaments). It's worth a visit to check out the Art Deco doors of the elevators. The Empire State Building, at Fifth Avenue and 34th Street, provides wonderful views of the city. (King Kong enjoyed a visit to the top in 1933.) If you walk up Park Avenue from midtown, you'll come across the famed Waldorf Astoria Hotel; the Byzantine St. Bartholomew's Church (St. Bart's), with its wonderful ornate detail and gold dome; and prime examples of the steel-cage architecture of the 1950s, Lever House (Fig. 10-66) and the Seagram Building.

Do not forget to spend time in Central Park, one of the city's greatest works of art, regardless of the time of year. It's never too hot to sunbathe or too cold to enjoy the Wollman Skating Rink or a horse-drawn carriage ride (there are blankets in the carriages). Designed by Frederick Law Olmsted, the park is a rectangular strip of grass, trees, hills, and lakes some 21.2 miles long (running from 59th Street to

110th Street) and almost a mile wide (running from Fifth Avenue to Central Park West, which is the equivalent of Eighth Avenue). It forms the geographical and spiritual heart of Manhattan. Museums and other landmarks line its edges. Joggers circle the reservoir, young (and old) children guide miniature yachts in the sailboat pond, animals stretch and growl in the zoo, and lovers meander along its paths. New Yorkers pay a premium for apartments with a view of the park. Multiple roadways pass above and below one another so that through traffic, pedestrian walkways, and bridle paths all function simultaneously. Forty-six bridges and arches-all different—contribute to the harmonious functioning of the transportation system or simply provide decoration. Next to the lake (many blocks below the reservoir), you'll find Bethesda Fountain, where dozens of movies have been shot. A path around the lake will take you into wooded areas that might be 100 miles upstate.

It's worth the extra dollars to eat at the Boathouse (on the lake near Bethesda Fountain) or at Tavern on the Green

CHINATSU BAN, VWX Yellow Elephant / HIJ Kiddy Elephant.

Chinatsu Ban, VWX Yellow Elephant Underwear/HIJ Kiddy Elephant Underwear, 2005. Sculpture at Doris C. Freedman Plaza, 60th Street and Fifth Avenue. A Project of Public Art Fund and the Japan Society. Courtesy Marianne Boesky Gallery, New York. Photo by Tom Powel Imaging. © 2005 Chinatsu Ban/Kaikai Kiki Co., Ltd. All rights reserved.

("the Green" is Central Park). In the summer, enjoy the amateur acrobats and break-dancers at the fountain, the beat of African drums, and the Rollerblade dancers nearby.

Then there is the unexpected. One summer, for example, New York was invaded by cows. We know that Rockefeller Center has a grand Christmas tree during the holiday season, but unusual pieces of art also show up, like big yellow elephants.

To continue your tour and learn more about New York City, go to our Premium Companion website.

GLOSSARY

- Abstract art A form of art characterized by simplified (abstracted) or distorted rendering of an object that has the essential form or nature of that object; a form of nonobjective art in which the forms make no ref-
- Abstract Expressionism A style of painting and sculpture of the 1950s and 1960s in which artists expressionistically distorted which artists expressionistically distorted abstract images with loose, gestural brush-work. Also see *expressionistic*. Academic art A neoclassical, non-experimental style promoted by the Royal French Acad-
- emy during the eighteenth and nineteenth centuries.
- Action painting A contemporary method of painting characterized by implied motion in the brushstroke and splattered and
- Afterimage The lingering impression from a stimulus that has been removed. The after-image of a color is its complement.
- Altar A raised platform or stand used for sacred ceremonial or ritual purposes.
- Alternate a-b-a-b support system An architectural support system in which every other nave wall support sends up a supporting rib that crosses the vault as a transverse arch.
- Alternate support system An architectural support system in which alternating struc-tural elements bear the weight of the walls
- and the load of the ceiling. **Ambulatory** In a church, a continuation of the side aisles of a *Latin cross plan* into a pas-sageway that extends behind the choir and apse and allows traffic to flow to the chapels, which are often placed in this area
- (from *ambulare*, Latin for "to walk"). **Amphitheater** A round or oval open-air thea-ter with an arena surrounded by rising tiers of seats
- (1909–1912) during which objects were dis-sected or analyzed in a visual information-gathering process and then reconstructed on the canvas
- Annunciation The angel Gabriel's announce-ment to Mary that she would give birth to lesus.
- Apocalypse The ultimate triumph of good over evil foretold in Judeo-Christian writings.
- Apse A semicircular or polygonal projection of a building with a semicircular dome, espe-cially on the east end of a church. Aqueduct A bridge-like structure that carries a canal or pipe of water across a river or valley
- canal or pipe of water across a river or valley (from Latin roots meaning "to carry water").
 Archaic period A period of Greek art dating roughly 660 480 BCE. The term *archaic* means "old" and refers to the art created before the Classical period.
 Architectural style A style of Roman painting in which walls were given the illusion of
- opening onto a scene.
- Architrave In architecture, the lower part of an entablature, which may consist of one or more horizontal bands.

Archivolts In architecture, concentric moldings that repeat the shape of an arch. Athena The Greek goddess of wisdom, skills,

- and war. Atmospheric perspective The illusion of
- depth that is created through grades of texture and brightness, color saturation, and warm and cool colors. An indistinct or hazy effect produced by distance and the illusion of distance in visual art (the term derives from recognition that the atmosphere between the viewer and the distant objects would cause the effect). Atrium A hall or entrance court.
- Automatic writing Writing based on the psy-choanalytic concept of free association, as practiced by Dadaists and Surrealists.
- Automatist surrealism An outgrowth of automatic writing in which the artist attempts to derive the outlines of images from the
- unconscious mind through free association. Avant-garde The leaders in new, unconventional movements; the vanguard (from French, "advance guard").
- Balloon-frame construction In architecture, a wooden skeleton of a building constructed from prefabricated studs and nails.
- Baroque A seventeenth-century European style characterized by ornamentation, curved lines, irregularity of form, dramatic lighting
- and color, and exaggerated gestures. **Basalt** A dark, tough volcanic rock. **Bay** In architecture, the area or space spanned by a single unit of vaulting that may be marked off by piers or columns. Bevel To cut at an angle.
- Black-figure painting A three-stage firing process that gives vases black figures on a reddish ground. In the first, oxidizing phase of firing, oxygen in the kiln turns the vase and slip red. In the second, reducing phase, oxygen is eliminated from the kiln and the vase and slip turn black. In the third, reoxidizing phase, oxygen is reintro-duced into the kiln, turning the vase red once more.
- Brightness gradient The relative degree of intensity in the rendering of nearby and dis-tant objects, used to create an illusion of depth in a two-dimensional work.
- Buddha An enlightened man.
 Byzantine A style associated with Eastern Europe that arose after 300 CE, the year that Emperor Constantine moved the capital of his review for a particular that the Statement of the statemen his empire from Rome to Byzantium and renamed the city Constantinople (present-day Istanbul). The style was concurrent with the Early Christian style in Western Europe.
- Canon of proportions A set of rules governing the proportions of the human body as they are to be rendered by artists.
- **Capital** In architecture, the area at the top of the shaft of a column that provides a solid base for the horizontal elements above. Capitals provide decorative transitions

between the cylinder of the column and

- carolingian Referring to Charlemagne or his period. Charlemagne was emperor of the Holy Roman Empire from 800 to 814 CE.
- Carpet page A decorative Medieval manuscript page that resembles textiles. Catacomb A vault or gallery in an under-
- ground burial place. Cella The small inner room of a Greek temple,
- used to house the statue of the god or goddess to whom the temple is dedicated. Lo-cated behind solid masonry walls, the cella
- cated behind solid masonry walls, the cella was accessible only to the temple priests. **Central plan** A design for a church or a chapel with a primary central space surrounded by symmetrical areas around each side. Contrast with longitudinal plan.
- Chiaroscuro An artistic technique in which subtle gradations of value create the illu-sion of rounded three-dimensional forms in space; also termed modeling (from Ital-ian for "light-dark").
- Cinerary urn A vessel used for keeping the
- Charles y min A vessel used for keeping the ashes of the cremated dead.
 Classical Art Art of the Greek Classical pe-riod, spanning roughly 480 400 BCE; also known as Hellenic Art (from "Hellas," the Greek name for Greece).
- Clerestory In a Latin cross plan, the area above the triforium in the elevation of the nave, which contains windows to provide direct lighting for the nave.
- direct lighting for the nave. **Coffer** A decorative sunken panel. **Collage** An assemblage of two-dimensional objects to create an image; works of art in which materials such as paper, cloth, and wood are pasted to a two-dimensional sur-face, such as a wooden panel or canvas (from *coller*, French for "to paste"). **Colonnade** A series of columns placed side by side to support a roof or a series of archer
- side to support a roof or a series of arches. Color-field painting Painting that uses visual elements and principles of design to sug-gest that areas of color stretch beyond the canvas to infinity. Figure and ground re-
- ceive equal emphasis. Combine painting A contemporary style of painting that attaches other media, such as found objects, to the canvas.
- **Composition** The organization of the visual elements in a work of art.
- Compound pier In the Gothic style, a complexly shaped vertical support to which a number of colonnettes (thin half columns)
- are often attached. **Conceptual** Portrayed as a person or object is known or thought (conceptualized) to be; not copied from nature at any given mo-ment. Conceptual figures tend to be stylized rather than realistic.
- Conceptual art An anticommercial movement begun in the 1960s in which works of art are conceived and executed in the mind of the artist. The commercial or communal aspect of the "work" is often a set of in-structions as to how to create that which exists in the artist's mind.

- **Conceptual space** Space that is depicted as conceptualized by the artist rather than in
- realistic perspective. Content All that is contained in a work of art: the visual elements, subject matter, and underlying meaning or themes
- Contrapposto A position in which a figure is
- contrapposed A position in which a right is obliquely balanced around a central vertical axis. Also see *weight-shift principle*.
 Cool color A color such as a blue, green, or violet that appears to be cool in temperature and tends to recede spatially behind warm colors
- Corbel A supportive, bracket-shaped piece of metal, stone, or wood. Corinthian order The most ornate of the
- Greek architectural styles, characterized by slender, fluted columns and capitals with an acanthus leaf design. Cornice In architecture, a horizontal molding
- that projects along the top of a wall or a building; the uppermost part of an entablature.
- Cosmetic palette A palette for mixing cosmetics, such as eye makeup, with water.
- Crossing square In architecture, the area that defines the right-angle intersection of the vaults of the nave and the transept of a church.
- **Cubism** A twentieth-century style developed by Picasso and Braque that emphasizes the two-dimensionality of the canvas, characterized by multiple views of an object and the reduction of form to cube-like essentials.
- Cuneiform Wedge-shaped; descriptive of the characters used in ancient Akkadian, Assyrian, Babylonian, and Persian alphabets.
- Dada A post-World War I movement that sought to use art to destroy art, thereby underscoring the paradoxes and absurdities of modern life.
- Daguerreotype A photograph made from a silver-coated copper plate; named after Louis Daguerre, the innovator of the method.
- Deconstructivist architecture A Postmodern approach to the design of buildings that disassembles and reassembles the basic ele-ments of architecture. The focus is on the creation of forms that may appear abstract, disharmonious, and disconnected from the functions of the building. Deconstructivism challenges the view that there is one
- correct way to approach architecture. Der Blaue Reiter (The Blue Rider) A twentiethcentury German Expressionist movement that focused on the contrasts between, and combinations of, abstract form and pure color
- **Design** The combination of the visual ele-ments of art according to such principles as balance and unity.
- De Stijl An early twentieth-century movement that emphasized the use of basic forms, particularly cubes, horizontals, and verticals
- Diagonal rib In architecture, a rib that connects the opposite corners of a groin vault. Die Brücke (The Bridge) A short-lived Ger-
- man Expressionist movement characterized by boldly colored landscapes and cityscapes and by violent portraits. **Digital art** Art that makes use of—or is devel-
- oped with the assistance of —electronic in-struments, such as computers, that store and manipulate information through the use of series of zeros and ones (digits). Digital arts bits of bits and ones (digits). Digital and sinclude but are not limited to web design, graphic design, and digital photography.
 Dome In architecture, a hemispherical structure that is round when viewed from beneath.
 Doric order The earliest and simplest of the sinclude for the sinclude structure of the since sinc
- Greek architectural styles, consisting of relatively short, squat columns, sometimes unfluted, and a simple, square-shaped cap-ital. The Doric *frieze* is usually divided into *triglyphs* and *metopes*.

- **Dynamism** The Futurist view that force or en-ergy is the basic principle that underlies all events, including everything we see. Ob-jects are depicted as if in constant motion, appearing and disappearing before our eyes.
- Eastern Orthodox A form of Christianity dominant in Eastern Europe, western Asia, and North Africa.
- **Empire period** The Roman period from about 27 BCE to 395 CE, when the empire was divided.
- Entablature In architecture, a horizontal structure supported by columns, which, in turn, supports any other element, such as a pediment, that is placed above; from top to bottom, the entablature consists of a *cor*-nice, a *frieze*, and an *architrave*.
- Entasis In architecture, a slight convex curvature of a column used to provide the illusion of continuity of thickness as the column rises.
- Equestrian portrait A depiction of a figure on horseback
- Etruscan From ancient Etruria, located along the northwestern shores of present-day Italy. **Expressionism** A modern school of art in
- which an emotional impact is achieved through agitated brushwork, intense color-ation, and violent, hallucinatory imagery.
 Expressionistic Emphasizing the distortion of
- color and form to achieve an emotional impact.
- Fantastic art The representation of fanciful images, sometimes joyful and whimsical, sometimes horrific and grotesque.
- Fauvism An early twentieth-century style of art characterized by the juxtaposition of ar-eas of bright colors that are often unrelated to the objects they represent, and by dis-torted linear perspective (from the French wild beast"
- Fertile Crescent The arable land lying between the Tigris and Euphrates rivers in ancient Mesopotamia. Fertile Ribbon The arable land lying along
- the Nile River in Egypt. Fetish figure An object believed to have magi-
- cal powers. Figurative art Art that represents the likeness of human and other figures. Flying buttress A buttress that is exterior to a
- building but connected in a location that permits the buttress to support an interior vault.
- Foreshortening Diminishing the size of the parts of an object that are represented as farthest from the viewer. Specifically, ren-dering parts of an object as receding from the viewer at angles oblique to the picture plane so that they appear proportionately shorter than parts of the object that are
- Form The totality of what the viewer sees in a work of art; a product of the composition of visual elements
- Forum An open public space, particularly in ancient Rome, used as a market and a gathering place.
- Frieze In architecture, a horizontal band be-tween the *architrave* and the *cornice* that is often decorated with sculpture.
 Futurism An early twentieth-century style that portrayed modern machines and the dy-
- namic character of modern life and science.
- Genre painting Simple human representations; realistic figure painting that focuses on themes taken from everyday life.
- Geometric period A period of Greek art from about 900 to 700 BCE during which works of art emphasized geometric patterns.
- Greek cross plan A cross-shaped design, particularly of a church, in which the arms (nave and transept) are equal in length.

- Haniwa A hollow ceramic figure placed at an-cient Japanese burial plots.
- Hard-edge painting A contemporary style in which geometric forms are rendered with precision but with no distinction between foreground and background. Hellenism The culture, thought, and ethical
- system of ancient Greece.
- Herringbone perspective A portrayal of space in which orthogonal lines vanish to a spe-cific point along a vertical line that divides a canvas
- Hierarchical scaling The use of relative size
- Herarchical scaling The use of relative size to indicate the comparative importance of the depicted objects or people.
 Horizon In linear perspective, the imaginary line (frequently, where the earth seems to meet the sky) along which converging lines meet. Also see vanishing point.
- Horus The ancient Egyptian sun god. Hudson River School A group of nineteenth-century American artists whose favorite subjects included the scenery of the Hud-son River Valley and the Catskill Moun-tains of New York State. Hue Color; the distinctive characteristics of a color that enable us to label it (as blue or
- green, for example) and to assign it a place in the visible spectrum.
- Humanism A system of belief in which humankind is viewed as the standard by which all things are measured.
- Hypostyle In architecture, a structure with a roof supported by rows of piers or columns
- **Ibex** A wild goat. **Idealism** The representation of forms according to a concept of perfection. Illumination Illustration and decoration of a
- manuscript with pictures or designs. Illusionistic surrealism A form of surrealism
- that renders the irrational content, absurd juxtapositions, and changing forms of dreams in a highly illusionistic manner that blurs the distinctions between the real
- and the imaginary. Imam A prayer leader in a mosque; a religious and temporal ruler of a Muslim community or state.
- Impressionism A late nineteenth-century style characterized by the attempt to capture the fleeting effects of light by painting in short strokes of pure color.
- **Incise** To cut into with a sharp tool. **Installation** A work of art created for a spe-
- cific gallery space or outdoor site. Intarsia A style of decorative mosaic inlay. International Gothic style A refined style of painting in late fourteenth-century and early fifteenth-century Europe character-ized by splendid processions and courtly scenes, ornate embellishment, and attention to detail.
- International style A post-World War I school of art and architecture that used modern materials and methods and expressed the view that form must follow function
- Ionic order A moderately ornate Greek architectural style introduced from Asia Minor and characterized by spiral scrolls (volutes) on capitals and a continuous frieze.
- Jamb In architecture, the side post of a doorway, window frame, fireplace, etc.
- Ka figure According to ancient Egyptian be-lief, an image of a body in which the soul would dwell after death.
- Kore figure A clothed female figure of the Greek Archaic style, often adorned with intricate carved detail. A counterpart to the
- male kouros figure.
 Kouros figure The male figure as represented in the sculpture of the geometric and Ar-chaic styles (from the Greek for "boy").

Lapis lazuli An opaque blue, semiprecious stone.

- Latin cross plan A cross-shaped church design in which the nave is longer than the transept.
- Linear Determined or characterized by the use of line.
- Linear perspective A system of organizing space in two-dimensional media in which lines that are in reality parallel and horizontal are represented as converging diagonals. The method is based on foreshortening, in which the space between the lines grows smaller until it disappears, just as objects appear to grow smaller as they become more distant.
- Linear recession Depth as perceived through the convergence of lines at specific points in the composition, such as the horizon line.
- Lintel In architecture, a horizontal member supported by posts.
- Living rock Natural rock formations, as on a mountainside.
- Longitudinal plan A church design in which the nave is longer than the transept and in which parts are symmetrical against an axis. Contrast with central plan.
- Lunette A crescent-shaped space or opening (French for "little moon").

Magazine In architecture, a large supply chamber. Mandala In Hindu and Buddhist traditions, a

- circular design symbolizing wholeness or unity.
- Mannerist art A sixteenth-century, post-Renaissance style characterized by artificial poses and gestures, vividsometimes harsh—color, and distorted, elongated figures.
- Manuscript illumination Illustration or decoration of books and letters with pictures or designs

Medium The materials and methods used to create an image or object in drawing, painting, sculpture, and other arts (from Latin for "means").

- Megalith A huge stone, especially as used in prehistoric construction.
- Megaron A rectangular room with a twocolumned porch. Mesolithic Of the Middle Stone Age.

Metope In architecture, the panels containing

- relief sculpture that appear between the *triglyphs* of the Doric *frieze*.
- Middle Ages The thousand-year span (400 1400 CE) from the end of Roman Classical Art to the rebirth of Classical traditions in the Renaissance. Although this period is sometimes referred to as the Dark Ages, it was actually a time of important contributions to economics, science, and the arts.
- **Mihrab** A niche in the wall of a mosque that faces Mecca and thus provides a focus of worship.

Mimesis The practice of exact imitation in artistic representation.

- Minimal art Contemporary art that adheres to the Minimalist philosophy.
- Minimalism A twentieth-century style of nonobjective art in which a minimal number of visual elements are arranged in a simple fashion.

Modern architecture See modernism.

- Modernism A style of architecture that rejects classical models, deemphasizes ornamentation, and frequently uses strong, recently developed materials.
- Monolith A single, large block of stone; in sculpture, monolithic refers to a work that retains much of the shape of the original block of stone.
- Mortuary temple An Egyptian temple of the New Kingdom in which the pharaoh wor-shiped and was worshiped after death.

- Mosaic A medium in which the ground is wet plaster on an architectural element, such as a wall, into which small pieces (tesserae) of colored tile, stone, or glass are assembled to create an image.
- Muezzin Crier who calls Muslims to prayer five times a day from a minaret.
- Mural Image(s) painted directly on a wall or intended to cover a wall completely (from *muralis*, Latin for "of a wall").
 Mural quality A surface suitable for mural
- painting.
- Narthex A church vestibule that leads to the nave, constructed for use by the cate-chumens (individuals preparing to be baptized).
- Naturalism Representation that strives to imitate nature rather than to express intellectual theory
- Naturalistic style A style prevalent in Europe during the second half of the nineteenth century that depicted the details of ordinary life.
- Nave The central aisle of a church, constructed for use by the congregation at large
- Neoclassical style An eighteenth-century re-vival of Classical Greek and Roman art, characterized by simplicity and straight lines
- Neo-Expressionism A violent, figurative style of the second half of the twentieth century
- The second half of the twentieth century that largely revived the German Expressionism of the early twentieth century.
 Neolithic Of the New Stone Age.
 New image painting An art style of the second half of the twentieth century that sought to reconcile abstraction and representation through the use of simplified images to convey the grandeur of abstract shapes without dominating visual elements such as color and texture.
- New Objectivity (Neue Sachlichkeit) A post-World War I German art movement that rebelled against German Expressionism and focused on the detailed representation
- of objects and figures. Nirvana In Buddhist belief, a state of perfect blessedness in which the individual soul is absorbed into the supreme spirit.
- Nonobjective art Art that does not portray figures or objects; art without real models or subject matter.
- Oculus In architecture, a round window, par-
- ticularly one placed at the apex of a dome (from Latin for "eye").**Op Art** A style of art dating from the 1960s that creates the illusion of yibrations through afterimages, disorienting perspec-tive, and the juxtaposition of contrasting colors. Also called "optical art" or "optical painting."
- Optical Portrayal of objects as they are seen at the moment, especially depicting the play of light on surfaces. The painting of optical impressions is a hallmark of Impressionism. **Optical art** See *Op Art.*

- Oran A praying figure. Orthogonal Composed of right angles. Oxidizing phase See *black-figure painting*.
- Painterly Characterized by an openness of form, with shapes demarcated by variations in color rather than by lines or contours **Palatine chapel** A chapel that is part of a palace
- **Panel painting** A painting, usually in tempera but sometimes in oil, whose ground is a wooden panel.
- Pastoral Relating to idyllic rural life, especially of shepherds and dairymaids.
- Patrician A member of the noble class in ancient Rome.

- Pattern painting A decorative contemporary style that uses evocative signs, symbols, and patterns.
- Pediment In architecture, any triangular shape surrounded by cornices, especially one that surmounts the entablature of the portico facade of a Greek temple. The Romans frequently placed pediments without support over windows and doorways.
- Pendentive In architecture, a spherical triangle that fills the wall space between the four arches of a groin vault in order to provide a
- circular base on which a dome may rest. Peplos In Greek Classical Art, a heavy woolen
- wrap. **Piazza** An open public square or plaza. **Pictograph** A simplified symbol of an object or action; for example, a schematized or or action; for example, and schematized or abstract form of an ancestral image, animal, geometric form, anatomic part, or shape suggestive of a cosmic symbol or microscopic life.
- Picture plane The flat, two-dimensional surface on which a picture is created. In much Western art, the picture plane is viewed as
- a window opening onto deep space. **Pilaster** In architecture, a decorative element that recalls the shape of a structural pier. Pilasters are attached to the wall plane and project very little. They may have all the visual elements of piers, including base, shaft, capital, and entablature above
- Planar recession Perspective in which the illusion of depth is created through parallel planes that appear to recede from the picture plane.
- Plasticity Capacity of a material to be molded or shaped.
- Plebeian class In ancient Rome, the common people
- **Pointillism** A systematic method of applying minute dots of unmixed pigment to the canvas; the dots are intended to be 'mixed" by the eye when viewed. Also called "divisionism."
- Pop Art An art style originating in the 1960s that uses commercial and popular images and themes as its subject matter.
- Portico The entrance facade of a Greek temple, adapted for use with other build-ings and consisting of a colonnade, entab-lature, and pediment (from the Greek for porch").
- Postimpressionism A late nineteenth-century style that relies on the gains made by Im-pressionists in terms of the use of color and spontaneous brushwork but that employs these elements as expressive devices. The Postimpressionists, however, rejected the essentially decorative aspects of Impressionist subject matter.
- Postmodernism A contemporary style that arose as a reaction to Modernism and that returns to ornamentation drawn from
- Classical and historical sources. **Poussiniste** Referring to Neoclassical artists who took Nicolas Poussin as their model. Contrast with Rubeniste.
- **Prairie style** A style of architecture innovated by Frank Lloyd Wright early in the twenti-eth century and characterized by houses with low, horizontal lines that blended with their flat prairie sites, a central chimney, an open plan that allowed living spaces to flow together, and use of win-dows, doors, and decking to encourage the integration of interior space with sur-
- rounding terrain. **Prefabricate** In architecture, to build before-hand at a factory rather than at the building site.
- Pre-Hellenic Of ancient Greece before the eighth century BCE.
- Propylaeum In architecture, a gateway building leading to an open court in front of a

Greek or Roman temple; specifically, such a building on the Acropoli

- **Quatrefoil** In architecture, a design made up of four converging arcs that are similar in appearance to a flower with four petals.
- Radiating chapel An apse-shaped chapel, sev-
- Rationalism Chapter An appenshaped chapter, several of which generally radiate from the ambulatory in a Latin cross plan.
 Rationalism The belief that ethical conduct is determined by reason; in philosophy, the theory that knowledge is derived from the intellect, without the aid of the senses.
- Realism A style characterized by accurate and truthful portrayal of subject matter; a
- nineteenth-century style that portrayed subject matter in this manner. **Rectangular bay system** A church plan in which rectangular bays serve as the basis for the overall design. Contrast with *square* schematism.
- Reducing phase See *black-figure painting*. Reformation A social and religious movement of sixteenth-century Europe in which various groups attempted to reform the Roman Catholic Church by establishing rival religions (Protestant sects).
- Register A horizontal segment of a structure or work of art. Relative size The size of an object or figure in relation to other objects or figures or the setting.
- **Renaissance** A period spanning the fourteenth and fifteenth centuries CE in Europe. The Renaissance (French for "rebirth") rejected medieval art and philosophy; it first turned to Classical antiquity for inspiration and then developed patterns of art and philoso-phy that paved the way toward the modern world
- **Reoxidizing phase** See *black-figure painting*. **Representational art** The kind of art that presents natural objects in recognizable
- Republican period The Roman period lasting from the victories over the Etruscans to the death of Julius Caesar (527–509 BCE).
- Rococo An eighteenth-century style during the Baroque era that is characterized by lighter colors, greater wit, playfulness, oc-casional eroticism, and yet more ornate decoration
- Romanticism A nineteenth-century movement that rebelled against academic Neoclassicism by seeking extremes of emotion as enhanced by virtuoso brushwork and a brilliant palette.
- Rosette A painted or sculpted circular ornament with petals and leaves radiating from the center.
- **Rose window** A large circular window in a Gothic church, assembled in segments that resemble the petals of a flower, usually adorned with stained glass and plantlike ornamental work.
- Rubeniste Those Romantic artists who took Peter Paul Rubens as their model. Contrast with Poussiniste.
- Salon An annual exhibition of the French Academy held in the spring during the eighteenth and nineteenth centuries. Salon d'Automne An independent exhibition

of experimental art held in the autumn of 1905; named the "Salon of Autumn" to distinguish it from the Academic salons that were usually held in the spring. **Sarcophagus** A coffin or tomb, especially one

made of limestone.

- Saturation The degree of purity of hue mea-
- sured by its intensity or brightness. **S curve** Developed in the Classical style as a means of balancing the human form, con-sisting of the distribution of tensions so that tension and repose are passed back and forth from one side of the figure to the other, resulting in an S shape. Also referred to as contrapposto.
- Seal A design of stamp placed on a document as a sign of authenticity.
- Shade The degree of darkness of a color determined by the extent of its mixture with black.
- **Shaft grave** A vertical hole in the ground in which one or more bodies are buried.
- Shaped canvas A canvas that departs from the traditional rectangle and often extends the work into three-dimensional space, thus challenging the traditional orientation of a painting.
- Shinto A major religion of Japan that empha-sizes nature and ancestor worship.
- Shiva The Hindu god of destruction and regeneration.
- Slip In ceramics, clay that is thinned to the consistency of cream for use in casting, decorat-
- ing, or cementing. Square schematism A church plan in which the crossing square serves as the basis for determining the overall dimensions of the building. Contrast with rectangular bay
- system. Steel-cage construction A method of building that capitalizes on the strength of steel by piecing together slender steel beams to form the skeleton of a structure.
- Stele (or stela) An engraved stone slab or pillar that serves as a grave marker. Stoicism The philosophy that the universe is
- governed by natural laws and that people should follow virtue, as determined by reason, and remain indifferent to passion or emotion.
- Stroboscopic motion The creation of the illusion of movement by the presentation of a rapid progression of stationary images, such as the frames of a motion picture.
- Stupa A dome-shaped Buddhist shrine. Stylobate A continuous base or platform that
- supports a row of columns.
- Subject matter The figures or objects depicted in a work of art; the "story" being told. Surrealism A twentieth-century art style
- whose imagery is believed to stem from unconscious, irrational sources and that therefore takes on fantastic forms. Although the imagery is fantastic, it is often rendered with extraordinary realism.
- Synthetic Cubism The second phase of Cubism, which emphasized the form of the object and constructing rather than disin-
- tegrating that form. Synthetism Gauguin's theory of art, which advocated the use of broad areas of unnatural color and primitive or symbolic subject matter.

- Tenebrism A style of p ainting in which the artist goes rapidly from highlighting to
- deep shadow, using very little modeling. Texture gradient The relative roughness of nearby and distant objects in two-dimensional media; nearby objects are usually rendered with more detailed and rougher surfaces than distant objects. Tholos In architecture, a beehive-shaped tomb.
- Tint The lightness of a color as determined by the extent of its mixture with white. Transept The "arms" of a Latin cross plan, used by pilgrims and other visitors for ac-cess to the area behind the crossing square.
- Transverse rib In architecture, a rib that connects the midpoints of a groin vault.
- Tribune gallery In architecture, the space between the nave arcade and the clerestory that is used for traffic above the side aisles on the second stage of the elevation.
- **Triforium** In a church, a gallery or arcade in the wall above the arches of the nave, transept, or choir.
- Triglyph In architecture, a panel incised with vertical grooves (usually three; hence, triglyph) that serve to divide the scenes in a Doric frieze
- Trompe l'oeil A painting or other art form that creates such a realistic image that the viewer may wonder whether it is real or an illusion (from French for "fool the eye").
- Tympanum Semicircular space above the doors of a cathedral.
- Vanishing point In linear perspective, a point on the horizon where parallel lines appear to converge.
- Venus The Roman goddess of beauty; a pre-historic fertility figure, such as the Venus of Willendorf.
- Venus pudica A Venus with her hand held over her genitals for the sake of modesty. Video art Works that use a video screen or an assemblage of screens or monitors; images shown on video monitors.
- Visitation In Roman Catholicism, the visit of the Virgin Mary to Elizabeth; a church feast commemorating the visit.
- Visual elements Elements, such as line, shape, color, and texture, that are used by artists to create imagery. Also termed plastic elements.
- Volute In architecture, a spiral scroll orna-menting an Ionic or Corinthian capital. Volute krater A wide-mouthed vessel (krater) with scroll-shaped handles.
- Warm colors Colors-reds, oranges, and yellows-that appear to be warm and to ad-vance toward the viewer. Contrast with cool color.
- Weight-shift principle The situating of the human figure so that the legs and hips are turned in one direction and the chest and arms in another. This shifting of weight re-sults in a diagonal balancing of tension and relaxation. See contrapposto.
- **Ziggurat** A temple tower in the form or a ter-raced pyramid, built by ancient Assyrians and Babylonians.

INDEX

The bold page numbers indicate photographs or artwork.

Abbey Church of St. Michael at Hildesheim (Germany), 85, 85, 88, 92 Abstract art, 7 Abstract Expressionism, 260-71 Abstract sculpture, contemporary, 283-85, 288 Abu Temple statues (Sumerian), 22, 23, 52 Academic art, 194-96, 208 Academic Salons, 228 Academie Royale de Peinture et de Sculpture (Paris), 194 Academy of Fine Arts (Madrid), 251 Acropolis, 55 Action painting, 263 Adam and Eve (Dürer), 106, **107** Adam and Eve Reproached by the Lord (Ottonian), 88, 88 Aegean art, 36-41 Aeschylus, 46 African art/sculpture, 160-65, 233, 234 Afterimage, 241 Agony and the Ectasy, The, 119 Akhenaton, King of Egypt, 35 Akhenaton (Egypt): pillar statue of, 34; reign of, 32, 34-36 Akkadian art, 24-25 Albers, Josef, 260, 271 Alberti, Leone Battista, 101, 116; Palazzo Rucellai, 115, 115 Aldred, Cyril, 35 Alexander the Great, 26, 42, 60, 175 Alighieri, Dante, 107, 130 Alloway, Lawrence, 271 Altar, 79 Altar of the Hand (Benin), 160-61, 161 Alternate a-b-a-b support system, 91 Alternate support system, 88 Amarna period, 33, 36 Amarna Revolution, 32-36 Amasis Painter (Greece), 48, 48 Ambulatory, 80, 85, 88, 89 Amen-Re, Temple of (Egypt), 34 Amenhotep IV (Egypt), 32. See also Akhenaton, reign of America. See also United States: artists in, 217-18, 220; neoclassicism and, 188 American Gothic (Wood), 1, 5, 5-7, 257 American Institute of Architects, 307 Amorous Couple (Mayan), 4 Amphitheaters, 67 Analytic cubism, 234-35, 237, 244 Ancestor poles (New Guinea), 166-67, 167 Ancestral couple (Dogon), 164-65, 165 Ancestral figure (Kongo), 164, 164 Ancient art, 17–44 And They Are Like Wild Beasts (Goya), 286, 287. 287 Angel (Salle), 313, 313 Annunciation scene (Reims Cathedral), 98, 99 Annunciation to the Shepherds, The, Lectionary of Henry II, 92, 93 Anthemius of Tralles: Hagia Sophia, 81, 81 - 82Antoinette, Marie, 8

Antonius and Faustina in the Forum, Temple of (Rome), 74, 74 Aphaia, Temple of (Greece): Dying Warrior, 51, 51; Fallen Warrior, 51, 51-52 Aphrodite of Melos (Venus de Milo) (Greece), 36. 61. 61. 224 Apocalypse, 98 Apoxyomenos (Lysippos), 59, 59–60 Apse, 79, 79, 88, 89, 91, 97 Aqueduct, 66 Ara Pacis (Altar of Peace), 71, 71 Arbol de la Vida (Tree of Life), no. 294 (Mendieta), 290, 290 Arc de Triomphe (Paris), 224 Arch of Constantine (Rome), 67, 67 Archaic period, in Greece, 47, 49-53, 54, 61,62 Archipenko, Alexander, 237-38; Walking Woman, 238, 238 Architectural Style, 65, 66 Architrave, 50 Archivolts, 98 Argonaut Krater (Niobid Painter), 58, 58 Armory Show (New York), 243 Arp, Jean, 250 Arrangement in Black and Gray: The Artist's Mother (Whistler), 217, 217, 224 Art history: defined, 2 Art Institute of Chicago, 256, 257 Art Nouveau, 220-21 Art photography, modern art and, 207 Art Students League, 263, 266, 267 Art Tour of Chicago, 254 Artaxerxes II, 26 Artist in the Character of Design Listening to the Inspiration of Poetry, The (Kauffman), 187, 187-88 Assyrian art, 26 Athena: defined, 55 Atmospheric perspective, 14 Atrium, 79, 79 AT&T Building (Burgee Architects with Philip Johnson) (New York City), 304. 304 Attic Lekythos vessel (Greece), 48 Au Naturel (Lucas), 309 Augustus, Roman emperor, 63, 66, 71, 71 Augustus of Primaporta (Rome), 71, 71 Automatic writing, 251 Automatist Surrealism, 251, 253, 261, 263 Avante-garde: defined, 199 Aztecs, 169, 169, 171 Babylonian art, 25–26 Baciccio: Triumph of the Sacred Name of Jesus, 141, 141 Bacon, Francis: Head Surrounded by Sides of Beef, 270, 270 Balance: defined, 14 Balcony, The (Manet), 204 Baldacchino (Rome), 75 Balla, Giacomo: Street Light, 238-39,

239. 316

Balloonframe construction, 256

Bamboo (Li K'an), 179, 179-80, 182

Ban, Chinatsu: VWX Yellow Elephant, 317

152, 152 Barber of Sevilli, The (Rossini), 131 Bargello, The (Florence), 131 Bargueño, 170, 170 Barney, Matthew, 307-8; Cremaster 2, 308. 308 Baroque period, 133-55; defined, 134, 144; in England, 152-53; in Flanders, 146-47; in France, 150-51; in Holland, 147-49; in Italy, 134-44; postimpressionism and, 208; Rococo and, 153-55; in Spain, 144-46 Barrel vault, 90, 91 Bartlett, Jennifer, 275; Spiral: An Ordinary Evening in New Haven, 276, 277 Basalt, 25 Basketry: in Greece, 48 Basquiat, Jean-Michel: Melting Pot of Ice, 280, 280 Bauhaus, The, 253-54 Bayeux, Cathedral of, 93 Bayeux Tapestry, 93, 93 Bearden, Romare: Prevalence of Ritual: Mysteries, 267, 267 Beaux Arts (Chicago), 256 Beckmann, Max: Departure, 232, 232 Bed, The (Rauschenberg), 271, 272 Beecroft, Vanessa, 307; VB43, 308, 308 - 9Beehive tomb, 40 Beijing Stadium (China), 69 Belvedere Torso (Greece), 75 Benin people: Altar of the Hand, 160-61, 161 Benton, Thomas Hart, 263 Berlin Museum: extension of, 306, 306 Bernini, Gianlorenzo, 135-39, 150; David, 122-23, 123, 138; Ecstasy of St. Theresa, 138, 138-39; piazza of St. Peter's, 135, 135, 136, 136, 138 Bester, Willie: Semekazi (Migrant Miseries), 10, 11, 11 Bethesda Fountain (New York), 317 Beveled: defined, 39 Bible Quilt: The Creation of the Animals (Powers), 219, 219 Big Ben (London), 156, 156 Bingham, George Caleb, 257 Bird in Space (Brancusi), 246, 246, 316 Birnbaum, Dara: Hershman and, 300; PM Magazine, 296-97, 297 Birth of Venice, The (Botticelli), 114, 114 - 15Black-figure painting, 49 Blake, Jeremy: Winchester, 299-300, 300 Blue, Orange, Red (Rothko), 265, 265-66 Blue Movie (Warhol), 273 Blue Period, 233 Blue Room, The (Valadon), 200, 201, 201 Boating Party, The (Cassatt), 216, 216 Boboli Gardens (Florence), 131, 131 Boccioni, Umberto: Dynamism of a Soccer Player, 238, 240, 241; motion and, 239; Unique Forms of Continuity in Space, 238, 239, 316

Banqueting House at Whitehall (Jones),

Bonheur, Rosa: Horse Fair, 199, 202, 202 Book of Hours, 103 Borghese, Pauline, 188 Borromini, Francesco: San Carlo alle Ouatro Fontane, 144, 144; Wren and, 153 Botticelli, Sandro: Birth of Venice, 114, 114-15; Michelangelo and, 120 Bottle of Suze (Picasso), 236, 236 Bouguereau, Adolphe William: Matisse and, 228; Nymphs and Satyr, 195, 195 Bourgeois, Louise, 259 Bourke-White, Margaret: Living Dead of Buchenwald 274 Brady, Mathew, 207 Bramante, Donato, 116, 135 Brancusi, Constantin, 243, 245-46; Bird in Space, 246, 246, 316; Kiss, 5, 7, 7 Braque, Georges, 234-35, 236, 243; Gorky and, 261; Portugese, 235, 235 Breton, Andre, 251, 253 Breuer, Marcel: tubular steel chair, 254, 254; Whitney Museum of American Art, 254, 275, 284, 316, 317 Bridge in the Rain (van Gogh), 182, 183 Brightness gradient, 14 British Airways London Eye (London), 157 British Museum, 57, 157, 157 Broadway (New York), 316 Brody, Sherry: Doll House, 288-89, 289 Bronzino: Venus, Cupid, Folly, and Time (The Exposure of Luxury), 10, 11, 11 Brooks, James, 260 Bruegel, Pieter the Elder: Peasant Wedding, 128. 128 Brunelleschi, Filippo, 109-10, 111, 130; Florence Cathedral dome, 112; Sacrifice of Isaac, 110 "Brutalism," 301–2 Buckingham Palace (London), 157 Buddha, 175–76 Buddha Calling on the Earth to Witness (India), 176, 176 Buddhism, 175, 178, 180 Bunshaft, Gordon: Lever House, 301, 303, 303, 304, 317 Buonarroti, Michelangelo. See Michelangelo Burgee Architects: AT&T Building, 304, 304 Burghers of Calais, The (Rodin), 220, 220 Burial of Count Orgaz, The (Greco), 127, 127-28 Burnham and Root: Monadnock Building, 256, 256 Burnt Piece (Winsor), 288 Bursts series (Gottlieb), 266 Butterfield, Deborah, 282-83; Horse #6-82, 283. 283 Byzantine art, 79-82, 85, 109 Cabrera, Miguel, 231; Castas, 170, 170 Calatrava, Santiago: Ground Zero trans-

Bona Lisa (Lee), 248-49, 249

Caldrava, Santago, Ground Zeto Hansportation hub, 307; South Street residential tower, 307, **307** Calder, Alexander, 257, 283; Untitled, 284, 284

Callicrates: Parthenon, 55, 55 Calvary (Jerusalem), 43, 43 "Cambios" exhibition, 170 Cambrensis, Giraldus, 83 Cameron, Julia Margaret, 207 Campin, Robert: Merode Altarpiece, 104, 104-5, 112 Canada: native art of, 172-73 Canoe prow (Maori), 166, 166 Canon of proportions, 31 Canova, Antonio, 188; Pauline Borghese as Venus, 189 Canvas, shaped, 268, 277–78 Capital: defined, 50 Caravaggio: Conversion of St. Paul, 139, 139-40; Dying Gaul, 74; head of Constantine, 74; Judith and Holofernes, 140, 140-41; St. John the Baptist, 74; Velázquez and, 144 Cardo (Jerusalem), 43 Carolingian art, 84-85, 88 Carpet page: Lindisfarne Gospels, 83, 83 Carson Pirie Scott department stores (Chicago), 256 Carter, Howard, 34, 36 Carving: in Greece, 58; Olmec, 167; of Period of Recognition, 79 Casa Mila Apartment House, Barcelona (Gaudi), 221, 221 Cassatt, Mary, 217; Boating Party, 216. 216 Cast iron, 222 Castas (Cabrera), 170, 170 Castel Sant'Angelo (Rome), 75, 75 Catacomb, 78-79; di Priscilla (Rome), 78, 78; of Sts. Pietro/Marcellino, Good Shepherd, The, 78, 78, 79 Catacomb di Priscilla (Rome), 78, 78 Cataract 3 (Riley), 241, 241 Cathedral of Bayeux, 93 Cathedral of Notre Dame (France), 96, 96, 98, 225, **225** Cathedral of Saint-Lazare (France), 92, 92 Cathedral of St. Étienne (France), 91, 91, 92.95 Cathedral of St. John the Divine (New York), 316-17 Catlett, Elizabeth: Harriet, 286-87, 287 Cave of Addaura (Italy), Ritual Dance cave painting, 20 Cave paintings: Stone Age, 18 Ceiling decoration, Baroque, 141 Ceiling painting, Renaissance, 141 Ceiling structure, 90, 95 Ceiling vault, 91 Cella, 49 Central Library (Koolhaas) (Seattle), 306, 306-Central Market (London), 157 Central Park (New York), 316, 317; Gates, Central Park, New York, 294, 294-95, 295 Central Souk (Jerusalem), 43 Ceramic portrait jar (Peru), 171, 171 Ceramics: in Chinese art, 179; in Japanese art, 180; in Peru art, 171 Ceremonial vessel (Guang), 178, 178 Cézanne, Paul, 210-11, 243, 244; Cubism and, 232-33, 235; Fauvism and, 229; Gorky and, 261; Miró and, 252; Modern Olympia, 193, 193; New York and, 316; Picasso and, 233, 234; Still Life with Basket of Apples, 210, 211, 257 Cézanne Still Life #5 (Segal), 281, 281-82 Chaillot Hill (Paris), 224 Chair, tubular steel (Breuer), 254, 254 Champs-Élysées (Paris), 224 Chantilly (Paris), 224 Chartres Cathedral (France), 96, 96–97, 98, 98, 224 Chevreul, Michel-Eugène, 209 Chiaroscuro, 14, 114, 117, 120, 125, 198 Chicago: art tour, 256-57

Chicago, Judy: Dinner Party, 289, 289, 291; "Menstruation Bathroom," 288; Schapiro and, 288-89: Womanhouse, 288-89. 289 Chicago Cultural Center (Chicago), 256 Chicago Theatre (Chicago), 256 Chichen-Itzá, Maya palaces of, 260 Chinese art, 178-80, 260 Chippendale, Thomas, 304 Chirico, Giorgio de: Mystery and Melancholy of the Street, 247, 247, 250 Christian art, 77-99. See also Christianity Christianity. See also Christian art: in Jerusalem, 42, 43; Roman Empire and, 46,73 Christo, 283, 291; Gates, Central Park, New York, 294, 294-95, 295; Running Fence, Sonoma and Marin Counties, California, 295; Surrounded Islands, Biscayne Bay, Greater Miami, Florida, 295; Wrapped Reichstag, Berlin, 295 Chrysler Building (New York), 317 Church of San Vitale (Ravenna), 80, 80, 84, 85, 109 Church of Santa Maria della Vittoria (Rome), 138 Church of St. Sernin (France), 89, 89-91 Church of the Holy Sepulchre (Jerusalem), 43, 43 Church of the Holy Wisdom (Istanbul), 81. See also Hagia Sophia (Istanbul) Cimabue, 107-9; Madonna Enthroned, 108, 108-9 Cinerary urns, 62 Citadel (Jerusalem), 43 Cité des Dames (de Pisan), 288 Classical art, 45-75 Clementine Hall (Rome), 136, 137 Clerestory, 91, 96, 97 Cloisters, The (New York), 316 Coates, Robert M., 260 Coatlicue, Statue of (Aztecs), 169, 169, 171 Coffered, 70 Cole, Thomas: Oxbow, 218, 218, 220 Collages: Cubism and, 236; iconography and, 10 Colonnades, 32 Color: defined, 12 Color field, 265-66, 268; gesture and, 266-67; Op Art and, 275 Color-field painters/painting, 268-69 Color wheel, 12-13 Colossal Buddha (Afghanistan), 176, 176 Colossal head (Olmec), 167, 167-68 Colosseum (Rome), 67-69, 68, 74, 74-75, 75, 115, 257 Column (Gabo), 244, 244, 305 Combine painting, 271 Competition: in Renaissance, 109-12 Composition with Red, Blue, and Yellow (Mondrian), 244, **245** Compound piers, 91 Conceptual artists, 14-15 Conceptual space, 178 Conceptually: defined, 196 Confucianism, 178 Congo: Nkisi nkondi (hunter figure), 164. 164 Constantine: Roman emperor, 42, 43, 72-75, 77, 79, 81 Constantine, Arch of (Rome), 74 Constructivism, 244-46 Contemporary abstract sculpture, 283-85, 288 Contemporary art, 259-315 Contemporary figurative sculpture, 281-83 Content: defined, 10 Contrapposto, 99, 113 Conversion of St. Paul, The (Caravaggio), 139, 139-40 Cool colors, 13, 14

Cooper-Hewitt National Design Museum (New York), 316

Copley, John Singleton: Portrait of Paul Revere, 155, 155 Corbelled vaults, 168 Corinthian order, 49, 50, 50, 67, 70, 75, 115 Cormorant or Duck figurine (Stone Age), 20, 20 Cornice, 50, 223 Coronation Gospels (Gospel Book of Charlemagne), 86, 86-87 Cosmetic palette, 29 Courbet, Gustave, 196, 197, 199, 224, 227; Stone-Breakers, 197, 197; Whistler and, 217 Covent Garden piazza (London), 157 Creation of Adam, The (Michelangelo), 120, 121 Cremaster 2 (Barney), 308, 308 Crossing, The (Viola), 297, 297 Crossing square, 88, 89, 91, 112 Crow people: Custer's Last Stand, 172, 173; headdresses, 173 Crucifixion, The (Grünewald), 106, 106 Crusades, 42, 43, 89 Crystal Palace (Paxton) (London), 222, 222 Cubi Series (Smith), 283, 283 Cubism, 232-38, 242, 243; analytic, 234-35, 237, 244; Deconstructivist architecture and, 304; Duchamp and, 250; Hofmann and, 261, 262; Mondrian and, 244; New York School and, 260; nonobjective art and, 244; sculpture of, 236-38; synthetic, 236 Cubist grid, 235 Cubist sculpture, 236-38 "Cubo-Realists," 243 Cuneiform, 22, 25 Custer's Last Stand (Crow people), 172, 173 Cycladic idol, from Amorgos, 37 Cyrus (Persia), 26 Dada, 246, 249, 250-51 Daguerre, Jacques-Mande, 206 Daguerreotype, 206 Dalí, Salvador: Persistence of Memory, 251, 251-52, 316 Damascus Gate (Jerusalem), 42 Dance around the Golden Calf (Nolde), 230, 230 - 31"Dark Ages," 46, 82, 83. See also Middle Ages Das Staatliche Bauhaus, 253 Daumier, Honoré: Third-Class Carriage, 196, 196 David, Jacques-Louis: Ingres and, 195; Intervention of the Sabine Women, 310, 310; Mondrian and, 245; neoclassicism and, 186-87; Oath of the Horatii, 8, 8-9, 186, 186–87, 224; space and, 186 David (Bernini), 122-23, 123, 138 David (Donatello), 110, 111, 113, 121, 122, 122-23, 138 David (Michelangelo), 74, 121, 122-23, 123, 130, 131, 138 David (Verrocchio), 112, 113, 121, 122, 122-23, 138 Davis, Stuart, 260, 261 de Beauvoir, Simone: Second Sex, 286 de Kooning, William, 2, 260, 264-65; figurative painting and, 269; Gorky and, 261; Two Women, 265, 265; Women series, 269 de Pisan, Christine: Cité des Dames, 288 De Stijl, 244 Death of Sardanapalus, The (Delacroix), 190-91, 191, 224 Deconstructivist architecture/architects, 244, 304-7 Degas, Edgar, 182, 205-6, 214; Cassatt

and, 216; Chicago and, 257; New York and, 316; Rehearsal, 205, 206 Dein Goldenes Haar, Margarethe (Kiefer),

278-79, 279

Delacroix, Eugène, 188, 194, 225, 243; Death of Sardanapalus, 190-91, 191, 224; Liberty Leading the People, 286, 286-87; Odalisque, 190, 192, 192-93 Deleuze, Gilles, 159 Demuth, Charles: My Egypt, 243, 243 Departure (Beckmann), 232, 232 Deportation Memorial, 225 Depth: illusion of, 13 Der Blaue Reiter (The Blue Rider), 230, 231, 246 Derain, André: London Bridge, 228, 228, 316; Matisse and, 229 Derrida, Jacques, 304 Deux Magots (Paris), 225 Diagonal ribs, 91 Diagonal (Rothenberg), 276, 277 Dialogue with Mona Lisa (Odutokun), 248-49.249 Die Brücke (The Bridge), 230-31 Digital art, 298-300 Digital Venus (Hershman), 300, 300 Dinner Party, The (Chicago), 289, 289, 291 Dipylon krater, 58 Dipylon Vase (Greece), 47, 47, 49 Disasters of War (Goya), 287, 287 Diskobolos (Discus Thrower) (Myron), 54, 54 Disneyland Paris, 224 Divine Comedy, The (Alighieri), 130 Dogon people: ancestral couple, 164-65, 165 Doll House (Brody and Schapiro), 288-89, 289 Dome of the Rock, The (Jerusalem), 42, 42, 43 Donatello, 116, 131; David, 110, 111, 113, 121, 122, 122-23, 138; Verocchio and, 113 Dorians, 39, 41 Doric order, 49-50, 50, 55, 56, 67, 75, 115 Doryphoros (Spear Bearer) (Polykleitos), 57, 57,71 Dragon (Pfaff), 284, 284 Duchamp, Marcel: contemporary art and, 260; Fountain, 250, 272; Hamilton and, 271; Johns and, 272; Mona Lisa (L.H.O.O.Q.), 248, 248-49, 250, 272; Nude Descending a Staircase #2, 240, 240, 243, 250 Duomo (Florence), 130, 131 Durant, Will, 227 Dürer, Albrecht: Adam and Eve, 106, 107; Rubens and, 146 Dying Gaul, The (Greece), 60, 60-61, 74 Dying Lioness from Nineveh, The (Assyrian), 26, 26 Dying Warrior, Temple of Aphaia (Greece), 51, 51 Dynamism, 238, 240 Dynamism of a Soccer Player (Boccioni), 238, 240, 241 Eakins, Thomas: Gross Clinic, 217, 217-18; Man Pole Vaulting, 240, 240 Early empire, in Rome, 66-67, 69-72 Early Minoan period, 37 Easter Island stone figures, 166, 166 Easter Lilies (Krasner), 264, 264 Eastern Orthodox church, 81 Easy to Remember (Simpson), 314, 314 Ebbo Gospels (Gospel Book of Archbishop Ebbo of Reims), 86, 86-87, 88 Ecstasy of St. Theresa, The (Bernini), 138, 138 - 39Effigy vessel (Mexican), 168, 168 Egyptian art, 27-36; Akhenaton/Nefertiti reign in, 32, 34-36; Armana Revolution in, 32-36; Greece and, 46-47; Middle Kingdom, 31; New Kingdom, 31-32; Old Kingdom, 27-31;

Tutankhamen and, 33

Eidos Interactive: Lara Croft, 200, 201, 201 Eiffel, Gustave: Eiffel Tower, 222, 222, 224, 224 Eiffel Tower (Eiffel) (Paris), 222, 222, 224, 224 89 Seconds at Alázar (Sussman), 311, 311 El-Aqsa Mosque (Jerusalem), 42-43 Ellison, Ralph, 267 Embroidery: in Middle Ages, 48 Emphasis: defined, 14 Empire period, 66 Empire State Building (New York), 317 England: Art Nouveau in, 221; Baroque period in, 144, 152-53; neoclassicism and, 188 Engraving after Raphael's The Judgment of Paris (Raimondi), 199 Enlightenment: in Baroque period, 54-55 Entablature, 50 Entasis, 56 Entombment (Pontormo), 128-29, 129 Ephemeral art, 291 Equestrian portrait, 72 Ernst, Max: Two Children Are Threatened by a Nightingale, 250, 250, 316 Escobar, Marisol. See Marisol Eskimo mask, 171, 172, 173 Ethnographic art, 234 Etoumba mask, 162, 163, 163 Etruscans, 61–64 Euclid, 46 Europe: abstraction in, 244-46 Evans, Arthur, 37 Evaristti, Marco: Ice Cube Project, 293, 293 Existentialist expressions: in Kokoschka, 5 Expatriates, American, 216–17 Exploded Piece (before and after) (Winsor), 288, 288 Expressionism/expressionistic, 214-16, 230-32, 242, 260, 263; defined, 7; Der Blaue Reiter (The Blue Rider), 231; Die Brücke (The Bridge), 230-31; New Objectivity, The (Neue Sachlichkeit), 232 Expressionist Image: American Art from Pollock to Now, The (New York), 292 Fag Show, The (Lucas), 312, 312 Fallen Warrior, Temple of Aphaia (Greece), 51, 51-52, 60 Fan K'uan: Travelers among Mountains and Streams, 178, 178-79 Fantastic art/fantasy, 246-47, 250, 253 Farnsworth House (Miës van der Rohe), 254, 301, 302, 302-3 Fauvism/fauvist, 228-30, 231, 232, 235, 261.262 Federal Art Project of the WPA, 260 Feingold, Ken, 307; If / Then, 309, 309 Feminist art, 286, 288-91 Fertile Crescent, 27 Fertile Ribbon, 27 Fetish figures, 164 Feudalism, 89 Field Museum (Chicago), 257 Fifteenth-century northern painting, 102-7 Figurative art, 6 Figurative painting, 265, 269-70 Figurative sculpture, 50, 54, 62, 281-83 Fine Arts Project, 2 Fireproofing, in Romanesque architecture, 89 Fischl, Eric: Visit To / A Visit From / The Island, 279, 279-80 Flack, Audrey, 273-74; World War II (Vanitas), 274, 274 Flanders: Baroque period in, 144, 146-47; Renaissance in, 102-6; van Eyck and, 121 Flemish painting, 102-6 Florence: art tour, 130-31; competition in, 109; "Davids" and, 122; Early Renais-

sance in, 107; High Renaissance and, 116; Titian and, 124; Venice and, 124 Florence Cathedral (Italy), 97, **97**, 98, 112 Flying buttresses, 96, 98 Focal point: defined, 14 Fontainebleau (Paris), 224 Foreshortening, 18, 25 Forget It, Forget Me! (Lichtenstein), 4, 5 Form: defined, 10 Fort Tryon Park (New York), 316 Fortuna Virillis, Temple of (Rome), 64, 65 Forums, 73 Fountain (Duchamp), 250, 272 Fragonard, Jean-Honoré, 204; Happy Accidents of the Swing, 153, 153 France: Baroque period in, 144, 150-51; neoclassicism and, 188 Francois I: Palais du Louvre, 224 Francois Vase (Kleitias), 49, 49, 50, 58 Frankenthaler, Helen: Lorelei, 268, 268 Frick Collection (New York), 316 Frieze, 50, 56, 64 Funerary mask, from Grave Circle A (Mycenae), 40-41, 41 Futurism, 238-42, 243, 244 Futurist obsession, 240 Gabo, Naum: Column, 244, 244, 305 Gaddi, Taddeo, 131 Gagosian Gallery (London), 308 Gainsborough, Thomas: Mrs. Richard Brinsley Sheridan, 155, 155 Galleria degli Uffizi (Florence), 130, 130 Galleria dell'Accademia (Florence), 131 Garden of Gethsemane, The (Jerusalem), 42, 42 Gardner, Alexander: Home of a Rebel Sharpshooter, Gettysburg, 207, 207 Gare d'Orsay (Paris), 224 Gates, Central Park, New York, The (Christo and Jeanne-Claude), 294, 294-95, 295 Gaudi, Antonio: Casa Mila Apartment House Barcelona, 221, 221 Gauguin, Paul, 214, 243; Derain and, 228; expressionism and, 230, 232; Kandinsky and, 231; Te Arii Vahine (The Noble Woman), 200-201, 201; Vision after the Sermon (Jacob Wrestling with the Angel), 213. 213 Gehry, Frank: Guggenheim Museum, 305, 305; Pritzker Pavilion for Millennium Park, 257, 257 Genre painting, 105, 128 Gentileschi, Artemisia: Judith Decapitating Holofernes, 140, 140-41; Susannah and the Elders, 142-43, 143 Geometric period, in Greece, 46-47, 49.61 Georges Pompidou National Center of Art and Culture (Paris), 225 Georgia O'Keeffe Museum (New Mexico), 243 Geralda of Seville, 260 Géricault, Théodore: Raft of the Medusa, 188, 189-90, 190, 224 German art, 106, 107 Gerowitz, Judy. See Chicago, Judy Gesture, 262-67 Getaway #2 (Oursler), 297-98, 298, 316 Ghiberti, Lorenzo, 109-10, 112, 115, 130; Sacrifice of Isaac. 110 Ghirlandaio, Domenico, 121 Giotto, 107-9, 114, 116, 131; Bacon and, 270; Madonna Enthroned, 108, 109 Giovane, Palma il, 124 Giovanni Arnolfini and His Bride (van Eyck), 105, 105-6 Gizeh, pyramids in, 30, 31, 33 Glaber, Raoul, 89 Glazing: Titian and, 125 Glimcher, Arnold, 292, 292

Global Groove (Paik), 296, 296

Globalization, 159

Gold work: in Aegean art, 40-41 "Golden Age": in Greece, 46, 54, 167, 178; in Spain, 170 Golden Wall, The (Hofmann), 262, 262 Golgotha (Jerusalem), 43 Good Shepherd, The: Catacombs of Sts. Pietro/Marcellino, 78, 78, 79 Gorky, Arshile, 260; de Kooning and, 264; Liver Is the Cock's Comb, 261, 261 Gospel Book of Archbishop Ebbo of Reims, 86, 86-87 Gospel Book of Charlemagne, 86, 86-87 Gothic art/Gothicism, 90, 91, 93, 95-99, 102, 109 Gottlieb, Adolph: Bursts series, 266; Green Turbulence, 266, 266-67 Goya, Francisco, 191, 243; Disasters of War, 287, 287; Klee and, 246; And They Are Like Wild Beasts, 286, 287, 287; Third of May, 194, 194 Grande Odalisque (Ingres), 188, 190, 192, 192 - 93Grant Park (Chicago), 257 Grant Park Symphony (Chicago), 257 Grave Circle A Funerary mask (Mycenae). 40 - 41.41Graves, Nancy: Tarot, 284-85, 285 Great Pyramids at Gizeh (Egyptian), 30, 31 Great Stupa, The (India), 175, 175 Great Wall of China, 257 Greco, El: Burial of Count Orgaz, 127, 127-28; Picasso and, 233 Greco-Roman art, 63 Greece, 45-62; Archaic period in, 47, 49-53; classical art in, 54-58; early classical art in, 54; Etruscans and, 61-62; Geometric period in, 46-47; hellinistic art in, 60-61; late classical art in, 58-60; Rome and, 63, 64, 66; School of Athens and, 118; women weavers in, 48 Greek cross plan, 82, 135 Greek Revival style, 45 Green Coca-Cola Bottles (Warhol), 273 273 Green Turbulence (Gottlieb), 266, 266-67 Gropius, Walter: Breuer and, 254; Shop Block, 253, 253 Gross Clinic, The (Eakins), 217, 217-18 Ground Zero: transportation hub, 307 Grünewald, Matthias: Crucifixion, The, 106, 106; Isenheim Altarpiece, 106, 106 Guang ceremonial vessel, 178, 178 Guattari, Felix, 159 Guernica (Picasso), 236, 237 Guerrilla Girls, 292, 292 Guggenheim Museum (Bilbao): Gehry as architect, 305, 305 Guggenheim Museum (New York): Wright as architect, 255, 305, 316, 316 Guston, Philip, 260 Gutenberg Bible, 316 Habitat (Safdie), 302, **302** Hagia Sophia (Istanbul), 81, 81-82 Hall of Bulls (France), 18, 19 Hamilton, Richard: Just What Is It That Makes Today's Homes So Different, So Appealing?, 271, 271 Haniwa, 180 Hanson, Duane: Tourists, 282, 282 Happy Accidents of the Swing (Fragonard), 153, 153 Hard-edge painters, 268 Hardouin-Mansart, Jules: Palace of Versailles, 151, 151 Haring, Keith: Untitled, 298, 298 Harmenszoon, Rembrandt. See Rembrandt Harriet (Catlett), 286-87, 287 Hasegawa Tohaku: Pine Wood, 182, 182 Hatshepsut, Mortuary Temple of Queen, 32.32

Hawass, Zahi, 33 Head of a Roman, The (Rome), 64, 64 Head of Constantine the Great (Rome), 73, 73.74 Head Surrounded by Sides of Beef (Bacon), 270, 270 Headdresses (African), 162 Headdresses (Crow people), 173 Headdresses (Kwakiutl), 172, 173 Headdresses (Yoruba people), 162 Headstone: in Aegean art, 40 Hellenism, 46, 60-61, 138 Hepworth, Barbara: Two Figures (Menhirs), 5.7.7 Hermes and Dionysos (Praxiteles), 58, 59 Herodotus, 46 Herod's Gate (Jerusalem), 42 Herringbone perspective, 66 Hershman, Lynn: Digital Venus, 300, 300 Herzog & De Meuron: Beijing Stadium, 69 Hesiod, 46 Hierarchical scaling, 92-93 Hildegard of Bingen: Liber Scivias, 94, 94; Vision of the Ball of Fire, 94, 94 Hindu temples, 177 Hinduism, 174-77 Hiroshige, Ando: Rain Shower on Ohashi Bridge, 182, 182 Hirst, Damien: Mortuary, 314, 314; Physical Impossibility of Death in the Mind of Someone Living, 313-14 Hofmann, Hans, 260, 261-62; Golden Wall, 262, 262; Krasner and, 264; Pollock and, 263; Segal and, 281 Holabird and Roche: Monadnock Building, 256. 256 Holden, Stephen, 307 Holland: Baroque period in, 147-49, 152 Holy Land, Jerusalem, 42 Holy Sepulchre, Church of the (Jerusalem), 43.43 Holy Trinity (Masaccio), 111, 111-12 Holy Wisdom, Church of the (Istanbul), 81. See also Hagia Sophia (Istanbul) Homage to New York (Tinguely), 285, 285 Home of a Rebel Sharpshooter, Gettysburg (Gardner), 207, 207 Hopper, Edward, 257 Horizon line, 14 Horse #6-82 (Butterfield), 283, 283 Horse Fair, The (Bonheur), 199, 202, 202 Horta, Victor: Staircase in the Hotel van Eetvelde, Brussels, 221, 221 Horus, 31 House of the Vestal Virgins (Rome), 74 Houses of Parliament (London), 156 Hue: defined, 12; pure, 13 Huizinga, Johan, 104 Humanism, 46, 99, 102, 116, 183 Humanistic style, 58 Hyperrealism, 273-74 Hypostyle, 173-74, 304 Hyskos, 31 Iberian art, 234 Iberian sculpture, 233 Ibexes, 26 IBM Building (Rohe), 257 Ice Cube Project, The (Evaristti), 293, 293 Iconography: defined, 10 Ictinos: Parthenon, 55, 55 Idealism, 46, 70, 73, 188 Iderre, door from (Yoruba), 161, 161-62 If / Then (Feingold), 309, 309 Illinois Institute of Technology, 253 Illumination: manuscript (See Manuscript illumination); Vision of the Ball of Fire

(Hildegard of Bingen), 94, **94** Illusion of motion, 240–41

Imperial Procession from Ara Pacis Augustae

Illusionistic Surrealism, 251

(Rome), 71, 71

Imam, 173

Implied movement, 54, 58, 138 Impression: Sunrise (Monet), 202-3, 203. 216 Impressionism, 202-6 Impressionist school of painting, 4 Incas: Fortress of Machu Picchu, 171, 171 Incised detail, 28 Indian art, 174-77 Ingres, Jean-Auguste-Dominique, 46, 188, 190, 194; David and, 195; Degas and, 205; Grande Odalisque, 188, 190, 192, 192 - 93Installation, 284 Insurrection! (Our Tools Were Rudimentary, Yet We Pressed On) (Walker), 314-15, 315 Intarsia, 108 Intensity, of color, 13 International Exhibition of Modern Art, 243 International Gothic style, 99 International style, 103, 107 International Survey of Recent Painting and Sculpture, An, 292 Intervention of the Sabine Women, The (David), 310, 310 Inuit mask, 171, 172, 173 Ionic order, 49, 50, 50, 56, 64, 75 Isenheim Altarpiece, The (Grünewald), 106. 106 Isidorus of Miletus: Hagia Sophia, 81, 81 - 82Islam: Indian art and, 175; Jerusalem and, 42 - 43Islamic art, 173-74 Italy: Baroque period in, 134-44, 147; Renaissance in, 102, 107-26 Jacobs, Deborah L., 306 Jahan, Shah: Taj Mahal, 174, 174 Jambs, 98, 98, 99 Japanese art, 180-83, 205, 214, 216, 217, 260 Jardin des Tuileries (Paris), 224, 225 Jeanne-Claude, 283, 291; Gates, Central Park, New York, 294, 294-95; Running Fence, Sonoma and Marin Counties, California, 295; Surrounded Islands, Biscayne Bay, Greater Miami, Florida, 295; Wrapped Reichstag, Berlin, 295 Jerusalem: art tour, 42-43 Jewish Museum (New York), 316 Johns, Jasper, 271-72; Painted Bronze (Ale Cans), 272, 272 Johnson, Philip, 305; AT&T Building, 304, 304 Jones, Inigo, 152-53; Banqueting House at Whitehall, 152, 152 Journal of Personality and Social Psychology: van Gogh and, 212 Judgment of Paris, The, engraving after Raphael (Raimondi), 199 Judgment of Paris (Raphael), 199 Judith and Holofernes (Caravaggio), 140, 140 - 41Judith Decapitating Holofernes (Gentileschi), 140, 140-41 Julius Caesar, 63, 66, 130 Jupiter, Temple of (Rome), 74 Just What Is It That Makes Today's Homes So Different, So Appealing? (Hamilton), 271, 271 Justinian and Attendants, Church of San Vitale (Ravenna), 80, 81 Kandariya Mahadeva Temple (India), 177, 177 Kandinsky, Wassily, 242, 243, 244; Gorky and, 261; Sketch I for Composition VII, 231, 231

Karanek, Yael: World of Awe, 299, 299

Kauffman, Angelica: Artist in the Character of Design Listening to the Inspiration of Poetry, 187, 187-88 Kaufmann House (Wright), 255, 255 Kelly, Ellsworth, 268 Ken Moody and Robert Sherman (Mapplethorpe), 6, 6 Khafre, statue of (Egyptian), 29, 29, 31 Kiefer, Anselm: Dein Goldenes Haar, Margarethe, 278-79, 279 Kinetic artists, 14 King, L. W., 25 King Tut. See Tutankhamen (Egypt) Kiss, The (Brancusi), 5, 7, 7 "Kitchen" (Weltsch), 288 Kiyonaga, Torii, 182 Klee, Paul: Twittering Machine, 246-47, 247 Kleitias (Francois Vase), 49, 49 Knossos, 37-38, 38 Kokoschka, Oskar: Tempest, 5, 6, 6, 7 Kollwitz, Käthe, 215-16; expressionism and, 230; Outbreak, 215, 215-16, 286, 286 - 87Kongo ancestral figure, 164, 164 Koolhaas, Rem: Central Library (Seattle), 306, 306-7 Kooning, William de. See de Kooning, William Kore, 52-53 Kosuth, Joseph, 259 Kouros figure (Greece), 52, 52 Krasner, Lee: Easter Lilies, 264, 264 Krater, 47, 49 Kruger, Barbara: Untitled (We Don't Need Another Hero), 8, 9, 9, 290; We Won't Play Nature to Your Culture, 290, 291 Kuba people: Mboom helmet mask, 162, 162 Kubota, Shigeko: Three Mountains, 296, 296 Kumano Mandala (Japan), 180 Kwakiutl headdress (British Columbia), 172, 173 L-SF-ES-#2 (Tworkov), 3 Laocoön (Greece), 75 Laon Cathedral (France), 95, 95-96, 96 Lapis lazuli, 24 Lara Croft (Eidos Interactive), 200, 201, 201 Las Meninas (Velázquez), 145, 145, 311 Last Supper, The (Tintoretto), 126, 126, 138 Last Supper, The (Vinci), 14, 116-17, 117, 118, 120, 126, 187 Latin American Art (Westbrook), 170 Latin cross churches, 80 Latin cross plan, 79, 135 Latrobe, Benjamin, 188; U.S. Capitol Building, 189 Law Code of Hammurabi (stele inscription) (Babylonian), 25, 25 Lazzarini, Robert: Payphone, 299, 299 Le Corbusier: Chapel of Notre-Damedu-Haut, 300, 301, 301-2 Le Déjeuner sur L'Herbe (Luncheon on the Grass) (Manet), 198, 198-99 Le Moulin de la Galette (Renoir), 204, 204 Le Tour (MacConnel), 277, 277 Le Vau, Louis: Palace of Versailles, 151, 151 Lectionary of Henry II, Annunciation to the Shepherds, The, 92, 93 Lee, Sadie: Bona Lisa, 248-49, 249 Léger, Fernand, 260 Leicester Square (London), 157 L'Enfant, Pierre, 188 Les Demoiselles d'Avignon (Picasso), 224, 234, 234, 316

Les Très Riches Heures du Duc de Berry,

103 - 4

"May" (Limbourg Brothers), 103,

Lever House (Bunshaft), 301, 303, 303, 304, 317 Levitt, William: Levittown, 301, 301 Levittown (Levitt), 301, 301 Li K'an: Bamboo, 179, 179-80, 182 Liber Scivias (Hildegard of Bingen), 94, 94 Liberty Leading the People (Delacroix), 286, 286 - 87Libeskind, Daniel: extension of Berlin Museum by, 305, 306 Lichtenstein, Roy: Forget It, Forget Me!, 4, 5; representational art by, 6 Limbourg Brothers: Les Très Riches Heures du Duc de Berry, "May," 103, 103-4 Lincoln Center for Performing Arts (New York City), 280, 316 Lindisfarne Gospels illuminated manuscript (Medieval), 83, 83 Line: defined, 12; as visual element, 12 Linear A, 37 Linear B, 37 Linear perspective, 14, 185 Linear recession, 185, 188 Linear style, 2, 188 Lintel, 39, 39, 98 Lion Gate at Mycenae, 39, 39 Lipchitz, Jacques: Still Life with Musical Instruments, 237, 237 Liver Is the Cock's Comb, The (Gorky), 261, **261** Living Dead of Buchenwald, The (Bourke-White), 274 Living rock, 31 London: art tour, 156-57 London Bridge (Derain), 228, 228, 316 Longitudinal plan, 79 Lorelei (Frankenthaler), 268, 268 Los Angeles Women's Building, 289 Louis, Morris, 268 Louvre Museum, 199, 224, 225, 248, 310 Lucas, Sarah: Au Naturel, 309; Fag Show, 312, 312 Lucie-Smith, Edward, 249 Lumière, Louis: Young Lady with an Umbrella, 207, 208 Lunettes, 78 Luxembourg Gardens (Paris), 225 Lysippos: Apoxyomenos, 59, 59-60 MacConnel, Kim: Le Tour, 277, 277 Machiavelli, Niccolo: Florence and, 131; Prince, 130 Machu Picchu, Fortress of (Peru), 171, 171 Maderno, Carlo, 135 Madonna Enthroned (Cimabue), 108, 108 - 9Madonna Enthroned (Giotto), 108, 109 Madonna of the Rocks (Vinci), 14, 15, 117, 118 Magazines: defined, 37 Man Pole Vaulting (Eakins), 240, 240 Manasticism, 89 Mandala, 180, 181 Manet, Edouard, 196, 205, 210, 224, 227, 243; Balcony, 204; Cassatt and, 216; Le Déjeuner sur L'Herbe (Luncheon on the Grass), 198, 198-99; New York and, 316; Olympia, 193, 200, 200-201, 224 Mannerism, 127, 128-29 Mannerist art, 128 Manuscript illumination: Charlemagne and, 85; in Ottonian art, 88; in Renaissance, 102-3; of Romanesque art, 92-93 Maori people: canoe prow, 166, 166 Mapplethorpe, Robert: Ken Moody and Robert Sherman, 6, 6 March, Werner: Olympic Stadium (Berlin), 68, 69 Marcus Aurelius on Horseback (Rome),

72, **72** Mardigian Museum (Jerusalem), 43

Marie Antoinette and Her Children (Vigée-Lebrun), 154, 154 Marina City corncob towers (Chicago), 257 Marinetti, Filippo, 238 Marisol: Women and Dog, 282, 282 Marquette Building (Chicago), 256 Marshall Field and Company (Chicago), 256 Martin, Agnes: Untitled, 269, 269 Masaccio, 110-12; Holy Trinity, 111, 111 - 12Masks: African, 162, 224; Eskimo mask, 171, 172, 173; Etoumba mask, 162, 163, 163; Inuit, 171, 172, 173; Mboom helmet mask, 162; Yoruba, 162 Mass: Constructivism and, 244 Masson, Andre, 251 Matisse, Henri, 21, 228-29, 242, 243; Hofmann and, 261; Miró and, 252; Red Room (Harmony in Red), 229, 229, 230 Maxentius and Constantine, Basilica of (Rome), 72, 73, 73, 74 Maya palaces of Chichen-Itzá, 260 Mayans: murals, 168, 168-69 Mboom helmet mask (Kuba), 162, 162 Medici-Riccardi (Florence), 131 Medieval art, 82-88 Medium, 14 Mediums, 14 Megaliths, 21 Megaron, 49 Melanesian art, 166-67 Melting Pot of Ice (Basquiat), 280, 280 Mendieta, Ana: Arbol de la Vida (Tree of Life), no. 294, 290, 290 "Menstruation Bathroom" (Chicago), 288 Mentuhotep (Egypt), 31 Merode Altarpiece (Campin), 104, 104-5, 112 Mesolithic: defined, 18 Mesolithic art, 20-21 Mesopotamian art, 47 Metopes, 50 Metropolitan Museum of Art (New York), 316 Mexican sculpture, 168 Mexico: native art of, 167-69, 171, 260, 280 Michelangelo, 119-21; Agony and the Ectasy and, 119; Baroque period and, 134, 135, 137; Creation of Adam, 120, 121; David, 74, 121, 122-23, 123, 130, 131, 138; Florence and, 131; history and, 101, 102, 115-16; International style and, 103; mannerism and, 128; Moses, 75, 75; Pietà, 75, 119, 315; Rubens and, 146; Sistine Chapel, 74, 75, 119-21, 120, 130, 137, 141; Slaves, 131; St. Peter's Basilica, 130, 156; Titian and, 125 Michelangelo de Merisi. See Caravaggio Middle Ages, 48, 72, 82-84, 89, 94. See also "Dark Ages"; Medieval art; Japanese art and, 183; Renaissance and, 101, 109, 112, 115 Middle Kingdom, Egyptian art in, 27, 31 Middle Minoan period, 37 Miës van der Rohe, Ludwig, 253-54; Farnsworth House, 254, 301, 302, 302-3; IBM Building, 257; model for a glass skyscraper, 254, 254; Seagram Building, 254 Mihrab: mosque at Isfahan, 174, 174 Millennium Bridge (London), 156 Millennium Park (Chicago): Pritzker Pavilion for, 257, 257 Mimesis, 183 Ming dynasty vase, 179, 179 Minimal art, 268-69 Minimalism, 268-69

Minoan periods/Minoans, 37-39 Miracle Mile (Chicago), 257 Miró, Joan, 251, 252-53; Gorky and, 261; Painting, 252, 253 Mobiles, 284 Mochica culture: ceramic portrait jar, 171, 171 Modern art, 154, 185-223, 228 Modern Olympia, A (Cézanne), 193, 193 Modern sculpture, 220 Modernism: defined, 301 Modernist architecture, 304 MOMA. See Museum of Modern Art Mona Lisa (L.H.O.O.Q.) (Duchamp), 248, 248-49, 250, 272 Mona Lisa (Vinci), 118, 118, 176, 224, 248, 248-49 Monadnock Building (Burnham and Root; Holabird and Roche) (Chicago), 256, 256 Monasteries, 89 Mondrian, Piet, 244-45; Composition with Red, Blue, and Yellow, 244, 245; Krasner and, 264; Rietveld and, 245 Monet, Claude, 202-3, 224; Chicago and, 257; Derain and, 228; Impression: Sunrise, 202-3, 203, 216; New York and, 316; Rouen Cathedral, 203. 203 Monogram (Rauschenberg), 271 Monolithic: defined, 64 Monotheism: in Egyptian art, 32, 34 Mood: in Ottonian art, 88 Moore, Henry, 161, 167, 168; Reclining Figure, Lincoln Center, 280-81, 281 Morgan Library (New York), 316 Morisot, Berthe, 204-5; Young Girl by the Window, 205, 205 Mortuary (Hirst), 314, 314 Mortuary temple, 31-32 Mortuary temple of Queen Hatshepsut, Thebes (Egyptian), 32, 32 Mosaics, 79; of mosques, 174; of San Vitale, 80; in St. Mark's Cathedral, 82 Moses (Michelangelo), 75, 75 Mosque, Great (Djenne), 165, 165 Mosque, Great (Samarra), 173, 173-74 Mosque at Córdoba (Spain) sanctuary, 174, 174 Mosque at Isfahan (Iran), mihrab, 174, 174 Mosque at Samarra (Iraq), 173, 173-74 Mosque of the Ascension (Jerusalem), 43 Motherwell, Robert, 185, 266 Motion: illusion of, 240-41; stroboscopic, 241; as visual element, 12, 14 Moulin Rouge, At the (Toulouse-Lautrec), 214, **214**, 257 Mount of Olives (Jerusalem), 42 Mount Zion (Jerusalem), 42 Movement: implied, 54, 58, 138 Mrs. Richard Brinsley Sheridan (Gainsborough), 155, 155 Muezzin, 173 Mulvey, Laura, 193 Munch, Edvard, 214-15; expressionism and, 230; Scream, 214, 215 Mural painting, 58, 64 Mural quality, 98 Murals: in Mayan culture, 168, 168 Murray, Elizabeth, 277; Sail Baby, 278, 278 Muschamp, Herbert, 306-7 Musée de l'Homme (Paris), 163, 224, 234 Musée d'Orsay (Paris), 224-25, 225 Museo del Barrio (New York), 316 Museum of Contemporary Art (Chicago), 257 Museum of Modern Art (MOMA), 285, 292, 304, 316 Muslim art, 165 Muslims: in Jerusalem, 42-43 My Egypt (Demuth), 243, 243

Mycenae/Mycenaeans: Aegean art and, 39-41; architecture of, 39-40; Crete and, 37, 38; megaron and, 49 Myron: Diskobolos (Discus Thrower), 54, 54 Mystery and Melancholy of the Street, The (Chirico), 247, 247, 250 Mysticism: Baroque period and, 147; Greco and, 127 Nadar: Sarah Bernhardt, 207, 207 Napoleon's tomb (Paris), 224 Naram Sin, Stele of (Akkadian), 24, 24, 29 Narmer Palette (Egyptian), 28, 29 Narthex, 79, 79, 88, 89, 91, 97 Nataraja: Shiva as King of Dance (India), 177. 177 National Gallery (London), 157 National Gallery of Art, 284 National Portrait Gallery (London), 157 Native art: of Canada, 172-73; of Mexico, 167-69, 171, 260, 280; of Peru, 171; of United States, 172–73 Naturalism: in Akkadian art, 24; in Assyrian art, 26; in Baroque period, 133, 147, 154-55; in Egyptian art, 31, 34, 36; in Gothic art, 99; in Greece, 46, 57; in Ottonian art, 87; paleolithic art and, 18; in Renaissance, 102; of Romanesque art, 92.93 Naturalistic style, 58, 255 Nave, 79, 79, 88, 89; Baroque period and, 135; Gothic art and, 95, 96, 97, 98; Romanesque art and, 90, 91, 93 Near East art, 22-27 Neel, Alice, 269; Pregnant Woman, 270, 270 Nefertiti (Egypt): bust of, 32, 34, 35 Neo-Expressionists/expressionism, 278-80, 313 Neoclassical sculpture, 188 Neolithic: defined, 18 Neolithic art, 21-22 Nervi, Pier Luigi: Palazzo dello Sport, 69, 69 Neshat, Shirin, 307; Still from Passage, 312, 312 Neue Sachlichkeit, 230, 232 New Guinea: ancestor poles, 166–67, **167** New Image painting, 275–77 New Kingdom, Egyptian art in, 27 New Objectivity, The (Neue Sachlichkeit), 230, 232 New Spirit in Painting, The (London), 292 New St. Paul's Cathedral (England), 152, 152 New York: art tour, 316-17 New York Art Tour, 254 New York School, 260-69 Newman, Barnett, 265 Night Café, The (van Gogh), 12, 13 Niobid Painter: Argonaut Krater, 58 Nirvana, 175, 176 Nkisi nkondi (hunter figure) (Congo), 164. 164 Nochlin, Linda, 9, 192-93; Women, Art, Power, and Other Essays, 286 Noland, Kenneth, 268 Nolde, Emil, 17; Dance around the Golden Calf. 230, 230-31 Nonobjective art, 7, 244 Nonobjective painting, 260 Notre-Dame, Cathedral of (France), 96, 96, 98, 225, 225 Notre-Dame-du-Haut, Chapel of (Le Corbusier) (France), 300, 301, 301-2 Nude Descending a Staircase #2 (Duchamp), 240, 240, 243, 250 Nude with Drapery (Picasso), 163, 163 Nunnerv, 94 Nymphs and Satyr (Bouguereau), 195, 195 Oath of the Horatii, The (David), 8, 8-9, 186, 186-87, 224

Object (Oppenheim), 13, 13 Oceanic art, 165-67, 234 Oceanic sculpture, 233 Oculus, 70 Odalisque (Delacroix), 190, 192, 192-93 Odalisque (Ingres). See Grande Odalisque (Ingres) Odutokun, G .: Dialogue with Mona Lisa, 248-49, 249 Oil painting: Titian and, 125 O'Keeffe, Georgia, 242-43; New York and, 316; White Iris, 242, 243 Old Bridge (Florence), 131 Old Guitarist, The (Picasso), 233, 233, 257 Old Kingdom, Egyptian art in, 27-31 Old St. Peter's (Rome), 79, 79, 88 Olmec people: colossal head, 167-68, 168 Olmsted, Frederick Law: Central Park, 317 Olympia (Manet), 193, 200, 200-201, 224 Olympic Stadium (Berlin) (March), 68, 69 One (Number 31, 1950) (Pollock), 263, 263 Op Art, 240-41, 275 Oppenheim, Meret: Object, 13, 13 Optical painting, 275. See also Op Art Optically: defined, 196 Orangun-lla, Airowayoye I, ruler of (Yoruba), 162, 162 Orans, 78 Oriental Institute (Chicago), 257 Orion (Vasarely), 275, 275 Orozco, José Clemente, 260 Orthogonals, 66, 118, 187 Ottonian art, 85–88 Oursler, Tony: Getaway #2, 297-98, 298, 316 Ourussoff, Nicolai, 69 Outbreak, The (Kollwitz), 215-16, 216, 286, 286-87 Overlapping, 14 Owens, Jesse, 69 Oxbow, The (Cole), 218, 218, 220 Oxidizing phase, 49 Paik, Nam June: Global Groove, 296, 296 Painted Bronze (Ale Cans) (Johns), 272, 272 Painterly style, 2 Painting: action, 263; black-figure, 49; combine, 271; fifteenth-century northern, 102-7; figurative, 265, 269-70; Flemish, 102-6; genre, 105, 128; mural, 58, 64; New Image, 275-77; nonobjective, 260; oil (See Oil painting); optical, 275 (See also Op Art); panel, 102; pattern, 277; vase (See Vase painting); wall, 58, 65,66 Painting (Miró), 252, 253 Palace of Versailles (Le Vau and Hardouin-Mansart) (France), 151, 151, 153 Palais du Louvre (Francois I), 224 Palatine Chapel of Charlemagne (Aachen), 84, 84-85 Palazzo dello Sport (Rome) (Nervi), 69, 69 Palazzo Rucellai (Alberti) (Florence), 115, 115 Palazzo Vecchio (Florence), 130 Palazzos Pitti (Florence), 131 Paleolithic art, 18-20 Palladium (London), 157 Panel paintings, 102 Panofsky, Erwin, 28-29, 105 Pantheon (Rome), 70, 70, 75, 81 Papal Palace (Rome), 136 Papier collé, 236 Paris: art tour, 224-25 Paris Opera, 260 Parthenon, 50, 55, 55-57, 71, 93, 144, 157 Pastoral: defined, 199 Patricians, 63 Pattern painting, 277 Pauline Borghese as Venus (Canova), 189 Paxton, Joseph: Crystal Palace, 222, 222

Payphone (Lazzarini), 299, 299 Peasant Wedding, The (Bruegel), 128, 128 Pediment, 50, 56 PEI, I. M.: Pyramid at the Louvre, 224 224 Pendentives, 82 Peplos Kore (Greece), 52-53, 53 Père Lachaise (Paris), 225 Pericles, 54, 55, 56 Period of Persecution: in Christian art, 78 - 79Period of Recognition: in Christian art, 78,79 Perrault, John, 304 Persian art, 26-27 Persistence of Memory, The (Dalí), 251, 251-52, 316 Peru: native art of, 171 Pfaff, Judy, 277, 283; Dragon, 284, 284 Phalle, Niki de Saint: Stravinsky Fountain, 225 Phidian style, 56-57 Phidias, 56, 57 Philip Golub Reclining (Sleigh), 193, 193 Photography, modern art and, 186, 205, 206-7,216 Photojournalism, modern art and, 207 Photorealism, 273, 288 Physical Impossibility of Death in the Mind of Someone Living (Hirst), 313-14 Piano, Renzo: Pompidou National Center of Art and Culture, 225 Piazza della Signoria (Florence), 130, 130, 131 Piazza of St. Peter's (Bernini), 135, 135, 136, 136, 138 Picasso, Pablo, 2, 55, 64, 139, 149, 242, 243; African art and, 182; Blue Period of, 233; Bottle of Suze, 236, 236; Braque and, 234, 235, 236; Cubism and, 233; de Kooning and, 264; Etoumba mask and, 163, 163; Gorky and, 261; Guernica, 236, 237; Krasner and, 264; Les Demoiselles d'Avignon, 224, 234, 234, 316; Miró and, 252; Moore and, 280; Nude with Drapery, 163, 163; Old Guitarist, 233, 233, 257; Pollock and, 263; Rose Period of, 233-34 Pictographs, 37 Picture plane, 13, 185 Piero della Francesca: Resurrection, 113, 113 - 14Pietà (Michelangelo), 75, 119, 315 Pilasters, 223 Pilgrimages, 89 Pine Wood (Hasegawa), 182, 182 Place de la Concorde (Paris), 224 Place de la Revolution (Paris), 224 Place de l'Étoile (Paris), 224 Planar recession, 185, 188 Plasticity, 144 Pliny, 60 PM Magazine (Birnbaum), 296-97, 297 Poe, Edgar Allen, 45 Pointillism, 209 Pollock, Jackson, 2, 261-63, 268, 280; Krasner and, 264; Long Island studio, 262, 263; New York and, 316; One (Number 31, 1950), 263, 263 Polykleitos: canon of properties, 57, 59; Doryphoros (Spear Bearer), 57, 57, 71 Polynesian art, 166 Pont du Gard (France), **66,** 66–67 Ponte Vecchio (Florence), 130, 131, 131 Pontormo, Jacopo: Entombment, 128-29, 129 Pop Art, 271-73, 281, 288 Pope, Alexander, 133 Pope.L, William, 307, 312-13; Training Crawl, Lewiston, ME, 313, 313 Porticoes, 31, 70 Portrait of Paul Revere (Copley), 155, 155

Portraits, modern art and, 206-7 Portugese, The (Braque), 235, 235 Post-and-lintel construction, 64 Postimpressionism, 208-14, 228, 229 Postmodernist architecture, 304 Pottery: in Greece, 48 Poussin, Nicolas, 192; Rape of the Sabine Women, 150, 150-51, 310 Poussinistes, 192, 290 Powers, Harriet: Bible Quilt: The Creation of the Animals, 219, 219 Prairie style, 254-55, 257 Praxiteles: canon of properties, 59; Hermes and Dionysos, 58, 59 Pre-Hellenic Greece, 36 "Precisionists," 243 Predynastic period, 28 Prefabricated, 222 Pregnant Woman (Neel), 270, 270 Prehistoric art, 18-22 Prevalence of Ritual: Mysteries (Bearden), 267. 267 Prince, The (Machiavelli), 130 Principles of design, 14, 15 Pritzker Pavilion for Millennium Park (Gehry) (Chicago), 257, 257 Processional Frieze (Royal Audience Hall), 27 Proportions: defined, 14 Propylaeum, 79, 79 Proto-Renaissance, 109 Pueblos, of Arizona, 260 Pure hues, 13 Pyramids: Egyptian, 31, 33, 260; in Gizeh, 30, 31, 33 Ouatrefoil, 109 Quetzalcóatl, Temple of (Teotihuacán), 169, 169 Quiltmaking, 219 Radiating chapels, 89 Raft of the Medusa (Géricault), 188, 189-90, 190, 224 Raimondi, Marcantonio, 199; Engraving after Raphael's The Judgment of Paris, 199 Rain Shower on Ohashi Bridge (Hiroshige), 182, 182 Raking cornice, 50 Rape of the Daughters of Leucippus, The (Rubens), 146, 146-47, 191 Rape of the Sabine Women, The (Poussin), 150, 150-51, 310 Raphael, 2, 14, 75, 116, 125, 128, 150; Judgment of Paris, 199; School of Athens, 14, 118-19, 119, 145; Stanze della Segnatura fresco, 75 Raptus (Sussman), 310-11, 311 Rationalism, 46, 99 Rauschenberg, Robert: Bed, 271, 272; Johns and, 271-72; Monogram, 271 Realism/realist, 13, 60, 99, 181, 183, 202, 230; modern art and, 186, 188, 195-99, 202, 220; postimpressionism and, 208; in Roman art, 63-64, 70, 72, 73; of Romanesque art, 92 Realistic: defined, 6-7 Realistic style, 2 Reclining Figure, Lincoln Center (Moore), 280-81, **281** Rectangular bay system, 96 Red Library (Simmons), 290 Red Room (Harmony in Red) (Matisse), 229, 229, 230 Reducing phase, 49 Reformation, 134 Registers, 29, 58 Rehearsal, The (Degas), 205, 206 Reims Cathedral (France), 98, 99 Reinstein, Silvia: Untitled, 183, 183 Relative size, 14 Reliance Building (Chicago), 256

Relief sculpture: defined, 13 Rembrandt, 2, 147-49; Bacon and, 270; Goya and, 194; Self-Portrait, 147, 147, 148; Syndics of the Drapers' Guild, 148, 148-49; Vigée-Lebrun and, 153 Renaissance, 101-29; competition in, 109-12; Cubism and, 235; defined, 101; early, 107; fifteenth-century northern painting in, 102-7; Flemish painting in, 102-6; Florence art tour and, 130-31; German art in, 106, 107; in Greece, 45, 75, 82; high, 115-21; in Italy, 107-26; Japanese art and, 183; mannerism and, 128-29; at midcentury/beyond, 113-15; outside Italy, 127-28; in Venice, 121, 124-26 Renaissance Classicism, 115 Renoir, Pierre-Auguste, 203-4, 224; Le Moulin de la Galette, 204, 204; New York and, 316 Reoxidizing phase, 49 Representational art, 6 Republican period, in Rome, 63-66 Restraint: in Greek art, 54; modern art and, 187 Resurrection (Piero della Francesca), 113, 113 - 14Retreating space, 65 Rexer, Lex, 183 Rhythm: defined, 14 Rietveld, Gerrit: Schroeder House, 245, 245 Riley, Bridget: Cataract 3, 241, 241 Ritual Dance cave painting (Italy), 20, 20-21 Rivera, Diego, 260 Robie, Frederick, 257 Robie House (Wright), 254-55, 257, 257 Robusti, Jacopo. See Tintoretto Rock-cut tombs (Egyptian), 30 Rockwell, Norman, 9 Rococo, 153-55, 186 Rodin, Auguste, 221, 224; Brancusi and, 245; Burghers of Calais, 220, 220; New York and, 316 Rodin Museum (Paris), 224 Rogers, Richard: Pompidou National Center of Art and Culture, 225 Rohe, Ludwig. See Miës van der Rohe, Ludwig Rokeby Venus (Velázquez), 315 Romanesque art, 87, 88-94, 90, 95 Romanticism, 186, 189-91, 194-95, 208, 232, 252 Rome, 61-75; art tour, 74-75; Baroque period and, 134; catacombs in, 78; Christian art and, 79: classicism in, 107: Corinthian order in, 50; early empire in, 66-67, 69-72; Etruscans and, 61-62; late empire in, 72-73; Renaissance and, 116, 131; Republican period in, 63-66 Rookery (Chicago), 256 Rose Period, 233-34 Rose window, 95 Rosenberg, Harold, 263 Rosetta Stone, 157 Rosettes, 38 Rossini, Gioacchino: Barber of Sevilli, 131 Rothenberg, Susan, 275; Butterfield and, 283; Diagonal, 276, 277 Rothko, Mark: Blue, Orange, Red, 265, 265 - 66Rouen Cathedral (Monet), 203, 203 Rousseau: Miró and, 253 Royal Audience Hall, 26-27, 27 Rubenistes, 188, 190, 192 Rubens, Peter Paul, 2, 146-47, 150, 192; Rape of the Daughters of Leucippus, 146, 146–47, 191; Vigée-Lebrun and, 153 Rue de Rivoli (Paris), 224 Running Fence, Sonoma and Marin Counties, California (Christo and Jeanne-Claude), 295 Rushdie, Salman, 173

Russia: Constructivism in, 244 S curve, 58, 113 Saatchi, Charles, 314 Sacré Coeur (Paris), 225 Sacrifice of Isaac (Brunelleschi), 110 Sacrifice of Isaac (Ghiberti), 110 Safdie, Moshe: Habitat, 302, 302 Sage Kuya Invoking the Amida Buddha, The (Japan), 181, 181 Sail Baby (Murray), 278, 278 Saint-Chapelle (Paris), 225 Saint-Lazare, Cathedral of (France), 92, 92 Salisbury Cathedral (England), 97 Salle, David: Angel, 313, 313 Salon (1855), 197, 227 Salon (1863), 199 Salon d'Automne, 228, 229, 233, 245 Salon de la Paix (Versailles), 154 Salon des Réfusés (Salon of the Rejected Painters), 199, 227, 245 San Carlo alle Quatro Fontane (Borromini), 144, 144, 153 San Vitale, Church of (Ravenna), 80, 80, 84, 85, 109 Santa Barbara Museum of Art (California), 170 Santa Croce (Florence), 130, 131, 131 Santa Maria della Vittoria, church of (Rome), 138 Sanzio, Raphael. See Raphael Sarah Bernhardt (Nadar), 207, 207 Sarcophagi, 62 Sarcophagus from Cerveteri (Etruscan), 62.62 Saturation, 13 Savoldo, Girolamo: St. Matthew and the Angel, 87, 87 Scale: defined, 14 Schapiro, Miriam: Chicago and, 288-89; Doll House, 288-89, 289 Schliemann, Heinrich, 36, 37, 40, 41 School of Athens (Raphael), 14, 118-19, 119, 145 Schroeder House (Rietveld), 245, 245 Science: in Baroque period, 154-55 Scream, The (Munch), 214, 215 Sculpture: African, 233; contemporary abstract, 283-85, 288; of contemporary art, 280-85, 288; contemporary figurative, 281-83; cubist, 236-38; Egyptian art and, 27, 28-31, 31, 52; of Etruscans, 62; figurative, 50, 54, 62, 281-83; of Gothic art, 98-99; in Greece, 50-53, 56-57, 58-60, 60-61, 99; Iberian, 233; Mexican, 168; at midtwentieth century, 280-81; modern, 220; neoclassical, 188; Oceanic, 233; of Ottonian period, 88; of Period of Recognition, 79; of Romanesque art, 91-92; in Rome, 63-64, 70-72, 73, 99; Stone Age, 18, 19; visual elements and, 13 Sculpture-in-the-round, 13 Scythian plaque (Siberia), 83, 83 Seagram Building (Miës van der Rohe), 254, 317 Seals, 174 Sears Tower (Chicago), 256 Second Sex, The (de Beauvoir), 286 Segal, George: Cézanne Still Life #5, 281, 281-82 Self-Pietà (Taylor-Wood), 315, 315 Self-Portrait (Rembrandt), 147, 147, 148 Self-Portrait with Bandaged Ear (van Gogh), 212, 212 Semekazi (Migrant Miseries) (Bester), 10, 11.11 Seurat, Georges, 210; Sunday Afternoon on the Island of La Grande Jatte, 208-9, 209, 257 Severe style, 54 Shaft graves, 40 Shape: defined, 12; as visual element, 12

Shaped canvas, 268, 277-78 Sherman, Cindy, 257 Shinto shrines, 180, 180-81 Shiva, 174 Shop Block (Gropius), 253, 253 Simmons, Laurie: Red Library, 290; "Stepford Wife," 290 Simpson, Lorna, 307; Easy to Remember, 314, 314 Sistine Chapel (Rome), 74, 75, 119-21, 120, 130, 137, 141 Site-specific works, 291-93 Sketch I for Composition VII (Kandinsky), 231. 231 Skyscraper, model for a glass (Miës van der Rohe), 254, 254 Slaves (Michelangelo), 131 Sleigh, Sylvia: Philip Golub Reclining, 193, 193 Slip, 49 Sloan, John, 266 Small Symphony for Women #1 (Snyder), 291 291 Smart Museum (Chicago), 257 Smith, David: Cubi Series, 283, 283; Winsor and, 285 Smithson, Robert, 283; Spiral Jetty, 293. 293 Snyder, Joan: Small Symphony for Women #1, 291, 291 Soliloguy III (Taylor-Wood), 315 Solomon R. Guggenheim Museum (New York). See Guggenheim Museum (New York) Sony Plaza (Burgee Architects with Philip Johnson) (New York City), 304, 304 South Street residential tower (Calatrava) (New York), 307, 307 Space: in ancestor poles, 166; in Baroque period, 134; conceptual, 178; Constructivism and, 244; Cubism and, 237; illusion of, 13; modern art and, 185-86; in relief sculpture, 13; retreating, 65; as visual element, 12 Spain: Baroque period in, 144-46, 147; "Cambios" exhibition and, 170 Spanish art, 127 Spiral: An Ordinary Evening in New Haven (Bartlett), 276, 277 Spiral Jetty (Smithson), 293, 293 Square schematism, 88, 89, 96 St. Bartholomew's Church (St. Bart's), 317 St. Denis (France), 95 St. Étienne, Cathedral of (France), 91, 91, 92, 95 St. James Cathedral (Jerusalem), 43 St. James Park (London), 157 St. John the Baptist (Caravaggio), 74 St. John the Divine, Cathedral of (New York). 316-17 St. Mark's Cathedral (Venice), 82, 82, 124 St. Matthew and the Angel (Savoldo), 87 87 St. Michael at Hildesheim (Germany), Abbey Church of, 85, 85, 88, 92 St. Patrick's Cathedral (New York), 317 St. Paul's Cathedral (England), 152, 152, 156, 157 St. Peter's Basilica (Rome), 75, 130, 136-37, 137, 152, 153, 156 St. Peter's Cathedral (Rome), 134, 134-35, 135, 136, 138-39 St. Sernin, Church of (France), 89, 89-91 Stability: in Greek art, 54 Staircase in the Hotel van Eetvelde, Brussels (Horta), 221, 221 Stanze della Segnatura fresco (Raphael), 75 Starry Night (van Gogh), 211, 211, 213, 215, 316 Static works, 14 Status Quo, 43

Steel, 222 Steel cages, 222, **223,** 225 Steichen, Edward, 315 Stele: in Aegean art, 40; Law Code of Hammurabi (Babylonian), 25, 25; of Naram Sin (Akkadian), 24, 24, 29 Stele of Naram Sin (Akkadian), 24, 24 Stella, Frank, 277 "Stepford Wife" (Simmons), 290 Stieglitz, Alfred, 242, 243 Still, Clifford, 266 Still from Passage (Neshat), 312, 312 Still Life with Basket of Apples (Cézanne), 210, 211, 257 Still Life with Musical Instruments (Lipchitz), 237. 237 Stoicism, 72 Stone Age, 17-18. See also Prehistoric art Stone-Breakers, The (Courbet), 197, 197 Stonehenge (England), 18, 21, 21 Stravinsky Fountain (Phalle), 225 Street Light (Balla), 238-39, 239, 316 Stroboscopic motion, 241 Strokes of paint: Titian and, 125 Studio Museum (New York), 316 Stupas, 175 Style, 2-7; Architectural, 65, 66; Greek Revival, 45; humanistic, 58; International, 103, 107; International Gothic, 99; linear, 2, 188; naturalistic, 58, 255; in Ottonian art, 86, 88; of Period of Recognition, 79; Phidian, 56-57; of photographs, 206; realistic, 2; Severe, 54 Stylobate, 50, 55 Su Dongpo, 179 Subject matter: defined, 10 Sullivan, Louis: Carson Pirie Scott, 256: Wainwright Building, 223, 223 Sumerian art, 22-24, 27 Sunday Afternoon on the Island of La Grande Jatte (Seurat), 208-9, 209, 257 Surrealism/surrealist, 250-53; automatist, 251, 253, 261, 263; defined, 13 Surrounded Islands, Biscayne Bay, Greater Miami, Florida (Christo and Jeanne-Claude), 295 Susannah and the Elders (Gentileschi), 142-43, 143 Susannah and the Elders (Tintoretto), 142, 142 - 43Sussman, Eve: 89 Seconds at Alázar, 311, 311; Raptus, 310-11, 311 Syndics of the Drapers' Guild (Rembrandt), 148, 148-49 Synthetic cubism, 236 Synthetism, 213 Taj Mahal (India), 174, 174 Tapestry: of Romanesque art, 93 Tarot (Graves), 284-85, 285 Tate Britain (London), 157 Tate Modern (London), 156, 157 Taylor-Wood, Sam: Self-Pietà, 315, 315; Soliloguy III, 315 Te Arii Vahine (The Noble Woman) (Gauguin), 200-201, 201 Techniques, artistic, 14 Tempest, The (Kokoschka), 5, 6, 6, 7 Temple Mount (Jerusalem), 43 Ten Books on Architecture (Vitruvius), 115 Tenebrism, 140 Teotihuacán (Mexico): Temple of Quetzalcóatl, 169, 169 Terra Museum of American Art (Chicago), 257 Texture: as visual element, 12, 13 Texture gradient, 14 Theatricality: in Baroque period, 134, 138, 151 Theotokopoulos, Domeniko. See Greco, El Third-Class Carriage, The (Daumier),

196, 196 Third of May, The (Goya), 194, 194 Tholos, 40 Three-dimensional mediums, 14 Three Goddesses (Parthenon) (Greece), 56, 56-57 Three Mountains (Kubota), 296, 296 Tiffany, Louis Comfort, 256 Tiger, Lionel, 77 Time: as visual element, 12, 14 Tinguely, Jean, 283; Homage to New York, 285, 285; Winsor and, 288 Tintoretto, 125; *Last Supper*, 126, **126**, 138; mannerism and, 129; *Susannah and the* Elders, 142, 142-43 Tints, 13 Titian: Greco and, 127; mannerism and, 129; Poussin and, 150; Venus of Urbino, 124, 124-25, 188, 200, 200-201, 300 Tomb of the Virgin (Jerusalem), 43 Toulouse-Lautrec, Henri de, 213-14, 243; Moulin Rouge, 214, 214, 257; Picasso and, 233; representational art by, 6; Two Girlfriends 5.5 Tourists (Hanson), 282, 282 Tournachon, Gaspard Felix. See Nadar Tower Bridge (London), 156 Tower of David Museum (Jerusalem), 43 Tower of London, 156 Training Crawl, Lewiston, ME (Pope.L), 313. 313 Traitors' Gate (London), 156 Transept, 79, 79, 88, 89 Transverse ribs, 91 Travelers among Mountains and Streams (Fan K'uan), 178, 178–79 Treasury of Atreus (Mycenaean), 40, 40 Tribune gallery, 90, 95 Tribune Tower (Chicago), 257, 257 Triforium, 95, 96, 97 Triglyphs, 50 Triumph of the Sacred Name of Jesus (Baciccio), 141, 141 Trompe l'oeil, 63, 141, 188, 235, 251, 274 Tuscan order, 115 Tutankhamen and the Golden Age of the Pharoahs exhibition, 33 Tutankhamen (Egypt), 27; coffin of, 33, 35, 36; discovery of, 34-36; technology and, 33, 33 Twentieth century art, 227–55 Twittering Machine (Klee), 246-47, 247 Two Children Are Threatened by a Nightingale (Ernst), 250, 250, 316 Two-dimensional media, 14 Two Figures (Menhirs) (Hepworth), 5, 7, 7 Two Girlfriends, The (Toulouse-Lautrec), 5,5 291 Gallery, 242-43 Two Women (de Kooning), 265, 265 Tworkov, Jack: contemporary art and, 260; information for, 2; L-SF-ES-#2, 3; Untitled (Study for View of Bay, Provincetown), 3; Watergame, 3 Tympanum, 91-92, 98 Ulysses in the Land of the Lestrygonians (Rome), 65, 65-66 Unique Forms of Continuity in Space (Boccioni), 238, 239, 316 United States. See also America: abstraction in, 242-43; native art of, 172-73 Unity: defined, 14 Untitled (Calder), 284, 284 Untitled (Haring), 298, 298 Untitled (Martin), 269, 269 Untitled (Reinstein), 183, 183

Untitled (Study for View of Bay,

REMOVED FROM COLLECTION OF PRINCE WILLIAM

PUBLIC LIBRARY

Untitled (We Don't Need Another Hero) (Kruger), 8, 9, 9, 290 U.S. Capitol building (Washington D.C.), 188, 189 Valadon, Suzanne: Blue Room, 200, 201, 201 Value: defined, 12; as visual element, 12 van Eyck, Jan, 121; Giovanni Arnolfini and His Bride, 105, 105-6 van Gogh, Vincent, 211-13, 214, 228, 243; Bacon and, 270; Bridge in the Rain, 182, 183; Chicago and, 257; expressionism and, 230, 232; Japanese art and, 182, 183: Miró and, 252: Mondrian and, 244; New York and, 316; Night Café, 12. 13: Self-Portrait with Bandaged Far. 212, 212; Starry Night, 211, 211, 213, 215, 316 van Rijn, Rembrandt. See Rembrandt Vanishing points, 14 Variety: defined, 14 Vasarely, Victor: Orion, 275, 275 Vasari, Giorgio, 111 Vase painting: in Greece, 49, 58 Vatican Museums (Rome), 75 Vatican Palace (Rome), 75 VB43 (Beecroft), 308, 308-9 Vecellio, Tiziano. See Titian Vedic religion, 175 Velázquez, Diego, 144-46; Bacon and, 270; Goya and, 194; Las Meninas, 145, 145, 311; Rembrandt and, 148; Rokeby Venus, 315 Venice: Renaissance in, 121, 124-26 Venus, Cupid, Folly, and Time (The Exposure of Luxury) (Bronzino), 10, 11, 11 Venus de Milo. See Aphrodite of Melos (Venus de Milo) (Greece) Venus of Urbino (Titian), 124, 124-25, 188, 200, 200-201, 300 Venus of Willendorf (Upper Paleolithic), 19, 19, 37 Venus pudica, 125 Venuses: defined, 19 Vermeer, Jan: Young Woman with a Water Jug, 149, 149 Verrocchio, Andrea del: David, 112, 113, 121, 122, 122-23, 138 Versailles, Palace of (Le Vau and Hardouin-Mansart) (France), 151, 151, 153, 225 Vespasian, 74 Vesta, Temple of (Rome), 74 Via della Conciliazone (Rome), 75 Via Dolorosa (Jerusalem), 43 Video art, 296–98 Vigée-Lebrun, Élisabeth, 153-54; Marie Antoinette and Her Children, 154, 154 Villani, Giovanni, 98 Vinci, Leonardo da, 115, 116-18, 250; on art, 116; Last Supper, 14, 116-17, 117, 118, 120, 126, 187; Madonna of the Rocks, 14, 15, 117, 118; mannerism and, 128; Mona Lisa, 118, 118, 176, 224, 248, 248-49; Titian and, 125; Verrocchio and, 113 Viola, Bill: Crossing, 297, 297 Visible spectrum, 12, 13 Vision after the Sermon (Jacob Wrestling with the Angel) (Gauguin), 213, 213 Vision of the Ball of Fire (Hildegard of Bingen), 94, 94 Visit To, A / A Visit From / The Island (Fischl), 279, 279-80 Visitation scene (Reims Cathedral), 98 99.99 Visual elements: defined, 12-15 Vitruvius, 115 Volute krater, 49

Provincetown) (Tworkov), 3

Volutes, 27, 115

von Helmholtz, Hermann, 209

VWX Yellow Elephant (Ban), 317

Wailing Wall (Jerusalem), 43 Wainwright Building (Sullivan), 223, 223 Waldorf Astoria Hotel (New York), 317 Walker, Kara: Insurrection! (Our Tools Were Rudimentary, Yet We Pressed On), 314-15, 315 Walking Woman (Archipenko), 238, 238 Wall painting, 58, 65, 66 Warhol, Andy, 2, 257; Basquiat and, 280; Blue Movie, 273; Green Coca-Cola Bottles, 273, 273; Hanson and, 282; New York and, 316 Warm colors, 13, 14 Watergame (Tworkov), 3 We Won't Play Nature to Your Culture (Kruger), 290, 291 Weaving: in Greece, 48; in Middle Ages, 48 Weight-shift principle, 57, 58 Weltsch, Robin: "Kitchen," 288 Westbrook, Leslie: Latin American Art, 170 Western Wall (Jerusalem), 43, 43 Westminster Abbey (London), 156, 157.257 Whistler, James Abbott McNeill, 216-17; Arrangement in Black and Gray: The Artist's Mother, 217, 217, 224 White House (United States), 188 White Iris (O'Keeffe), 242, 243 White Temple at Urak and Ziggurat (Sumerian), 22, 23 Whitney Museum of American Art (Breuer) (New York), 254, 275, 284, 316, 317 Winchester (Blake), 299-300, 300 Winsor, Jackie, 285; Burnt Piece, 288; Exploded Piece (before and after), 288, 288 Wohl Museum (Jerusalem), 43 Wojtyla, Karol, 136 Womanhouse (Chicago), 288-89, 289 Women, Art, Power, and Other Essays (Nochlin), 286 Women and Dog (Marisol), 282, 282 Women series (de Kooning), 269 Women Working Wool on a Loom (Greece), 48 Wood, Grant: American Gothic, 1, 5, 5-7,257 Works Progress Administration (WPA), 2,260 World of Awe (Yael), 299, 299 World Trade Center (New York), 303 World War II (Vanitas) (Flack), 274, 274 WPA. See Works Progress Administration (WPA) Wrapped Reichstag, Berlin (Christo and Jeanne-Claude), 295 Wren, Christopher, 152-53, 156; New St. Paul's Cathedral, 152, 152 Wright, Frank Lloyd, 301; Guggenheim Museum, 255, 305, 316, 316; Kaufmann House, 255, 255; Robie House, 254-55, 257, 257 Wrigley Building (Chicago), 256 Yakshi bracket figure, 175, 175 Yoruba masks, 162 Yoruba people: door from Iderre, 161, 161-62; headdresses, 162; ruler of Orangun-lla, Airowayoye I, 162, 162 Young Girl by the Window (Morisot), 205, 205 Young Lady with an Umbrella (Lumière), 207, 208 Young Woman with a Water Jug (Vermeer), 149, 149 Zeitgeist (Berlin), 292 Ziggurat, 22-23